An exhibition organised by the
Whitechapel Art Gallery,
80–82 Whitechapel High Street, London E1 7QX

Whitechapel Art Gallery, London
27 September–26 November 1995

Malmö Konsthall, Malmö, Sweden
27 January–17 March 1996

The Solomon R. Guggenheim Museum (SoHo), New York
mid-June–mid-September 1996

Concept and General Editor

Organising Committee
at the Whitechapel Art Gallery

Editor

Designer

seven stories

WHITECHAPEL

Support of the exhibition in Great Britain

Sponsored by Standard Bank London

A member of the Standard Bank Group of South Africa

Supported by a Pairing Scheme award

Standard Bank London is an award-winner under the Pairing Scheme (the National Heritage Arts Sponsorship Scheme) for its support of the exhibition *Seven Stories about Modern Art in Africa*. The Scheme is managed by The Association for Business Sponsorship of the Arts (ABSA).

Supported by the European Development Fund

The catalogue *Seven Stories about Modern Art in Africa* is supported by The Baring Foundation.

With additional support from The Henry Moore Foundation, British Airways and Afrique en Créations.

Initial research supported by Visiting Arts.

Education programme supported by Tate & Lyle.

Seven Stories is the key modern art exhibition in africa95, a season celebrating the arts of Africa taking place in Britain from August to December 1995

Sponsor's Foreword

Pieter Prinsloo
Executive Vice Chairman

The Standard Bank Group is perhaps a new name to many in the London arts scene. In its home base of South Africa, however, the group is well established as a major sponsor of the arts.

In this field it is best known for its longstanding association with the National Arts Festival in Grahamstown, in South Africa's Eastern Cape Province. The bank first became involved in 1983, since when the Standard Bank National Arts Festival has grown from a small, regional and somewhat parochial event to what is now probably Africa's largest single gathering of performing and visual arts and artists. More recently, the Festival has attracted significant and growing foreign participation, especially from other African countries.

The Standard Bank Collection of African Art, housed at the University of the Witwatersrand in Johannesburg, is among the more important collections of its kind, while the bank's own extensive collection of paintings and sculptures is especially rich in the work of South African artists. Items from the Collection of African Art, as well as the work of successive winners of the prestigious Standard Bank Young Artist awards, are among the high-quality exhibitions to which the public is welcomed at the Standard Bank's own gallery, opened in 1990 in Johannesburg.

As part of a major regional banking institution with a strong commitment to the arts and an African presence extending into 14 African countries outside South Africa, Standard Bank London is delighted to be able to make its own contribution to the africa95 initiative through *Seven Stories about Modern Art in Africa*.

contents

Acknowledgements

Artists

Mohammed Abdalla
Bill Ainslie†
J. B. Alacu
El Anatsui
Kevin Atkinson
Elizabeth Atnafu
Godfrey Banadda
A. K. Birabi
Rebecca Bisaso
Skunder Boghossian
Jerry Buhari
Norman Catherine
Gebre Kristos Desta†
Achamyeleh Debela
Rashid Diab
Ndidi Dike
Erhabor Emokpae†
Ibrahim El Salahi
Ben Enwonwu†
Meek Gichugu
Girmay H. Hewit
Robert Hodgins
Kamala Ibrahim Ishaq
Jacob Jari
B. K. Kaunda
Souleymane Keita
Abdel Basit El Khatim
David Koloane
Wosene Kosrof
Ezrom Legae
Leonard Matsoso
Severino Matti
Kagiso Pat Mautloa
Dumile Mhlaba
Peter Mulindwa
M. K. Muwonge
Hassan Musa
Sybille Nagel
Jenny Namuwonge
Sam Ntiro†
Sam Nhlengethwa
Amir Nour
Gani Odutokun†
Olu Oguibe
Chika Okeke
Uche Okeke
Bruce Onobrakpeya
Richard Onyango
Joel Oswaggo
Tayo Quaye
Issa Samb
Kefa Sempangi
Pilkington Ssengendo
Ignatius Sserulyo
Paul Stopforth
Etale Sukuro
El Hadji Sy
Obiora Udechukwu
Sane Wadu
Osman Waqialla
Zerihun Yetmgeta

Other Contributors to the Catalogue

Tayo Adenaike
Elsbeth Court
Clémentine Deliss
Abdou Diouf
Jeff Donaldson
Salah M. Hassan
dele jegede
Jonathan Kingdon
Pierre Lods
Es'kia Mphahlele
Everlyn Nicodemus
Wanjiku Nyachae
Andries W. Oliphant
Ola Oloidi
Okot p'Bitek
Ivor Powell
Léopold Sédar Senghor

Also

Norbert Aas
Jill Addleson
Jide Adeniyi-Jones
Johanna Agthe
Fieke Ainslie
Funke Akinyanju
Bernard Akpokavie
Jean Allan
Friedrich Axt
Rayda Becker
Simi Bedford
Georgina Beier
Ulli Beier
Sylvia Bello
Berenice Bickle
Carol Brown
Rob Burnet
Michael Caine
B. Calmeau
Alec Campbell
David Carrington
Jeremy Coote
Julius Court
Marie Yvonne Curtis
David Dale
Francisco D'Almeida
Elizabeth Dell
Helen Denniston
Godfried Donkor
Osman Fathi
Girma Fisseha
Kojo Fosu
Alan Furness
Janice Garraway
Mark Gisbourne
Linda Givon
Theresa Gleadowe
Stephen Goldsmith
Monique Goulyetonda
Michael Graham-Stewart
Jackie Grille
Nicole Guez
Tapfuma Gutsa
André Mainersma
Malcolm Hardy
Elizabeth Harney
Jane Havell
Rebecca Hossack
Stanley Ifamene
Rose Issa
William Karg
Anna Kindersley
Zuleika Kingdon
Afolabi Kofo-Abayomi
Erica Kruger
Atta Kwami
David Landau
Jay Levenson
Robert Loder
Tim Llewellyn
John McAslan
Ann McEwen
Lindsay Macmillan
Marilyn Martin
Natalie Morphet
Abigail Moss
Stan Moss
Usman Mu'azu
Donald Munro
John Nance
Francis Nnaggenda
Sune Nordgren
Annabelle Nwankwo
Felicia Onibon
Patricia Pearce
Patrice Peteuil
Les Phillips
John Picton
Pieter Prinsloo
Lorna Raby
Elizabeth Rankin
Colin Richards
Ian Rogers
Kristian Romare
Sue Rose
Rose-Marie Rychner
Sarenco
Margaret Saville
Ruth Schaffner
Diederik Schönau
Bouna Medoune Seye
Warren Shaw†
Bisi Silva
Penny Siopis
G. T. Sirayi
Sunmi Smart-Cole
Sultan Somjee
Lesley Spiro
Anthony Sprake
Janet Stanley
Kate Stephens
Djibril Sy
Kalidou Sy
John Talbot
David Tate
Hamdel Tayeb
J. F. Thiel
Adrian Thomas
Andrew Thomas
Suzanne Tise
John Udeh
Ekpo Udoma
Elaine Unterhalter
Alessandro Vincentelli
Claire Whitaker
Roger F. L. Wilkins
Pat Williams
Roger Williams
Stephen Williams
Liz Willis
Felicity Wright
Ahmadu Yakubu

Whitechapel Staff

Maya Alexander
Norinne Betjemann
Grace Boylan
Lucy Crowley
Emma Davidson
Judith Digney
Andrew Gault
Catherine Granaghan
Nicky Hirst
Denise Hurst
Rebecca Hurst
Juliet Ireland
Joanna Jones
Ursula Kossakowska
Janice McLaren
Alex McLennan
Jon Newman
Urve Opik
James Peto
Jill Porter
Jane Sillis
Mark Sladen
Deborah Smith
Kate Storey

Foreword

Catherine Lampert

The subject of contemporary African art is surrounded by a steadily expanding atmosphere of receptivity, respect and polemics. As the professional art world in the west begins to absorb information about what has happened across the continent and in the diaspora, nuggets of experience are translated, sometimes over-hastily into a generalised view, and – with an increased rate of exchanges, collections and exposure – inevitably after promises come divisions and much ground still to cover. Notwithstanding such knowledge, this exhibition, *Seven Stories about Modern Art in Africa*, has been organised with the confidence that, by listening first to the personal viewpoints of distinguished African artists and curators, attention will be directed to the serious achievements of artists, both those working as individuals and those who have contributed to movements.

A further belief is that by showing the exhibition in public galleries which genuinely welcome a broad audience there will occur strong and unexpected responses which extend the dialogue beyond the art profession. The startling and subtle achievements of African painters and sculptors merit future invitations extended on the terms offered to artists nearer to home. From this ever-widening exposure, it should follow that young audiences will become as familiar with and sympathetic to the visual arts in Africa as they now are with its music.

The exhibition has been deliberately planned on a relatively modest scale, for spaces that best accommodate the seven stories, each admittedly distilled. In consequence it

seeks to avoid the numbing effects of a more neutral survey, or those exhibitions where material is selected according to categories and a perspective that conforms to practice in the west. To balance the concentration on just 'seven' stories, a broader, more documentary view emerges in the publication. Its contents extend the geographical area, address theoretical issues and provide background information through the essays, interviews, reprinted material and notes, the voices interspersed with images. In each venue the opportunities for performances, symposia, workshops and unstructured gatherings of people should facilitate dialogue, not least between Africans, helping to overcome artistic isolation which is intensified by sheer distances.

The introductory essay by Clémentine Deliss describes the origins of africa95 in the seminars she organised with the School of Oriental and African Studies, London, in 1991. The following year the Whitechapel greatly welcomed the idea of continuing to the present the historical story of African art which the Royal Academy was preparing. From the research visits Clémentine Deliss made and her preliminary concept came the invitations to a forum in autumn 1993 and, shortly after, decisions on the approach and those who might be commissioned to act as co-curators.

The Whitechapel's initiative took account of the longer history of the representation of African art in the west and its many proponents. Since the fifties, ambitious young African artists have arrived at foreign art schools; those from Anglophone countries were linked especially to the Slade, the Royal College and Goldsmiths', while many have remained for long periods in Britain or Sweden, France, Germany and the United States. A number of small galleries have shown work over the years and there have been projects which did not come to fruition, such as the Hayward Gallery's plans associated with Festac in 1977, and others like Rasheed Araeen's *The Other Story* in 1989 which set a context. In a way, the postponement to 1995 and the association of the exhibition with the nationwide event of africa95, has allowed responsibility to fall to a particularly confident younger generation of artists/curators, who acknowledge the determination and talent of their post-independence mentors while feeling free to exercise hindsight.

Their well-informed judgements do not operate, of course, in a vacuum. As the Tanzanian artist Everlyn Nicodemus cautions in her essay: 'We are circumscribed by wishful shortcuts and by prefabricated notions attached to Africa as a construction and to Africa as a projection of the world's dreaming and its longing for exotics.' By focusing on the art itself, this familiar question of Africanity and its relation to 'traditional' or 'tribal' culture has to be reassessed. Gradually, the romantic authenticity automatically associated with the 'untrained' artist has become an exhausted assumption, except in the media and among some collectors. Indeed, the curators and galleries participating in this exhibition have chosen an approach that welcomes educated and intellectually rigorous thinking and acknowledges African art as being cosmopolitan while at the same time its content may abound in local and personal references.

One of the salutory consequences of seeing African art in a western context is the offering of new models and alternative aesthetics. Some of these clash with the mode and moulds current in art valued in the west, and indeed the monochromic, pristine aesthetics and expected individuality. The five co-curators themselves chose contrasting structures: several organise the art along narrative or thematic lines, and others have assembled elements in order to reconstruct them in a new environment. Similarly, an equilibrium is shown between the essays in the 'Stories' section that rely on the visual syntax created by the images, such as El Hadji Sy's and Chika Okeke's, and the contributors to the Nigerian 'Recollections' who give historical accounts of complex cross-references. Recounting the origins of these movements reminds us of the determination of artists living in Nairobi, Dakar, Washington D.C. (through AfriCobra) and elsewhere in the seventies and eighties

to avoid the élitist post-colonial gallery system by making and showing art in the street. Especially in Africa, one finds that some of the most radical art began with collective endeavours, at times identified with memberships, manifestoes and magazines.

It is familiar in catalogue forewords to describe the sacrifices and struggles of artists, especially when young and unknown, to make work, and equally the dedication and cooperation of those involved in preparing exhibitions. Even the relatively brief experience of working to prepare this exhibition, placed in the context of many years' experience of other complex projects, puts in perspective the endeavours of those who contributed, both for myself and for my colleagues, especially Felicity Lunn, the other Whitechapel curator responsible for *Seven Stories*. The contributors stand as heroic and deeply generous. Their dedication begins, for most African artists, with the lack of financial underpinning or infrastructure by the state and the tourist-oriented market, which puts unusual pressure both on the making of experimental art and on the means of preserving it. Negotiating one's way with integrity amidst local political agendas is often treacherous, exile is at times unavoidable, while travel to Europe and America is routinely hindered by obstacles to getting visas and passing unchallenged through immigration. At a more mundane level, the channels of telephones and faxes fail and there have often not been enough funds or people to ease the arrangements.

Our gratitude is also directed to those who have given financial and practical support. Initiating communication and gathering visual records was rightly extended over several years. The viability of this exhibition depended on help: Robert Loder's steadfast encouragement; Visiting Arts grants for research and the forum, and africa95 whose assistance brought essential contacts to the Whitechapel, not least the sponsor Standard Bank London, whose support has been matched by the ABSA Pairing Scheme award. We have also benefited greatly from the support of The European Development Fund, British Airways, The Baring Foundation for the catalogue, Afrique en Créations, Tate & Lyle for the education programme, and the Henry Moore Foundation. In collaboration with the Institute of International Visual Arts (inIVA) we have produced a resource pack. It also gives the Whitechapel great pleasure to work together with the other museums that will be hosting this exhibition: the Konsthall, Malmö, Sweden, and the Solomon R. Guggenheim Museum, New York.

In the acknowledgements on page 8, the gratitude that is extended takes account of these conditions, and is made not only in the name of the Whitechapel but comes also from Clémentine Deliss, Elsbeth Court and the five co-curators: Dr Salah Hassan, David Koloane, Wanjiku Nyachae, Chika Okeke and El Hadji Sy. In the early stages we benefited from the experienced advice of Kojo Fosu and Ulli Beier, and are also grateful to Etale Sukuro for his help in initiating an approach to the representation of art in Kenya. Similarly, Bruce Onobrakpeya offered very welcome advice on the Nigerian section, and Jacob Jari extended to Zaria and a younger generation information and practical help which assisted Chika Okeke. It should go without saying that the Whitechapel and the other venues in turn thank the curators for undertaking such demanding work, which necessitates invidious choices. The vision, intellectual curiosity and warm friendship of all, especially demonstrated by Clémentine Deliss's unflagging dedication, has set the tone and the standards. Listed are some of the people (and we apologise if we have inadvertently omitted others) who shared their scholarship, contacts and many other kinds of expertise, not necessarily because they were integrally involved in the exhibition or publication but because they wished to see the ignorance and prejudices that still exist defeated by the reality of the achievement. They include those who have lent works for a year-long period, many of which qualify to be considered part of the national patrimony.

Above all our debt goes to the artists.

7+7=1: Seven stories, seven stages, one exhibition

Clémentine Deliss

The exhibition for our times is indeed one that truly celebrates the bounty of styles, themes and exploratory verve from a continent where every act or product of the imagination is always conveniently summed up by the word 'African'. Yes indeed, there is an entity called 'Africa', but the creative entities within its dark humus – fecund, restive, and protean – burst through the surface of a presumed monolithic reality and invade the stratosphere with unsuspected shapes and tints of the individual vision. Wole Soyinka[1]

When the exhibition *Seven Stories about Modern Art in Africa* was devised in July 1992, it proposed to do two things: first, to provide a series of personal interpretations, by artists and historians from Africa, of specific movements or connections which have significantly qualified twentieth-century modern art in Africa and, secondly, to experiment with the idea of the exhibition as a pooling system for a plurality of approaches to curating, that run in tandem with the specificities of the works on show and that signal different ways of making, looking at and presenting art. It acknowledges and highlights the African flow in the cross-currents running between Europe and Africa in this century, focusing on their translation into the visual arts through the experiences

of leading artists and movements in Nigeria, Senegal, Sudan, Ethiopia, South Africa, Kenya and Uganda. The catalogue complements this visual articulation, with a number of seminal manifestoes from the late 1950s onwards, as well as new texts by artists, critics and historians from Africa and the African diaspora. A close focus on specific moments in the recent modern histories of art in seven African countries and a reinterpretation of these dynamics through a personal and often engaged relationship is aligned to the notion of a reconnaissance, with all the partiality that term implies. As a consequence, *Seven Stories* has emerged as a set of seven fragments offering individual perspectives on the visual arts of Africa, sourced as often as possible from the artists' points of view and inserted into a visually constructed and nearly theatrical frame. The gallery provides seven temporary stages, upon which each co-curator has created constellations of key works by many artists whose work has not been seen in such a specific and personalised context before. The exhibition is not intended to be comprehensive or complete in its narratives, but invites audiences to experience a small part of the conceptual and aesthetic manifestations of the visual arts in Africa during the second half of the twentieth century.

The first steps towards devising *Seven Stories* began in late 1991 when the School of Oriental and African Studies enabled the art historian John Picton and me to set up a three-month series of interdisciplinary seminars and discussions around contemporary African art and criticism.[2] These seminars and artists' talks were attended by African and African-descent artists either resident in the UK (e.g. Sonia Boyce, Olu Oguibe, Sokari Douglas Camp, Pitika Ntuli) or passing through (David Koloane, Ato Delaquis), as well as historians, independent critics and administrators from institutions such as the Arts Council and the Institute of Contemporary Art.

It was a time of exposition and growing awareness of the arts currently being practised on the African continent, and it coincided with a number of large-scale exhibitions in Europe and the USA that presented African art as part of global post-modernism.[3] Suddenly, Africa's arts were no longer dormant or even extinct.[4] The creative energy expressed through 'tribal art', the one area of the international art market in which Africa provided a lucrative cultural commodity (effectively controlled from the outside since the turn of the century), was in question. Contemporary African arts were generally seen from a 'tourist' or 'popular art' idiom; the idea that there was real talent was not dismissed, but more often relegated to the living rooms of expatriate diplomats and Afrophiles.

The growing surge of international interest in the late 1980s in new work from Africa immediately exposed the lack of published and easily available information. The curatorial and museological pendulum of African art exhibitions in Europe and America continued to swing unsatisfactorily between the anachronisms of 'ethnographic' models and market-inspired, glamorous, bijou displays of 'tribal art' closely courted by private dealers.[5] The first-hand involvement of artists and critics practising today in Africa barely featured at all in the new wave of interest, and Africa's contemporary art became just one more artifice in the fashion for thematic and curator-flavoured shows. When artists from Africa were included in the Paris exhibition of 1989, *Magiciens de la Terre*, they were selected without the organisers having adequate knowledge of the complexities of the art discourses relative to the works' socio-political and conceptual make-up in Africa over the last eighty years.[6] This period – corresponding to modernist and post-modernist tendencies in Europe – was by no means underdeveloped in the African context. A number of powerful wellsprings and cross-connections linked artists from the east of Africa to the west and south, and beyond the north to Europe and the USA. The cumulative effects of exploitation and colonialism over several hundred years, the

destruction of cultural and religious values by missionaries among African peoples, the extensive looting of African art, and the tumultuous post-independence periods that impacted on art production during the 1960s, may have affected the ability of the art infrastructure in several African countries to interact within the international mainstream, but it did not reduce the expectancy and intentions among practising artists.

Indeed, the majority of texts in circulation on twentieth-century modern art in Africa were produced by Europeans or Americans between the 1940s and the 1970s, and were few and far between.[7] The dilettante flavour of the European art patronage system in the Africa of that period meant that most works were purchased by diplomats, voluntary service workers and tourists whose amateur enthusiasm encouraged a particular projection of African art as isolated, untutored and expressionist rather than deeply intellectual, agitational and in dialogue with several cultural partners, including artists working in other parts of Africa, Europe and the USA.

In 1984, the Museum of Modern Art in New York presented *Primitivism in Twentieth-Century Art*, marking the beginning of an international transformation of the conventional 'tribal art' model from the formalist stasis to speculation in a new art from Africa. This art would be fused with the pop culture of global industrialisation while retaining the associative spiritual qualities of Africa's past. Moreover, it could now be introduced in its own right as contemporary work and interpreted beyond the tropes of early modernism in which 'elective affinity'[8] had connected Europe with Africa. In an élan of discovery, *Magiciens de la Terre* and its offshoot *Out of Africa* brought to the fore artists such as Cyprien Toukoudagba and Esther Mahlangu, whose 'African' iconography was unmistakable and showed no contamination from European modernist sources that might have been received from the African art college system (excepting only that the medium was recast from murals to paintings on pre-purchased calico and wooden stretchers, to enable easy transportation and display). Collectors who neither knew Africa nor were ready to engage with the problematics of the local art critical situation could effectively begin to build up an important body of work characterised by its foolproof graphic 'Africanness', often connected with folk or religious activities rather than a distinctive and selfconscious art practice. While this bias could be supported by the argument of individual taste on the part of the foreign patron, it led, in the context of the late 1980s and the rekindling of European and American curiosity, to the canonisation by default of a disparate grouping of artists with little personal or practice-based interconnections. Exhibitions such as *Out of Africa* drew more criticism for their style of curating and selection than for the works on show, which all too often missed out on analysis, rather as if their distinction was the immediacy of their impact and the non-intellectualism it implied. An increasingly artificial division began to appear between academic and self-taught artists. Although this was a response to the reality of becoming an artist in Africa (as elsewhere), it was extended into a framing device to establish the criteria of a new authenticity, quality and, ultimately, marketability for a western-led audience suddenly keen on 'zippy, energetic, narrative billboard art'[9] or 'le look africain'.

This approach failed to acknowledge that since the beginning of the century artists from Africa had travelled to Europe to study, imbibing and responding to early modernist experiences and redefining their various sources in the light of their respective home environments both in Africa and elsewhere. The much-referenced pioneer artist from Nigeria, Aina Onabolu, succeeded in introducing art education into primary schools in his country in the early 1920s and in dedicating himself to naturalist portraiture, actively contradicting colonial perceptions of Africans' inability to paint. Today, Onabolu is a beacon figure in the recognition of the two-way traffic that has existed in the arts of Africa and Europe throughout this century.

In Uganda and Nigeria, fine art colleges based on the countries' colonial counterparts (in this case English) emerged as early as the 1940s and rapidly spread throughout the continent. Independent initiatives set up by expatriate Europeans in the 1960s in the form of workshops created a counterflow of auto-didactism and a particular genre of painting, sculpture and printmaking that seemed, as time went by, to place itself further in opposition to the post-colonial African art academy. In Nigeria, the contrast between the Oshogbo artists gathered around Suzanne Wenger and Ulli and Georgina Beier, and the concurrent efforts of the artists at Ahmadu Bello College in Zaria in the north to establish an autonomous base in the context of a newly gained independence and a history of disempowerment and resistance, is emblematic of the conditions that run throughout the modern history of the visual arts in Africa. While African artists were beginning to transform and make their imprint on the art colleges in Africa in response to a new post-colonial identity, art amateurs living in Africa were presenting a more unorthodox and bohemian approach, in line with European post-war liberation. In addition, numerous pan-African art fairs led to contacts between artists right across the continent, and a close reverberation between art and political intent.[10]

The international visibility of the various African avant gardes has been overshadowed by a potentially racist view of African artists as being unable to construct themselves vis-à-vis their work and dangerously derivative of Europe if exposed to its art systems and, in particular, its academies. The *Out of Africa* exhibition took this art-educational distinction as a central criterion in launching the new wave of contemporary African art; together with the American exhibition *Africa Explores*, which set up an equally stifling categorisation of art practice in Africa, it helped to entrench arguments about the pre-eminence of the self-taught over the academic artist, and of the popular over the international.[11] In effect, the reality was a situation not much different from the multifarious forms of art production and their respective discourses in the west, whereby a huge diversity of expressions co-exist, fine-tuned to different audiences, some of which interlock and engage with the international mainstream. If we were witnessing in the early 1990s in Thomas McEvilley's mind an 'erosion of boundaries' whereby the 'world's cultic ambience' was 'diminishing' or at the least its membership had 'broadened dramatically',[12] then this phenomenon of post-modernism was itself founded on the earlier 'border-crossings' of artists to and from Africa, Europe and the USA.[13] Viewed from African shores, these cross-currents are integral to an understanding of Africa's modern art movements, its cycles and generations, which are historically entwined with Europe and the USA as well as with various pan-African and nationalist incentives at home.

The 1991 seminars at SOAS greatly informed the conception of *Seven Stories about Modern Art in Africa*. In 1992 the Whitechapel Art Gallery in London became the first institution in the UK to support the Royal Academy of Arts in developing the africa95 season of events. As a result, the small africa95 nucleus of which I was a part[14] received generous assistance from the Visiting Arts of Great Britain with the brief that I should pursue these discussions directly with artists in several African countries, including Senegal, Côte d'Ivoire, Ghana, Nigeria, Kenya, Uganda, Ethiopia, South Africa, Zimbabwe, Zambia, Mozambique, Morocco and Tunisia. These discussions were to inform an 'artist-led' approach, which became not only the lead characteristic of africa95 but an integral part of the methodology of the exhibition. Several meetings centred on how one might devise collaboratively an exhibition in the UK which reflected the memories of past movements in Africa through the dynamics of current conditions, involving artists directly in the curatorial process. The readiness of the gallery to prepare the exhibition on a long-term basis, with the involvement of several consultants and co-curators from

Africa, allowed adequate scope for what was clearly going to be a complex process, in many respects the first of its kind. Research revealed far more material than could be adequately exhibited in the available space. Given the focus on distinctive artists' movements and dynamics in Africa, seven episodes were identified which, although they could not represent the continent as a whole, were nevertheless emblematic of a common sensibility among other artists and movements in Africa at the time.

In October 1993, *Seven Stories* began to be moulded at a critical and visual round-table forum, which triggered the process of communication between the co-curators from Africa and the gallery, and continued throughout the following two years. Apart from a general exchange of information, different curatorial strategies for each section began to be formulated, and the necessary logistical structure was set in place to identify artists and their works.

Several leading artists and historians from Africa participated in the forum, including Prof. Kojo Fosu from Ghana; Dr Salah Hassan, originally from Sudan but currently based at Cornell University; the painter and curator El Hadji Sy from Senegal; Etale Sukuro, responsible for 'art to the people' crusades in Kenya, and David Koloane, a leading black South African artist involved in a number of watershed movements during apartheid. Ulli Beier, the German protagonist of the Mbari Club in Oshogbo, gave first-hand experience of his relationship with artists in Nigeria in the 1960s and thereby enabled the forum to engage directly with issues surrounding early European art educational initiatives in Africa. He stressed that these workshops were not academies, and that he did not impose models on his students but sought to discover and criticise together with them.

Such European initiatives form an intrinsic aspect of Africa's modern art history. Strong parallels can be found between the visions of the Frenchman Pierre Lods in the Congo and Senegal, Julian Beinart and Pancho Guedes in Mozambique, Frank McEwen in Zimbabwe and Cecil Skotnes and Bill Ainslie in South Africa.[15] In their own manner, these figures contributed catalytic energies to the formation of the arts in Africa in the late 1950s and 1960s, with effects that have lasted well into the 1990s. Frank McEwen's passion for stone sculpture has created an exceptionally lucrative art market in Zimbabwe, with works being transported worldwide at huge cost by outside collectors, keen on the autochthonous qualities of the stone and the gentle features of the carvings. Other 'schools', such as Poto-Poto in the Congo and Oshogbo in Nigeria, have lost the energy of the early days. Several of the original art educators in Africa, including Pierre Lods and Frank McEwen, have died. For *Seven Stories* to work in 1995 and speak of the modernist experiences on the African continent, the questioning of the interchange between artists and art infrastructures in Africa and their Euro-American counterparts would clearly form part of its composition.

What the forum finally exposed was the need for a far greater circulation of information on the materials, perceptions and models of art practice within the various artistic communities in Africa and beyond its shores. The sheer scale of the African continent and the cross-currents which link its artists at home and abroad could not be given justice in just one exhibition, inevitably limited in time and space. The selection of the seven stories was made after careful consideration and consultancy with numerous artists and historians in Africa and the UK. The final choice of locations depended on the intensity of the dynamic or on connections which grew out of them and the possibility of identifying works in good condition that could play parts in telling the tales. Alongside this catalogue, the reconstruction of recent history would have to succeed through visual means in the first instance, introducing key works to create a resonance around others and through these counterpoints transform their significance into memories for the

future. The narrator and actor would be combined: the artist would tell the story through direct intervention in the gallery site. The involvement of artists from Africa as curators and intellectual observers is an essential aspect of the exhibition's storytelling process. David Koloane, Etale Sukuro, El Hadji Sy and Chika Okeke had all themselves been part of the kind of artist-led initiatives that they were proposing as curatorial focus points.

This organic proximity to the subject, its thesis and practicability in visual terms, is one of the exhibition's most vulnerable yet experimental points of entry. 'As cultural forces drift into new conformations that will not yet hold still long enough to be inspected, the artist proposes a sign system for the future that is necessarily dark, oracular and ambiguous,' wrote Thomas McEvilley in 1992.[16] While one might question the mythologising connotations of the term 'oracular', as emblematic of western presuppositions that the artist in Africa is still bound to ritualistic and spiritual practices, the pre-eminence of the artist's role is an essential part in the weighting of a new interpretative configuration, to which McEvilley alludes and within which Africa plays a major part today. 'Oracular' suggests that the artist can, following Franz Fanon's words, be the new visual communicator, and art the 'mouthpiece of a new reality in action'.[17] The models offered by artists today cross over practical and ideal registers, taking their cues from the immediate histories within which their art has evolved yet extending these into propositions for a wider, literally international circulation, where the relationship between the artist and audience is heightened and called into question.

The spotlight on the artist as storyteller and visionary for the people is not new. Artists in Europe in many instances in the twentieth century have affiliated themselves with causes which, while being essentially aesthetic interventions, have carried messages of a collective will to implicate oneself in the cultural politics of the country. The Futurists, Dadaists, Surrealists, Vorticists, Constructivists and Situationists are examples of selfconscious, 'naming or self-named' groups that ran into alignments with contemporary political currents, ranging from fascist tendencies to more anarchic forms of organisation.[18] In the USA, AfriCobra, the 'African Commune of Bad Relevant Artists', was formed at Howard University, Washington, D.C., in 1967. Based on an Afrocentric impulse, AfriCobra was one of the most influential groupings in the USA. It declared a merging of African with African-American stylistic elements in the service of an ideology of civic and aesthetic liberation. Its membership included Jeff Donaldson, Dean of Howard University, the Sudanese sculptor Amir Nour and the Ethiopian artist Skunder Boghossian, as well as a number of African-American artists. Salah Hassan has explored this transatlantic lifeline in his 'Khartoum and Addis Connections' (pages 102–39) and Jeff Donaldson responds to the AfriCobra philosophy of art and existence (pages 249–51). On the African continent this proximity of art and politics can be recognised in a number of artist-led initiatives in the early 1960s – in Nigeria and Senegal, for example, or later in the 1970s and 1980s in Sudan, Kenya and South Africa.

Movements or collectives with notions of self-management and concern about audience isolation can lead to social breakthrough by generating cultural and artistic crises. This understanding connects the activist notion of art as contact and communication with the reinstatement of the artist, whose performance and identity are central to the group's public agitational expression on an individual as well as a collective level. Issa Samb, critic and philosopher of the Laboratoire Agit-Art in Senegal, recognises the earlier social role assumed by the artist in the post-independence period of the 1960s and 1970s in West Africa. Today, he suggests, the issue is no longer solely that of the political position of the artist in the urban environment of the new nation–state, but revolves instead around making art and the discussion and interpretation of it. There has been a fear of returning energy back to objects in Africa, and all experimentation in

creating new object–relationships has been diverted. Museums have emasculated their social power; whereas international investment in the music of Africa is desired, the perceived value of the material object is still muted.[19]

The Laboratoire Agit-Art corresponds in great part to this notion of the socialisation of an aesthetic, in the form of an activist avant garde that inserts itself within the wider cultural discourse of Senegal but refuses to follow its institutional and formal criteria. It was set up by artists in Dakar in 1974 as a multi-purpose and cross-media site, around which they could come together and experiment. The strongly performance-based aspects of the Laboratoire's activities over the last twenty years have transformed painting and sculpture into operational activities intended more as ephemeral statements, aesthetic and conceptual trip-wires, than as permanent objects of contemplation. In a courtyard at the back of a house off Dakar's central avenue, a table and chairs are available for anyone who wishes to stop, pass time and enter into dialogue.[20] Aphorisms and interjections are chalked on an old school blackboard which hangs off a tree. The Laboratoire's activities are imprinted with Dakar's daily life, the deforestation of the Xelcom region of Senegal and the Sét Sétal graffiti initiative to clean up the city.

El Hadji Sy (alias El Sy) is responsible for the visual arts activities of the Laboratoire, and in his additional capacity as actor and stage designer has contributed substantially to the model of a non-text-based intervention that characterises the Laboratoire's philosophy of gesture and articulation. In an experimental piece, a group of masked and mummified actors interpellate a swirling painting by El Hadji Sy (see cover), taking their cues from the gestures codified in the details of the strokes and drawing in other objects and people from the Laboratoire as social and aesthetic bodies (see pages 98–99). In silence, these objects of performance and the responses they incite represent an ongoing engagement with, and reaction to, the Senghorian philosophy of Negritude with its specification of poetry as the soul of all art. They also remind one of the concept of theatre of the French visionary Antonin Artaud, in which 'puppets, enormous masks, objects of unusual proportions will appear by the same right as verbal images to emphasise the concrete aspect of every image and every expression.[21] Artaud's gestural language of the stage corresponds closely to the Laboratoire's sense of immediacy as he writes, 'we shall not perform any written plays, but shall attempt to create productions directly on stage around subjects, events or known works. The very nature and arrangement of the room require spectacle and there is no subject, however vast, that can be denied to us'.[22] On the open stage of the Laboratoire, objects rather than words become operational within a temporary setting; actors take their cues from cloth mannequins, wire sculptures, paintings and banners hung on trees. This 'theatre without the verb' suggests a realism rooted in mediatic action, a masquerade of ongoing recuperation in which the architectural vocabulary of the space is ultimately secondary to its operative fluency. While the original Laboratoire carries years of patina and traces of encounters, the curatorial transformation of its precepts in the gallery is an appropriate transference in today's setting. You shift site, and in dislocating the stage you tighten its propositions and question the contraflow between the local cultural context with its own audiences, and the new engagement that may be possible with visitors to the gallery.[23] Similarly, the decrepitude of the Laboratoire's art works – constructed out of paper, rice-sacking, metal sheeting, wire and discarded household items – is secondary to the potential of trans-ferring their meaning to a further support structure.

El Hadji Sy's story is not a survey but a conversation piece between important strands in Senegalese art today, caught midstream in the current of a new sensibility. In it, he takes the Laboratoire Agit-Art as the focal moment and intercuts its historical

reconstruction with Souleymane Keita's round paintings. Keita – whose work appears to be closely connected to the formalist qualities of the Dakar School, the more conventional genre of painting that emerged as a result of Senghorian art policies – needles the Laboratoire's frayed edges and reverses the element of homage into a contemporary dialectic between painting and surface. His circular canvases are, in effect, like deep black holes into the sea off Gorée Island where he lives and works. Through Keita's telescope we see amorphous strands of colour, the tails of organisms flitting across space and the fish-hook hieroglyphics of cultural memories, African memories buried deep in the sea-bed of this ex-slave-trading island off Dakar's shores. Against these circular forms or 'marbles', El Hadji Sy places an enlarged NASA satellite photograph of Africa, creating a polarity between the vision of the past and the future with this man-made representation of the continent at the centre. His curatorial strategy in the installation of this section involves a return to the relationship between the body of the works within the physical space of the human being. At every point in the gallery space, an object of performance interpellates one's active movement, shifting the dominant perspective from a single site to a temporary series of visions.

For El Hadji Sy, the dislocation of discrete art works from the actor who engages with them and from the neighbouring environment of other objects is only one view of exhibiting. In photographing his own work, the compilation and arrangement of separate pieces, oil paintings, rice-sacking and trapped objects defy the single frame and conventions of distinction. The language he proposes rests on a visual syntax. He places rice-sack paintings on the floor, hangs them off the wall, layers oil paintings over their coloured surfaces, thereby dispelling the standard border of white neutrality around a discrete work. A group of 'trapped objects', made of blocks of wood caught in sacking, draws the wall hangings out into the open space of the room, extending volume, colour and line. At moments like these, his paintings and sculptures become part of a conscious move to decentre our vision of art. His body is never far away: to photograph the art works is to frame not only a juxtaposition of different pieces but the figure of El Hadji Sy himself as part of the act. This is more than an installation; it does not rely predominantly on the frame in which the work is shown, but on the object itself becoming an extension of the person's own space.

Chika Okeke, who presents 'The Quest: from Zaria to Nsukka' (pages 38–75), looks at the movements of artists within different centres in Nigeria. The circuit he proposes is triangular in shape, spanning key works by artists such as Ben Enwonwu and Erhabor Emokpae based in Lagos in the late 1950s and early 1960s, to artists' movements at the university towns of Zaria in the north and Nsukka in the east. He follows the trajectories of Uche Okeke and Bruce Onobrakpeya and contrasts their early initiatives and work with that of the young generation of Nigerian artists today.

1959 was the year in which the Zaria Art Society at Ahmadu Bello University in the north of the country came together as a group, declaring its intentions to perform a 'natural synthesis' for the future from the many histories of art that had been witnessed in Nigeria since the beginning of the century. In Chika Okeke's words, the Zaria Art Society, which existed concurrently with the winning of Nigerian independence, was in effect 'marking a shift from its earlier ambivalence to a more clear-cut, indigenous centre drawing on ideas from the more peripheral west.' Other artists in the south of country equally sought a form of conceptual interaction which would best reflect the changing social and cultural configurations emerging with independence. The semi-abstract paintings of the early 1960s by Erhabor Emokpae, an enigmatic artist who later moved into large-scale wood sculpture and died in the mid-1980s, are strong indications of the intersection of methods and new approaches to materials. An impressive sculpture by

Emokpae stands in the centre of the gallery that forms part of the National Theatre complex in Lagos. This three-metre tall stylised body is covered from top to toe with 'kobo', the smallest denomination of Nigerian currency, and cowrie shells, which once signified so much in the circulation of goods and people within and beyond Africa.[24] Emokpae's work in paint shows a graphic translation process from the line of three-dimensional carving to the volume of a flat plane. He returns again and again to highly loaded icons from the cowrie to the handprint, to blood, the cross and the calabash, the swastika and the act of sex. In his essay on Emokpae, dele jegede sheds more light on this artist whose early paintings are the key to an understanding of 1960s modernism in Nigeria.[25]

Of the same generation, Bruce Onobrakpeya, who was a leading member of the Zaria Art Society, attempts to occupy the space of representation between relief and imprint, building upon the negatives and positives of the printmaking process. The breadth of his vision, combined with his detailed archival research on the folktales and iconography of Urhobo and Benin art, is an ongoing preoccupation with the past and the present, enabling him to confound time and its cultural references as he recasts earlier plates, builds shrines and columns from resin and splashes their core with acrylics. Onobrakpeya, recognised as one of the most important artists in Nigeria this century, has provided, through his gallery and museum in Lagos, important learning facilities and printmaking opportunities for the younger generation of artists in Nigeria such as Tayo Quaye, who is now resident in Kaduna in the north and is part of the new Zaria grouping around The Eye.

From the formation of the Zaria Art Society, Chika Okeke introduces a movement in time and space to the far east of the country and the University of Nigeria at Nsukka. There, the Igbo sensibility which Uche Okeke[26] had explored while still in Zaria is taken one step further in the 1970s by Obiora Udechukwu, the Ghanaian El Anatsui, and several others including Chika Aniakor and the historian Ola Oloidi. Against the 'din of war' (Chika Okeke) from neighbouring Biafra, they form a cultural group and create *uli* (an Igbo word for women's body painting), which quickly becomes the quintessential idiom of Nigerian contemporary art, spanning two generations and infusing contemporary painting, sculpture, poetry, art criticism and musical composition with Igbo thought and culture. He concludes this trail with a return to Nsukka and Zaria today, where another society, that of The Eye, has succeeded in grouping artists in the north of Nigeria once more. Originally gathered around the painter Gani Odutokun, who died tragically in a car accident at the beginning of 1995, The Eye will hopefully continue to provide the energy generated by its original nucleus. The works of Jacob Jari, editor of *The Eye* journal, and his fellow member Jerry Buhari are significant in that they combine the experimentation in painting that characterised Odutokun's own work with conceptual mechanisms specific to their practice in Nigeria as artists in the 1990s. Jari's cornstalk paintings are not only about recuperating cheap materials from the immediate environment, they act as graphic inserts or pixellated mosaics of Nigeria's visual landscape. In a similarly energetic way, Chika Okeke's paintings resemble a series of cartoon scenarios, *Marvel* comics transposed on to the mythologies of contemporary existence in Nigeria.

Chika Okeke's story of 'The Quest' is only one of the many narratives that could have been proposed on the richness and diversity of the visual arts in a country as huge and as populated as Nigeria. The storyline was developed in consultation with Jacob Jari and Bruce Onobrakpeya, who provided enormous assistance in confirming the sense of purpose that motivated earlier groupings such as the Zaria Art Society. It can be read from many angles, according to where one joins the trail and, although the sense of

reduction is inevitable given the limitations of the gallery space and the elaborate histories of modern Nigerian movements, the works on show testify to the complementary sensibilities and wealth of references of the artists and their works. 'The artists presented here are like masquerades,' concludes Chika Okeke. 'As we have seen, they continually change their interests, attitudes and techniques as dictated by their individual enquiries into the nature and essence of art, or due to associative influence from other artists. Each artist is a masquerade in the arena, performing before an active audience.

Chika Okeke's references to masquerading and to the classical art of Igbo, Urhobo and Benin introduce the central issue of the relationship between past artistic traditions and current practices in new work from Africa today. As both Ola Oloidi and dele jegede confirm in their essays, the early impetus among artists of the 1960s in Nigeria was not one that drew its dynamism predominantly from past practices in masquerading, sculpture or two-dimensional art. Indeed, it emerged, says jegede, in antithesis to traditional art and defying existing categorisations along the axis of 'tribal art' and ethnic affiliation. Modernity in post-independence Nigeria would infuse new principles into the arts and speak to a new set of audiences. The recent nationalist governments needed art to 'consolidate the identifying bonds of kinship and nationalism among the varying ethnic compositions of their new nations.'[27] Consequently, direct lineage between so-called 'traditional' and 'contemporary' arts in Africa is a debatable issue.[28] In his book, *Twentieth Century Art of Africa*, the Ghanaian historian Kojo Fosu shows how 'ironically, at the time that European artists were beginning to appreciate the aesthetic qualities of African traditional art, and were therefore experimenting with them in their own works, African artists were also equally fascinated with European aesthetic conventions of realism and were also experimenting with them in their works. Both groups of artists were therefore incorporating aspects of each other's works in their own expressions. Thus, coincidentally, the twentieth century ended the active practice of traditional art on both continents.'[29]

The conditions in which traditions transform are complex in any cultural environment and those that affected art production in African countries are characterised, in several instances, by these satellites of activity, *traits d'union* or configurations between artists, their memories and practices, and the educational opportunities and independent incentives on which they embarked. This sense of the past in the present transpires in the timings and punctuation with which the various art dynamics in Africa have chosen to identify, rather than a mere grafting of iconography from the past. To incorporate a historical moment and create continuity with the past, this moment has to be recognised as a valid proposition in current practice. In contrast with Ngugi wa Thiong'o's 'quest for relevance'[30] and autonomy that affected Kenyan and Nigerian artists and led to cultural and educational formations in these countries, the Laboratoire Agit-Art in Dakar, Senegal, stresses a less explicitly didactic, non-verbal transferral of values, 'l'esthétique sans le savoir', according to El Hadji Sy.[31] Although the Laboratoire's activities benefited from the cultural climate in post-independence Senegal, the reference here to tradition is oblique, anti-institutional and taunting of nationalist alignment. This form of art is the closest to the understanding of Malian philosopher Amadou Hampaté Bâ of reconnaissance as visual communication.[32]

Mythologies are recast in the work of Ugandan artists who painted at the Margaret Trowell School of Art at Makerere University during the Idi Amin Dada and Milton Obote II regimes. At this premier art college in Africa, artists were commissioned by the country's leading politicians to produce state regalia. Meanwhile, the atrocities of war and destruction were fed into the memories of everyday life as the lecturers and students

at Makerere struggled to survive from one moment to the next. The paintings they produced between the late 1960s and early 1980s speak of a stacking of humanity, space swallowed by the nightmares of the imagination and fears of torture and dying. These large paintings on hardboard with their Hieronymous Bosch-like imagery of mutant humanity and nature devouring itself are so closely interconnected that to see them together and in the context of works by neighbouring Kenyan artists is an extraordinary experience. Like visual broadsheets, the paintings overflow with apocalyptic scenes of mass mutilation, densely peopled with mythical animals and extraodinarily hybrid forms of humanity.[33] What type of reading did these paintings propose to the Ugandan audiences of the time? When Jonathan Kingdon, the British art-teacher and zoologist, taught at the Margaret Trowell School between 1960 and 1973, he encouraged students to approach freely the subject of art and its articulation. His courses in 'Objective Study' involved day visits with students to different locations to draw. Together they visited markets, circuses, hospitals, abattoirs, brothels, nightclubs and zoos while also looking closely at traditional masks, terracotta figurines from Uganda's past, bark cloth paintings and skulls. Other teaching aids included books and slides of artists such as Hieronymous Bosch and Breughel, but Kingdon insists that ultimately this influence was at a remove – it was contained within a particular attitude of mind that saw European or outside influences as just one further area of discovery, a tool in the analysis of representation.[34]

Relatively little is known today of the various students at Makerere who painted these fearful storyboards. Scattered like the works in the school's collection, many no longer practise and, with the economic hardship facing the school, students are fewer and fewer. Much of the vitality in Ugandan contemporary art has now shifted temporarily into theatre, with over six hundred registered companies operating in the capital Kampala alone. The productions, which are broadly scripted and last up to four hours, combine drama with dance, live music and epic narratives in which the political condition of the country, Aids, corruption and neo-colonialism are parodied. Audiences fill the local theatres and most of the productions are entirely self-financing. In contrast to the rise of popular theatre in Uganda, the works on show from the Margaret Trowell School of Art suggest a contained and episodic moment in the history of Ugandan art, when the experience of painting for lecturers and students alike was cathartic and collective. Ugandan art may continue to oscillate between performative arts and more static forms of visual expression, but there is no doubting the vigour and intensity of this period in its history.

In his article on Sisi Kwa Sisi – the 'Art to the people' or 'For us by us' movement in Kenya of the early 1980s – Etale Sukuro discusses the relationship between art works and their impact on the local inhabitants of market towns in Kenya. Together with his colleagues from the university in Nairobi, Sukuro set up open-air exhibitions and carried out surveys listing reactions to the painted scenes of rural life, images of heroes and biting satirical cartoons. Up to ten thousand people visited the exhibitions, which were strategically placed near markets and points of social gathering. Kenyan artists, like many in Africa and elsewhere in the world, do much to socialise the legal and political system through cultural codings. This grass-roots socialism enables artists, should they wish, to remain strongly in touch with the transformation of their daily reality as part of a social or political community. Sisi Kwa Sisi was set against the increasing commercialism of art in Kenya and the dominance of expatriate-run galleries that dealt primarily in paintings as souvenirs from the safari world of East Africa. Etale Sukuro's discussion of the relationship between art works and local responses in Kenya provided a crucial dimension to the exhibition on which the curator Wanjiku Nyachae has built.

The result of Nyachae's research is the juxtaposition of selected works from Kenya against those from Uganda, which recast the existing polarity between academically trained and self-taught artists discussed earlier. Her storyline focuses on the predominance of core narrative concerns in East African art, the preparation by artists of visual understandings of the human condition *in extremis,* through powerfully evocative symbolism and mythical imagery that can be easily accessed and prove stimulating to diverse audiences. In effect, both the Ugandan paintings from Makerere and the Kenyan art works are exceptionally political expressions; while apparently expressionist and child-like in their formal dimensions, they speak of violence and instability in the face of natural and man-made disasters. With Richard Onyango, Sane Wadu and Etale Sukuro, satire becomes the dominant trope with which comments on corruption, food shortages, industrial dumping and urban/rural differences in modern Kenya can be explored in an apparently 'naive' stylistic vein. In contrast to the West African stories, the 'Visual Narratives and Concrete Prose' of the east appear more fluid, less selfconsciously collectivising on an artist-to-artist basis and ultimately less preoccupied with questions of painting *per se*. Here, painting becomes a graphic statement on the many realities in East Africa. This is not to say that Onyango's work does not possess a clear style of its own nor that Meek Gichugu is not playing with scale, but that the desire to open the trap-door of perception and visualise day-to-day existence with all its associated traumas is a greater prerogative.

The African situation reveals itself as a testing ground for various forms of artistic engagement. Each story presented in the exhibition speaks of a different configuration in the conditions of artistic practice. The philosophies and ideologies of Uhuru, Negritude, Nkrumah's 'African Personality', and the Black Consciousness movements have provided models of resistance and collectivity that artists have espoused in attempts to modify the various economic, class, race and art-historical divisions in modern society, and develop an appropriate aesthetic. Heroes, wars, and the edification of art in the nation-building process connect several artists' movements and manifestations in different parts of Africa. Public art flourished in the 1960s in the newly independent countries in the east and west of the African continent. It was not only modernity that was taken on, but the idealism of constructing a new Africa through its post-independence institutions, embedding art and cultural vocabularies literally into their newly mounted edifices. The concretisation of culture in the 1960s and 1970s was essential to building up a wide national audience and successfully developing the numerous Panafrican art fairs that marked this period of cultural reconstruction. 'Culture' was in many respects the main interlocutor, instilling a self-referential tension into the creative dialogue of artists. Today, the notion of movement is increasingly attuned to cross-border, cross-nation activities between artists in different parts of the continent or the world. Cultural identifiction becomes a far more flexible item in the conception of new works. The *Seven Stories* are both specific to themselves and in alliance with each other, criss-crossing models and offering personal interpretations of the struggles which have affected lives and soldered artistic contact.

In pehaps the most topical of them, David Koloane (born in 1938) traces a finely distilled history of South African art from his own personal perspective as a black South African painter. The first black artist to have been given unlimited access to the collections of South African art in Johannesburg, Cape Town, Durban and Fort Hare, Koloane's narrative is partly the reconstruction of influences that informed his own perception of art, and a chapter in the new reconstruction of the modern history of art in South Africa. Koloane begins his storyline in the late 1950s with two oil paintings by Ephraim Ngatane which, while they recall the earlier township scenes of Gerard Sekoto

and George Pemba, already contain key elements of abstraction that Koloane plays on later in the *dénouement* of his tale. From the colonial past, the exhibition moves straight into the most tragic events in the history of apartheid, the Sharpeville massacre and the death in detention of the black activist Steve Biko. This sombre vision of a moment in art is explored through a selection of works by both black and white South African artists, in particular Sam Nhlengethwa and Paul Stopforth. Stopforth's drawings of Biko's hanging limbs have all the sinister quality of cheap newspaper shots and X-rays by police medics, while Nhlengethwa's collage of the dead hero pursues the theme of dismemberment. The examination of a hero is just one dimension in Koloane's story, which places the politicisation of art within the realm of space and expression.

Moving on from the metaphor of detainment, Koloane takes us through to a period of transition, characterised by an increasing interest in large-scale abstraction, colour and process-based work. Landscapes, a favourite subject in white South African art, offering the quintessential portrait of white settler domination, become reinterpreted as metaphorical and gestural openness in the canvases of Kevin Atkinson, Bill Ainslie and the Thupelo workshops of the mid 1980s. Here, for the first time, black artists could spread out and break the creative isolation that had stifled their development.

The Thupelo workshop model – based on the Triangle initiative in New York by the British sculptor Anthony Caro and the art patron Robert Loder – has been largely responsible over the last ten years for interconnecting practising artists in South Africa. Together with Bill Ainslie, David Koloane has been central in extending the circuit to include South Africa which, in 1986 when the first Thupelo workshop took place, was still under the apartheid regime. As Koloane reminds us, Thupelo was a facilitating structure enabling South African artists (both black and white) to define a new territory of practice and exchange. The original model – in part inspired by Clement Greenberg's theories of artistic expression – was rapidly transformed in response to local conditions and artists' incentives.[35]

In contrast to Thupelo, the Zimbabwean version Pachipamwe, first set up in 1988, chooses today to focus far more specifically on sculpture. On the initiative of Tapfuma Gutsa, one of the most experimental sculptors practising in Africa, it has effectively supported more radical conditions of engagement and expression, encouraging artists to continue defying the straitjacket of stylistic uniformity. The Triangle workshop model recently extended its outreach to include West Africa with Tenq, the first international workshop in Senegal and the first africa95 event.[36] Koloane ends his story with a question mark: in the search for a new South African identity, who can tell how quickly and effectively the existing configurations between black and white artists will be transformed and, more importantly perhaps, what shape of engagement and exposition to the public that black artists, in particular, will seek?[37]

Whereas several of the *Seven Stories* show concentrations of energy and common artistic vocabularies, Salah Hassan's section looks at the issues of itinerancy, immigration and the splintering of artistic connections in Sudan and Ethiopia across Africa into the USA and as far as the Arabic Gulf States, where several artists live and work today. His story begins from two centres, the capital cities of Khartoum and Addis Ababa, and follows the trajectories of artists who, although they never formed a 'school', were connected through the common heritages that informed their work, ranging from Islamic to Coptic Christian and North African influences. Salah Hassan emphasises the sense of a generational divide in artistic principles in Sudan, and features El Salahi who studied at the Slade in London and became one of the leading exponents of 'Sudanism' in 1960s Khartoum, with a visionary ideology that led him to speak of the 'breeding desert', borrowing metaphors from landscape to describe the hybrid state of the Afro-Arab

culture of Sudan. On the Ethiopian side, Skunder Boghossian and the late Gebre Kristos Desta illustrate the circuit of exchange that brought artists into contact with each other's work in the late 1960s and early 1970s. Skunder infuses his paintings and scrolls with the materiality and iconography of his home ground while a member of the AfriCobra group in the USA, while Kristos Desta explores both abstract and figurative languages in building stage décors for the poet Tsegaye Gebre Medhin. In this intricate storyline, the younger generation of Sudanese and Ethiopian artists are equally dispersed: Hassan Musa is now resident in France, Rashid Diab in Madrid and Wosene Kosrof in Germany. Salah Hassan shows us how the channelling of energies abroad created a trans-continental link, a *métissage* of modernisms and critical discourses.

The 'Khartoum and Addis Connections' (pages 102–39) extend in many respects to the art of the north of the continent and illustrate the borderline between sub-Saharan and Maghrebian trends and influences. They cannot represent the propositions of a wide geographical field, but their syntax – built on Islamic beliefs, the pre-eminence of the Word, Arabic calligraphy and ideologies of artistic freedom in the context of the nation-state – links them to the manifestations of several artists north of the Sahara.[38] Although the possible inclusion in the exhibition of a north African dynamic was closely considered, discussions especially in Morocco and Tunisia suggested that the notion of discrete artist-led collectives was less evident in the organisation and practice of artists in these countries. Given restrictions of space, the Sudanese story therefore acts as a pivotal point of articulation between north and sub-Saharan artistic and cultural influences, exploring these in the context of the late twentieth century.

Unlike Chika Okeke, David Koloane and El Hadji Sy, Salah Hassan and Wanjiku Nyachae are not practising artists. Their interpretations coincide with other curatorial visions that correspond with models of artistic development in eastern Africa. In this sense, the seven short stories presented by the exhibition are inevitably inconclusive, incomplete and open to different interpretations. The question of women artists in Africa appeared throughout like a disturbing omission, which preoccupied each co-curator involved in the preparation. The preponderance of male artists in Africa is undeniable; although women did attend colleges in the formative years of post-independence, such as Etsu Clara Ugbodaga-Ngu in Nigeria who also studied at Chelsea Art College and the University of London, their careers for the greater part dissolved and very few have maintained lives as professional artists. This historical fracturing of women's practice made it impossible to locate a formation specific to women artists, with the exception of Kamala Ishaq's Crystalist revolution in the Sudanese context. Ndidi Dike, who studied under El Anatsui at Nsukka, is one of the few successful women artists in Nigeria of the younger generation, and indeed in West Africa. With the quality of determination, Dike furrows paths through hardwood panels creating a bas-relief effect which, similar to Jacob Jari's assemblages, suggests ridges and root shapes on the earth's surface. Her work carries the Igbo signature of segmentation in the burnished lines which cross over the total space of the composition that is built up of wooden panels. Kamala Ishaq and Ndidi Dike represent complementary poles among the women artists who qualify developments in modern art in Africa. Education and professional development are only two of the complex sets of circumstances that affect the ability of women to become full-time practising artists. There is no single answer to their presence or absence; although *Seven Stories* recognises this inconsistency, it has chosen to follow each co-curator's vision and respect the specificity of their focus. Nevertheless, the question is raised as to how artistic practice is defined and what form of intervention it presupposes. Is Oumou Sy, the costume designer from Senegal, not also one of the leading women artists in Africa today, creating spectacular arrangements in free style and working closely with

local weavers to develop new designs and permutations in traditional clothing? Although she does not exhibit in the conventional exhibition environment, but instead projects her designs into cinema, Oumou Sy's clothes are examples of the way in which in Africa close relations are maintained between different art forms, enriching their multireferentiality with each model of communication, be it in dance, cinema, poetry or the aesthetics of style.

Seven Stories about Modern Art in Africa is the outcome of an elaborate curatorial process over three years, for which the Whitechapel Art Gallery provided continuous enthusiasm and support. Every stage in the exhibition's development was connected to extensive logistical questions and communications between Africa and the UK. Against the constraints of technology and sheer geographical distance, the commitment of the artists and curators who informed the early research, attended the Whitechapel forum and proposed models for each section has resulted in a network of contacts. Although the exhibition will unfold after a year of touring, the experience of working together will not fade. The exhibition becomes part of a new technology of artistic interaction, re-routing the context of communication to include Africa and the visions and socialisation procedures of artists there.

In an exhibition with such a 'hands-on' format, my involvement as co-curator has been in conceiving the exhibition's structure and negotiating with the section curators on the precision of each vision. The interest in cross-fertilisation is in line with a current international tendency to question the parameters of artistic intervention and with it a search for a revised technology of presentation. Roles are constantly in definition, and the exclusivity of responsibilities held by the artist, the curator and the historian are negotiated. With this exhibition, the focus has not been on the presentation and documentation of individual artists, so much as on a collective effort to inscribe and disseminate some of the recent histories of the visual arts in Africa. Ephemeral, yet fundamentally historical, the interpretations are personal recollections that infuse the notion of a modern art history of Africa with the transformational capacity of its own objects, diverse in expression and routed through cross-continental dialogue. In effect, several 'stories' illustrate a merging of the categories proposed by the exhibitions *Out of Africa* and *Africa Explores* discussed at the start of this essay, casting their distinctions into more fluid models of practice, defined in the first instance by the artists and their philosophy. Examples include the interconnections between the urban Sét Sétal graffiti initiative in Dakar and the Laboratoire Agit-Art's conceptual recuperation of it, into the context of a debate around the socialisation of aesthetics, or the introduction of 'fine arts' mechanisms of exhibiting into the popular market environment of Kenya by the Sisi Kwa Sisi group. The notion of movement becomes multidimensional, alternating between concentration and dilation. Each co-curator has chosen a particular focus. Whereas Salah Hassan has gathered together a large number of works and artists with which to tell his tales, El Hadji Sy has preferred to limit his perspective to three artists whose work operates within a sense of collective experience. In their personalised styles, the *Seven Stories* together display the diversity of artistic expression in the visual arts of Africa in this century, introducing audiences to the artists' own understandings of their recent histories. Working closely with each co-curator has been an enriching experience which we will undoubtedly build upon for the future. We hope to maintain contact between different centres of artistic practice in Africa and the UK.

Inside. Outside

Everlyn Nicodemus

The zone where the natives live is not complementary to the zone inhabited by the settlers. The two zones are opposed, but not in the service of a higher unity. Obedient to the rules of pure Aristotelian logic, they both follow the principles of reciprocal exclusivity. No conciliation is possible, for of the two terms, one is superfluous.

The settler's town is a strongly built town, all made of stone and steel. It is a brightly lit town; the streets are covered with asphalt, and the garbage cans swallow all the leavings, unseen, unknown and hardly thought about. The settler's feet are never visible, except perhaps in the sea; but there you're never close enough to see them. His feet are protected by strong shoes although the streets of his town are clean and even, with no holes or stones. The settler's town is a well-fed, an easy-going town; its belly is always full of good things. The settler's town is a town of white people, of foreigners.

The town belonging to the colonised people, or at least the native town, the negro village, the medina, the reservation, is a place of ill fame, peopled by men of evil repute. They are born there, it matters little where or how; they die there, it matters not where, nor how. It is a world without spaciousness: men live there on

top of each other, and their huts are built on top of each other. The native town is
a hungry town, starved of bread, of meat, of shoes, of coal, of light.

The native town is a crouching village, a town on its knees, a town wallowing in
the mire. It is a town of niggers and dirty arabs. The look that the native turns on
the settler's town is a look of lust, a look of envy; it expresses his dream of
possession – all manner of possessions: to sit at the settler's table, to sleep in the
settler's bed, with his wife if possible. The colonised man is an envious man. And
this the settler knows very well; when their glances meet he ascertains bitterly,
always on the defensive, 'They want to take our place.' It is true, for there is no
native who does not dream at least once a day of setting himself up in the
settler's place.[1]

The gulf between the settlers and the natives in Africa is, to an overwhelming degree, as
frightening in our day as it was 35 years ago, when Franz Fanon wrote the above lines in
his book *The Wretched of the Earth*. If something has been added to the relations between,
for instance, the township of Soweto and a white zone in Johannesburg, it would be the
sophisticated electronic devices locking the doors in the latter – devices that might soon
be applied on the gates of fortress Europe.

The world sometimes seems to stand still, but nevertheless changes. We live in a
modern age where supranational economic powers, expanding markets and worldwide
division of labour inevitably drag every corner of our planet, the remotest villages and
towns, into the land of contemporaneity. An age where far from everybody has shoes, but
where old collective structures break up and where development forces men and women
into the naked condition of being individuals.

Today, to talk about modern African art, a 90-year-old chapter, is to talk about
artists as individuals who have domiciled themselves in change and in our common time.
This is the ultimate criterion of modernity in visual art. The exclusion Fanon wrote about
has had its continuation in the west's arrogant denial of our existence. But at least it has
lately become obvious that, of the two art worlds, one cannot any longer be held to be
superfluous. Modern African art is here.

To talk about this today is to talk from a post-colonial, post-apartheid, even post-
modern point of view. African countries – like other parts of the world long denied self-
determination – reconquer self-reliance in hardships and dependences of a new kind. At
the same time, the once dominating world, which goes on dominating, has lost its
illusions of righteousness. This is at the base of the thinking called post-modernism – a
kind of western introspection, when overweening pride in modern progress reached the
self-critical, self-denigrating, self-dismantling stage.

The tables are turned. We, the Africans, can only watch from outside the
performance of western remorse. But when western thought jettisons the helms and
stays – enlightment, reason, morals, the subject as acting and answerable in history –
when it seems to let the notion of a creating author/artist disappear behind texts and
textures, then we do not want to follow. We cannot, as Edward Said has worded it, like the
post-modernists in the west seize upon an ahistorical weightlessness.[2] We are still
concerned with modernity, we are anxious about how we are going to keep up life itself.
This is why I firmly believe that what will challenge the world today in its confrontation
with modern African art will be the adventure of those artists who have the courage – as
once was the case in the dawn of modernism – to act as the creators and inventors of new
realities, involved as they undoubtedly are in a historical process of survival and
emancipation.

While European and North American art reveal a more complacent, cynical attitude, retreating to manipulations and programmation, African art has still the spirit of modernity, as the Latin American critic Juan Antonio Molina observes.[3] It keeps the utopia alive. It exists in a space of aspirations, not as a past present. And this means also that you do not any more just contemplate a remote, imagined Africa when looking at it. With the works in this exhibition, Africa is in another way present: as contemporary artists addressing you.

All the dynamic cultures of the world have borrowed from other cultures in a process of mutual fertilisation.[4] It goes for the genesis of modernism which, fecundated by Japanese and African seeing, took place in Europe, then to flow back to the rest of the world as the visual answer to our common time. But for most of this century, Africa has been used as a source of inspiration and imitation while being denied the majority right of cultural appropriation. The world has refused to recognise its twentieth-century art as the conquest and natural growth that it has in fact been, and insists on considering it a western implant, a colonial alien infliction. Yet the achievement of one of Africa's most headstrong artists suffices to deny this.

The Nigerian Aina Onabolu started as a youngster in the late nineteenth century to explore certain new phenomena in his environment, the photographs and naturalistic pictures in British magazines and books.[5] Onabolu found out for himself the craft of drawing and painting. In 1906, he signed his first portrait as a self-made easel-painter. He exposed. He wrote about the new notion of art. And he helped introduce art education to the schools of Lagos. His willpower started a development which has led to Nigeria today having forty art schools and academies. Onabolu was part of an African current of modernisation, triggered since centuries by the confrontation with the outer world and specifically carried by the many freed slaves who, uprooted and displaced, had built a new existence and found new trades in the bridgeheads of the tides of western ideas and religion. From there came the advocates of African nationalism and progress, whom Onabolu portrayed.

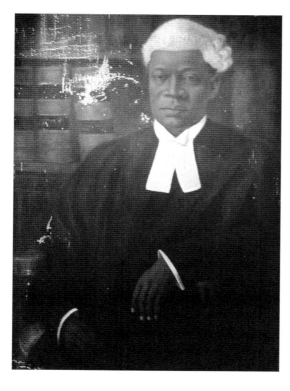

Aina Onabolu
Portrait of a Lawyer
Date unknown
Oil on canvas

What is painting? For Europeans of the time, painting was painting, something self-evident that they believed to be universal. And yet we know now that this self-evidence in the shape of art history was a recent invention, dating to early in the same century that saw Onabolu amazed before those reproductions. Having been brought up in a culture in which abstraction was at the base of visual expression, he first experienced European art as pure magic. How could one create images that were a facsimile of man himself? His enterprise was nothing less than a restructuring of both perception and representation in art. It was the opposite of an 'infliction'. It was a revolt. Christianity, which miscredited traditional African art as pagan idolatry, obstructed the handing over of its knowledge to new generations. Missionary schools did not teach art, they taught handicrafts. The colonisers haughtily believed that Africans were unable to create fine arts. This was prejudice at the very heart of a racist concept of black humans as being 'primitive' and at a lower evolutionary stage. Onabolu waged his war against this denigrating prejudice very consciously. He wanted to prove, and he did prove, that painting as well as the new notion of art was not a western prerogative.

Africa is a pure construction and an invention. V. Y. Mundimbe refers to the whole historical landscape of stereotypes about Africans, taken from the myth of Ham in the Bible, which brands us as the thralls of our white brethren – from the constructed justifications of our colonisation to the 'scientific' inventions of the latter's auxiliary troops at the universities, the anthropologists and the ethnographers.[6] But the idea of 'Black Africa' as a fabrication was put forward in even plainer terms six hundred years ago when, at a desert fort in Sahara, Ibn Khaldun wrote his introduction to a history of the world. The inhabitants of the north, he wrote, are not identified by the colour of their skin, because the people who established the conventional sense of the words were themselves white. Hence whiteness was something common, and not sufficiently remarkable for a specific term; instead, you find distinct nations and peoples with specific names. But for the south, they stated that all the black inhabitants descended from Ham: 'their prejudices about the colour of skin led them into this fabrication.'[7]

So why do I then in this essay use the loaded constructions 'Black Africa', 'Africa south of Sahara' or simply 'Africa' instead of writing of the art of the distinctive nations, peoples and cultures located on today's map? You might find the dilemma, as well as the answer, reflected in the title and aim of our exhibition: *Seven Stories about Modern Art in Africa*. Let me put it in this way: when we are at last allowed to speak about modern African art, should we then restrain ourselves from talking about it for semantic reasons? Are we not living among simultaneous constructions and deconstructions today – a European entity being run up here, a Yugoslav identity and a Soviet construct being dismantled there? Admitting that I have chosen a construction, I feel free to speak about modern art in Black Africa, trying to observe this Africa of the artists not as the old, closed-off continent, but rather as an interconnected part of the world scene.

The first half of this century, with its turmoil, sent waves through all African countries. The First World War was in many ways a sequel to the colonial scramble for Africa and it ended as a European moral bankruptcy. In the trenches, the white man lost the last appearance of elevation, while new signals about equality were heard from many quarters – revolutionary Russia, the United States, the League of Nations. Colonial troops returned from the war and from occupation services as 'agents of change and progressive ideas, quickly forming a body of enlightened opinion.'[8] Communication, media and exchange jumped. When Aina Onabolu left for London and Paris to gain academic diplomas in 1920, money was raised for him through an advertisement in a Lagos newspaper. And still the world goes on believing the myth that modern times never reach an Africa absorbed in the rhythms of the tomtoms!

In the 1930s, departures and movings reached a peak. The Ghanaian artist Oku Ampofo studied medicine and art in Europe for nearly a decade from 1932, and discovered the abducted sculptural heritage of Africa in its museums. British art teacher Kenneth Murray, who went to Nigeria at the instigation of Onabolu, presented an exhibition in London in 1937 of the work of his first group of students, among them Ben Enwonwu, one of the fathers of modern Nigerian art.

Another art teacher, Margaret Trowell, saw this exhibition before she moved to East Africa the same year. She set up an art workshop in Kampala, Uganda, which was to develop into one of Africa's most important art schools, the Makerere University College art school, which produced pioneers like Gregory Maloba and Sam Ntiro. At the same time, refugees from Nazi Germany brought modern lines with them, especially H. W. Meyerowitz, who ended up as director of the Achimota art department in Ghana, the springboard for artists like Kofi Antubam and Vincent Kofi.

In South Africa, two friends, painter Gerard Sekoto and sculptor–painter Ernest Mancoba, who were teaching at a school for black children in Transvaal, talked about going to Paris. Mancoba went in 1938; Sekoto nine years later. During that time, he painted urban black social reality with a rare empathy, drawing inspiration from the new artistic incentives brought from France by the South African 'New Group'. Sekoto initiated, along with John Koenakeefe Mohl, the modern portrayal of township life; he became a role model for black South African artists.

The Second World War, which eclipsed the first as a catastrophe, was at the same time a tornado that sent streams of migrating ideas and people in all directions. In South Africa, which had fought with the Allies, there was an influx of radicalising incitements. On the threshold of imprisoning itself in the mortal convulsions of the colonial, racist apartheid of a blindfolded white minority, the country experienced for a short while a race between progressive and reactionary cultural forces. The focus when it came to art was the Polly Street Centre, a social experiment in Johannesburg in the 1950s and 1960s, which became the formative freehold of a new generation of black artists.

For the first time, black artists could meet and find out together about new techniques and materials. Two extraordinary and unhesitatingly modern black sculptors, Sidney Kumalo and Ezrom Legae, were at the centre of this activity and succeeded the animator of the workshop, Cecil Skotnes. Around them developed a rich taking and giving of artistic knowledge and thoughts. Fellow artists, like the Italian Eduardo Villa, shared the know-how of preparing for casting. The German immigrant gallerist Egon Günther, said to have introduced Kumalo to classical West African sculpture, sold an entire exhibition of Kumalo's bronzes. This proved to black artists and their community that it was possible for them to earn a living from art.

The main secret of the Polly Street Centre (reflected rather than documented in existing literature) was the merging of a black philosophy of life and a progressive thinking in South Africa.

> One of the most fundamental aspects of our culture is the importance we attach to man and the capacity we have for talking to each other, out of a desire to share. The western attitude to see people not as themselves but as agents for some particular function, either to one's disadvantage or advantage, is foreign to us. We enjoy man for his own sake. We always refrain from using people as stepping stones.[9]

The Second World War finally made it evident to all colonised peoples that the dominance of the self-imagined master-race was untenable. The proofs appeared in rapid succession: India, China, the Algerian war of liberation... The whole period following the

war – the decades before and after independence was attained in one African country after the other – was a time full of expectations and of fighting spirit in most of Africa, with an electrifying sense of the dawning of a new era.

Art was crucial in the political–cultural process. In the same way as the African nations aspired as a matter of course to an equal position among nations in a modern world, African artists took up a modernist course. Major institutions of art education and professional training were established throughout Africa, schools that became focal points for creative growth and innovation around individual artists and teachers.

The most important centres were, in chronological order of development: 1946 in Khartoum, Sudan, where Ahmed Mohammed Shibrain and Ibrahim El Salahi were among the inspirers; 1953 in Zaria, Nigeria, with the Zaria Rebels at the Nigerian College of Arts, Science and Technology, soon followed by other Nigerian educational art institutions in Lagos, Ibadan, Nsukka and Benin; 1957 in Addis Ababa, Ethiopia, with among others Gebre Kristos Desta and Skunder Boghossian; 1958 in Kampala, Uganda, where the Makerere University College art school got a more clearly modern direction; 1961 in Dakar, Senegal, where Iba N'Diaye and Papa Ibra Tall were called to direct the new Ecole des Arts, one teaching art, the other applying the Negritude ideas of President Léopold Sédar Senghor; and 1966 in Abidjan, Côte d'Ivoire, where the string-sculptor Christian Lattier inspired the Vohu-Vohu group.

With independence approaching, a search for identity was intensified. 'In the sixties,' writes the instigator of the Zaria rebellion, Uche Okeke, 'there was the inner necessity for Nigerians in all walks of life to rediscover their roots, to forge an identity that is distinguishably African.' This was also a political necessity. New governments and pioneer artists found common ground in the need for coining new visual symbols to replace the old, colonial ones. Elements from traditional art, distinguishably African, were amalgamated in a modern expression, its symbolic function comprising that of the hoped-for merging of ethnic group solidarities into a single identity that would be modern and national.

But the confrontation between modern and traditional was nothing new in the artists' thinking. The Ghanaian pioneers Oku Ampofo and Kofi Antubam, for instance, expressed diametrically opposite attitudes. Ampofo urged his fellow African colleagues to reconquer their artistic heritage, while Antubam protested against the idea that the conjunction of traditional Africa and western modernism (especially Picasso and Cubism) should force 'the Ghanaian in the twentieth century . . . to go and produce the grave and ethnological museum art pieces of his ancestors.'

There was a wider problem underlying the search. The political and intellectual élite, trained and moulded in the west, which carried the national modernisation of African societies, began to realise its marginality, and wanted to overcome its isolation from the masses of native farmers and workers. While this was to become the key to Amilcar Cabral's revolutionary thinking, in Nigeria it triggered a cultural grassroots revolt. The young artists gathering in the classes of the first domestic art school in Zaria refused to accept the through-and-through western routine of its curriculum.

A group was formed including Uche Okeke, Demas Nwoko, Bruce Onobrakpeya, Yusuf Grillo and others. Endless discussions were devoted to a re-evaluation of the colonial legacy, to the role of the African artist in the new society, and to his involvement in the cultural past and in living traditions, which had to be rediscovered and studied in the light of what was going on internationally. It was not simply 'back to the roots'. The dynamic of a multi-ethnic locus was analysed. Young artists were finding their way about their social and political as well as their cultural situation, and about thoughts, customs and everyday reality among their own people which they wanted to address.

All over the world, post-colonial artists entering the field of modernism have been torn between the will to take up abode in a new time and the wish to retain some kind of identity linked to locality and traditions. Already Fanon was warning that the path backwards in search of a national art may prove to be a blind alley, and that artists who turn away from actual events towards the past may end up embracing nothing but 'the cast-offs of thought, its shells and corpses'. His warning has a new urgency for Africa.

What has made the negotiations extremely difficult for modern African artists and turned the equation of cultural heritage and modern individual creation into a dilemma, is the circumstance of our extreme exposure. We are circumscribed by wishful short-cuts and prefabricated notions attached to Africa as a construction, and to Africa as a projection of the world's dreaming and its longing for exoticism. We have to cope with the pressure from expectations of manifest roots and affirmed Africanity, expectations that imply a denial of our domiciliary rights in modernity. This pressure emanates from inside as well as from outside, and it is often impossible to discern internal African contributory causes from external ones. Attitudes and values once connected with foreign rulers during the colonial time seem sometimes to be taken over by domestic authorities and applied to cultural policies that function as if they served external tourist demands. Fanon's observation of how colonialism's distorted thinking remains mutually internalised keeps much of its validity.

But it is important to remember that the impact of the outer world's reception of African art on our visibility has been and continues to be considerable. It goes even for the appreciation, the frantic celebration of the cultural heritage of Africa. The world's cult of Africa's classical masks and figures, its appetite for exotic festivals of music, traditional dances and costumes, not to mention a worldwide business in copied and faked art objects, all tend to block the sight of modern African creation simply by making African time look like an eternal past. Only film and literature seem to have escaped this inverted time-machine.

So how do African artists take their position in the universal exploration of new artistic modes and means? How are they supposed to be free to solve their intricate identity problems and to proceed, if the admission ticket to markets in some wealthier parts of the world appears to consist of slipping among the works some traditional or primitive elements, thus signalling that 'distinguishable Africanity' expected from them? This is basically a question of integrity and resistance. The warped western dealing with contemporary African art culminated in the 1980s with some big exhibitions and collections, blazoning abroad sign-paintings and folklore artefacts as genuine cultural expressions, while suppressing the existence of modern, professionally trained artists. It came close to an ideological warfare against modern African art as such. It has provoked strong reactions in intellectual and artistic quarters all over Africa and in the black diasporas as well. We have seen that all this twaddle about 'hybrid' objects and 'transitional' art is nothing but a refusal to acknowledge the paradigm shift which is at the heart of modern African art; it is a clinging to the same kind of prejudices against which Onabolu launched his war ninety years ago.

There was a prehistory of a similar western interference in the course of African art in the 1950s and 1960s, but at that time it was inside Africa. Painting workshops for unscholared and 'untouched' Africans were put up by European dilettante art tutors such as Pierre Desfossés, Pierre Lods with his Poto-Poto school in the Congo, Ulli Beier with his Oshogbo in Nigeria and Frank McEwen with his Shona construct in Zimbabwe. They helped each other to market their products as *the* genuinely African contemporary art. Paradoxically, they managed to dominate the scene for decades. This issue brings to the fore the question: what is an artist? It is a question most urgent for Africa. The workshop

patrons may have brought with them some confused offsprings from the ideological surplus of Europe, mainly in the form of loose, anti-academic ideas. But underlying their taste for spontaneity and their common anxiety to protect their 'children' from harmful western influences was a very colonial notion of Africans as children of nature, with some primitive sense of art in the blood, a stereotype that was met with a full response by the western public.

By marketing their activities, they also propagated the weird notion of an African artist as the very opposite of an intellectual, a slander not without its vicious effects. This absurdity stands out when we consider that Beier's Oshogbo activity started half a century after art education was initiated in Nigeria, and more than twenty years after the establishment of the first professional art schools in Africa.

There is every indication that this chapter will soon be relegated to the margins by Africans of a new generation. The notion of an artist is under reconstruction. 'There is no way you can move into art which is not an intellectual process,' said Uche Okeke when I visited him in Nimo, Nigeria. And the critical discourses in recent decades among the black diasporas have contributed to make it as self-evident for Africa as for elsewhere that art and literature are the creative, intellectual enterprises of autonomous individuals, and that art must be conceived as visually mediated ideas, not as thoughtless, spontaneous expression.

Theoretical work and critical rethinking are on the agenda. It is a process of conquering freedom of thought and of a 'self and the world' consciousness, of which the Zaria rebellion was one of the early stages. This process is irreversible. It will, in my opinion, necessitate the jettisoning of spasmodic thinking about traditions and identity – preoccupations that will prove as superfluous in the rest of Africa as they were nonexistent from the beginning in South Africa, where Gerard Sekoto's paintings reflected the industrialisation that brought the black masses to the towns. There is nothing mystic about modernisation; if there ever was, it has been dissolved in the information society's flow of speeded-up media and waves of television pictures. New incitements may now come from the south, from inside Africa, strengthening an already ongoing liberation as African artists join the universal common adventure.

The progress of an artist is a creative parable of the path of a human's individuation, and a sequel to it. Thus it is also a search for identity, but with no promises of loyalty! We experience all over the world today how easily group identities can turn from a sense of belonging and solidarity within a creed or a people into enforced submission to the dictates of a different kind of fundamentalist intolerance against 'others'. Artists are by profession predestined insurgents, potential dissidents *vis-à-vis* family, nation, religion, even gender; finally, they are intransigents before their own inner identities, which are continuously called into question in the act of artistic creation. Art thus visualises, as a matter of fact, that 'identity' for a human can be only a process, a search. This may lead, as for Buddhists, to a void; or it may also take us to a multiplicity of identities.

What is it, for instance, to be an African? It is something I know nothing about; or, at least, it is a thousand things. The thought that it is a mere coincidence that I was Kilimanjaro-born challenges me to picture to myself what it would be to be a human in Kamchatka, Kyoto, Saskatchewan or somewhere else. My experimentation with thinkable identities – just as the handling of colours, forms, symbols – opens up a world to me. I am the other, and the other is me. The secret of universalism, writes Leon Wieseltier, is that it functions.[10]

the quest: from zaria

o nsukka

a story from nigeria by chika okeke

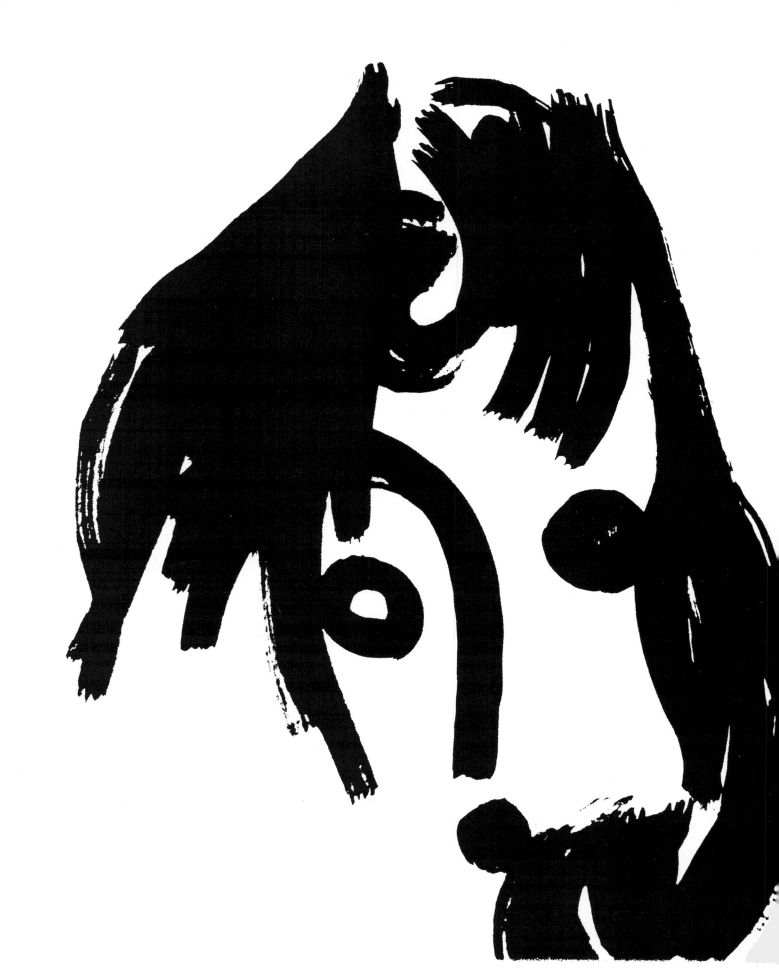

The Quest: from Zaria to Nsukka
Chika Okeke

I. Charting the Journey

The standard history of modern Nigerian art begins with the pioneering efforts of Aina Onabolu at studying and copying what he believed was 'true' painting: academic portraiture. The most significant moments in that history, however, began in the late 1950s when a group of young artists at the Nigerian College of Arts, Science and Technology at Zaria formed an association for the primary purpose of reconsidering for the first time the validity of the Onabolu legacy, which was evident everywhere. They commenced a collective search for alternatives informed by their indigenous art traditions – of sculpture that was savaged, but prized, by the colonial officers; and of painting whose existence was denied, much against the overwhelming evidence of the compound walls in Igbo and Yoruba land. The members of the Zaria Art Society were clearly aware of the continuing elision of the art traditions of their own peoples in the evolution of the new art that was being taught in the academy. There was, in their estimation, something fundamentally wrong in this apparent self-denial by emerging Nigerian artists. A reversal was needed if true, modern Nigerian art was to be established. In order to focus their thoughts, the Zaria Art Society advanced their theory of Natural Synthesis which, essentially, called for the merging of the

best of the indigenous art traditions, forms and ideas with the useful western ones. Uche Okeke, Demas Nwoko and Bruce Onobrakpeya championed the cause of the Zaria Art Society, even beyond the academic tutelage at Zaria. Interestingly, their individual attitudes to the synthesis theory, although similar in conceptual terms, varied in form. The same could be said of the other members of the Zaria Art Society whose collective goal was subsumed under Natural Synthesis.

The events in Zaria, however, were not without precedents, however remote, however indistinct. A possible foundation had been laid by the British art teacher, Kenneth Murray, who came to Nigeria at the suggestion of Onabolu. He taught his students, Ben Enwonwu among them, to reflect their cultural environments in their art. But the 'reflection' hardly called for a vigorous study or analysis of the conceptual and formal nuances of indigenous cultural manifestations. It was only much later that Enwonwu, and perhaps he alone, moved further in 'reflecting' the art traditions of his people in his art. The Zaria Art Society took up the challenge, from that point employing more dialectical means in its quest for a truly modern Nigerian art. But it was not alone. In cultural centres around the country several other young artists were involved in the process of seeking alternatives to the status quo, which was synonymous with the colonialism that the coming independence was set to overthrow. The response of these artists differed from the logic of Natural Synthesis but it also provided an alternative platform for that search, the quest for a new art in the spirit of independence.

In later years, after the 1960s, reactions to Natural Synthesis yielded even more interesting results. At the University of Nigeria, Nsukka, there developed a strident, sympathetic response beginning in the early 1970s. The *uli* style, for which Nsukka is known, is a consequence of a vigorous advancing of the preachments of the Zaria Art Society. In more recent times, and perhaps due to the success of the *uli* experiment at Nsukka, a similar idea called *Ona* is being developed at Obafemi Awolowo University, Ife. If there is any modification of the idea of 'synthesis' in both Nsukka and Ife, it is a redefinition of Natural Synthesis, marking a shift from its earlier ambivalence to a more clear-cut, indigenous centre drawing on ideas from the more peripheral west.

Then, in Zaria in the mid 1970s, there was a reversal: a rejection of the very idea of synthesis developed in the institution where it was born. This reversal represents a continuation of the ideas of the artists who, in the 1960s, took on a different attitude from the 'Zarianists' in articulating the new art. For the later Zaria artists, the art experience had to be founded on the individual, not on collective inheritances. The artists saw a contradiction in the insistence of uniqueness or the emphasis of difference in a world replete with cultural bridges which, impinging on the individual, define his or her new personality. That personality had to be reflected in the work of the new artist existing beyond cultural and national specificities – the global artist, making universalist art. Again, this attitude later devolved to other art schools – an example is the Auchi Polytechnic whose artists have made some impact on recent painting in Nigeria.

What we witness in the works of the younger generation of artists in Nigeria follows or modifies, in relative terms, the Nsukka and Zaria archetypes.

The underlying principle in all cases, however, is the quest for a true, modern, Nigerian art.

This exhibition does not tell the whole story; it cannot. Through it we are attempting to relate some of the significant developments from the epoch-making phenomenon of the Zaria Art Society. We look particularly at the works of two artists who took part in the activities of the Society, and of one who epitomised the alternative route taken in the 1960s towards defining true Nigerian art. Due to the historical nature of our enquiry, we adopt a method of presentation that makes it necessary to look a little further back – to an artist who may have planted the seed that flowered in Zaria in the 1950s. Beyond these, we trace responses to the 'Zarianists': to Nsukka which became a watering hole for younger 'pro-Natural Synthesis' artists; and to Zaria, again, where the response was somewhat different. These two schools represent the diverse currents evident in modern Nigerian art.

This exhibition is an attempt to begin to understand the larger narrative of Nigerian art, by looking at a part which, in essence, contains the fundamental elements of the entire story. It is not the whole story, neither does it define the entirety of the phenomenon, but it is one through which we can begin to appreciate the scope, diversity and unity of artistic expression in Nigeria. It shows the several paths Nigerian artists have taken in their quest for the ultimate essence that unifies all.

II. The Story

Ben Enwonwu is arguably the first important post-classical Nigerian artist who became conscious of the sculptural traditions of his people. That awareness profoundly affected the nature of his art, which in turn set in motion the renegotiation of the earlier constructs for modern Nigerian art. The British art teacher, Kenneth Murray, had in his own way attempted to direct the conceptual focus of his students, including Enwonwu, away from the academic portraiture tradition of Aina Onabolu, the pioneer Nigerian artist. Murray's methods, however, did not yield much: his students, even Enwonwu at the time, settled for the kind of painting that became a contemporary tradition. Many artists today are building on that legacy, the hallmark of which is the landscape genre typical of the Yaba School in Lagos.

In 1944, Enwonwu travelled to England, where he studied at Goldsmith's, Ruskin College and, finally, the Slade. That experience helped him to sharpen his skills and techniques and in the process assimilate some of the finest traditions of sculpture and painting that European academies offered. In the end, however, Europe did not satisfy his yearning for an appropriate response to the existential, even dialectical, problems many African artists faced after encountering Europe and its culture during the colonial period. Beyond the wonder that was academic art lay a deeper mystery. Enwonwu's great learning had made him virtually a stranger to the art traditions of his own people. He needed to return home.

On his return, Enwonwu also returned to Nigeria's cultural environment, but

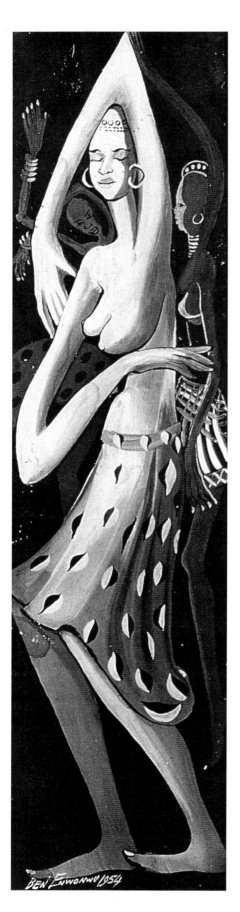

Ben Enwonwu
Dancer
1954
Gouache on paper
50.5 x 12.5 cm
Collection of Michael
Graham-Stewart, London

not in the manner that Murray's earlier classes may have allowed. He had become more sensitive to the nuances of his cultural inheritance, having accepted the preachments of Léopold Sédar Senghor's philosophy of Negritude. But his search for a new language offered him the opportunity not so much to create visual correlations to Negritudist thought as earnestly to retune his sensibilities to the art and cultural traditions of his own people, the Igbo.

From the earliest period of Enwonwu's 'African style', he seemed to have been preoccupied with two major ideas: the woman and the masked dancer. His Negritudist leaning may have informed his initial interest in the idea and form of the African woman, who was both Mother Africa and the alluring beauty whose colour elicited superlatives, her body an object of much poetic contemplation. The Enwonwu woman is a dancer, and dance, Senghor said, is the unifier – a most natural, physical, even emotional expression of all African peoples. The female dancer is the icon, the essence, of a people's cultural expressions that had been discouraged, debased and heathenised by colonialism and its institutions. Her movement in its frenzy approximates an outward manifestation of a resilient spirit that defies 'cultural cleansing'. In her attenuated physique is the glory and the grandeur of past and evolving Africa, Africa that must reach out to its destiny, hopeful Africa.

The second most enduring subject in Enwonwu's art are the Igbo masked spirits, *Agbogho Mmuo* and *Ogolo*. The woman and the masked dancer share a common denominator, even if one exists in the sensual world and the other in the para-cognitive plane. Dance connects both. Even when, as is sometimes the case, Enwonwu's female dancers seem like hastily choreographed performers, they still suggest a frenzied transition, through inspired motion, from the physical to spiritual states. It is the type of dance that Ekwefi, the mediumistic woman in Achebe's *Things Fall Apart,* may have performed. Enwonwu's choice of masked dancers is therefore important beyond its signification of a 'return to roots'.

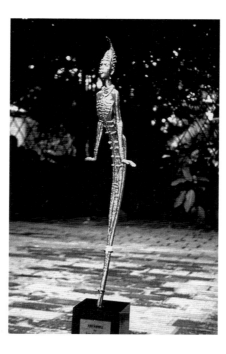

Ben Enwonwu
Anyanwu
1975
Bronze
Height: 91 cm
Collection of Colonel
Ahmadu Yakubu

Agbogho Mmuo or *Ogolo* (and the *Nne Mmuo*) represent only a fraction of the pantheon of Igbo masked spirits, but they are some of the finest dancers. Their dance, ever graceful, is a sublime recasting of the kinetic essence of Igbo female dance steps. The dancing act not only bridges the distance between the mundane and the other-worldly, but also unifies two spiritual power nodes. After all, the woman in many African societies has immense power, *ase*, which translates to a higher spiritual consciousness. When she dances or the masked spirit performs, the experience for the audience becomes that of a real or conceptual metaphysical contemplation.

Critics of Enwonwu see in his art the quintessential split personality of the confused African artist, trapped at the cultural crossroads with the inheritance of the Mazruian 'Triple Heritage'. The reasoning is that Enwonwu's method of delivery remains technically faithful to the academy, even if his subject is not. The same, however, could not be said for many pioneering efforts that must break away from the known to the unknown. His is an attempt at translating the secular, sensual process of painting or sculpture into a contemplative, metaphysical experience. If his earlier *Agbogho Mmuo* or *Ogolo* appear illustrative, suggesting Negritudist nostalgia, they are also the beginning of sustained attempts to capture and tame the evanescent spirit behind the mask, and relocate it from the space–time reality of the market square to canvas and bronze. We do not see in these works the frustrations of a 'detribalised African' yearning for his mythic roots. We see a creative consciousness manipulating relevant skills and media to attune itself to the spirituality embodied by the masked dancer and to the inner essence that contemplates a metaphysical form and idea. Enwonwu got very close to that goal towards the end of his career.

Enwonwu was peerless. His colleagues from the Kenneth Murray days mostly took to teaching in teacher training colleges, hardly going beyond the simplistic genre typical of the Murray school. If Enwonwu had any group forum through which his new ideas could have been passed on to the younger artists of the time, the transmission process might have been markedly faster and more direct. Or had he taken up a teaching position at Zaria or any other college, he might have turned his students into Enwonwu proselytes. But since there was no group forum, and since he neither taught art nor established a workshop, Enwonwu's legacy devolved to the next generation of artists only indirectly.

As has been noted earlier, Negritude provided Enwonwu with the ideological basis for his enquiry into indigenous cultural phenomena and his articulation of a new artistic reality. It gave him the impetus to become confident and assertive in his conceptual convictions. This is Enwonwu's legacy to the generation of Nigerian artists after him, who became active in the late 1950s at the dawn of political independence. To them, Enwonwu was a spectacular summation of professional success. His image loomed large in the minds of the younger artists. Yet due to the exigencies of approaching political independence, they became more involved in the dialectics of nationalism and an even deeper appreciation of Nigerian cultures, especially classical art traditions. If impending independence would bring with it a new Nigerian polity, reasoned these young artists, then an appropriate new Nigerian art had to emerge. The time had arrived for a redefinition of individual and collective

identity. In search of that much needed identity, therefore, a group of art students at the Nigerian College of Arts, Science and Technology (now Ahmadu Bello University) at Zaria met and formed the Zaria Art Society, with members including Uche Okeke and Bruce Onobrakpeya.

The members of the Zaria Art Society were later to be known as the Zaria Rebels due to their radical approach to the new art. They practically rejected western models and design constructs, preferring to draw directly from art forms indigenous to their various cultural backgrounds. Yet, as if to build on a more resilient foundation, the theoretical basis upon which their art derived sustenance, Natural Synthesis, advocated a merging of the best of indigenous and foreign (western) art forms and ideas. To Uche Okeke, the ideologue of the Zaria Art Society, *uli* became the art form upon which he founded his new art.

Uli body and wall decoration among the Igbo is one of the most striking drawing and painting traditions in Africa. It existed long before Aina Onabolu, who claimed that there was no painting tradition in Nigeria before him. During the colonial period many western ethnologists and anthropologists came to Igbo land and documented *uli* (as part of 'vanishing Africa') for their museums and journals. Their interest hardly went beyond this 'salvage scholarship'. Drawing is central to *uli* aesthetics, but it was not the kind of drawing Zaria taught Uche Okeke. So he embarked on a vigorous study of *uli*, visiting museums that had relevant material and learning the skills from his own mother, who herself was an accomplished *uli* draughtswoman and painter. The *uli* lexicon, though varied and dynamic, consists mainly of abstract forms derived from nature: animal, plant and cosmic forms. The

Okanumee Mgbadunwa
Wall painting in Nnobi
c. 1987

artist distils the formal essence of the design elements through manipulation of line. These principles posed a challenge to an artist in search of a new, modernist idiom.

Uche Okeke found in *uli* the path to such formal sensibilities as were sympathetic to pre-independence nationalist aspirations. He also found his personal artistic independence. His art went through quick, evolutionary turns within a short period before attaining what seems to have been the goal he set for himself. By 1962 his drawings had become organic, lyrical and appreciably abstract.

Okeke produced an important set of small format drawings, the *Oja Suite*, at the time he was awaiting his travel papers in Abule Oje, Lagos, in 1962. These drawings display the gestural nuances of *uli*. Vegetative and human forms are stripped of superficialities, leaving only the essential components: the same reductivist process that yields 'traditional' *uli* design motifs. In the *Oja Suite*, done with pen and ink, lines twirl in ambient space, engaging the negative space so that the spatial dynamics of the positive and the negative are sensitively organic. The strength of the lines is uniform. They move, avoiding in most cases the straight course, developing ultimately into whorls and spirals. There is a cleanness of line here that approximates to that of *uli* body designs. The major difference, however, is Okeke's consciousness of his compositional format; the wall painters share this spatial sensitivity much more than the body decorators.

At the end of 1962, Uche Okeke travelled to Germany to train at the Franz Meyer Studio in mosaic and stained glass techniques. During this period he produced his *Munich Suite* drawings, taking up the brush. This transition from the pen suggests a heightened technical confidence, a facility with the drawing tool. The lines are broad and more expressive, and have lost much of the sensitive elegance of the earlier drawings. He appears to have internalised the *uli* drawing technique, which he was employing to serve his modernist sensibilities. Do we see a reversal of the Enwonwu situation here? There is a way in which these drawings carry the expressive power of Franz Kline's, but they do not suggest the brutality and restrained violence of the latter. The brush strokes avoid the angular, preferring the curved path. The masses are heavy, leaving the unworked space as a complex arrangement of shapes that acquire active presence, not merely acting as background. The *Munich Suite*, for Okeke, marks a high point in the Natural Synthesis doctrine of the Zaria Art Society.

In the works of Bruce Onobrakpeya, one of the leading members of the Zaria Art Society, we see an interpretation of Natural Synthesis similar to Okeke's. But due to Onobrakpeya's different cultural background and his own independent creative sensibility, he arrived at a unique formal expression. Having spent his early years in Benin (the locus of the vast, rich artistic traditions of the Edo culture that produced the famed Benin bronzes), Onobrakpeya drew upon not only his native Urhobo culture but also that of Benin in his response to the ideological stand of the Zaria Art Society. He studied painting in Zaria with Uche Okeke, but it was in printmaking that he found a more responsive vehicle for developing a new formal identity. In his earliest prints, in Zaria, he explored new forms using linoleum and wood cuts. The experience that was to change the direction of his art happened after Zaria, at the printmaking workshops in Ibadan.

Uche Okeke

From left to right

*a) Beggar-Jos
Self Contemplating
(Nok Suite)*
1958

*b) From the Forest
Head of a Girl
(Oja Suite)*
1962
Pen and ink
27 x 19 cm
Collection of the artist*

Uche Okeke
Lament of the Funerary Cult
(Igbo Folk Tales)
1958
Pen and ink
27 x 19 cm
Collection of the artist

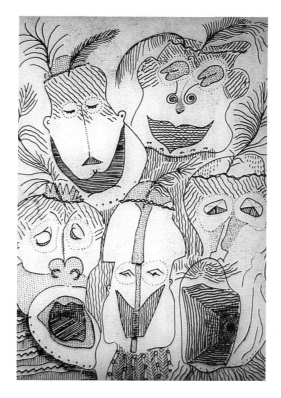

The early post-independence period saw a ferment of creativity in art, theatre and literature around the country, but it was at Ibadan that the finest young artists and writers met to exchange ideas and work together. Artists from around the country gathered at the Mbari Club to present, exhibit and discuss new, original works. There were also studio workshops directed by expatriate artists. Bruce Onobrakpeya participated in the printmaking workshops and it was there that he was introduced to the etching technique. He immediately took up this process, pushing it to its logical limits: for him the journey yielded by Natural Synthesis was not just a new idea, but also a new process and medium.

The first successful step towards that goal came in the late 1960s when he 'accidentally found' the plastographic technique in the course of his etching

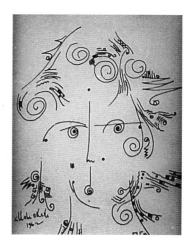

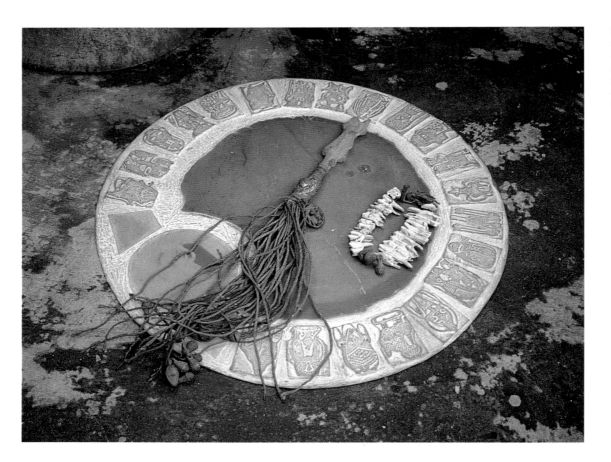

Bruce Onobrakpeya
Shrine Set (detail, disc)
Plastocast, plastograph,
copper foil, bronze,
plywood and stainless steel
305 x 305 x 183 cm total
Collection of the artist*

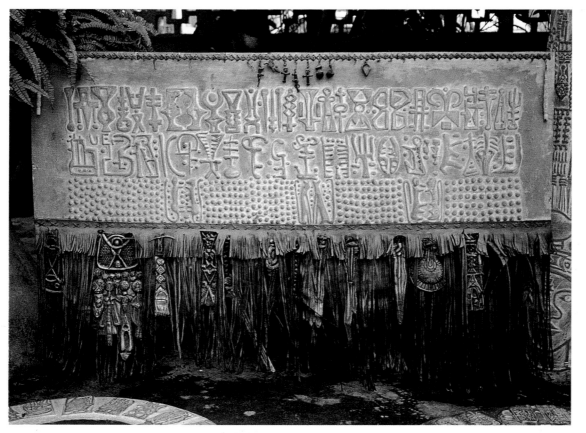

Bruce Onobrakpeya
Shrine Set (detail, wall piece)
Plastocast, plastograph,
copper foil, bronze,
plywood and stainless steel
305 x 305 x 183 cm total
Collection of the artist*

experiments. The transition from deep etching to plastography (he continued to call his new prints 'deep etching' until much later) may have been the result of a studio accident, but the formal progress of his work from the planar, two-dimensionality of normal etching, to deep etching, plastographs and plastocasts, and a matching transfer from flat surface, to low/high relief and three-dimensional sculptural installations does not seem like an accident. As his techniques change, becoming increasingly complicated, they are sustained by the formal complexity of his designs and compositions. It is not surprising, therefore, that he reached beyond the Edo–Urhobo culture for inspiration: he draws from Yoruba, Igbo, Hause–Fulani and even Akan sources.

The sculptures of Onobrakpeya are casts taken from 'negative' resins, which is why he calls them plastocasts. The process yields only two-dimensional reliefs, which the artist rolls into columnar sculptures. In the course of his search for a rich and complex symbolic form, he has incorporated into his plastocasts Akan brass gold-weights, Fulani leather works and other assorted objects from diverse African cultures. The monolithic nature of the rolled-up column is in itself a comment on the tubular bronze staffs of Urhobo shrines, the bronze ivory mounts of Benin court art, and the thousand-year-old cylindrical bronze anklets unearthed at Igbo Ukwu in the heart of Igbo land.

Much as Onobrakpeya's installations may be appreciated from the standpoint of late twentieth-century western installation art, their historical antecedents are to be found in the shrine art of the Bini and Urhobo – a tradition that flourished

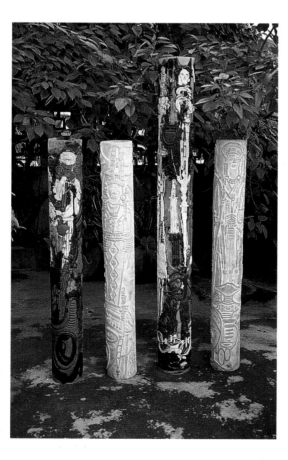

Bruce Onobrakpeya
Shrine Set
(detail, four columns)
Plastocast, plastograph,
copper foil, bronze,
plywood and stainless steel
305 x 305 x 183 cm total
Collection of the artist*

millennia before the birth of modern art in the west. Rather than affect the stark absurdism of much western installation art, Onobrakpeya's work approximates to the emotive object–space symbolism of African religious shrines. His is the modern shrine, the secular altar of the new-age priest. In these installations, art and religion, priest and artist, ritual and spectacle, all become one as in the masquerade performance. There is an interface between the object and the subject, between a modern sensibility and 'traditional' reality, which is the essence of Natural Synthesis.

We may recall that the members of the Zaria Art Society derived much impetus from the euphoric pre- and post-independence nationalism. But, as has been suggested earlier, they were not alone in that quest for a new art. Several other young artists – who formed no associations – were conversant with the political and cultural currents of the time and were equally involved. A number of them trained in the technical institutes and colleges, while a few trained in Europe. One attitude they all shared (which differed markedly from that of the Zaria Rebels) was that they believed there was no future for a modern Nigerian art located in, defined and sustained solely by indigenous art traditions. For them, the spirit of political independence also dictated a replacement of colonial academic art with avant-garde, modern (read western) form and idea.

Erhabor Emokpae was one of the most prominent of the artists whose sensibility was fundamentally different from that of the Zaria Rebels. Emokpae trained at the Yaba Technical Institute at Lagos which, like Zaria, had a conservative academic style. However, after his two years there, Emokpae took to abstraction and severe stylisation, especially in his paintings. That change was his own way of rejecting colonialism, of celebrating collective political independence, and also of expressing his personal creative freedom – the freedom to create something new. But he did not, like Okeke or Onobrakpeya, seek new forms based on the art of his own people, the Edo, whose traditions are among the richest anywhere in the world. He was not bound to any cultural specifics; rather, his freedom to draw from such international 'rebel' art as surrealism and the biomorphic abstractions of contemporary western sculptors informed the direction of his painting in the early 1960s and his sculpture a little later.

His early paintings affected the pictorial nuances of surrealism by a recourse to abstract automatic drip-painting in some cases, and the juxtaposition of shocking, stylised images in others. It was in the later mode that his series of important, mainly black-and-white pictures evolved. Emokpae felt the need to question and even controvert established knowledge, especially Christian religious dogma. He took up that most visible of colonial institutions, challenged its fundamental principles and judged them deficient, even primitive. In one of his most important pictures, he claimed that the Last Supper, the feast of Christ's flesh and blood, is essentially based on cannibalistic instincts.

Emokpae's sculpture combines both western and African imagery, but the former exerts considerably more influence on their form. Most often his subject matter touches on Yoruba traditional concepts, but his forms are realised through a combination of the reductivist tendencies of Constantin Brancusi; the feel for negative and positive volume typical of Henry Moore; and the clean, almost

mechanical, finish of Barbara Hepworth. The formal influence of African traditional sculpture is minimal.

The 1960s therefore saw the redefinition of the direction of Nigerian art by the members of the Zaria Art Society. Within the decade, an alternative attitude – developed in tandem with that of the Zaria Rebels – also emerged. Kojo Fosu calls the protagonists of this reactionary tendency 'Kindred Rebels', artists concerned with evolving an independent creative sensibility founded more on multi-universal sources than on indigenous art traditions. At the end of the 1960s the stage was set for the emergence of another generation of artists, whose careers were to be defined by their responses to these parallel currents in Nigerian art. At this time, too, the bitter civil war (1967–70) had a profound influence on the atmosphere of the nation.

The civil war was especially important, culturally, on the Biafran accessionist side; a significant creative ferment among the new generation of artists matched the Ibadan Mbari phenomenon. Many of these artists had earlier participated in the activities of the Mbari Club at Enugu under Uche Okeke's directorship. In the din of war, artists, along with poets, novelists and dramatists, organised themselves into cultural groups. They produced art, literature and performances reflecting the war experience. One of the most important of these young artists was Obiora Udechukwu, who had begun his training at Zaria in 1966, but was forced to move to the University of Nigeria, Nsukka, due to the exigencies of the war.

The war had a profound influence on Udechukwu, just as it did on many of his generation and even the next. It heightened his awareness of the humanity of man – his failures, his hopes, his tragedy. But while he recorded war images, the troubled times did not allow him to develop an appropriate visual language that could convey the philosophical depth of his creative consciousness. When the war ended in 1970, he commenced what was to become a long, faithful quest for a new idiom.

Erhabor Emokpae
The Last Supper
1963
Oil on board
Collection of Colonel
Ahmadu Yakubu

Overleaf
Erhabor Emokpae
*Struggle between Life
and Death*
1962
Oil on board
61 x 122 cm
Collection of Afolabi
Kofo-Abayomi, Lagos*

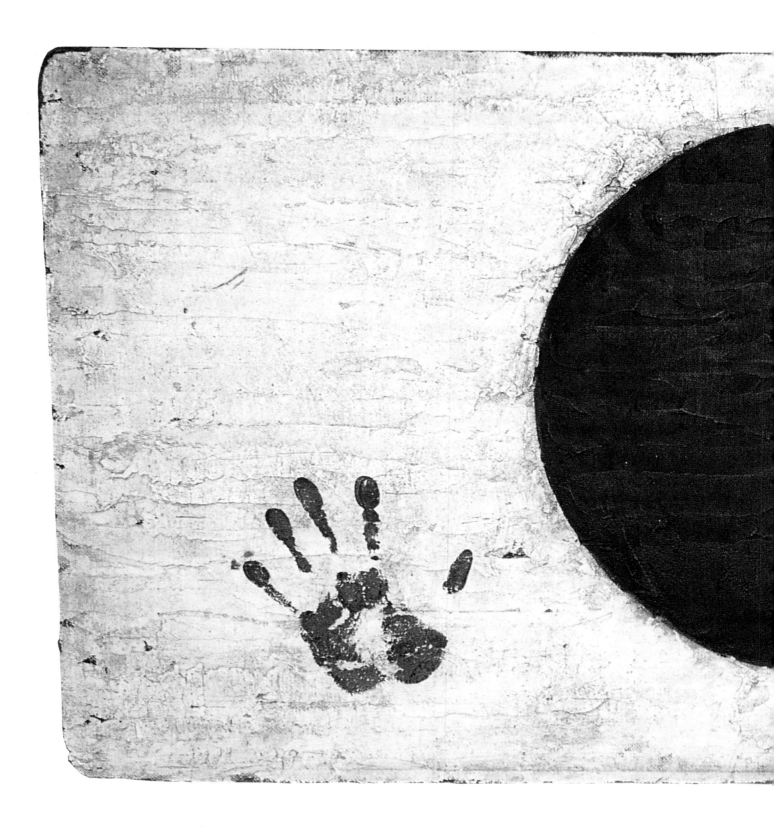

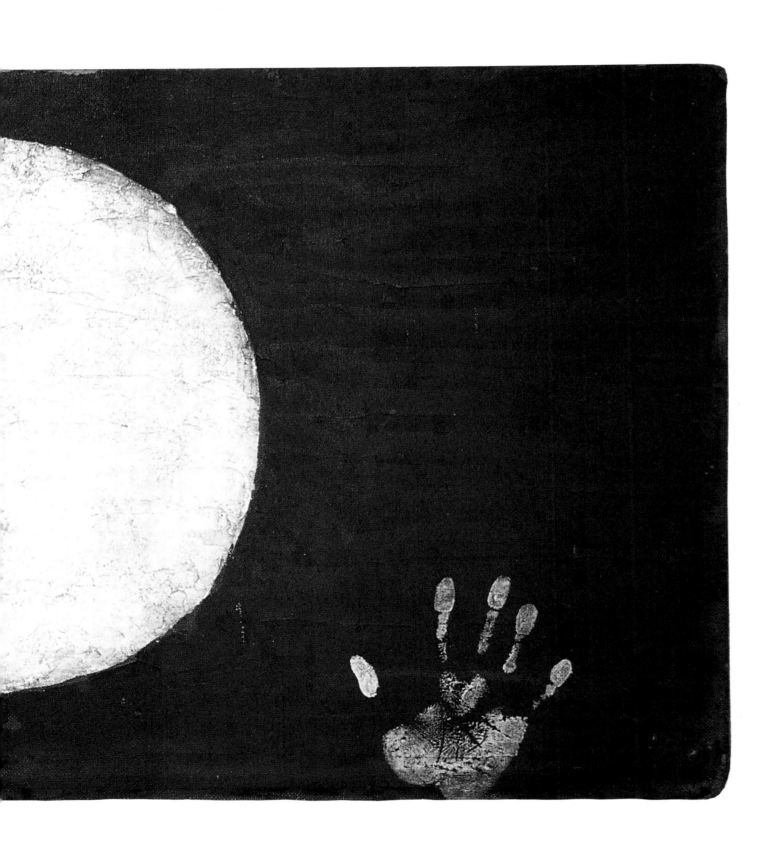

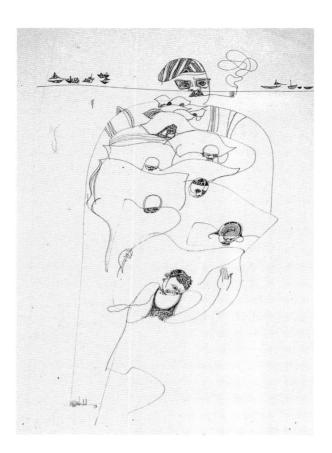

Obiora Udechukwu
Tycoon and Stevedores
1979
Pen and ink
Collection of Iwalewa-Haus,
Bayreuth*

As a child, Udechukwu had seen the beautiful *uli* murals that decorated family compound walls and the revered shrines to the deities of his Agulu community. He knew about Uche Okeke's new paintings and drawings before the war began, but did not then perceive any associations between them and the *uli* murals. Udechukwu had yet to see in *uli* the limitless formal and conceptual possibilities that could be useful to his own art. It was at Nsukka, while he was training under Uche Okeke, that the message of the synthesis theory of the Zaria Art Society reached him. That theory was in agreement with his own personal convictions, so he began in earnest a process of distilling the *uli* essence of elegance and sensitivity of line. His draughtsmanship was strong enough for the new work, and by the mid 1970s his drawings had acquired the formal *uli* lyricism. His lines from then on became powerful vehicles for social commentary and visual poetry that drew their richness from the verses of Christopher Okigbo and Igbo oral poetry.

During this period, Udechukwu also studied Chinese calligraphy: the Chinese *li* and Igbo *uli* share a tendency towards formal simplicity. While Udechukwu studied the wall painting and drawing techniques of Igbo women artists, he also learned the principles of Chinese gestural ink and brush work, the *tao* of painting. Brevity of statement and spontaneity are fundamental to both traditions, qualities that Udechukwu considers paramount. He called the result 'cerebral art'. This synthesis of Igbo and Chinese design principles in his drawing is interesting: he merges an indigenous art form, not with a western one, but with another non-western one. In this way he re-affirms the essential tenets of Natural Synthesis.

In the evolution of Udechukwu's own *uli* forms, there is a conscious incorporation of *nsibidi,* the pictographic script of the Efik and north-eastern Igbo cultural area. The result is a unique pictorial invention that combines the beauty of *uli* and the symbolism of *nsibidi.* Having developed the appropriate visual language, his drawings then became vehicles for social criticism and satire. Due to this preoccupation with the socio-political dynamics of the post-oil boom era, Udechukwu's drawings combine the truculence of media cartoons with the profundity of philosophical treatises. Satiric terseness takes the form of a poetic elegance, acquiring a certain suggestivity that leaves a lot unsaid, requiring the viewer to participate in the completion of the picture and the idea.

In more recent times, Udechukwu has shifted his focus from drawing to painting, from line–space dialogue to the dynamics of shape and texture. The change results from his many years of research into the techniques and processes involved in the making of *uli* wall painting by the Igbo women muralists. Although this interest started early in the 1970s, it was in the 1980s that he embarked on several projects that allowed him to witness *uli* artists at work, demonstrating the procedural techniques of their art. In this way Udechukwu studied and perfected the consummate skill required of an artist in engaging large open spaces with expansive colour fields.

The women create textures to break up the monotony of flat colours by using a scrubbing technique that produces a *sgraffitto* effect. In addition, they use stippled dots to 'hem' actual or virtual lines that delineate borders between shapes of colour.

Obiora Udechukwu
A Pattern of Figures
1993
Watercolour with ink wash
and acrylic
31 x 41 cm
Private Collection

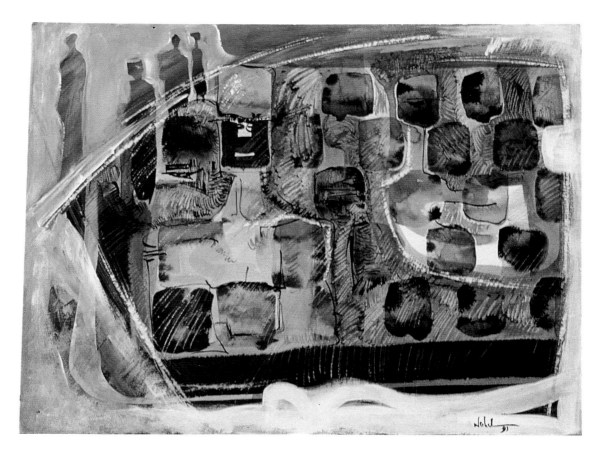

Udechukwu pulls all these together in his recent paintings. However, while the women are restricted to earth colours and occasional blue from imported 'washing blue', Udechukwu's palette is rich with colours. What is more, he goes beyond his earlier social commentary to take on deeper philosophical questions, using even such unlikely subjects as landscapes and the seasons.

A similar approach to appropriating *uli* and enriching it with other parallel art traditions is to be found in El Anatsui's more expansive sensitivity to diverse African art. Since the mid 1970s, Anatsui has worked closely with other artists at Nsukka, developing a unique form based, in his own case, not only on *uli* and *nsibidi*, but also on Nok, Ewe and Ife art traditions. He is a student of Africa's history, especially of its great migrations, the impact of slavery and current developments.

His training at the Kumasi College in Ghana gave him proficiency in sculptural techniques in the western academic mode. That experience proved useful in his later exploration into African sculptural traditions at Nsukka. Modern art, for Anatsui, can claim no legitimacy if it is not based on one's originary art traditions and culture, from which vantage it can then seek to appropriate suitable foreign ideas or techniques. Nsukka provided Anatsui with the enabling environment for that realisation.

In ceramic sculpture, Anatsui made some of his most forceful formal statements. In the 1979 series of ceramic and stone ware, *Broken Pots,* we see echoes of Nok and Ife terracotta sculptures as well as Ewe ritual pottery. The pot is a metaphor for decay, break-up, dilapidation and regeneration. Its shards play important roles in African ritual votive offering; when further broken up, they form the grog that strengthens a new pot. In this cyclic evolution there is a re-enactment of the movement of life from birth, to death, to re-incarnation. Even when Anatsui creates whole pots, they are never complete to the point of suggesting any practical function: their components are bound together by their ritual contents, which defy formal logic. The anatomy of the pots and their broken fragments also raise memories of a past spirituality and of rich traditions, portending the fragmentation of a fragile, secular, communal bond.

El Anatsui
Broken Pots Series
1979
Ceramic
40 cm diameter
Collection of the artist

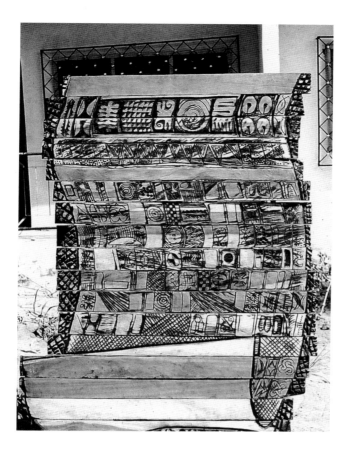

El Anatsui
Invitation into History
1995
Iroko, oyili oji, wood
and tempera
202 x 205 x 15 cm
Collection of the artist*

Prior to his ceramic sculptures, Anatsui made wooden wall plaques. He carved and burned linear patterns that drew from *uli* aesthetics on mostly circular formats. After his experience with fired clay in the early 1980s, he introduced the power-saw and blow-torch as carving tools. At that point the direction of his sculpture changed entirely: he made composite panels that bore the ravaging marks of the saw and the scorch of the flame. The saw and the fire now became metaphors for slavery and colonialism, while the victims – the wood panels – symbolised the many African peoples who share a collective cultural devastation.

In his *Migration Series* Anatsui tells the histories of the African continent, the movements of whole settlements before and during the days of slavery, and the forced relocation of entire groups that occurred on the grounds of colonialist commercial considerations. In recalling these histories, he seeks to trace the present 'otherisation' of Africa to the systematic sabotage of its true history of rich civilisations by an imperialist western culture. It is the awareness of these historical realities by contemporary African peoples that could engender the necessary collective re-affirmation. The design form in the panels draws from the decorative designs of *uli* and the symbolic motifs of *adinkyra*. These combine with the ideograms and pictographs from such African syllabary as *nsibidi, Bamun, Njoya* and *Bolange* to create a complex new form.

At about the same time that Anatsui arrived at Nsukka in the mid 1970s, an interesting development was starting in Zaria. When the members of the Zaria Art Society and the other artists sympathetic to the doctrine of Natural Synthesis left the

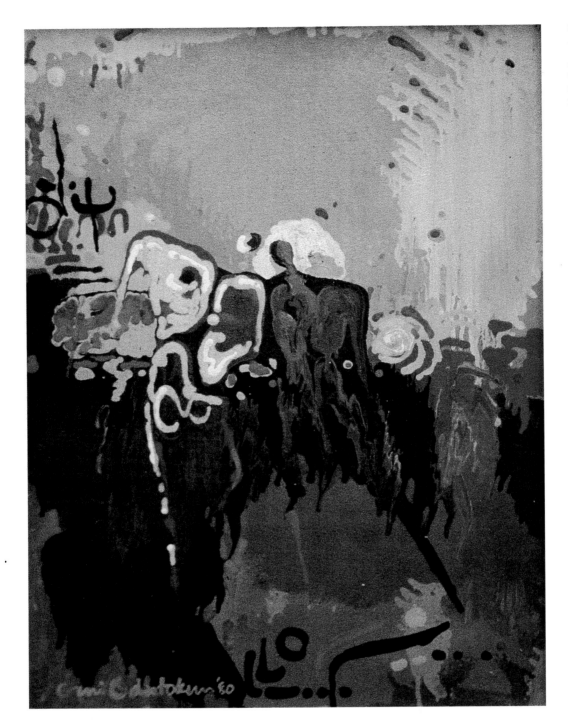

Gani Odutokun
Friendly Whispers at Sunset
1980
Oil on board
75 x 45 cm
Collection of the Odutokun
family*

school in the early 1960s, there remained the old Zaria that had existed before the Rebels (whose impact on the school did not last). This remained the standard academy, and observable stylistic changes came mostly from the expatriate western teachers who remained in the institution until very recently. The most significant of these was Charles Argent, whose influence on Zaria painting is still evident in recent work although he left Zaria almost two decades ago. Argent insisted that the painter must explore colour in order to understand fully its nuances, its hidden character. In the process of doing this, the artist unites established theories of colour with his own

personal experience with painting processes and media. The artist who seems to have carried Argent's precepts to their logical conclusion is Gani Odutokun (died 1995).

Odutokun reinstated Zaria to its position of influence; he also changed the direction of Zaria painting. His art benefited from the faculty, which was made up of artists from diverse cultures. Rather than insist on drawing from indigenous art traditions, he predictably preferred a universalist approach. For Odutokun the world was his constituency, and he was a legatee of its multiculturality. The only determinants of the sources from which he drew inspiration are technical – studio exigencies and the changing environment. He reclaimed the individual freedom of the artist: the freedom to absorb or reject any particular art tradition, also the freedom to combine all since the modern artist is a product of many cultures, the new global experience. It is important to note the similarity between this attitude and that of Emokpae in the 1960s. Whereas the Nsukka artists of his generation took to the tenets of Natural Synthesis, Odutokun aligned himself with the ideas of Emokpae.

Early in his career, Odutokun made a series of paintings with liquidised oils, thinning his pigments until they became fluid, dripping his colours directly on to the canvas. In this process there are obvious allusions to the action or automatic painting that blossomed in the west several decades ago. But Odutokun's attitude was different: he strove to control the intractable process in order to create pictures. In his later paintings he seemed to have finally mastered the liquidised oils technique, for he easily simulated Islamic calligraphic symbols and Hausa architecture and design with dripped lines of colour. The most interesting pictures, however, are those where a combination of bleeding, stained colour and a maze of vertical, horizontal or whirling lines define recognisable forms. In them we see the artist speak of the complexities of modern, existential man. There are no definite boundaries between what is African and what is not. Only the instincts and intentions of the artist are important and constant; everything else is variable.

In the same manner that Islamic calligraphy and architecture contribute to the richness of Odutokun's design sources, Hausa calabash and leather work form part of Tayo Quaye's formal repertoire. In his prints there is a confluence of sources from

Gani Odutokun with his family

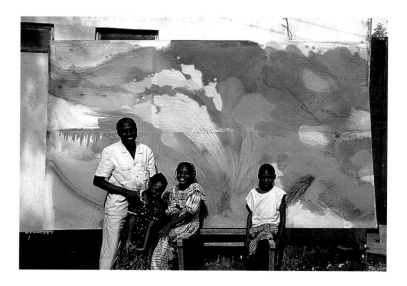

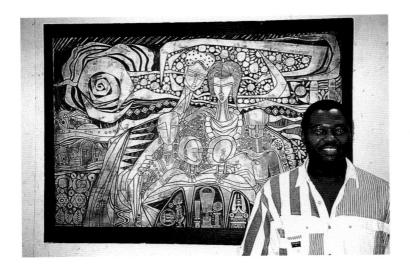

Tayo Quaye
Family
1991
Lino relief
90 x 130 cm
With the artist

contemporary art and the cultural traditions of northern and southern Nigeria. Since his graduation from Yaba College of Technology at Lagos, Quaye has maintained contact with Odutokun, and his residence in Kaduna has ensured his continuing interaction with nearby Zaria artists.

However, Quaye's art draws essentially from Bruce Onobrakpeya, with whom he had his earliest training, working as a studio assistant between 1974 and 1976 and assimilating the rudiments of his master's art. Onobrakpeya's studio has over the years served as a training ground for many younger artists. In some ways, it plays the same role as the art schools in Zaria and Nsukka, where ideas have continued to devolve from the studio teachers. Yet, even if Quaye's work shows an originary attachment to Onobrakpeya's, it is significantly different and several factors account for this.

Quaye was born and grew up in Lagos, so from his childhood he knew and experienced cosmopolitan life. His ideas and understanding of 'tradition' in later years, therefore, are framed by the urban realities of Lagos and whatever semblance of Yoruba cultural traditions the city offered. After his training with Onobrakpeya, Quaye had his formal training in painting at Yaba. The Yaba experience contributed in distancing him even more from his former master's preoccupation with 'traditional' art and lore, but its influence on him was not strong enough to make him take to Yaba's landscape 'style'. Nor could it turn him away from printmaking.

Quaye's lino-engravings and relief prints represent some of his most striking work. They have the same dense pictorial composition that one sees in Onobrakpeya's prints; however, his forms are stronger and his design motifs bolder, highlighting his sensitive draughtsmanship. This facility in drawing is responsible for the elegant, confident lines, especially the ones defining major compositional structures. One also finds the characteristic emphasis on the beauty and visual power of the line that is reflected in the work of the finest Nsukka artists.

In 1981, the year that Quaye left the Yaba College for Kaduna, Jerry Buhari graduated from the art department at Zaria. His teachers were drawn from Nigeria, Britain, the United States and the Philippines. However, it was Gani Odutokun who had a lasting influence on him. These two artists defined the direction of painting in

Tayo Quaye
Beggar
1990
Lino print
91 x 61 cm
Collection of the artist*

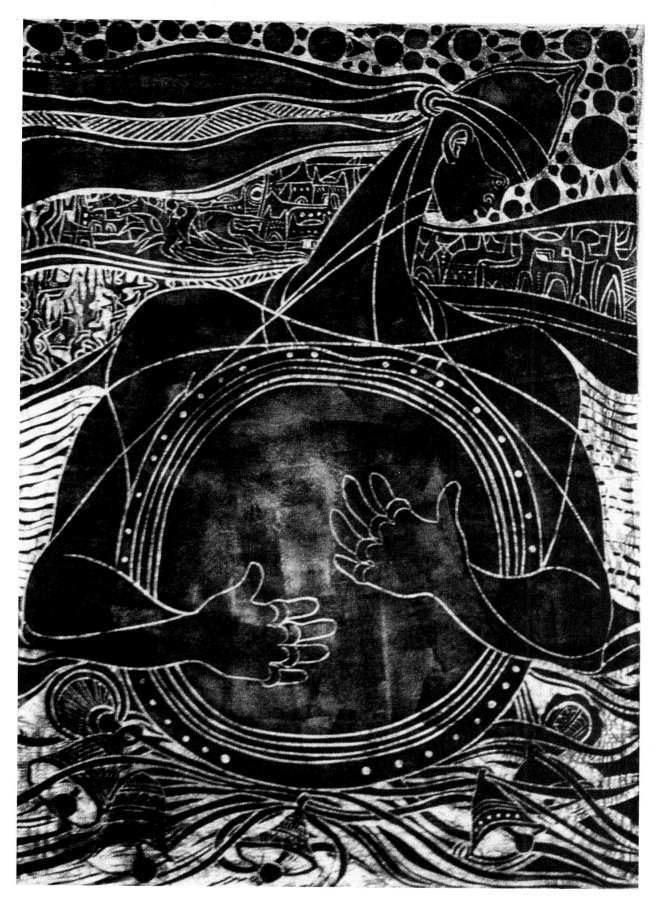

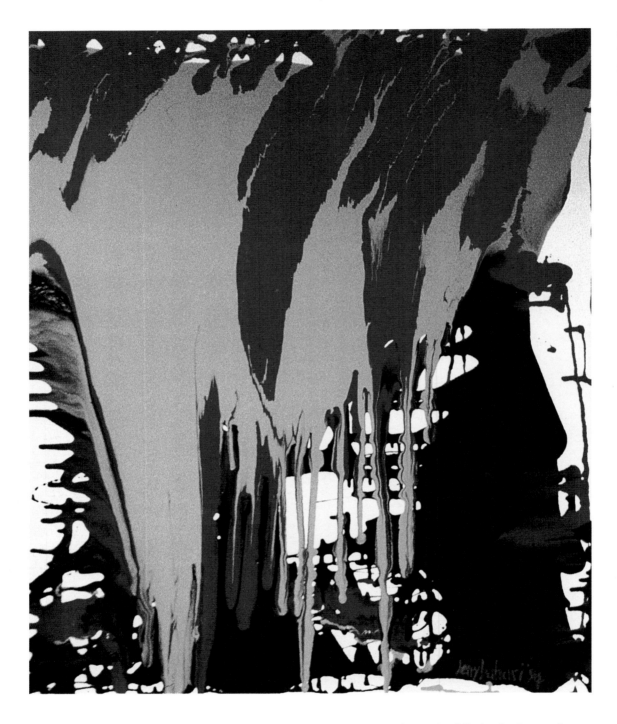

Jerry Buhari
Bush Fire
1994
Enamel on canvas
102 x 84 cm
Collection of the artist*

Zaria. Buhari shared with Odutokun the urge to experiment with techniques from the traditional to the unconventional. Both agreed that the painter must not strive to make paintings that are tied to African cultural specificities. Yet there is a marked difference in their sensitivity to colour. Whereas the aesthetics of colour is fundamental to Odutokun, for Buhari its expressiveness is paramount.

The Zaria doctrine of transcultural art is evident in Buhari's paintings: he never aspires to create art that could be defined as 'Nigerian'. His explorations into colour and method derive from his personal encounter with nature and his social environment. In 1989 he made a series of paintings, *Floral Notes,* in which he

explored the symbolism of colour using the flower as a metaphorical source. He subverts the natural association of flowers with beautiful colour, with flowers that are troubled, their colours bright and clashing as if simulating contemporary social realities. The feeling of restrained violence is heightened by his temperamental brush work. The outcome is unsettling.

In his more experimental, liquidised oil paintings, Buhari shows a tendency towards complete abstraction. He makes little effort to control the flow of colours when he tilts his canvas, allowing them to flow down and out of the canvas – wasting away. This very act of the deliberate wasting of 'precious' pigments is the artist's way of reacting to his social environment; he draws a parallel between his actions and the wasteful destruction of the natural environment by man. There is also a different interpretation of the process: the painter takes on a purist approach to the creation of pictures, much as in automatic painting where intuition takes over from logical reasoning. Accident becomes design. The colours create their own associations as they flow down the canvas without the artist's intervention.

While Buhari strives to create new forms through the manipulation of the painting process, Jacob Jari's interest is in finding an alternative painting medium. Earlier, Jari (Buhari's classmate) had taken part in experiments with colour and technique led by Gani Odutokun. But he gradually redirected his search towards a different goal: developing a cheaper, newer, painting medium, something different from oils and acrylics. He devised cornstalk mosaics.

In the earliest of these mosaics, Jari is preoccupied with understanding the language of the new medium. He begins with geometric designs and then moves on to complex pictures such as landscapes. He works out the possible colour variations given the limited tesseral colours. His realistic pictures are simple, with bold areas of colour, since mosaic painting does not allow for detailing. His recent pictures are abstract: the degree of formal success, therefore, is dependent upon the interplay of colour and allusive shapes or patterns. From the complex to the simple, the mosaics make no definite statements: they suggest forms and ideas that come to full realisation in the mind of the viewer. In the same way as Odutokun and Buhari believe in the universality of the language of art, Jari makes no allusions to any indigenous African art form or concept. His cornstalk mosaics are not a reaction to the art of the 'outsider', nor the sentimental return to 'tradition' and local materials that some of the *Ona* artists at Ife have pursued. His is a search for a convenient, eloquent medium for advancing a purely personal, modernist iconography.

There is a formal relationship between Jari's multi-picture compositions and Buhari's round-format arrangements. In both cases the artists attempt to make allusions to multiple psychological states, to which those encountering the pictures, given their own mental dispositions, will relate in their own way. The effect may not be the same, due to the different media of expression, yet the underlying conceptual structures are correlative.

Ayo Aina, one of the newest generation of Zaria artists, considers his ultimate goal to be the realisation of pure sensual beauty through a sheer manipulation of colour. There may be in this attitude a suggested summation of the formalist strivings of the Zaria artists. Aina does not use the liquidised oils medium, but

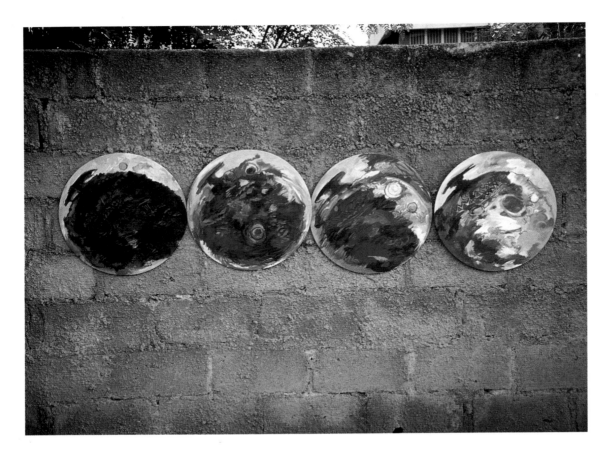

Jerry Buhari
Ritual Pots Series
1994
Oil on board
c. 61 cm diameter each

instead paints with palette knife and brush, displaying the same gestural boldness of Odutokun's earlier oils. His 1992 paintings are almost entirely in the abstract mode. In these he engages the picture space with broad knife strokes of brilliant colours. Sometimes the patches of colour seem like collage compositions, each statement an element that derives its justification from its relationship with the others.

Gradually, his abstract compositions are giving way to illustrative pictures with human and linear decorative elements. But there is a conscious attempt to subjugate recognisable images, which must not interfere with the celebration of colour but are intended to be seen only as areas of colour. The pertinent question, perhaps, is who determines what colours and what colour combinations are most likely to approximate to sensual beauty? Aina believes that the artist makes all the decisions. The colours he chooses represent the beautiful, and his personal aesthetic sensibility accounts for their organisation in a particular way in a given painting. If at the end of the process he is satisfied with the result he then *hopes* that the viewer shares in his experience of colour now transferred to the canvas. The very acts of stripping colour of any symbolism; of insisting on the irrelevance of suggested images; and of imposing titles that create associative mind pictures may be the artist's ploys to tease us away from any inhibitive subject matter – a way of drawing us into the world he creates, where non-associative colours are all that remain, all that matter.

The 1980s in Nsukka marked the emergence of a third generation of *uli* artists with the presence of Tayo Adenaike, who trained under Uche Okeke and Obiora

Jacob Jari
*Mosaic consisting of
six works*
1993
Cornstalks on board
165 x 153 cm total
Collection of Captain
Usman Mu'azu*

Udechukwu. He is also one of the first major non-Igbo *uli* artists. Since 1980 when he had his first solo exhibition, *Childhood Fears,* Adenaike has refined his technique and form, weaning himself away from the earlier influences of Udechukwu in the process. He has developed a distinctive style that is informed by his Yoruba background and his experience of Igbo *uli* painting. His early drawings are heavy and less lyrical, but with more decorative *uli* motifs than Udechukwu's or even Okeke's works. The same may be said of his early attempts at using watercolour. With time, Adenaike's watercolours have come to acquire a certain fluidity and originality that is remarkable. Interestingly, he has worked almost entirely in watercolour for the past thirteen years, exploring the formal possibilities of *uli* design in that medium more than any other artist so far.

Adenaike does not display the typical linear sensitivity that has become the hallmark of the older generation of *uli* artists, yet he still conveys the same formal elegance with his fluid, distinct boundaries between areas of colour. In his more recent work, he combines bold geometric patterns which – though based on *uli* – are reminiscent of Yoruba *adire* textile design, with brilliant colours that have hitherto not been associated with modern *uli.*

Adenaike synthesises the myths and folklore of the Yoruba and Igbo and draws from proverbs and stories he recalls from his childhood years spent with his grandmother. These sources form the basis for his enquiries into contemporary subject matter. More importantly, this fusion of traditional myths and lore with contemporary existential realities yields interesting currents, which combine with

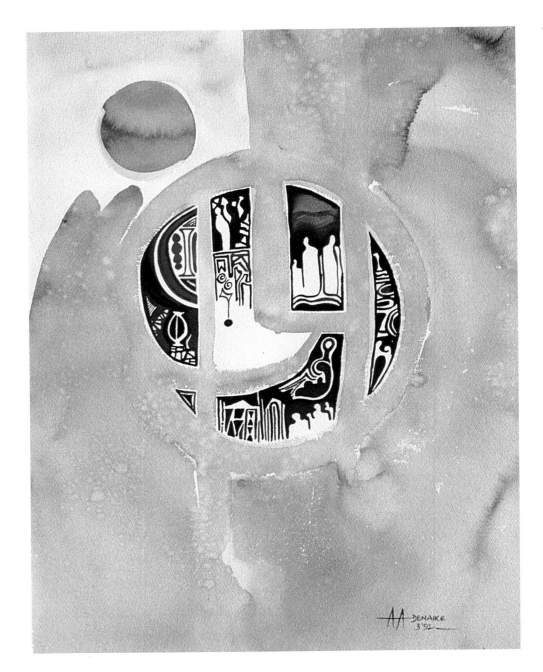

Tayo Adenaike
Untitled
1992
Watercolour

an *uli*-based design to produce what Adenaike considers to be the essence of his distinctive art.

By the mid-1980s further developments were continuing with Ndidi Dike, who trained at Nsukka. Dike trained as a painter, but later took to sculpture, with her painting experience continuing to modify her glyptic sensibilities. In her painting she explored a variety of natural media, especially dried banana fibres, seeds and sand. She did not take to *uli* in the manner of Obiora Udechukwu or Uche Okeke; her interest in drawing was perhaps not enough to sustain the demands of *uli* for linear elegance and essentialisation of forms. Although she had recourse to basic *uli* compositional formats – the dynamics of positive and negative spaces – her pictures drew attention more to the interplay of diverse, unusual media. Her painting

changed from normal canvas or Masonite, through fire-stained boards, and finally to sculptural mixed media, work in relief and three-dimensional sculptures. This development parallels Onobrakpeya's transition from painting to printmaking to installations.

Dike's relief sculptures are composite and, like Anatsui, her tools range from manual and power-assisted carving tools to the blow-torch. Her works derive their formal complexities not so much from the interchangeability of the composite parts as from the inclusion of brass figurines, coins, animal and vegetable fibres, and cowrie shells. Although the composite form defies the monzylogosity of much African wood sculpture, the extraneous materials make a symbolic gesture to their African contextual background. With Dike, as in Onobrakpeya's mixed media installations, objects from Akan, Fulani and Igbo material cultures fuse together to create something tellingly African, dispassionately contemporary (there is also an unmistakable presence of *uli, nsibidi* and *akwete* motifs and designs in her work). Dike pays fleeting attention to the indigenous art traditions of Africa, as though leafing through a vast volume of African cultural history: images do not stay long enough to make any lasting impression. She is drawn to the culture and art of Africa, yet she is distanced from it to the extent that she enjoys her freedom to take as much from the vast resources as her spirit wills. Consequently, her sculptures merely suggest their cultural provenance, making no definite claim to particulars.

Unlike Ndidi Dike, Olu Oguibe's attitude to the recovery of 'tradition' is fundamentalist. His training at Nsukka under Udechukwu made him conscious of the raw visual power of *uli* wall painting. The result of that experience for him was a

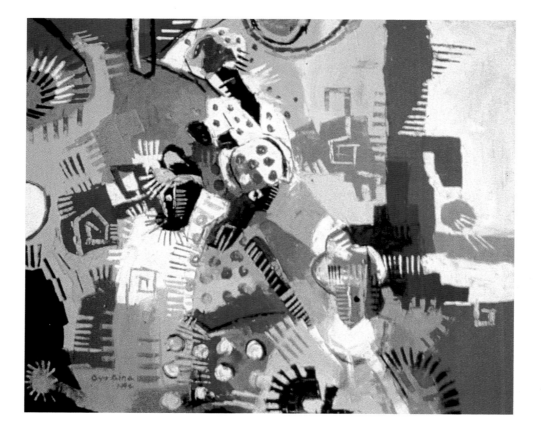

Ayo Aino
Untitled
1994
Acrylic(?) on canvas
106.5 x 76 cm
Collection of the artist

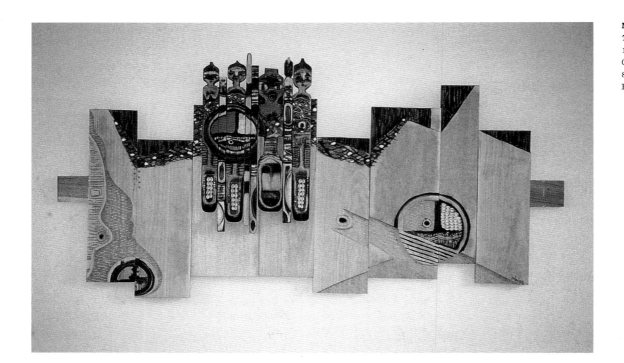

Ndidi Dike
The Spirit of African Art
1994
Carved wood panels
85 x 250 cm
Private Collection*

reversal, a return to the basis of the modern *uli* experiment. The design and compositional nuances of the *uli* mural, which were only beginning to inform Udechukwu's new paintings, defined the formal structures of Oguibe's. Oguibe learned the techniques of the *uli* artists, internalised them and then refashioned them to create a new form that is at once 'traditional' and 'modern'. The problem he seems to have had is that *uli* does not readily yield itself to the needs of an artist whose mission is to communicate, literally, with his audience. So Oguibe combines *uli* and *mbari* aesthetics with a powerful communicative element: the written word.

In the *National Graffiti* series painted at the time the Babangida dictatorship was beginning its intrigues, Oguibe makes a beautiful and powerful statement about the worsening socio-political environment. Even the fact that the pictures are printed on woven mats is not without reason: the political protest develops into a cultural one as he rejects modern, western 'specifications and delineations'.

A purer response to *uli* is evident in his *Nsukka Triptych*, where he simulates classical *uli* design. Oguibe's design is simple, clean, and sets a clear background for the graffiti. As in the earlier *National Graffiti*, the phrases, words and signs allude to historical and political issues that form part of our collective national experience. The social commentary championed by Udechukwu becomes more biting, more declamatory and turns into a form of protest. Graffiti gives the artist an opportunity to give vent to his gut feelings about his society. It is also the *vox populi* from which one can read the times: Oguibe continues a tradition that had long been established inside prison cells, public toilets and railway stations. Against the backdrop of a rich art tradition, we hear the individual and collective voices of a society in the throes of great change.

Chika Okeke came after Oguibe at Nsukka and shares similar thematic preoccupations with the older artist who had left Nigeria for England by the end of

Ndidi Dike
Ikenga
1993
Wood
60 x 75 cm
Collection of Captain
Usman Mu'azu*

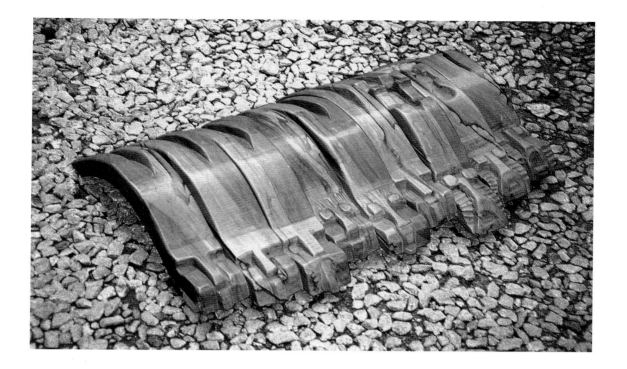

the 1980s. Okeke's training in sculpture under El Anatsui, and in painting under Obiora Udechukwu, as well as his association with Olu Oguibe at Nsukka, provide the background for his art. In his painting there is an unmistakable influence of the sculptural form. The realistic or stylised figures and the sometimes rigid handling of colour point to this; even when there is an attempt to seek a balance, form and composition still supersede colour in importance.

In Okeke's earlier work, the use of space was in accordance with quintessential *uli* design, but this has changed with time. Even if there is still a recourse to the power of line, there is also that evolving form that includes not just the *uli* line, but also *mbari* geometric design patterns and ideographic forms based on *nsibidi* scripts. Also, the fundamental negative–positive space dynamic evident in earlier *uli* is replaced by dense pictorial compositions that leave no major areas of positive and negative space. The expressive, illustrative form recurs in his work due to a strong need to engage in social criticism and political commentary. Similarly, symbols from *uli* and *nsibidi* sources interact with those from contemporary life, thereby giving the resulting picture several levels of meaning that, in the end, recount and disparage the spectre of dictatorship in Nigeria.

III. In the Arena

But what is that essence all the artists in this story seek for? Is it even possible that there is one essence, a collective goal that may be called Nigerian, a characteristic product, a common quest? We seek here for explanations in the phenomenon of the masquerade – the masquerade that exists in and beyond the world of finite senses; the masquerade of several parts, each equally spectacular, awesome, beautiful, intriguing, different, yet complementary to the others. Like the Igbo *Ifele* mask, the

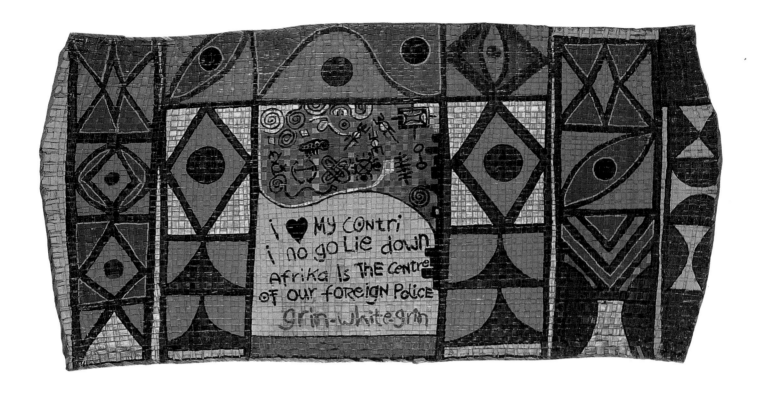

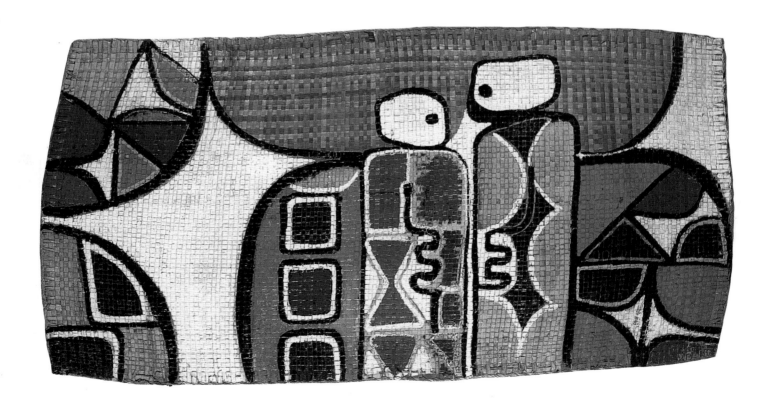

Olu Oguibe
National Graffiti (details)
Enamel on mat
338 x 356 cm in total
(in eight parts)
Collection of Olu Oguibe*

masquerade is a summation of a people's culture and philosophy. Its beauty can hardly be comprehended in stasis, but rather in its pirouetting movement, its constantly changing position. Its 'multiplicity of frames' is its beauty, its essence.

The artists presented here are like masquerades. As we have seen, they continually change their interests, attitudes and techniques as dictated by their individual enquiries into the nature and essence of art, or due to associative influence from other artists. Each artist is a masquerade in the arena, performing before an active audience.

It is as if, in the beginning, Ben Enwonwu learned a new dance step that had been introduced before his time. He refined his movement and danced so well that he became the most spectacular masquerade in the arena. But because his performance included many of the styles he learned from other lands, his interpretation of the musical rhythms was not convincing enough to draw the next performers to this style. However, the new masquerades learned one thing from Enwonwu: the need to add vigour to their dance.

The members of the Zaria Art Society took to the square after Enwonwu: they danced in a manner never seen before. They did acrobatic movements, somersaults and gesticulations that drew largely from those of the ancestors. This got the audience ecstatic with pride. Even though the Art Society masquerades knew and acknowledged foreign dance steps and even incorporated them into their dance repertoire, they insisted that only when the masquerade had mastered the steps of the ancients could it add 'flavour' by borrowing from other lands. As in the cases of Uche Okeke and Bruce Onobrakpeya, each had a different ancestry and temperament, so their performances were not entirely the same.

While the Zaria Rebels took the centre stage, in a corner of the arena there were other masquerades who added variety to the entire event by doing dance movements from foreign lands, adapted in ways that their audience was able to understand. Erhabor Emokpae was one of these off-centre stage masquerades who felt that the origin of a dance step did not matter, provided that the performer did it well and that his audience understood it.

Time elapsed, and new masquerades arrived at the arena, doing all kinds of dances at the same time. Also, the centre stage split in two. Obiora Udechukwu and El Anatsui took one corner. There they were inspired by the dance of the Zaria Rebels whose member, Uche Okeke, had gone to the very corner to continue the dance he had begun earlier. Udechukwu added even more to Okeke's style and it became richer, while Anatsui (who came from another community) brought with him his own ancestral dance steps and others he had learned along the way.

In the other corner, Odutokun started a new dance that included several movements, some of which he learned from dance masters from other lands. In fact, he borrowed freely from any of the many styles he knew, both those of his people, the audience, and those from distant and nearby villages. Even as he danced these recognisable steps, he also did some that were unique because no one in the audience could readily say where they came from. However, there was something in his performance that was similar to Emokpae's eclectic dance.

Time moved as it always does. Many more masquerades, all of them new, took

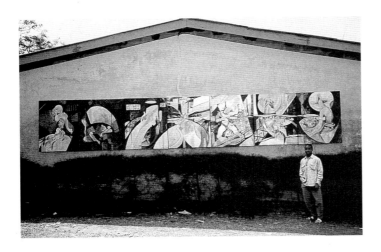

Chika Okeke
Tyranny and Democracy
1994
Acrylic on canvas
152.5 x 853.5 cm
(in seven parts)
Collection of the artist*

to the arena. In the Zaria corner, these new masquerades are re-interpreting Odutokun's steps, adding a few of their own. Close to that corner another one dances in a way that reminds us of Onobrakpeya's performance, except that its dance includes steps also learned from other, older masquerades. The same process is going on in the Nsukka corner, where many raise memories of their ancestral dances as they were performed by the masquerades that had earlier taken up positions.

So what do we make of all these? How do we watch several masquerades performing at the same time, turning, changing steps in either slow or quick turns? Perhaps we can do it by altering our own positions as often as necessary. However, it is not yet time to pass judgement on what the masquerades are doing or from which corner the best performance comes. That really is not quite necessary, for the eternal music continues, and the masquerades, since they exist in paranormal spheres, will continue to perform, satisfying our appetites and filling our imaginations with excitement. However, given that the arena is so vast, given that from here one can see only what goes on in two corners, we must not forget that these do not make the whole market square, the entire arena. We can say with certainty that the similarity and variety of the masquerades and performances we see here are but pointers to what goes on elsewhere in the arena.

As the masquerades perform, many more are bound to emerge. If there is anything they have in common it is the need to dance those steps that are best suited to their type, stature and size in order to enthral the audience and themselves. That is the quest. And since a masquerade does not perform in an empty arena, without an audience, and since there are several masquerades, the one thing that unifies all is the space where the events take place. That arena is Nigeria, and the summation of the ever-changing experience of the masquerades is perhaps what we may call Nigerian art. No attempts at characterising the events at the arena with reductionist classifications in definitive terms would suffice. Everything – the masquerades, the audience, even the experience – is in a state of flux.

Chika Okeke
Tyranny and Democracy
(detail)
1994
Acrylic on canvas
152.5 x 122 cm
Collection of the artist*

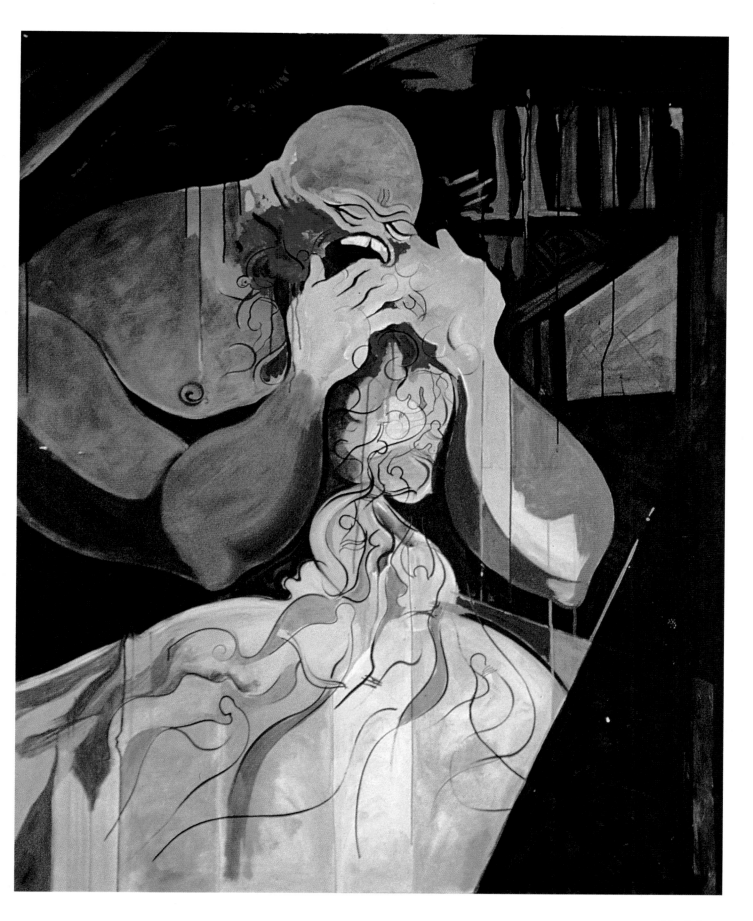

objects

of performance

a story from senegal by el hadji sy

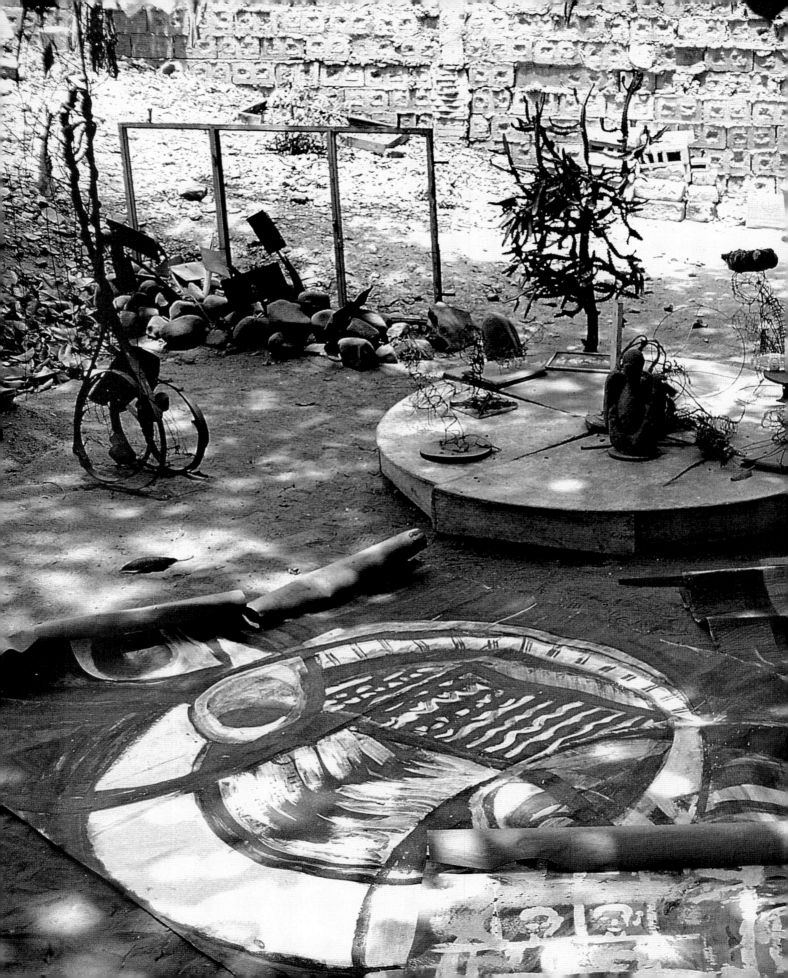

Objects of Performance

El Hadji Sy

It seems as if it was only yesterday that people were analysing African art purely on the strength of the object alone, disregarding the creature who made the object itself. Without man – the artist, the creator – being considered as one with his object, a fresh analysis of contemporary arts in Africa could turn out to be an outmoded social phenomenology, its basis at the same time the harbinger of its obsolescence.

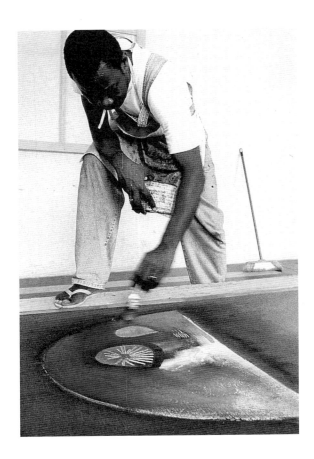

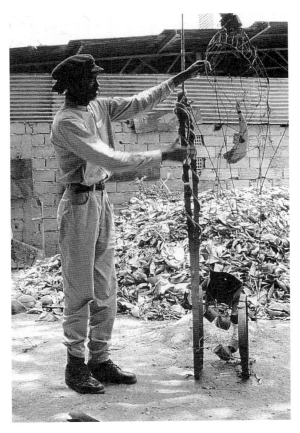

Experiencing and expressing human sensitivity in some of its most
exalted forms, African people are spontaneously artists. They know how
to organise the visible: state ceremonies, ceremonies for initiations,
baptisms, marriages, funerals, festivals, dances, music, etc. These
qualities, as the Senegalese writer Jean Pierre N'Diaye has stated, mean
that – in the absence of any historical forecasts, of any intention by other
peoples to dominate, whether by colonisation or apartheid – African art,
this black culture, is highly successful in generating vitality and power
in its strongest and most intense forms of expression, at the slightest
hint of freedom. Of all the stories told by painting and sculpture, these
modes of expression, which have become irrepressible and highly
significant, have modified the aesthetics of the twentieth century.

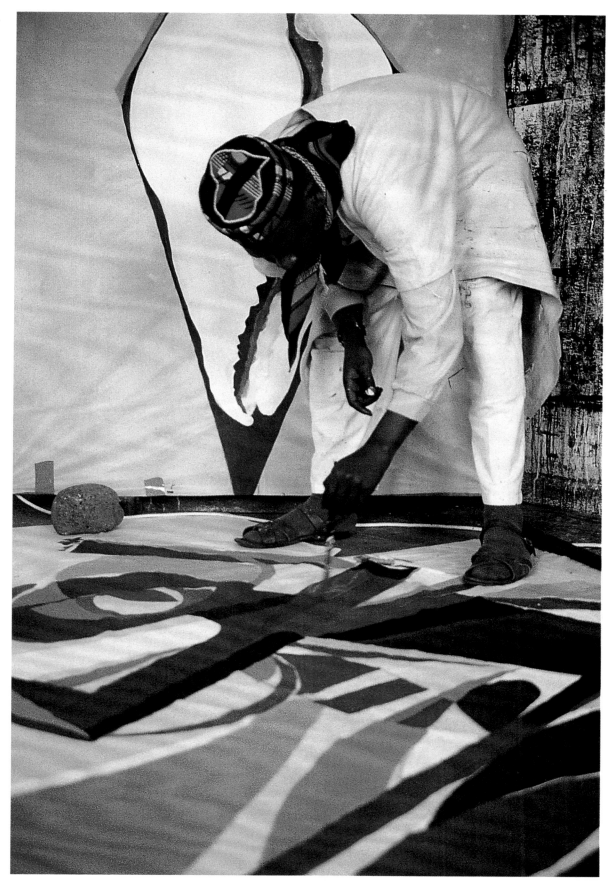

El Hadji Sy working on
5-metre kites for
Youssou N'Dour's
Chimes of Freedom,
Dakar, November 1993

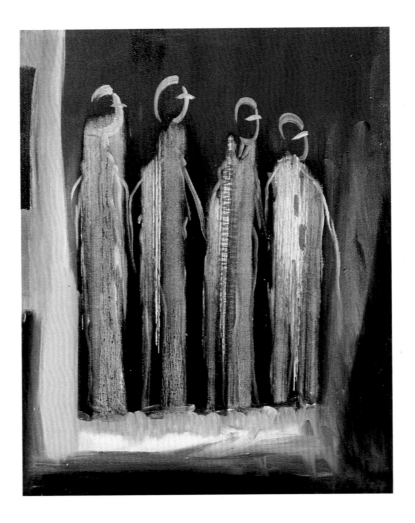

Issa Samb
Untitled
1992
Acrylic on canvas
90 x 60 cm
Collection of the artist

Souleymane Keita
Untitled (detail)
1993
Oil on canvas
Collection of the artist

El Hadji Sy
Untitled (detail)
1989
Oil on canvas
103 x 90 cm
Collection of Friedrich Axt

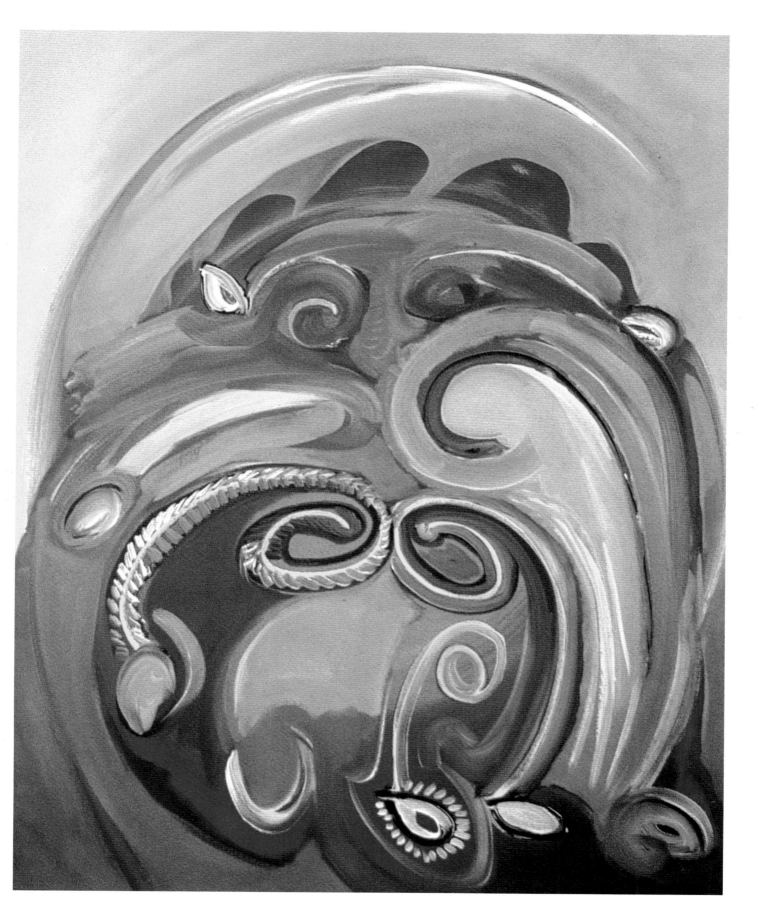

Sét Sétal
Mural
Dakar, 1991

But under the combined influence of critics from the west and because of intense Islamicisation, genuinely African art went into hibernation for several decades. The history of the African continent is taking place at a disturbing, crucial and unprecedented turning point in the history of world civilisation. The cultural creations produced at a certain time by mankind or, as it happens, by a particular race, as with the contemporary visual arts in Senegal, cannot be separated from events which, in the recent or distant past, govern or have governed the destinies of mankind or of that particular race. So painting and its history are part of culture, which is the most important ingredient of history.

Life in certain sprawling black suburbs, towns and countless villages in Africa is often experienced by the open-minded and receptive foreigner as a fully realised, fantastic opera taking place at the heart of a population that lives naturally (consciously or unconsciously) in a state of performance. These transcendental elements are best translated by that supreme form of art, negro art. This art, as you know, transformed the vision of the western world. In 1956, Léopold Sédar Senghor, who created the theory of Negritude, wrote: 'a negro style of sculpture, a negro style of painting, even a negro brand of philosophy, have now made themselves keenly felt and have become part of humanity's shared heritage.'

Sét Sétal
Mural
Dakar, 1991

Sét Sétal
'Don't touch my mate'
SOS racism slogan
Mural, Dakar, 1991

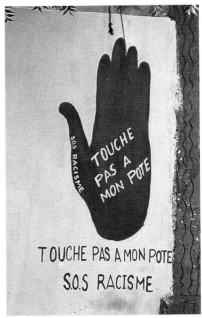

In the full assurance of this, on Senegal's independence in 1960, Senghor gave the country various cultural infrastructures to support his ambitious artistic programme. He devised this as an artistic movement called Negritude. However, Negritude was as much the artistic apparatus for a political movement as an aesthetic programme. The artists and art professors, Papa Ibra Tall and Iba N'Diaye, each created an individual body of work. Examples were exhibited: in the case of Iba N'Diaye, at the gallery adjoining the Maison des Arts at the end of 1961; and, in the case of Papa Ibra Tall, at the beginning of 1962 at the Hôtel Croix du Sud in Dakar.

Sét Sétal
Dakar, 1991

Sét Sétal
Mural (detail)
Dakar, 1991

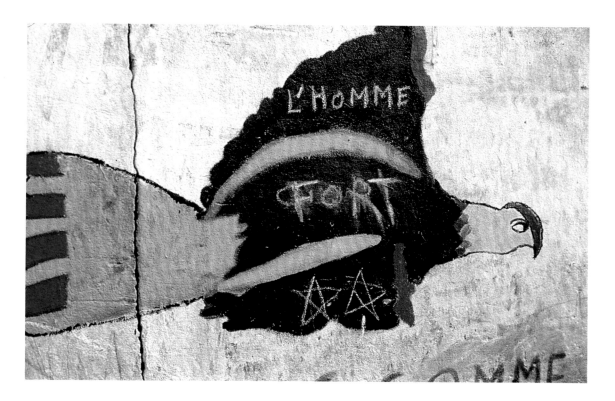

Sét Sétal
Mural (detail)
Dakar, 1991

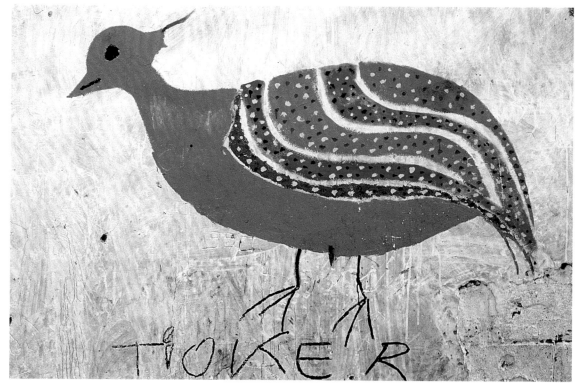

Pierre Lods
Dakar, 1987

President Léopold Sédar
Senghor
1960

Having been in contact with Pierre Lods (whose memory I honour here),
the cultural authorities of Senegal, at the invitation of President
Senghor, planned to cooperate with the founder of the Art Centre in
Brazzaville, Poto-Poto. Pierre Lods arrived in Dakar in May 1961 to
work with Papa Ibra Tall. Senghor again took up an idea he had had
long before for the creation of a tapestry workshop, and in 1964 the
Manufactures Sénégalaises des Arts Décoratifs was established, first at
Dakar and later at Thiès.

Souleymane Keita
Le Massacre des Tutsi
1991
Oil on canvas
174 cm diameter
Collection of the artist

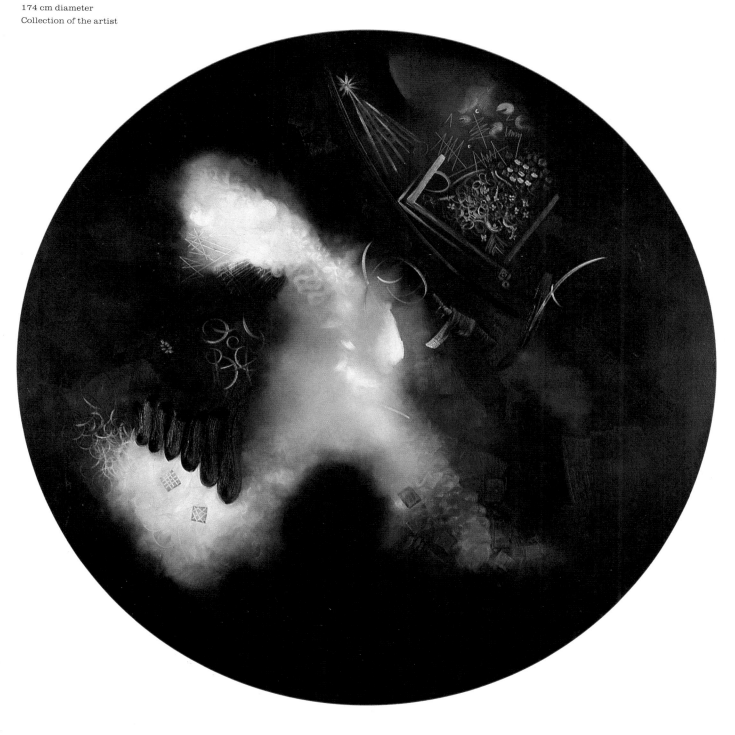

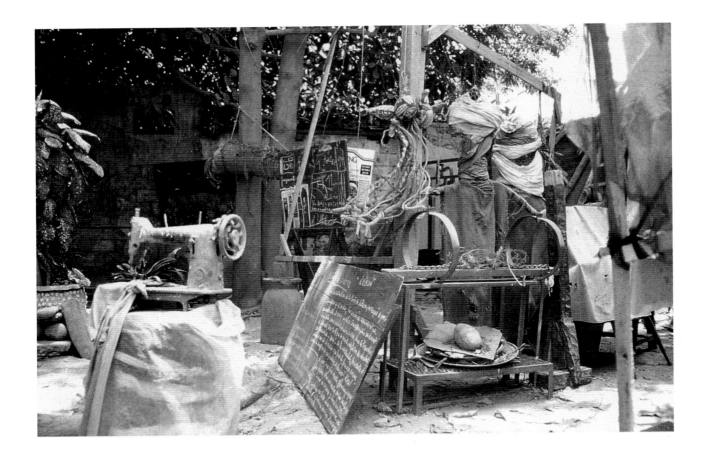

Having agreed to the designation of the 'Dakar School' (as a response to the Paris School), the first generation of artists made it possible, before the Premier Festival Mondial des Arts Nègres was held in 1966 in Senegal, to take their rightful place in the contemporary art scene on the occasion of this festival. The next international festival saw the first official Senegalese exhibition at the Grand Palais in Paris in 1974, which toured Europe and America. Reactions were encouraging.

Objects of Performance
Laboratoire Agit-Art,
Dakar, 1992

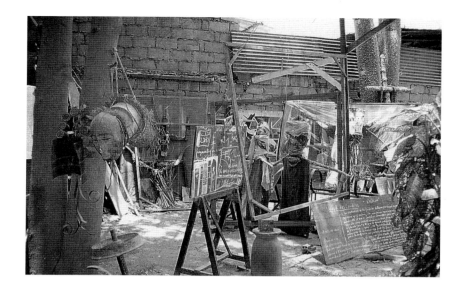

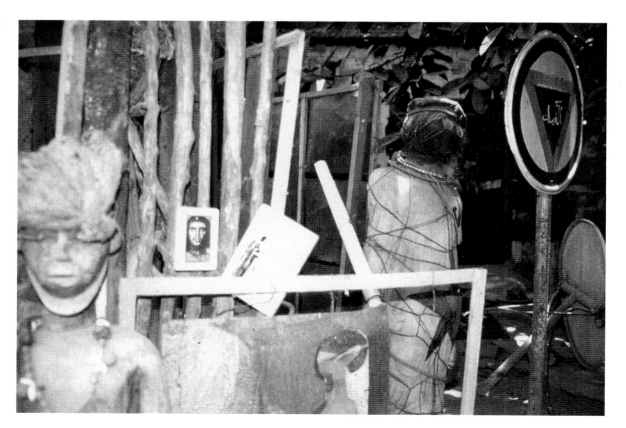

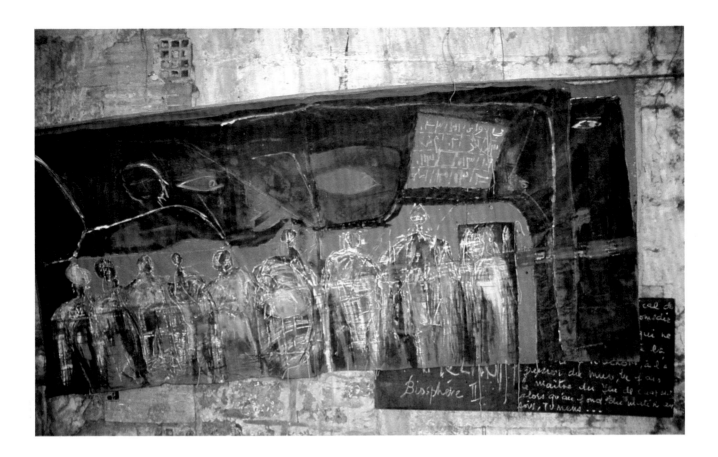

Despite a certain number of bright intervals here and there, the specificity which characterised Senegalese culture in the Senghor years is now more of a memory. The world of art is not the exclusive province of the practitioners. Sét Sétal, which dates back to 1980–81, was taken up by the people in the towns and various districts in 1990–91. Issa Samb, also known as Joe Ouakam, is the key innovator and witness of the Sét Sétal and of the experiments of Laboratoire Agit-Art as arenas for speaking out, as much in theatre workshops as in street performances. Laboratoire Agit-Art is a group of artists and intellectuals who have chosen the media of experimental workshops, public debates, theatrical performances and visual creations to consider and analyse the body of questions relating to arts development. Due to its non-bureaucratic, anti-official and rather informal nature, the Laboratoire was able to be the vanguard and the forerunner of the revolt by men, women and children, with the Sét Sétal of 1990. This happened well before it was taken up by the District of Dakar and the political authorities.

Issa Samb
Untitled
1992
Mixed media (tarpaulin)
100 x 260 cm
Collection of the artist

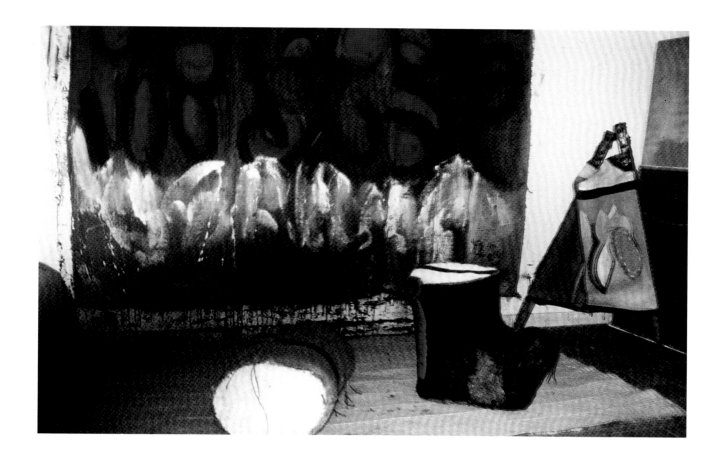

El Hadji Sy
Installation of work
including rice-sack paintings,
trapped objects and
The Stretcher of Gorée
1992
Mixed media: jute, wood,
acrylic, tar

Objects of Performance
(painting)
1992

Issa Samb,
Laboratoire Agit-Art
Blackboard
1992
100 x 120 cm
Collection of the artist*

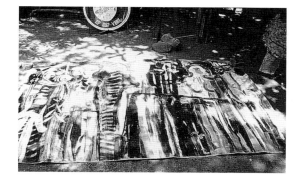

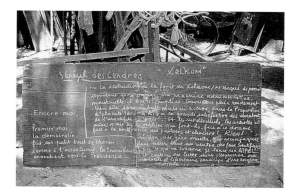

This was a cultural phenomenon – linked to the everyday Senegalese environment in its determination to clean up the districts and make them smarter and safer – which saw young people, fired with enthusiasm by the music of Youssou N'Dour's 'Set', throwing themselves into painting walls and erecting sculptures on the roundabouts.

Issa Samb,
Laboratoire Agit-Art
Work on Presidents
Bokassa and Giscard
d'Estaing
1993
Mixed media
120 x 40 cm
Collection of the artist

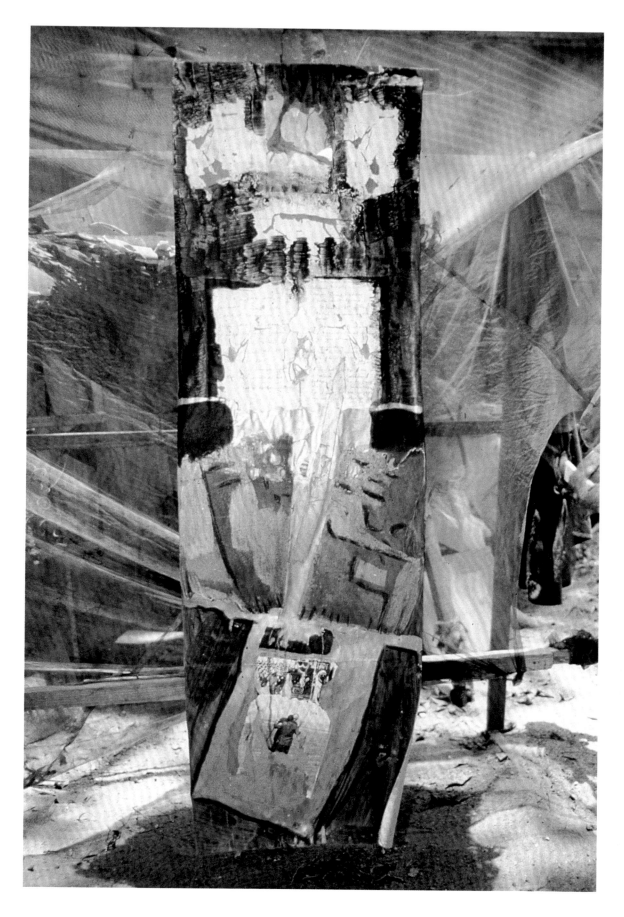

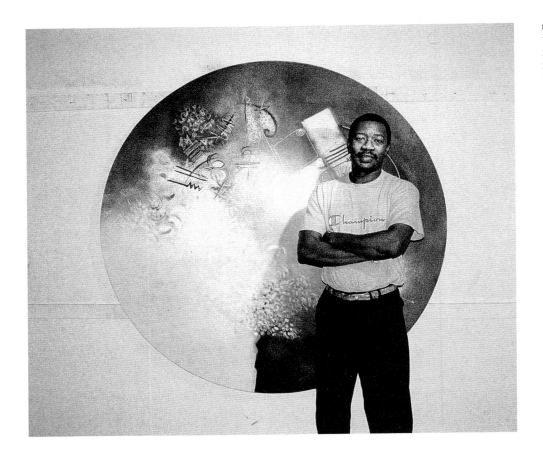

Souleymane Keita
With circular canvas in
his studio, Gorée, Senegal,
December 1992
174 cm diameter

Since we decided to create a *mise-en-éspace* in the gallery in the form of
an opera of dramatic and visual objects, the area devoted to the
Senegalese exhibition is made up of objects placed, suspended and hung,
by authors Issa Samb and El Hadji Sy from the Laboratoire and the poet
from Gorée, Souleymane Keita. The curator and author has chosen the
works of art as illustrative objects, theatricalised objects, objects used in
play, object–actors. A creative spirit always animates the environment
and the accessories of life. It manifests itself in spite of the absence of
costly and unusual media, on all types of support structures – such as
walls, doors, shutters, discs, sheets of metal, bits of wood, wire, rice
sacks, cloth, etc.

El Hadji Sy
In front of cowrie shell
painting, Dakar, 1995
Fibreglass cloth

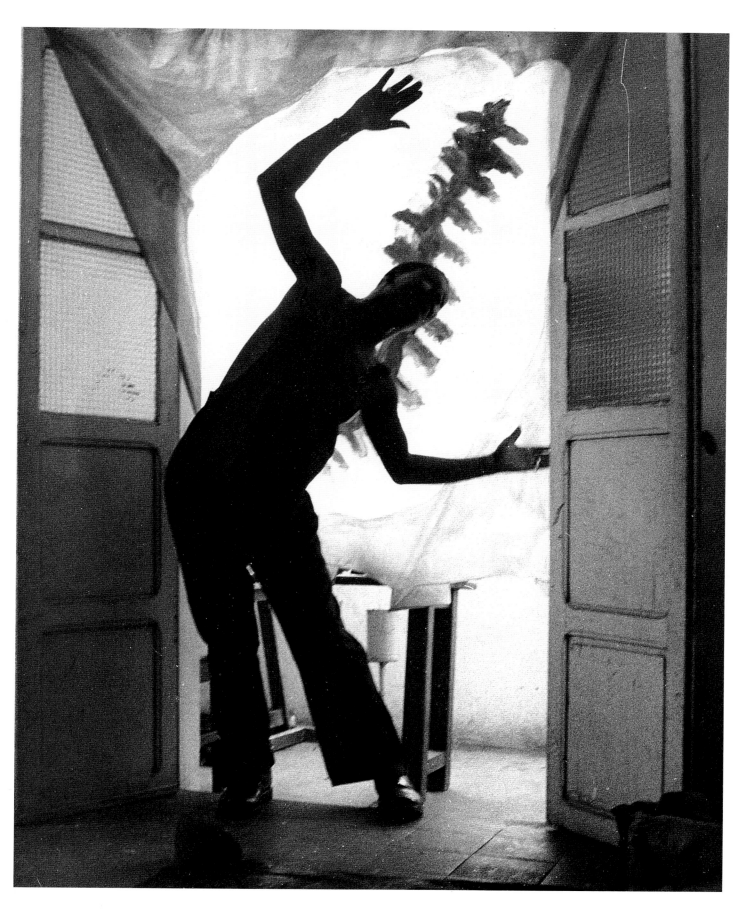

 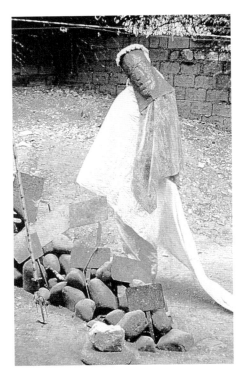 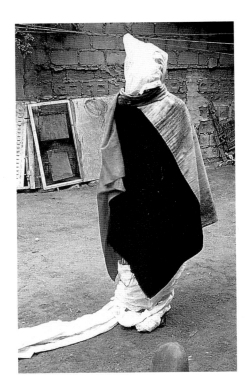

For the black African, the visible is merely a manifestation of the invisible, which informs surface appearances, giving them colour, rhythm, life and meaning. What moves black people, wrote Léopold Sédar Senghor, is not so much the appearance of the object as its underlying reality, not so much the sign as its meaning. Perceptible appearance is merely the reflection of an object's essence.

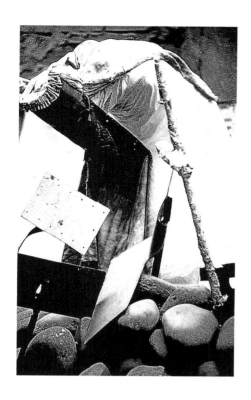

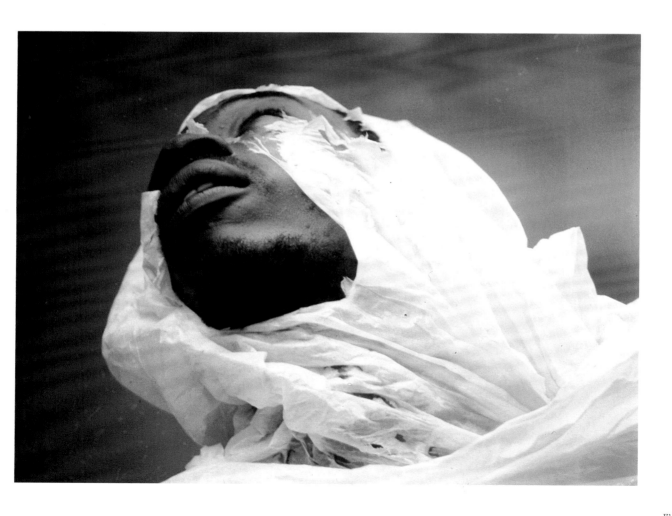

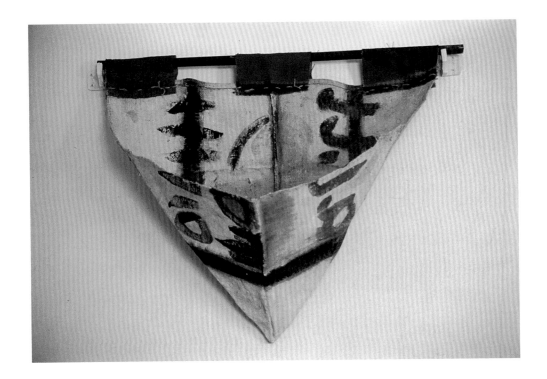

El Hadji Sy
Untitled (bags)
1995
Acrylic, tar, jute
Left: 98 x 108 x 56 cm
Below: 167 x 108 x 56 cm
Bottom: 161 x 111 x 50 cm
Collection of the artist*

Opposite
El Hadji Sy
Installation of work
including rice-sacking,
oil on canvas and
The Stretcher of Gorée
opened out
Dakar, 1991–93
Mixed media: jute, wood,
acrylic, tar

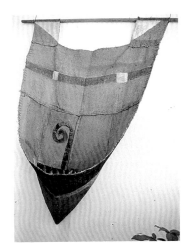

The development in contemporary visual art in Senegal offers clear
proof that it is taking over from the most interesting of traditional arts,
through forms that are as yet unfinished. Its complete unfolding will
amaze. Let this exhibition contribute to the dialogue between cultures,
helping to bring people closer together.

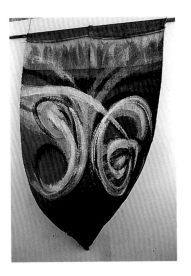

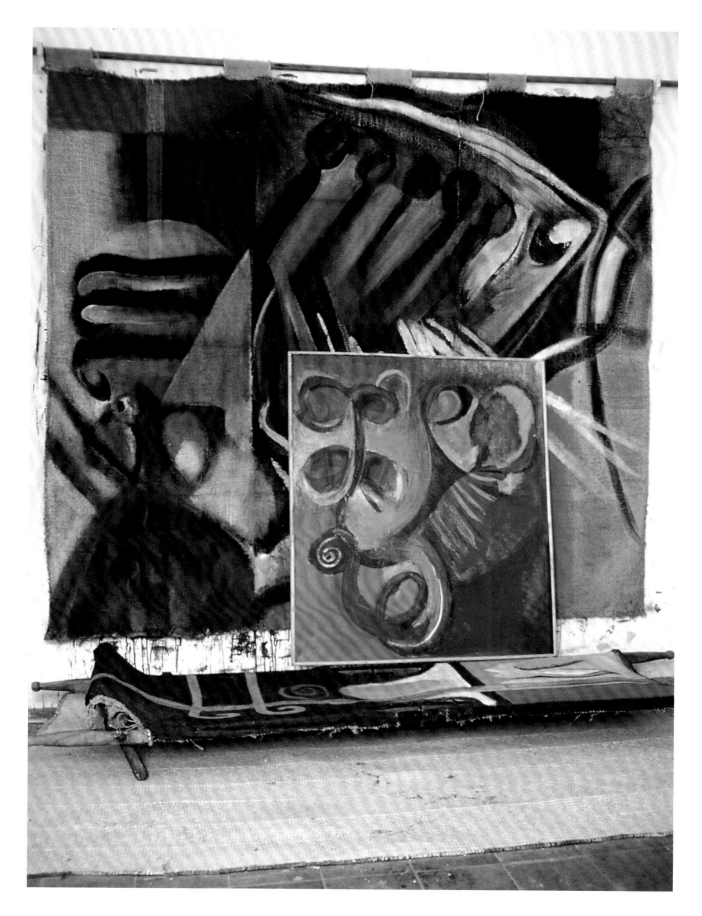

the khartoum and

addis connections

two stories from sudan and ethiopia
by salah m. hassan

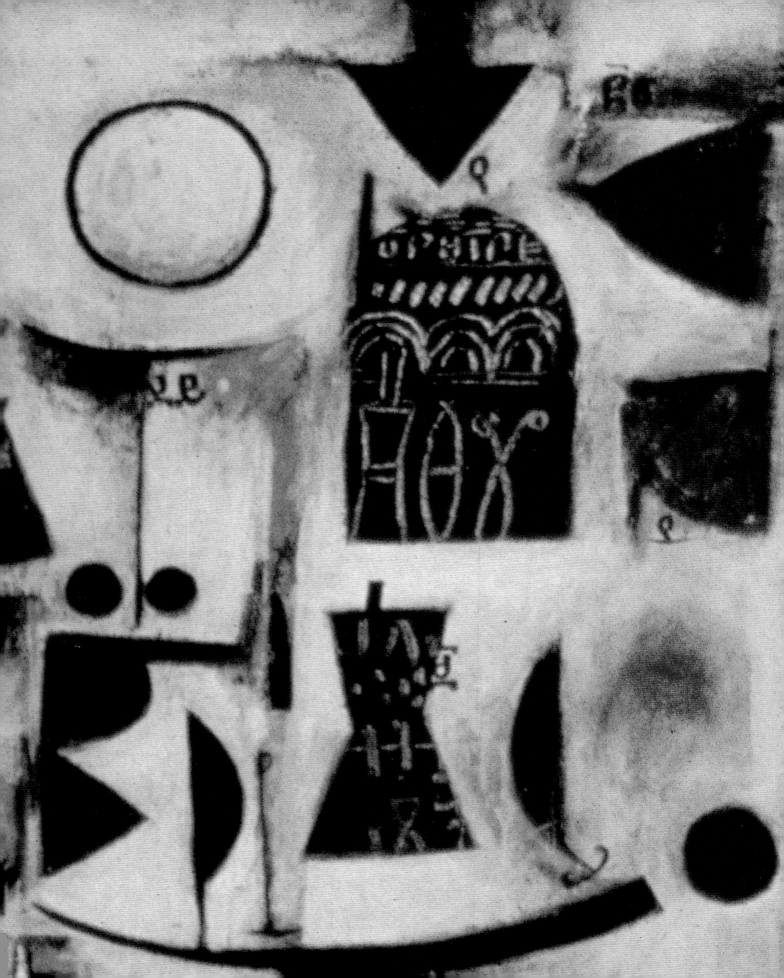

The Khartoum and Addis Connections

Salah M. Hassan

Introduction

This section of *Seven Stories*, featuring works by selected artists from Sudan and Ethiopia, is a distillation rather than a survey, and treats the Sudanese and Ethiopian material as two separate stories. These art works are not perceived as the product of coherent schools or of homogeneous movements, but rather as visions of dynamic movements and artists whose diverse works reflect some connections, continuities and ruptures with each other. These artists share certain ideological, intellectual and formal concerns, which they have sought to express through consistent and related visual devices and vocabularies. Hence my preference for the term 'connections', rather than 'schools' or specific movements.

Prominent figures – such as Ibrahim El Salahi and Osman Waqialla from Sudan, and Skunder Boghossian and Gebre Kristos Desta from Ethiopia – are regarded as pioneers or 'elders' of each respective story: their work forms a point of departure within each. Unlike their predecessors within the modernist experience, they did not engage in art as a mere academic exercise, nor did they uncritically accept what they had learned of the western tradition. They were pioneers, who developed a new visual vocabulary of iconography, symbolism and technique which

continues to define the modern art movements in their countries. Hence their work is viewed in 'dialogic' relationship with works by other, younger, artists.[1]

The similarities and parallels to be drawn between the Sudanese and the Ethiopian modern art movements include the creative use of calligraphic forms and a literary heritage of religious mysticism. Both possess a rich verbal history, and traditions in both written and oral forms. Artists from both nations have sought to integrate certain morphologies and structures from their past, such as the shapes of Amharic, Geez or Arabic calligraphy. Symbols of Coptic or ancient Nubian origin drawn from monuments and architecture have been infused with modern forms, and executed in modern style. One language shared by some of those artists is the incorporation into their work of poems in calligraphic style or of folk-tale illustrations. Several also replicate directly from traditional mural reliefs or paintings, or decorations on canvas, wood or other media.[2]

The connections and influences between different artists are many and various. Abdul Rahman Sharif, who became Dean of the Fine Art School in Addis Ababa in 1974, began his training first in 1959 in Khartoum under the tutelage of Ibrahim El Salahi.[3] The Harmon Foundation exhibition in the early 1960s brought together several Sudanese and Ethiopian artists. Wosene Kosrof acknowledges the influence of El Salahi in his work, as well as that of Shibrain's creative use of Arabic calligraphy. Several Sudanese and Ethiopian artists met abroad while studying, or their roads crossed in other countries, as in the case of El Salahi and Skunder, who met in the 1960s in Paris and London.[4] Above all, due to the political situation in their countries, artists from Sudan and Ethiopia have shared destinies of exile (intellectual, political or economic) and a massive exodus to the west. These include most of the participants in this exhibition, with the exception of Abdel Basit El-Khatim and Zerihun Yetmgeta.[5]

Central to their common goals has been the idea of a 'Sudanese' or an 'Ethiopian' art that is modern and relevant to the artists' own societies and to the world at large, an art that is both rooted and global. One important feature of their new vocabulary is the inclusion of motifs and decorative elements from ancient, folk or traditional arts and crafts. Some make use of, or seek inspiration from, traditional techniques, materials, tools or colours. Several have tried to develop a symbolic language of colours and forms. Through paintings, drawings, sculpture or other forms of plastic art, most have depicted scenes from traditional or urban life, or from their native landscapes.

It is difficult to draw lines showing which artists have followed a certain pattern or another. Some have combined several elements, and others have remained faithful to one style or technique. Their visual repertoire is not limited to their countries, for some of them have, consciously or unconsciously, transcended national boundaries and incorporated motifs and elements of continental African origins. In other words, several Sudanese and Ethiopian artists have also embraced a Panafricanist vision in their artistic practice and aesthetic pursuit.

Osman Waqialla
Opening of Surat Ya Sin, *Chapter 36* (detail)
From *The Prophets' Series* [*Al-Anbiyaa*]
One of four small units forming one related work
1408 Hjiri 1982
Inks and gold on hand-made paper
18 x 23 cm
Collection of the artist

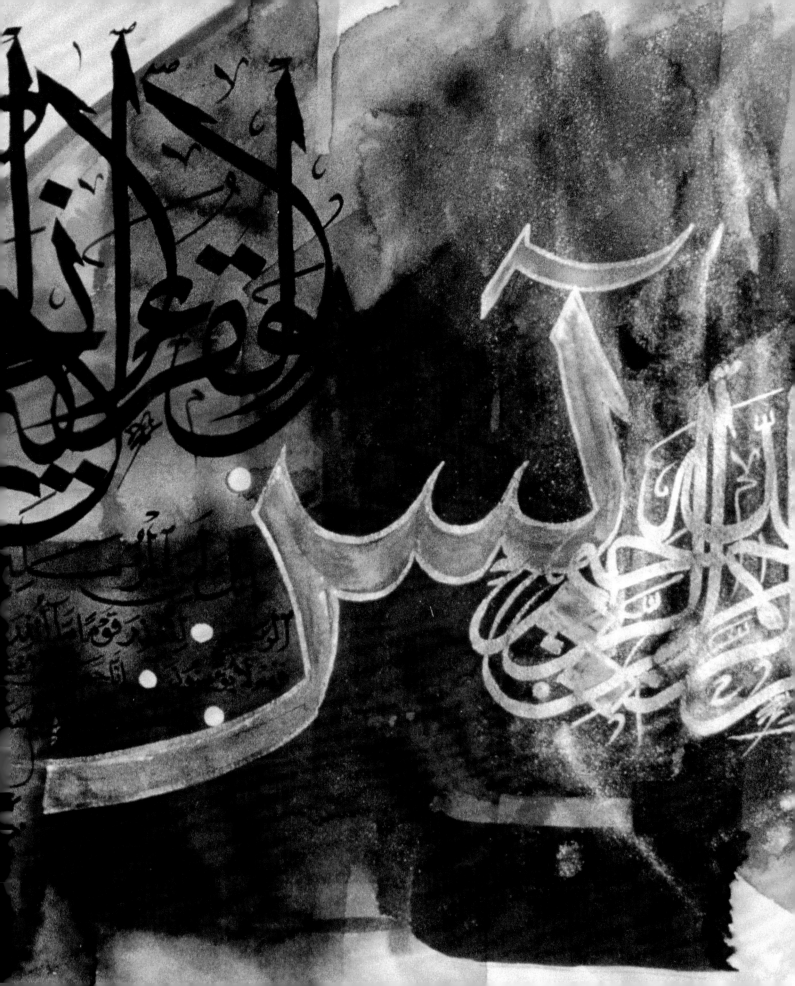

**Mohammed Ahmed
Abdalla**
Pot (with narrow neck)
(detail)
1986
Porcelain stoneware,
reptilian crackled surface,
glazed beneath
21.5 x 18 cm
Collection of the artist*

1 Khartoum connections: the Sudanese story
Salah M. Hassan

The history of modern art in Sudan is deeply embedded in the British colonial educational system, and most specifically linked to the rise of higher education.[6] The British educational policy was consistent with its goals as a coloniser. It was mainly 'functional' and aimed at producing clerks and lower-rank officials and civil servants to fit colonial administrative needs.[7] Ironically, the influence of certain 'liberal' colonial administrators and educators – perhaps frustrated and dismayed by the cruelties of the British colonial experience in India and other third world countries – contradicted this official policy.[8] These educators recognised the role of art in education, even within the limitation of the colonial system. Art was introduced at the elementary, intermediate and secondary levels during the early 1930s; initially, local materials were used, and written curricula were developed later. At tertiary level, art was first introduced at Bakht al-Rudha Institute for Teachers in the 1930s by a committee headed by the country's General Director of Education, Mr Cox.[9]

The College of Fine and Applied Art in Khartoum can be traced to the early 1930s, when a department of art was established within Gordon Memorial College (now the University of Khartoum). The department evolved in 1946 to become the School of Design; the late Jean-Pierre Greenlaw played a great role in establishing and developing the curriculum.[10] This was intended first to function as a vocational

centre in which students could learn practical skills in carpentry, architectural draughtsmanship and drawing, surveying and design. In 1951 it was moved from Gordon Memorial College to a building within the Khartoum Technical Institute;[11] it then became a separate department and in 1971 the School of Fine and Applied Art. Today, it is a semi-independent college affiliated with Sudan University of Technology. Since its early inception, the College's curriculum, fashioned after western artistic tradition, offered basic courses including painting, sculpture, Arabic calligraphy, graphic design, ceramics and textiles; to these are now added theoretical courses in art history, aesthetic and history of design.[12]

Art produced by the pioneer generation – many of whose members travelled abroad to study in 1944 and 1945 – formed the genesis of the modern movement. However, in form, style and aesthetic, their art reflects a strict adherence to the western academic schooling they received in Europe, although their subject matter was largely drawn from their own environment and experience in Sudan. An exception was Osman Waqialla, whose early explorations of Arabic calligraphy led to the evolution of a unique style.[13] On his return to Sudan in 1951, Waqialla taught at the College of Fine and Applied Art until 1954, when he formed Studio Osman in the centre of Khartoum, a meeting place for artists and others concerned with the arts until 1964. Studio Osman was also responsible for the design and execution of major art assignments following Sudan's independence; an example is the calligraphic design on the first Sudanese currency.

The aesthetic value of old calligraphic forms, their balancing masses of light and dark, attracts people to old manuscripts in Chinese, Arabic, Hebrew and Geez. Waqialla's interest in Arabic calligraphy can be seen in his early sketch books and works from his days as a student in London. His mastery of the traditional skills and styles is certainly indisputable; he engraved calligraphic designs in marble on a tomb dedicated to the Prophet Muhammad in Al-Madina, Saudi Arabia. He should be credited for liberating Arabic calligraphy from its traditional boundaries of the sacred text, and for his daring explorations of calligraphic expressions in non-traditional, secular Arabic texts in both poetry and prose.[14] Waqialla's influence was widespread; his students included Ibrahim El Salahi, Taj Ahmad, and Ahmad Shibrain. By the late 1950s calligraphy had evolved into a particular tradition within what came to be known as the Khartoum School.[15]

The history of the modernist experience is not complete without the important contribution of a group of self-trained artists, who worked in the modern genre since at least the 1930s and prepared the ground for the academically trained Khartoum artists who followed. Unfortunately, since they are viewed as non-academic, 'naive', painters, their history and contributions have never been seriously studied or fully documented. During the colonial period, expanding urban living brought about new aesthetic needs, and hence new genres in music, poetry and the visual arts. In several major cities such as Khartoum, Wad Medani and El Ubayid, self-taught artists – exposed to western traditions of painting and other forms – started to produce new types of art works, mostly landscape paintings representing rural or urban modern life, portraits of stereotypical rural or urban women with folkloric costumes or hairstyles, and important Sudanese historical figures. Ali Osman, active in the 1930s

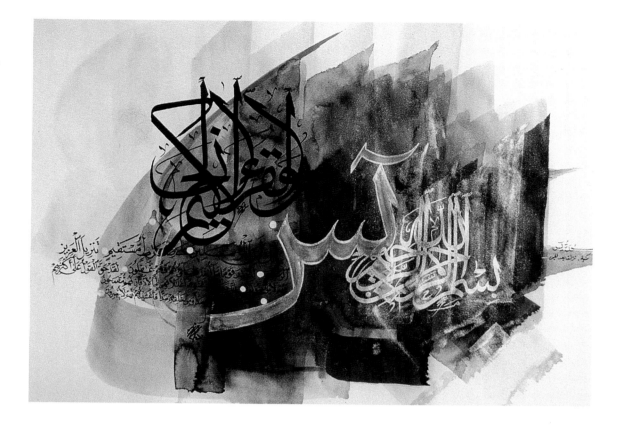

and 1940s, was among these pioneers who achieved a legendary level of recognition. Others were Uyun Kadis, nicknamed 'Cat's Eyes' in recognition of his ability to copy portraits and to draw figures, and Jiha, a skilled painter, sign-designer and magician. Most memorable was Ahmad Salim, who continued to be active up to the 1960s, developing a style which is indistinguishable from the so-called academically trained artists who followed him. The works of these artists were bought (sometimes commissioned) by prosperous urban families, and could be seen in private houses, in restaurants and cafés. Some of the artists exhibited in public spaces, and hence introduced a new culture of art and aesthetic appreciation directly to the public.[16]

The real breakthrough within this new tradition came in the late 1940s and early 1950s with Ibrahim El Salahi and his colleague Ahmad M. Shibrain, with Magdoub Rabbah and Taj Ahmad, among others, who led a distinct new movement, which evolved into the Khartoum School.[17] This was publicised by the western expatriates, art critics and collectors who were its early patrons.[18] Today, several of its founding members consider it simply as a phase in their evolution; others have dissociated themselves from it as a movement, while several artists never wanted to be part of it as a 'school', even though they are connected with it as a movement. As a group, these artists never practised as one workshop, issued a manifesto, or produced critical literature to buttress their aesthetic concerns or artistic claims. Hence it is more fruitful to look at the Khartoum School as one aspect of a very complex, multi-faceted and highly fluid movement of a group of artists.

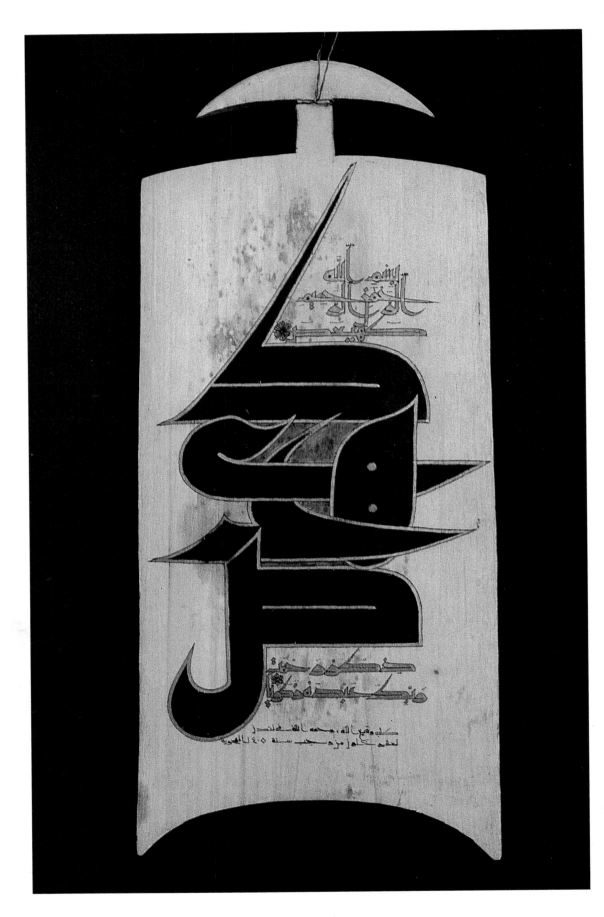

Osman Waqialla
Loh (Hausa Quranic Board)
With Quranic texts
on both sides
Side 1: opening of *Surat
Mariam*, Chapter 19
Side 2: Verse 44, *Surat
Ghafir*, Chapter 4
1405 Hjiri 1984
Ink and gold on wooden
board
49 x 22 cm
Collection of the artist*

Intellectual and Cultural Origins

Almost every ethnic and linguistic group on the African continent is represented within the borders of Sudan, which is the most culturally diverse of all African countries.[19] This diversity is polarised into two major cultural groups: a highly Islamicised and relatively Arabised culture, fused with local pre-Islamic elements, in northern and central Sudan; and other groups of strongly 'African' cultural elements, stretching south and into the peripheries of the northern region, represented by Christians and believers in traditional religions. A rich diversity of art forms has always existed; historically, art history in Sudan can be traced back to the ancient Nubians.[20] The search for, and definition of, a Sudanese national culture that cuts through ethnic pluralism have become the focal point for a new national consciousness, expressed mainly in literature and art.[21] In most cases, such efforts have transcended social and political reality, stressing the creativity of racial intermixture. Terms such as 'Sudanese culture,' 'identity,' 'literature' or 'arts' soon became central to this discourse,[22] forming the basis for a new politico-cultural vocabulary. The influential Sudanese literary critic of the 1930s, H. E. Tambal, claimed that 'Sudanese identity is an ideal to which we should all work, it must be reflected in all our work.'[23] This ideal evolved into arts movements characterised by the conflict and reconciliation of identities.[24]

In the late 1950s and early 1960s a group of poets and literary critics, including Muhammad al-Makki Ibrahim, Muhammad Abdal Hai and Salah Ahmad Ibrahim, formed together under the name of *Madrasat al-Ghaba wa al-Sahraa,* 'School of the Desert and the Jungle'. They claimed that Sudan's artistic and literary heritage is a synthesis of desert and jungle, a metaphor borrowed from the landscape to be a symbol for Islamic African elements.

> *(both) the Water Buffalo of the forest and Onyx of the oasis are*
> *(the symbols of) our nations...[25]*
> *Liar is he who proclaims: I am the unmixed, the pure pedigree.*
> *The only. Yes!, a liar!...[26]*

For another group, Apedemik – god of arts, fertility and war in Meroe, an ancient Nubian civilisation – became a symbol with which Sudanese artists and writers identified.[27]

The Khartoum School and other artists connected to it were certainly part of the native intellectual movement in colonial and post-colonial Sudan. After the first two decades of colonial rule, minority, western-educated, urban élites began to emerge. The members of this new class recognised their 'marginal' situation, caught as they were between the masses of rural and urban workers whose culture and identity were kept intact, and their own aspiration to a way of life similar to that of the foreign ruling class.[28] They were prisoners of the contradictions of their social and cultural reality. However, the influence of the colonial power's culture was almost nonexistent beyond the urban centres.[29]

Khartoum School artists faced similar problems, and joined in efforts to construct new tropes of self-representation. Their main ideological and intellectual

concern, shared with fellow poets, novelists and literary critics, was the making of a 'Sudanese' art and aesthetic. Artists such as Ibrahim El Salahi, Magdoub Rabbah, Taj Ahmed, Ahmed Shibrain and Osman Waqialla were closely associated with their literary compatriots in the School of the Desert and Jungle. Their main question was how far the artist should be obliged to shake off western and other influences and produce art that is uniquely 'Sudanese'.

In nearly all his writings and public statements, El Salahi has stressed his goal in keeping Sudanese motifs in his art, even if its technique may be basically western. El Salahi studied at the Slade School of Art in London in the late 1950s and early 1960s, and found on his return that many of the ideas he had acquired abroad isolated him in his own country, and that his work seemed meaningless and without character in Khartoum.[30] He summed up his experience:

> I left Sudan and came back, then suddenly I started to look around and I started to look for things, for patterns. I have always been fascinated with patterns in local Sudanese handicrafts and what simple peasants were doing and carving and decorating and painting. And suddenly I think that the beauty of it came to me and hit me – it's so strong. I lived with it all my life and yet I never saw it before, until I went outside and came back, with a different outlook towards things. And this is when I started looking – just travelling all over the Sudan and looking at whatever people did – at their homes, their beds, the praying carpets, the way they put the saddles on their camels or oxen. And this fascinated me a great deal and I started just to observe and to draw.[31]

Although Salahi claims that his work has become Sudanese in flavour as a result of this experience, he does not deal with it in terms of locality. As a Sudanese individual he felt he could do something distinct: 'I find the colour in its particular looks very much like our earth, and maybe that's why I feel it's Sudanese'.[32]

El Salahi is known for his fascination with the shapes created by Arabic letters and the spaces between them. In his early works such as *Allah and the Wall of Confrontation* or *The Last Sound*, Arabic-like characters and crescent motifs are easily observed. He encountered Quranic scripts as a young child (his father was a Muslim cleric and teacher who held a Quranic school in his house) and later studied them in the British Museum. He also makes use of non-Islamic motifs, mask-like faces and figures and natural elements combined with forms of Islamic derivation. In defence of these inclusions and in contrast to popular perceptions of the Muslim faith, he states: 'in a way, it is a kind of prayer, too, because you are appreciating God's creation and trying to think about it and meditate on his creativity'.[33]

To the Islamic motifs in *The Last Sound* is added a human-like face executed in an African mask style. Blue and various shades of earth colours are dominant in his early paintings. They are symbolic of the Sudanese landscape and of the adobe and mud architecture of northern and central Sudan. *Funeral and Crescent* shows his main concern with the human figure. Under a crescent moon – an Islamic motif – a procession of mourners carries the deceased aloft. Figures are elongated and emaciated. Points of articulation – knees and elbows – are emphasised and delineated

with spirals. The male sexual organ is exaggerated, a style similar to some traditional African sculpture.[34] Similar figure stylisation and intensity of facial expression are evident in his earlier works *The Donkey in My Dreams, Poor Woman Carries Empty Basket* and *Death of a Child*, which make a sharp commentary on contemporary Sudanese life and culture. Expressing his search for a new synthesis of the various elements of Sudanese culture, El Salahi's later work stands in sharp contrast to the European influence of his student days. His art has undergone several transformations, reflecting both the circumstances of his personal life (he was briefly imprisoned in 1975, and has since lived in exile in Qatar and Oxford), and his long and prolific career. It is difficult to enclose him within the boundaries of the Khartoum School, as his early experimental work has given way to a more philosophical orientation. Over the years, sombre earth colours first gave way to a more colourful period in the early 1970s, then to a more assured exploration of themes in black and white. He does not subscribe to the traditional distinction between painting and drawing in western art, which associates colour and shape with painting, and line with drawing. 'I am more concerned now with the internal structure of the work, which I prefer to express in black and white . . . in the end all images can be reduced to lines.'[35]

These latest works are often accomplished separately on medium-sized paper; structurally related, when assembled together they form one large unified work, which can grow to monumental size, as with *The Inevitable* of 1984. A strong social and political commentary on a significant event in Sudanese contemporary history, this work is evidence of his remarkable technical mastery and a sophisticated philosophical vision. It remains possible still to trace his fascination with Arabic calligraphy in these late works.

Ahmad Muhammad Shibrain, like Osman Waqialla, visualises letter forms as living elements; in his work, Arabic letters gain a plastic aesthetic value. As a vehicle of the Quran, the Arabic language is viewed as sacred, but this does not necessarily contradict his artistic interest. He uses the plastic potential of calligraphy within an Africanised Sudanese framework: 'it is a mixture of images, African–Arabic and Islamic'.[36] In his innovative pen-and-ink *Calligraphic Abstraction*, Arabic-like characters are arranged in a Kufi style on a plain background. Individual characters are hardly decipherable; letters are shortened or elongated, compressed or expanded, and become part of a larger abstract composition. In the oil painting *Message 40* he includes traditional Islamic decorative motifs such as the rosette, crescent and semi-floral arabesque in addition to calligraphy. In other works Shibrain stresses a symbolic use of colours as encountered in the Sudanese landscape. For him blue and bluish-green are the hues of the Blue Nile; red, yellow and brown are those of the earth and of Sudanese traditional architecture.[37] Shibrain is also a successful designer and interior decorator who has undertaken commissions for public spaces, including Jeddah Airport in Saudi Arabia, and for international hotels and companies in Sudan. His public pieces include calligraphic designs as a basic element, executed as low relief in wood with paint.

Of a relatively different orientation is Magdoub Rabbah, who expresses his ideas through techniques and materials that can be traced back to traditional

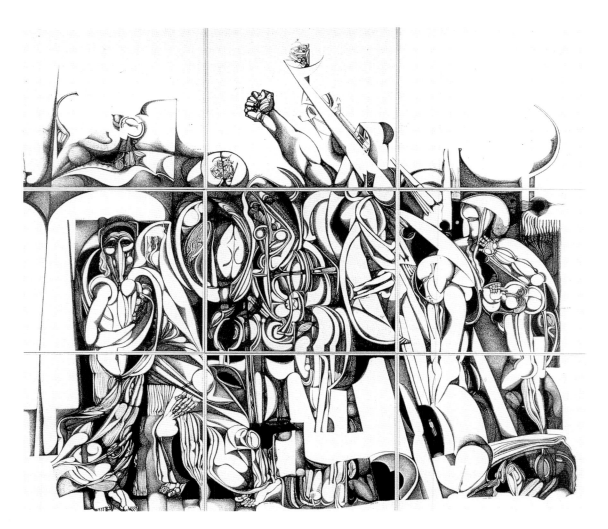

Ibrahim El Salahi
The Inevitable
1984/85
Indian ink on paper
82.5 x 93.6 cm (nine units)
Collection of the artist*

origins. He has invented 'solar engraving', a printmaking technique in which commercial magnifying lenses concentrate the sun to burn patterns into hardwood boards. The low-relief etchings are then enhanced with locally made, natural colours and dyes.[38] *The Gate* shows the gate of a traditional mud house and a goat, a scene typical of the northern Sudan landscape. Here, political graffiti as well as traditional calligraphy can be identified.[39] In *Prayer*, he reduces calligraphy to the margin, and includes his own signature as part of the composition; rows of people praying in traditional garb can be seen scattered on the board.

The Legacy of the Khartoum School

In the early 1970s, younger artists started to rebel against the work of these pioneers. Their critique of the early generation of the Khartoum School was very much coloured by the general disappointment with the ruling classes in post-colonial Sudan and frustration with their hegemonic policies. Two major critical movements can be identified, with specific philosophical orientations regarding art. This was a vibrant period in Sudanese intellectual history: serious dialogue on art, literature and culture was accompanied by rich theoretical and critical writings on the

relevance of contemporary art and literature to culture and society. However, the renaissance was short-lived, and soon followed by a crackdown on left-wing and liberal intellectuals, among whom were several artists.[40] Many left the country in a mass exodus that rendered the Sudanese cultural scene greatly impoverished.

Along with two of her students, Muhammad Hamid Shaddad and Nayla Al Tayib, Kamala Ibrahim Ishaq, initially part of the Khartoum School, founded a group called the Crystalist School. Her main themes were drawn from ceremonies and rituals like Zar, a cult of spirit possession practised by women in central Sudan. Interestingly, Ishaq's interest in Zar was triggered by her fascination with William Blake, whose life and work she studied at the Royal College of Art, London, in the 1960s. She found in his work themes of spirit possession similar to those she had observed in her home town of Omdurman, where Zar was widely practised. A series of huge paintings was inspired by the research she conducted in Omdurman.[41] These paintings are the first known records by a modern artist of an established cult of spirit possession, depicted and experienced from within.[42]

In an exhibition at the National Museum of History, Khartoum, in the mid 1970s entitled *The Crystal Cubes*, Ishaq declared the beginning of a new direction and a conscious departure from the Khartoum School. A degree of transparency was infused into her colour scheme through the depiction of women's faces and distorted figures imprisoned in crystal cubes. However, her colour scheme still reflected the 'earthy' style of the Khartoum School, and her stylisation of the human figures remains similar to her earlier work *Women in Crystals*.

In 1978 Ishaq, Shaddad and Tayib issued the Crystalist Manifesto, outlining the philosophy and aesthetic of their art (see page 242).[43] Echoes of the avant garde, existentialism and other European art movements could be traced in it. It was

Ibrahim El Salahi
Faces
Early 1960s
Pen and ink on paper
37 x 53.5 cm
Collection of Ulli Beier

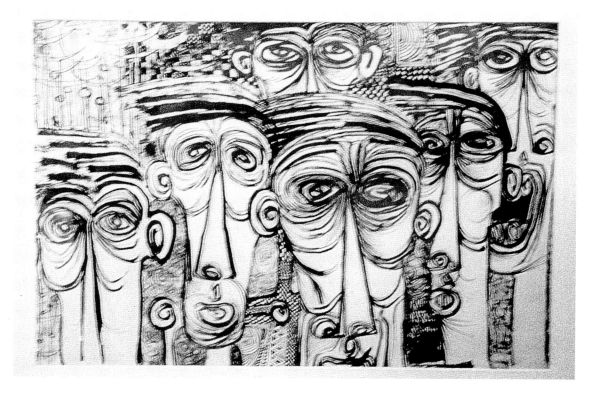

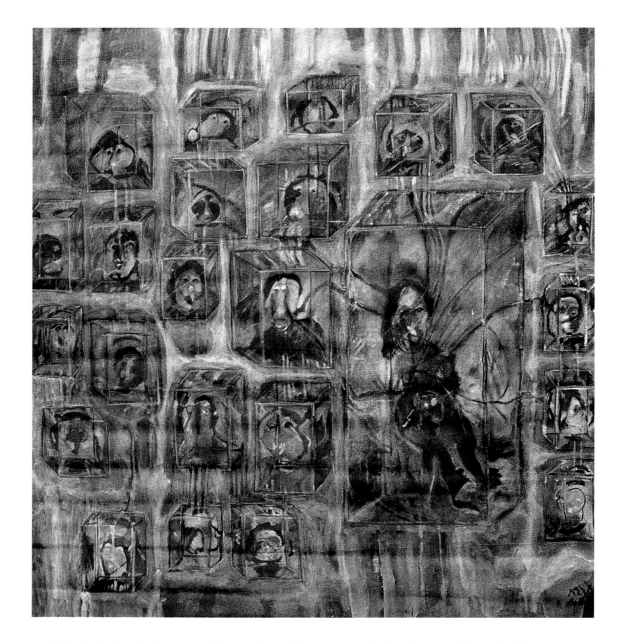

Kamala Ibrahim Ishaq
Images in Crystal Cubes
1984
Oil on canvas
175 x 175 cm
Collection of the artist*

certainly intended as a critique of the Khartoum School, even though this was not directly stated. It was also an attack on another group of artists and art critics led by Hassan Musa and Abdalla Bola (see below). According to the Crystalist Manifesto, the essence of the universe is like a crystal cube, transparent and changing according to the viewer's position. Within this cube, human beings are prisoners of an absurd destiny. The nature of the crystal is constantly changing, according to degrees of light and other physical conditions. Shaddad held an exhibition in 1978 in which he showed piles of melting ice cubes surrounded by transparent plastic bags filled with coloured water. The immediate response to the Crystalist project was mostly negative. At the time, it was not taken seriously and was criticised for being bohemian and imitative of the western avant garde.

A more serious challenge to the early generation of Khartoum artists came from a more systematic group of artists, led by Hassan Musa and Abdalla Bola,

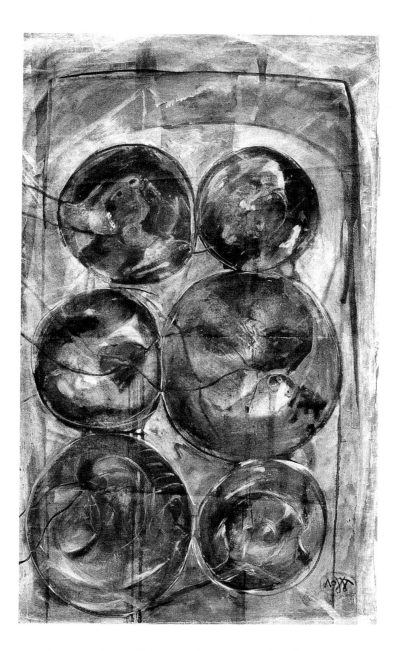

Kamala Ibrahim Ishaq
Images
1985
Oil on canvas
175 x 100 cm
Collection of the artist*

graduates of the College of Fine and Applied Art, Khartoum. They were inspired by the ideas of Fanon and Cabral on national culture, the nature of the third-world petty bourgeoisie and its role in the post-colonial era. They accused the early generation of Khartoum artists of being ethnocentric in their intellectual orientation, and claimed that their works were merely reactive to the colonial situation, and not a proactive response to the west. They claimed that the Khartoum School perpetuated an exotic image of Africa by borrowing motifs from traditional arts and crafts in response to the requirements of western tourists. Their exhibitions – held in European cultural centres or galleries, or in local first-class hotels – were accessible only to foreigners and native élites.[44]

Musa and Bola argued that, by borrowing selectively from motifs and decorative elements in the traditional cultures, the Khartoum artists had deprived themselves of creating new forms or compositions by limiting themselves to certain

 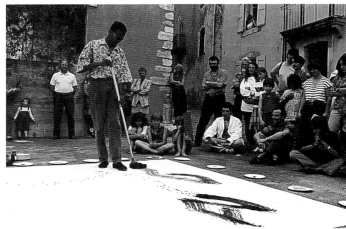

Hassan Musa
Cena Africana
Graphic Ceremony,
Castellet, France
July 1993

colour schemes, and negated the diverse and dynamic socio-cultural realities of Sudan.[45] Musa and Bola rejected the symbolism of certain colours that the Khartoum School had adopted as lacking in any objective foundation.[46] In a sense, they were arguing against any direct symbolism in art: their main tenet was that the essence of any visual art work is either line and colour, or mass and volume in space. These basic units exist as open-ended possibilities and as a dialectical process in creating plastic work. The artist's mission should be to create new relationships between these units. The real value of a visual art work lies purely in its aesthetic quality. In contrast to the ethnocentrism of Khartoum, they advocate the right of Sudanese artists to be open to all world art as a common heritage. However, their own art remains controversial and questionable; it is executed in the conventional codes of western art which are based on symbolic and expressive values. It is representational, and similar in style to some of the Khartoum School conventions.

Over the years, Hassan Musa and Abdalla Bola have changed a great deal. Musa moved to France to study in the late 1970s and has stayed there, engaged in a totally new genre of work and ideas. Since the late 1980s, he has been working on public performances called 'Graphic Ceremonies', which are intended to deconstruct the very idea of art exhibitions as rituals. During these, he executes large paintings on textiles spread on the floor and invites the audience's participation. He emphasises the creative act and not the finished artistic product which, he argues, is lost in the ritual of the exhibition. In regular correspondence with colleagues and friends, Musa uses mixed media on mailed envelopes, transforming their surfaces into plastic works. More recently, he has taken on biblical themes popularised in Renaissance paintings, creating his own versions in a satirical style. These are mostly large paintings executed in textile ink on printed cloth. In his latest series, entitled *The New Testament*, he deals with *The Last Supper* and *The Annunciation*, creatively blending the designs of the fabric with his own painting.

Like Hassan Musa, Abdalla Bola also moved to France. In the early 1980s he retracted some of his earlier statements regarding the essence of visual arts, and has commended the efforts of the pioneer Khartoum School artists for inventing new expressive codes that were legitimate and acceptable. However, he still insists that the artist's energy should be directed towards enriching the pure aesthetic

experience rather than reducing codes of expression to symbols that serve ethnocentric motivations.[47]

The criticism of the Khartoum School did not generate the expected dialogue; most importantly, it elicited no serious critical response from the Khartoum School artists themselves. Ibrahim El Salahi was alone in being vocal and active in writing. Some of their practices may have been ethnocentric or non-eclectic in theory and practice, and some of their views of Sudanese culture were ahistorical and romantic. However, this should not be linked in a simplistic manner to the political opportunism that characterises the ideologies and practices of the native élites in post-colonial Africa. In the realm of arts and literature, the response to the colonial situation – and the identity crisis created by that situation – takes a different shape. It is mostly expressed as a search for the common roots of a 'national culture' and a common heritage of symbols that cut through ethnic diversity. This is not a voluntary step, but rather the only viable response to the powerful pressure of historical necessity. It is a response determined mostly by irreconcilable contradictions between colonised society and colonial power. Post-colonial realities require that each indigenous social stratum must define its position. A return to 'sources' or 'roots' is historically significant only if it involves critical analysis of the colonial and post-colonial phenomenon, and the role of culture in relation to the struggle for total liberation. Such a framework of analysis is not an apology for the Khartoum School, but the only way in which its claim to create a 'Sudanese' art and aesthetic can be properly understood.

Recent Developments

In the mid 1980s, the use of Arabic calligraphy within the Khartoum School took on a distinct ideological shape when Ahmad Shibrain joined the Society for Islamic Thought (*Jama'at al-Fikr al-Islami*).[48] He and other artists joined in the new wave of Islamic revivalism, associated with the regime of General Nimarie and the current Islamic fundamentalist military junta in Sudan. In 1986, a group of artists led by

Hassan Musa
The Annunciation
1994
Textile ink on printed cloth
140 x 128 cm
Collection of the artist*

Hassan Musa
Cena Musa
(The Last Supper)
1984
Textile ink on printed cloth
246 x 128 cm
Collection of the artist*

Ahmad Abdel Al, a painter and a student of El Salahi and Shibrain, issued a manifesto of a new school, named *Madrasat al-Wahid,* the School of the One (see pages 244–46). While acknowledging the legacy and contribution of the Khartoum School as positive and legitimate, they claim that a new link with the Islamic and Arabic heritage gives their work a much-needed spiritual dimension. The School of the One advocates an exploration of the arts of Islam, especially calligraphy and the aesthetic of the Quran.

The incorporation of Arabic calligraphy is not unique to Sudanese artists; it has been popular among Arab artists since the early 1940s.[49] Many have seen its use as a source of spiritual salvation and a practice of belief in the unity of Allah as an Islamic principle. Shakir Al Said, an Iraqi artist, claims in his book *The One Dimension* to have connected this abstract artistic practice to spiritual salvation.[50] It is important to add, however, that not all artists who use calligraphy are necessarily leaving representation for abstraction. For most Sudanese artists, calligraphy has been one among many favoured motifs and elements. To assert a Sudanese identity, they emphasise local styles associated with popular Islamic schools, known as the *Khalwa* style. This is closer to the Kufi-derived Maghribi tradition known in north and west Africa as *Sudani* style, than to the *Naskh* tradition popular in the eastern part of the Islamic world.[51]

In practice, the work of the School of the One is a continuation of the Khartoum School's tradition of synthesising the African and Islamic elements of Sudanese

Mohammed Ahmed Abdalla
Deep Rimmed Bowl
1991
Burnished, high-fired
porcelain stoneware
15.5 x 16 cm
Collection of the artist*

culture. It is true that it puts more emphasis on the Arabic and Islamic identity and, like Al Sa'id, its member artists claim to have sought a spiritual salvation through artistic creativity. However, its manifesto acknowledges the distinct nature of Sudanese culture as hybrid and Africanised. After all, the works of Ahmad Abdel Al, Ibrahim Al-Awam and Ahmad Abdallah Utaibi are not different from typical Khartoum School work in form and content, or in their use of calligraphy and other motifs. The works of Ahmad Abdel Al in particular, a remarkable painter and excellent colourist, bear close resemblance to those of El Salahi and Shibrain. Utaibi's work follows the path charted by Shibrain in using calligraphic forms in exploring religious, social and political themes. In his work *Azza*, Utaibi uses a well-known Sudanese song of national significance as the theme of his calligraphic design.

The Current Scene

The Sudanese modern art movement, distinguished by its complexity and breadth, is difficult to sum up briefly, but may be illustrated by reference to certain representative artists. Mohammed Ahmed Abdalla, Abdel Basit al-Khatim and Salih El Zaki are examples of the variations that can be seen in terms of technique, style and content. Mohammed Ahmed Abdalla, the eminent master potter and ceramicist and graduate of the Khartoum College of Fine and Applied Art, has been living in London since 1966.[52] His work shows an impressive understanding of various

Mohammed Ahmed Abdalla
Pot (with narrow neck)
1986
Porcelain stoneware, reptilian crackled surface, glazed beneath
21.5 x 18 cm
Collection of the artist*

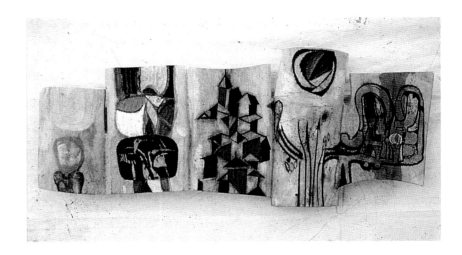

Abdel Basit El Khatim
Painted Sculpture
Oil on carved wood
Collection of the artist*

ceramic bodies and glazes, gained from a training in chemical analysis of clay and other ceramic material at North Staffordshire in the early 1960s. In form and technique, his work also reflects his deep knowledge of Sudanese traditional and ancient pottery techniques.

Abdalla's earlier works were mostly well designed and utilitarian pots with beautiful delicate glazes. He has since moved through several phases, experimenting with forms, glazes and surface treatments. New slips and different textural surfaces resemble reptilian scales or the bark of trees, and sometimes igneous volcanic surfaces in their colours and tones.[53] In a technique he calls burnishing, Abdalla applies glazes with slip to the leather-hard pot; when set, they are burnished with a very hard pebble or stone. He then sprays on a black or blue glaze and sometimes incises the rims with decorative designs. To the careful viewer, these techniques and incised designs are recognisable from ancient Meroetic and traditional pots as well as traditional Sudanese wooden bowls.

Like Abdalla, Abdel Basit El Khatim, who lives and works in Sudan, has experimented with diverse material, techniques and forms, creatively synthesising Sudanese motifs and calligraphic elements with recognisably west African forms and designs.[54] In his recent works, he has combined painting and sculpture in a unique style, carving wooden forms and figures in low relief, then painting over them and assembling the separate pieces in works reminiscent of Nigerian Kalabari ancestral screens. Parts of the wood are sometimes left unpainted, and their natural colour blends with the overall design.

Amir Nour's sculpture and the etching of Mohammed Omer Khalil were exhibited in Washington, D.C., in 1994.[55] Nour has had commissions for public sculpture from the cities of Chicago and Atlanta, and the Moroccan Ministry of Culture. His work consists of geometric forms such as rectangles, with images including domes and arches, cattle horns, calabashes and sandhills – forms recognisable from the adobe architecture of northern Sudan. *Grazing at Shendi,* a stainless steel sculpture composed of 202 semi-circles of varying sizes, was inspired by his childhood memories of watching goats grazing on the outskirts of his home town. Gourds, simplified to plain hemispheres, can be seen in his Chicago sculpture *Calabash 4.*

Mohammed Omer Khalil, who teaches at the New School of Social Research and the Graphics Center of Pratt Institute, owns a printing workshop in New York City, and has printed editions for such internationally known artists as Louise Nevelson, Romare Bearden and Jim Dine. His early works reinterpret typical Sudanese folkloric and historical symbols and motifs. More recently, Khalil has started to explore abstract compositions, focusing on light and darkness in addition to colour and patterns. The dominant imagery is of found graphic materials – often stamps, letters and envelopes with press type – with Khalil's own geometric patterns, as seen in his series of large etchings, *Bob Dylan Series*.

Rashid Diab, who has lived in Madrid, Spain, since 1982, is one of the successful younger Sudanese artists. He has participated regularly in the Havana Biennale for many years, and exhibited in the First Johannesburg Biennale of 1995. He has mastered techniques including etching, silk screening and engraving, and has experimented with genres ranging from installations and graphics to furniture design. Diab's work reflects a synthesis of his Sudanese heritage and an awareness of contemporary artistic developments in Europe. His imagery and symbols range from Arabic illuminations and calligraphic designs, animals, human figures, traditional folk and historical motifs, to mythical and mask-like African motifs. His distinct use of calligraphy can be seen in several of his works such as *Series of the Red Space 11*, where the written word becomes part of the overall design and the Arabic letter forms acquire an independent aesthetic value. *Walking on Desert: Homage to Nuba Body Art* is a multimedia figural work with colourful improvised images, juxtaposed on a Sudanese woven textile.

Modern art in Sudan is a rich synthesis of heritage and a new global modernism or post-modernism, in which local influences are strengthened by the experience of diaspora in the west. As the stories of these artists reveal, their work reflects cross-currents of ancient and contemporary African, Arabic, Islamic and western influences. Their pieces are a testimony to the sophistication and maturity of Sudanese artists – the quest of the pioneering members of the Khartoum School has matured into a fascinating, multi-faceted and complex movement.

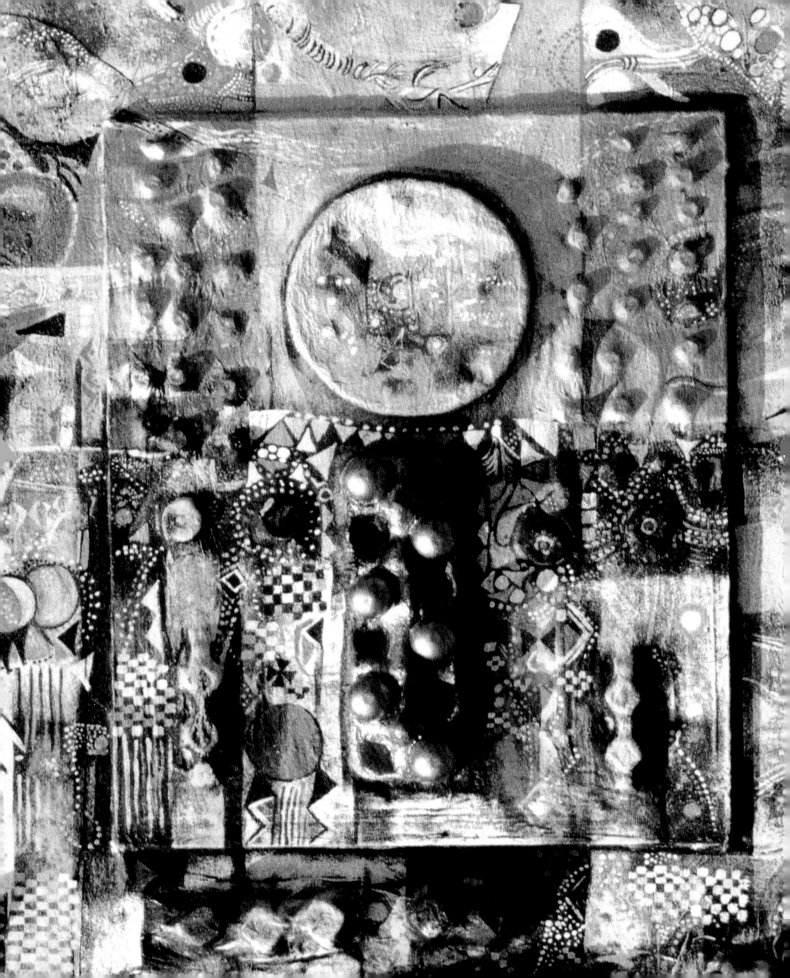

Girmay H. Hiwet
Crown of Creation
(detail)
1991
Mixed media, relief
140 x 120 x 6 cm
Collection of the artist*

2 Addis Connections:
the making of the modern Ethiopian art movement

Salah M. Hassan and Achamyeleh Debela

Today, the making of art in Ethiopia as elsewhere in Africa is rooted in what has evolved within the dynamics of socio-cultural, political and economic changes and exchanges. Ethiopia has a rich human heritage: findings such as the 'Dinkinesh Lucy' – for all practical purposes the remains of the mother of all humans – have endowed the area with the title 'cradle of humanity'. Ethiopian rock paintings date to the second millennium BC; these were followed by civilisations such as the pre-Axumite (fifth century BC to the first century AD) and the Axumite era (first to the eighth centuries AD), with evidence of architecture, reliefs and pottery.

Travellers to this part of the horn of Africa have especially documented the magnificence of the interior decorations of early churches. Several Arabic documents from the seventh century speak of the wonderful wall paintings illustrating the life of the Virgin Mary at the Cathedral of Axum, of which sadly nothing remains. The statuary of the renowned Hawlti people is among the earliest examples of sculpture in the round. Sculpture and architectural traditions abound in many monasteries and churches, such as Debra Damo (eighth century), Degum and Zarema (both ninth century). Ethiopia's long, uninterrupted history of pictorial art includes eleventh-

and twelfth-century manuscripts; fourteenth- to sixteenth-century church murals; mobile panels in the forms of diptychs and triptychs, and magnificent processional crosses. Many of these important works, especially the manuscripts, are now abroad: in the British Museum and the Victoria and Albert Museum in London; in the Musée de l'Homme and the Bibliothèque Nationale in Paris; in the Pierpont Morgan Library in New York.[56]

Pictorial art continued to bloom in Orthodox Christian schools, aimed to aid religious teaching and veneration.There are fine examples of eighteenth- and early nineteenth-century murals in Axum, Addis Alem and many other provinces of present-day Ethiopia. Although towards the end of the eighteenth century clerics began to practise outside the church, introducing the figures of kings and the nobility into paintings along with the saints and the Holy Family, their art continued to be primarily pedagogic: the church determined what themes and subject areas were appropriate. 'Ethiopian religious art, in spite of its function as an educational instrument, remained subject to the ideological content of religion, hence determining the artist's attitude to reality.'[57]

Around the beginning of the nineteenth century, Ethiopian pictorial art, especially painting, made a gradual transition from the religious to the secular. Patronage from the nobility and the royal family, particularly the emperor, led in time to art with a secular content. This new art form began to address a wide range of subject areas: the presentation of folk heroes, the depiction of hunting scenes and of battles scenes from the past. Artists became more mobile, going to where their services were required; most came to reside in larger towns, especially Addis Ababa which provided the newer clientèles of tourists, foreign diplomats and occasionally collectors. Later came the still newer breed of traders and middlemen, who began to sell art works commissioned from the now urban-based but traditionally trained artists. Popular themes were the Battle of Adoua and old biblical legends such as the visit of the Queen of Sheba to King Solomon. Imported commercial oil colours began to be preferred over tempera on parchment. But although the media and the themes changed, the style remained in the rigid tradition that had characterised religious painting for hundreds of years: most noticeable in these new secular art works is the rendering of eyes, which continued to be a stylistic hallmark of Ethiopian painting. Discussion by modern critics of this transition often implies that traditional religious painting ended, and gave way to modern secular art. In fact, the two traditions continue today to survive side by side, and religious art continues to function within church institutions.

The Rise of the Modern Movement

The modernist experience in Ethiopian art began with a new generation of artists whose training was based in the school system established in the 1920s. Unlike most African nations, Ethiopia was never colonised, except for the short Italian occupation of 1935 to 1941. Yet it has its share of turbulent events and political crises stemming from its multi-ethnic, muticultural and multi-religious society, coupled with inequalities in power-sharing and access to national wealth. Colonialism, if not direct

foreign occupation, still played a role in shaping modern Ethiopia's history and culture, and the modern art movement is part of this experience. The modernisation programmes initiated in the early 1920s were conceived within a westernised model of development. They were reinforced nationwide by Emperor Haile Selassie in the 1930s, only to be interrupted by the Italo–Ethiopian war. Despite the limitation of his autocratic and feudal rule, his reforms opened a window of western influences and contacts, ushering in a new era in Ethiopian education, culture and society. The rise of the modern school system enabled several artists to travel abroad for training in western academies as opposed to the traditional Ethiopian Church school.[58] Sculptor Abebe Wolde Giorgis (1897–1967) and painter Agegnehu Engeda (1905–50) were among the earliest artists to travel abroad and then return to practise in Addis Ababa. Wolde Giorgis returned after eighteen years in France and began to work on designs found in the former Parliament building, the Addis Ababa Municipality, Emperor Menelik Secondary School and the Addis Alem Church.[59] The painter Agegnehu Engeda studied at the Ecole des Beaux-Arts, Paris, from 1926 to 1933. His work, particularly his self-portrait (now in the National Museum in Addis Ababa), indicates his talent in handling realism; his treatment of facial expression shows a sensitive and introspective analysis.

Unlike their predecessors, these artists could expand their clientèle to include government offices, Parliament, the Municipality, schools, foreign dignitaries and expatriates, as well as tourists. Remaining faithful to their academic training, they applied a realistic style to traditional Ethiopian subject matter. The modernist urge in Europe in the 1920s did not seem to affect them. Conformity to their patrons' tastes and the absence of a strong, western-educated, middle or expatriate class may help explain this preference. Their most significant achievement was the establishment of private art schools, however short-lived, in which they enrolled small numbers of students who were taught classes in painting and drawing. These schools formed the foundation of what became the Addis Ababa School of Fine Arts in 1957.

The School of Fine Arts and the Modernist Pioneers of the 1950s and 1960s

In the early 1950s and 1960s, as in other African nations, Ethiopian artists were making tremendous contributions to the recognition of art as a vital instrument of national liberation and nation-building. Art was an instrument in signifying and symbolising the identity and rich heritage of Africa and the urge to build modern nation states. The painter Afewerk Tekle made such a contribution with his famous stained glass window in Africa Hall, the headquarters of the United Nations Economic Commission for Africa in Addis Ababa. *The Struggle and Aspiration of the African People*, 1959–61, has a singular monumentality, reverberating through the Panafrican ideals and optimism of the 1950s. Afewerk, who studied at the Slade in London in 1947, has become one of the best known of modern Ethiopian artists for introducing, on a larger scale, western techniques of painting and sculpture. His style is predominantly realistic, with geometric tendencies. He is the artist most frequently commissioned by the government, through changes in power from the

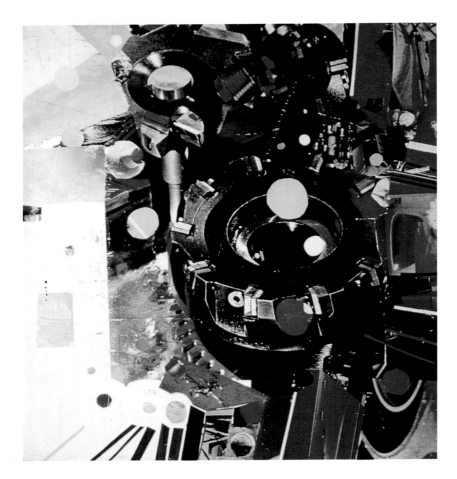

Gebre Kristos Desta
Power
1973
Oil on hardboard
90 x 81 cm
Private Collection,
deposited in the
Staatliches Museum für
Völkerkunde, Munich*

late Haile Selassie I to the infamous Derge regime of Mengistu. Presently, he serves as art advisor to the government of the EPDRF under the Ministry of Culture and Education.

The rise of the Fine Arts School is closely associated with Ale Felege Selam, another important pioneer modernist painter. Born in 1929 to a family of traditional painters, he was selected by the Ministry of Education to study abroad following his success at the Addis Ababa Technical High School. The first Ethiopian art student to study in the United States, he completed his studies at the Chicago Art Institute in 1954, and returned home determined to teach. Since there was then no formal arts school in Ethiopia, Ale Felege Selam began teaching on his own at the Ras Imiru compound, where he had rented a house. He recruited students simply by going to the high schools in Addis Ababa and announcing that he would be teaching art at the weekends and that anyone interested should join him. More students came than he could handle alone, and he realised the need for a fully fledged school. He began to raise funds by organising exhibitions of his students' work and by inviting members of the royal family and foreign diplomats to purchase them.

When, with the assistance of a committee, he had raised 75,000 Ethiopian dollars, he approached the emperor and argued passionately for help. With a contribution from Emperor Haile Selassie and the cooperation of the Ministry of Education, the Addis Ababa Fine Arts School was founded in 1957 with Selam as its first director. Its main objective was to train art teachers for secondary schools, but

it also had an interest in training professional artists.[60] The school has attracted talented and aspiring artists from all parts of Ethiopia. Teachers have included the painter and calligrapher Yigazu Bisrat (1926–79), who studied art with Wolde Giorgis and Engeda, and expatriates from Germany and Italy such as Herbert Seiler, Vincenzo Fumo and Hansen-Bahia.

Gebre Kristos Desta and Skunder Boghossian

With the founding of the Fine Arts School, two of Ethiopia's most influential painters, Gebre Kristos Desta (1932–81) and Skunder Boghossian (born 1937), returned from exile in Europe to teach there. They immediately brought a new creative energy to their students, and added to the atmosphere of cultural renewal in Addis Ababa, which had been chosen as the headquarters of the Organisation of African Unity. Theatre, literature, music and art all began to thrive, and serious art criticism was born in the writings of Solomon Deressa and Kifle Bese. Within a short time, both Skunder and Desta were having a profound impact on a new generation of artists. They created a significant following both locally and abroad, with a number of major exhibitions that received widespread reviews; both received the National Award for Fine Arts. Each in his own way left an indelible print on the students he taught and nurtured at the school. Gebre Kristos Desta taught there from 1962 to 1978; Skunder for just three years until his departure to the USA in 1969.

Desta had studied in Cologne, and was highly influenced by Germany where his exhibition of 1962 was positively received. His work ranged from portraits to

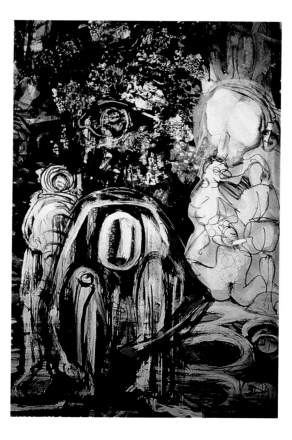

Gebre Kristos Desta
A Long Day
1979
Oil on hardboard
65 x 50 cm
Private Collection, deposited in the Staatliches Museum für Völkerkunde, Munich*

landscapes, issues of human destiny, exile, isolation and the daily social and political concerns of the poor and the oppressed. His style is an infusion of abstract expressionist language and geometric representation. His pioneering, adventurous spirit was reflected by the works in his exhibition of 1963, which was attacked by critics as abstract, alienated and removed from the tradition and experience of his people.[61] The best example of his early work is *Golgotha* (1963) which uses the theme of the Crucifixion to reflect on the human tragedy. In his later work, Desta journeyed through different phases. In the late 1960s and early 1970s he explored flowers in several works characterised by high intensity of colour and brilliant light. He also moved towards more abstraction in exploring issues of shape, light and colour. His concern with the underprivileged and the oppressed became more abstract and expressionistic in style with *Shoe Shine Boys* (1967). His social activism and dismay at the Derge regime led to a renewed life of exile in 1978, first in Germany and later in the USA, where he died in 1981. He left a legacy with great impact, and a number of works now in Munich.[62] Although his later works reflected his pessimism and personal isolation, he continued to explore issues of the underprivileged with a Panafrican perspective.

Desta's colleague Skunder Boghossian had a far briefer stay in Ethiopia, but he revolutionised and set new standards for the Ethiopian modern art movement. In 1955 he had received a government scholarship to study in Europe, and went to St Martin's Central and the Slade in London. In 1957 he moved to Paris, where he attended and taught at the Ecole des Beaux-Arts and the Académie de la Grande Chaumière until 1966. Skunder is one of Africa's best-known contemporary artists and widely exhibited internationally. For the last twenty years his art and style have defined modern Ethiopian painting. He was the first Ethiopian artist to have works purchased by both the Musée d'Art Moderne in Paris, in 1963, and the Museum of Modern Art in New York, in 1965.

Skunder's period in Paris, which at the time was a meeting place of diverse intellectual trends, provided him with a vigorous experience and shaped his personal philosophy and artistic style. He became associated with the Senegalese scholar and philosopher, Cheikh Anta Diop, and other major figures in the Panafrican and Negritude movements. He worked closely with artists from Africa, Latin America and the USA, especially African-American artists, and was particularly influenced by Paul Klee, André Breton, Georges Braque, the Cuban painter Wifredo Lam, Max Ernst, and a group of West African artists.[63] Like Ibrahim El Salahi of Sudan, his influence transcends Ethiopian art to the larger Panafrican and African diasporic art movements.[64] He now lives and works in Washington, D.C., and is an associate professor of painting at Howard University where he has been teaching since 1974. In 1992 the Smithsonian Institution's National Museum of African Art acquired several of his paintings.

Skunder uses the most diverse techniques and media to enhance the power of expression in his paintings. His work combines relief with bark cloth and goat skin, and painting in oil acrylic, gouache, crayon and pen and ink. *Time Cycle II* (1982) offers the finest example of his innovative techniques and media experimentation. Like Max Ernst, he begins a painting by deliberately creating accidental effects. He

Zerihun Yetmgeta
Scale of Civilisation
1988
Mixed media on wooden
looms
100 x 62 cm
Inv. 90-312 959,
Staatliches Museum für
Völkerkunde, Munich*

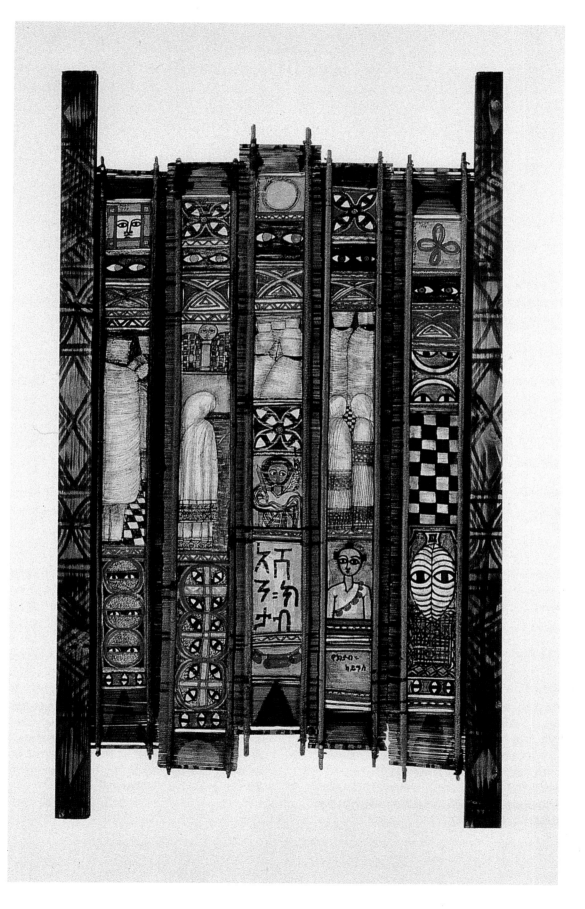

has developed a method of splashing water on the canvas, then spraying it with paint to create a surface alive with molecular energy. His works are vibrant in colour and enriched with symbols, motifs, forms and shapes drawn from his own Ethiopian heritage and the larger African continent, as well as his contemporary surrounding. His work synthesises his country's rich and powerful traditions with European techniques: in *The Spirit is Landing* (1987–89) he included painted scrolls on a vibrant background which became his distinguishing mark. Other examples of this synthesis are *Scroll I* and *Scroll II* (see page 243).

After moving to the USA in 1969, Skunder continued to make an impact on Ethiopian painting through several of his fellow countrymen who followed him to Howard University and studied under him. Forming a circle around Skunder, this group of younger artists was deeply influenced by his personality and inspired by his art. They include Zerihun Yetmgeta, Wosene Worke Kosrof, Tesfaye Tessema, Alemayehous Gebra Medhin and Assefa Telala, all of whom have pursued graduate studies in fine art. Others, such as Girmay H. Hiwet and Theodros Tsige Markos, left for Europe. All except Theodros Tsige Markos were students at the Addis Ababa Fine Arts School and studied under both Skunder and Desta; a strong stylistic and/or technical derivation from Skunder's work are among their distinct characteristics.

Zerihun Yetmgeta (born 1943) graduated from the School of Fine Arts in 1968 and has been influenced, especially in his woodcut work, by Hansen-Bahia as well as Skunder. His distinct style includes experimentation with mixed media on bamboo strips to recreate his own vision of Ethiopian cultural evolution in a larger Panafrican scale (see *Scale of Civilisation*, left). Yetmgeta uses a visual equivalent of the literary tradition of 'wax and gold,' as traditional Ethiopian poetry is known, in many of his works.[65] Magic and scroll-like images mixed with such symbolism is observed in *Fishing the Evil Eye* (1989) and *Diamond on Gold* (1986). In both works, the message is enhanced by the use of mixed media, oil or pen and ink, on goat skin.

Wosene Kosrof and Girmay Hiwet were highly influenced by Skunder's work; today, both have developed distinct styles and characters in their work. Both have sometimes used goat skin stretched to a thin membrane, and have experimented with different media, adding to the surfaces of their work texture and layers of enamel, wood relief and vibrant colour. Their works are full of references to Coptic symbols, calligraphic forms in Amharic and Geez, and Panafrican-derived imagery.

Wosene (born 1950) was a 1972 graduate of the School of Fine Arts in Addis Ababa and then obtained an MFA from Howard University in 1980. Unique among Ethiopian artists for his explorations of calligraphy in his paintings, Wosene makes use of the aesthetic as well as literary potential of letter forms in Amharic and Geez. In some of his paintings, the aesthetic dimension of calligraphy is enhanced by its literary content through the incorporation of folksongs and poems.[66] However, as he explains: 'I am not in pursuit of a readable message with my calligraphy; rather, I do paintings in which the Amharic language is incorporated as part of the aesthetic value of the whole work.'[67] In *Graffiti Magic* and *Africa: The New Alphabet*, Wosene has consciously worked towards building what he calls 'a vocabulary of signs and symbols'. *Words of the Ancestors II* (1993), is the best example of calligraphic explorations in which the aesthetic and magical qualities of language and the

Wosene
Words of the Ancestor II
1993
Acrylic on canvas
52 x 49.5 cm
Collection of the artist*

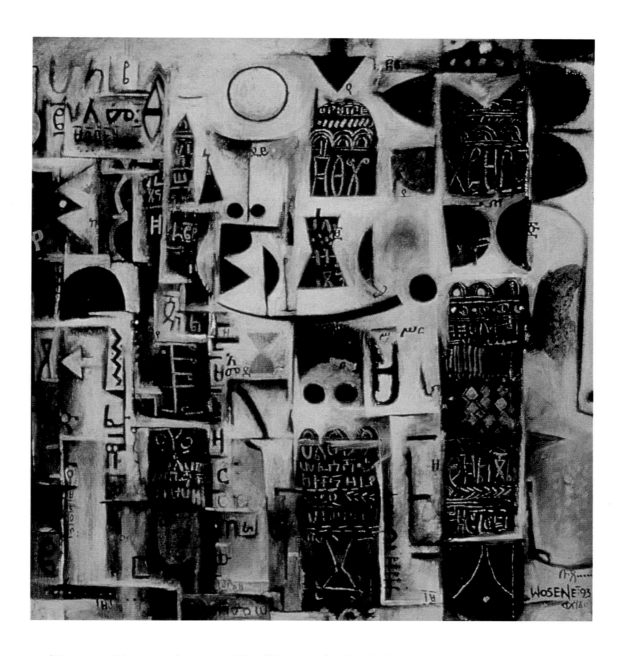

written word become inseparable. Wosene also includes patterns in his work which echo the rhythms of jazz, a reflection of his experience of living in the USA and his affinity with African-American culture and creative expressions. *Martin Luther King* (1987) reflects a jazz-like improvisational spirit and quilt patterns with calligraphic forms and magical scroll-like images. In *She Ethiopia V*, he uses mixed media on goat skin with Visa cards, Coca Cola cans, nails and aluminum.

Girmay Hiwet (born 1949) graduated from the Fine Arts School in 1971, and has been living and working in Switzerland since 1972, with a year's study spent in Washington, D.C., in 1983, when he worked with Skunder, other Ethiopians, African and African-American artists. This experience is embodied in *Harambee Africa* (1983). Since then, his work has evolved to be more Panafrican in imagery and content. In *Shields of the Forefathers* (1989), he uses mixed media to creative a low-relief-like painting with a central form representing the portal leading into Ethiopia,

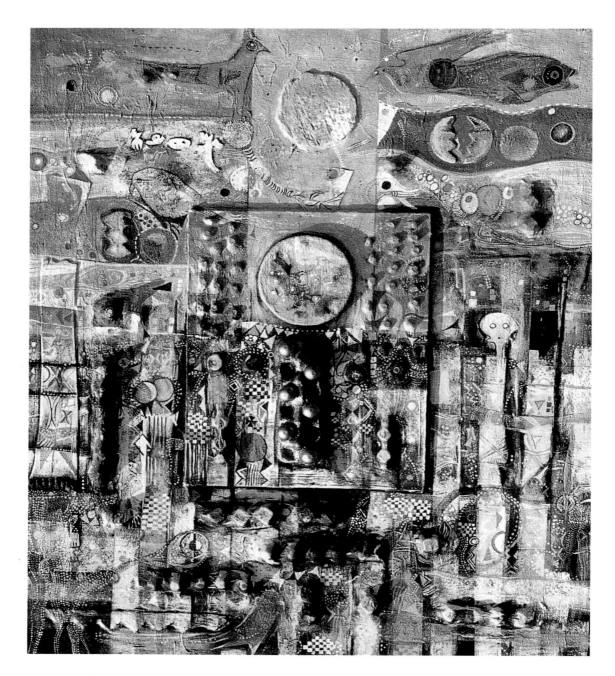

Girmay H. Hiwet
Crown of Creation
1991
Mixed media, relief
140 x 120 x 6 cm
Collection of the artist*

a recurrent theme in his work. One can also see a round shield with his signature in Amharic: the name Hiwet means 'life'.[68] Other symbols include the sun, horns and moon birds, all traditionally Ethiopian. *Crown of Creation* (above) is in mixed media, with similar symbols recurring in colourful patterns of low relief and scrolls.

Other students whose works do not directly reflect either Desta's or Skunder's still regard the influence of those artists as a defining moment; certainly, the dynamics of their works are heightened by situating them in this 'intertextual', dialogic and interactive manner. These include Achamyeleh Debela in the USA; Yohannes Gedamu and Berhe Temelso in Germany, and many others presently in Addis Ababa. Liz Atnafu, for instance, has intentionally tried to escape the commanding influence of Skunder but still defines her work within a parameter of

an Ethiopian art, which she perceives as global and modern. Now based in Washington, D.C., Atnafu is one of the few women on the Ethiopian art scene.[69] Born in Addis Ababa, she went to Howard University where she graduated in 1975. She gained recognition with the receipt of the United Nations' International Women's Artist Award in 1976. Several of her paintings have graced the covers of jazz records by Ornette Coleman and Charles Hayden, among others. Her works have been in many group shows in the USA and abroad, and are now part of the permanent collection of the Museum of Prints and Photography in Paris, and the Museum of Modern Art in Mexico. Atnafu's paintings are large and mosaic-like, with cumulative layers of dazzling paints on canvas with mixed media of paper and found objects. Recently, she has moved towards installations and conceptual art forms. *Modern Witch* (1994) is an installation executed in her typical style of vibrant raw colours accompanied by broad slashing strokes. Another recent installation, *A Shrine for Angelica's Dreams* (below) is an eclectic work, conceived in a shrine-like form, consisting of a white dress, a fancy hat, mixed media and collectable items – personal letters, memorabilia, and curios of every kind from Ethiopian amulets to Hallmark greeting cards. Angelica, the subject, is a South American immigrant of Hispanic origin and a great storyteller. Yet the piece 'is about other women too, their dreams, aspirations, disappointments and fantasies'. As she asserts: 'my paintings and drawings are reflections of my fantasies and the presentation of everyday things in life.'[70]

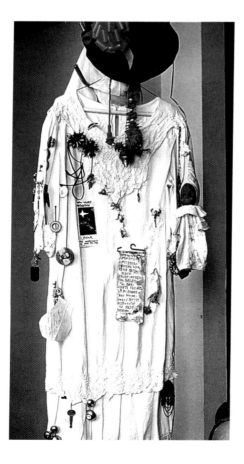

Elizabeth Atnafu
A Shrine for Angelica's Dreams
1994
Mixed media
180 x 180 x 15 cm
Collection of the artist*

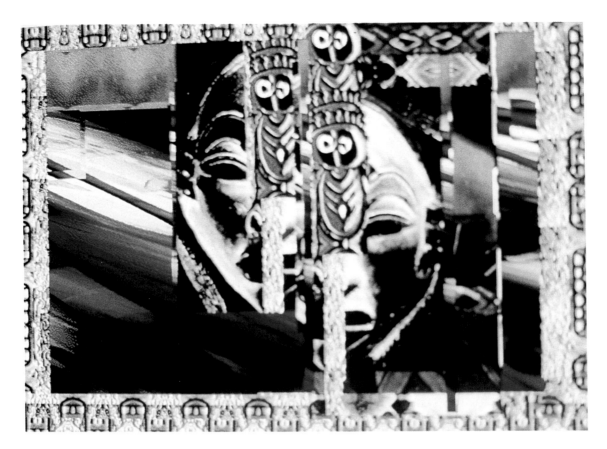

Achamyeleh Debela
Song for Africa
1992/93
Cibachrome print, Iris print,
digital painting
76 x 101.5 cm
Courtesy of the artist
and Contemporary
African Art Gallery,
New York*

Achamyeleh Debela is one of the very few African artists trained in computer graphics and programming, which he uses as an artistic medium. He started his training as a painter at the School of Fine Arts, studying mostly under Desta. After his graduation in 1967 he was awarded a scholarship to study at Ahmadu Bello University in Zaria, Nigeria, an experience that widened his Panafrican imagery, a resource he continues to draw on. He then moved to the USA, completed a doctoral degree in Ohio in computer art, and is now a professor of art and director of the Computing Center for the Arts at North Carolina Central University. His earlier work, which tends to be figurative, was highly influenced by Desta, but he has gradually shifted to programming. The computer allows him to create a series of images that he can store and later retrieve to manipulate for the final product, which is then printed.[71] Good examples of his recent experimental work in computer-assisted art are his series *Song for Africa* (above) and *Spirit at the Door*: both are Cibachrome prints produced by computer. In *Spirit at the Door,* Debela has superimposed the image of an elaborately carved Senufo door on an enlarged image of an Ashanti funeral head; doorways are frequently the sites of ritual activities in Africa, where the belief that portals attract spirits is widespread. *The Waiting Series* (1994) is another excellent example of his computer-aided work, this time miniature pieces in wax transfer prints. Debela also continues to paint in oil and acrylic.

The Revolution of 1974 and its Aftermath

The Ethiopian Revolution of 1974, a genuine people's uprising hijacked by the Derge regime, marked the end of the monarchy, but the beginning of another politically oppressive era in Ethiopian history. The art scene suffered the exodus of those influential figures who had emerged in the 1950s and 1960s. However, several artists and creative individuals opted to stay in Ethiopia, and have continued to create under extremely difficult circumstances, compounded by shortages in everything from basic economic needs to art materials, and the absence of liberty and individual freedom.

Not only did the post-revolutionary Derge era impact on the Fine Arts School's instructional programmes, but it ultimately affected the nature of the works that students and artists produced.[72] Artists were expected to turn their talents to promoting the socialist ideas espoused by the new regime. A version of the ideals and aesthetics of Soviet Socialist Realism was propagated as standard for most acceptable art. The state, through its Ministry of Culture, became more active in the arts, mobilising artists to promote the new social order and participate in art competitions and state propaganda through the mediums of posters, murals and billboards. It is no coincidence that new subjects relevant to these pursuits have been introduced into the school, such as graphic design and poster art. Pre-revolutionary abstract and modernist art was criticised as 'élitist' and 'non-objective', and consequently discouraged. Supposedly more purposeful, realistic, collective and democratic arts have been encouraged. The state has argued that artists must deal with topics such as rural and urban labour, literary heroes and the emancipation of women. The outcome of all these developments has yet to be studied.[73]

Several other areas remain problematic, including the place of Eritrea and Eritrean nationalism. Now that Eritrea is a separate nation state, many questions arise as to what distinguishes the art of this new nation.[74] Should we view the nations as having two separate traditions? Are there any demarcations between the two, bearing in mind historical influences and links in culture, religion and language? Another area is in the assessment of the cultural scene in today's 'post-post-revolution Ethiopia', supposedly transitional/democratic. One hopeful sign is in the opening of the country and its gradual democratisation, which has allowed many exiles to return or visit their homeland. Such an opening is yet to be made available to the many exiles from Sudan.

The breadth and contribution of the modern Ethiopian art movement are difficult to assess within one essay. The works of the artists discussed here are, it is hoped, representative of the complexity of this movement and the different directions it has taken. Their art is an expression of the rich heritage and wealth of experience gained from studying and growing up in Ethiopia, and from their exile and diasporic experiences in western centres of modernism. Today, Ethiopian artists continue to be active and several among them have enjoyed a remarkable success and exposure in international circles.

moments in art

a story from south africa by david koloane

Bill Ainslie
Pachipamwe No. 3
1989
Acrylic on canvas
141 x 181 cm
Made in the Pachipamwe
Workshop
Collection of Mr and Mrs
Lindsay McMillan*

Moments in Art

David Koloane

Objective

To assemble a South African component of a major series of exhibitions from different countries on the continent. The project is an integral aspect of the africa95 arts season, with the prospect of an international tour as well as the main venue in London.

Procedure

It is a historical development for an African curator to be entrusted with such a major responsibility in the South African context. The apartheid policy as practised by successive governments effectively prohibited communities from actively participating in the visual arts disciplines, except as practising artists only.

> *Black art exists almost exclusively by virtue of white liberals' benign interest. Teachers are white, art administrators are white, gallery directors are white, and so are the critics and buyers.*[1]

Criterion

The challenge of curating the exhibition revolved around such pertinent questions as:

What defines a South African expression?
What paradigms would typify the expression?
What criterion to employ in a society virtually divided into two distinct and separate worlds?

> *The geographic, intellectual and political climates, the fauna and flora, our ideas and the way we live all conspire through a complex alchemy.*[2]

Precedent

In 1990, after the release of Nelson Mandela and other major political prisoners from Robben Island, the unbanning of the African National Congress, Panafrican Congress and the Azanian People's Liberation Movement, celebrations were staged locally and abroad. The most prominent was the Mandela Concert at Wembley Stadium in London. It was later followed by the Zabalaza Festival, celebrating the 'dawn of a new day', also in London. David Elliot, Director of the Museum of Modern Art in Oxford, came to South Africa to curate an exhibition as part of the festival. The exhibition would travel to major British cities.

The concept of the exhibition was largely that of presenting a survey of work produced around the country in all its varied forms. I was fortunate to be appointed co-curator. We travelled to different areas to consult with various community-based and 'official' structures to appraise work. I acquired valuable experience from this project.

> *Our investigative journey took us to art schools and teachers' studios, to the studios of the well-off and the workplaces of the impoverished, to community centre workshops, museums and opulent collections . . .*[3]

Politics

The apartheid ideology and South Africa had become so inextricably intertwined that the country became a pariah in world politics. The apartheid system earned an international wrath paralleled only by the reaction to Nazism during the Second World War. Ironically, both ideologies were based on the fallacy of racial superiority, which resulted in immense human tragedy.

The catalogue of tragedy in South Africa includes the Sharpeville massacre of 1963 in which harmless protesters were shot. The Soweto student uprising of 1976 was the result of an inferior education system for the black

communities and the death in detention of Steve Biko, leader of the Black Consciousness Movement. He was brutally assassinated by security police interrogators, then his handcuffed, naked body was driven in the back of a jeep 1,628 kilometres from the coastal town of Port Elizabeth to the inland prison hospital at Pretoria.

The crisis of legitimacy which directly stems from the apparatus is not solely confined to the law, politics or institutions, but is extended to all areas of human exchange.[4]

Sam Nhlengethwa
It left him cold – the death of Steve Biko
1990
Collage, pencil and charcoal on paper
69 x 93 cm
Standard Bank Collection housed at the University of the Witwatersrand Art Galleries, Johannesburg*

Concept

The pervasive role played by politics in the existence of the South African populace affects both victims and perpetrators alike, and therefore every sphere of life. The Biko event, more than any other occurrence, touched every human chord when explicit details of the incident were revealed at the inquest. It provoked international outrage.

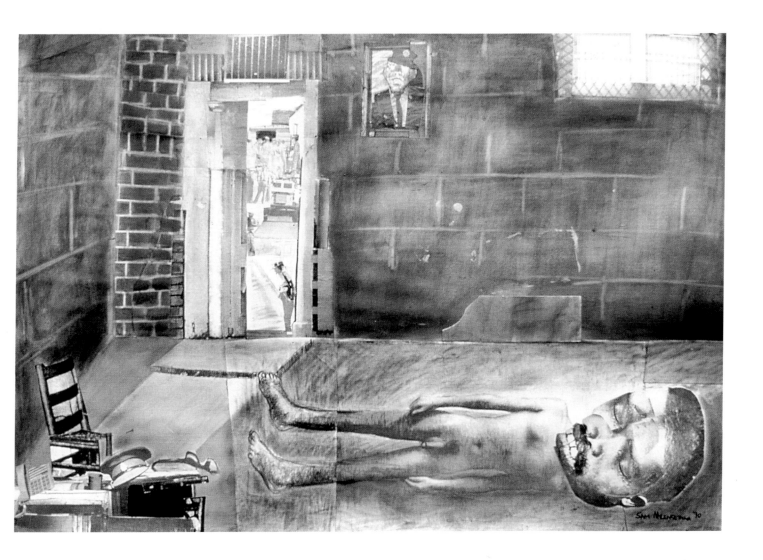

A creative upsurge developed around the event as different artists in the visual, literary and performing spheres produced a variety of work. It became evident, then, that a Biko dedication should become the central aspect of this exhibition. Work by various artists would epitomise how the apartheid ideology interrupted the spontaneous flow of existence within the diverse cultural groups.

The human condition has become for African artists the icon around which their expression revolves. The exhibition would therefore be centred on events which have become catalysts to the artists at different moments.

> A radicalisation of this humanist tendency of the 1960s emerged in the 1970s, as protest art particularised commitment expressed in a variety of basically figurative stylistic modes.[5]

The work of the first wave of professional artists who were products of the Polly Street Art Centre will be represented by the work of the late Ephraim Ngatane. Ephraim Ngatane was one of the most innovative artists who transcended the socio-environmental expression of his colleagues in the late 1960s. The concluding part of the display will comprise work from different Thupelo art project workshops conducted in Johannesburg.

The Thupelo art project was initiated by artists in South Africa in 1985. It employs the workshop concept modelled on the Triangle International Artists' Workshop, initiated in upstate New York in 1982 by the British sculptor Anthony Caro and the art patron Robert Loder. The format is a two-week work session for painters and sculptors in a secluded venue away from day-to-day distractions.

The workshop concept was not adopted in South Africa with any specific aesthetic programme: its concerns were wholly pragmatic.[6]

Format 1950–1960

Polly Street

The Polly Street Art Centre was the first to bring artists from different areas together under one roof in South Africa in the 1950s. The first group of African professional artists emerged from this centre; their work was largely concerned with the social conditions in their segregated settlements. The work of Ephraim Ngatane represents this period.

Paul Stopforth
No title (hand)
1980
Graphite liquid wax
on paper
64 x 50 cm
Johannesburg Art Gallery*

Paul Stopforth
No title (two feet)
1980
Graphite liquid wax
on paper
66.5 x 50 cm
Johannesburg Art Gallery*

Paul Stopforth
No title (foot)
1980
Graphite liquid wax
on paper
63 x 50 cm
Johannesburg Art Gallery*

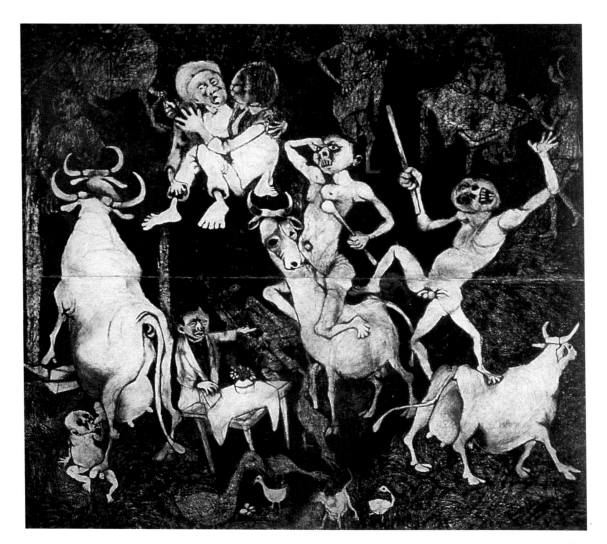

As things turned out, this small, undistinguished institution became the seminal source of a minor cultural revolution.[7]

Death in Detention

In 1977 Steve Biko dies in detention. Seventeen organisations and two newspapers are banned from the inquest.[8]

The story of Steve Biko's tragic death will constitute the major concept of the exhibition. The work includes a series of drawings by Paul Stopforth; the *Chicken* series of drawings by Ezrom Legae; a collage composition by Sam Nhlengethwa, and a painting composition by Alfred Thoba.

The Thupelo Art Project

There is a general tendency in South African art circles to expect that black artists should not express themselves in a non-representational mode.[9]

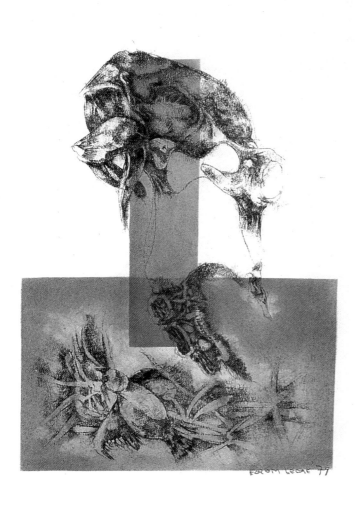

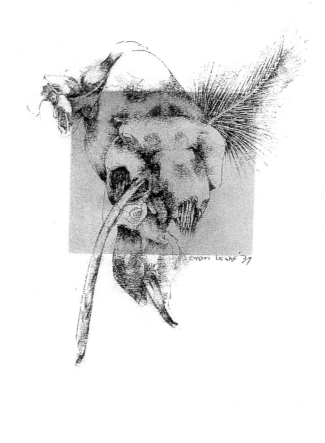

Ezrom Legae

Above:
*Drawing from Chicken
Series B*
Conte and wash on paper
47.5 x 34.5 cm

Right:
*Drawing from Chicken
Series D*
1979
Conte and wash on paper
47 x 34.5 cm
Collection of Mr and Mrs
D. Brown, South Africa*

The Thupelo display will comprise work done in different workshops over the years, displayed to emphasise the experimental aspect of the workshop process as a creative facility rather than as an abstract expressionist movement.

Collections, Galleries and Museums

Most of the work identified in the different sections of the display can be located in various collections around the country; only a few are in private collections. It is important to note that apartheid legislation, including the Separate Amenities Act of 1950, prohibited the sharing of facilities such as cinemas, libraries, theatres and art museums by different racial groups. I had not been inside an art museum until I was in my mid-thirties. The Separate Amenities Act was relaxed in 1972. The important galleries and museums in which to find work are the Johannesburg Art Gallery; the Gertrude Posel Gallery, Johannesburg; the University of Witwatersrand; the Durban Art Gallery, and Fort Hare University Collection in the Eastern Cape.

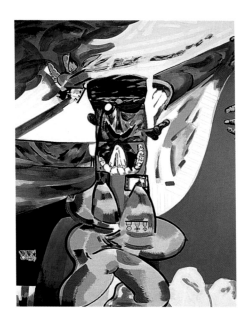 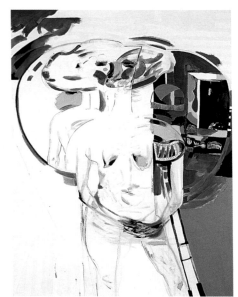 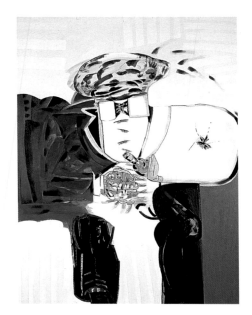

The work in the store-room of both the National Gallery in Cape Town and the Johannesburg Art Gallery comprises large-scale canvas pieces generally painted in oils, colour litho and silkscreen prints, and black-and-white drawings. Most of the early work is composed of landscape, portraits, still life, wildlife and nude studies. Later work from the 1960s aspired towards Euro-American modernistic movements. The work from the Gertrude Posel Gallery, which houses the University collection, was relatively modern in approach and trend work by African artists in these collections was few and far between. The scale of work produced by white artists was also reflected in several respects, especially in the disparity in living conditions between the different communities.

Landscape

> *The view of Table Bay and Table Mountain has been one of the world's most admired and represented landscapes.*[10]

The landscape genre which is so characteristic of 'official' South African expression means different things to artists from different cultural backgrounds. To the white artist it is an icon of privilege and propriety, and to the black artist it is a symbol of repression and dispossession.

> *The Native Trust and Land Act of 1913, which confined African land ownership to native reserves comprising only 12 per cent of the land, effectively reduced the possibility of livelihood in rural areas and disrupted the traditional patterns and cultural unity of rural society.*[11]

It is not surprising therefore that the apartheid system discouraged and prohibited the free movement of African artists from one area to another.

Hardly surprising then is that expressions by black artists from the Western Cape in the 1980s as elsewhere are not concerned with reflections of scenery, with nature in all its splendour, but by common intent with the urban landscape.[12]

It is evident that, with a few exceptions, the work in the collections under discussion reflects a Euro-American aesthetic concern. There are samples and faint echoes of Expressionism, Cubism, Impressionism, Symbolism, Sport, Pop modernism and related manifestations.

The Fort Hare University Collection is unique and the only one of its kind in the country. It was initiated by the anthropologist Professor E. J. De Jager as an extension of the department of African Studies in 1864. Among other aspects, the collection represents a visual narrative of the effects of racial discrimination in South Africa. The work provides the viewer with a glimpse of the segregated landscape which conceals a backyard of overcrowded deprivation.

The compositions are social-realistic expressions of segregated township settlements. These comprise row upon row of matchbox-design dwellings in monotonous uniformity and greyness.

The artificial, inorganic nature of the township is reflected in its physical environment, which is particularly dehumanising.[13]

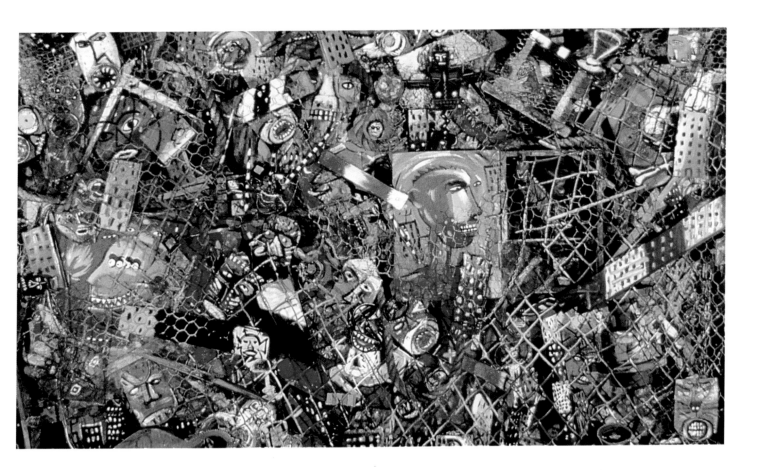

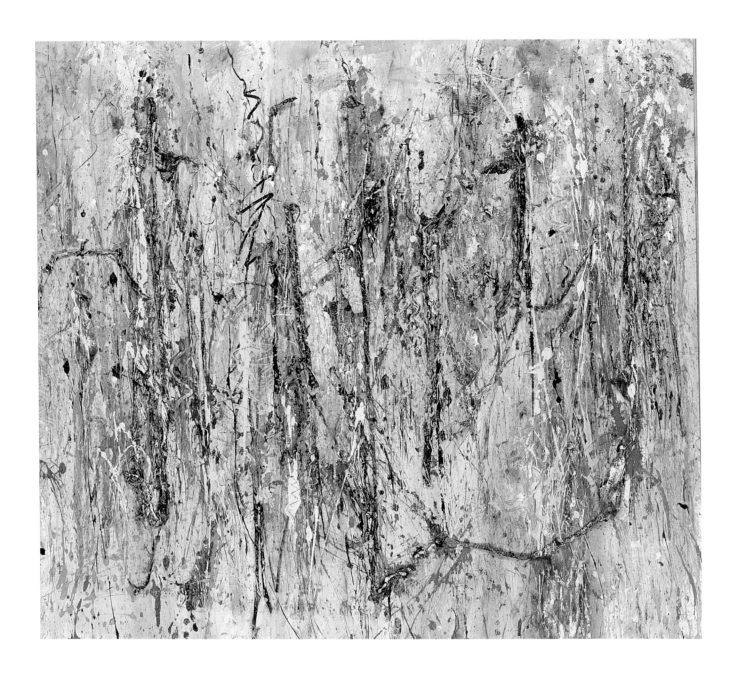

The collection also contains work by a younger generation of artists who have transcended social-realistic concerns and are exploring new vistas.

 The privilege of being allowed into the previously forbidden territory of gallery holdings without being regarded with a hint of suspicion or doubt, without being hastily asked, by a face with a 'fixed' smile, if I could be assisted – this represented the crossing of a threshold. During the implementation of the Separate Amenities Act, an African could only be allowed into a bus, cinema, theatre or art museum if accompanied by a white and, by implication, superior person. Galleries were a revelation which exposed the futility of the erstwhile imposition of a culture of alienation, denial and secrecy against oppressed communities.

Dumisani Mabaso
Untitled
1988
Acrylic and cloth on canvas
169 x 183 cm
Made in the Thupelo workshop
Private Collection*

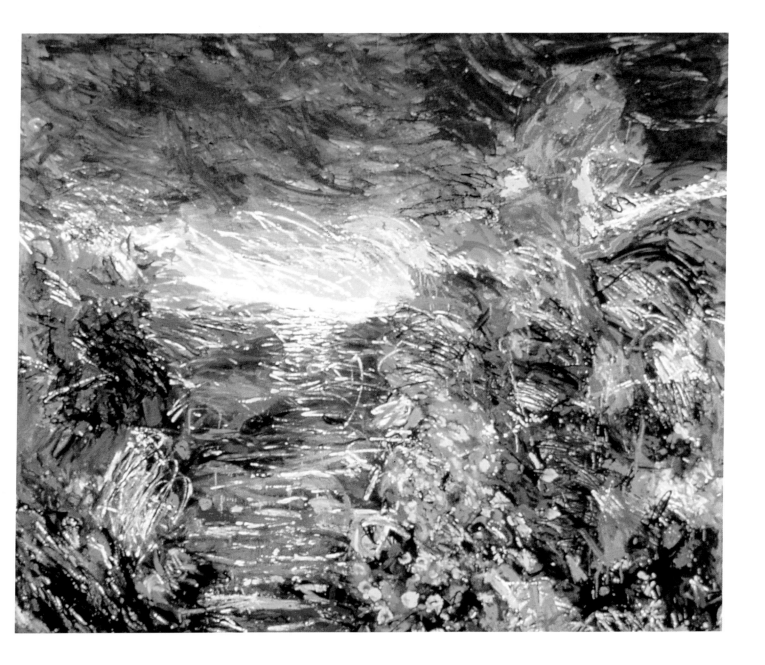

Kevin Atkinson
White African Landscape
1982
Oil on canvas
300 x 300 cm
South African National Gallery,
Cape Town*

Most of the early work in these collections displays an opulence of scale and material, but are devoid of inspired composition. Some of the work was narcissistically feeding upon itself and the isolation of a distant Europe, rather than assimilating or confronting the African presence.

It is in the later work of the 1970s and 1980s – when the brunt of repression resulted in numerous tragedies in the form of shootings and deaths in detention – that some artists identified with the occurrences. Some of the work produced during this period is still unrivalled in its uncompromising intensity. The Fort Hare Collection provides a radical contrast to the other collections in scale, technique, content and approach.

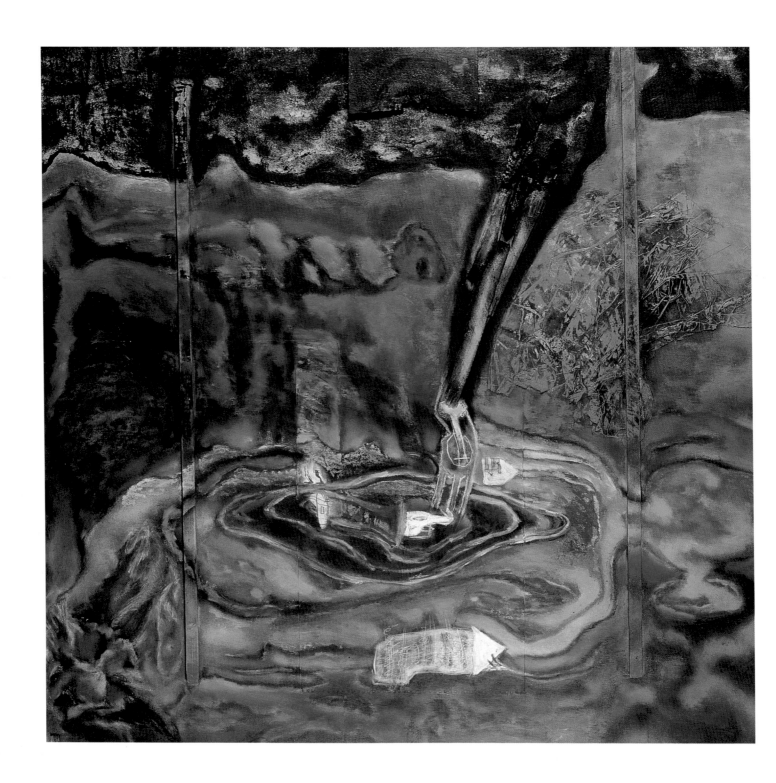

Sybille Nagel
Deep Touch
1992
Acrylic, wood, charred
wood, nails,
textile, cartridge paper,
newsprint, pencil and
oil pastel on plywood
129.5 x 130 cm (framed)
Johannesburg Art Gallery*

At times I had the feeling that some people felt it was virtually impossible for good art to be made under the conditions of apartheid...[14]

The work in the collection is by both urban and rural artists and is, as such, a vital research and educational facility. Its accommodation at Fort Hare University could not be more historically appropriate: the university is one of the first tertiary institutions in southern Africa for African students. It has produced an illustrious roster of leaders and educationalists, among whom are Nelson Mandela; Robert Mugabe, President of Zimbabwe, and Gouan Mbeki, father of Vice-President Thabo Mbeki. The Fort Hare Collection is a visual complement to the struggle for liberation.

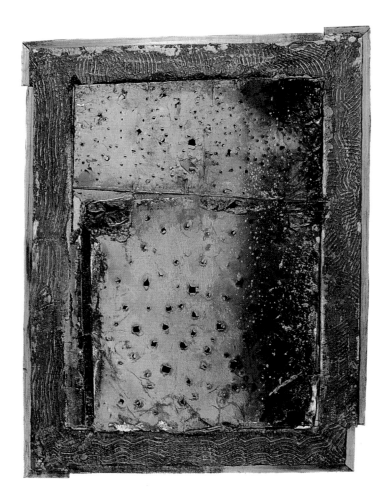

Kagiso Pat Mautloa
Tablet
1993
Metal, wood, canvas, oil,
rail, rivets
143.5 x 109 x 2 cm
Johannesburg Art Gallery

concrete narratives

and visual prose

two stories from kenya and uganda
by wanjiku nyachae

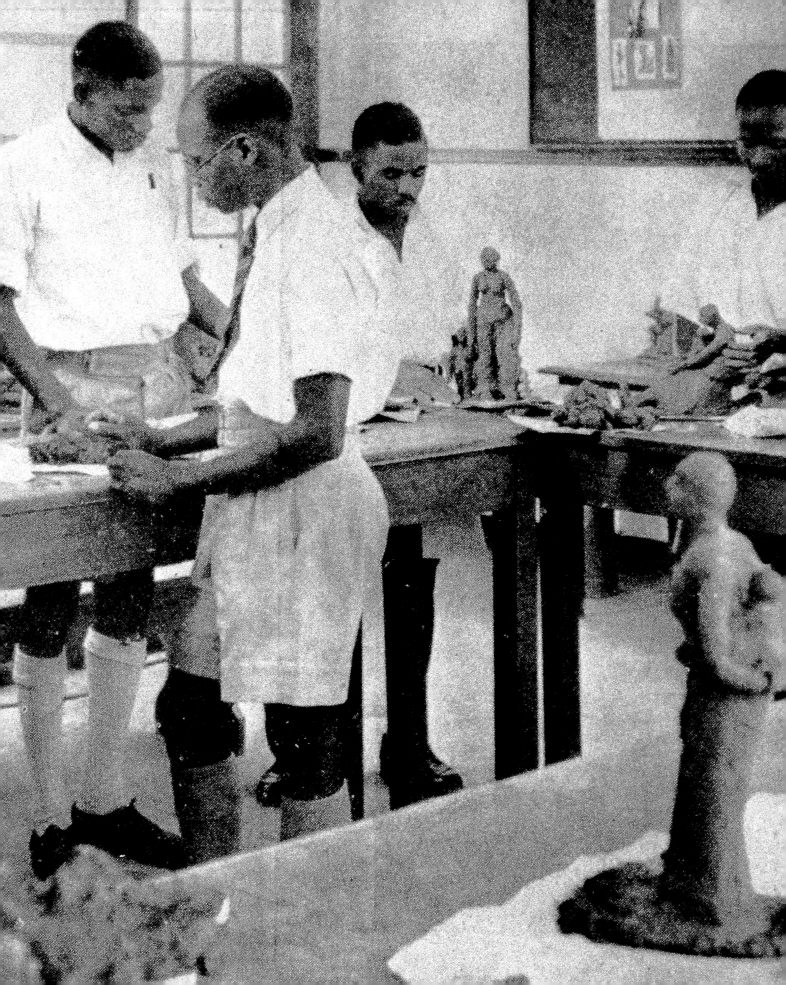

Geoffrey Maloba teaching
at the Margaret Trowell
School of Fine Art,
Makerere University,
Kampala

Concrete Narratives and Visual Prose

Wanjiku Nyachae

Introduction

'Is there contemporary art in East Africa?'

Yes! There is a great deal of contemporary art in East Africa – art that is defined by individual and collective logic, distanced yet not antagonistic towards the exigencies and exercise of western visual art practice. Contemporary art in East Africa draws inspiration from myth/reality; execution is figurative/symbolic, derivative/pure, contained/unruly. In other words, contemporary art in East Africa is the same inspiring fusion of paradoxes as is expected and accepted of contemporary art in other parts of the world.

These two short essays deal with work from Nairobi and Malindi in Kenya, and from Kampala in Uganda. They are neither academic theses nor potted art histories. Close one eye and look through the funnel of a kaleidoscope: if you keep very still, a pattern emerges which is derived from the random movements of individual pieces falling to make an understandable and pleasing pastiche. Twist or slip and the pattern changes before your very eyes. And so it is with these essays. Apart from the random element in this comparison, I am presenting frozen moments relating to

specific movements of contemporary art in three post-independence urban centres between early 1962 and late 1993.

East Africa, with its steppe and savannah topography, unpredictable levels of rainfall and seven-year drought cycle, served as the crossroads for massive long-term migrations through the ages. Geographical and physical conditions of passage, especially the necessity for frequent movement, dictated that the region's multiple ethnicities developed highly portable elements of material culture. Hence the primacy and strength of Kenya's and Uganda's narrative tradition, the decoration of functional objects, and body adornment.

Art historians interchange the phrases 'traditional African art' with 'African fine art', using both as generic terms for sculpture – religious, ritual and educational – from the pre-colonial period. The mask 'discovered'; *Demoiselles d'Avignon* revolutionises. Traditional African art or fine art from Africa is recognised. But there were not a lot of masks in East Africa, nor was there a wealth of sculpture. People travelled light in contrast to the settled peoples of West Africa. 'Only in three parts of East Africa were works of fine art produced in significant quantity before the colonial period: around Lake Victoria and in the interlacustrine area; in southern and south-eastern Tanzania among the Makonde, Yao, Makua and Ngindo; and in the hinterland of the Kenyan coast, among the Mijikenda'.[1] The absence in East Africa of sculptures and masks of a genre similar to those associated with traditional African art from North, West and Central Africa led scholars and collectors to conclude that there is no 'serious art' in East Africa.

A strange concept has gained international credence: the absence of a wealth of traditional art executed along defined 'African plastic principles' indicates a corresponding absence of contemporary art. This dogmatic view – compounded by the fact that another set of critics and curators judge African art according to the media used – has led to craft and 'airport' or 'tourist' art (which are derided as non-art), being held up as the sum total of East Africa's plastic creativity.

I would like to attempt an explanation for the lack of participation of Kenyan and Ugandan artists in the current critical debates about contemporary art. The artists are operating in a parallel dynamic, which is contemporary to their reality. Western painting media are new to us – new and exciting. East African artists are interested in what is happening abroad, but the majority of our artists literally cannot access, and/or afford to engage in, debate and experimentation. The erratic momentum of our national economic and political development impacts directly on the provision of materials, and of formal and informal art education. Government and self-imposed constraints on freedom of expression in our political circles naturally limit the rate at which creative boundaries are pushed. So, while the post-colonial histories of economic and political development in Kenya and Uganda have differed significantly, there are traditional and current areas in common that influence the development of contemporary art.

The most important shared cultural factors are the strength and influence of narrative on contemporary art; and the effect of foreign traders,[2] European missionaries, teachers, artists and, later, dealers. Artists draw on a rich store of oral tradition, and extend these tools to interpret current issues. The works of two

contemporary artists, Jak Katarikawe and Kivuthi Mbuno, illustrate the link between narrative and visual execution.

Mbuno did not give titles to his earlier pictures but provided oral commentaries about each scene in clear, simple terms. 'They were resting somewhere under a tree. At the time they were resting there, this woman looked up and she saw this snake on the tree. That's why she wants to stand up.'[3] Mbuno's more recent works have complete narratives, which are now documented. The pictures are no longer frames in a larger, more complex action, but stories in the format of the Akamba tales with which he grew up.

Jak Katarikawe, a Ugandan based in Kenya, produces oil paintings portraying emotions about states of life or of society. Animals express human desires, and field sports reflect the state of play between countries. 'This one is my country at lunch time. When it is after... lunch time people feel very happy, starting to enjoy. He is a cow. He is very happy, he smiles... This one (the one on the right wearing spectacles) is sad.'[4] 'This is football between Kenya and Uganda... And each one wants to win. And only God is going to judge for them. Tomorrow is football.'[5]

With respect to the influence of traders, teachers, dealers and missionaries, although their intervention has been central to the exposure of East African art in the international arena, it is important to emphasise that 'they did not create the talents, rather set them free and in some instances simultaneously reduced them to technical craftsmanship, as in the case of airport art.'[6] I fight the inappropriate impulse to play down the role of dealers; in spite of their avarice and questionable business ethics, they have been catalysts for the growth in numbers and reputation of artists through commercial activity. My reservations lie in the fact they have succeeded in the commodification of certain types of contemporary art, such as the 'naive' or 'primitive' school nurtured primarily by Ruth Schaffner, the director of Kenya's foremost commercial art gallery, Gallery Watatu. The now disbanded Malindi Artists Proof, brainchild of the concrete artist Isaia Mabellini, alias Sarenco, has promoted a small number of Kenyan artists to the extent that their works are represented by galleries in Italy, Germany, France and the USA.

A third common factor is formal and informal education and, within that, the central role played by the Margaret Trowell School of Fine Art at Makerere University, Kampala, Uganda, and institutions such as Kenyatta University Collage, Nairobi; Paa Ya Paa centre in Kiambu, Kenya; the Watatu Foundation in Nairobi, Kenya, and Malindi Artists Proof, Malindi, Kenya. The Margaret Trowell School is an important shared experience among the 'older' generation of artists from Kenya, Uganda and Tanzania who subsequently became teachers and mentors to the younger taught and self-taught contemporary artists. The Watatu Foundation and Malindi Artists Proof cater largely for autodidactic artists, while Paa Ya Paa serves both formally and informally trained artists as a workshop and exhibition space.

Finally, I touch on the issue of art for the people through Sisi Kwa Sisi as explained by the artist and critic Etale Sukuro. This was an artist-led initiative to bring Kenyan art to the people starting in 1977 and realised in 1982. It sought to identify and acknowledge the indigenous audience for local art through nationwide exhibitions.

In this exhibition, the pieces from Uganda, made by artists with formal tertiary level art training, display a discourse about resistance and the survival of the spirit. Each has been made under the extraordinary circumstance of a college of fine art remaining open through a period of civil war and mass genocide, or following a life-threatening personal experience at the hands of 'authority'. Forming a matrix bounded by the recognisable way that individual practitioners share a style of painting, and by repeated symbols that evolve or assume recurrent themes, Uganda's 'Visual Prose' introduces a group of artists who assume individual positions that address communal concerns – about betrayal and the appalling abuses of power that fuelled a state of civil unrest in the country for fourteen years.

The exhibits from Kenya consist mainly of art from practitioners who have had no specialised training in the form of degrees or diplomas; they explore personal narratives about the tensions inherent in mortal and spiritual survival. Theirs is a fluid and less prescribed creative process. Their productivity is acutely sensitive to market forces: on the one hand they actively seek patronage from individuals and institutions abroad that demand works glorifying the increasingly suspect categories of 'naive' and 'primitive' art, while on the other they are equally at ease with experimentation and the articulation of personal and collective social, religious and political concerns.

Background

The British Colonial Government's administrative tool for the East African sector of its empire was the East African Common Services (EACS), which covered transport, a common currency and a judicial system for Uganda, Kenya and Tanzania. Uganda was a protectorate; Kenya was a settler colony, and Tanzania was formed in 1964 when Zanzibar united with Tanganyika, originally a German colony which became a trusteeship following the defeat of the Germans in the First World War. These definitions impacted on every aspect of the countries' life. Uganda and Tanzania, for example, were afforded a degree of governmental autonomy not shared by Kenya. Uganda's status as a protectorate facilitated the successful establishment of art as a subject officially taught in Ugandan schools well before independence; the achievement of extending art education beyond secondary level can be credited to the visionary efforts of Mrs Margaret Trowell.[7] 'Margaret Trowell had her heyday during the Second World War. Her husband was a doctor with the missionary service, which was her power base. Only someone with her clarity of vision could have pushed through the art school. No man could have done it. White men were by definition philistine; the colonial woman was not.'[8] In Kenya, in keeping with the policy of racial segregation, the colonial government did not consider art a necessary part of the curriculum in African schools, although it was taught in white schools. These details in education funding and practice have become central to the dynamics of contemporary art production in Uganda and Kenya and, by extension, to the exhibitions we are considering today.

Following independence in the early 1960s, the East African Community was formed, a union based on the popular Panafrican mood of the era which sought

brotherhood between the three countries. The Community continued to share a number of functions, including the University of East Africa.[9]

Differences between Presidents Obote of Uganda, Nyerere of Tanzania and Kenyatta of Kenya resulted in the dissolution of the East African Community in 1970. The three universities agreed initially to exchange students whose subjects were taught only at one or another of them.[10] The historical division of functions had located fine art in Uganda at the Margaret Trowell School; industrial design and architecture at the Department of Design, Nairobi University College in Kenya, and theatre arts in Dar Es Salaam University College in Tanzania. By 1978, however, tension between the three countries, the worldwide economic slump precipitated by the oil crisis, and insecurity in Uganda following the ascent to power of Idi Amin Dada in 1972, led the School of Fine Art in Makerere to cater exclusively for Ugandans. Herein lie the roots of Uganda's and Kenya's contemporary histories of art production: respectively, they were didactic and autodidactic. The shows implicitly acknowledge the profound and dynamic impact of this difference from the period immediately preceding the Second World War to the present day.

The degree of importance awarded to art education, the practice of art and the status of the artist differ greatly between Uganda and Kenya. While in both countries successive governments have used artists to build monuments that acknowledge various stages of change, art and the artist have a recognisably stronger public position in Uganda then they do in Kenya. Certainly, there are more formally trained artists in Uganda in spite of nearly ten years of civil unrest, and Uganda has a national gallery, the Nommo Gallery. However, one could safely estimate that Kenya's self-taught artists earn significantly more in foreign exchange for the country than do Uganda's graduate artists.

External categorisations of art from Uganda and Kenya centre on discussions about their 'inability' (especially of Kenyan art) to stand up to European academic structures, thus intimating a centre–periphery relationship, with western art in the centre and all else revolving like satellites in constellations of ever-decreasing importance. Graduates of Makerere justifiably seek to deconstruct this debate while engaging with the structures of western art history, believing that 'an understanding of western art history is important for African artists, because it is another tool for the artists to express their particular and delicate dialogue. It is an important element in developing an artist's vocabulary.[11] These deliberations, however, are of no concern to Kenya's self-taught artists.

Far from making an uninformed and defensive rejection of the European tradition for carefully and tightly classifying the products of creative processes, these individuals are simply expressing their position at the centre of their own world. In addition, the multitude of tribes and the nature of tribal society in both Kenya and Uganda have meant that the citizens recognise that 'there are just others, that we ourselves are just "others" amongst an "other".[12] Ugandan and Kenyan artists lay claim to their own vibrant and complex, personal *and* collective, histories of art while respecting the right of the 'others' to articulate their art history, too.

Kefa Sempangi
Reptile
1967
Oil on board
99 x 107 cm
Private Collection*

Sempangi spent a period in
Australia; he made this
painting in response to a
photograph of an indigenous
lizard which made a strong
impression on him.

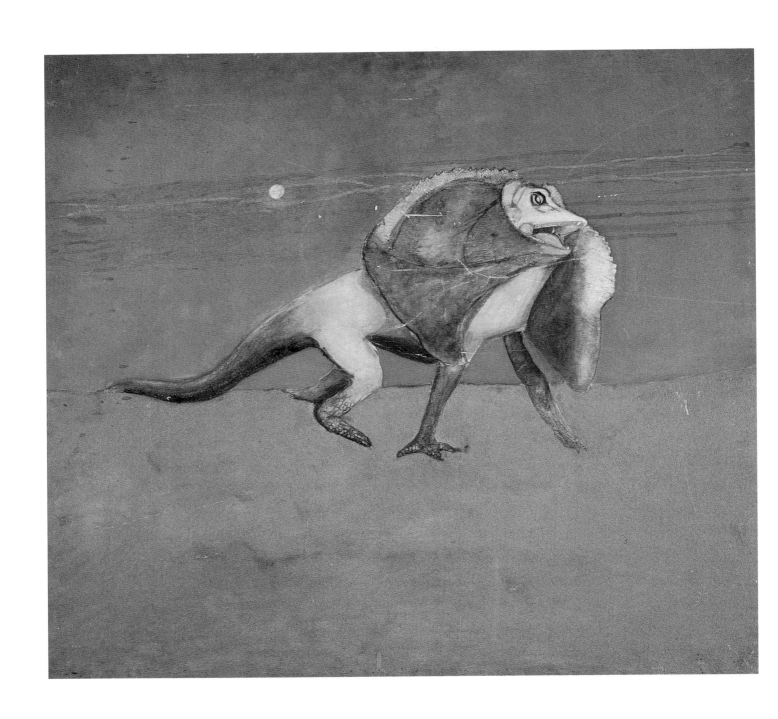

Uganda: Visual Prose

Survival Songs from Makerere Hill

There is a large Mukebu tree on the path to the school. Traditionally, the Mukebu is highly respected. One day, while walking home, I saw that somebody had burned grass against this magnificent tree, resulting in part of the trunk collapsing and blocking the path.

I was very upset by this wanton destruction. Somehow it seemed so connected to the war [1982–85], and symbolic of the thoughtless killing of human beings. I rescued the burnt and broken piece of wood; it became War Victim. *By the way, this piece is not just about Uganda...'*[13]

In Francis Nnaggenda's *War Victim* (1982–86), the wood's brown hues poignantly echo a thousand variations of skin tone, its sensuous texture hardly hinting at the ordeal of fire which afforded the artist so apt a medium. A monumental male form, the wood's massive density is defied by a refined, exquisitely balanced and athletic movement. The head and neck appear to have been severed from the torso. There is no right arm. The left arm is withered, and fused to the side of the chest. One well-muscled leg sinks into the ground, the other leg is amputated in a clean motion at the upper thigh. A change of direction twists the body's trunk forward and a few degrees to the right. Housed in the atrium of Makerere's Central Library, with its direct and

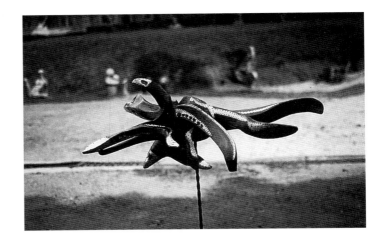

Francis Nnaggenda
War Victim
1982–86
Wood
Makerere University Library

Lillian Nabulime
Flight
1994
Metal on wood
c. 50 x 100 cm
Collection of the artist

beautifully executed references to man's violence, *War Victim* is infused with an aesthetic sensibility which is both intellectually and spiritually informed.

Discussions about African artists often allude to a deeply mysterious, spiritual impetus which literally drives practitioners, and apparently justifies the appearance of art on a continent where the majority of artists have had little or no formal western art training. As with artists all over the world, there are indeed those who are spiritually led at certain points in their lives, but romantic or racist as the notion might be – and it can be either, depending on the context of the categorisation – this is not the sole preserve of the 'African' artist. In our discussion (see pages 272–73), Nnaggenda spoke about his internal life. 'The European is reluctant to acknowledge the inner life of Africans,' he said, 'an inner life which is greatly affected by external events.' Spirituality is deeply rooted in the psyche of most Ugandan artists, who believe that surviving, living, growing and continually forgiving is not possible without religious faith.

Lillian Nabulime's *Flight* (above, right), worked from the root of an ancient dead tree, embodies the new spirit of the 1990s at Makerere College.[20] Uganda, the phoenix, rises from death – more robust, wearing her scars with mature dignity. Exploring sculpture through dictated form, Nabulime places a premium on communicating emotion. Using an appliqué technique to tack slivers of metal on to the root, she orchestrates enhancement, exaggeration and distortion.

The marriage of spiritual belief and art is strongly expressed in the works of Kefa Sempangi. The son of a Muluka chief, Sempangi studied at Makerere between 1963 and 1967. His work externalises an internal dialogue about religion and morality, expressed as an ongoing conflict between old and new:

Theresa Musoke
Birds
Oil on canvas
Gallery Watatu, Nairobi, Kenya

Overleaf
Peter Mulindwa
The Owl Drums Death
1982
Oil on board
122 x 244 cm
Private Collection*

Mulindwa (MA in Fine Art, Makerere University, 1994) is currently a headmaster in Bunyoro and Senior Secretary in Housing at the Ministry of Education. This painting depicts a drumming owl, the Ugandan symbol of death, surrounded by other fantastical creatures.

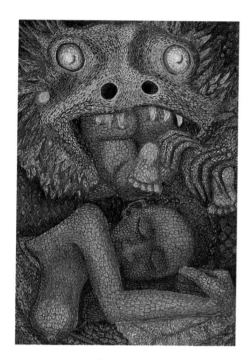

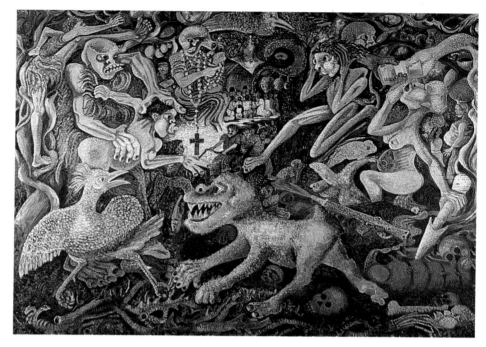

Josephine Alacu
Mother's Nightmare
1980
Oil on board
84 x 56 cm
Private Collection*

Josephine Alacu
Legend
1980
Oil on board
122 x 163 cm
Private Collection*

Opposite
Jenny Namuwonge
The Market
1990
Oil on board
122 x 81 cm
Private Collection*

Jenny Namuwonge's major work for her third year at Makerere substitutes big sugar ants, known as *bikenyembe*, for people to emphasise the atmosphere of a market as a heap of insects moving around with their different loads. The ants' antennae form the arcs that demarcate the sections of the market, while the colours denote strong characters in the foreground and weaker people in the background.

I am a firm believer that the things we see are made active by the power of invisible forces behind them, and it is these hidden forces behind the natural, behind the superficial, behind the seen, that I dedicate myself to capture and portray in my artistic world.[14]

Sempangi's paintings are simple, almost stark, compared to the work of fellow undergraduates during his student years. Slashing the board into flat screens of colour, he creates a sense of light and distance without losing a fine balance.

An owl – traditional harbinger of death – stares open-beaked through cold human eyes. Two small horns above the arched brow reinforce the dreadful message. A hooded Australian lizard, drawn from a postcard that captivated Sempangi, is magnified into a terrifying night beast, stalking across a barren landscape.

Creating icons and manufacturing tension through the optical effects of coloured planes, Sempangi's expressions stand out with a clarity that is passionately expressed in his sculptural works. Though obviously organised in a similarly bold and self-assured manner, his sculptures show an intense concentration of feeling, texture being given as much spatial weight as form. The surfaces of *Prostitute* and *Feudalism* display a raw energy which is almost violently passionate.

This exploration of the internal landscape was encouraged in students at Makerere during the late 1960s and early 1970s by Jonathan Kingdon and Geoffrey Maloba as a means of liberation.[15] Cecil Todd, Dean of the Margaret Trowell School of Fine Art from 1958 to 1971, formalised teaching at the school by introducing a programme of world art. He significantly increased the staff, employing Kingdon, Ali Darwish, Taj Ahmed, Michael Adams and Theresa Musoke; the nature of their training resulted in the 1960s sometimes being referred to as 'the RCA decade'.[16]

After independence, Milton Obote, Uganda's first president, abolished the

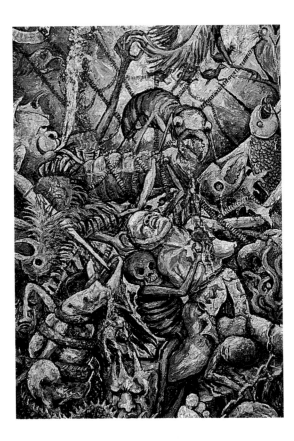

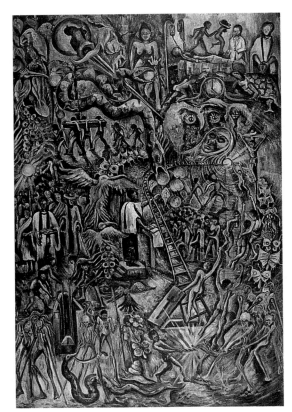

M. K. Muwonge
Misfortune
1985
Oil on board
197.5 x 91 cm
Margaret Trowell School of
Fine Art, Makerere University*

The artist has used the metaphor of the spider's web to visualise Uganda's imprisonment in a cycle of violence and destruction. The crested crane is the traditional symbol for Uganda; insects at the edges of the painting emphasise the ravaging of the country and her people by both war and Aids.

Godfrey Banadda
The Last Hope
1984
Oil on board
183 x 121 cm
Private Collection*

Using both Christian interpretations and traditional indigenous beliefs concerning death, the painting tells a story about the crimes of humanity. Beginning at the top of the picture, the snake tempts Eve, as well as the Church in the form of a preacher; after eating the fruit the sinners are given blood in hospital, but the result of evil is presaged by the hooting owl, the Baganda prophet of death. The grave below is not the end of the story, however; it is followed by the tug-of-war between the spirits and the humans. The rope snaps and opens the gate of resurrection.

Rebecca Bisaso
Woman's Burden
1990
Oil on board
122 x 64 cm
Private Collection*

Bisaso (MA in Fine Art, Makerere University) currently lives in the US. This painting, her graduation work, is about the suffering borne by women in Uganda following the loss of relatives in the war and to Aids. Beauty is shown to harbour death; the owls and vultures that roost on the tree are agents of death; and the hoot of the owl announces death.

ancient kingdoms, exiling their royal families. A sense of unease developed between the peoples of northern Uganda (Obote was an Acholi from the north) and those of central and southern Uganda. When Idi Amin came to power after ousting Obote in 1971, he understood the importance of symbols, coats of arms and monumental works in the glorification of his regime. Makerere stayed open, providing him with medals, military decorations, gifts of sculptures and paintings for visiting dignitaries, and fulfilling commissions for officers for their large appropriated homes, shiny new cars and adoring families. Mulindwa, Ifee, Alacu and Muwonge provide a representative overview of various movements in painting during the period 1960 to 1986.

A Toro, Mulindwa came from a family of Shamans, and wrote his postgraduate thesis on traditional beliefs. As with Sempangi, such beliefs encompassed many forms of devotion. Mulindwa's painting depicting the Luganda Martyrs examines a literal and metaphorical execution of 'purity'. By comparing the suffering of the martyrs to that of Christ, the missionaries used this historical incident to bring Ugandans closer to Christianity; the theme became part of Uganda's iconography. *The Owl Drums Death* relates to possession. Spirits are traditionally evoked through music played on horns which embody the power of the ancestors. The owl is decorated, the embellishment reducing the fearfulness of death or the strength of the bad omen being foretold. The same message is carried by the vibrancy of the foliage and the predominance of oxygenated reds in the people's clothing.

Student work in the 1980s expressed the trauma of brutalised adolescence and adulthoods paralysed by fear and insecurity:

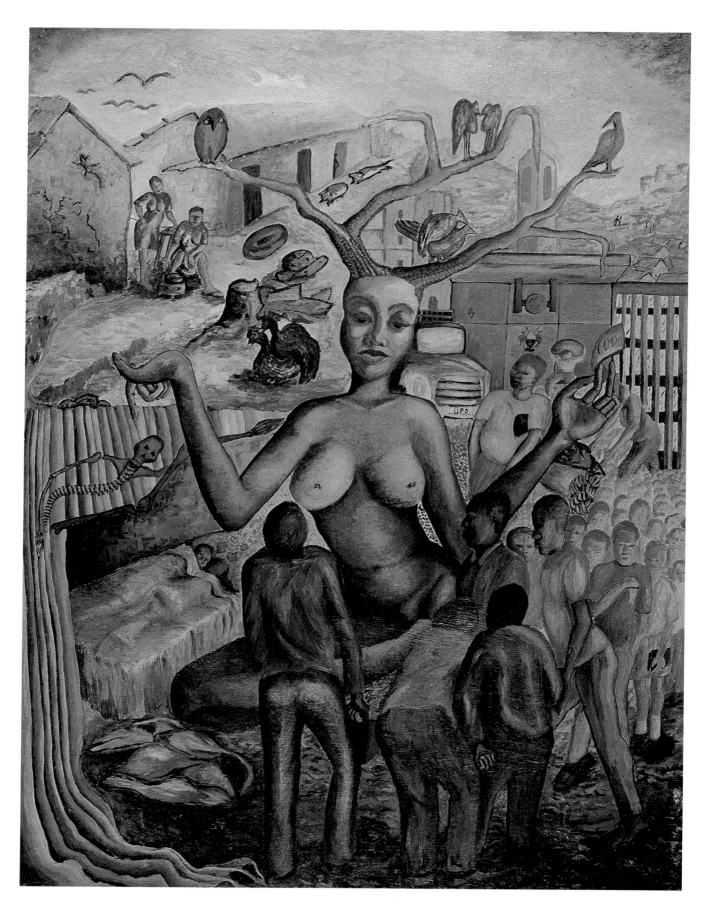

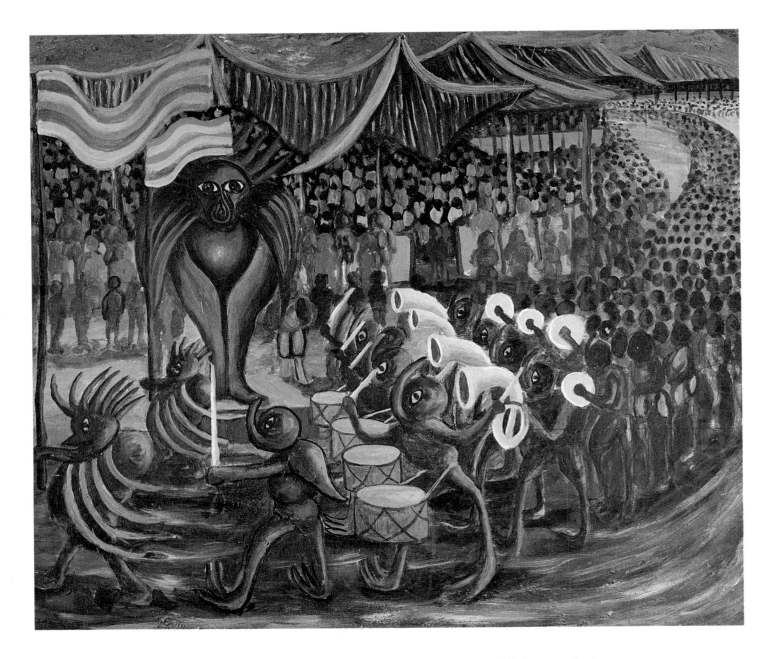

C. Driciru
Crowds and Insect
1976
Oil on board
91 x 104 cm
Private Collection*

Artists learned to use the medium to subvert both regimes; to criticise, protest and express emotions which were of concern to society. When someone was bundled into the boot of a car in front of you, there was nothing you could say or do. You knew they would disappear. So many disappeared.[17]

Where once the army had represented liberation and progress, they came to portray all that was brutal, inhuman, corrupt and oppressive. 'The insects are coming,' or 'Beware the insects,' became coded messages warning of the military's presence. Termites and ants in East Africa literally eat everything, but their destruction is simply and easily controlled. Alien because of their reversed physiology, when under control they are simply an irritation; out of control, however, they quickly wreak havoc and destruction.

M. K. Muwonge's *Misfortune* of 1985 demonstrates the Makerere tradition of

Severino Matti
Ding-Dingi
1973
Oil on board
60 x 83 cm
Collection of Jonathan
Kingdon*

Ding-Dingi is a dance
performed by the Acholi
people. In this work, Matti
celebrates the social and
cultural aspects of the
African peoples, such as
dances, the rain ceremony
and traditional weddings,
believing that art should
visualise the importance and
beauty of human life.

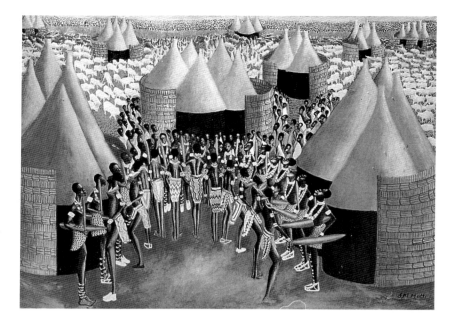

Pilkington Ssengendo
Erupting Landscape
1987
Oil on board
53 x 53 cm
Collection of Jonathan
Kingdon*

Ssengendo is Dean of the
Margaret Trowell School of
Art at Makerere University.
This is typical of the work he
made in the late eighties,
when he was exploring
decoration and the
expression of colour and
pattern. He used dark
colours to represent
heaviness in the landscape,
with the lighter shades
creating an aerial
perspective.

Ignatius Sserulyo
Coffee Picking
1965
Oil and acrylic on board
137 x 122 cm
Collection of Jonathan
Kingdon*

Sserulyo's parents grew
coffee for a living; as well as
helping them to pick and
dry it, the artist appreciates
it as the source of the money
that paid for his education.
The painting is based on
studies of the coffee trees
near Kampala, as well as
observations of Sserulyo's
father working in the
shamba. The artist attempts
to record textures and
colours beyond what the eye
sees, and has incorporated
real coffee beans to give
texture.

using an assemblage of symbols to 'tell' the picture. Uganda is being disembowelled of a stillbirth – her future – and besieged by termites and ants. Magnified and out of control, they represent an alien force committing the unspeakable in shades of shameless obscenity – impure purples, bleeding reds and fleshy browns. The civil war following Obote's manipulation of the 1982 election led to what became the worst period, in which 'people were killed as though they were cockroaches.'[18]

The existence of the Makerere school and its gallery, the fact that art continued to be taught and that something of a symbiotic relationship developed between the school and Amin and later Obote, facilitated the survival of the artists and their works. 'Ugandan artists are articulating something which no other people in the same situation are expressing,' said Jonathan Kingdon.[19]

Destruction exists but the spirit must survive – amputated but still full of resistance.[21]

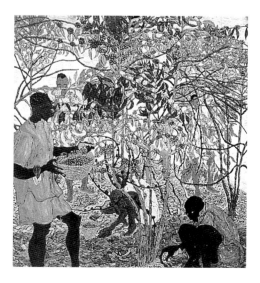

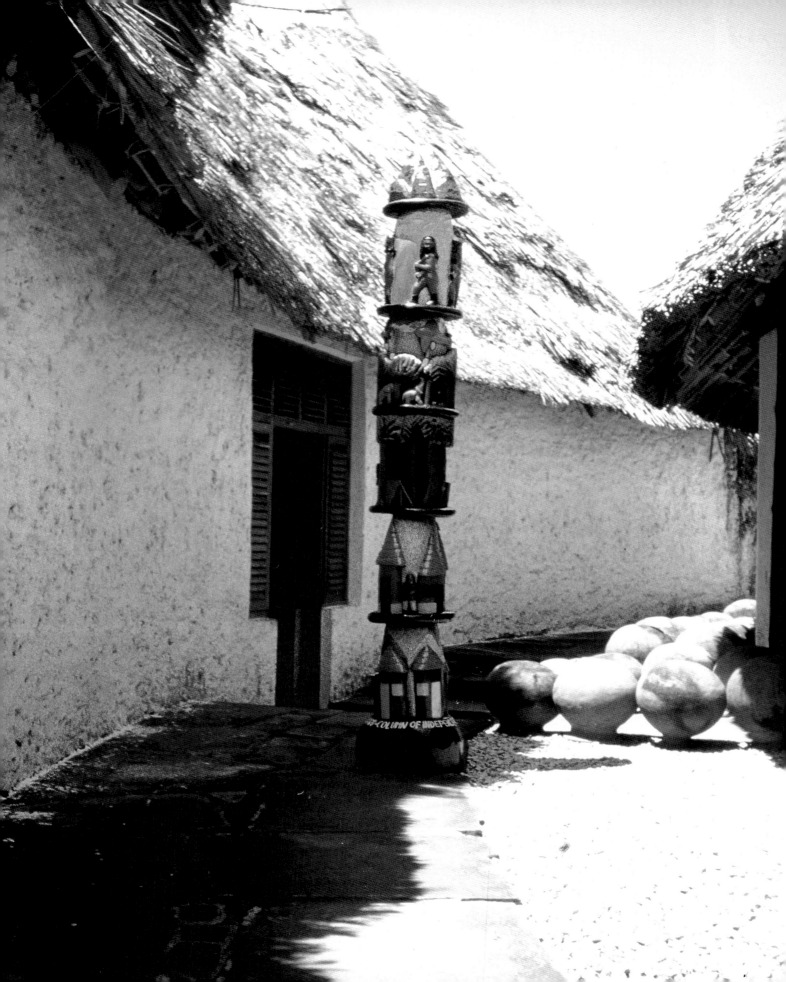

Kenya: Concrete Narratives

Kenya has no national gallery: there have been spirited and inspired efforts to open such an institution, thwarted by lack of public finances. At independence in 1963, there were attempts to establish a national gallery with regional branches in the provinces.[22] Former Vice-President Mwai Kibaki sought to establish one, while another former Vice-President, the late Joseph Murumbi,[23] campaigned tirelessly for such an institution. Murumbi bequeathed his collection, of mainly West African art and artefacts, to the national archives.

The British Council, the French Cultural Centre and the Goethe Institute all offer exhibition spaces, at no cost to the artists, in the centre of Nairobi; they do not take a commission but cover expenses from commercial sales. The United States Information Service (USIS) sponsors shows from the USA and joint group shows with Kenyans, but does not have an exhibition space and the shows are non-commercial. Hotels also hold exhibitions in their banqueting rooms and public lounges.

The Gallery for Contemporary East African Art, housed in the main building of the National Museum, sells work on exhibition, as does the Paa Ya Paa centre in Kiambu, a suburb of Nairobi. Gallery Watatu in the city centre is Nairobi's best exhibition space and is run on purely commercial lines. The Mashariki Gallery, which opened in 1995, is based in the BMW showroom in Nairobi.

The Watatu Foundation for East African art exhibits twice yearly in Gallery Watatu, and the new Kuona Trust associated with the Museum Society of Kenya already has an exhibition space in a converted house opposite the National Museum. Both are charitable societies which may facilitate the sale of artwork but may not operate as commercial businesses.

In 1975 seventy East Africans were known publicly as artists, of whom a fifth were freelance.[24] In Johanna Agthe's 1990 catalogue *Wegzeichen*, she lists 27 of the foremost artists including Ugandans and South Africans based in Kenya. It is not possible at this moment to give accurate statistical data about the numbers of practising artists in Kenya. However, the Watatu Foundation sees on average seventy 'young' artists on its monthly artist day, when free materials and art criticism are offered. The majority of these artists are self-taught, and currently outnumber those with specialist formal training, largely because of the paucity of access to art education at tertiary level[25] and the complete absence of government patronage for the plastic arts.

Although Kenya has a largely literate population, the cost of education is very high relative to per capita income. Therefore even when a child is able to attend school, parents are obliged to pay for all materials, including art materials. Locally produced paper and coloured pencils or crayons are expensive; imported materials are prohibitively priced. The techniques outlined in the curricula are based on western educational criteria, and are therefore sometimes beyond the scope of the available materials; certain aspects of the exercises are either culturally alien to all but a few urban children belonging to the élite, or inappropriate.

The limited number of places on further education courses are allocated almost by lottery. Sebastian Kiarie, one of Kenya's most talented young artists, is studying agriculture because that was the place he was offered at university. He paints during the holidays and when the university is closed. Fine art graduates tend to gravitate to formal employment, either in the civil service or in media and advertising. Like most Kenyans, many hold down a day job while running a small business on the side or keeping a *shamba* (small farm). They need the extra income to meet spiralling living costs. In these circumstances, many stop producing their own art.

Self-taught artists tend not to have been willing or able to find work within the formal sector, and therefore devote themselves to making art for a living. It may also be that because there are very few art graduates each year, possibly only ten, they are not making as strong an impact on the scene; one can only guess.

It was and remains difficult to channel scarce resources into art; the first government of independence under Jomo Kenyatta had pressing development issues. Artists 'competed' for representation within a shrinking number of commercial galleries, and exhibitions were increasingly driven by the vagaries of buyers' tastes.[26]

By 1973, indignation with dealers' thinly disguised commodification of indigenous art was strongly expressed at the Goethe Institute's East African Artists' Workshop. 'Now, whatever goes by the name "art" and "artists" in our society today is so much dictated by the whims of the tourist... who, by definition, is so limited in the knowledge and appreciation of our creativity [and] now dictates... every

endeavour in the artistic creation of so many of our artists. It is pitiful! It is outrageous! It is lamentable!'[27] Twenty years later, this remains the 'standard' for art criticism in Kenya.

The growth in the number of art practitioners in Kenya, and of national and international interest in Kenyan art, can to some extent be followed through the philosophies of four individuals: Elimo Njau, Director of Paa Ya Paa; Etale Sukuro, artist and sociologist; Ruth Schaffner, Director of Gallery Watatu and, recently, Isiah Mabellini, alias Sarenco.[28]

Elimo Njau, a Tanzanian Makerere graduate based in Kenya, pioneered an art movement rooted in African aesthetics and a strong belief in the celebration of God through art. A teacher and entrepreneur, he directed Paa Ya Paa Gallery in Nairobi city centre until high rents forced it to move in the early 1970s to Ridgeways, in the suburb of Kiambu. Njau established an exhibition space and arts centre which became a meeting space for writers, musicians and artists, a place for the celebration of all things African within a cosmopolitan milieu. He continued to teach children and adults at Paa Ya Paa, offering constructive criticism to promising artists and increasing a collection of works that have been described as the kernel of a national collection.

In the last decade, the spirit of the centre seems to have dissipated, leaving Njau's philosophy intact but without having inspired the emergence of a strongly defined school or movement. The nature of the centre has changed; with the addition of residential spaces, Paa Ya Paa is now able to offer residencies to foreign artists and researchers (who come mainly from the USA). The gallery function remains strong, but Ridgeways is such a distance from the centre that the cost of transport inhibits many local people from attending the exhibitions and occasional workshops.

Etale Sukuro, a sociologist and artist trained at the University of Dar es Saalam, was a driving force in the organisation of art exhibitions brought to the people through Sisi Kwa Sisi. In 1982, the Department of Culture provided transport and panels so that work could be exhibited in schools, social halls, market places and the populous suburbs. The open-air exhibitions were conducted over a period of six months and the high-impact, low-cost formula attracted up to 12,000 people at certain venues in the course of a day. The exhibitions were innovative and accessible, and focused on an audience alienated from the main exhibition spaces. They addressed individuals who are usually intimidated by, or denied access to, exhibitions in the formal spaces. For the first time, Kenyans celebrated the fact that their own people were involved in the plastic arts: 'For the past few years, foreign artists were the only ones who could portray Africa.'[29]

Sisi Kwa Sisi's philosophy is being extended through programme proposals by both the Kuona Trust and the Watatu Foundation. They realise the need to create a wider local audience and to extend art support projects to areas outside Kenya's urban centres. However, without diminishing the importance of Sisi Kwa Sisi as a movement in embryo, I would argue that the initiative fell short of its stated aim. Sisi Kwa Sisi were addressing the people from a position of inequality: they did not extend the dialogue to encourage a critical discourse, or any intervention from the constituency. Audience reactions were noted, but instruments for further access –

such as workshops – were not initiated, nor was the audience encouraged to contribute works on an ad-hoc basis. Those who normally occupied the chosen venues were not included in the majority of the organisational aspects of each show, so that they did not become part of Sisi Kwa Sisi.

Ruth Schaffner, director of Gallery Watatu and chair of the Watatu Foundation, has profoundly shaped the art market. The gallery's wonderful space is a fitting venue for the display and sale of contemporary art. Almost single-handedly, the proprietor has succeeded in broadening the constituency for Kenyan art to the international arena, through interaction with museums and researchers from all over the world and through facilitating participation in the Dakar and the Johannesburg Biennales. The gallery has developed extensive archives of its artists' work, and represents some of the most prominent artists in Kenya, including Jak

Etale Sukuro
The Well-Fed and the Non-Fed
c. 1985
Pastel on paper
50.5 x 35 cm
Museum für Völkerkunde,
Frankfurt-am-Main*

Katarikawe and Theresa Musoke (both Ugandans based in Kenya), Kivuthi Mbuno, Samuel Wanjau and Sane Wadu, in addition to a number of foreign artists. Schaffner recognised the need for subsidising local artists; she established and invested heavily in the Watatu Foundation, which offers free artist-led workshops to selected artists. However, it is Schaffner's selective nurturing of 'naive' or 'primitive' art that has been a great commercial success and had the greatest impact. She believes that Africans literally have a different way of seeing, and that this in the autodidactic artist must not be affected.

The success of the Watatu Foundation's workshops, accompanied by sales of 'naive' art, has led to large numbers of artists feeling comfortable and validated in their output, especially when their efforts are rewarded financially. This has to some extent encouraged the adoption of a formulaic, self-conscious 'primitivism' that inhibits development: 'if it works, don't fix it.'

The majority of Gallery Watatu's 'naive' artists come from rural or peri-urban areas of Nairobi. The most gratifying thing about Schaffner's work is the evolution

of an artist-led movement in the village of Ngetcha, just outside Bannana Hill, north of Nairobi. Following the success of just one artist from the village, the majority of young people from Ngetcha are now exploring painting as a medium of expression. They have been attending Watatu Foundation artist days for the past three years and, in 1995, established their own artists' co-operative, which runs alongside workshops held by Schaffner at the YMCA in Ngetcha. One hopes that this phenomenon will spread to other parts of the country, and that the artists themselves will set a new brief with a vision that goes beyond market-led primitivism. '"Primitive art" is an equally contradictory construction, consisting of artefacts produced by people without a concept of primitivism for peoples who utilise these artefacts to objectify this concept.'[30]

Primitive art is bought by expatriates and foreigners at good prices, but

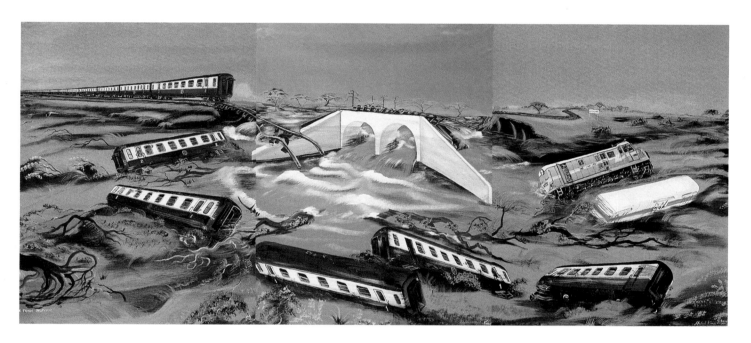

Richard Onyango
The Train Disaster (triptych)
1993
Acrylic on canvas
160 x 360 cm
Collection of Sarenco*

Kenyan collectors shy away from this movement. The success of this school is justified by the income it yields for the artists and the gallery, which has led to the commodification of this style. In so far as this type of art dominates the international commercial market, curators and collectors adopt a restricted view. Now not only are the materials used as a criterion for judging authenticity, but practice is constrained by a largely external and questionable qualifying construction.

Schaffner adopted a first world pricing structure, thereby setting a precedent eagerly adopted by local artists. Works by relatively unknown artists have leapt in price from about Ksh.1500 (£25) to Ksh. 20,000 (£330); those by 'mature' artists, like the painter Jak Katarikawe, are priced in the range of Ksh.100,000 (£1600). Gallery Watatu is an expensive business to run – rents are high and staffing levels must be adequate. However, these prices are now leading the whole market, and they are way beyond the affordable even for the Kenyan élite, let alone for ordinary people. I believe that they now outstrip international market realities, and it will take a while for the artists to return to more realistic pricing.

Malindi Artists Proof, now disbanded, represented the artists Richard Onyango, Abdullah Salim and Cheff Mwai. Directed by Sarenco and his Italian business partner Tanzini, the business employed the artists directly, paying them wages well above the average in exchange for the total ownership of all their output during their contractual period. Richard Onyango, for example, accepted an offer of Ksh. 40,000 (£670) per month under this arrangement, rising to Ksh. 120,000 (£2,000) with the success of his *Drosie* series in 1992.[31] In a country where the average monthly wage is £128, Richard's fees are extremely high. Sarenco and Tanzini were able to fetch prices as high as £3,200 per painting. I have personal reservations about the egalitarian nature of this exchange, but not about the success with which Tanzini and Sarenco launched Onyango, Mwai and Salim.

Sarenco continues to represent the artists contracted to the Proof, and has welcomed two new ones including John Nzau and David Ochieng Onyango, Richard's younger brother. The painters all use canvases of 160 x 240 cm, since they are commissioned wholesale; the sculptors tend to work on installations rather than one-off pieces. Richard's and David's painting styles hint at a neoclassical approach with respect to colour, brushwork and composition, while the highly decorated figures forming Abdullah Salim's wry installations have echoes of the Memphis school. John Nzau's approach is that of a sign-painter dealing with medico-educational hoardings,

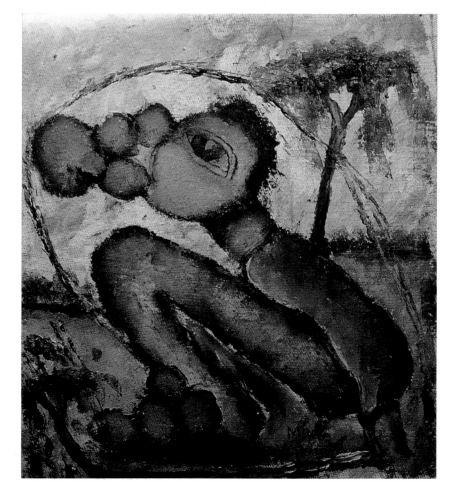

Meek Gichugu
Fruit Like
1992
Acrylic on canvas
20.5 x 20 cm
Private Collection*

Meek Gichugu in front of his work

Joel Oswaggo
Scarification
c. 1987
Crayon on paper
12 x 16.5 cm
Museum für Völkerkunde,
Frankfurt-am-Main*

while Cheff Mwai's painted wood carvings are a completely original fusion of traditional approaches and new materials. The works of these artists is of great appeal to the local audience, who find the subject matter and styles of rendition accessible, humorous and familiar. These men form a group that might yet fuel an urban movement.

Njau, Schaffner and Sarenco, all strong and inspired individuals, have developed viable models for the production, dissemination, marketing and management of art, but they have not worked together; indeed, to some extent, they have developed mutually antagonistic relationships. By remaining isolated, and by isolating the artists they represent, they have missed the opportunity for holistic direction of the considerable energies and potential returns embodied in the enthusiasm, originality and drive of Kenyan contemporary artists.

The Artists

With a mere 18 per cent of the adult population in formal employment, artists concentrating on one-off pieces rather than multiple productions destined for the tourist market are still considered to be rebellious or insane.

Once upon a time, a schoolteacher from the village of Ngetcha, about two hours' bus ride from Nairobi, decided to stop teaching in order to devote himself entirely to painting. He bought four metres of canvas. His wife, the village tailor, was extremely upset, and fashioned the canvas into a suit. He secretly painted on the suit. The village stopped calling him by his real first name of Mbogua and started to call him Insane. Mbogua travelled to Nairobi, wearing the suit and carrying a bundle of other paintings on shopping bags. The director of Gallery Watatu gave him materials and, four months later, he had a solo show. Mbogua now calls himself Sane.

A powerful visual narrator, Sane Wadu's work is informed by the communal anxieties of ordinary people. His paintings address specific and current concerns, such as the appropriation of public spaces by private interests, or the plight of the dispossessed. A multitude of issues are formalised on each canvas, appearing like so many visual bubbles which gradually merge into a massive coherent testimony.

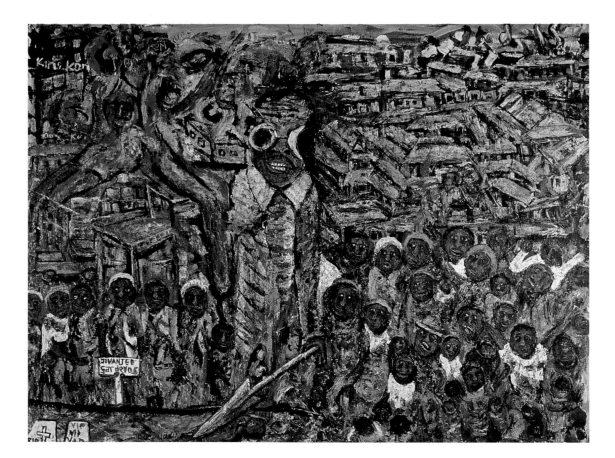

Sane Wadu
Jivanjee Gardens
Oil on canvas
139.5 x 180.5 cm
Gallery Watatu, Nairobi,
Kenya*

In *Market Scene*, members of the General Service Unit (GSU) are on a 'cleaning up' exercise, evicting hawkers from a piece of public land.[32] They wield *rungus* against the larger women who are taking up defensive positions. The bewildered face of one soldier stares out of the canvas, his expression representing a conflict of loyalties: the *mwanainchi* is forced to act against his own kind, his own nature.[33] Wadu's use of bright colours, exuberant detail and a foreshortening of objects to create flat space creates tension within a tight composition. His painting style suggests a surrender to spontaneous impulses, tempered by a storyteller's penchant for relevant detail.

Black Moses, God Save My Soul and *Jivanjee Gardens* both relate to the period when the pro-democracy movement was gaining momentum, and demonstrate an absence of self-consciousness. Wadu's approach is deceptively frenzied in both paintings. Expressions differ, but the crowds share the same face – in other words, the same mind. A boss-eyed deity watches the action: friend or foe? This is not the 'naive' product of an individual psyche; Wadu's work represents the concrete record of a communal experience.[34]

Wadu was the first highly successful painter from the village of Ngetcha. His achievements influenced first his sister, Lucy Njeri, then his friend Wanyu Brush, and finally other occupants of the village including James Wainaina and the emerging talent, Sally Mbogua.

Sane Wadu
Waiting
1991/92
Oil on canvas
102 x 180 cm
Private Collection*

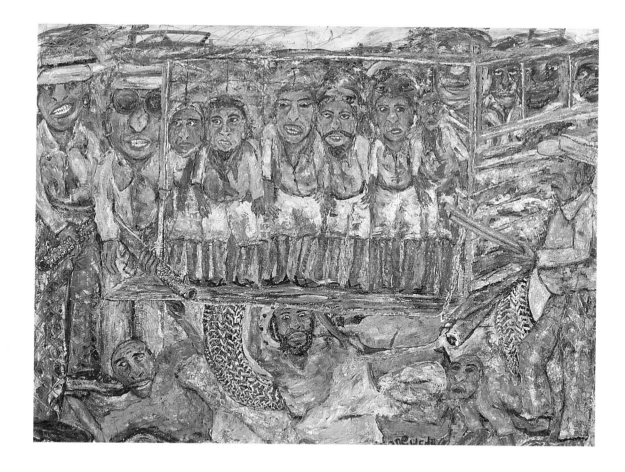

The pre-colonial African world... with different stages of social development among the varied regions and peoples, was on the whole characterised by the low level of development of production forces. Hence it was dominated by an incomprehensible and unpredictable nature, or rather by a nature to an extent only knowable though ritual, magic and divination.

This world was reflected in the literature it produced, with its mixture of animal characters, of half-man-half-beast and of human beings all intermingling and interacting in a coexistence of mutual suspicion, hostility and cunning, but also occasional moments of cooperation.[35]

Sane Wadu in front of his work

The connection between narrative tradition and the self-taught artists is very strong. Ngigi Wa Thiong'o could here almost be describing the works of Lucy Njeri, Kivuthi Mbuno or Meek Gichugu. Lucy Njeri's humans and domestic animals relate in cruel powerplays. Using a limited colour spectrum, she explores the essence of pain. Mbuno, on the other hand, is rooted in the world of ancient stories, in which the bipeds are neither humans nor apes, but 'beings' in highly personal visual catalogues of Akamba oral tradition.

Defying petty moral preoccupation, Meek's compositions are surreal circuses of animated hybrids. Deceptively tame reds, ochres and powdered blues echo the colours of the earth and sky in Kenya's highlands, perfect backdrops for the miniature traditional hut, erect phallic forms, flowing water, red ball, and carnivorous blossom with sexually swollen lips. These symbols recur in different combinations accompanying strange beings tumbling, cycling or strutting through his vertical landscapes.

Joel Oswaggo works in crayon on paper, making anthropological studies of his people, the Ja Luo, and their traditions. His earlier works were about 'the ancient times and how those people lived'.[36] Recording what happened without value judgements, Oswaggo depicts his people in caricature to catch the diversity of their shapes and personalities and to present the essence and content of participation. These are not uncritical studies of a romanticised ethnicity, but descriptions of specific areas of traditional activity.[37]

Oswaggo's visible commentaries are in a language that does not require extensive translation, as he moves between the traditional and the modern with equal ease. More recent work, like *Healing of Invalids*, captures the fusion of traditional and Christian beliefs in the supremacy of supernatural powers over earthly trials. His illustrations for children's books and the award-winning poster for the UN Bio-diversity conference confirm him as the illustrator-turned-artist and the artist-made-illustrator *par excellence*.

Safari, with its physical and metaphorical implications, is an important experience for Kenyans. The Kiswahili word means journey; long-term migrant workers often cover extensive distances from their places of employment in the urban centres to their rural homes. Richard Onyango's love of automated vehicles is strongly related to safari. The life of Richard, a Ja Luo, brought up in Kisii and resident hundreds of miles away in Malindi, has been a series of safaris. His triptychs are heavy with a sense of foreboding: mysterious accidents halt the safari. Produced as Kenya headed for its first multi-party elections, these works immediately evoke a sense of the hope and danger which characterised the years 1992 and 1993. The electorate went on a long, dangerous journey to an unknown destination. Taking comfort in numbers does not prevent trains from being derailed, nor buses from crashing at wide crossroads. Being fully *cognoscente* in a sunken plane does not reduce the sense of insecurity. Richard is committed to the simple and direct expression of truth through the manipulation of appearance. Painting with clear colours and defined outlines, his choice of subject – combined with conventional composition and technical ideals – results in canvases which are highly individual and often humorous narratives.

Conclusion

In the final analysis, contemporary art in Kenya is a commercial activity without material support from the public sector. The right art in the right place provides an income for both artists and dealers. This simplistic assertion hints at the reason for the success of 'naive' art. However, without going into an analysis of how and why the sources of demand – expatriates, and Japanese, American and European dealers and collectors – have chosen to invest so heavily in this genre, the idealisation of western art paradigms such as 'naive' and 'primitive' oppress the appreciation and emergence of a culturally distinctive Kenyan aesthetic. Restricting myself to a narrow definition of contemporary Kenyan art as art made using imported western media, I posit that contemporary art history, less than fifty years old, is larger than the precepts of western art history. It is a different and ever-changing dynamic currently being held to ransom because of the need for survival, yet still deserving of equal respect.

Autodidactic artists from Kenya absorb and personalise concepts about form, colour, composition and the use of light. Their work is informed by urban and rural culture, by gender, age, tribal and clan affiliations. Partially through economic and physical isolation from the preoccupations and expressive modes of practitioners in other parts of the world, artists have been working within a vortex of economic commodification, vital efforts towards maintaining integrity, and the mixed gifts of multiple 'authenticities'. They embrace social responsibility and assume a duty long outmoded in the west – that of the artist as hero, as oracle, and as producer of work that cuts across the barriers of language and literacy.

recollections

from nigeria

Art and Nationalism in Colonial Nigeria

Ola Oloidi

First published in the *Nsukka Journal of History*, 1989

It is very painful to know that the richness and contributions of the modern Nigerian art tradition are largely unknown to contemporary Nigerian society. This art seems to be ignored or underrated by art scholars, for their main research interests are heavily on the traditional rather than the modern art experience. The implications of this position are many, the most obvious being the total neglect of modern art traditions when considering the historical, socio-cultural or socio-political experiences of Nigeria. The recently celebrated Silver Jubilee of Nigerian independence gives evidence of this assertion. In the media, visual art was not at all celebrated like the other arts.

In the context of this article, 'nationalism' is taken to mean a sympathetic devotion to, or preoccupation with, those meaningful experiences that promote national and racial rather than personal, group or ancestral interests. It is an instrumental ideologisation of convictions or grievances that are of national interest. 'Traditional art' is used here to mean the transmissibly acquired, unadulterated visual imageries which, before colonisation, were the guiding and controlling force on Africans' perception and philosophy of life. 'Modern art', by contrast, means non-traditional forms of visual representation – western, modernist, academic – which can be formally or informally learned in contemporary educational institutions.

What brought nationalism to modern Nigerian art? The historical background in Nigeria has been one of systematic cultural influences brought about by foreign incursions. As early as 1485, Portuguese traders were engaged in commercial activities in Nigeria.[1] The impressions of these early European traders as regards the art forms they encountered (particularly in the mid-western parts of the country) were essentially not different from those of their counterparts – anthropologists, researchers and missionaries both Christian and Muslim – who followed them five centuries later. The abstract forms of traditional African art led Europeans to conclude that in general Africans had no creative ability to draw a 'true' picture.[2]

Traditional Nigerian art was seen as the product of raw emotion and infertile minds, its technical processes based mainly on accidental and intuitive, rather than methodical and calculable, artistic actions.[3] Consciously or unconsciously comparing African traditional art forms with their own, Europeans simply could not understand their philosophical, religious and psychological essence. For many, this misunderstood concept became an effective and dynamic factor in the rapid growth of various dehumanising racial theories or pseudo-theories which had already been propounded in the west. Seeing African art as ugly, wretched and funny, they believed therefore that 'the Africans have no feelings for beauty'.[4] And yet they could not resist its attractive mystifying aura, and so the western acquisition of African art began.

Many collectors were simply fulfilling the desire to 'make further ridiculous stories possible back home in Europe'.[5] Traditional African artefacts had been finding their way to Europe from very early times: in the sixteenth century the Duke of Burgundy had a collection, and many museums in Germany, Austria and Sweden contain collections made before the end of the seventeenth century. This avid collecting co-existed with systematic ridicule: the pieces were mere 'curios',[6] research objects through which the African mind could be further analysed for a European audience.

The major change to this attitude of tolerant ridicule was brought about by Christian evangelisation, whose effect on African art was negative and devastating. Christianity, as a formal religion, made its first appearance in Nigeria in the sixteenth century, but serious and sustained evangelical efforts did not begin until 1842.[7] By 1900, various Christian denominations were well established.[8] These missions did not simply aim to expand the Christian faith, but to eradicate all manifestations of what were regarded as the 'haunting and fear-laden spiritualities'[9] in the people's minds. Traditional art was made a target in the war of evangelisation, a war which continued until the fifth decade of the twentieth century. Nigerian traditional artistic images were considered 'wretched, irritating and grotesque',[10] 'graven images that can separate you from the church and therefore from God'.[11] Regarded as idolatrous, they were publicly burned or smashed in many parts of southern Nigeria, the leading role in this destruction being taken by zealous Nigerian converts who even conducted house-to-house searches for objects to destroy.

The situation for traditional art in Muslim northern Nigeria was even worse. Parts of the north had been totally

Islamicised as early as the fourteenth century, and the faith's syncretic nature made it easy to dispossess people of traditional images which had been no less dynamic than those in the south. By the twentieth century, all traces of them had been completely wiped out.[12]

The great pioneer of western art in West Africa, Aina Onabolu (1882–1963), accepted that these consequences of Africa's missionary history were inevitable. What he abhorred, and was very bitter about, was the popularly accepted racist notion of the non-missionaries that no African – not even a culturally Europeanised one – was endowed with the creative ability to produce art like white people. Determined to prove them wrong, he succeeded in becoming a portrait painter of international renown.

Onabolu was born in Ijebu-Ode and as a young child gained greatly from his father's friendship with Dr J. K. Randle, one of the pioneer medical practitioners in Yoruba at the end of the nineteenth century. He displayed artistic talent at primary school, and Randle – whom he saw as a second father and who later became his sponsor and guardian[13] – encouraged him to believe that he could one day become a professionally capable artist on a par with the white man. At secondary school in Lagos, Onabolu was a sensation: he was the only black African ever seen to draw and paint in a western style.

A portrait in oils of 1903, one of his first commissions, was so good that it was not believed to be his unaided work.[14] Three years later, his portrait of Mrs Spencer Savage, painted in the presence of friends and some uninvited but curious visiting Europeans, was one of his masterpieces, and marked the beginning of the public acceptance of his talent. By 1910 he was a celebrated portraitist and well known as a modern artist in Nigeria and West Africa generally; this year marked his official recognition by the white people of Lagos when he was awarded a special prize at the Agricultural Show.[15]

Over the next ten years, Onabolu painted numerous portraits of the Lagos élite, missionaries and Yoruba kings. Not satisfied with his provincial popularity, and still entirely self-taught, he set off in 1920 for London and the St John's Wood School of Art. He took care before leaving, however, to have an art exhibition in Nigeria, the first in the history of West Africa. As a student in London, he surprised his teachers and fellow students with a standard comparable with that of his instructors. He won prizes and was featured in the London press. Members of the West African Congress who visited him in London included the Hon. J. E. Casely Hayford, Herbert Macaulay, Chief Lijani Oluwa and Bankole Bright. Macaulay saw his works as a 'clear, marvellous vindication of our struggle – a manifestation of our much repeated feelings that Africans are capable politically, intellectually and creatively'.[16]

Onabolu returned to Nigeria in 1922, 'respected by his countrymen and Europeans alike',[17] and officially introduced formal art teaching to schools in Lagos. He became more avowedly pan-African and nationalist in feeling, seeing his portraiture as a means of immortalising all those, European and African, who were helping the African cause. In 1924, he won the poster design competition for the Nigerian section of the British Empire Exhibition in Wembley. Entitled *The Nigerian Weaver*, his entry showed a traditionally dressed Yoruba woman at her loom; this image was eventually chosen as the emblem of the entire exhibition.

If Onabolu's nationalism took the form of opposition to racial prejudice and anti-African stereotyping, that of Kenneth C. Murray was stimulated more by the urge to bring cultural rehabilitation, parity and pride to the arts and indeed the entire cultural heritage of Nigeria. Murray (1902–1972), born in England, came to Nigeria in 1927 to teach art at King's College, Lagos, at the instigation of Onabolu. He quickly became disillusioned with the negative effects of Christian teaching, and greatly attracted to Nigerian cultural traditions. Expecting him to continue in Onabolu's footsteps, his students were shocked when he began to advocate traditionalism in art, as opposed to Europeanism or conventionalism.[18] He urged them to 'be local in your conception, interpretation, characterisation and general attitude to art'.[19]

In 1933 Murray moved to the long-awaited, newly opened Ibadan College, where his cultural philosophy became more dynamic and provocative. He told his art students – among them Ben Enwonwu, A. Umana, D. Nnachi, U. Ibrahim and C. C. Ibeto[20] – to reconcile themselves with traditional subjects, to make their drawings, paintings and sculpture look

Akintola Lasekan
Portrait
1940s
61 x 30.5 cm
Collection of Afolabi
Kofo-Abayomi, Lagos

like the traditional art forms of their parents. He discouraged them from taking subjects from modern art or European experience, which he regarded as superficial to their heritage and a cultural sell-out. Perhaps his attitude is best captured in his statement: 'the real creative impulse is stimulated by close association with visible experiences in one's immediate environment and not by imagined ones one has not personally experienced or felt. I think it is more proper for pupils to be able to draw "themselves" first before drawing others. In fact, these Nigerian experiences are by far richer than the Western ones.'[21] In 1937, an exhibition of his students' work was held in London at the Zwemmer Gallery, and by 1940 Murray had largely succeeded in making Europe appreciate the forms of Nigerian traditional art.

Murray's admirable teaching ideology went hand in hand with his vocal and dissenting response to the current European attitude towards Nigerian antiquities. When he arrived in the country, many of its oldest artefacts were being destroyed or rejected. He began to collect them, spending money to prevent them falling into the hands of collectors whose interest was only financial. With escorts and interpreters, he explored deep into the western and eastern provinces. His 1949 London exhibition of Nigerian masks and headdresses, which he garnished with disarming philosophical comments, helped him to catch the favourable eye of the colonial government. By 1950 he had persuaded it to enact the Antiquities Law, by which the exportation of any Nigerian art treasure was made a criminal offence. By now he was prevailing over many of the Christian missionaries whose myopic orthodoxy he had earlier condemned: the tide had turned.

In 1957 he achieved a lifetime's objective when the Nigerian, now the National, Museum was officially opened in Lagos, with his own collection donated to form the nucleus. The first European art teacher in Nigeria and its first Director of Antiquities, Murray died in a road accident at 69 on his way to the new Benin Museum; he is buried in Lagos.

Standing in contrast to the different paths taken by Onabolu and Murray in their confrontation with racial prejudice and cultural suppression, Akintola Lasekan (1916–72) attacked the abrasive experiences of British colonial rule. His nationalism was mainly directed towards political freedom, social justice and mental 'decolonisation'. A painter and cartoonist, he was born in Owo, now in Ondo State. Like Onabolu, he became recognised as an artist at primary school; he was kept on to teach art there and by 1932 was familiar with the activities of both Onabolu and Murray.[22]

His name first became known nationally in 1933 when, following his performance in a national art competition sponsored by the government, he was selected to study art in Europe.[23] However, the government did not fulfil its promise, and the young artist therefore left for Lagos where, by 1936, he had become an artist with the Church Missionary Society bookshop. Through the influence of Onabolu, and art correspondence arranged for him by the CMS, Lasekan had begun to distinguish himself by 1940 as a self-taught nature painter, book illustrator and an outstanding cartoonist. In 1945 he travelled to London but, unlike his mentor, he did not stay to study, regarding the standards of the schools which accepted him as far too low.

Lasekan became well known for a series of political cartoon books, beginning in 1940 with *Nigeria in Cartoons*, in which he particularly attacked racial segregation. In 1948 he was appointed by Nnamdi Azikiwe as cartoonist and art advisor to his nationalist newspaper *The West African Pilot*. Under the name 'Lash', he was the first newspaper cartoonist in Nigeria, a role that allowed him to become more provocative in his ideology. He developed a close friendship with Azikiwe (Zik), later Governor General and President of Nigeria, whom he had known since 1937.[24] With Lash's art, Zik acquired a powerful weapon with which to fight the colonial masters and their Nigerian agents. Other newspapers, such as *Nigerian Outlook* and *The Sunday Times*, tried in vain to poach him; he remained loyal to Zik. 'I am relying on you', the latter said to him, 'to use your good offices to help cement and preserve the unity of this new Republic.'[25]

By the early 1950s it was clear enough that the nationalist activities of Murray and Lasekan had had an effect on the Nigerian modern art tradition. This was particularly so in the art department of the Nigeria College of Arts, Science and Technology at Zaria (now Ahmadu Bello University). By 1957 Zaria and the Yaba College of Technology (Yaba Institute) both offered courses leading to a diploma in art. These were without doubt a credit to Onabolu's pioneering work, with course content and programme structures closely based on the British academy tradition.

The seventeen first art students at Zaria – who included Irein Wangboje, now a professor of art education, and T. A. Fasuyi, the former Federal Art Advisor – had from as early as 1955 been uncomfortable with some of the methodologies of their training. Nationalism generally in Nigeria was reaching new levels of energy and focus. Various political, social and educational experiments, especially in the south, were vigorously charged with the desire to gain freedom from colonial rule. The Zaria students wondered why their teaching staff should be predominantly European; the only African was Etsu Clara Ugbodaga-Ngu, the first female artist to teach in Nigeria, but she had little influence on the administration. Neither were they happy with the Europeanised, academy-oriented programme, which they saw as culturally slavish and creatively unrelated to their own artistic heritage. They wanted a change.

The Zaria Art Society was formed in 1958, with eight members. Through its president Uche Okeke, the concept of Natural Synthesis was developed: the marriage of the relevant past with elements from the present which would realise a culturally realistic, non-enslaving future. As stated in their manifesto, the students had a duty 'to promote, through art, Nigerian cultural values with utmost dedication, love and willpower'. They communicated their intentions directly to Azikiwe, the Ministry of Home Affairs, the Information Services in all three regions, many high-ranking government officials and some foreign missions. Leading member Bruce Onobrakpeya tells their inspiring story on the following pages.

Considering all the nationalistic experiences in the colonial period, art was clearly instrumental both in the winning of independence and in the de-colonialising of the country's environment and cultural heritage. Without any doubt, the modern Nigerian art experience has been richly endowed and historically fertile.

Bruce Onobrakpeya
Untitled
1959
Painting

The Zaria Art Society
Bruce Onobrakpeya

During the early years of the Nigeria College of Arts, Science and Technology at Zaria (now Ahmadu Bello University), a few students came together under the name of the Zaria Art Society. Their mission was to examine how their study of academic art related to their society, which was emerging from the traditional to the modern, from the colonial to independence. The guidelines they arrived at became pivotal to the development of the most important direction in contemporary art in Nigeria. This is the story of the achievement of the members of the group and their contributions during both their student days and later professional lives. It is a story of change and continuity, a response to a call to move forward, to explore frontiers with new techniques and ideas, and yet keep faith with the ancestors whose legacy they were reshaping and transforming.

The oldest two of the original eight members of Zaria joined the Fine Art Department in 1956. Independence was still four years away, and most Nigerians were deeply influenced by what was described in local parlance as the colonial mentality. The people's faith in themselves, their institutions and values had been eroded; they looked to the west for all standards. For a few, however, independence would restore their self-confidence so that they could grow into modernity, taking with them their identity

as a people. Development of the arts and culture was to be the key: these were areas seriously neglected during colonial rule, and their role in the emergence of a new nation was slow to be appreciated by many Nigerians.

The leading members of the Zaria Art Society were the president Uche Okeke (born 1933), Demas Nwoko (born 1935) and Bruce Onobrakpeya (born 1932), all from the class of 1957. Encouraged by a new sense of pride in their culture, they approached their studies with confidence and dignity: they were not ashamed to be seen sketching in the market place or drawing the vultures that scavenged outside the college dining hall. All needed to achieve scholarships by the end of their first year in order to continue; they cultivated a habit of hard work which they could not discard even when scholarships came. Joining them in the new Society were Yusuf Grillo (born 1934) and Simon Okeke (1937–1969) from the class of 1956; and Oseloka Osadebe (born 1935), Okechukwu Odita (born 1939) and Ogbonaya Nwagbara (1934–1985) from the class of 1958. These eight remained the members for all four years of the Society's existence. Simon Okeke majored in sculpture, Nwagbara in graphics, and the other six specialised in painting. All had had secondary school backgrounds; all except for Grillo, a Yoruba Muslim born in Lagos, were Christians who had been exposed to traditional culture, including art and religion. Onobrakpeya was from the Urhobo ethnic group of Delta State; the remaining five were all Ibos.

The guiding philosophy of Natural Synthesis, articulated by Okeke, the group's poet and philosopher, was expounded by Onobrakpeya:

I seek to go backward in time to rediscover our time-tested values, which we left behind in ignorance and hurry to catch up technologically with the so-called advanced worlds. Going back in time is progressive rather than regressive.

The contemporary African artist should aim at the development of the total man through creating artistic awareness, appreciation and skill by a process of natural synthesis which combines the best of our values with those from outside.

The world is getting smaller every day, and there is nothing we can do about

foreign influences, which are quite formidable, entering our culture. We can, however, use these influences to advantage and maintain our identity through determined efforts to draw from our roots and rich heritage.

In short, this guiding principle calls for re-examination of our values, to identify what is good, and upgrade it where necessary with equally good ideas from outside. This will guarantee life fulfilment for the present, and a march towards a progressive future.

All the lecturers in the Zaria Fine Art Department, with the exception of Clara Ugbodaga, a Nigerian painter trained in London, were westerners recruited from Britain; they modelled their curricula on the ones at home, particularly Goldsmiths' College, to which the department was affiliated. Teaching and materials were of the highest quality. The only weakness arose from those teachers who arrived in Nigeria knowing nothing of the country, its culture or its art; they had great difficulty in understanding the ideas that their students were struggling to express in their assignments. Also, the lecturers frowned on students' attempts to stage exhibitions outside the college. But neither the Society members nor the other art students were in revolt against the form and content of the teaching; what Society members did was meet for informal discussions during free time where they dwelt on how best to use their newly acquired techniques in a way that would be relevant to the emerging new Nigerian society. They produced non-course works, which were not shown to the lecturers.

The themes of these private art works were drawn from history, folklore, myth, cosmology and philosophy; other sources of inspiration were landscape, plant and animal life, masquerades, festivals, religion, politics and other socio-economic aspects of life. Each saw and admired the others' works, but each developed an individual style in which western and traditional forms sometimes blended. In common was a spirit of renaissance, which could be felt in all the works. Uche Okeke's were mainly black-and-white line drawings inspired by *uli* forms; *Ojadili*, the wrestler from the spirit world, and *A Maiden's Cry* are from this period. Demas Nwoko's paintings were poetic renditions of everyday subjects – *Bathers, Children Cycling* and *Northern Landscape with*

Cows. Others, like *Women Preaching, Ogboni Chief* and *Nigeria 1959* were wrapped in a compelling feeling of mystery. This was Nwoko's most rewarding period as a painter, in which he used large formats with colours glazed in layers to produce rich hues of green, yellow, brown and red. Bruce Onobrakpeya's paintings were inspired by Urhobo and Benin folktales, mythological figures and landscapes – examples are *Hunters' Secrets*, the exploits of *Ahwaire the Tortoise*, and *Eketeke and Erhevbuye*, two lazy people engaged in a fight. He also painted northern landscapes including *Zongo* in his *Zaria Indigo* series. His interest in printmaking started at this period; he used linocuts and silkscreen, sometimes to reinterpret subjects he had treated in paintings. These exciting prints were seen by chance by the head of the Art Department, Clifford Frith, who asked him to include them in his final diploma exhibition. Yusuf Grillo, inspired by the life and culture of Lagos, celebrated womanhood: in *Mother of Twins*, a woman carrying two infants is engaged in a dancing rite for their protection. Grillo's interest in mathematics is shown in his treatment of planes and in the general composition of his paintings. Simon Okeke was specialising in sculpture, but chose watercolour painting for his private work, in which human figures grow like sculptures from dark backgrounds to highlights: *Scared Labour* is one example.

News of these private efforts spread beyond the college, and attracted the attention of Michael Crowder and Ulli Beier, who were to play very important roles in the development of art in Nigeria. Crowther was director of the exhibition centre at the Marina, an arm of the Ministry of Information, and also the editor of *Nigeria Magazine*. Beier was an extramural lecturer at the University of Ibadan. They visited members of the Zaria Art Society, and during the holidays involved them in workshops, seminars, symposia and exhibitions.

By June 1961 the older members of the Society were graduating, and it was disbanded. Wangboje joined a television network, Simon Okeke went to the National Museum of Antiquities, and Grillo did a postgraduate course in art education, followed by a period as art teacher at King's College, Lagos; he later became Director of the School of Fine Art and Design at Yaba College of Technology. Onobrakpeya gained a postgraduate Certificate of Education and later taught

at St Gregory College in Lagos, while Nwoko studied in Paris on a French government scholarship, returning to a lectureship in the Department of Theatre Arts in the University of Ibadan. Uche Okeke left for Munich to study stained glass and mosaic; on his return he established the Mbari Centre Workshop at Enugu which he ran from 1964 to 1967. Odita and Osadebe became lecturers in art at the University of Nigeria, Nsukka, while Nwagbara became a commercial artist for the Ministry of Agriculture at Enugu.

This dispersal of the eight members of the Zaria Art Society all over the country played an important part in raising awareness in Nigeria of contemporary art. They worked as lecturers, teachers, graphic artists for newspapers and television, industrial designers and art critics. They created sculptures, paintings and murals for churches, and public and private buildings. Students were taught to look at the beauty of masks, and ignore the stigma which had been destroying them since Christianity had condemned them. Exhibitions enabled their parents to learn that art could be a progressive instrument in society. These new art professionals lived respectable, honoured lives: extra income from private sales enabled them to raise their living standards beyond those of many other professionals. Gradually, the prejudice against art and artists began to crumble, and parents no longer hesitated to sponsor their children through art studies.

Lagos, then the federal capital, attracted many artists. In 1964, members of the disbanded Society began to come together again, in a new association called the Society of Nigerian Artists (SNA). Its first president was Grillo, and many of the original Zaria members were involved with it – along with Solomon Wangboje, Isiaka Osunde and T. A. Fasuyi, who were acquainted with the Zaria activities. Four new members sympathetic to Zaria earned the tag 'Kindred Rebels' – they were Erhabor Emokpae, El Anatsui, Ben Osawe and Abayomi Barber.

The later lives of the Zaria Rebels bear out claims for their widespread influence. Odita and Osadebe interacted with the Mbari group at Enugu and participated in some overseas shows. Both left for the USA before the civil war in 1966, and settled there, Odita becoming a lecturer at Ohio State University and contributing immensely to the acceptance of modern

African art in the west. Uche Okeke – artist, poet and cultural ambassador – has represented Nigeria for UNESCO. Formerly Director of Visual Art at the University of Nigeria, Nsukka, he is responsible for the serious regard in which *uli* art is now held, at home and across the world. A great teacher, he has already inspired three generations of artists to create new forms drawn from this source. His Asele Institute serves as a studio, art gallery, museum for his collection, documentation centre and thriving art school.

Demas Nwoko designed and built the New Culture Studio for painting, sculpture, theatre arts and aesthetics, where he ran workshops assisted by Gbenga Sonuga and Franca Wamaka Egbuna. A stone and colour block building, it stands beautifully on terraced hill ground in Ibadan, and has helped him experiment in almost all forms of visual art. His terracotta work in particular, inspired by Nok pieces, is outstanding: it includes the *Adam and Eve* series, *Philosopher*, *Soja Come*, *Soja Stay* and *Soja Go*. He is the producer of *New Culture* magazine. Inspired by traditional design, the Studio won for him many architectural commissions, including the Cultural Centre in Benin City; he is one of very few Nigerian architects who have produced a surely modern Nigerian style.

As well as painting, Bruce Onobrakpeya has continued to experiment with printmaking techniques, using woodcuts, engraving, intaglio and plastography. Religious art for churches led to a commission in bronzed lino relief depicting St Paul which is now in the Vatican Museum, Rome. In the 1980s he took the endangered environment as his theme, producing *Sahelian Masquerades*. Now his work has developed from low relief into a kind of sculpture in the round, assembled in units similar in appearance to traditional shrines. His studio in Lagos, Ovuomaroro, continues to produce experimental art work, as well as catalogues, monographs and posters. Its programme, which includes artists in residence, has helped to produce art historians as well as artists, and has developed the perception of Nigerian art in a world context.

Yusuf Grillo is synonymous in Nigeria today with mural art, especially mosaic and stained glass; examples of his work adorn churches all over Lagos and other cities. In Yaba, the dome of the Presbyterian Church and the altar of All

Saints are radiant examples of his style, which in colour and design reflects the montage of Yoruba costume. His paintings, sometimes sculptural in form, are drawn from the same geometric designs which are associated with his love of mathematics. Like other modern artists, he draws on world sources other than African, and he encourages his students to be open to all good influences. President of the Society of Nigerian Artists for almost two decades, Grillo has helped to mould a new landscape for Nigerian art and moved it forward.

After 37 years of work both in and outside Nigeria, the eight members of the Zaria Art Society and their associates are still breaking new ground today. Ulli Beier has described their efforts as a 'revolution', while Kojo Fusu has pointed out 'their new functional approach to bringing the appreciation of contemporary art to the ordinary people rather than the market of European expatriates in modern Nigeria.' Their achievements go beyond blazing a trail, by helping to define the concept of contemporary art in Nigeria, and creating new techniques and forms. The breakthrough they achieved is to be found mainly in the transformation of the Nigerian people from being outward- to inward-looking, from apologising for

their lives to cherishing their natural endowments, languages, cultures, values and creations. The group's work has helped to create a sense of pride, of respect for what is beautiful no matter where it comes from, and of self-identity that has ceased the wholesale assimilation of foreign cultures. It has helped build new forms out of folklore resources, from the ashes of the rich traditional art works that were destroyed by foreign acculturation. In other words, the ideas and works of the group have helped to give their people a soul.

Members of the Zaria Art Society and their associates are therefore in the vanguard of the struggle for cultural independence. This is more difficult than political independence, which colonial powers may readily grant, while holding on to people's culture because they know that this is how they can re-colonise them. Artists who have come after Zaria and were inspired by it proudly bear the torch and are in turn relaying it to younger generations. As we enter a new century, it is our fervent prayer that the combined efforts of these generations, old and new, will enable us to move forward into the challenges of the future.

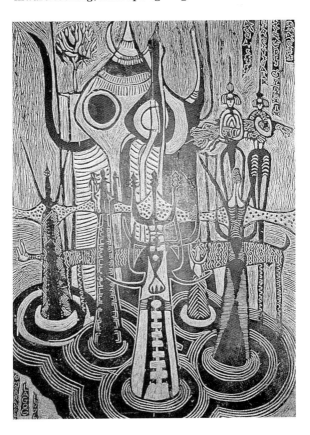

Bruce Onobrakpeya
Untitled
1970s
Plastograph
Collection of the artist

Wherever something stands,
something else will stand beside it.

This Nigerian adage captures the essence of the work of Erhabor Ogieva Emokpae, and provides a key to a meaningful contemplation of its philosophical and ideational underpinnings. This adage indeed becomes a metaphor that locates this contemplation in the protean domain of formalistic and discursive relationships: between understanding and appreciation, perception and cognition. For to perceive Emokpae's work is to see the physical entity, an affecting presence (to invoke Robert Plant Armstrong) that may, like most authoritative works of art, inspire different but no less valid interpretations in its viewers; it is to see that 'something else' that is a subtle or fugitive companion to his art. But to understand it – to appreciate and enjoy it – is to be able to identify the phenomenon,

The Essential Emokpae

dele jegede

Erhabor Emokpae
1978
Photograph, *Peace to Erhabor Emokpae*

this 'something else' that legitimises and amplifies the work; the 'something else' that imbues Emokpae's art with meaning, investing it with power while embedding it firmly within the artist's cultural and creative cosmology.

Understanding Emokpae's work requires the exploration of the deep notional recesses within which the artist often took refuge; it means unravelling the complex and sometimes ambivalent levels at which he functioned, simultaneously at times, solitarily and selectively at others. Emokpae's work is an extension of his life. And like the artist, the work is steeped in an existentialist world in which complementary and

antipodal relationships constitute the foci of attention and the arena for creative mediation, becoming at once the point of departure and the point of return. Emokpae's œuvre is the objectification of a philosophical principle which is anchored in dialogue and dualism. This is the doctrinal matrix from which his manifesto comes:

I see in life and death a dialogue between the womb and the tomb. They are the parentheses within which we love and hate, laugh and cry, grow and decay. This duality appears in varying dimensions throughout the complex pattern of creation and has been very largely the determining factor in the visual interpretation of my experiences. I speak of good and evil as contained in the motions of our thought and actions. I speak of the physical and metaphysical as expressed in the human experience. I speak of man and woman, their agonies and their ecstasies. I speak above all of life and death as [indivisible] whole.[1]

What manner of artist was he? What type of work did he produce? This manifesto offers us a glimpse into the fertile mind of an ebullient and flamboyant avant garde. By all accounts, he was a dashing, colourful, larger-than-life artist who lived, in the words of Yusuf Grillo, 'the eccentricities of an artist.'[2] He created prodigiously and, as if to demonstrate his total immersion in dialogue and dualism, lived big and expired at mid-life. It was a fulfilled life, essentially because he immortalised himself, not merely by leaving a large family (having three wives and about eighteen children is certainly a significant achievement among his Edo people, as well as in several African societies) but on account of his large body of work in an assortment of media. The embodiment of seemingly incompatible tenets, he was at once a competent graphic artist and skilful illustrator who basked in the affluence that attended his success in the advertising industry, and a cerebral artist who oscillated comfortably between painting and sculpture; a commercial (some indeed have implied a mercantile) virtuoso and an egocentric showman; an exuberant extrovert who exulted in validating the public perception of the avant-garde artist as an eccentric, and a reticent, monosyllabic traditionalist whose strength lay (to echo Mathilda, one of his wives) in his silence.[3]

Within Emokpae's philosophical cosmos, his work is iconic and multi-layered. It becomes a visual representation and reification of the symbols and splits which have become so much a part of our lives that we hardly notice their presence, but which may in fact circumscribe our perceptive ability. These splits speak of convergences and divergences and span a wide field of thoughts, precepts and processes: the celestial and the mundane; good and evil; positive and negative; black and white; spirit and matter; male and female; the secular and the spiritual; the physical and the metaphysical; life and death, high and low, pure and dirty – the combinations are overwhelming. These are the notions that he explored in his *Dialogue Series*, the gamut of work that he produced in painting and sculpture during the sixties and the seventies.

Examples of these are seen in such sculptures as *Form Fossil* (1970), and *Iya Ibeji* and *Iya Abiku* (both 1977). In these titles, we have an understanding of the artist's preoccupation with dualism, as well as his exploration of the sequences of life and death, positive and negative: the inevitable dialogue that orders cosmic relationships. In Yoruba, *iya ibeji* means 'mother of twins'; *iya abiku* is the descriptive title for the mother of any other-worldly child who makes cyclic journeys into this world – a child who chooses its mother, and dies at will, only to be born again and again. Emokpae's sculptures, carved in *iroko* or ebony, are usually huge, in keeping with his practice of working only for the largest number of viewers. Regardless of their size, the essential Emokpae is always present: mass is perceived as a necessary counterfoil to void, both of them existing in a mutually beneficial order. The premise for this should by now be clear: Emokpae's art is infused with universalist concerns that are derived from dualism.

Emokpae enjoyed living on the turbulent crest generated by his controversial work. The effortlessness with which he unified conflicting concepts and seemingly oppositional roles can be traced, in part, to his education and upbringing. Son of a Bini chief, he was born on 9 May 1934, and grew up imbibing and integrating the best of two worlds – the one provided through exposure to western education, and the other acquired through birth into a large family in Benin. It was from his Bini roots that the artist cultivated traditional culture as the bedrock of a lifelong

education and a *sine qua non* for success. In his work and utterances, Emokpae displayed the same stubborn pride in, and allegiance to, tradition – of the type that saw Chief Ologbosere deal a mortal blow to the pride of the arrogant British impostor J. R. Philips in 1897, an event which led to the inglorious invasion of Benin and the plundering of thousands of its inestimable treasures.

Unlike his peers Uche Okeke, Bruce Onobrakpeya, Demas Nwoko and Yusuf Grillo who received their formal art education at the premier department in Zaria in the late fifties and early sixties, Emokpae received his professional training from eclectic sources. As a young child, he dwelled in the midst of the Benin guild of carvers, where he would carve whatever unused wood he could. At the end of his secondary education at Government School and Western Boys' High School, Benin City, in 1951, he moved to Lagos and attended the Yaba Trade Centre. He also studied privately with a graphic artist, working for Kingsway, a department store in Lagos. In 1953, he joined the Federal Ministry of Information as a commercial artist. But it was not until 1954, when he went to Enugu on a transfer, that his career blossomed. Now having sufficient time to himself, he devoted much of it to improving his art, and to reading.

By the time Nigeria became independent from British imperialism in 1960, Emokpae had established himself as a powerful player in the emergent domain of modern Nigerian art. Here was a brilliant young man who, having acquired the necessary professional training and an appropriate business acumen to go with it, was ready to play a major role in creating and implementing a cultural agenda for the new nation. He fraternised with political juggernauts who perceived him as perhaps the most sociable of the growing number of contemporary Nigerian artists, who were generally regarded with suspicion or benign contempt or both. As the Publicity Secretary of the Society of Nigerian Artists, inaugurated in 1964, and as the honorary Secretary of the Nigerian Arts Council between 1966 and 1976, Emokpae not only influenced government policy in the culture sector, but also helped substantially to define the public perception of, and reaction to, contemporary Nigerian art.

In any analysis of Emokpae's work, there is a need to separate his popular,

commercial genre from his major creative sculptures and paintings. Furthermore, the paintings and sculptures of the early sixties should be distinguished from those he did later, especially during the mid seventies, when his career literally erupted and he became the sole artist handling the décor for the venues in Lagos, Kaduna and elsewhere of the Second World and Black Festival of Arts and Culture (Festac '77). However, any consideration of the numerous sculptures and fibreglass friezes that he signed during this time should be made bearing in mind the enormous other pressures he was under – the overwhelming volume of work, the pressure to meet deadlines, a myriad of contractual obligations, and the controversy raised by his choice of the Benin ivory pendant as Festac 77's emblem and the British Museum's refusal to release the original piece on loan to Nigeria. Indeed, the pressure of work from government and other quarters must have

influenced his decision to retire in 1976, after eighteen years, as the creative director of Lintas.

Emokpae was highly versatile in threading the two domains of mercantilism and intellectualism. He combined the sensibilities of a technically superb illustrator and popular artist striving to satisfy the demands of his clients, with those of a possessed, philosophising artist who created primarily to satisfy himself. In the first category, his primary function was to earn a decent living by pandering to the tastes of ordinary folk and laymen – a responsibility that he discharged efficiently, as can be seen in the heroes' calendar which he did for the Federal Government of Nigeria in 1976. In the

second category, Emokpae moved to the cerebral plane, where he promptly declared his art out of bounds to laymen: 'I cannot really expect the layman to readily understand my paintings which have a message because it needs schooling to appreciate such things.'[4]

Who are these laymen that Emokpae was speaking of? And what manner of art did he do that demanded that his audience must be schooled? To appreciate these issues, we need to place the artist within his own period – the Nigeria of the sixties. The newly independent nation bubbled with hope, excitement and enthusiasm. Finally, the crusade initiated in the 1920s by Nigeria's pioneer modern artist, Chief Aina Onabolu, had begun to yield bountiful dividends: Nigeria's first department of fine arts was established in 1953 and, in 1958, the Zaria Art Society was formed by a group of young intellectuals led by Uche Okeke.[5] Members of the Society reacted to the patronising, colonialist, pedagogical style of their expatriate teachers by issuing a manifesto that proclaimed synthesis as a doctrine. Although these young, visionary artists realised the importance of their mission in the new Nigeria, they were clearly ahead of their time; it would take the Nigerian public another decade or two to come to terms with the new creative dispensation. Art galleries were mostly non-existent and most art exhibitions were attended by expatriates who ended up buying perhaps the best of the early works by contemporary Nigerian artists. The culture of art criticism was at a very early stage, dominated largely by Ulli Beier and the late Michael Crowder. Whatever comments offered by the Nigerian *cognoscenti* of the period showed an

unrelenting aversion for abstract works, a preoccupation with realism, and a repulsion for exorbitant price tags. This, in a nutshell, is the Nigeria populated by Emokpae's laymen. But it was also a Nigeria rumbling with the irrepressible ebullience of a creative force – that of the second generation of contemporary Nigerian artists to which Emokpae belonged.

The Art of Understanding – a huge mural of granite, concrete and mosaic at the Nigerian Institute of International Affairs – exemplifies Emokpae's unquestionable status as a modernist with a penchant for irregular or unusual formats and mixed media. The title of the work itself underlines the sub-theme of universalism and dialogue which the artist constantly explored within the philosophical ambiance of dualism. This work provides the overarching concept which frames the artist's encounter with, and generous accommodation of, the Other. It does more: it buries the bogey of modernism as an exclusively white property. Abstraction which has been appropriated by the white cultural establishment and sanctimoniously installed as the soul of modernism is, in the artist's view, modern only to them: African art has always been based on abstraction. In other words, long before latter-day apologists of modern art arrived in Nigeria in the sixties armed with maps and compasses, bags full of brown papers, brushes and emulsion paint and a new philosophy of cultural imperialism, Emokpae and artists like him had demonstrated, in thoughts and in deed, the nascence of modernism on the African continent.

Many of his paintings are invested with an iconographic visual syntax that is typically Emokpaesque. The picture plane becomes an arena for the display, manipulation and juxtaposition of universal symbols and icons – ideological, religious, philosophical and economic (the hammer and sickle, the star of David, the cross, the star and the crescent, the swastika) – through which the plight of the marginalised and the oppressed is highlighted, literally and metaphorically.

One work which reveals the modernist discernment of the artist is *The Last Supper* (see page 53). Dated 1963, this painting is dominated by a large bowl of blood presided over by a white, bloodied cross. Framing the bowl from three sides of the canvas are eleven agitated hands, representing those of Christ's apostles.

What is in a title, you might ask? For Emokpae, it is the associational aura that this title invokes that matters, a title that Leonardo Da Vinci popularised and that the bible sermonised on. But that is where the association ends. In this painting, there is nothing of the compositional arrangement of Da Vinci, in which Christ plays the role of the superstar. Rather, Emokpae uses simple but invocative icons to render a stark, non-representational canvas. For the clergy and the laity, however, this painting is sacrilegious. It constitutes an indictment – indeed, a trivialisation – of one of the respected covenants of Christendom. Listen to the artist explain himself: 'I found on closer inspection that Christianity is a cannibalistic religion; Christians eat their Deity. Yet they tell people that cannibalism is wrong. . . .Christians present the Last Supper as the only food for survival. To my mind, this is a form of disrespect and I set out to say so in this painting.'[6]

Heretical as this may sound, this painting introduces us to the culturally and politically sensitive Emokpae. He had no illusions about the pernicious effects of Christianisation and colonialism. Is it not the same white man who came to condemn African religion who ended with looting the continent of its treasures? The history of art on the continent of Africa is the history of racial inequity; it is the history of the expatriate manipulator masquerading as the benefactor of the so-called underprivileged, establishing 'schools' at random but maintaining the age-long stranglehold and perpetuating the prejudicial hegemonic imperative that continually re-invents and markets colonialism in 'new and improved' terms. Emokpae saw through this veneer of deceit when he declared that he was against foreign patrons and would resist his works being taken outside Nigeria. To some extent, he succeeded. He chose murals, paintings and sculptures that are either immovable or so intimidating in size as to guarantee their permanent residence in Africa.

Before he died on 16 February 1984, Emokpae's contributions to contemporary Nigerian art were recognised by the government, which conferred on him the Officer of the Order of the Niger (one of only three visual artists in Nigeria to be so honoured, the other two being Ladi Kwali and Ben Enwonwu). On his final trip to his native Benin on 24 February 1984, this time in a black hearse, the heavens opened up in a hail of lightning and thunder, accompanied by a brief hurricane that uprooted structures and a downpour that flooded the Benin streets, sending people scampering for shelter.[7] The spirits of the ancestors had finally accepted Erhabor Ogieva Emokpae. It was a tumultuous end to a creatively boisterous life. But, in the logical sense of Emokpae's dualism and dialogue, the artist continues to live. This continuity is the theme of the sonorous and tearful Bini dirge which was rendered as a final tribute to a worthy son:

> The sun goes to the sea
> Tell my personal god I'm not coming yet
> Only when my hair greys to perfect whiteness
> Will I come.

Erhabor Emokpae
Untitled
1963
Collection of Colonel Yakubu

Erhabor Emokpae
Baby in a Mother's Womb
1963
Oil on board
122 x 61 cm
Collection of Afolabi Kofo-Abayomi, Lagos

The Oshogbo Experiment

Tayo Adenaike

B.A. thesis, University of Nigeria,
Nsukka, 1979

Oshogbo is a Yoruba town 96 kilometres
north-east of Ibadan, the largest
settlement of the Yoruba-speaking
people of Nigeria. In 1963 its population
numbered just under 210,000.

Historical background

In the late eighteenth century, two
powerful hunters – Timehin from Oyo, and
Larooye from Ilesa – met during an
expedition. They became friends and,
during the course of their hunting, they
disclosed the problems of their different
towns. Coupled with severe drought, both
hunters had heard of an invasion from the
north (this was the period of the Fulani
invasion of the northern Yoruba lands).
Instead of returning home, they agreed to
remain in the forest.

After almost two weeks in the forest,
Timehin became ill, and at about the same
time Larooye discovered water – the source
of the Osun river as we know it today. The
two men settled at the bank of the river. It
is believed that during one of their meal-
times Timehin and Larooye accidentally
set fire to the foot of a tree, which later fell
into the river. As soon as the tree fell, the
goddess of the river cried, 'Osho igbo o,
gbogbo ikoko aro mi ni won ti fo tan
[spirit of the forest, they have broken all
my pots of dye]'. For the burnt and fallen
tree, Timehin and Larooye had to shout,
'Osho igbo pelo O [spirit of the forest,
forgive us]' to pacify the spirit. They
pleaded with the goddess for forgiveness,
and solicited her help against any danger
that might befall them. She agreed, and
the two hunters promised to worship her
regularly.

Many other people fleeing the war
zones joined Timehin and Larooye and, in
time, people settled on the two banks of the
Osun. It is believed that this settlement is
the cradle of the present-day Oshogbo, and
Larooye is credited as its founder. The
word Oshogbo is the contracted form of
'Osho Igbo', meaning 'spirit of the forest'.

Another story has it that the people of
Oshogbo fled from Ibokun around Ilesa
just before the middle of the eighteenth
century, and settled at the source of the
Osun river where they were promised
protection by the river goddess. Every
August, according to the vow made by the
first settlers, homage is paid to the
goddess of the river; the colourful
ceremony attracts people of all walks of
life from all over the world.

Traditional art heritage

The traditional art heritage of the people of
Oshogbo is various: it includes music,
wood and stone carving, brass and iron
work, pottery and cloth dyeing.

Every ceremony in Oshogbo in the past
and now is accompanied by music. Parents
teach their children this art they learned
from their fathers, and the children in turn
respond well to the teaching. Young boys
from six to ten years old manipulate with
ease the talking drum (gongon) to blend
with songs.

The Oshogbo people are not reputed
carvers or workers in brass and iron, but
some forms of these arts are practised.
Most of the works worthy of mention are
sacred and in most cases not for public
viewing. Where it is possible to see them,
photography is not permitted. However, it
is important to note that all the drums with
their intricate designs used to mark the
beginning of the Osun festival, and the
figures worshipped during this period,
were carved in Oshogbo. These figures and
drums are thought to be as old as the town
itself. Another work of art worthy of
mention is the metal lamp which burns for
seven days in front of the king's palace to
mark the beginning of the festival.
Emitting light from sixteen points, the
lamp is believed to have been made by an
unknown smith who lived some two
hundred years ago in Oshogbo. Today,
beautifully designed jewels of copper or
brass are bought by both foreigners and
local people; they serve as reminders of
this fast-dying artistic culture.

Pottery flourished in the early days of
Oshogbo, when potters produced pots for
drinking water and cooking. With the
introduction of pipe-borne water, many
houses in Oshogbo now have taps, or a
public tap within a short walking distance.
Local potters still produce cooking pots,
however, in some commercial quantity.

Like the Egba-speaking people of
Abeokuta, the people of Oshogbo are
known for producing tie-and-dyed cloths
called adire. The word is derived from 'Aso
ti a di, ti a si re sinu omi aro [the cloth
which we tie and soak in a solution of
dye]'.[1] The dyes are locally dug, and the
colours are indigo, blue, yellow and red.
Apart from tying, starch, which renders
the cloth water-resistant, is also used as a
means of registering designs before
dyeing. Unlike in northern Nigeria where
dying is done in pits, the people of Oshogbo
do theirs in large carved wooden bowls
called opon.

The use of local dyes is becoming a thing of the past, with preference now given to imported dyes which work faster. Despite this change, however, local people still say, '*Aro nbe ni Oshogbo ni Oshogbo fi nwuni* (it is because of the abundance of dyes at Oshogbo that make people love Oshogbo)'. In a wider sense, it might be right to say that the art of dyeing will for many years to come be cherished by the Oshogbo people.

The town today

Like some other Nigerian towns, Oshogbo is witnessing rapid changes, with relics of her past still in existence. The first settlement of the people – the source of the Osun river – is now kept sacred, with the developing town one kilometre away. Gradually, old mud houses of eighteenth-century Brazilian architectural style are giving way to modern cement buildings accessible by well tarred roads.

The town is very busy during the day, with the *Oja Oba* [King's Market] on Mission Road the most important centre for buying and selling. Directly opposite is the king's palace. The horns of the palace musicians can be heard blaring into the air from the time the king rises until he goes to bed. This practice is an age-old tradition which, despite the influx of western culture, is still very strongly upheld.

During the last thirty years, Oshogbo has developed many industries, as well as good educational and medical facilities. Foreign religions have come into the town: sprawling all over Oshogbo are numerous mosques and churches of different sizes and sects. In spite of these, one thing is evident: the people still cherish their age-old figures. The yearly crowd-pulling Osun festival, apart from being a tourist attraction, shows that the people of Oshogbo choose with care what to absorb and what to reject of what is foreign. They have preserved their cultural identity, and are very proud of it.

The Oshogbo school

The late 1950s was a quite remarkable period in the history of Africa, a time when many African countries felt they could do without the services of their colonial masters. Many who had had the chance of studying abroad now wanted to put into practice the knowledge they had acquired. Léopold Sédar Senghor's re-proclamation of the philosophy of

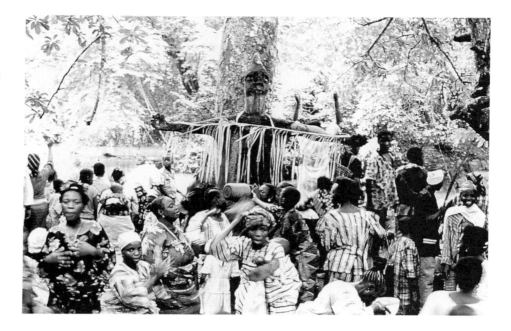

Negritude and Kwame Nkrumah's call for an 'African Personality' also occurred within this period. In general, a silent revolution was under way: many writers and creative artists emerged with a sense of purpose – mainly to break away from the shackles of colonialism. The literary arts took the lead over the visual arts in terms of disseminating the new ideology, but both maintained the same course.

Nigeria was not left out of these events. What may be described as the most recent revolution in modern Nigerian art took place in the late 1950s. It has since

Osun ceremony
Oshogbo, 1990s

Osun ceremony
Oshogbo, 1990
(In background, cement sculpture by Suzanne Wenger)

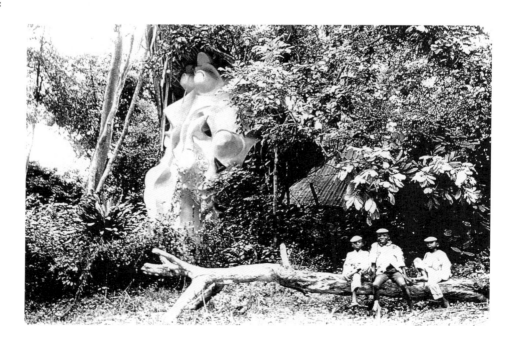

Suzanne Wenger
Oshogbo, 1991

Ulli Beier at Iwalewa House
Bayreuth, 1994

unfolded new creative ideas which make it possible to talk about the transitional as well as the contemporary art of Nigeria. By the early 1960s a radical Zaria group of art students emerged and, when they linked up with the literary and theatrical groups of Ibadan, an end was put to the domineering and ineffective administratiion of the British Arts Council.

This coalition gave birth to the Mbari Club of Ibadan 'in July 1961 under the presidency of Es'kia Mphahlele – a South African',[2] with other important members such as Demas Nwoko and Uche Okeke, both of the Zaria group. Another important member was Chinua Achebe, a writer, who suggested the name Mbari. Others included D. O. Fagunwa, Wole Soyinka, Yetunde Esan, Mabel Aig-Imoukhuede, John P. Clark, Michael Crowder, Ulli Beier and Francis Ademola.

The Mbari Club at its inception set out to promote an 'understanding and appreciation of permanent values and new trends in arts, literature, music and theatre, and to seek complete integration of these values' into the streams of life.[3] Paradoxically, while the club intended to break away from the shackles of foreign influences, it had to survive on financial support from the Congress for Cultural Freedom founded in Paris in 1950. The Congress's aim was 'to foster the growth of a worldwide community of scholars, writers, scientists and artists who are bound together by a common appreciation of the traditions of creative endeavours.'[4] By 1969 the club was also enjoying the sponsorship of the Farfield Foundation of New York City, but it soon became clear that the available funds were not sufficient to meet the needs and programmes of the club. Two years later it ceased to operate.

During the ten years of its existence, the club was a centre of attraction for both the literate and the illiterate classes in Ibadan. It started the Mbari Publication, the first of its kind geared towards publicising African writers and artists. It sponsored Wole Soyinka's Kongis Harvest, Frank Aig-Imoukhuede's Ikeke and John Pepper Clark's Ozibi. In Yoruba entertainment theatre, Kola Ogunmola and Duro Ladipo were also sponsored by the club. In the visual arts, the club organised exhibitions geared towards popularising African art, notably an exhibition of drawings by Uche Okeke.

The successes of the Mbari Club of Ibadan were not unconnected with the opening of another Mbari club at Oshogbo, even though the latter was disadvantaged in terms of location, size and interested audience. The founding of the Oshogbo Mbari Club 'rests on the shoulders of Duro Ladipo, and Ulli Beier who at this period was a lecturer at the Department of Extramural Studies at the University of Ibadan.'[5] Duro Ladipo, a composer at Oshogbo, had visited the Ibadan Mbari Club and, impressed at what he saw, was prompted to start a club in his home town. The first major problem of finding suitable premises was solved by Duro, who gave his father's house. With the financial backing which Ulli Beier was able to extract from foreign organisations (most probably the same as that of the Ibadan club), the house was converted into a theatre and a gallery.

By the first quarter of 1962, the Oshogbo Club had become a weekend resort for many Nigerian art-lovers and, especially, the foreign staff of the University of Ibadan. Works by Suzanne Wenger, Vincent Kofi and other foreign artists were exhibited at the gallery, while the theatre produced Duro's first Yoruba music dramas – Eda [Humanity] and Oba Koso [The King did not Hang].[6] These brought him into the Nigerian limelight and eventually to international fame. Within a few months, Suzanne Wenger – an Austrian artist who had been in Nigeria for eleven years and had already exhibited her works at the club – moved from Ilobu (a town some 24 kilometres away) to Oshogbo. She later joined Ulli and both became responsible, with Duro, for managing the club's affairs.

With Duro's fame extending beyond local boundaries, an attempt was made to increase the numbers in the group, to create more full- and part-time job opportunities. Duro's Yoruba music and entertainment drama group grew from about fifteen to twenty-five people (including a few of his wives!). But it could not last: the gate receipts were insufficient to pay for so many. Suzanne Wenger recollects: 'it was in the light of this problem that Ulli and myself started thinking of some other alternatives which might eventually give the members of the group some extra income... There were so many problems involved: most of [the new artists] hardly ever went beyond class six in the primary school; job opportunities were few at Oshogbo, and even the available ones these pupils cannot aspire to, because of their insufficient qualifications.'[7]

It was because of these problems, and the need to keep the participants busy

whenever they were off the stage, that Ulli and Suzanne finally agreed to try an experimental art workshop at the club. A trained artist, she declares: 'I knew it was not going to be the problem of what kind of work they were going to produce, but if the works would find any market.' Busy researching Yoruba myth, Suzanne confined herself to offering suggestions, while Ulli did most of the groundwork for the workshop.

The idea of an experimental art school did not originate in Nigeria. Quoting Ulli: 'the idea of a brief concentrated art school in which students are made to work from morning to evening for eight to ten days was developed in Europe.' He wrote that in Europe such organised schools were for 'students who had previously received some training or who were already practising artists.'[8]

Frank McEwen's first attempt at establishing an experimental art centre in southern France was curtailed by the Second World War, but his dream became a reality in Rhodesia in the middle 1950s when he was Director of the Rhodesian National Gallery. Another experiment of this nature was simultaneously going on in Congo-Brazzaville where Pierre Lods, a French painter, was in charge of affairs. Both experiments met with considerable success. Most of the works produced at Potopoto under Lods were purchased in great quantity, as were the works made in Rhodesia. It is important to note that, in just a few weeks, artists were made out of farmers and many other poor citizens of these countries, some of whose works are now to be found in galleries in many western countries.

Experiments carried out at the Ibadan Mbari Club were similar. Market men and women were given the chance to try their hand at painting, side by side with art graduates and other professional artists. It produced good results. It is not impossible therefore that the successes in Rhodesia, Potopoto and the Ibadan Mbari Club formed a basis for Ulli's inner visions, even though he claims that at the time they knew little about Rhodesia.

Ulli had never professed to be an artist, but in a strict sense one might consider him one because of his powerful vision. To ensure a good start for the experiment, he invited Dennis William in October 1962, just after the second Ibadan Mbari workshop. Suzanne recollects that 'most of the artists in Duro's group were present ... to my surprise, many from within the Oshogbo environs had also heard about

the experiment ... It was some joy to Ulli, Dennis and myself when at the first summer school over a dozen students turned up at the Oshogbo Mbari Club.'[9] Most of the students, however, were both illiterate and young – under twenty. Students were given materials and asked to paint freely whatever they could. At the end of the first school some talents were discovered, but Jacob Afolabi was the only one to return the following year for Dennis's second school, which is when Rufus Ogundele's talent was noticed. The third workshop was conducted by Georgina Beier in her home in 1964, not long after she had moved to Oshogbo. Through her efforts, four more talented artists emerged – Jimoh Buraimoh, Adebisi Fabunmi, Taiwo Olaniyi (Twins Seven-Seven) and Muraina Oyelami.

Jacob Afolabi recollects that over a hundred students took part over the three years of workshops. The selection of those who remained to work regularly with Georgina 'was done by Ulli Beier, who was always around to offer suggestions'. Jacob admits that none of them 'knew what they were doing at least for the first three years ... it was a matter of leaving for Georgina's house after rehearsals and working till we were tired ... Financially, we were below average in terms of being able to buy essential things we needed.'[10] Jimoh stresses that 'if Ulli Beier had not started buying some of the works we were producing we could have all left.'[11] Although all involved agree that the atmosphere was cordial, some of them felt that they were being used by Ulli Beier, since they knew little about what they were doing, while others remained simply because he was an *Oyinbo* (Yoruba for a white man), and believed that whatever he said was right.

One might have expected that because the students lived in very similar environments, had the same cultural background and, most importantly, worked at the same workshop, that the works they produced would be similar in style, theme and technique. In this respect, the Oshogbo experiment was a surprise: from the outset, despite the informality of the instruction, each artist had his own personality and created his own style.

Twins Seven-Seven was undoubtedly the most talented of the newly discovered artists. Before he became Ulli's houseboy and finally entered the school, Twins had been a dancer with a traditional doctor. He recollects that 'there were times when I felt

dying or killing myself would have been better than dancing for six naira [then three pounds] a month ... I was happier when I joined the school.'[12] Twins mostly worked in inks, gouache and oils, portraying a fantastical world inhabited by monsters and imagined animals.

Sadly, Twins is no longer the prolific artist today that he used to be; he regrets that 'too many things cut across my painting period these days.'[13] He is actively involved in politics and a musical group, but he still doodles in pen and ink on which he later applies transparent colours. He is still concerned with bizarre imaginings and his work is filled with visions of supernatural beings, but thematically there is a slight change. One can trace the source of some of his inspirations to his personal experience. The influence of what Ulli read to him from Amos Tutuola's books can still be noticed in some of his titles like *Strange Hunters* and *My Life in the Bush of Ghosts*.

Jimoh Buraimoh, also from the 1964 intake, started off with painting but soon became interested in using beads with oil colours on board, and later moved into mosaic. He concentrated on heads, which bear some relation to Yoruba traditional sculpture, but also used symbolism to suggest various elements from his cultural background. He now explores the use of space in creating very interesting works, with strong use of colour and an intermingling of dramatic lines accomplished by using beads on threads. Recent works are much more exploratory, impressive and better composed. For his more successful works, his inspirations are derived from traditional Yoruba wood carvings and some other cult figures, especially in the portrayal of the powerful magnetic eyes typical of such carvings. Sadness, grief or mysterious contemplation create the atmosphere in most of his pieces. Currently, Jimoh is experimenting with a mixture of oil and Araldite (a fast-setting chemical adhesive) as a painting medium on board.

Muraina Oyelami was also discovered in the 1964 school; unlike the others, he was fortunate to have completed two years' study in a modern school after his primary education. This was quite an achievement at the time, but he could only get a job as a petrol station attendant. He claims it was Rufus Ogundele and Jacob Afolabi, his companions from Duro's group, who invited him to the school. His work is distinctive, despite the fact that one might have expected others in the workshop to

imitate Twins Seven-Seven at this time because of his fame. Unlike his fellows, Muraina at first showed little interest in Yoruba myth, portraying instead undefined figures; barely three years later, his style became completely non-figurative, with a very strong use of colour. Muraina now has a good job at the Institute of African Studies of the University of Ife, where he is able to continue with his painting. His style has changed from its earlier abstraction. His themes are centred on capturing man in his environment or man in the present; he can now be described as a historical painter. He places very little emphasis on drawing, but has a good sense of proportion and his forms are bold and decisive. He uses palette knives, rollers and brushes in achieving his effects on paper; he rarely paints on board.

Jacob Afolabi began as a painter (an early piece is a mural at the petrol station in Oshogbo), but really came into his own when shown how to make prints. He made a series of prints based on stories from Yoruba folklore. The oldest artist from the Oshogbo experiment, he has now finally settled at Oshogbo after travelling in many parts of northern Nigeria. Faced with many financial problems after his initial productive period, his works are now very few, and have not shown any major development.

Adebisi Fabunmi's early work was very similar to Muraina's, with whom he shared some aspects of style and technique. Like Muraina, he began with figurative art, and later went abstract. In 1969 he gave up painting in favour of printmaking, and continues as a full-time printmaker.

At a later experimental school conducted by Suzanne Wenger, students were introduced to cement sculpture. One result was the emergence of Adebisi Akanji and Buraimoh Gbadamosi, who had been doing some stone carving. The sculptural works at the Osun shrine today were produced through their efforts and under the supervision of Suzanne Wenger.

Just about the time that Ulli and Georgina Beier left Oshogbo, during the Nigerian civil war, another experiment geared towards discovering and using local artists started at Ile-Ife – the Ori-Olokun Art Centre, some 26 kilometres from Oshogbo. Unlike the Oshogbo experiment, the Ori-Olokun Art Centre had the financial backing of the University of Ife and some of the academic staff of the University were involved in the project. Akin Euba was in the music section,

Michael Crowder handled the theatre section, while Irein Wangboje and Agbo Folarin were principally responsible for the visual arts. Ulli Beier later joined the Ori-Olokun Art Centre, and along with him some of the newly discovered talents at Oshogbo were invited to take part. The new centre certainly helped to increase the fame and exposure of artists like Muraina. But by 1972, the Ibadan Mbari Club, the Oshogbo Club (by this time called Mbari-Mbayo), and the Ori-Olokun Art Centre had all closed down.

In general the period from 1970 onwards showed little or no development in terms of the quality of works produced by these and the other experimental artists. By this time they were no longer under any form of tutelage, and whatever they produced came from their personal visions and creative abilities. Many of them are interested in making money quickly through the sale of their works without any serious attempt to improve on the standard they were able to attain through the help of Ulli Beier.

Another major problem is caused by the inflow of tourists who have read or heard about the 'wonderful Oshogbo artists' and are keen on seeing them. During my stay at Oshogbo I observed that most of the artists resident there received no fewer than four foreign visitors a day. These all had to be entertained, often lavishly, in anticipation of publicity campaigns or purchase of works. Inevitably, there were several disappointments and invariably financial problems arose. It is not impossible, therefore, that five or six years hence only those who have incomes from other occupations and who still have a flair for painting will remind the curious about the one-time 'Oshogbo experimental art school'.

The Oshogbo school today exists only in name. Many people around the world still clamour to see Oshogbo and visit its artists, but this is probably due to its massive initial publicity and the quality of the early work. Individually all the artists are struggling, and many are near giving up. Those with financial problems (due to excessive spending, or lack of patronage, or the absence of any good-quality work to offer) blame those who are apparently more fortunate. The atmosphere is one of attacks, counter-attacks and petty jealousies. The 'spirit of oneness' which one would expect in a group of individuals with the same cultural background and upbringing is lacking among these artists. Perhaps they should all be

pardoned; in life one hardly achieves the ideal.

There is a so-called younger generation of the Oshogbo school. They number over thirty and are scattered all over the country. With the exception of David Osewe who hails from Bendel State, all the others are from Yoruba and are related to the initial students. Without the full knowledge of what art is, without any knowledge of the problems faced by most of their brothers, and deceived by their brothers' apparent affluence, these young boys from the ages of 17 to 25 no longer engage in any form of academic education. Most of them resident in Ibadan make batik and tie-and-dye works, while a few of them produce prints.

Conclusion

The rich arts traditions of Yorubaland provided a starting point for the execution of Ulli Beier's ideas and the development of the visions of the artists. The Oshogbo experiment was inaugurated after the western art world had begun to learn something of 'Africanness' in painting through Modigliani, Braque and Picasso, and remained curious to know more, acquire more and own more African art. This period also coincided with Léopold Sédar Senghor's proclamation of the Negritude philosophy, which many others have since professed since the early 1940s. Many writers were propagating the Negritude movement in the early 1960s in Africa, while artists in formal art schools were rediscovering themselves as well as their traditions and cultures.

Uche Okeke had to turn to his traditional Igbo culture. This gave birth to his *uli* style, which a younger generation – students past and present of the Nsukka School – are experimenting on with the aim of further discoveries. Bruce Onobrakpeya's artistic excursion into Urhobo traditional folklore has brought him fame as one of Nigeria's foremost printmakers, while Demas Nwoko went 2,000 years back to discover the artistic possibilities of Nok terracotta pieces.

What happened in Oshogbo was different: traditional culture was unadulterated and so, too, were the visions of the artists during their formative period. They had nothing to 'rediscover' – all they did was to put down sincerely visions which were based on the mythologies of their own environment. But they lacked the ability to express themselves verbally or to lead critics or

ordinary observers to their works. They knew little about why they were doing what they did until recently. It is difficult to believe, for example, that they were themselves responsible for the titles of their early works. Probably Ulli Beier produced the titles after discussions with the artists. In my opinion, quite a lot of problems emanate from the translations of these titles: if they had been left as the artists had intended them, they might have created another and a different point of interest.

Of Ulli Beier, one is inclined to feel that he believes an artist can be made of anybody who is willing to paint, and that academicism in art rarely produces better artists. It might be necessary to say here that masters like Michelangelo and Tintoretto were apprenticed in one *bottega* or another and never had any formal training in the modern sense. But they were under strict tutelage, watching their masters at work, producing what their masters felt they should produce, and not just what they wanted. At Oshogbo the near opposite was the case: Ulli Beier was a man of great vision, but he was no artist and never proclaimed himself to be one.

'Essentially a natural catalyst and impresario',[14] he did have remarkable promotional abilities. In less than six years after the experiment's take-off, Oshogbo as a town and its artists were topics of discussion all over the world, and this remains the case today. His exhibitions helped to carve a new status for these artists who might have passed through life in their former professions without any meaningful contributions to human knowledge. Awareness of the value of art has been rekindled in the minds of the Oshogbo people, increasing the number of those who appreciate some form of art in Nigeria. It would be pointless to emphasise, however, the unfortunate truth that most Nigerians today have not developed any criteria that would enable them to make critical evaluations of their own art.

This uncritical attitude is encouraged by non-African buyers who are always willing to purchase African works of art, not necessarily for their value but because they are African. It is rather unfortunate that the Oshogbo school in its latest stage has fallen into this trap. Rather than maturing in the sense of continued creative growth, the school today, such as it is, is a pitiably bad case of commercialisation.

Demas Nwoko describes Ulli as 'a missionary . . . a missionary in the sense that, like any other missionaries Africans are accustomed to . . . they do a thankless job'.[15] Chinua Achebe feels that 'Ulli Beier is an energetic worker who was able to produce something out of nothing.'[16] Uche Okeke considers that 'the experiment was rightly timed [in the sense that] it was inaugurated at a time when the world was looking towards Africa for a solution to world art problems.'[17] Bruce Onobrakpeya believes that 'Ulli Beier has done his best . . . it is too early to say his best is a success or a failure.'[18] He feels very strongly that 'the products of the experimental school and their works will finally tell the world at large the limits and delimits of Ulli's aims and achievements.'[19]

Much has been said about the Oshogbo artists without any knowledge of what they do when they work; this is especially true of their early years. One could ask which is more important – the finished product, or the process of realisation? Perhaps one could also ask whether intuition supersedes reason. Ulli Beier could be considered as a man interested in changing the course of history, most probably with an optimistic view.

I see a bleak period ahead for the school, although certain personalities do give me some hope: Muraina Oyelami, Jimoh Buraimoh and Adebisi Fabunmi are very devoted to their profession. The so-called younger generation is composed merely of extended family groups of the more famous founding students. I apportion blame for the present situation to the buying public, who care very little for quality; to writers, who are not critical enough, and to those artists who are prepared to cheapen themselves for financial gain. But perhaps these three groups should go unscathed, since Nigeria cannot as yet boast of serious art critics. With the present growth of art schools and the teaching of art history in the institutions of higher education, I foresee a time when serious critics will emerge, and serious writing will commence.

Finally, I hope that some day we will be able to tell the story not only of the Oshogbo experiment, but also of Nigerian art, in a convincing manner to the outside world. And if other countries in Africa can also do this, perhaps the puzzlement and mystery with which most foreign writers view African art will be solved. Only then will we be able to say with any real conviction that African art is revolutionising the art of the world.

Natural Synthesis

Uche Okeke

Zaria, 1960

Young artists in a new nation, that is what we are! We must grow with the new Nigeria and work to satisfy her traditional love for art or perish with our colonial past. Our new nation places huge responsibilities upon men and women in all walks of life and places, much heavier burden on the shoulders of contemporary artists. I have strong belief that with dedication of our very beings to the cause of art and with hard work, we shall finally triumph. But the time of triumph is not near, for it demands great change of mind and attitude toward cultural and social problems that beset our entire continent today. The very fabric of our social life is deeply affected by this inevitable change. Therefore the great work of building up new art culture for a new society in the second half of this century must be tackled by us in a very realistic manner.

This is our age of enquiries and reassessment of our cultural values. This is our renaissance era! In our quest for truth we must be firm, confident and joyful because of our newly won freedom. We must not allow others to think for us in our artistic life, because art is life itself and our physical and spiritual experiences of the world. It is our work as artists to select and render in pictorial or plastic media our reactions to objects and events. The art of creation is not merely physical, it is also a solemn act. In our old special order the artist had a very important function to perform. Religious and social problems were masterly resolved by him with equal religious ardour. The artist was a special member of his community and in places performed priestly functions because his noble act of creation was looked upon as inspired.

Nigeria needs a virile school of art with new philosophy of the new age – our renaissance period. Whether our African writers call the new realisation Negritude, or our politicians talk about the African Personality, they both stand for the awareness and yearning for freedom of black people all over the world. Contemporary Nigerian artists could and should champion the cause of this movement. With great humility I beg to quote part of my verse, *Okolobia*, which essayed to resolve our present social and cultural chaos. The key work is synthesis, and I am often tempted to describe it as *natural synthesis*, for it should be unconscious not forced.

Okolobia's sons shall learn to live
from father's failing;
blending diverse culture types,
the cream of native kind
adaptable alien type;
the dawn of an age –
the season of salvation.

The artist is essentially an individual working within a particular social background and guided by the philosophy of life of his society. I do not agree with those who advocate international art philosophy; I disagree with those who live in Africa and ape European artists. Future generations of Africans will scorn their efforts. Our new society calls for a synthesis of old and new, of functional art and art for its own sake. That

Uche Okeke
Nza the Smart
1958
Pen and ink
29.5 x 25 cm

Uche Okeke
Fabled Brute
1959/60
From the collection
of Ulli Beier

Yusuf Grillo
Untitled

the greatest works of art ever fashioned by men were for their religious beliefs go a long way to prove that functionality could constitute the base line of most rewarding creative experience.

Western art today is generally in confusion. Most of the artists have failed to realise the artists' mission to mankind. Their art has ceased to be human. The machine, symbol of science, material wealth and of the space age has since been enthroned. What form of feelings, human feelings, can void space inspire in a machine artist? It is equally futile copying our old art heritages, for they stand for our old order. Culture lives by change. Today's social problems are different from yesterday's, and we shall be doing grave disservice to Africa and mankind by living in our fathers' achievements. For this is like living in an entirely alien cultural background.

Demas Nwoko
Asele Institute,
Anambra State,
Nigeria, designed for
Uche Okeke

Growth of an Idea

Uche Okeke

Zaria, 1959

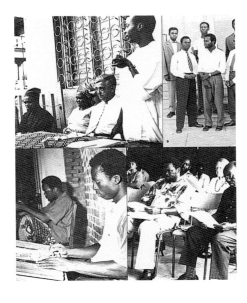

Top left: Mbari Artists' and Writers' Club, Enugu, 1964.
Top right: members of the Zaria Art Society, 1960. Left to right, front row: Bruce Onobrakpeya, Simon Okeke, Uche Okeke; back row: Odechukwu Odita, Demas Nwoko, Oseloka Osadebe.
Bottom left: Uche Okeke and Bruce Onobrakpeya at work in Lagos in preparation for the 1960 Independence Exhibition.
Bottom right: at the Symposium on Contemporary Nigerian Art, Continuing Education Centre, University of Nigeria, Nsukka, 1976.

It is about a year ago, on 9 October 1958, that the inaugural meeting of the Art Society was held. Like all great organisations, its inception was as humble as it was stormy. And we, the inaugurators, breasted it all with indomitable courage, striving with all our might to have the Society well grounded, not minding the many and varied obstacles put in our way. In the face of all these initial difficulties I think and hope the Society will grow from strength to strength, preparing the way for what may yet be a great organisation of national significance.

Our discussions on art generally and on our culture, and our great devotion to the study of African art idioms and art forms, are all of immense value to us and have opened up new worlds of thought to us all. We now are aware of the fact that our art should be based on our past, present and possibly on our future ways of life in this country. In all, we are fully aware of our responsibilities as Nigerian artists. We know that art is a fallow field in this country and one that has unfortunately suffered from the hands of the shortsighted schemers of our inadequate educational system. The unfortunate position into which we are thrown calls for hard work, and we have right from the beginning dedicated ourselves – our very beings – to champion the cause of art in Nigeria and, indeed, in Africa. In our difficult work of building up truly modern African art to be cherished and appreciated for its own sake, not only for its functional values, we are inspired by the struggle of such modern Mexican artists as Orozco and his compatriots. We must fight to free ourselves from mirroring foreign culture. This great work demands willpower, originality and, above all, love for our fatherland. We must have our own school of art independent of European and Oriental schools, but drawing as much as possible from what we consider in our clear judgement to be the cream of these influences, and wedding them to our native art culture. We shall be found out if we shirk the great responsibility of working out this experiment to the best of our ability.

It would appear as if the Society achieved nothing during its first year of existence. I personally hold the view that much was accomplished. The Society received wide recognition, governmental and otherwise; a number of the Society's members were recipients of prizes in art competitions – for example, the Gotstchalk Textile competition and the Esso National Art Competition for Independence Calendar; two member of the group held successful art shows in Jos Museum and at Ughelli; every member, I hope, carried art home to the people by explaining its importance to societies both old and new. Much research work was done by individual members and these were of immense benefit to us all. The Society was able to make plans for the exhibition of works of members and for the publication of its first magazine. All these and others I cannot now enumerate are achievements we must not overlook.

I am particularly happy about the spirit of comradeship which marks out our society – a spirit born of mutual trust and understanding of our common interest. I need not belabour you with sermons on the untiring efforts of executive members who spared time and labour for the general good. It is my wish that we continue wisely; that we hold fast to our noble ideas and ideals; that we get even closer together, pooling our experiences and financial resources together to attain our golden goal. In spite of financial setbacks, I am fully convinced that we shall rise supreme above this situation – we shall rise if we have the will and courage to dare.

The future, we must persuade ourselves to believe, is bright – it is not bleak. We have no reason to think otherwise, more so when national independence is fast coming. In future years, after October 1960, our firmament shall broaden. Foreign visitors and

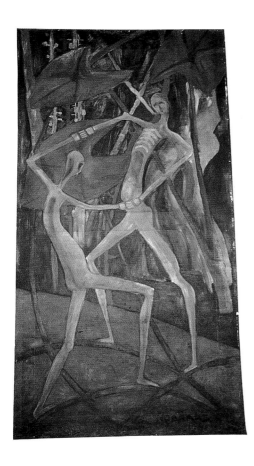

Bruce Onobrakpeya
1961
Painting
Zaria

enlightened Nigerians alike shall increasingly wish to study and appreciate contemporary Nigerian art. We must not live always in the past – exhibiting Nok, Igbo Ukwu, Ife, Benin and so on, glorifying the past to the detriment of the future. We should love the past, if we may, and get our inspirations from it. Our present efforts shall, in the process of years, be looked back to as of the past.

We shall strive to play our parts creditably in the Nigeria Exhibition to be organised by the Federal Government to coincide with the independence celebrations next year. We shall have our first art show and work together to produce the first number of our society's magazine. When we put our thoughts into action and produce effects, when we toil for the cause of art, we must realise that we are making history. We must therefore have faith and trust in our ability to search for knowledge and truth.

Jimo Akolo
Horseman
1954
Zaria

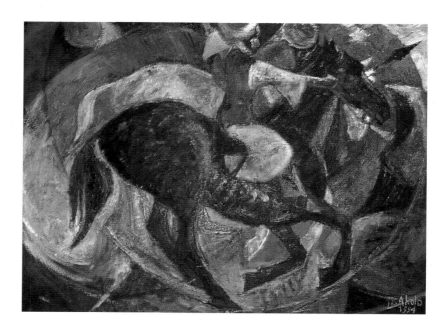

Manifesto

The Society believes in the freedom of the artist to use his varying experiences for the benefit of mankind. Such experiences embrace the whole of human imagination – deriving, for example, from such phenomena as nature, tradition, science and technology.

While it acknowledges the presence of tradition in all societies it is aware, however, that every society is affected by cultural changes. These changes may be brought about or are influenced by the culture of others. It is insincere, therefore, for an artist to pretend not to notice these changes and to insist on portraying his society as if it were static. The Eye believes that the visual arts provide the forum whereby the dynamism of culture can be appreciated. Thus the Society does not expect artists to be tied down to mere local expectations to the detriment of other dynamic cultural developments of mankind through art. It identifies the seeming absence of progress in most developing nations as a resultant effect of such self-limiting methods that usually are propagated by those who often wish that artists chart a direction purportedly national in appearance but essentially parochial. In the present African and Nigerian circumstance, the Society believes that the artist should not be seen to propagate artistic narrow-mindedness.

The Eye Manifesto

Jacob Jari

1959

Objectives

The projection of the visual arts as an instrument of development of the society.

The documentation and analysis of developments and history in the visual arts.

The promotion of community projects in the area of environmental aesthetics, arts and crafts through workshops and other activities involving members and selected communities from time to time.

The organisation and promotion of exhibitions, workshops and symposia.

Jacob Jari
The Eye
1993
Cornstalks on board
55 x 55 cm
Collection of the artist

The Eye Society

Jacob Jari

The artists who trained at the Zaria Art School had always, it seems, been destined to fight, either collectively or individually, to survive one setback or another. In 1957 a rail accident at Lalupon killed almost all the passengers, who included several of the Zaria art students returning to school. Some of the students survived to wage and win a campaign to obtain recognition for their art programme from the Slade and later from Goldsmiths' College, London, to which they were eventually affiliated in 1958. The following year the Zaria Art Society was founded. According to founder-member Professor Uche Okeke, its purpose was to inculcate in members the need to 'realise in practical terms deeply felt ideas, ideas that bear relevance to . . . contemporary time and place,' as opposed to merely copying nature, as was imposed by their European teachers. Such had been the struggle by the future members of this society that they had been in the habit of creating two sets of works – one to satisfy their teachers, and the other to satisfy their own quest for an expression rooted in individual experiences and nurtured by cultural specifics.

It appears from the list drawn up by Professor Okeke that about eleven students became members.[1] One of them, Jimo Akolo, now a Professor of Art Education, later left the group. The zealousness of some members led them to believe that they should completely ignore their European teachers, whereas Akolo felt strongly that part of what he was being taught was necessary to his search for a personal expression. He was prepared to risk isolation from the group rather than expose himself to any deficiency in technique. He has continued to use the skill he acquired in drawing and design to execute what Mount refers to as 'intricately constructed pictures'.[2]

The contribution of the remaining members of the Zaria Art Society – also known as the Zaria Rebels – to the development of Nigerian art is immense. Much has been written about many of the members, and how their work has influenced the mode of expression of many younger artists. Professor Okeke, for instance, admits: 'The so-called Nsukka school has its roots deeply planted in the rich soil of the Zaria Art Movement of the 1950s.' In the two decades that followed, nothing could compare in importance to the founding of this society; perhaps the civil war of the 1960s and the oil boom of the 1970s tempered the commitment of artists to their profession.

In 1989 another society, The Eye, was founded in Zaria: the members are Jerry Buhari, Matt Ehizele, Gani Odutokun, Tonie Okpe and the present author. The Eye was founded out of a need to address some obvious threats to the development of the visual arts, particularly in Nigeria. The country's economic crash in the 1980s and the subsequent unsolved problems have given rise to a monstrous game of money-chasing by almost every citizen, including artists. There is also increasing expectation locally for artists to create distinctly African art works which must draw on tradition. This, unfortunately, coincides with a growing interest in the west for collectors to acquire kitsch. The most effective method of generating kitsch art, western connoisseurs have discovered, is to collaborate with some indigenous galleries to 'elevate' Nigerian contemporary art to kitsch. In return for guaranteed sales, owners of many established galleries pay handsomely for artists to produce exactly what they prescribe – essentially, eviscerated works which are immediately shipped to the west.

It is common knowledge that these galleries reject many works on the grounds that they are not marketable. Times in Nigeria are really hard: for artists to survive they have to produce saleable works – and this means, largely, saleable in the west. Now, in Zaria, some artists are again resorting to the tradition of producing two sets of work, one for the galleries and the other out of 'deeply felt ideas'. Philip Gushem confirms that one gallery in Lagos would prefer him to paint trite, postcard-like pictures on themes such as Fulani maidens and stilt dancers, rather than his conceptualisation of the Zaria landscape.

Members of The Eye regard this development with great concern. The consequences of elevating decadence to a commercially viable commodity can be horrendous. It has power to eclipse all creativity, and create a different set of parameters for aesthetic evaluation. For instance, western connoisseurs will advise African artists not to attempt to produce works in the manner of the international art scene, because such works – regardless of their efforts and *without exception* – will be distinctly inferior! One of The Eye's major objectives, therefore, is to undertake a massive but gradual education particularly of the Nigerian public, so that they may learn to appreciate creative contemporary art irrespective of what

inspires its production, as well as to build confidence in the artist to continue producing works based on 'deeply felt ideas'. The society believes that this will lead many more Nigerian art patrons to emerge, demanding creative works. It also believes that only when artists are free to produce what they believe in can they make a meaningful contribution to the development of their society.

As a first step, the society is publishing its own biannual art journal, *The Eye*. The first edition came out in December 1992. However, the journal is constantly under threat from the extremely high cost of production: only our determination to succeed has kept it in circulation. Each member is totally committed to the emancipation of the Nigerian contemporary artist, and this commitment is visible in their individual choice of expression.

Jerry Buhari held a solo show in 1989, and has continued to experiment with different forms and motifs in the hope of discovering new directions. At several group shows he has portrayed great diversity in technique and content: paintings range from those created by spilling enamel paint, to acrylics in a very austere palette, to miniature watercolours. He is, however, more popularly known for his floral studies. In these, he excites different emotions through the harmonisation of the shapes and colours both of human figures and of plants, in an environment overwhelmed by the presence of various-hued petals and a strong source of light. His commentaries lament the deplorable nature of some of his country's social institutions.

Matt Ehizele is now identified with mild steel welded sculpture, a medium he has been exploring for over a decade. There is much in common between the viewers' response to his sculptures and that of watching puppets. The skill involved in the creation of the steel structures is taken for granted, and their emotive powers accepted as almost natural. With very few rods and even fewer joints, Ehizele expresses a wide range of themes, sometimes inspired by rural or royal life.

The paintings of Gani Odutokun are a reflection of his philosophy of life. His exciting colour-splash landscapes are embellished with linear motifs through a method he calls 'accident and design'. Odutokun sees world cultures being brought together by ever-greater achievements in communication – such achievements, and even existence itself,

are possible through accident and design. Using a technique which he has perfected since 1977, he pours liquid colour on the canvas to begin a symbiosis of accidental flows with directed ones. These eventually culminate in a picture that can be representational or non-representational.

Destitute people have formed the subject matter of Tonie Okpe's sculptures for a long time. Usually he portrays them in single-figure compositions, symbolic of their loneliness. They are generally stylised, with varied shapes that are sometimes biomorphic abstractions which enhance the three-dimensionality of the forms. Okpe focuses the greatest attention on the figures' hands, which play a major role in begging: the manner in which hands are held will often determine the degree of sympathy, and hence the donation, that can be elicited from the public.

The present author has recently been using cornstalks as tools with which to paint. Objects discarded after the harvest, their usage connotes a second harvest: the process of creating pictures with them re-echoes this second harvest. In a sense, it is an attempt to convey the belief that Nigeria's terrible state of affairs today can be corrected by the values and the very people that have been discarded.

Jacob Jari
Reaching Out (detail)
1993
Cornstalks
53 x 50 cm
Collection of the artist

Mu'azu Mohammed Sani
In the Grave
1993
Collage (mixed media)
90 x 60 cm
Collection of the artist

The Expense of Expression

Jacob Jari

In March 1994, the Kashim Ibrahim library of Ahmadu Bello University, Zaria, perhaps the biggest library in black Africa, was shut down, on account of a painting by Mu'azu Mohammed Sani. The painting portrays a cross and a minaret. On the cross hangs a banner on which is written, 'I love Prophet Muhammed,' while the minaret's banner reads, 'I love Jesus Christ.' Apparently irked by the notion that Mohammed could love Christ, a Muslim fanatic studying physics attended the exhibition at the library and attempted to destroy the painting. The scuffle that ensued between those in favour of and those against his action led to the library's closure for three days, while negotiations on how best to cool down tempers were carried out by interest groups including the Muslim *ummah*. What saved the exhibition and the library from any further calamities was the fact that the painter was himself a Muslim.

recollections

from senegal

From *Ce que je crois*

Léopold Sédar Senghor

1988

During the 1930s, when I was a young teacher at the Lycée Descartes in Tours, I would often spend my weekends and short holidays in Paris. There I socialised more with the artists in the Paris School or, if you prefer, the Cubist movement, than with poets and other writers. More often than not, these were young, little-known artists, and foreigners, like the Spaniard Pedro Florès, who illustrated my first collection of poems, *Chants d'Ombre*. The Café Flore on the boulevard Saint-Germain, was a regular haunt of ours and I occasionally saw Jean-Paul Sartre there. As most of these artists were Mediterranean – Italian, Portuguese, Romanian and especially Spanish – one or other of them would occasionally suggest, 'Why don't we go to see Picasso?' He lived nearby, two or three streets away.

I still remember Pablo Picasso's friendliness, seeing me to the door as I was leaving and saying, looking me straight in the eye, 'We must remain savages.' And I replied, 'We must remain negroes.' And he burst out laughing, because we were on the same wavelength. The artists in Paris were well aware that Cubism or the Paris School had drawn its inspiration primarily from black African art. It was no coincidence that this school of art sprang up in Paris at the same time as Surrealism, or that it was Tristan Tzara, again, who best described it in his book on Picasso: 'In this artist's works,' he specified, 'the surface elements, the solid masses, are arranged in such a way as to dispel the illusion that the flat surface of the canvas has real depth.' In other words, he had done away with the effects of perspective. And if the result of this, as in the case of negro and surrealist poems, was to move the spectator or listener deeply, it was because it had appealed to their emotions and, going deeper still, had touched their mystic soul.

As for Mother Africa, the reason why the Senegalese painters of the present-day Dakar School won such acclaim, not only in Europe, but above all in the United States, was that they had stayed true to the black African aesthetics of 'rhythmical, melodious and analogical images'. As André Malraux told me at the inauguration in Dakar of the Premier Festival Mondial des Arts Nègres: 'You have, here, in Senegal, five or six artists who can match the greatest European artists for stature.' I am thinking of Ibou Diouf and Papa Ibra Tall, of Bokar Diong and El Hadji Sy. These painters have done away with the effects of perspective in order to play on colour, on colours: a tapestry by Papa Ibra Tall which hangs in my house in Dakar contains as many as ten different hues.

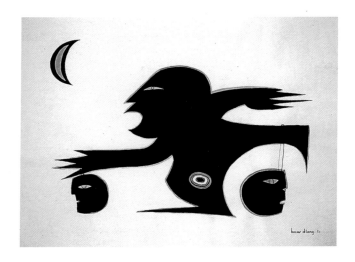

Bocar (Pathé) Diong
Nightwalker
1980
Ink and watercolour
on paper
50 x 65 cm
Private Collection

The Painters of Poto-Poto

Pierre Lods

Second Congress of Black Writers
and Artists, Rome, 1959

This unprecedented century has already heaped on us unimaginable atrocities, incurable wounds to the body and soul, as well as unexpected and splendid passions, These heaven-sent rewards in the realm of human endeavour are of a kind which were not foreseen by our western forefathers, entombed as they were in a coffin-like humanism by the study and inner contemplation of dead civilisations which they believed to be irreplaceable in their distant glory. Ashamed, we have stomached both the disclosure of the unexpected, violent and degrading bestiality of nations that were alleged to be the most civilised on earth, and the proof of the subtlest intelligence and the most sophisticated cultural techniques from peoples accused of the most primitive barbarism.

This will be one of the hallmarks of our times. 'A new romanticism is on the way. I am not waiting for it, I am its herald,' said Léon Moussinac in 1940. Decent modern people, freed from their complexes and filled with wonder, can now carry out a cultural survey of humanity, assisted by easy travel and technical methods of reproducing pictures and sounds. No pleasure is more intense than that of comprehending the true nature of your time, and contributing to it.

The unforgettable camaraderie between members of different social groups in the *maquis* during the wartime occupation of France opened my eyes to the futility of class prejudice. And, if I had been racially prejudiced, it would not have survived the revelations of my stay in Africa. I will never forget a night of conversation with an old fisherman from Sangha while our paddle-boat was stranded on a sand bank, and the question he put to the 'omniscient and naive' white man: 'Where does this road come from, which has advanced since my birth and since the birth of my father and since that of my father's father?' His French was basic, my *lingala* derisory, but our fierce need to communicate and the fact that, according to Mezz Mezrow, 'the air was teeming with things we would not have missed for all the world,' made us so receptive that words were almost redundant. I understood the meaning of what he added about the myths of his tribe to my overly rational explanation for the cycle of water . . . An angel passed by . . . 'Same for water, same for men,' said the fisherman from Sangha, his words reflecting the tenets of a higher philosophy, that 'everything is circle and sphere'.

So I developed a different way of looking at the world; my understanding of Africa

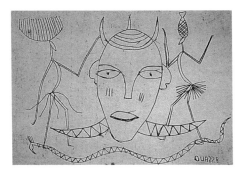

and my involvement in its actual life date from that night. I was on the road to my 'future education in Poto-Poto'. I will never forget my servant Ossali's pleasure when I found him, after two days' absence, painting blue birds on an old navigation chart from Oubangui. They were disturbing and comical, these birds, shaped like knives being thrown; they had a presence similar to that of the finest African masks. I had never seen anything like it in any area of African art, but they were unquestionably negro – by the effectiveness of their impact, and the sense of greatness and magic that emanated from them.

The next day, Ossali painted a scarlet mountain against a black background, in oils. Above, five red lines represented a palm tree, like an open hand, the same thing repeated twice below. The brush was trailing some black into the red – in answer to my remark and advice to prevent what I believed to be a gaffe, Ossali replied, 'But it's more beautiful like this!' And he was right. We had the most mysterious mountain in Africa, overflowing with life and death, visionary and alluring. This was my first lesson in silence and respect and, afterwards, one of the key principles of my technique.

During the following days, young brothers, cousins and friends tried their hand. I brought everyone to my house, to my hut–studio in Poto-Poto. At first there was a glut of talent, a squandering of ideas, a breathtaking flowering of inspiration, a paradise of colours, joy and song. Paper, cardboard and canvas, a sacrificed sheet, boards, walls, windows and doors were all covered with gesticulating people, hunting, dancing, at the market, fishing, in battle; with birds, insects, fish, plants, masks, incredible heads – at times everything was all mixed up together. There were no flowers or arrangements of objects that one might call a 'still life' – not a hint of that at all. And all of it, although clumsy to begin with, displayed harmonious colours, was well composed, teemed with inventions as if by miracle. In short, it was an omen presaging the imminence of a genuine style of painting, far removed from the obsessions of the Musée Imaginaire. I was moved to tears, fascinated, unable to sleep for several nights. I dared not say a word for fear of breaking the spell...

That first sleepless night when the possibility of assisting at the birth of an art was taking shape, I wandered feverishly through the huge village of squares under the palm trees of Poto-Poto, whose life was already a fantastic and fully realised opera. It was absolutely essential to channel this rich source of painting, to help it blossom, to draw attention to it. I thought back over that past year in the bush, to the sympathy and the welcome which had made me feel part of life in the villages everywhere. I had jotted down a dialect and the finer points of its grammar ('a beautiful language is a collective and unconscious masterpiece,' said André Demaison). I had recognised its timbre on the drum, I had been overwhelmed when I was able to understand some words and repeat them. I had been initiated into the *balafo*, to hunting and fishing, and later into even more prestigious ceremonies. In the evenings I had attended dances and storytelling events which became first a type of theatre, then a ballet – in the end I could not tell the actors and the spectators apart.

One morning, a dance chief led me to seven secret drums in a thicket behind a village: the ones that are heard, but must not be seen. On another occasion, a medicine man took me to a remote place in the forest to see the hanging remains of masks and statues which were rotting, eaten away by termites and the damp, never to be replaced. You can imagine the infinite sadness of these memories. And because, in the words of Roger Erell, architect of St Anne in the Congo, I had nothing to sell and nothing to buy, to assuage my guilt I promised myself that I would devote myself to protecting this art, or at least its living spirit; that I would help it to adapt to modern life in Africa. The start was decided by that fortuitous, unexpected explosion of talent among Ossali's companions.

Friends of mine, M. and Mme Pepper, who were devoting themselves to studying and recording African music, introduced me to the Director of Social Affairs. I explained my ideas to him. An intelligent and cultivated man, he understood and approved of my plan for a studio–museum, and helped me have it built using the country's materials. It was mainly a large, steeply sloping roof made of dry palms and supported by palmyra pillars; below it was a veranda and two adjoining rooms. It was completed in 1951.

Meanwhile, the painters had gone their separate ways. Ossali had disappeared, lured away by a man touting for workers in Gabon. I had to drum up support, to try out beginners. In a few days the studio was full. The miracle happened all over again! In two months, we had over a hundred paintings and mounted our first exhibition in Brazzaville, which was quite an event. An unbroken series of exhibitions followed: in Johannesburg, Pretoria, Salisbury and the Cape in 1953; in New York in 1954 and 1955; in Hamburg in 1956; in Switzerland and, finally, in Paris (at the Institut Pédagogique National) in 1957.

Max-Pol Fouchet said in 1952 at the first exhibition in Paris (at the Galerie Palmes): 'by the same token, battling Africa is taking part in the game. Spontaneously, because this time round it feels free and respected. And so we have an art which is like a breath of fresh air. Obviously, it has not come out of nowhere; that could not be. The African civilisations are represented very strongly here, mindful of signs. The ornamental motifs of the hut in the bush or the forest, those of the tam-tam or the ritual object crop up, rewritten in gouache made in Paris. Fortunately, a consistent style runs through it – in other words, the way people represent, not life, but the meaning they give to life. So, in one fell swoop, the "savages" get to the heart of aesthetic truth. They flatten the termites' nests of error. Faced with the absurd expanses of *trompe-l'œil*, which is more seriously a *trompe-l'âme* and a *trompe-l'homme*, they open your eyes, cleanse your soul, release mankind from its fetters.'

In *La Gazette de Lausanne*, Charles-Henri Favrod described a similar experience in Elisabethville: 'This freedom is a liberation. Unfettered images emerge

from the depths of time, from times of fear and death, and they appear at a time of contempt which they will end up by conquering.'

Due to this prodigious and unbelievable array of spontaneous talent, I was able to make a particular choice and hold only on to the painters who immediately displayed natural qualities of drawing, composition, harmony and imagination. This enabled me to avoid interfering, except to bolster up the artists' inner resolve, to encourage them or rid them of their doubts, to hand out materials and give them vital instructions as to the use of colours, brushes and the medium to employ, paper or canvas.

Our beginners were so talented that they were able to focus on various branches of the visual arts. This was my first plan, but we were too quickly overwhelmed by all the possibilities afforded by painting; we had to bide our time until funds, brought in by our successes, allowed us to expand.

For fear of fire, I decided not to collect works of art which were too good in the thatched studio. We put the idea of a museum on hold until we were able to build a permanent structure.

To fuel the painters' inspiration, I surrounded them with traditional African objects, and I organised festivals in the garden which boasted a wide variety of plants. We sometimes read African legends, proverbs, and poems which I felt were connected with the black world or which shared the same values (Senghor, Césaire, Saint-John Perse, Michaud, Prévert ... The infinite number of possible experiences, in a population where everyone was an artist, is the main reason for the success of the Studio at Poto-Poto.

It would have been impossible if I had been lumbered with pupils, albeit very gifted ones. We would have had laborious work, maybe even some excellent homework 'by students in class, not on their break' (Max-Pol Fouchet). For those people, colleges of arts or crafts are necessary. We do not want to compete with them, but to provide them with ideas; our collaboration can be effective and beneficial, but only on condition that their directors do not take umbrage at the anteriority of our successes, and do not grow stale in paths that are different from our researches and renown.

Our ambition is not to set down an eternal and unchanging method. This is merely a phase, a gesture, the harvest of a season of culture ordered by the chance conditions of the real life of young Africans; for the possibility in store of a future return to their roots. On the contrary, once our experience is rounded off by an experience shared by all the arts, once it is played out, protected and preserved, we must hope for the introduction of a universal culture in Africa, to counterbalance the impact of western civilisation's contrivances and inevitable bad influences. When confronted by a young girl from Poto-Poto who seemed delighted with the pink and blue images of tawdry religious souvenirs, I showed her, to prepare for her 'cleansing', some *bakouele* and *mpongwe* masks, followed by Raphael's most beautiful religious paintings.

André Parinaud has written: 'contemporary taste has undergone a prodigious change and has been enriched by all the sensibilities of the past.' And by the present ones of other races, one would like to add. One can predict with certainty that, even if western culture did not start with the influence of black Egypt (something which no one has yet dared discuss publicly with Cheikh Anta Diop), world culture, which has recently been given a new lease of life by African art, will be assimilated by Africa and given back to the world, newly dynamic and resplendent.

Thango
*Esprit des Poissons
du Congo*
Collection ADEIAO,
Paris (MAAO)

Ouassa
*Un masque, deux
danseurs*
Collection ADEIAO,
Paris (MAAO)

Pierre Lods
Dakar, April 1987

The Painters of the Dakar School

Issa Samb

1989

When the history of contemporary visual arts began, Léopold Sédar Senghor was the only black African writer to show a keen interest in visual artists as a critic and patron. He believed that the way forward for this type of art was not to deny the contribution of western civilisations; but, by yoking tradition and invention, to use it as the medium through which a struggle between intellectuals deeply attached to the seductive myth of 'evidence' would be expressed. This predilection for evidence was at the root of the final confirmation that African art stands in a paternal relationship to modern art, at least with regard to form. It also generated various ambiguities which, regardless of its much-vaunted determination to watch over the development of visual arts and artists' social conditions, were to bring about a situation in which creation and the market were made to work for the state. These ambiguities also prevented the growth of a forum for creativity and reflection on political, ideological, aesthetic and technical issues, and influenced the social and material existence of visual artists. This liking for evidence, in short, prevented all critical and open discussion of the works and the conditions governing the status and promotion of the painters.

In 1966, the history of visual arts in Senegal was still being written. During the eighties, its main protagonists could be seen gradually sinking deeper and deeper, in a social and material situation which was difficult for others to appreciate.

Sérigne Babacar Sy, researcher and aesthete, put a central question: 'Senegalese contemporary arts are beautiful and vivid but, paradoxically, the society they mirror is in crisis. This is unquestionable. In my opinion, there is one decisive criterion if you are to judge the visual value of a work, and that is to ask yourself whether, in the society from which this work of art comes, the artist is socially respected and has the physical and statutory resources to express himself freely.'

The answer is conclusive for the material life of visual artists: the point is that there are people, painters, who have no professional status, but who are in some way 'in contact' with the state, its institutions, its problems, its fears and attacks on it made by the people.

These painters create a forum for self-expression which is a completely alien environment, totally cut off from their own environment. In this social isolation, their work is materially restricted, consisting only in producing an often abstract 'universality'. There is no link between the life of a painter in the Dakar School and his concern for his society, apart from the idea of a function divorced from what forms his personal and most private work, an idea which results in an automatic separation: on the one hand, the painter for his colleagues and, on the other, the 'social' worker for the state. Here, the feeling of being a creator is divided: the artistic act itself does not generate it, and the created product is not realised in a state of passion for visual truth. The artist's distressing situation brings about a frame of mind which is linked, in some way, to the spiritual life of the individual but in contrast to his superficial, material needs. This situation is comparable to the one which contrasts the artistic ideal with the anxious response of a material life which has been wasted and which is therefore essentially at one remove from any ontological considerations.

Here, 'social' work is placed side by side, in an abstract manner, with genuine artistic work, a sign of the lack of a synthetic relationship between the artist and himself, between inspiration and material, spiritual and physical reality, his 'social' life and his work as a painter.

Unable to have a real social life, based materially on status, he does everything he can to make his work an arena in which the spirit is merely the empty expression of a universal functionality. However, the conclusive objection is not to do with this. Instead, it is to do with his relationship to a life which calls for the use of knowledge, where there are nothing but manipulative, mechanical abilities, even often a simple method of seemingly escaping the reality of a spiritual and material life to which he is obliged to sacrifice himself and on which he must confer a subject matter – since, if he is a painter, it is because the problem of spiritual existence and life is in his eyes more pressing than social and material problems.

Finally, and this is an unmistakeable pointer, this artistic endeavour has not generated any revitalisation of the very idea of social work and its appreciation by the public: the work of an artist is not social work, it is a collection of individual acts, some falling within the province of professional workers on the fringe, depending more or less on the charity of the state or the hypothetical sale of a

painting, others of low-ranking civil servants. Up until now, artists have not succeeded in conveying the practical need for status, so that they have never managed to form a serious, autonomous movement or school, but only a very mixed group in which a taste for beggary goes hand in hand with self-interest. This professional spirit, which has created a deep rift between the conscience of some people and that of others, was not born in the so-called Dakar School group. The idea of serving art is a human duty, not a case of artists performing an incidental function which, correctly, demands all or nothing. This attitude, which was generated by the ideas of the artists in the Village des Arts, centred around the Tenq[1] and in the most representative artistic confraternal groups, caused the failure of the attempt to organise the various trends into a genuine socially creative group. The desire for an artistic movement was there, epitomised by the lack of a solid basis for social work. If the painters were unable to give concrete shape to all that 'desire' (an example is in the Cité des Arts), this was because the 'will' could not be bent towards the whole. There were many attempts which displayed the symptomatic significance of minutely rehearsing, within their field, their professional habits in the service of their ethnic group, the marabout, the priest or the state who renounced them. There was a distinct schism here between art and the artist's social and material life. Confronted by all the egotism, by everything that makes social life overall a reality which speaks for itself, the painters have created a sort of life of exile or sanctuary for themselves within their field, but it lacks radical doubt, basic criticism, the necessary reappraisal of a concept of art which makes the artist a beggar or pariah.

Far from bringing a well-considered intellectual or artistic determination into play, the painters are following in the well-trodden footsteps of writers or politicians. The latter, with the exception of Léopold Sédar Senghor, have not in the least considered the real issues surrounding painting and the social life of painters.

However, when it is a matter of getting to the heart of society's problems, the Dakar School, in its self-styled apolitical minority, has not set any participatory or courageous act in motion, but instead hypocritically has several strings to its bow, which are both deceptive and misleading. Its activity is dangerous in so far as this attempt aims, while claiming to be representative of Negritude, to pass itself off as a fighting force for fashionable political activity.

In fact, the painters are now missing from the forums where, socially, decisions are made. They are no longer fighting an intellectual war side by side with the poets, scholars and writers. Formerly children spoilt by the state, most of the painters are still following in the wake of a political idea and are also torn between an idea that public opinion has formed of them and the call of artistic inspiration.

Today, painters are affected by professionalism, this 'distortion' of the creative spirit into a workmanlike spirit, which sets them apart from a creative spirit which does not beg and which has not been pressed into public service. This ambiguous situation is the symptom, as painful as it is obvious, which arouses contempt for any attempt at research and free art that is unrelated to the state. The state gives the illusion of providing various services which, in fact, it is unable to do; it is orchestrating a battle between hyena and donkey. This encourages the painters in their behaviour as minors, precluding total devotion to painting and self-sacrifice in favour of a new generation, one that is socially qualified for the freedom demanded by art.

Iba N'Diaye

Modou Niang
1975
Tapestry design

Cheikh Cabibel
1977
Drawing
Early work from the
years with Pierre Lods
Collection of Axt/Sy

Bocar (Pathé) Diong
*Advertisement for
tapestries from
Manufactures
Sénégalaises*
1966

The Role and Significance of the Premier Festival Mondial des Arts Nègres

Léopold Sédar Senghor

Address, Dakar, 1966

*Negritude has only one ambition –
to contribute to twentieth-century Humanism.*

We are deeply honoured on the occasion of this Premier Festival Mondial des Arts Nègres to welcome so many talented people from the four continents: the four horizons of the mind. But what is an even greater honour for us, and one which does you the greatest credit, is the fact that you will have participated in a much more revolutionary undertaking than the exploration of outer space: the development of a new brand of Humanism which, this time round, will include everyone on this planet. So Senegal, led by Dakar, is fulfilling its vocation by welcoming you, its distinguished guests. Dakar, a black ploughshare cast into the teeming ocean, has always answered the call of the trade winds and acknowledged the greetings of visitors by sea and air, in order to enter into the dialogues which give birth to civilisations – at any rate, to culture.

We are all here together. Ethnologists and sociologists, historians and linguists, writers and artists – your task will be to find, to explain, the role of negro art in the life of black people. Its role, in other words, its symbols, and even more importantly, what lies beyond the symbols: their meaning. Today, as a veteran fighter for Negritude, I have a more modest aim: to explain not so much the role and significance of negro art (I have already tried to do that elsewhere), but the role and significance that this festival has for us Senegalese. In short, the reason why we have shouldered the incredible responsibility of organising this festival is the defence and celebration of Negritude.

Defence

People, here and there, all over the world, continue to deny negro art along with Negritude – in other words, negro values of civilisation. Then, when they are unable to deny negro art any longer because it is so unmistakeable, their aim is to detract from its originality, its human truth.

Negro art has been denied ostensibly because it has taken so many different forms. In fact, if it displays a high degree of unity, this is due to the diversity of its subjects, its genres and, indeed, its styles. Similarly, European art, below its Italian, French, German, Russian or Swedish features, shares some of the characteristics of Graeco-Latin civilisation, of discursive reasoning prompted by Christianity. European art, despite having been rocked by frequent revolutions, remains the same as it always has been, in terms of its basic features. Negro art possesses an even higher

degree of unity because, although its role has always been to actualise its subject, its nature, on the other hand, has always been to portray this subject using unchanging symbols – the same underlying style involves the *stylisation* of the subject.

As a result, it is impossible to deny negro art for long, particularly as it was Europeans who were the first to discover and define it; black Africans preferred to experience it. It has been championed by leading European artists and writers, from Pablo Picasso to André Malraux, whose attendance here I welcome as convincing evidence. And this is not to mention the black writers and artists from Africa and America who, in the interwar years and after 1945, compelled recognition in a world which was badly fragmented and therefore searching for unity, for authenticity.

So, because people were unable to deny negro art, they wanted to minimise its originality under the pretext that it did not have a monopoly on emotion, or analogical images, or even rhythm. And it is undeniable that any true artist is endowed with all these gifts, whatever their continent, race or nation. For all that, it took Rimbaud to identify with Negritude, Picasso to be stirred by a *baoulé* mask, and Apollinaire to sing of wooden fetishes before western European art could accept, after some two and a half thousand years, the relinquishing of *physeos mimesis*, the imitation of nature. To a large extent, negro art is to blame – a fortunate and, in any case, productive burden of guilt – if western artists now

draw their inspiration, like Bazaine, from the 'most obscure labour of instinct and sensitivity'; if, like Masson, they define a work of art as 'a simple interplay of legibly ordered forms and values' – in short, a simple rhythm, 'a play of forces', as my friend Soulages would have said, because rhythm is the harmonious, and consequently meaningful, movement of forms.

Celebration

It is not simply a matter of defending the negro art of the past, examples of which are being exhibited today at the Musée Dynamique; it is more a case of celebrating it, by demonstrating that it is, in the mid twentieth century, a torrential and inexhaustible source, an essential component of the Universal Civilisation which is taking shape before our very eyes, through us and for us, through everyone and for everyone.

And primarily through and for black writers and artists, which is clearly shown by the modern art exhibition entitled, significantly, *Tendances et Confrontation* [Trends and Confrontation]. Following the First then the Second World War, everywhere – in Africa, America, in the very heart of Europe – young black men and women rose up like young trees, shaped by events. From the depths of their ancestral experiences, from the depths of their more recent experiences as slaves and colonised populations or, simply, as people of this century, welcoming all types of input, seeing the world through fresh eyes, they derived new words which they used to delineate the *new negro*. Their works did not have to be collected in anthologies or museums for them to be able to fulfil their role, which is by depicting life, by making it known, to help everyone to live better.

Above all, their role is to help their black brothers. Consider the former black slaves of America, deported from Mother Africa. If they did not give in to *taedium vitae*, if they did not allow themselves to behave like other races, doomed to die, weak, dejected and listless, it was because they brought within them from their native land, along with their 'lust for life', the power of creation, which is the hallmark of art. Art is none other than the primeval activity of *Homo sapiens* who, by making life known through the image-symbol, uses rhythm to intensify it and, by glorifying it in this way, gives it an eternal quality. At least, this is what negro

art does, and so does the art of the negro spirituals and the blues. The most mundane work of the peasant, the most arduous work of the slave, is revitalised because it is glorified by words, by song, by dance: by rhythm-energy, which is the very stuff of life.

Slavery is a thing of the past. Today, in Senegal, to take a topical example, a new national art, rooted in the black basalt of Cap Verde, is in the making at this Dakar symposium, where the air is filled with images and ideas, pollen from all over the world. It is still negro art which, rescuing us from despair, supports us in our struggle for social and economic growth, in our stubborn determination to live: our

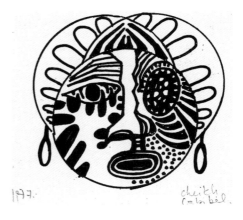

poets, our storytellers and novelists, our singers and dancers, our painters and sculptors, our musicians. Whether they are painting violent, mystical abstractions or depicting the noble elegance of the courts of love, whether they are carving the national lion or singing of the differences between cultures, black African artists, the Senegalese artists of today, are helping us to live fuller, better lives: to live more fully, more intensely, by shoring up the characteristic, striving nature of the north-Sudanese face of black African civilisation; to live better, in order to solve the practical problems which have a bearing on our future.

Listening to me, you might believe that negro art is nothing more than a technique, a set of devices pressed into the service of a civilisation which revolves around comfort or, at any rate, material production. Let me be very clear: I was referring to the 'development' not only of economic 'growth', the complementary unity of the physical and the spiritual, of economy and society, body and soul, I was referring to the production of both

physical and spiritual assets. When I talk about Negritude, I am talking about a civilisation in which art is both technique and vision, craftsmanship and prophecy – in which art conveys, in Ogotommeli's words, 'the identity of physical actions and spiritual forces'. This is the same venerable negro who declared, on another occasion, 'The weaver sings while plying his shuttle, and his voice enters the warp, encouraging and drawing in that of the ancestors.' What does this mean, if not that all art – weaving, sculpture, painting, music, dance – in black Africa is speech or, more accurately, language; in other words, poetry?

The forms and colours, hues and shades, movements and even materials used by artists are as effective as language as long as they have rhythm. Speech has become language because it has imbued the forms of the named objects with rhythm, reflecting primeval movement, recreating them, making them more immediate, more *realistic*. In this way, art completes the creator's work because, by renewing it, it keeps it alive and confers eternal life on objects and living things by giving them energy, by glorifying them. Over and above its vital function, this is the significance of negro art: *it makes us part of God by involving us in his creation.*

Conclusion

By contributing to the defence and celebration of negro art, Senegal is aware that it is helping to build the Universal Civilisation. Even before our national independence, for some twenty years our policies have always been based on dialogue in all fields, but especially in that of culture, because culture is the first requirement and ultimate goal of development. But in order to communicate with others, to take a hand in the common effort of people ruled by conscience and determination who are rising up throughout the world, to contribute new values to the symbiosis of complementary values which defines the Universal Civilisation, we negroes must finally be secure in our dignity – our redeemed identity.

We must be ourselves, cultivating our own distinctive values, like those found when we went back to the sources of negro art: those values which, over and above the underlying unity of their humanity, because they were born of biological, geographical and historical particulars,

are the hallmark of our originality in thought, feeling and action. I say we must be ourselves (borrowing if necessary, but not existing by proxy) by our own efforts – individual as well as collective – and for ourselves. Without this, we will be nothing more than poor replicas of others in the *musée vivant* – as were the negroes in America when they were slaves until the end of the nineteenth century; as we were, we negroes in Africa, when we were colonised, until just before the outbreak of the Second World War.

What the young black men and women of my generation wanted in the interwar period was to forsake the genius for imitation of the old order, and to recover, along with the awareness of our dignity, the genius for creation which had been, for thousands of years, the stamp of Negritude, as can be seen by wall paintings on the African continent. We wanted to become once more, like our ancestors, the authors of civilisation. As we were well aware, twentieth-century Humanism, which must be synonymous with a Universal Civilisation, would be poorer if it lacked one single value from one single people, one single race, one single continent. Once again, the problem was seen in terms of complementarity, of dialogue and exchange, not in terms of opposition and racial hatred. How could we negroes reject the scientific and technical discoveries by the European and North American peoples, which have enabled human nature itself to be transformed in tandem with the natural world?

Researchers and teachers, artists and writers, you are the true humanists of modern times. Because Senegal has elected to be the homeland of dialogue and exchange, Senegal would like to be your second home. We hope, in any case, that the wide-ranging dialogue which has been initiated here today will help to build the earth, to perfect humanity.

Le Musée Dynamique
Léopold Sédar Senghor

Inauguration address, Dakar, 1966

Here we are, in front of the Musée Dynamique which will be the real hub of the Premier Festival Mondial des Arts Nègres and in the future its most meaningful testament. How could you not give an enthusiastic welcome to this visit by various masterpieces of negro art to their native continent: this solemn visit by our ancestors and our gods? Some say that if these masterpieces chose to talk, they might utter the words attributed by the Greek tragedian to Helen: 'The son of Priam thinks to possess me. A futile delusion: he embraces only a phantom. What was defended by Phrygian bravery, the prize lusted after by the valour of the Hellenes, was not my body, it was merely my name.' Some claim that masterpieces of negro art have taught Europe and America nothing or, at the most, a handful of technical formulas.

Personally, I do not agree with this view. Of course, a work of art is not an industrial product. If it is to be understood, it must be assimilated. It must, like a seed in the ground, sink below the mind and into the soul. It must decay in order to germinate, grow and flower. As it happens, after sixty years – seventy years, William Fagg would say – of research, deliberation and assimilation, negro art is now understood by Europe and America, whose in-depth view of it can be seen by the conference taking place in Dakar now. Negro art, to paraphrase André Malraux, has entered the living museum [*musée vivant*] of the soul.

This is why I do not agree with the Greek tragedian, whose view is purely an opinion. According to ancient tradition, the Trojans – who belonged to the 'dark-skinned Mediterranean race' dear to my former teacher, Paul Rivet – had, in their war with the Greeks (Indo-Europeans), called on their brothers, the Ethiopians, for help. That made the war a racial war, reflecting the paradox that, as in any racial war, the aim was to fill a want with the wealth of the enemy: to fulfil a *need for complementarity*. The Trojans were defending not so much the fair Helen's name but her body, and not so much her body as the productive, because complementary, contributions of the Indo-European civilisation. What was really at stake was Helen's soul, the Hellenic soul.

Since the Renaissance and the victory, after four centuries, of discursive reasoning, it now seems only natural that it should be Africa who lusted after Hellenism. But it was not always the case, especially among the Greeks and in the Mediterranean world. Did not the Greek tragedian place the same Helen of Troy on the Egyptian island of Pharos, and make her utter this nostalgic lament?

Here are the waters of the Nile,
Of the Nile with its beautiful nymphs,
Who, when the time comes for the
snow to melt,
Waters, not the plains of Zeus,
But the fields of Egypt.
Proteus was king of this land
And took a sea-nymph for his wife.

The truth is that the African continent played an important role in the development of Greek civilisation. It is significant that Plato studied in Egypt. More broadly speaking, the Greeks approved of acknowledging their debts to the Egyptian civilisation. Early Greek *kouroi* retained a touch of the hieraticism of sculpture from the Nile. But the Egyptians themselves made no mystery of their borrowings: they named black Nubia as the source of their civilisation, their religion, their art, even their writing.

You can judge the import and the full significance of these reminders. The African continent, and Negritude with it, were always – despite inevitable lapses – involved in the development of the civilisation centred around the Mediterranean. Prehistorians are constantly reiterating this fact: the Eurafrican School, in which the negro and dark-skinned Mediterranean peoples probably played a key role, was present at the birth of art. Well before the appearance of the Nok civilisation in Nigeria, negro masks were already decorating rock-faces in the heart of the Sahara.

By making its presence felt in western civilisation as early as 1897 after the Benin expedition, by supporting the '1889 Revolution', which shook up the old order of discursive reasoning, not to destroy it but to enrich it by filling in the gaps, Negritude played its lifelong role, which began in prehistory. In my opinion, particularly with regard to artists, Negritude strengthened their concerns and their refusals, it answered their questions – not exactly by presenting them with a ready-made solution, a lifeless reply, but a living exhortation to continue the new line of research they had embarked on.

Our contemporary society, in the second half of the twentieth century, preoccupied by materialistic problems, inundated by electronic calculations and technically orientated solutions, our society which, being in distress, perceives the spiritual dimensions to its problems, can be helped by the negro masterpieces here to live a better life and thereby fulfil its human vocation for universality. The masterpieces on display here do not teach us a new *Weltanschauung* so much as how to deepen our vision by setting the imagination free, by putting it back in touch with its intuitive qualities. They do not teach new visual techniques so much as the need to subordinate the hand to the vision, to the rhythms of the vital forces which are the stuff of the sub-real: of true *reality*. Empowering creation by deepening vision to produce images, creating compact modes of expression by intensifying the rhythm of these images – this is the very simple lesson we are taught here by Negritude, whose main strength lies precisely in its economical methods and in their humanity.

Musée Dynamique,
Dakar
1987

Pablo Picasso
L'Atelier
1933
Lead pencil
26 x 34.5 cm
Musée Picasso, Paris

Picasso en Nigritie

Léopold Sédar Senghor

Inauguration address, Picasso exhibition,
Dakar, April 1972

As you are all aware, the human phenomenon we call *civilisation* did not come into existence, nearly five million years ago, with the first stone tools, or even with the first halting attempts at language, but in the Upper Palaeolithic period, with the first work of art: the first fertility statuette. It was for this reason that *Homo faber* was then named *sapiens*, 'wise' – in other words, civilised.

Why is this exhibition of the work of Picasso taking place in black Africa, and in Dakar? Before answering, I must take a few words to introduce the exhibition itself. Apart from the sculpture, this exhibition covers all the genres in which the artist worked. There are paintings, original drawings, signed engravings, pottery, tapestries, posters and, last but not least, a collection of thirty books devoted to Picasso or illustrated by him.

Why Picasso *en Nigritie*? The success of an experimental Chagall exhibition last year encouraged us to continue the initiative. So we came up with the idea of organising, from 1973 onwards, an annual Dakar season, in which the visual arts would hold pride of place with an internationally renowned artist as guest of honour. This year, we are giving the idea a trial with Pablo Picasso.

No artist could be more exemplary. The Dakar School regards Picasso as a model whose kinship serves as a firm promise, and whose differentness serves as a powerful encouragement. This is what makes our choice so natural and so strange...

To come back to Picasso and the visual arts – and especially to painting, the most intellectual of these arts – the Andalusian artist did, of course, have precursors, if not instructors: Cézanne and Gauguin, Vlaminck and Derain and, last but not least, Matisse, as Jean Laude shows in *Peinture française 1905-14* and *L'Art nègre*. Nevertheless, he was the first, with his *Demoiselles d'Avignon*, to break ruthlessly with classical aesthetics, to go even further than his semantic and syntactic borrowings from negro art to get to the heart of things – in other words, to change not so much his language as his vision, even his *reality*. As he commented one day to one of his critics, 'one of the fundamental tenets of Cubism was to displace reality; reality no longer resided in the subject, it was in the painting'. And again, 'painting is never prose, it is poetry, it is written in verse with visual rhymes.'

The Andalusian felt, therefore, that it was necessary to turn away from the concept of art as imitation, and replace it with that of art as invention. It was no longer a case of *re-presenting* nature but of *re-producing* it in the image of God's voice and actions, to create a more humane natural world – an *objet d'art* which conveys, visually, in the same way as a poem does verbally, our idea-sentiments or, more accurately, our sentiment-ideas. This line of enquiry led Picasso to his encounter with negro art, which convinced him he was on the right track. Let us hear what he had to say about his first visit to the Musée de l'Homme in Paris: 'I was so depressed that I wanted to leave, there and then. But I forced myself to stay, to examine these masks, all these objects which had been made by men with a sacred, magic purpose in mind, so that they would act as intermediaries between them and the unknown, hostile forces which surrounded them, trying to master their fear in this way by giving it colour and form. *And I then realised that this was the true meaning of painting*. It is not an aesthetic process; it is a type of magic which stands between the hostile universe and us, *a way of seizing power, by giving shape to our fears and our desires.*'[1]

This appears to run counter to the opinion of many critics, who insist on the intellectual nature of Picasso's works. This needs clarification, because the latter has often said that he is an 'anti-rational' artist, and that, initially, he has only a vague idea of the object to be created, which appears much like a 'controlled' dream, but one dreamed by a sleepwalker. I remember that day in the 1940s when Picasso, accompanying myself and his Andalusian compatriot the painter Pedro Florès, said,

'We must remain savages.' Again, there is a striking similarity with Arthur Rimbaud who, in *Une Saison en Enfer*, named the Barbarians – not only his Gaulish and Scandinavian ancestors, but also negroes; in short, primitivism – as his source of inspiration and expression: 'I went back to the east and original, eternal wisdom.' This caused Jean Laude to say to André Salmon, 'By choosing primitive artists, he was not ignoring their barbarism. But he logically understood that they had tried to achieve a true representation of being and not the sentimental realisation which, more often than not, we achieved. He wants to present us with a complete representation of people and objects. This was what the barbaric sculptors wanted to do.'

This proves, people would argue, that Picasso condemned sentimentality in an artist's work. It probably does. To explain why, I must finish my analysis. Although Picasso often took exception to sentimentality, it was for its lower-middle-class, exaggerated and naive aspects. *Sentiment*, in other words emotion, is something else again, being the trance which buoys up the creator while he is working: the *poet*, to get back to the original meaning of the word. What Picasso condemns in the self-styled 'modern' artist is the factual vision that the average European has of people and objects, educated as he is in the mould of western rationalism. The twentieth-century artist, rather than being ruled by the conventional notion which has prevailed in the west for over two thousand years, and by the feelings stirred up by the external natural world which is physical, should instead use them as a dictionary of forms and colours to translate the true response of our inner nature, which is moral. In fact, as Rimbaud wrote, the 'fight' is 'spiritual'. So, using the dictionary of the external natural world as well as that of our dreams, the aim is to compare the two types of 'nature', by giving a form or forms to the sentiment-ideas born of our desires, our fears and our joys – in other words, to reveal our inner vision, as well as our striving, by substituting the overall structure of the object that is both felt and thought for an anecdotal and diverting multiplicity of feelings. This is at the root of the so-called 'stylisation' of forms and, consequently, of their abstract nature. Once again, it is no longer a matter of aesthetics, of pleasing forms and colours, but of *magic* – a set of procedures, here visual, to tap the cosmic forces and trap them, using analogical but rhythmical images. This was the same problem which

Rimbaud had faced earlier, and he had come up with the solution: 'I invented the colour of vowels! I regulated the form and movement of each consonant and, using instinctive rhythms, I prided myself on inventing a poetical language, accessible, one of these fine days, to all the senses. I kept the translation back.'

This magic – in other words, the new procedures and forms – was sought and found by the Andalusian among his Mediterranean ancestors, going back to the earliest, the Iberians. They obtruded on him, as on any genuine artist. 'There's nothing I can do,' he had to admit to his critics. 'Painting does not choose. Certain forces obtrude on it. And they sometimes come from an inheritance which dates back to a time before animal life. It is extremely mysterious and terribly irritating.' As has been stressed, pre- and proto-historic Iberian sculpture had led him to other Mediterranean sculptures dating from around the same period: Etruscan, Aegean and Egyptian. The point is that these pre-Indo-European sculptures had their origin in the same feeling for magic and poetry, and employed the same vocabulary, the same syntax, even the same style. And since black blood had nourished Saharan art, from which early Egyptian art derived, it should come as no surprise that when he discovered negro art Picasso found in it a strong confirmation of his Mediterranean research, particularly as many Spanish historians believe that the prehistoric art of the Levant has African origins.

It is these methods of Picasso's art-magic that we are going to try to summarise, by referring to the conventions of pre-Indo-European arts, and firstly those of negro art, not to mention Rimbaud's poetics. The first of these procedures is synthetic structure, the simultaneous representation of reality in its essence and in its entirety. So, after *Les Demoiselles d'Avignon*, Picasso often depicts his subject – man or god, object or dream – from various angles: full face or from the back, in profile or three-quarter view, from above, from below, from the side, as well as in a fixed state of immobility. The subject is promoted from a changeable individual to the rank of type, of eternal archetype.

If we come down from the philosophical, ontological level to the operational, poetical level of the work, once again we come face to face with the artist who, like the ancient Mediterraneans and black Africans, used

analogical images, form-symbols, both to express his inner vision and make it known.

The Mediterraneans and black Africans have bequeathed us a complete 'repertory of forms' scorned by European, and especially Graeco–Latin, classicists, who are primarily concerned with detail and imitating nature. Picasso himself highlighted the difference in a graphite drawing, entitled *l'Atelier*.[2] The repertory of forms in question is basically made up of lines and masses or volumes: straight lines, curves and angles, circles, squares and rectangles, spheres, cones and cylinders, etc. *L'Atelier* contains two compositions: you can perceive at first glance the difference between the reclining nude on the easel and the recreated nude on the table, between prosaic description and lyricism. In the composition on the right, the artist has retained only the most significant elements of femininity, while adding other symbolic elements of virility which are not in the easel painting. Over and above the repertory of forms, which were not ignored by the classicists, Picasso's originality resides in having restored their symbolic roles. Everything has its significance in Africa: form and colour, images, of course, but also material, even the fabric used for the picture. However, Picasso's genius went even further, inventing new forms, new groupings, new structures, while giving a new meaning to the same integrated, assimilated and transformed form.

The images are not important in the classical manner, for the story they are telling. The forms, to use the most general term, have a symbolic value achieved only by visual means. This is why Picasso begins by rejecting the devices employed by classical rhetoric: perspective and its space, chiaroscuro and its light and shadow, the model and other devices. He does away with the space by filling it with a 'balanced architecture of forms,' breaking free of a single focus of light, and giving the objects in the painting a greater degree of reality by dint of their sculptural 'corporeity'. This is achieved by drawing the forms more boldly, joining together the various parts of the body, the subject or the landscape more distinctly, presenting them like an interplay of geometric masses. Last but not least, blacks and whites are substituted for colours, or are used as values which are more spatial than symbolic.

That was the second set of procedures, relating to vocabulary and syntax. We will now finish with the 'figures', which I liken

to 'visual rhythms'. These correspond perhaps more precisely to alliteration, assonance and rhyme in poetry – in other words, to style. As you know, black people reign supreme in the field of rhythm, whether dance or music, sculpture or painting, poetry or drama. Here again, Picasso makes use of Mediterranean and black African rhythmic devices, integrating them, yet transcending them by highlighting the most original. His style is more easily understood if we go back to *L'Atelier* once more. The artist only retains – or adds – significant elements of femininity and virility, but far from using them to form a couple he creates a new being. And he moves us – which is the aim of art, rather than to please – probably less due to the array of symbols than to their rhythmical grouping.

What makes Picasso remarkable is that, once again, he goes as far as possible, to the utmost limits, in the originality of his chosen methods. His use of rhythm is anything but monotonous. It is not a simple repetition of an element, a sound, a word, a visual phrase – in other words, a form. It is a varied repetition: in another place, on another level, in a new light or colour, even taking another form. It is a *syncopated* rhythm, made up of asymmetrical parallelisms, with the famous 'swing', before the term was ever invented. In other words, there is also a rhythm of contrasts and antitheses, of dissonances and 'counter-rhymes' – in short, a dynamic, living rhythm, even in the sculptural nature and apparent immobility of the representation.

In conclusion, the great lesson to be learned by us all, but none more than the Africans, from Picasso, is not so much his allusions to non-Indo-European arts, particularly to 'negro art', as his rejection of *art as imitation* in favour of *art as invention*. The lesson takes on a deeper meaning if we consider that, to be an inventor of new forms, a creator of beauty yet above all of human emotion, Picasso began by going back to his racial roots, the mix that comes from the Mediterranean, the crossroads of all routes and races, and consequently the home of civilisation.

The Andalusian artist teaches us – Arabo-Berbers and black Africans – that there is naturally no such thing as art without the active assimilation of foreign contributions and, above all, no such thing as original genius which is not rooted in a native land, which is not loyal to its ethnicity. I do not mean its 'race', but its national culture.

Issa Samb
1995

A Criticism of Representativeness
Issa Samb

1989

Destroying a concept of race

We must put an end to a commonplace: that concern with the 'representativeness' of a race, of an art, belongs by rights to inevitably sectarian party members. 'Representativeness' is merely an aggressive and tiresome insistence on painters having a message and poets a specific, political bias. As a result, it is – 'politically' speaking – edifying and 'poetically and scientifically propagandist'. Instead of this, work initiated in 1966 by painters in the Negritude movement involved the colouring in of forms without any desire to prove, in a visual sense, anything at all. Impressed by the theoretically unexplained, intangible nature of material; happy to make shift with a sustained 'appreciation'; enhanced by poetical 'criticism', 'painting by instinct', letting the heart feel what the mind was unable to grasp, the painters set down only what was invisible: politics, poetry and what was regarded as the perfect articulation of the defence and celebration of a civilisation – Negritude.

Their effort was rewarded, and we were grateful to them for providing 'evidence' of the paternity of 'modern art'. Having established their 'representativeness', the rest of their problems revolved around replacing pompous discourses with either the absence of criticism or with a host of supportive comments, the use of strong terms (genius, beauty, original masterpiece) and *a posteriori* commentaries precluding analysis. 'Criticism' – or a basis for a critique of 'representativeness' (and of positivity) – came into being with Senghor, the poet who sang of Negritude and who, at the inauguration of the conference on negro art in April 1966, pronounced: 'Whether they are painting violent, mystical abstractions or depicting the noble elegance of the courts of love, whether they are carving the national lion or singing of the differences between cultures, black African artists, the Senegalese artists of today, are helping us to live fuller, better lives.'

Over two decades have gone by, and the question of criticism is still being raised. But, more than ever, it is being raised in the wrong way – within an ideological and pseudo-scientific framework rather than within a visual and technical one.

What is the stuff of criticism?

Connotations. Criticism involves adding meaning, displaying a 'hidden' subject matter, revealing over-determinations, stating – in order to pass judgement – what is being denied, dodged or half-said by the object under criticism. How far is this a matter of truth? Senghor, the critic, believes that connotation is a dynamic element which gives rise to and assimilates denotation. Connotation implies that there is always an added or a leftover meaning, taken care of by a second language (a meta-language) – for example, critical language, visual language. In a system like this, the difficulty is obviously how to mark the boundaries of denotation: where it starts and finishes. With the exception of Senghor's works, the lack of criticism in the field of black visual arts research stems from this difficulty. As a general rule, denoted meaning is defined by the communicative function of language: the denoted meaning is the obvious, immediate and functional meaning: 'see how this colour is fading' is an illusion, which has a delusory effect. 'Denotation', wrote Roland Barthes in *S/Z*, 'is not the primary meaning, but it pretends to be; labouring under this delusion, it is in fact merely the least important of the connotations (the one which seems to start and conclude the reading at one and the same time), the higher myth which enables the text to pretend to return to the nature of language, to language as nature.

Doesn't a phrase, whatever meaning it seemingly releases later at its utterance, give the impression that it is telling us something simple, literal, primitive and true, compared with which everything else (which comes after, above it) is literary?'

Denotation suggests an ideology

The ideology is that of true meaning, the complete meaning which speaks for itself. Certain artists, western writers and poets in the Negritude movement found this completeness in the works of black artists – works which were celebrating the integrity of denotation. Now denotation is growing old, dwindling, changing. What is now seen in contemporary black art? Connotations. Malraux, in 1966, does not 'denote', he 'connotes'. And it is clear what he is connoting. In other words, it is perhaps daring, in the face of history, to have faith in an obvious or natural meaning. It may be ideologically risky to 'denote' too energetically: look at how the black visual arts can be viewed in this respect (admittedly, contemporary Senegalese art seems to take its trust in denotation and its contempt for genuine criticism to an extreme).

These reflections seem to suggest a lesson to be learned: in order to establish a meaning in any contemporary visual work, it is desirable to allow the connotations 'to speak for themselves', to avoid blocking the denotative meaning.

The signifier must be given a certain amount of visible freedom. This at least is one way to account for the success of the members of the Dakar School, and the blindness or paralysis of the majority of the critics when faced with the meaning of their works.

This paralysis is often evidenced by the word 'reminiscences'. This term, applied to all contemporary works, especially by poetic 'criticism', actually reflects the position of the critics themselves, who are at a loss to know whether they should be passing a negative judgement or not. It is used to suspend the critical act. It is, moreover, amazing that one of the few critics after Léopold Sédar Senghor who tried to go beyond that word, J.-F. Brière, did so in private, by systematically visiting studios and examining the characters and situations depicted along the lines of denotation: 'Senegalese visual artists are deciphering, unawares, like secret texts for which they have no key, the impulses which went astray in the past in a secular sign language, but which have now found the upward path of vocation.'

This critical technique, perfectly legitimate, is very clever since it simultaneously thwarts and reveals the system on which the painting of the Dakar School is based: disturbing the denotation in such a way that the works, which have gone around the world, of course denote Negritude, but connote something else as well. And this 'something else', in theory undefinable (the painter's psyche), in the last analysis destroys the meaning of the answer to a question that the painting never asked, and to which, through it, criticism should have replied.

The multiple nature of reality

When all is said and done, criticism must take into account the internal movement of the laws governing the work of art which, beyond the savage certainties of various 'races', is producing an image, albeit still hazy, of mankind's past, present or future. It must undermine history and the 'theories' which make the world a place where the spirit exhausts itself in countless conflicts. If art has a revelatory function, it must not be a justification or a place where discourses of 'evidence' and anathemas are aired, but instead (since it allows us to keep our finger on the pulse of the times, whose rhythm defeats our ambitions to dominate) a place where the multiple nature of reality can be revealed.

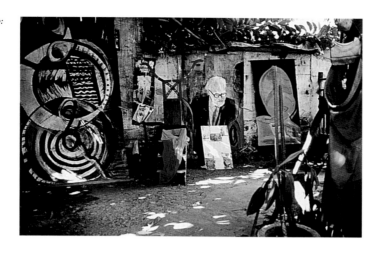

Recalling the Future

As M'Bengue

Dakar, 1984

Is Dakar an interesting African metropolis? I dare say! The brains and, to all intents and purposes, the life blood of Senegal? Absolutely!

But it's an extremely dirty town! And disorganised enough in many respects. Already, an angel flies past whispering to anyone with ears to hear, 'What about the recession? What about . . .?'

For the fairly detached observer, the sight of the capital's streets conjures up a general feeling of nonchalance, recklessness and even insouciance, questionable though that is. Reality may seem so 'mixed up', as if seen through a slightly distorting prism, that one may even become blasé about it all.

There is absolutely no point in condemning any of this – in some situations, not condemning can even be appropriate, in the same way as non-choice is, in many respects, a type of choice. Right from the start, I should stress that the prevailing tone of this essay is far from polemical. The aim is more to encourage careful thought – and to be cool about it!

To say today that things have changed is a tame euphemism (I balk at using the word 'truism'). The difficulty lies more with the way in which the discourse is put together and ordered. It is no small matter that the the discourse's order is, literally, invested with its disorder. Methodological wisdom would, in this respect, involve having an adequate understanding of the dialectics of order and disorder, and satisfactorily mastering the subtle distinctions between the order of the disorder and the disorder of the order.

Which reminds me, it is one year ago to the day that the forces of 'order' invaded the Village des Arts to drive out the artists. That's in the past, of course! If it was today, let's say, 'No comment'! The main thing here is that we remember it, it being understood that we place a considerable emphasis on the importance of memory. What is more, we have decided that certain facts – events that are culturally significant – which happened in the past (meaning the present), should not be consigned to oblivion. History is being written increasingly in the present – this is not our fault, nor perhaps anyone else's. In the meantime, let's remind those who need it that the Village des Arts was at 126 avenue A. Peytavin, facing the Atlantic Ocean.

That may be the stuff of dreams! To be more exact, what a fine opportunity for daydreaming! But careful! Let's not get things 'mixed up'. It's tempting, but at the same time there is a danger that it won't work. A key point is that, above all, the Village provided a setting for artistic crystallisation; it was not an orchestrated structure nor one that could be orchestrated. The one thing in its favour is that at least it existed. And, luckily, its creators are not dead. Creativity may have been damaged, but it has not faded. Dakar bears witness.

If we must speak of Senegal again, we must accept that seeming and being engage in some questionable dealings there. Let's not wait to hear an angel murmuring something to us about Bazin, embroidery or double Tabaski . . .

We are convinced that, in the end, we know very little about [the Supreme Being]: *but above all, we must listen to it.* Listening to it proves that we can communicate, and is therefore an invitation to be rational. Such a prerequisite is clearly needed if you bear in mind that the reality of Dakar in 1984 is that it is bursting at the seams with signs and markers which raise all kinds of questions by virtue of their multiplicity and their versatility.

In fact, quite apart from its filth, Dakar is a town filled with madness and begging. A perfect witness, the deaf, dumb and blind man knows what he is *talking* about when you interrogate him on the subject. All this goes to show that the boundaries of the recession should be qualified somewhere in order to identify and characterise certain unprecedented phenomena within the context of our changing society. In short, a more accurate analysis is needed to distinguish between external destabilising factors and internal destabilising factors.

Although it may be true that nothing

great is achieved without passion, we continue to be relaxed enough to avoid joining with that heartfelt cry of the ardent supporters of speeding up history: 'What isn't going to the dogs in this country?' We prefer to re-phrase the question, turning it round to ask: 'What "lasts forever" in any of this?' Aren't we being faced with a situation which is complex because it is too cultural?

This puts us in mind of another speaker, deaf and dumb but this time sighted. Using a form of non-verbal communication which need not be described here, he gave us to understand that, personally, he feels that, after more than twenty years of genuine artistic creation, he is witnessing a 'muffling of culture' in Senegal. He went on to say: 'The question is perhaps to wonder when the milk is going to turn...' Nevertheless, we must realise that the country's survival is partly a question of cultural action (but for how much longer?).

This raises some serious problems of ambivalence, here and elsewhere! One is then only a short step away from calling for a transformation of values, a step we will take cheerfully. We have to do this – and quickly! Just as we must refuse the status quo at the deepest level. Isn't this because the history of the present has the irritating habit of unfolding in the present? Taking one year with the next, Machiavellianism and a national crisis of confidence are connected!

Only yesterday, we warned that an attack on creation and creativity would have serious consequences. It could mean forcing culture to toe the line. So let's ask ourselves what a silenced culture would mean – but dispassionately, so that we don't consign the realm of imagination too quickly to the prison world.

Quiet please, action! The title of the film is *Jump*. But be careful! Was there a run-through first? Well, never mind! We're finished!

The play *Le lait s'est-il caillé?* [*Has the milk turned?*] implicitly and explicitly led to a shift in perspective as far as acting was concerned. It gave rise to new ways of linking, on the one hand, oral expression and mime, and, on the other, the acting order and dramatic discourse.

We are not underestimating the contribution made by Eugène Fink in his work *Le jeu comme représentation du monde* [*Acting as a representation of society*]. This has taught us that acting is a subject which philosophy and many of the social sciences would find worthwhile

studying. Acting actually has mythical origins and no mistake. And this was useful to know.

This more or less brings us to a more detailed examination of the effectiveness of an artistic education. We are following in the footsteps of Joël de Rosnay when we say that artistic education forms the perfect apprenticeship for intuition, invention and creation. It puts the emphasis on the creative process rather than on accurate reproduction. And, still paraphrasing de Rosnay, a variety of modern forms of expression exist to help people find their feet again. These forms can be effective in encouraging them to refocus themselves, find a new sense of unity.

We would point out, in passing, that the President of the Republic cares deeply about national culture. The Cultural Charter exists in embryo. Critics might say it is actually at a standstill, but no problem! We say that it will come in its own good time. Recently a piece of sculpture brought it into the limelight – this was not a bad thing, since the newspaper *Soleil* devoted a certain amount of coverage to the story. After various vicissitudes, the sculpture was broken up, for the reason that Islam 'would not allow representation'. This is iconoclasm, isn't it?!!

The forthcoming Charter makes this point the subject of an enquiry. What is a socialised, cultural object? What part will live models play within the Charter? Are there no monumental sculptures likely to be erected in the city?

There are so many questions to be clarified: to think before speaking is the minimum requirement! We are wondering why the National Gallery, on avenue Albert Sarrault, remains closed after an investment of 100 million francs and one single exhibition, the one to mark its

inauguration by the President of the Republic.

Senegal is undoubtedly a land of coincidences and a country of paradoxes. Along with this present discourse (which is not a discourse in the nature of discourses, far from it), an experiment in 'spiral theatre' is taking place in the country. According to the latest reports, one performance in Grand-Yoff could not be completed because it was interrupted by children throwing stones. Their reason was that the adults had taken all the good seats in this free theatre, instead of putting their children in front and sitting behind them. Moral: the shoe will pinch somewhere!

Last but not least, the almost certain appointment of 'administrative' as opposed to 'cultural' staff to the top arts administration posts seems to provide clear proof of a determination to make every aspect of cultural life 'administrative'. We hope we are mistaken. And this is because we continue to place our hope and our trust in a country which has virtually nothing left of these qualities.

And our slightly disillusioned reply to the wet blankets and the sworn enemies of prejudice who would retort that there is a risk of a totalitarian regime? 'Who knows?' In short, something is in a bad way in 'Sunugal'. Something is showing the cloven hoof.

Wanting to lose no time in getting to this bitter admission, we have passed up the opportunity to talk about theatre. But, in any case, theatre is being created. It is accepted and it is not. Moreover, what can we do? That is the question!

And now, 'Quiet, please, we are going under'!!!

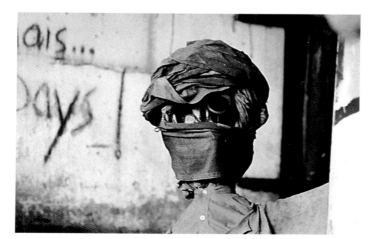

Objects of Performance: Mannequin
Laboratoire Agit-Art
1988

Nigerian Art

Léopold Sédar Senghor

Address at the Premier Festival Mondial des Arts Nègres, Dakar, 1966

I am delighted to open this exhibition of Nigerian art. Firstly, because the Federal Republic of Nigeria is an ally with which Senegal has always cooperated closely. But the reasons we have given Nigeria pride of place at this Premier Festival Mondial des Arts Nègres are not political but cultural, and they arise from Nigerian art.

Our first reason is that, in the words of William Fagg, 'of all known African sculptures whose age can definitely be placed at over one hundred years, nine out of ten' come 'in all probability' from Nigeria. In fact, there are hundreds, thousands, of Nigerian works which have been taken out of Africa or kept here: in museums, public monuments, private collections and in nature.

But there is a better reason than quantity. In sub-Saharan Africa, apart from rock carvings and frescos, it is Nigerian art which has the longest history and, therefore, the longest evolution: it spans some 2,500 years. And the most remarkable thing is that throughout these two and a half millenia, the diversity of these artistic manifestations has not damaged their underlying unity.

The third feature of Nigerian art is this diversity, which makes it a microcosm of black African art. It is found first and foremost in the type of materials used, which can be and are dependent on the place and the circumstances: earthenware, bronze, soapstone, quartz, granite, ivory, wood, etc. Diversity is also found in the individual styles, which are a reflection not only of geography and history, not only of the tribe – a reality which simultaneously expresses them and transcends them – but also of individual genius. For it is true that in Africa, too, the work of art, although the manifestation of a culture, is even more the manifestation of an individual, precisely by virtue of being art. This diversity ranges from the realism of the Guinean forest to the abstract art of the Sudanese savanna or, perhaps more accurately, from portraiture from the royal courts to the rhythmic art of the religious societies with their secret rituals.

Art Against Apartheid

El Hadji Sy

Opening address, Dakar, 1986

Your Excellency, Mr President of the Republic and Mr President in Office of the Organisation for African Unity, Madam President, Ministers, Ambassadors, Representatives of SWAPO, the ANC in Dakar, Ladies and Gentlemen, Honourable Guests —

Mr President, we are well aware of the great honour you are doing us by agreeing to preside in person over the private viewing of our annual exhibition. This amply demonstrates your deep commitment to our country's art and culture. Thank you from the bottom of our hearts.

The fact that you are attending this feast of art with us is not only grounds for legitimate pride but also a much appreciated sign of encouragement for our Association. People have been too quick to generalise about the desperate behaviour and social appearance of several unfortunate individuals numbered among our colleagues. In fact, they are experiencing frustration when faced with a demanding job which calls for superhuman efforts within a tough, even traumatic social context. The first professional artists in our country at this present time are trying to alter this prejudice by joining forces to form the Association Nationale des Artistes Plasticiens du Sénégal (ANAPS). They have socialised their differences or, more accurately, their ways of defending themselves, of achieving a more dignified standard of life and of making the outside world accept their right to be morally and culturally respected.

It is no mere coincidence that we have retained the title *Art Against Apartheid* for the second Salon organised by ANAPS. Our aim is to use the means of expression peculiar to art – so much more effective than is commonly believed – to contribute to Africa's struggle for freedom. This is because Senegal's visual artists have always kept abreast of events in Africa and have always focused on the inexhaustible wealth of our national culture. In fact, we want to turn the spotlight on the permanent nature of our solidarity and support for people fighting racism and depersonalisation. How can the artist, an individual kept constantly on his toes by the divisive, pleasing or passionate events taking place in his society and in the world, shaping himself in their image, not be interested in others? It is not a question of being a missionary or an original artist, it is a question of being a realist. Our profession represents the chance to change ourselves and, by doing so, to change the community. Moreover, it is hard to imagine a society of blind and dumb people, because the need to see, to point out what is worth seeing – first and foremost, light, space and unique details – is as old as time. The visual arts, like other media which are based on sight, are the most effective aids to learning how to experience and therefore how to understand and act, as much for the artist as for the spectator. In this respect, art is also a powerful weapon; in a century dominated by pictures and sounds, it can help to discredit inhuman, puppet regimes. Art revitalises and restores: this is also why it is worthy of attention.

Mr President, your illustrious predecessor, President Senghor, whom you accompanied yourself on many occasions as Prime Minister to exhibitions like the one you are going to inaugurate today, is a great art lover. I quote his words and pay him tribute: 'What is admirable is not that the artist has triumphed over difficulties which we can imagine. What is admirable is that he has not used these difficulties as an excuse for mediocrity, mistakes and a lack of imagination.'

I am not trying to surprise workers in the arts when I say that creation requires comprehensive investment. Very often, creators of socialised cultural objects do not understand the workings of the administrative machinery, finding it hard to comprehend and accept that nine months are needed to bring out their contracts. In addition, there is the extremely high cost of art materials, which brings us to the concept of a cooperative to meet our needs and those of the two combined national art schools – I am referring to the Ecole Nationale des Beaux Arts and the Ecole Normale Supérieure d'Education Artistique. The National Gallery in avenue Albert Sarrault could play the host, providing an arena for meetings and a forum for marketing artistic products, as well as being the seat of our Association.

Doesn't the fact that we have jumped at the chance of organising our annual exhibition ourselves – naturally, with the support of our parent ministry – demonstrate our real determination to become more involved in our country's artistic and cultural life?

Thirdly, our exhibition this year falls within the framework of preparations for the forthcoming Festival Pan-Africain des Arts et de la Culture (Fespac) which has your invaluable support and which has taken as its theme the fight for freedom and technological revolution in Africa. Knowing the unremitting demands on your time from various quarters, including world problems at the highest level, we are deeply appreciative of your patronage, your sincere understanding and your genuine attention. Only the uncontrollable urge to waste no time in acting to recognise the legitimate rights of people who are asserting their human dignity enables us to allay any fears of abusing your availability. We are convinced that you will be the most accurate witness and the most active promoter in helping us bring this century and this millenium to a close by affirming and recognising African art.

Mr President, you who are the leading patron of the arts in our country, you who remain the champion of just causes, we are extremely honoured to welcome you, the personification of that self-sacrifice which has always shaped the destiny of men of goodwill. Welcome to the temple of art with all its new-found dynamism. Thank you for your kind attention.

President and Mrs Abdou Diouf and El Hadji Sy at the exhibition *Art Against Apartheid*. The large painting is by El Hadji Sy.

Art Against Apartheid

Abdou Diouf

Inauguration address, Dakar, 1986

It is no coincidence that, once more, we are gathered here together in this temple of art, this Musée Dynamique, and that the Head of the Senegalese State is inaugurating the Exhibition of Visual Arts by our country's Association Nationale des Artistes Plasticiens. To begin with, we are here because this is a celebration of the spirit, and therefore of culture, to which we have invited the Minister of Culture. This is also a good opportunity for us to take stock of the creative output of our visual artists. Last, but definitely not least, it revives a tradition by which the Head of State, patron of the arts and literature, has been invited to preside over the Senegalese Art Exhibition every year since the first one which was held here in the Musée Dynamique in 1973.

Despite the restrictions imposed by its economic and financial recovery, Senegal is duty bound to focus on its culture and, as a matter of priority, to develop the most representative manifestations of its originality. As I have said in other circumstances, 'Defining a cultural policy which reflects our authenticity, and setting up functional infrastructures able to implement this policy, are a gamble which Senegal thought worth taking. Firstly, because it is its calling and, secondly, because it is its mission.'

This is why, in our collective and abiding concern with championing and promoting the distinctive values of the Senegalese civilisation which forms the true basis of our cultural policy, we have naturally given pride of place to art, a key element in any civilisation. And this is because art reveals, in the words of Ogotommeli, 'the identity of physical actions and spiritual formalities'. From this angle, Senegalese art is perfectly in keeping with the general pattern of our culture, a blueprint of which we attempted to outline earlier.

Ladies and gentlemen, as you know, a genius for speech and language in its subtlest forms has generally enabled Africans, and in particular the Senegalese, to assimilate the colonial language to the point where French literature has been enriched in new and unexpected ways. In this way, Senegalese writers and poets have been able to reach an international readership. 'We are thieves of language,' declared one African speaker during the first Congrès des Ecrivains et Artistes Noirs at the Sorbonne in Paris in 1956, and most of his audience understood what he meant.

But the visual arts probably represent an improvement on this, since Senegalese painters and sculptors can express their art directly and be understood throughout the world without having to use a foreign medium or a translation. This is undoubtedly the advantage visual artists have over writers – and it means they can enjoy a clearer conscience in the eyes of their people. However, unlike literature, this possibility did not, with very few exceptions, see the light of day in Africa until after our states achieved independence.

In fact, in 1948, Professor Cheikh Anta Diop, whose memory I honour to this day, wrote: 'Culture is not only found in literary modes of expression, it also includes visual modes of expression.' What have we found in Africa to support this point of view? Virtually nothing, compared to what could be found in the field of literature: at that time, barely a handful of black artists proved to be submissive imitators of western forms. And the professor concluded by saying: 'There is nothing at present in the field of painting and, apart from our art forms of the past, there is nothing either in the field of sculpture.'

However, at that very time, following some chance manifestations, various spontaneous creative movements appeared which had merely been waiting for the opportunity and the materials to express themselves other than on the walls, shutters and doors of houses. So studios were set up, in particular on the outskirts of Ifé in Nigeria, and in Poto-Poto, a suburb of Brazzaville in the Congo. These studios won worldwide acclaim in the 1950s, for the same reasons as did the Haitian painters.

By coincidence and sheer luck, the

President Diouf cutting the cord at the opening of the exhibition, with El Hadji Sy (left), accompanied by Mrs Diouf and Makhily Gassama (formerly Minister of Culture) Dakar, 1986

purity and specificity of these experiments were authenticated from the start. Several exhibitions at the beginning of the 1950s clinched the success of this alternative art, particularly on behalf of a good many members of the intelligentsia who were supportive of *art brut* in the tradition of the painter Dubuffet and the surrealists. 'The more basic the means, the more apparent the sensitivity,' stated Gustave Moreau.

The type of painting created in these studios, like the art produced by Senegalese artists working with the same freedom – that is, the spontaneous choice not to copy nature, but to invent equivalent forms – happened quite naturally to reflect the concerns of modern western painting.

With hindsight, it could even be stated that this African style of painting often preceded, by several years, the work of young western artists, as if it had been inspired by a premonition. However, this is probably only the result of some incredible ability to tap magic currents well in advance of the planet's other inhabitants – and this to such an extent that artists abroad are now drawing their inspiration from contemporary African painting.

It is against this backdrop that the French painter, Edouard MacAvoy, after examining and greatly appreciating works by present-day Senegalese artists, could write: 'One will perhaps forgive a westerner, emasculated by centuries of culture, for being reduced to laying clever traps and obtaining secrets by insidious means. It is therefore of the utmost importance and urgency that this painting should be able to develop under the most favourable conditions, so that it can be acknowledged and endorsed before it is accused of merely following-my-leader.'

We keep coming back, therefore, to the influence of black African art, established at the turn of the century by Picasso and his peers, on the revival of European painting. Since the invention of photography, which allows the representation of reality to be achieved mechanically, this style of painting has freed itself from such figurative shackles to create a new language. Like all languages, it can be learned in order to enrich one's perception of the world and to communicate to others. This is how we get from Cézanne, Gauguin, Matisse and their fellow artists, to Picasso and his encounter with l'Art Nègre.

Whereas the works of these European artists may have arisen from experiments or intellectual games, in the work of the new African painters this language was natural. It flowed from an abundant and apparently inexhaustible source, whatever ill-informed critics may say about it.

This is a mark of superiority and a great asset. No one would dream of disputing the value of our painting now. It is African – indeed, even Senegalese. Full of colour and contrast, and boasting a natural inner harmony, it 'dawns on us', simultaneously naive, profound and searching. In a sophisticated, mechanised, conditioned world, our artists still paint for no reason other than to express their joy at being one with humanity. You have only to look at the canvases here to appreciate the freedom of inspiration displayed by Senegalese artists.

We are therefore delighted and moved to pay tribute here to the new face of Senegalese art, which is bound to play a prominent role in establishing our cultural identity. With this end in mind, we hail this exhibition as a witness to an exhilarating venture, which brings everyone together in a common, transcendental destiny.

Mr President of ANAPS, dear artists, the theme you have chosen for your second exhibition – *Art against Apartheid* – shows that you have set out with your paintings, drawings, canvases and sculptures to make an impact on your times and, by doing so, actively join forces with the freedom fighters in South Africa and Namibia.

In fact, your pictures which are here before our eyes reveal, with staggering compactness, all the facets of this heinous system. Yes, we are well aware that violent forces now hold sway in South Africa. Everywhere there is nothing but cruel tyrannies, deceptions and acts of violence. The silence of death hovers like an eagle over this apocalyptic world of darkness and terror. By adding your weight to the heroic struggle of the black African people, you are giving the fight for freedom all the nobility and grandeur it needs.

Dear artists, this exhibition proves most eloquently that you care about mother Africa and her fight for freedom and unity. By doing so, you give the Senegalese nation yet one more reason to be proud of you. In my capacity as President of the Organisation for African Unity, on behalf of Africa, I thank you from the bottom of my heart.

This is also the perfect opportunity for me to congratulate all our country's creators: musicians, writers, poets, actors, painters, sculptors, the most established but also the newest on the scene who this year have made a particular contribution, with an incomparable display of solidarity, to the intensification of our struggle.

Senegal welcomes foreign input, and aims to continue participating in the dialogue between cultures at the highest level. This is why our country will always play a crucial role in the glorious battle for freedom, justice and democracy. We will never stop fighting apartheid until a multiracial society is created in South Africa, based on justice, equality, tolerance and mutual understanding. This is one of the reasons why we would like the next Panafrican Festival of Arts and Culture to be not only a major forum for putting the cultures of Africa and the diaspora on the map, but also a key meeting place for all world cultures.

Senegal, true to its calling as a cultured country, will, I am sure, thanks to its creators, make a very important contribution. It is you, the artists, who uphold our people's right to assert their cultural identity. You have already affirmed this right by the calibre of your works, which have won worldwide esteem in the travelling exhibition *Contemporary Art of Senegal*, which has recently returned here after visiting all five continents over the last twelve years.

Your second Salon d'Arts Plastiques now stands as a monument to the vitality and dynamism of artistic creation in our country. By dedicating this exhibition to the freedom fighters in southern Africa, you have written a new chapter in our history and in our modern art. This chapter, overflowing with signs and symbols, with freedom and dignity, is also called *African solidarity*. We wanted this exhibition to be the finest, the most exhilarating and the most heavily visited because it carries the hope of an entire continent – a continent which is stirring, struggling and wanting to become involved in the move to revive and enrich the culture of the whole world.

May this exhibition remind us that, in people's lives just as in their art, there are other worlds to discover and perhaps to understand.

Thank you.

recollections from

sudan and ethiopia

These five proverbs, composed by Hassan Musa, accompany his 'Graphic Ceremony'. Each is followed by a text explaining its applicability, meaning and context of usage. The original French text of the proverbs is also published here to convey their poetic sense in that language.

As a metaphoric and artistic genre of communication, proverbs are composed of short phrases or groups of phrases, usually balanced in their stress and rhythm (a central rhetorical pause makes them memorable), in which allusions are made to recognisable attributes of things and beings. In some cases, as in Hassan Musa's creations, proverbs can be visually oriented verbal images, which reflect his unconventional way of thinking. Essential to the applicability of proverbs in differing situations is the ability to draw analogies between various circumstances – that is, between the concrete and the abstract. Hassan Musa has certainly managed to create a formula of relationships, connecting verbal and visual modes of communication by way of a process of double abstraction. His performance is a visual deconstruction of exhibiting as a forum and a means of communication, and his proverbs are given physical expression in this visual performance. The reference to proverbs in turn suggests that relationships within proverbs are typical of situations which the visual performance intends to expose!

Salah M. Hassan

African Proverbs of My Own Invention

Hassan Musa

Translated by Salah M. Hassan

1.

'The one who exhibits, is the one who is exhibited' or
'The one who exhibits, is exposed'

Qui expose s'expose.

This is said of artists who allow themselves to be trapped into exhibiting, and to be exposed by exhibition curators. They allow their work to be manipulated and reduced to a brief citation within a 'con-text'[1] over which they do not have power or control. The exhibition is an exercise in the contemporary marketing of art as a commodity. Its real stake is not to exhibit the works of art to the public, but to expose the objects for buyers. For its organisers, an exhibition is a rite of power exercised in a social space through the manipulation of a 'triad': the art work, its creator and the public. The ambiguity of exhibiting lies in

its creative dimension. The exhibition is, in effect, an independent creative act/exercise similar to painting, dance or astronomy. Experimentation in the area of installation shows the innovative potential of the exhibition as an act. Not all plastic art works lend themselves to the ritual of exhibition. The fragility of the painting's temporal dimension is not compatible with the exhibition's spatial dimension.

2.

'Who goes hunting with a double bass?'

Qui va à la chasse avec une contrebasse?[2]

This is said of one who becomes confused and looks for the essence of a painting (or a work of art) in an exhibition, when what is actually left of it there is nothing but traces of a spatio-temporal act. Such traces are of no more value than those left by the feet of dancers when the dance is over. My own plastic art project is concerned more with art as an instant product of the moment. That is when the art work is still a potential, lying between water and clay, between the primal matter and the 'final' matter. I search for this barren, virgin terrain which cannot be aesthetically captured in the finished artistic product. I am not concerned with the aesthetic of power, which privileges the object at the expense of the idea. The object is governed by an aesthetic of a closed, final and perfect product, which is unsusceptible to criticism.

3.

'In charity there is a tank' or
'Charity often conceals a tank'

Dans charité il y a char.[3]

Said of those charitable souls who set off one day to Africa to preach the word of capitalism in the name of human rights, and who ended up strangling Africans with debts and Aids. If you don't believe me, ask the Somali people or the Rwandese!

4.

'Those with nothing to do
search for their roots.'

**Qui ne sait que faire
cherche ses racines.**

Said of those who are engaged in the futile
search for the cultural identity of their dead
ancestors. Expelled by the logic of capitalism
from the dreams of our pre-capitalist
ancestors, we have not, however, been
allowed access to the capitalist dream. No! we
have been trapped in the eternal nightmare
of underdevelopment, with a new identity:
that of those who are excluded, both from the
past and from the present. The only possible
cultural identity should be that of the
creative human being.

5.

'You only die twice' or
'One can only die twice'

On ne meurt que deux fois.[4]

This is said of those who suffer a double
exclusion, material and intellectual, and
hence die – as Jean Dubuffet put it – once due
to lack of food, and again from *ennui* due to
lack of thought and art. Underdevelopment
impoverishes Africans materially and
condemns them to hunger, and the traders in
so-called Art-African-ism[5] sentence them to
spiritual impoverishment, confining them to
the reservation of ancestral folklore.

As long as the African peasant in
Madagascar makes 1.20 francs per hour of
hard work while his French counterpart
makes 50 francs for the same effort, the
African contemporary artist will remain
excluded from the discourse of scholars of
contemporary art. African artists will not be
allowed to smuggle their aesthetic
accomplishments into the prohibited garden
of contemporary art. They will remain
excluded from the circle of contemporary art
and criticism, except as superstitious figures
and specialists in black magic to entertain
tourists of the exotic. Western critics will
continue to sing the praise of Africans as
possessing natural rhythm in their bodies,
and an intrinsic artistic sense running in
their veins. Yet if these westerners would
stop for a moment and look at the real
Africans crowding their television screens,
they would see people emaciated by hunger
and malnutrition, who no longer have a
single drop of blood left that could contain
this natural African rhythm.

What remains of an art work?
When 'exhibited?'
What remains of a work?
When explained?
What remains of a work?
When achieved?
What remains of art
Once crossed one's mind?

I am searching for a mark
A living, mobile, breathing mark
A mark which runs the risk of hazard
And those of premeditation.

I am searching the way
Out of the old-well-beaconed labyrinth
Of the exhibition.

I think the traditional, ceremonial laying out
of the art exhibition loses the sense of art
work. It suggests that a work is finally closed.
In itself, the exhibition is a mere means of
communication, but it could be enticed from its
original purpose to become a field of creation,
where artists are rather quoted than exhibited.

I consider myself as a creator (an African?)
involved in research. What I find in graphic
research is the result of deliberate work rather
than a hereditary gift or some sort of tradition
that runs through generations and ages.

Of course I am concerned with our
traditional arts, but in no way would I neglect
other traditions nor would I disdain what the
contemporary world is offering me every day.

In 1990 while I was presenting a ceremony
in France, some friends asked me whether it
was 'African art'. No, this is not African art
and I won't pretend to be a spokesman for the
continent.

It is merely an attempt to communicate part
of the graphic work which is not transmissible
through exhibition: its mobile and
instantaneous aspect which comes out of the
unknown, the moment when the decision is to
be or is not to be taken.

No, it's not African art
Art is too fragile to support the burden of
African underdevelopment. And Africa is too
precious to be confined into an eternal abyss of
sublimation: the art of a triumphal,
everlasting Christian capitalist culture!

We are not the light of lights. We don't want
anybody to eat our flesh any more, or to drink
our blood any more! There is no more African
art except in the Western museums. There is
no more Africa except in tourism, and no more
Africans except in International Aids!

What Africans are producing now in Africa
is not 'African art'. It is just art produced by
people who consider themselves as partners in
a world that they invent every instant.

About 'Art-african-ism'
and about Art
Hassan Musa

Mohammed Shaddad
1978
Plastic bags filled
with coloured water

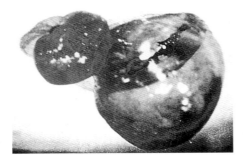

**Kamala Ibrahim
Ishaq**
Manuscript
1980
Watercolour and ink
on paper
Collection of the artist

The Crystalist Manifesto
(Al-Bayan Al-Kristali)

Translated by Salah M. Hassan, 1993

Kamala Ibrahim Ishaq
1969

The Crystalist Manifesto was first issued in Arabic in the late 1970s and was signed by Muhammad Hamid Shaddad, Kamala Ibrahim Ishaq and Naiyla Al Tayib.

1. The Crystalists testify with their kind minds that the Cosmos is a project of a transparent crystal with no veils but an eternal depth. The truth is that the Crystalists' perception of time and space differs from that of others.

2. The Crystalists' goal is to bring to life the language of the crystal and transform (your) language into a transparent one, to the extent that no word can veil another – no selectivity in the language. That is, people's utterance of one transparent word would be their utterance of the whole language. The whole language will extend to become one transparent letter that utterance of one letter would not block other letters. In that respect, language becomes one transparent tune that does not block other tunes. Otherwise, people should remain silent, which is in itself a crystal – that is, silence is a crystal.

3. We live a new life which necessitates a new language and a new poetry. A new life means that we have acquired new contents, which requires new forms and framing which are capable of expressing these modern contents. That is, we do not cling to the old forms because we do not like rhyming verses and old metric poetry.[1]

4. The Crystalists testify that there is no empirical (practical/experimental) knowledge. Everything that has been said about empirical knowledge is a myth. The human mind has not evolved, and will not make any progress, because of experimentation or practice. The essence of Crystalist thought is that the ability to know is also knowledge. The ability to know is older than experimental knowledge. The truth is that the mind is more intelligent, more holistic and complete than experience/practice. We (the Crystalists) have been asked about the place of this non-empirical knowledge in the mind. We have settled this debate by saying that what is originally in the mind is pleasure and not knowledge.

5. Yes, pleasure is intrinsic to knowledge. Our observations in life are but observations in pleasure. We should know that the dividing line between knowledge (science) and pleasure falls into absurd mirrors of water and light. The Cosmos is small and large, realised and non-realised, and what separates the two a dialectic of absurd mirrors composed of light and water. The world around us is calculated against a permanent one which is the light speed. Yet we focus our vision on the idea of the inverse of the light speed, so we can arrive at the edge and frontiers of the absurd mirrors.

6. We, the Crystalists, do not trust the law of evolution. The dinosaur has evolved into extinction. Vanished and extinct! You, men! you carry two breasts on your chests which are remnants of the woman in you which is extinct. You know, the breast has a function and there is no organ in the human body without a function to perform, now or in the past. Were you also breast feeding? What was your name?

7. We prefer vision (revelation) to skill and craftsmanship, and we oppose the trend which calls for skill and craftsmanship as a measure of a good work.

I conclude my talk without asking you to commit yourself to anything.

Skunder Boghossian

Left
Scroll I
1978
Cured parchment
rolled on
wood/acrylic
137 x 18 x 12.5 cm
Courtesy of the artist
and Contemporary
African Art Gallery,
New York

Right
Scroll II
1992
Cured parchment
96.5 x 10 x 7.5 cm
Courtesy of
Contemporary
African Art Gallery,
New York*

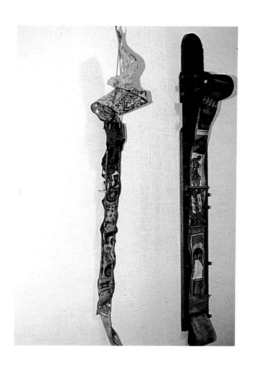

Artist's Statement

Skunder Boghossian

Interviewed by Solomon Deressa, 1985

Pen and paper is not the medium through which the painter communicates his message. And for me, a painter, it is very difficult to communicate in written words. I convey my meaning with colour. The viewer receives my message or non-message from colour on canvas, bark cloth, parchment, paper and aluminium.

The medium is second only to the message.

The message grows from the totality of my living experience. The message is a survey of an African artist in 'time and space' in search of himself and his roots. The message is a spiritual celebration that dares to paint the evil with the holy. The message is the sounding of a church bell on a Sunday morning. The message is a masochistic act of puncturing out the eye. The message is the self-healing process in a world where diseases abound.

The Sudanese visual artists, the undersigned of this manifesto, are of the opinion that contemporary artistic creation has no value without a civilised foundation. That is why they are connecting to the Arabic Islamic heritage, the heritage of the last human civilisation founded on a universal divine revelation. They are drawing on their heritage, not as a depository of past achievements, but as a dynamic living entity similar to other living things in weaknesses and strength. They are embracing its unlimited potential, and viewing it with gratitude, appreciation, scrutiny and an eye for its benefits.

'Verily this your order is one order, and I am your Lord, so fear Me'

Quranic verse (The Believer: 23/52)

The School of the One

(Madrasat al-Wahid)

Founding Manifesto

1986

Translated by Salah M. Hassan

The undersigned artists believe that any claim to internationalism in the arts must be founded on an awareness of the particular personal heritage of the creator.

The artists of the School of the One do not advocate the emulation of past creations. Instead, they make an effort to grasp their significance, and to develop their potential for constant growth and evolution.

For over half a century, the contemporary Sudanese visual art movement has reflected the above assertions, albeit with differences in levels of clarity and depth of individual contributions. It is in this context that the Khartoum School came into being as a civilised and historic project – a project which has been realised through the works of many Sudanese artists, yet without a clear theoretical vision.

The Sudanese artists, the undersigned of this manifesto, appreciate and take into consideration the contribution of the Khartoum School. The proposed project of the School of the One embodies all aspects of life in Sudan – religious, cultural, social, economic and political – and considers these aspects as branches and streams that nurture Sudanese contemporary plastic art works. Hence it is a project which is based on a holistic and civilised vision.

We, the undersigned, have agreed to call this project 'The School of the One' and define it as follows:

The School of the One is a Sudanese visual art school with Islamic, Arabic and African identity. It stands on the foundation of the civilised heritage of the people of the Sudan, in which Arabic and Islamic culture has ingeniously mixed with local African culture.

The School of the One draws its inspiration and aesthetic goals from the meaning of monotheism in Islam, the last of the divine revelations. The values of monotheism in Islam which have entered the life of the Sudanese people through Sufi Islam will remain the tie that binds the finest of their mannerisms to their arts and their literary traditions.

The School of the One upholds the principle of unity in diversity. Its motto in this matter is: 'Allah – The One and Only, The Almighty and Most Revered, The Healer, The Initiator, The Repeater, The Creator (Painter), The Creative, and The Creator of All Things, The Whole – *is* a Whole Who is manifested in a rhythm of multiplicity and diversity.'

We therefore regard nature with reverence as it is a divine creation. There is no separation between this new vision and the appearance of nature and its essence. Due to their place in the ladder of creation, human beings are entrusted with nature. In pursuing their aesthetic endeavours, human beings shall pay attention to the wisdom of the abundant beauty surrounding them.

We insist on revelation/inspiration as a creative necessity, which makes the art work a reminder of the need for a constant, vigilant consciousness. This means the need for a wise and more practical consciousness, which shall free human beings from the confines of inattention to the wisdom of the beauty of existence. Our relationship to the nature with which we have been endowed is one of inspiration and intimacy, and not a relationship of emulation, conflict or distortion.

The School of the One believes that the two pillars of creative experience are vision and skill. The revelation of the great vision requires a refined skill. This is why we are interested in improving skills and vocations as a means for civilised development. The artists of this school regard them as an entrance to charity and good deeds, and 'Allah requires charity on everything' (*Hadith*, or Prophetic Tradition).

The School of the One regards visual art as a system of thought and a way of thinking, even though it is channelled or expressed through colour, stone and other raw material. Therefore it advocates the need for a dialogue between creative individuals of all orientations. Creativity is the total sum and ultimate goal around which creative beings should gather, without any conflict.

In examining the reality of Sudan's cultural and religious diversity, the School of the One is guided by the principle of unity and diversity which has been essential to Islamic art throughout its different ages. It is the same principle which has been upheld throughout the vast land of Islamic civilisation, and

Utaibi
Askuti ya Jirah,
Silence, My Wounds
Ink on paper
32 x 46 cm

Utaibi
Quranic Text
Ink on paper

Utaibi
Decorated Gate
1986
Ink on paper

Utaibi
Get Up, Azza
1987
Ink on paper

has consequently led to the awakening of local national genius among the people of the nation of Islam. It embodies one aesthetic consciousness, with diverse traditional and conventional origins.

Throughout its ages, the Islamic civilisation has never destroyed any local heritages. Instead, guided by the principle of unification, it has tended to assimilate them. Sudan, with its fertile land for creative dialogue, has been an arena of cross-fertilisation and mixing, not of hegemony or conflict.

To implement the above goals, it is important to emphasise the need for aesthetic education throughout the different levels of the educational system in Sudan. We stress the importance of aesthetic and artistic research in institutions of higher education, especially the Khartoum College of Fine and Applied Art which must be enabled to fulfil its role in cultural, social and economic arenas. This can be achieved through a well-grounded curriculum and modernisation of its teaching tools.

The School of the One appreciates that 'nation' (homeland) is not a romantic expression, but an indisputable entity rooted in time and space. Its substance is the heritage of its people and their land, their present and future predicaments, their pain and triumph, and their aspiration to fulfil their ideal values within secure and happy lives.

In the end, artists of the School of the One find comfort in their belief in the unity of human existence. It is this conviction which makes their distinct creativity a long-awaited contribution to human heritage, a contribution in harmony with the uninterrupted prophetic orientation of the Islamic civilisation.

The artist who believes in the unity of God (i.e. in monotheism) is a struggling cultural entity. Therefore members of the School of the One believe that freedom is the essence of religious and moral responsibility. Freedom is a basic demand of all artists, as it is a demand of all people. Freedom is a means of revival and nation-building. At the same time, it is the only means of victory in the struggle against weakness, dogmatism, fear and poverty.

Artists of the School of the One believe that there is an urgent need for developing civilised unifying concepts, for the purpose of recreating a healthy Sudanese people who are able and productive in their lives. They consider this founding manifesto and, if Allah wills, their future works to be a necessary contribution towards these noble goals.

And Allah be behind our intention.

Signed:
Ahmad Abdel Al
Ibrahim Al-Awam
Muhammad Hussayn Al-Fakki
Ahmad Abdallah Utaibi
Ahmad Hamid Al-Arabi

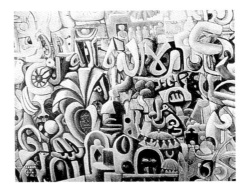

Ibrahim Al-Awam
Calligraphy
Oil on canvas

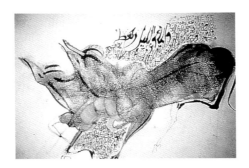

Ahmad Abdel Al
Untitled
1986
Ink on paper

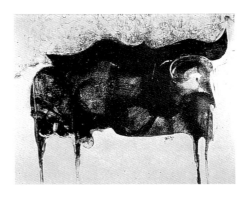

Ahmad Abdel Al
The Bull
1970s
Oil on canvas

Artist's Statement

Wosene

Distributed at an exhibition on
28 January 1994

In my current series entitled 'Africa: The New Alphabet', I am creating a vocabulary of signs and symbols, or *fiedel* (which means 'language symbols' in my language, Amharic). Creating this 'new alphabet' is an act of storytelling for me that grows out of traditional African calligraphy, graffiti, colours, textile patterns, woodcarvings and rituals. Yet I am exploring these sources to go beyond conventional meanings. I see my paintings as a bridge between traditional African arts and modern African expression.

In this new visual poetry, I am breaking apart and reconstructing the shapes of letters through distortion and exaggeration to create a portrait of the complex rhythms of the human drama. When I work with the magical words of traditional healers, words such as *Asmat, Zar, Metet, Tenquala, Buda, Denkara, Ganen*, I hear African peoples drumming and singing on my canvases. Through their voices and their movements in dance, I see them creating their lives and their cultures.

Besides the traditional African elements incorporated into all my works, I include the rhythms of jazz as a major source of inspiration. Jazz inspires the moods and movements in my paintings, the pacing and the silent spaces.

Gebre Kristos Desta: the Artist/Teacher

Achamyeleh Debela

1993

It is not unusual for a student to write about his teacher, and it is a rewarding opportunity to be able to do so. It is also easier when that teacher has made a lasting impact. I had the privilege of studying under Gebre Kristos from 1963 through 1967. During this time I came to know him as a dedicated teacher, and a friend who cared a great deal about the artistic and aesthetic maturity of his students. Perhaps his most significant quality was his ability to give a sensitive analysis and interpretation of a student's work. This was important because one learned from such criticism how to analyse and interpret oneself, and also to gain some insight into the direction of one's own work. Mostly he was there during the process of execution, as well as the conclusion. He was instrumental in students' struggles with decision-making about their work. Often his critical collaboration resulted in a successful accomplishment of a given creative and technical problem.

In short, Gebre Kristos as a teacher was highly inspiring and, at times, too demanding. His instruction grew out of personal discoveries and convictions, yet did not constitute a constricting influence on his students. The force of his personality was not dominating – rather, it was one that was at once respected and loved. As a result, he did not produce a host of 'little Gebre Kristoses' as did others whose dominating personalities, perhaps unknowingly, produced miniatures of themselves. Gebre Kristos believed in the development of critical standards within a student, standards that are congenial to the student's artistic personality as it emerges. When asked whether he taught because he had to or whether he felt that he had a vocation to teach, Gebre Kristos answered, 'I like to teach. It's true, I need the money I get from teaching, but even if I didn't, I would still want to help the young people get started . . .'[1]

Ever since his first successful solo show at the Gallery Kuppers in Cologne, Gebre Kristos Desta has held numerous exhibitions, both at home and abroad. He was truly an ambassador of his culture and his art. He served in an ambassadorial capacity, heading cultural delegations and travelling with touring Ethiopian art exhibitions in Europe. In 1965 he was the recipient of the Haile Selassie first prize (national) for the fine arts. In 1967 he was invited to exhibit his works and to visit important museums, and artistic and historical sites in the USSR. The same year he visited and exhibited his works in Czechoslovakia by invitation of the government. In 1970 he was invited by the Federal Republic of West Germany to present his work as well as visit important places of artistic interest.

In 1970, on the occasion of the founding of higher education in Ethiopia, Gebre Kristos was invited by the National University Alumni Association to exhibit his works at the Kennedy Memorial Library in Addis Ababa. The following year he was awarded 'Best Teacher of the Year' by the Ministry of Education and Fine Arts. A similar honour was bestowed upon him by the office of Addis Ababa schools in 1972. The same year the US Department of State invited him to visit as well as exhibit his work in America, followed, two years later, by the government of India.

In 1974 the Ethiopian revolution erupted. The Derge, which was then the provisional military government, proclaimed what was known as the *zamacha*, a National Campaign for Education through Cooperation. Some 60,000 students from high schools and the university were dispersed all over the country to propagate and assist in teaching rural Ethiopia about the new changes. Gebre Kristos, like many teachers, served in this campaign as an art expert. Upon his return to the capital he was awarded a certificate and a gold medal. Several studies of his experience and observation were included as part of a retrospective exhibition held in 1976–77. In 1976 he was invited by the Municipality of Addis Ababa to start the first National Gallery of Ethiopia; he became the founder and director of what became known as the City Hall Gallery.

Gebre Kristos was happy that the gallery gave young artists (including the talented Eshetu Truneh and Tadesse Mesfin) the opportunity to exhibit their works, but was clearly dissatisfied by developments that tended to perpetuate ideological rhetoric, suggesting that art was part of a new policy. His own work had suffered as a result of both administrative duties and demands for him to perform certain types of propaganda art. Today, it remains difficult when we have overnight Plekhanovists who churn out quotations from socialist realism. There is no clear foundation for argument, nor any consideration of existing Ethiopian reality or the experiences of other international artists, or even of the earlier history of culture

and art within Ethiopia and outside. Some make personal attacks, while others use this as a form of intimidation. You have to have a strong instinct for survival, or you fall into the wrong group.

Gebre Kristos finished working on a volume of poems as well as a book on art. Two years later, he was invited to participate at a workshop and exhibit his work at the Paa Ya Paa Gallery in Nairobi, Kenya. From there he travelled to West Germany where he languished for a year in an unsuccessful attempt to get asylum; he was simply told that he was too famous, and that the publicity would endanger the delicate diplomatic relationship between the two countries. In 1980, a Catholic church in Lawton, Oklahoma, offered him assistance and Gebre Kristos Desta – once the cultural ambassador to his country, who had exhibited his work all over the world – went to the USA as a refugee. He lived in a one-room apartment and began to work on small-scale stills, teaching art part-time in the local YMCA and later at a high school. But the pain, anguish and humiliation of his situation had taken its toll; he was taken ill suddenly and died in 1981.

Prior to his untimely death, he had a solo show in Oklahoma City at the Gallery of the Witchitas, where 47 of his most recent works were displayed. These ranged from small works to those measuring 16 square feet, using acrylic, oil, collage on paper, canvas and Masonite. They included *Military Checking*, *The Wheel Chair*, *Breaktime*, *On the Roadside*, *Football One* and *A New Home*, the majority of which contained still life studies of tulips and a variety of flowers and aquariums. Gebre Kristos Desta was a unique individual: a man, an artist *extraordinaire*, a poet, a teacher and an Ethiopian with his head high in the clouds and his feet firmly planted in the Ethiopian soil. He is indeed very much alive through his work, in which he shared his very being with the world.

AfriCobra and TransAtlantic Connections
Jeff R. Donaldson

Since its beginning in 1969 in Chicago, Illinois, AfriCobra – the African Commune of Bad Relevant Artists – has espoused an Africentric aesthetic vision designed to create 'awesome imagery' that reflects social responsiblity and technical excellence. AfriCobra imagists aimed for 'the spot where the real and the unreal, the objective and non-objective, the plus and the minus meet.'[1] At the same time, since it deemed demeaning art that posited African peoples as hapless victims, AfriCobra sought to produce a celebratory art – in short, an art that reflects cultural balance and aesthetic hegemony. Today, this concept of art and imagery resonates with that of many African and African-descent artists throughout the world, and that continuum has created an international concordance in contemporary art that can only be described as a 'transAfrican' style or movement. This apt combination term connotes 'across' (Panafrican aesthetics), 'beyond' (the multicontinental scope), and 'thoroughly changing' (individual or group perception) – the root connection of the imagery identified with it.

Remarkably, the artists and groups of artists whose works reflect salient elements and principles of this aesthetic developed their own individual and particular approaches to 'transAfricanisms' without external contemporary influences. It would appear that the artistic concordance among these highly independent individuals and groups is rooted in the autonomous emergence of liberation and decolonisation movements during the late 1950s and early 1960s.

The transAfrican art movement has developed quite rapidly since Wifredo

Members of AfriCobra, 1970
Left to right, standing: Sherman Beck, Carolyn Lawrence, Barbara Jones-Hogu, Jae Jarrell, Napoleon Jones-Henderson, Wadsworth Jarrell, Wadsworth Jarrell, Jnr. Kneeling: Gerald Williams, Nelson Stevens, Omar Lamar, Jeff Donaldson

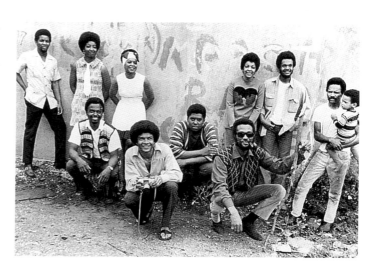

Lam, who may be considered the major progenitor of the style, returned to his native Cuba from Europe in the 1940s to create an astonishing blend of African, Asian and European imagery, reflecting an attitude towards life, a mystique – indeed, a distinctive world view – from a decidedly Caribbean perspective. Beginning in the 1960s, this tendency towards multicultural synthesis has grown exponentially among numerous individuals and groups of artists across the African continent, in several European countries and throughout the African diaspora of the west. Moreover, in the west, unrelated groups of artists – AfriCobra[2] in the United States and, in the Caribbean, Groupe Fwomaje of Martinique, Koukara of neighbouring Guadeloupe, and B'CAUSE in the Bahamas – have issued manifestoes that espouse region-related visions of the formal qualities of the transAfrican style/movement.

To all such artists in the diaspora, the connection with a diverse group of contemporary African artists is undeniable and reciprocal. In the case of AfriCobra, direct contact with continental African artists in a variety of venues has occurred over the last three decades – international conferences, major political events, cultural festivals, joint exhibitions, exchange programmes, trans-Atlantic studio visits and other mutually beneficial encounters. This sharing, of course, includes African artists and intellectuals across the full spectrum of artistic disciplines as well as in the humanities.[3] We have met and worked in fruitful relations with countless musicians, writers and intellectuals from all over the African continent. This creative exchange has also led to an informal international coterie of creative people of African descent, which has been pivotal in the development of multifaceted, multimedia forms of Africentric artistic expression, art of 'aesthetic toughness' – that is, 'art that defines and reveals and seeks to engage truths that go beyond temporal values but which are aligned with a collective pattern of existence, impacted and sustained by long-held cultural values without compromising aesthetic standards.'[4]

Of the many artists known to AfriCobra, Skunder Boghossian from the Horn of Africa in the east, and Papa Ibra Tall from the western extreme of the continent, have been the two contemporary African artists whose works

James Phillips
Ascension
1994/95
Acrylics
152 x 183 cm

embody the most salient features of the AfriCobra aesthetic approach. Stylistic characteristics of this work can also be found in the offerings of many of their compatriots and former students: Girmay Hiwet, Kebedech Teklaab and Wosene Kosrof of Ethiopia, and Ansoumana Diedhiou, Bocar Diong and Boubacar Coulibaly of Senegal.

AfriCobra first met Boghossian in 1970 at CONFABA, the Conference on the Functional Aspects of Black Art held at Northwestern University, Evanston, Illinois, 'a working conference of over 100 artists, art historians and educators, art consultants and critics . . . gathered from across the country to define and articulate both long and short term objectives, [and to] plan and develop strategies that would help to chart the [future] direction of African American art.'[5] This first encounter has led to sustained and mutually enriching personal and professional contact between Boghossian and AfriCobra throughout the ensuing years. Indeed, virtually all AfriCobra artists have been spiritually uplifted or formally influenced by the quintessential transAfrican qualities of his awesome œuvre and its aesthetic toughness. About the same time AfriCobra met Boghossian, we were introduced to Tall by Donald Byrd, the renowned musician and educator in Washington, D.C.

AfriCobra work is characterised by high energy colour, rhythmic linear effects, flat patterning, form-filled composition and picture plane compartmentalisation: these, among other attributes, inform the work of Tall.

Moreover, as much as any African

artists we know, both Boghossian and Tall aim to create an emotional intensity such as that achieved by African and African-American music. This has been an AfriCobra objective from the outset and, as A. B. Spellman notes, 'one liberating factor was the discovery, through African art and African and Afro-American music, of useful approaches to *rhythm*. This discovery moved them from the conceptual to the practical.'[6]

Over the past 26 years, AfriCobra has held around fifty exhibitions in diverse venues – from activist community centres to mainstream universities, private and municipal galleries and museums in cities of the USA, Colombia, Haiti, Martinique and Nigeria. Travel to many of these locales has led to significant contacts between AfriCobra and kindred spirits at home and abroad: Festac '77 in Nigeria brought together Wadsworth Jarrell and Uche Okeke, Nelson Stevens and Valente Malangatana (Mozambique), and Napoleon Jones Henderson and Jimoh Buraimoh. Akili Ron Anderson, Murry DePillars, James Phillips and Frank Smith met Twins Seven-Seven at the Studio Museum in Harlem and later in Washington, D.C., in the early 1970s. Michael Harris lived with Moyo Okediji while researching in Nigeria in 1992. We encountered the work of Ibou Diouf, Aissatou Gaye, Fodé Camara and Amadou Sow of Senegal, Zerihun Yetmgeta of Ethiopia and Lyolo M'Puanga of Zaire at Dak'Art '92 in Senegal.

In 1971, AfriCobra artists met Bruce Onobrakpeya when he exhibited at Howard University in Washington, D.C., and through him first became aware of the work of Uche Okeke, Yusuf Grillo,

Solomon Wangboje, and others formerly associated with Ahmadu Bello University. They aspired to create art laced with values gleaned from the traditional art, mythology and symbolism of Benin, Urhobo, Igbo and other Nigerian cultures, just as AfriCobra sought to do in the context of its history. At the same time, their attempts to target their art primarily at the Nigerian populace also resonates with AfriCobra's objectives in the United States.

Even earlier, in 1969, we had been introduced to a three-generation continuum of East African artists whose work reflected certain key AfriCobra principles. Beginning with the tradition pioneered by Osman Waqialla, who 'masterfully exploited the aesthetic potential of Arab calligraphy within a Sudanese context', Ibrahim El Salahi and Ahmed Shibrain carried this a step further by 'incorporating calligraphic motifs into their paintings as part of intricate design and overall composition'[7] to express Sudanese aesthetic and ideological concerns.[8] Rashid Diab, now working in Spain, who may be said to represent the third generation of transAfrican Sudanese artists, credits Shibrain, Taj al-Sir Ahmed and, specifically, Kamala Ibrahim Ishaq, as well as others at the Khartoum School of Fine Arts, with invaluable 'direction in the effort to research the different components of the Sudanese culture and heritage and transform them into artistic facts.'[9] The aesthetic and ideological concerns of AfriCobra arose from a similar search for a national culture in the African-American milieu, and its definition in the context of a new international consciousness.

Like other artists discussed here, Kobina Buckner (1934–75) from Ghana sought to draw upon the African sculptural idiom in the conception and execution of expressionistically fluid two-dimensional forms, uniting foreground and background in orchestrated or improvisational movement. His art resounds with rhythmic syncopation of form and colour (a prime AfriCobra objective), as does that of Kwabena Ampofo-Anti, a graduate of Howard University, who has employed similar methods in the production of outstanding ceramic sculpture. His contemporary and countryman, Edinam Wisdom Kuidowar, known as 'Wiz', has profoundly absorbed transAfrican principles in his compelling image embellishment and cultural symbolism.

Bogolan Kasebane – a group organised in Mali consisting of Kandioura Coulibaly, Fallo Baba Keita, Boubacar Doumbia, Souleymane Goro, Nene Thiam and Deletigui Dembele – has been unique in its approach to transAfrican aesthetics, specifically and emphatically adopting not only traditional iconography, but also traditional techniques of working and the use of exclusively indigenous materials in creating works based on Malian textile designs. Moreover, the entire Bogolan Kasebane art-making enterprise is collaborative and communal. Collaborative efforts and communal critiques have been hallmarks of the AfriCobra modus operandi from the outset.

AfriCobra meets regularly in partial or small group sessions for constructive criticism of members' work in progress, to achieve aesthetic concordance with group objectives. Presently, geographical dispersal has reduced gatherings of the entire membership to twice a year, but constant contact is maintained between members by electronic media. Founders Jeff Donaldson and Wadsworth Jarrell reside in Washington and New York City, respectively.[10] Charter members Nelson Stevens and Napoleon Jones-Henderson live in Springfield and Roxbury, Massachusetts. Other current members are spread over five states along the US east coast: Murray DePillars in Richmond, Virginia; Frank Smith in Baltimore, Maryland; Akili Ron Anderson and James Phillips in Washington, D.C.; Michael Harris in Chapel Hill, North Carolina; Adger Cowans in New York City. This geographical diversity has greatly increased contacts with other Africentric artists in the various cities, thereby intensifying individual expression within the context of aesthetic unity.

While the work of AfriCobra artists has always been highly individualistic (like that of the other African artists mentioned here), to promote group solidarity and to highlight particular contemporary issues, we continue to produce collective work on agreed subjects. Examples include *Black Family Solidarity* (1970) and *Southern African Resources* (1976). This last 'theme piece,' which restricted colours to those of the abundant strategic minerals in southern Africa, called attention to the fact that political empowerment and equal distribution of economic and material assets, as much as apartheid and discrimination, were key issues in the struggle for control in embattled South Africa. This work caught the eye of the

African National Congress and the Panafrican Congress United Nations representatives in New York, who arranged a commission for AfriCobra to create a salute to the courageous youth of Soweto. The *Soweto – So We Too* suite of ten works was exhibited in the UN Security Council in 1980.

AfriCobra has mounted an average of two group exhibitions annually since 1969, and in 1989 organised a joint exhibition in Washington, *Universal Aesthetics*, with Groupe Fwomaje from Martinique. During 1991–93 the retrospective *AfriCobra: the First Twenty Years* toured seven states in the USA. Individual members have participated in hundreds of solo and group exhibitions, have received many major public and private commissions, and are represented in important collections both in the USA and abroad.[11]

AfriCobra has benefited immeasurably from its trans-Atlantic connections and looks forward to increased joint endeavours with these and other kindred spirits we have yet to meet. Following the exhibition *Seven Stories about Modern Art in Africa*, we await the first multi-continental transAfrican art exhibition, now being organised as a keystone of the Eighth Annual 'Zora!' Festival in Eatonville, Orlando, Florida for 1997.

recollections

from south africa

Paris in the 1960s

Es'kia Mphahlele

From *Autobiography*, 1984

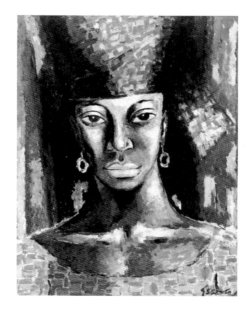

Gerard Sekoto
The Senegal Woman
1973
Oil on canvas
65 x 50 cm
De Beers Centenary Art
Gallery, University
of Fort Hare

Tonight I'm thinking of you, Sekoto. The Paris nights we crawled from one night club to another until the wee hours of the morning. It's – what – fourteen years now. And you had already been there for fifteen! Why do I think of you? Your large painting of an African head hanging on the wall opposite me. A young woman's. The most precious of my art collection. Remember how, as you told us, it was the first few years in Paris, how very sick you were? After nights of slaving in nightclubs playing the guitar to keep yourself in food, clothing and shelter? How the proprietor used to throw wine into your mouth constantly just so you wouldn't tire, to kill that sharp and nagging pain in your soul. Only a little so that you'd enough left to feed the notes from your guitar. How you survived the Parisian cold cuts, the coleslaw and salami of the *charcuterie*... Then you had to live in hospital so you could come to a self-realisation. The

memory of Pretoria, of your painting and the crumbs of recognition from white liberals.

The memory of your departure to brave the cut-throat life of Parisian salons and galleries. How blood-sucking it was to be, you would not have known. You had come into your own by the time we met, but you were still hacking your way through the forest just to be in a group show. One-man shows were beyond your reach, you had to keep sending work back to the home country and to American galleries.

Yes, this African maid you painted. Tonight, as so often, she seems to take on a

different life. But I know it goes according to how the lights dip and beam inside of me. And tonight the sounds I hear from my stereo help paint the mood. You must remember, of course, the blue that is dominant in your painting, varied by patches of white, toned down by dim artificial lighting in my living room – Nairobi, Denver, Philadelphia, Lebowakgomo (Northern Transvaal), Johannesburg. Big eyes, big lips, firm, youthful jaws, a handkerchief casually but elegantly worn. A stylised straight neck, a collar-bone pulling with a horizontal tension.

Sounds. Tonight I am playing music on the stereo that plunges deep, down to my very crotch. And she continues to stare obliquely out of the wall, now part of the scene, now aloof from it. I began with the late Errol Garner (you know of course that he died a day after the beginning of 1977) and took in Oscar Petersen, Coleman Hawkins. Can you imagine a crystal stone sculptured by the elements with carefree precision? Then, looking more deeply, you come to the tinges of black and blue in the very heart of the stone, giving it warmth – lyrical warmth – and sweetness such as never cloys. That's how Errol's and Oscar's piano comes to me. Hawkins's tenor has been saying other things to me. Not quite the simple if bold story line from Hodges. But still basic.

I came to Miles Davis's 'Kind of Blue', with the late Cannonball, Coltrane, Evans, Kelly; then Miles Smiles. And the maid kept staring obliquely out of the wall, out of the grassmat decor we have provided for her to serve as a backdrop.

Am I boring you with all this stuff – this recital? I don't care. I just need to talk to you. We come through Stanley Turrentine's 'Mister T' and 'The Blue Hour', Sonny Rollins's 'Bless this Child' and 'Good Morning Heartache', and 'The Freedom Suite'. Talking about 'Good Morning Heartache' brings to mind Diana Ross. Remember how she used to miaow her part in The Supremes? And then she found herself acting Billie Holliday's life in *The Lady Sings the Blues*. Whatever critics may say about some lapses in that movie portrayal of Billie Holliday, it did Diana Ross plenty of good. Learning to sing the blues gave her voice depth and the sadness that echoes African-American history. She wouldn't have got that any other way. The feline composure and gaiety is gone. She's a full woman with a full voice.

And the maid keeps looking that way with her large this-is-me eyes.

'The blues ain't nothing but a woman,' the

tragic Dinah Washington sings to me. 'Georgia on my mind,' Billie says. 'I want a little sugar in my bowl,' pleads Nina Simone. Bessie Smith's 'Jailhouse Blues' comes through again, travelling on Dinah's voice. And Roberta Flack's 'I don't want no tears anymore.' How they link up with Miriam Makeba and Letta Mbuli and take me back to the real and only blues voice I have ever heard in South Africa – Dolly Rathebe's – is more than I can say. But I feel it in my spine. All the thrills that come from art always register in the nape of my neck and travel down the spine as far as the shoulder blades. Enough.

I stay on a sustained blue note, you'll observe. Long, painful, solitary. What women! Maybe what accentuates my mood is that it's raining outside. Philadelphia is in the Delaware Valley. When it rains here, spring, summer *and* winter, it feels as if life is one long, dripping, weeping, drizzling siege. And you coil into yourself, gather up your reserves of warmth and faith and hope. And all you can do is indulge yourself, hang on that blue note as you play one record after another.

Uncanny the way events throw you this way and bounce you that way, isn't it? Here I am among blacks who long, long ago came here, as slaves, from our continent. Life is rough for them up here in the northern cities, where whites will give them at best an inch at a time. An inch which they must fight for. Whites hardened by their own ethnic-immigrant complexes – Irish, Jewish, European continentals of all kinds. Northern white racism hits you suddenly. So often African-Americans prefer to return to the south – that territory which we tend to think defines the savage prehistory of racism.
'I'm goin' back,' one keeps hearing in the African-American blues, 'goin' down south to shake the dust of this town off my feet.' And I find myself pulled into the mood, find myself returning to my own south. And it's T-Bone Walker's 'Funky Town' blues all over again. It's way back to the 1920s when Walker worked with Ma Rainey. Leadbelly, Lightnin' Hopkins? Of course.

I'm back to Dinah.

*Blues ain't nothing but a woman crying
for a man... when she wants loving...
a feeling that will get you down...
feeling bad...
disgusted and feeling sad...
a common heart disease...*

For a moment I hear only the line about loving a married man: just one of the many

heart diseases. Because suddenly she seems to be singing about the woman in *our* deep south. The woman who'd wait for a man, a son, who may never return, ever. Or will return from jail when she is wasted. Or will return dragging a corpse of a mutilated something inside him. And she starts to work on him, to try to mend him. How long has the train been gone? And she cries all night long.

Your African maid still does not flinch. Never will. The arrested, contained beauty of Keats's 'Grecian Urn'... unheard melodies... Just thought you should know where I'm coming from, Gerard, as they say over here.

What about you, Gerard? You always wanted to go back to Africa in those days. But not South Africa, not *our* deep south. When I said wouldn't it be better for your painting you said, yes. But something in those soft eyes told me you were a little afraid. Perhaps plain scared. You had been so long in Paris, you said, but not in so many words. I knew you weren't lonely any longer. You could handle Parisian life. Fourteen years, since 1948, you had been through a baptism of fire. Why not settle in Africa? I asked, when you were fighting so hard, bleeding so much, just for a group exhibition? The galleries, you said, belonged to a select group: what was a black painter worth in a European city glutted with artists?

You settled for a brief visit to Senegal. For purification, for a spiritual renewal. You returned with fascinating, exquisite paintings of the Senegalese human scene: the tall, delicate-looking figures, the women in sweeping garments, with stately headgear, the men in their long *bubus*. The texture of savannah air is all there. Spare grey colours... My good friend Ed Miles showed me what he had bought from you in Paris when he arrived back in Denver – before he left us for that fat post in Seattle, Washington.

A South African gallery failed to sell your Senegalese collection. Couldn't understand the art, you said, or some such thing. I remember there was a time in your early art life in Pretoria when white liberals boasted a Sekoto on their walls. The provincials! The Africans, for their part, couldn't afford the prices, of course, and hanging works of art on walls was not part of our tradition. The African exile and his audience... which audience? The eternal question: white liberals who can pay but whose interest has short legs, or blacks who *can* tune in but haven't the money? If it's any comfort to you, the African (and I

mean all who are not officially called white) writer in exile has the same dilemma. For him it's not so much the economics as the almost total absence of his works in South Africa. They are not available down there. You know the reason...

Tonight as I sit and look at your African young woman on the wall I shudder to think that a man can grow old outside Africa. Until he loses interest in returning. Someone – his name escapes me – reporting to the United Nations Refugees Commission, says that twenty years is the limit. Beyond that, the wish to return pales into rationalisations for staying out – to paraphrase him. I'm sure he's right. My ancestors have been on my mind these past ten out of twenty years. To refuse to do their bidding or not to have it in your power to... And how do you tame the malignant pain, knowing it's terminal?

I had a theory that for some of those who refused to return there was a frightening spectre out there on native ground. They believed they wouldn't be accepted because they had no cargo to bring back – some object of substantial value or some achievement that speaks for itself. Like the protagonist of Ayi Kwei Armah's *Fragments* who resists that cargo cult his fellow-Ghanaians – been-tos and their extended families – are constantly acting out. He dares return without any cargo. Then he cracks up. I'm not sure any longer about that theory – I don't know, Gerard, I don't know. But always Khalil Gibran's words return to me:

*Of what value
Unto them is the lamentation of an
Absent poet?...*

Although Gerard Sekoto was not having much luck with one-man shows, he lived moderately well. He had a patron who housed him – at rue des Grands Augustins, St Germain des Prés. He had a small studio he worked in at one corner of the apartment. He was doing much better outside Paris – in other European cities and in the United States. He was a frequent friend-guest in our apartment.

Breyten Breytenbach, on the other hand, was flourishing, both in Paris and outside. His satirical style, parodies, neo-surrealism, seemed to appeal to European sensibilities. It was not only Ed Miles who thought it was all 'horse-shit'. Mazisi Kunene, who was often in Paris, also thought Breyten was wasting his talent, that his work was all a dead-end joke, a sign of decadence. Certainly Breyten's

deformed shapes are impossible to live with, with the exception of one painting that I possess: a frog parodying man or the other way round. Ed and his wife Wanda thought the artist was being most unkind to the frog kingdom.

We saw much of each other – my family and Breyten and his wife Yolande.

Gerard, Breyten, K. P. from Nigeria, and I, all go bistro-crawling one night. Every time a joint closes for the night we go on to another. From St Germain des Prés, up St Michel, then back, and across the Seine. And we tear through the market area, stumbling over boxes. Three South Africans and a Nigerian in Paris at dawn. We throw down some more booze on the Right Bank as if to marinade ourselves. Then we have nothing to do but return to our territory across the river.

Out of the grey dawn Breyten says, 'Zeke, deep down I'm sober as a square Calvinist, but the other self says I'm drunk. Which am I to believe, eh?' Gerard says, 'Zeke, Breyten, K. P., I'm drunk as a hobo, and my arse is itching. In my boyhood days I'd use a dry maize cob.' I say, 'Speak for yourselves, boys. Me – shit, I'm drunk also.' And K. P.'s contribution is, 'Gerard, Zeke, Britain – you son of a Woortracker – why do you write such fuckin' good poetry in a language no one can read except yourself – if Zeke didn't paraphrase it in English how would I understand the damn thing? Why don't you write English paraphrases?' 'K. P.,' Breyten replies, 'you mouse in a chinashop, why do you write poetry as if you were taller than me?' 'China?' says K. P., then shouts, 'China, who be China, where be China, where be shop? Abi you tink I'm drunk-o.' And then he hollers up the Seine, '**China! Where's your shop**?'

We stop at K. P.'s hotel on St Michel to make sure he's where he's got to sleep. He straightens up, tries to square his shoulders, to become a foot taller than he is. All we hear as K. P. makes his grand entry is an eloquent *whaaaa!*

'The bull is sick in the chinashop,' Breyten observes, 'but don't worry, the porters are helping him up. Now Zeke,' he continues, as if he were the very personification of a conjunction between two sentences, 'tomorrow – I mean today – as I promised, Yolande and I will come and stay with the children for you, hear? Don't worry about a thing. You and Rebecca just fuck off to Geneva for your holiday. This Voortrekker and Vietnam will take care of things.'

We see Gerard to the door of his apartment.

Up St Michel, all alone, in the grey of dawn. Every so often I all but run into one of the trees growing in a row on the pavement. A strategy pushes through my thick brain and takes matters in hand, quite independently, as I reflect later, of the brain. I stomp up the boulevard, hitting the pavement heavily, like an African warrior. My shoes make a clatter that resounds in the hollow belly of a Sunday dawn, but the weight I put on my feet keeps me steady. Past the Luxembourg Gardens I know I'm almost home. A small voice comes through to ask, what about Geneva? What the hell does he mean *Geneva!* I say aloud, 'Geneva's next Sunday, dummy, not today!'

Mme Gomet, our *femme de ménage* – occasional domestic help – was an amiable person with a chubby face. She would come on the eve of one of those wild-cat strikes that characterise French life. There is a series of them throughout the year, workers laying down tools for a day. Mme Gomet would try to explain to Rebecca what she should expect. 'Demain,' she would say in single words climbing towards a sentence, 'grève – électricité, gaz (for cooking), water, the buses, trains – there will be a stoppage of all these, everywhere.'

She was very gentle with the children. Rebecca, always adventurous in these matters, would ask Mme Gomet for French recipes. The Frenchwoman always obliged and would even help Rebecca prepare some.

That was France in the early 1960s.

Africans – from West Africa, Madagascar, Mauritius, the Comores, the West Indies – converge in France. In Paris you see them mill around on the Left Bank, at ease, some hand in hand with white female friends. Paris in the spring: you should walk from the Right Bank, along the river to the left, past Place de la Concorde, past the Louvre. Paris was made for walking. It has a lot to tell you, and asks for nothing in return, no confidences, no commitment. Only one thing can sour a walk for me: dogs and their owners. They leave their obnoxious waste on the pavements and their owners indulge them all the same. Cats and dogs – the bane of my life . . . It's more than enough to contemplate the way dogs and cats walk in and out of the human condition in western society . . . Man alive!

Blacks in Paris. You take the French in small doses – they don't allow more than that, anyhow. You're all right if you understand that your friendship or acquaintance with them will go as far as the café or bistro, and rarely into their

homes. Not because you're black, people will tell you, but because they keep that area of their lives secluded, even in their relationships with one another.

So you strike your own level and coast along and relax, understanding that you are still an outsider, no matter what. They have a streak of cruelty, too, the French. Their former colonies can show you the ravages of the French personality. But in their own country, too. So you take them in doses, to avoid hurt. I don't know to what extent, if any, the traffic in any big city reflects a national character. To see drivers skirt round a blind man crossing the street (rather than wait) appals me.

Paris teems with exiles, ex-colonial blacks, which gives you the illusion that racism is minimal. Deep down in the French psyche it is expected that you, the outsider, should allow yourself to be sucked into its 'superior' culture, into a language that is the ultimate idiom of gentility and aesthetic enlightenment, one that you can't possibly resist if you are tuned into the charm and wisdom of western civilisation. It is expected that you should know that this assimilation is only possible on the Frenchman's terms. Deep down in such a psyche lies a calculating racism.

Gerard Sekoto
The Garden Worker
1973
Oil on canvas
65 x 50 cm
De Beers Centenary Art Gallery, University of Fort Hare

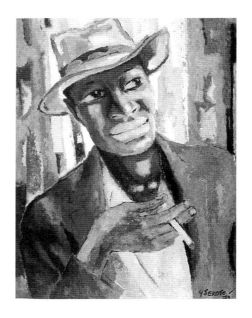

Paul Stopforth
The Interrogators

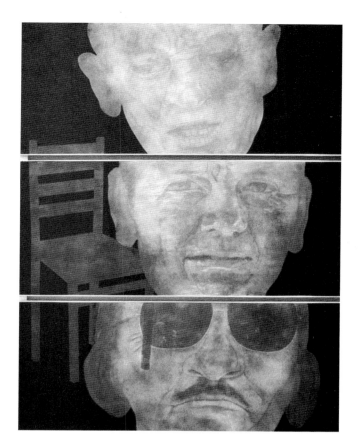

A Human Face: the Death of Steve Biko and South African Art

Andries Walter Oliphant

The white mythology which reassembles and reflects the culture of the west; the white man makes his own mythology, Indo-European mythology, his own logos, that is, the mythos of his idiom for the universal form of what he must still call Reason. Jacques Derrida[1]

Apartheid is dead. On 26 April 1994, white minority domination in South Africa ended. South Africa – for decades seen as an acute dramatisation of the history of the globalisation of colonisation, the struggle against it, and its imminent demise – has finally closed the book on colonialism in Africa. The topic of this paper, ironically, requires a return to the site of apartheid. In the early 1970s, while at the centre of the struggle against this site and some five years before his death, Steve Biko wrote his most comprehensive and incisive exposition of the movement he led. In his article 'Black Consciousness and the Quest for a True Humanity', first published in 1973, he articulates the vision, values, aims, tactics and strategies of Black Consciousness. He concluded his exposition by gazing into the future and wrote: 'We have set out on the quest for true humanity, and somewhere on the distant horizon we can see the glittering prize. Let us march forth with courage and determination, drawing strength from our common plight and our brotherhood. In time we shall be able to bestow upon South Africa the greatest gift possible – a more human face.'[2]

Some – even Black Consciousness adherents – may raise their eyebrows and wonder why the death of an anti-colonial hero is being dragged into an exhibition of South African art abroad, even if it is as part of a larger exhibition of work from Africa. Although the newly emerged official culture of South Africa will not, by the signs of it, commemorate Biko's death, his memory is still very much alive. The ideas and values he stood for have been internalised by a large section of the population. In this regard, his death can be viewed as an event constituted by contradiction. It belongs to that category of occurrences which simultaneously clarify and obscure. What some find reassuring in them alarms others. It brings with it a divergence of meaning governed, not by irony, but by the disseminating energies of refusal. His death revealed to the world the extremes to which the now vanquished white supremacy in South Africa was prepared to go. But to this day the true circumstances of his death, and those culpable, remain shrouded in half-truths. A great deal still remains well hidden from public scrutiny. Likewise, the full impact of his views in fields other than politics are buried under layers of misreading. Some claim that he would have been opposed to the historic settlement reached by the

liberation movement with the former white minority government, which paved the way for the transition to democracy. Others point out that towards the end of his life he argued for strategic alliances between blacks and whites committed to democracy. Where would he have stood today? His legacy to what is today packaged as post-colonial discourse is greatly underestimated.

The exhibition to which this text is hinged aims to set up a complex interplay between this historical event and the arts, an interplay focused on a historical context and an event. It is also related to contexts and events beyond these. In view of the dispersal this necessarily implies, it is not possible to assemble all the traces which bear upon the moment. In place of a detailed cultural history, a discontinuous and fragmentary perspective is offered. Although Biko's death is fully apportioned to the apartheid state and the individuals who assaulted him, the full truth is only partially decipherable. The staging of an exhibition which takes his assassination as a reference point is a symbolic act of presenting to the viewer evidence related to a kind of cultural inquest.

II

Steve Bantu Biko and the Black Consciousness Movement, as the world knows, enjoyed currency in South Africa during the late 1960s and reached its apogee in the mid-1970s. The Soweto uprising of 1976 is the historical event to which the name of Steve Biko adheres. What is frequently unacknowledged is that antecedents and recurrences of discourses with affinities to Black Consciousness are scattered across the entire history of colonial domination and the struggle against it in South Africa. In a very specific sense, the Black Consciousness Movement straddled two decisive historical moments in South Africa and served as a catalyst for one. It was a post-Sharpeville phenomenon. It informed the Soweto uprising of 1976. It had post-Soweto reverberations. Decontextualised from its geo-political specificity, its history and values are embedded in the earliest African articulations dealing with instances of foreign domination. Its presence is not dependent on conscious evocations or acknowledgements, nor on willed linkages. The force of its assertions, as a counter to the militant race consciousness

of white supremacy and the non-racial alternatives, has inscribed it implicitly in all questions concerned with race, culture and identity. In the case of South Africa, the issues voiced by Steve Biko, it can be argued, represent a kind of permanent presence.

The claim is sustained by the fact that Biko laid bare the psychological, social and cultural factors which racism in South Africa enlisted to entrench white supremacy. His labour was aimed at decolonising the self and restoring value and pride to black people and cultures. It rejected the negation inherent in the term 'non-white' and proposed 'black' as the antithetical term to 'white'. This signified the direction of the struggle to overturn the value assumptions of racism. Through personal example, he ignited in the youth and eventually in the people of South Africa the will to break the choking grip of racial oppression; with what an associate called his 'compelling eloquence', he inspired a generation of South Africans to renew the struggle. In time it would evolve, expand and fuel the liberation struggle.

His personal courage and sacrifice were not unique. Comparable determination in the face of what seemed to be an invincible adversary was displayed by many before and after him. What singles him out is the historical moment of his appearance, and the martyrdom to which his death in custody led. He knew and anticipated this. In an interview a few months before his final detention and death he remarked, 'You are either alive and proud of it or you are dead, and when you are dead you can't care anyway. And your method of death can itself be a politicising thing.'[3]

Today Biko is memorialised, despite his apparent public neglect, in a significant body of literature and art from the 1970s and 1980s. To approach this body, to identify and describe it from the vantage point of the present, is not without difficulties. In that virtually infinite and disorderly community of images to which art pertains, several images of Steve Biko are imprinted on my mind. These in turn are linked to other visualisations. The bare, unencumbered, factual particularities of these images are charged with the energies of the living body and the imaginative responses they trigger. There is a photographic portrait of him taken in King Williamstown, his place of banishment. Biko's head is turned to the camera. He stares into the lens, level with his eyes. The invisible photographer is crouching. The expression on his youthful face, with its

symmetrical features bathed in light, is a blend of seriousness and confidence, with an avuncular touch. The edges of his mouth, framed between a thin moustache and a stubby goatee beard, are tucked into a barely perceptible smile. This face floats before me as I write. It is an image of vitality with the irreducible ambiguities and nuances of life. Biko alive would later be disseminated on numerous placards, poster-portraits and collages.

There is an image of his dead body. It shows him prostrate on the table of a state pathologist. The invisible photographer hovers at an angle above the corpse. The scars of torture are all over his body. The face is bruised and puffy, his swollen eyelids are shut. What is the distance of time between his living image and the image of his corpse? Paul Stopforth's study in graphite of the cadaver flat on a stretcher is linked to this image. The lifeless body in rigor mortis is modelled with the solidity of opaque, lifeless matter. The deadweight bears down on the canvas of the stretcher. The clinical directness of the depiction gives way to the expressivity of the mouth in the otherwise featureless face. The luminous boundaries of the body resemble energy bursting from within it to frame the corpse with a phosphorescent outline.

Sam Nhlengethwa's collage is even starker. Where Stopforth's image suggests the monumentality of the martyr's corpse, Nhlengethwa presents the vulnerability of the body and its decimation through torture. The multiple perspectives are more than the mere formalities of the cut, paste, draw and paint techniques of his assemblage. They are the inscriptions of torture and dismemberment. The twisted figure lies naked on the floor of what can only be described as an interrogation chamber. The torso, resting rigidly on its side, is turned to the viewer. The feet, severed from the lower parts of the legs, are twisted upward to conform to a body lying on its back. The large head is fractured and bruised. The dark interior is filled with the icons of a police world. Beyond this, a universe in tumult looms.

Yet another image, a poster by Dikobe Martins, shows him with his eyes fixed on an invisible audience. Two manacled hands, not his own, clenched into Black Power fists, are held up before him as they snap the chains.

The narrative of these images is evident: life, death, martyrdom. Biko, as we saw, was fully aware of this narrative of resistance. It is the story of life

strangled, suffocated and extinguished by oppression, only to be rekindled and to triumph. In this sense, Biko's life and death are part of that pantheon of anti-colonial heroes of Africa and the diaspora.

To apprehend fully the broader context and the language it produced one has to attend more specifically to the historical moment. It was almost two decades after the triumph of apartheid when Biko emerged as a political figure. An atmosphere of fear and terror pervaded the black communities. The liberation movements, radical intellectuals and virtually everyone with a sense of social and political decency were muzzled, banned, imprisoned, exiled or murdered – judiciously or otherwise. With a few exceptions, the vast majority of the members of the privileged minority opted to remain silent.

The apartheid state was riding high. Nelson Mandela and the core of the African Nationalist Congress leadership were held on Robben Island. The South African Communist Party and the Panafricanist Congress shared the same fate. The liberation movements operating beyond the borders of South Africa, although no longer in disarray, were going through a process of recovery and reorganisation.

The late 1960s was, however, from a global point of view, a time of social ferment and political upheaval. It was a time of unrest and revolution. In Europe the student revolt rocked France. The United States was locked in a losing battle in Vietnam, while at home the Civil Rights Movement spread from the southern states across America. In the Soviet Union the post-Stalinist era with its new contradictions, tensions and upheavals in the eastern bloc arrived. In Africa decolonisation was proceeding. This process, which began in earnest after the Second World War, accelerated and acquired particular intensity in southern Africa. The struggle against Portuguese colonialism intensified, culminating in the liberation of Angola and Mozambique in the mid-1970s. A particularly intense anti-colonial discourse with clear Africanist tones was audible to those who listened. Panafricanism and Negritude were abroad. All this filtered through the curtain drawn around South Africa. Although the people of South Africa were isolated from the liberation movements, they had not sunk into a state of amnesia.

During the years following the inception of apartheid, South Africa itself was developing in such a way that internal economic and political realities came to contradict the grand designs of the apartheid architects. The segregationist policies destined to ensure white enrichment through economical expansion based on cheap black labour produced race and class cleavages which strained at the social edifice of apartheid. In due course it would impel revolt. The mass mobilisation and turbulence which marked South African life after the Second World War, and particularly after the ascendancy of the Nationalist Party in 1948, already suggested that repression would not succeed in extinguishing the militancy demonstrated by broad layers of South African society which included workers, rural communities, writers, artists and a cross-section of the liberal intelligentsia.

The imminent revolt was incubated in the townships and among the youth at black universities, schools and in the townships. It erupted under the banner of the Black Consciousness Movement led by Steve Biko. As a student leader he headed the South African Students' Organisation (SASO), launched in 1969 at the University of the North to wrest the initiative from the National Union of South African Students which was based on the liberal English-speaking universities. This marked the re-emergence of independent black political activity. The liberation of black people, Biko and his associates argued, depended on the role black people themselves were prepared to play.

The political philosophy of Black Consciousness was nothing new. Although first elaborated in the US after the Sharpeville massacre, it had antecedents in South Africa and abroad. This is how Biko articulated it: 'The philosophy of Black Consciousness... expressed group pride and the determination of the black to rise and attain the envisaged self. Freedom is the ability to define oneself with one's possibilities held back not by the power of other people over one but only by one's relationship to God and to natural surroundings... At the heart of this kind of thinking is the realisation by blacks that the most potent weapon in the hands of the oppressor is the mind of the oppressed.'[4]

III

It is hardly surprising that the Black Consciousness Movement was accompanied by an upsurge of a wide range of cultural and artistic practices. It served as a catalyst for a variety of literary and artistic developments. It directly addressed culture and the arts, and stimulated discussion on questions concerning creativity and development. It challenged and sought to decentre colonial culture in South Africa. Such a displacement was to be effected by a recovery and restoration of the African aspects of South African culture. This produced contradictory responses at all levels of life. At first it was

Paul Stopforth
Elegy
1980–81
Mixed media on board
149 x 240 cm
Durban Art Gallery, South Africa*

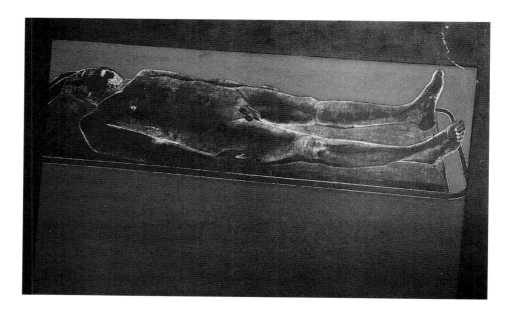

encouraged by the white government which interpreted it as supporting its own divisive ideology based on ethnicity; it was criticised on the same grounds by white intellectual liberals as a reactionary form of black exclusivity and chauvinism. Marxist intellectuals viewed it as yet another incarnation of African nationalism which failed to apprehend the capitalist nature of apartheid and the role of class exploitation. When the white authorities eventually came to comprehend the radical orientation of Black Consciousness, they suppressed it. These conflicting interpretations still prevail.

The cultural movement it spawned in the townships embraced oral poetry, theatre, photography, visual art and music, seeking to challenge the cultural coercion of minority domination. It rejected the imposition of cultural and artistic discourses which considered to be of value only those articulations and objects which conformed to the myth of universality as determined by colonial tastes, evaluations and prejudices. It insisted that black writing, art, music and performance detach themselves from the normative orbits and institutions of white intellectuals committed to colonial values.

Although uprisings occurred all over South Africa, Soweto was one of the crucial sites of the struggle. To many, and especially to outsiders, it was the metonymic structure of the period. It led one white critic to dub the poetry of the 1970s 'Soweto Poetry', to the chagrin of poets such as Mafika Gwala.[5] In the visual arts it spawned the label 'Township Art', which was in turn also rejected by black artists such as Matsemela Manaka.[6] In retrospect, it is clear that these categorisations were attempts to perpetuate the marginalisation of black art by the very institutions that black artists had come to reject.

In literature, poetry is the genre associated with the period. Figures such as Njabulo Ndebele, Mandla Langa, Mafika Gwala and Wally Serote fashioned a poetry that signalled a decisive shift away from an implied sympathetic white liberal readership, as was the case with Oswald Mtshali's *Sounds of a Cowhide Drum* (1971). This shift corresponds to the inward orientation of Black Consciousness, with its focus on inter-black communication. The language is styled on the speech of urban blacks and conveys a sense of urgency. It was a rupture with the humanist aesthetics of liberalism which informed the work of poets such as Arthur

Nortje, Dennis Brutus, Es'kia Mphahlele and Lewis Nkosi who emerged in the late forties and fifties. This uncoupling was a new manifestation of earlier attempts – by Peter Abrahams in *A Black Man Speaks of Freedom* (1940) and H. I. E. Dhlomo in *Valley of a Thousand Hills* (1941) – in which local social and political concerns and indigenous aesthetic traditions predominate. This move towards indigenisation was further marked by an increase in oral performance. The artists' individual identities gave way to the desire to articulate collective experiences.

This would register in all the arts. In the visual arts, the colonial trend of filtering South African subject matter through western stylistic conventions gave way to approaches through which style and subject matter were oriented towards the indigenous with greater conviction. It expressed itself in diversity of representations, which embraced the socio-political, the cultural and the religious, in the work of artists such as Sokaya Nkosi. Leonard Matsoso and Billy Mofokeng drew on the geometric forms of African sculpture. Artists like Fikile Magadlela, Thami Mneyle and Dikobe Martins emphasised the black body and drew on the psychological, social and cultural aspects which shape identity and its visual representation. For white artists like Cecil Skotnes and Walter Battis, to name just two who had consistently urged South African artists to fashion an aesthetics based on indigenous traditions, it was a period of ambivalence. As artists, Black Consciousness coincided with their own perception of themselves as Africans. Other white artists, such as Paul Stopforth and Gavin Young, responded to the time by expressing political solidarity with the oppressed by inscribing in their work explicit political attitudes and messages in condemnation of racial domination.

As the 1970s proceeded, the cultural dimension was woven into the resistance discourse with such effectiveness that the banning of the Black Consciousness organisations in 1977 included several cultural groups. The immediate post-Soweto forum for the arts was the multi-disciplinary journal *Staffrider*, established in 1978. It drew together poetry, fiction, social documentary, photography and art produced in the black urban communities and by white writers who identified with the unfolding democratic cultural process. It gave rise to a generation of writers – which included Mtutuzeli Matshoba, Ingoapele Madigoane, Achmat Dangor,

Ahmed Essop, Chris van Wyk, Mothobi Mutloatse and Kelwyn Sole – and reinserted the work of previous generations into the literary discourse.

In the visual arts important figures included Bongiwe Dhlomo, Dikobe Martins, Fikile, Paul Stopforth and William Kentridge. Photographers like Jimi Matthews, Ralph Nadwo, Judas Ngwenya, Paul Weinberg, Lesley Lawson and Omar Badsha forged an aesthetic which sought to reveal the conditions under which the majority of South Africans lived and to provide modes of resistance. The guiding practices were not so much a question of racial solidarity but the Soweto realities of South Africa and how these gestured towards a multicultural and democratic future. Other artists associated with the Johannesburg Art Foundation, such as David Koloane, Dumisane Mabaso, Tony Nkotsi and Bill Ainslie, developed a non-referential mode of resistance by establishing a space for visualisation which was not conditioned by the necessity to describe oppression. By foregrounding the act of art making they subtly commented on the ultimate irrelevance of apartheid. It was a repressive environment in which art came under such pressure that it is remarkable that it survived with integrity.

This contradictory process which developed over the last thirty years was the structure of engagements with the future, and the past as a site saturated with heterogeneous articulations. Its effects would eventually displace the images, objects and articulations of colonial domination and open the way for a diversity of practices in a post-apartheid South Africa. Stephen Bantu Biko was born on 18 December 1946. He died in police custody on 12 September 1977. His life's work did not end when he was assassinated. It is, when viewed from the perspective of Africa, work still in progress.

David Koloane and Ivor Powell

In Conversation

Ivor Powell: The so-called 'township art' styles which emerged among black South African artists during the later 1950s and continued to flourish well into the 1980s are by no means unique in Africa. Markets have long existed in many African countries for funky and sentimentalised representations of a (sometimes lost and sometimes imaginary) African lifestyle, barely touched by the rampant technologies of the west, retaining a spontaneously 'African' feel – or at least what the consumer would consider to be one.

In South Africa, as is the case in much of the continent, this notion of the spontaneously 'African' in township art is the merest invention. The roots of the style lie in European expressionism; it refers in no way at all to indigenous southern African tradition. This is Africa invented for the consumption of whites.

None of the above is unique to South Africa. Nevertheless, the special circumstances of South African society under apartheid entailed that such art styles, rather than existing merely as curiosities produced for tourists, came to constitute a mainstream among black artists in general and to define the position of black artists on the continuum of art production. It is only in the past decade that black artists have been in any kind of position to challenge and even to begin to redefine the aesthetic role assigned to them. Even now, in a democratic society, the challenge for black artists remains that of claiming a cultural space formerly reserved for whites only; of being perceived, in other words, as artists, without any further qualification.

The art centre at Polly Street in Johannesburg seems like a good place to start talking about the curious category of urban black artists in South Africa. But, before we start, it might be worth registering that this moment doesn't represent the beginning of black art in this country. Of course, there had been black artists earlier. First, there were those working in traditionally African modes, but they don't really come directly into this conversation. I think we agree that there's no real continuity between this so-called tribal work and the kind of representational, western-influenced art that grew up in the townships.

Second, there was Samuel Makoanyane and people like him whom current art history are wanting to see as forerunners of something or other. I'm not terribly convinced by this, except insofar as they prefigure the exploitation of later artists, and are subjected to similar market forces. I think it is more relevant to see people like Makoanyane as being, essentially, curio-sellers who therefore relate more interestingly to later rural artists such as Doc Phutuma Seoka and the Ndou brothers.

Third, there were artists like Gerard Sekoto, George Pemba and Ernest Mancoba, and maybe a few earlier like Gerard Bhengu, who were in fact working in imported western modes and in western materials such as oils and gouache. They are relevant to what we are talking about here.

But I'm particularly interested in art under apartheid, in the ways that black artists functioned, or didn't, in that context. So let's talk about the Polly Street Art Centre.

David Koloane: It didn't start off as an art centre. It was a recreation centre. A whole lot of different disciplines were being introduced to the urban black community – like ballroom dancing, music, boxing. Polly Street was started in the same spirit, to introduce all these sophisticated developments into the lives of blacks.

What made Polly Street important is that it was basically the first place where black artists could come together under one roof from different parts of Johannesburg and even further afield. It was only then that artists came to realise that there was interest in the visual arts in the townships, and came to know one another. From the core group came the first professional artists in the communities, people like Lucas Sithole, Louis Maqubela, Durant Sihlali, Ben Macala... In the early days, they came to Polly Street basically just for materials and to talk about their work and common problems.

Okay, let's put this in perspective. In 1952 the National Party government, having come to power in 1948, was busily pursuing the institution of its apartheid policies in the community at large. For blacks this meant, in particular, forcing them in one way or another into very specific and circumscribed roles in society, 'hewers of wood and drawers of water,' in Verwoerd's phrase. Now, this was

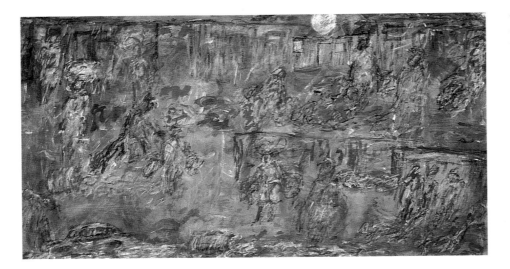

David Koloane
Made in South Africa,
No. 4
1993
Acrylic on canvas
Collection of the artist

In the whole of South Africa, fewer than thirty secondary schools under the old Department of Education and Training (the education authority for blacks) offer art as a subject. At primary school the vast majority of ex-DET schools still teach needlework for the girls and gardening for the boys, or a subject known as Skills and Techniques – which essentially trains children in imitative rather than creative skills – in the slot where art studies would be offered in white schools.

happening under the auspices of the Department of Native Affairs or Non-European Affairs or whatever it was called at the time, which appointed Cecil Skotnes as art instructor in 1952. I'm interested here in the underlying agendas... Am I basically right in saying that they encouraged white artists to work in one way and black artists in another?

For blacks, in a primitive, untutored way. If a black artist was referred to as primitive, that meant he was going in the right direction. Blacks weren't encouraged to pursue an academic training, or to become art teachers, for example.

When I was teaching at Unisa in the 1980s we graduated, if I remember, the first ever black honours student in the Fine Arts in this country. It was a real event.

What I find ironic is that artists were not encouraged to develop. Artists were not encouraged to read further, to find out about artistic modes or artistic movements. Yet they were using western techniques and western materials; one would think it would have been natural for them to explore these techniques and styles much further...

Personally, I find the whole thing pretty sinister in its contradictions. I mean, there is no meaningful continuity between traditional African art practices and the work that urban black artists began to make in the earlier decades of this century. What the emergence of representational art, oil painting, graphic media and so on actually signifies is an assimilation of

the modes and, to an extent, the values embodied in the western art tradition which has established itself as globally dominant. While there might be some kind of African inflection in the work, it is really a participation on the part of an emerging black middle class in the global civilisation which the west imposed via its colonialist activities.

Given this background, there is something particularly telling of the white South African mind about the refusal on the part of the dominant culture to allow black artists to participate fully in this post-tribal global civilisation – this insistence that black artists should not, if you like, be the heirs to the fullness of the western civilisation, should not own it in any way, but operate only on its periphery. That, for me, is the implication of this myth of the natural talent of the black, the idea that blacks are not thinking, but merely sensual, beings.... It is impossible not to see it in relation to the legally enforced inferior position in society that blacks occupied in the society as a whole.

Blacks are being forced to remain in an infantile mode, yes. Not only in the instruction they received, though; it was also in the way the galleries and the art buying public approached their work. In the 1950s and 1960s black artists' works were still a novelty. They had just come to the notice of art buyers, who were almost exclusively white. These whites were mostly seeing for the first time how blacks lived in the townships in the way the artists portrayed the townships in their work. But, on the other hand, they wanted to see this as a sentimental form of expression rather than a depiction of real social conditions.

Some time ago I was looking through two books on urban black art. One was Steven Sack's *Neglected Tradition* catalogue, and the other was De Jager's book on the Fort Hare collection. It struck me how circumscribed the actual subject matter of the work really was. I started counting. Of the work dated between 1950 and 1980 (after 1980 the rules change), in all the art represented in one of the books, there was one white person; in the other, there were no white people at all. There was one single motor car, but hundreds of horse- and donkey-carts. No suits except the self-deconstructing type, adorned with bottle tops and bits of silver paper and worn by

Professor Elizabeth Rankin of the University of the Witwatersrand has surveyed acquisitions in South African public museums and galleries. She notes that the Johannesburg Art Gallery acquired its first work by a black artist in 1940, and its second in 1972. The South African National Gallery purchased its first work by a black artist only in 1964. Most of the other major public collections similarly bought their first work by a black artist in the 1960s. That at Pietermaritzburg broke the cross-cultural ice only in the 1980s. As regards 'traditional' African artworks, such art came to be included in the collections of art galleries rather than ethnographic museums only much later. The Johannesburg Art Gallery, for instance, presented its first permanent exhibit of this kind only around 1990.

madmen. And so on. This funky fiction has hardly anything to do with the real life of the townships; it has no reference at all to the more or less technological world of the twentieth century that people actually live in, except for things like radios and musical instruments.

Blacks don't represent whites, but whites do constantly represent blacks. You think of artists like Anton van Wouw and Irma Stern; their work very often has black people as subject matter... But, you know, it's very seldom that these black people are really seen as human beings. It's the Mineworker, the Bushman, the Xhosa Women – they are objects with labels, they illustrate function, the psychology is not observed. There's a portrait of her maid by a painter called Dorothy Kay. The maid's in her uniform and holding an empty dish: I wondered when I first saw it if posing was one of the maid's duties. It's only much later, with artists like Keith Dietrich and Paul Stopforth, that you get the human condition coming through in the images of black people that whites have made.

In a way, it's just the other side of the same coin, the manipulation and the self-manipulation of the image of black people...

One thing that has constantly come up is this carefree attitude of blacks. They are always supposed to be happy. Music comes easily to them. So music was pretty much one of the major elements of subject matter for black artists of the period, especially when township art started being bought in the suburbs. Every artist made it a point to have at least one or three musicians' compositions in their work. Obviously those would sell much better than anything they could attempt to do in the way of serious composition, or even an honest representation of the social conditions.

As you pointed out, the market for the sentimental versions is exclusively white. We are not looking so much at black representation as at what the white consumer wants to buy... This is a key set of issues. Because of the nature of the market, black artists have to produce a certain kind of work if they want to sell, if they want to survive – and, by the same token, only the work that gets bought gets preserved or exposed to public attention.
Let's talk reality here, what is *not* there in the art. The 1960s and 1970s were the high point of township art in its various forms. The reality of the

townships is pass raids, forced removals, Bantu education, growing protest movements, Sharpeville...

Those years, I remember, were the most depressing periods for black communities anywhere, everywhere. But they were also the years when the work of these black artists first appeared on the market, when the artists could have exhibitions for the first time in white commercial galleries.

Each gallery would tell the artist what kind of work they were looking for, what kind of representation they wanted. For instance, the features had to be thick-lipped, the hands and feet oversized. In a sense, though, that came about because the artists themselves felt that the more they exaggerated some elements in the composition, the more they would appeal to the market. When Dumile started doing all those caricature-like drawings, he started a trend. There were a whole lot of younger people who tried to emulate that type of drawing and it ended up being something different from his intention.

If you didn't do this kind of thing it was harder. In 1977 and 1978 I started experimenting with collage, and I took some of these pieces to Gallery 21. The first thing the owner said was that I didn't do the work. And I said what did he mean by that? And he said no, because this is so un-African. He said for that reason he didn't feel comfortable buying it.

There was also another kind of market, actually there still is. When I was curator of the gallery at Fuba, lots of white people would come to me and say they were going away on holiday, and what they wanted to do was buy work that they could easily sell overseas, so that they could have spending money. That kind of thing happened mostly in the 1970s, which saw the height of that kind of alternative dealing, whereby the artist no longer worked through galleries but through these dealers. They were mostly buying and encouraging the worst kind of art, the most sentimental work. They wanted work that could make an easy sale. And the artists also knew that if they wanted easy money they could just do ten of those and give them to that particular dealer, and be paid maybe 10 or 20 rand for each one. They saw that as bread money, something that would keep them going while they did more serious work. But actually it had a terrible impact, because most of those artists today have fallen by the wayside.

You say that artists would do this work to support themselves while they

A number of black artists over the years have been employed directly, by the South African government ministry responsible for black affairs, to make art for a fixed retainer. One was the painter Ernest Mancoba, now in his nineties, who in the 1930s was offered such a deal.

He recounts that he was specifically instructed to make sculpture which felt generically 'African' and represented tribal figures and such like, despite the fact that no such representational sculptural tradition had survived in South Africa to that date. Mancoba at the time was exploring modernist abstraction, and was explicitly told that such explorations were not acceptable. Largely as a result of the experience, he left the country in 1937. He did not return until 1994.

did their more serious work. Did they actually do the more serious work?

No. Most got hooked on the easy money.

David, I'd like to go back a little here. There's a lot more to be said about art under apartheid. But I'd like to talk a bit about the situation as far as urban black artists were concerned before the National Party came to power. It seems to me that, while the old Union government was hardly better than the National Party, it was different in one significant respect: the fabric of oppression had a couple of little holes for the special cases to slip through. What I mean is that, while it certainly didn't facilitate the emergence of a black middle class, it didn't find it threatening in the same way that Verwoerd and his cronies did. So an intelligentsia was at least tolerated, a middle class of the kind that supports art did at least begin to emerge.

In terms of art, you have people like Sekoto and George Pemba and, before that, Mancoba and maybe a couple of other artists. I'm particularly interested in Sekoto in this context – Sekoto in South Africa, that is; after he left it was a different story. In his South African work of the 1930s and 1940s, there are a lot of pictures of his family, his brother, his sister or maybe his wife, I'm not sure.

Now the brother, for instance, is usually shown in the portraits in situations that suggest a certain cultivation and intelligence. There's usually something that says to the viewer that this is an upper middle-class kind of guy. And there are pictures of the artist's studio used as a background or the place where the sitters are modelling. A whole lot of clues are given to the effect that this is a thinking person's kind of world ... the life of the mind.

I remember the portrait of his mother by Sekoto and the way she is characterised. Interior scenes, as well – observed interiors have been very rare since that time.

At the same time, the way that Sekoto represents the townships departs dramatically from the work you would expect from the apartheid years. He sees them complete with symbols of progress, for want of a better word: telephone poles, cars, that sort of thing. Obviously, it's Sophiatown, and the reality is slightly different. Even so, there is something different about his subject matter as well, the way he approaches

the townships. He makes a point of finding the technology, the culture that is shared with the whites, I would think. At the very least, he does not shy away from these things in his work.

In a very similar way, there is a whole series of portraits by George Pemba of professors, doctors, eminent members of society. There is a strong sense in this body of work of a tradition beginning to emerge of black artists working in the same way as whites. They are also celebrating the attainment and aspiration of township dwellers in a way that later artists don't. In short, they are being artists, not *black* artists.

If you remember, Tim Couzens wrote a biography of the Dhlomo brothers; one was a writer. They formed a discussion group of black intellectuals in the late 1940s and the 1950s, mostly teachers who did this in their spare time. They wanted to appreciate all the creative disciplines; they wrote books and plays. Somebody like Sekoto would have been a respected member of that society, or at least a highly regarded figure. Their idea was to portray the black community with pride and with sympathy.

And there were also the beginnings of a class of black collectors ... This whole shift is something that nags away at me. One of the things that seems to have happened is that a lot of the people who were buying this work, the class that supported it – I'm thinking here of people like Nimrod Ndebele and Zeke Mphahlele —

— and Dr Xuma, the first professional African doctor, and his circle in Sophiatown —

— this intelligentsia, I would guess, went into exile in the early years of apartheid, or into gaol. Suddenly that growing middle class was destroyed in the early 1950s by the imposition of apartheid, by its relentless march. The position of blacks was standardised and bureaucratised. The collector class was crushed. Everything that supports, informs and defines the kind of art that people like Sekoto were making ...

Yes, particularly when the impact really began to be felt in the early 1960s. Most of the people who were buying this work that we're talking about were educationalists and, when Bantu education came into being, there was no place for them. Those were the first people who went into exile.

To jump a quarter of a century, the Thupelo workshops of the 1980s represent the first signs of a movement away from the special category of black art, and towards a situation where black artists are making art without the inverted commas.

Thupelo came about after Anthony Caro's visit in 1982. The late Bill Ainslie brought him to the Fuba art centre where I was teaching at the time. Tony told me about a workshop they'd started in America the previous year, the Triangle Workshop, which he had started with Robert Loder. So I sent some slides to New York, and was accepted the following year. What was very fascinating for me about the workshop was that artists came from different parts of the world to work together for two weeks. It was not so much the idea of the workshop. I felt this because we didn't have any kind of infrastructure in South Africa, and also because it was difficult at that time for artists to move from one point to another because of apartheid legislation like the Group Areas Act. We hardly knew one another because of these restrictions. I felt the workshop concept would, in a way, alleviate this problem. If we all came together for two weeks and if we got funding, we could bring in artists from all over the country and discuss common problems.

USSALEP gave us funding for the first year, which was 1985. The process they followed was to run a national competition, from which they selected fifteen artists to participate. They also invited some veterans like Sydney Kumalo and Ezrom Legae as guest artists. The mere fact that artists came together and worked together for the first time justified the concept. It was the beginning of a network, in fact.

But, at the same time, you always had foreign guest artists at the workshops and all of them were involved in a kind of modernist abstraction. This has always interested me because of its ironies. I remember, at the time, you came in for a whole lot of flak because the kind of work that was coming out of the workshops did not obviously reflect a committed or politicised kind of South African subject matter. Abstraction was viewed by most people – and I confess I held the same view at the time – as a kind of cop-out, a buying into American cultural imperialist agendas. In retrospect, though, it looks different. Its important feature was that it did decisively break with the old township art formulas, the expectations imposed on black artists in a white society. In a sense, it was going back to a zero point of art making...

I think for the first time many of the artists did confront materials, rather than follow a formula which they had been doing over the years, not thinking how this should best be done, just reproducing a stereotype and using the same old materials without exploring other media like collage or paint or metal or found objects. I think also that the workshops presented the environment to the artists, so they started looking around and seeing what they could use from the environment, which they had never done before. So artists started using collage and found objects. Some artists discovered for the first time that they could actually put things together and construct, rather than just paint or just draw.

It took a while, though, before Thupelo really began to bear fruit. My memory is that the first workshops threw up work that, considered as final product, was frankly awful. But, as time went on, a new kind of art did emerge. For some it was a question of artists engaging in new and direct ways with the environment in art making. Some artists started using collage as a way of engaging with reality; others like Pat Mautloa started using materials such as corrugated iron and official signage, which carried the traceries of their use. Your own shift is harder to define – it's like a return to a primal stylistic chaos. But it took a while. My sense is that, say, in your work, the shift happened about three or four years ago, for Pat maybe not even that long. There was a sense of people struggling to find new styles and real expression in the new modes of working. The real liberation happened only after a few years.

I saw Thupelo more as a facility than as a movement. I saw it as a process and I knew it was going to take time, like it takes time for any artist to develop a character of his own in his work. I don't think we are anywhere near that at the moment, but we are beginning to discover where our talents actually lie.

We also used to be hampered by the fact that we didn't have studio space, which is one way of maintaining consistency once the exploration process begins. You can't do it to its full benefit without studio space, when you are working once or twice a week, when you don't have the materials... I think the fact that artists started exploring different materials and media in the workshops also encouraged them to look for studio space where they could confront these issues on an ongoing basis. If an artist goes to a workshop for two weeks and comes back and doesn't have a work space, he has no way of releasing all that experience. He has to wait for the following year and the next workshop.

Hence the Bag Factory, the complex of studio spaces that Robert Loder facilitated and where the core Thupelo group now works. I think the Bag Factory has shown that studio space is one of the most essential things that artists require. Space is a problem in this country. Look at the townships: you can hardly extend any house to incorporate a studio unless you use a garage as an alternative studio space, that is if you don't have a car...

I remember something that Sam Nhlengethwa said to me, that he once gave one of his pictures to his mother. But she didn't hang it up. There wasn't enough space on the walls to accommodate it, just enough for the Virgin Mary and the calendar. So she said, no thanks...

Apartheid was a politics of space more than anything. If you look at the 1913 and 1936 Land Acts they are all about space, and much of the apartheid legislation was denying people the right to move. It's all about space, restricting space... Claiming art is also reclaiming space.

The Writer as Critic and Interventionist

Njabulo S. Ndebele

1988/95

Njabulo S. Ndebele, President of the Congress of South African Writers and recipient of the Noma Award for Publishing in Africa for his collection of short fiction *Fools and Other Stories* in 1984, was recently in Johannesburg where Andries Walter Oliphant spoke to him about his writing, his role in South African literature, and his interest in art.

Njabulo, your acclaimed collection Fools and Other Stories *draws* extensively on childhood and the experience of growing up in Africa. Was there perhaps a particular incident, event or experience in your childhood that was decisive for your writing?

First of all, I must say that I do not think I decided to write or started writing because of any particular experience as a child. On the other hand, whatever childhood experience seems to have found its way into my writing is mainly attributable to my inherent interest in writing itself. Perhaps even more significant is the fact that I started by writing poetry, and even then I seem to have been primarily concerned with the harsh injustices in this society and the ways in which this could be countered by means of the creative imagination.

While I was writing my poems concerned with children I encountered the writings of other poets who were concerned with similar themes. I can, for instance, mention here the work of Dylan Thomas whose language I found vigorous and complex. The same can, of course, be said of his imagination. I read his *Portrait of the Artist as a Young Dog*. I also explored the work of other fiction writers, such as William Golding's *Lord of the Flies* and James Joyce's *Portrait of the Artist as a Young Man*, and several other writers who concerned themselves with the themes of childhood and youth. Thus, by the time I came to write *Fools* there were a number of diverse influences which crystallised in my own prose.

Did your shift from poetry to prose precede or coincide with your departure from South Africa?

I started writing fiction before going abroad. In fact, I started experimenting with the short story form many years before leaving South Africa for studies abroad. I think it was around 1969–70 when I started writing short stories. It was during my first year at university. I remember writing a story quite similar to the Mozambican writer Luis Bernardo Honwana's *We Killed Mangy Dog*. The story was stylistically very close to what Honwana had done. I would say, therefore, that I made the transition long before I left the country.

On the other hand, while I was at Cambridge I did not do any creative writing. I was really reading as much as I could in modern European and eastern European literature. I delved into Soviet writing and the great tradition of Russian literature. By the way, I recall being particularly fascinated by Joyce's *Ulysses* and writing a couple of foolish imitations. That was about all the creative writing I did when I was in England.

When I left for the United States I started writing the story 'The Music of the Violin', which I completed there. The rest followed shortly afterwards, although the ideas for most of the stories had been with me for quite a while. In retrospect, I think that what the overseas experience afforded me, apart from reading and research opportunities, was a necessary distancing from South Africa. This, paradoxically, served as a means of recall, of retaining a kind of distilled memory. I found that being removed from some experiences at home served to recall those very experiences in a very vivid and compelling manner.

Yes, it is often claimed that exile leads to a diminution of intimacy with one's place of origin. This might be valid in the case of prolonged absence, but apart from the crucial aspects of recall and reflection, I think absence from a place with which one is deeply engaged can lead to the enhancement of the specificity of that place in relation to other places. This then may establish the possibility of engaging in a radically transformed fashion with one's place of origin.

That is quite true. I think it is very well stated in terms of my own experience.

Apart from your creative writing, you have also played a crucial role in directing and shaping critical discourse around South African literature. I am thinking here of your essays in which you expose the shortcomings in some South African creative as well as critical writings. Could you perhaps elaborate on the genesis of your critical thought?

Certainly. I think one has to note that, as in the case of my creative writing, I started reading widely in and on South African literature long before my departure abroad. My father, who has always been open to developments in the cultural field, subscribed to a variety of magazines such as *Africa South, Lantern, Classic, Contrast, New Coin* and others. These were available at home and so I came across the work of major South African writers. There were also banned books which my father kept in discreet places. Many of these books have, of course, since been unbanned. What is important, however, is that I had access to these right inside my home. So quite early in my life I became aware of the critical debates that were generated around South African literature.

I remember coming across Lewis Nkosi's now famous writings on South African literature.[1] I must admit, though, that I was very hostile to his point of view. I was a young man then. Today I understand and sympathise with impatient young writers who militate against cautionary strictures and advice on how to improve their writing. However, the necessity to formalise our creative intervention is something I was confronted with very early. It was necessary for me, and I think it is necessary for all young writers, to undergo an apprenticeship under the guidance of more experienced writers.

Apart from your creative and critical work, a third area of your participation in South African culture revolves around your leadership in the organisation of writers. Could we in this context talk about the recent formation of the congress of South African Writers in relation to the dissolution of PEN in the late seventies and developments in the intervening years?

To begin with, the dissolution of PEN is historically understandable. I have just recently been reading some of the documentation concerning this event. From this one can perceive the forces which were in operation then. Given the racist traditions which dominate life in South Africa it is difficult to conceive of leading one's life and participating in activities which are free of the oppressive distortions which govern this society.

The ideals of PEN came up against the disillusionment of blacks who had in the course of the mid seventies experienced the brutal extermination of children, the silencing and destruction of political and cultural organisations and pressure from the community to reconsider alliances with organisations which sought to disguise the racial aspect in the oppression by the South African State. Thus the withdrawal of blacks from an ostensibly multiracial organisation like PEN South Africa was perfectly understandable.

However, in the context of some of my earlier remarks, it remains important to be constantly vigilant that despite one's participation in the discourse of opposition and resistance, one does not conduct the opposition in the terms specified by the culture of oppression. A voice which rose clearly above this conflict was that of Mafika Gwala. I recall him saying that we must be careful not to reduce the problem in South Africa to race only, since it is also a problem of class.

I think the problem for me now is that I cannot ignore the phenomenal growth of the mass democratic movement over the past few years. This imposes a challenge on us within the cultural sphere to create a dynamic cultural movement which is inclusive and coherent. Therefore, the non-racial stance of the Congress of South African Writers, of which I am President, is very important. It should be understood that our insistence on non-racialism is not a form of privileging white people as some special category, but that it would be fatal at this point in time to resort to organisational strategies which were responsible for our oppression in the first place.

Your father collected early South African art. Did the other arts such as painting and music play any role in shaping your approach to literature?

Well, I think that the catholic taste I have I probably owe to my father. In our home there were not only books but also music and paintings. Some of the books were on modern art. So long before I entered university I was familiar with the main movements of modern painting such as Impressionism and Cubism, to name but two. The centrepieces of the art I grew with were the paintings of Gerard Sekoto. They were part of the world of my upbringing. Whenever I went into the living room I knew instinctively that there were Sekotos watching me. My father obtained the paintings from Sekoto before

he left South Africa for France, where he died recently. They both taught at Khaiso School along with Ernest Mancoba, another artist who left South Africa and revisited the country recently. I later learned that my father was in contact with a number of other artists. He also owned a pastel work of Andrew Motswadi who visited our home quite often. I also remember a work by Mandla Mahlobo who lived in our Nigel neighbourhood. I attended exhibitions at Gallery 101 and came into contact with artists like Lucas Sithole and many other South African artists of his generation.

Another important contact with South African arts came to me through the magazine *Classic*. Each issue had an art section with reproductions of paintings and sculptures accompanied by little write-ups on the artists. I later copied that format when I became editor of *Expression*, a student magazine at the University of Lesotho. As you can see, I grew up in that kind of environment in which the visual arts were a powerful presence. Yet, strangely, it is something I have not thought or spoken much about up until now. Maybe it says something about the fact that the visual arts are around us but we take them for granted. Take, for instance, the Northern Transvaal where I am now stationed. That region of the country probably produces the greatest number of art works in South Africa. One becomes aware of this when living there. Otherwise I doubt whether the rest of the country is aware of this. It is a matter that concerns me.

Did you, in the light of your exposure to South African art and artists, ever consider a career as a visual artist?

I did. I took some lessons with Mandla Mahlobo. He introduced me to George Boyce who worked from Doornfontein; I also took a few lessons with him. But I never pursued it. It was the same with music. My father paid for me to take piano lessons in jazz but I did not continue with it. I tried all art forms at one time or another. Later, when I was in the United States, I took up the flute and the guitar but not having the time and the persistence I gave them up. I had, I suppose like any young man, ambitions in a number of different directions but I eventually settled for the written word. If you read my story 'Uncle' in *Fools* there is a musician and a painter. They are drawn from relatives. The painter is in fact based on my cousin.

While I was studying in England I remember attending the Chinese exhibition of works discovered by archaeologists. I also went on a summer trip in France visiting some of the galleries there. During my stay in the United States I attended the African Literature Conference in Bloomington, Indiana. There was an exhibition of Mirhanda funerary sculptures. It was one of my most memorable encounters with art. There is an aura of timelessness about these works. It inspired me to explore African sculpture: although much had been said about Makondo sculpture, for instance, I had not taken much of an interest until then. Going back to Picasso's encounter with African art, I think there has been a progressive internationalisation of African art which is all to the good. In South Africa we have considerable gifts in this area and I think we must share them with the world. It is, however, important for us to retain them. That, I believe, is the best way of preserving art for posterity and sharing it with the rest of the world.

The magazine Staffrider *is in its tenth year of publication. You have over the years been an important contributor to the magazine. As editor of* Staffrider *I am particularly interested in assessments of the magazine, its achievements and failures over the past decade as well as the direction it should take from now on.*

Staffrider has in a very crucial and interesting way been involved with the re-emergence of the resistance movement in the seventies as well as the development of the workers' movement more recently. This is to say that *Staffrider* has been part and parcel of the spread of a democratic culture. It was instrumental in the process whereby more and more people in this country were enabled to have an effective say on the social, cultural and political affairs affecting them. On the cultural level this democratic option manifested itself in the formation of numerous cultural groups all over the country.

The work of these groups found its way into the magazine and even the most inexperienced writers were given the opportunity to articulate their experiences and views. This was important and the unevenness in the quality of the voices is the direct result of the non-élitist, democratic orientation of the magazine. It gave large numbers of young writers and artists the opportunity to be exposed to the broad South African public. As far as this is concerned *Staffrider* fulfilled its role very effectively.

However, in line with my belief in the spirit of self-criticism and self-evaluation, I believe this should also be applicable to *Staffrider*. Thus, while we are engaged in harnessing the necessary sophistication of conceptual, organisational and political means to effectively oppose apartheid, *Staffrider* too must come to terms with this. It has to focus on the fine points of writing, engage in the great cultural and political debates and help to crystallise the role of cultural workers and progressive intellectuals in this country. It has to analyse the social perceptions of the oppressed as well as the oppressor. It should aim at broadening the areas of discussion as far as possible. I think people are ready for this.

To conclude, could you give me an indication of the direction your own creative and critical writing will be taking?

First of all, I will be concentrating on expository writing, mainly in the field of academic research. I want to make a contribution in devising and preparing a new cultural and literary programme for educational institutions. At this point it entails a lot of research and writing. It does not help to say that you want a curriculum which reflects South African society unless you have the primary materials and the conceptual as well as critical means to carry this through.

In addition I will give equal attention to my fiction. I am working on a novel right now and I maintain a long-term interest in the short story. Among the things I would like to explore are the experiences I have absorbed while living in Lesotho. As a matter of fact, I have just finished a children's story which draws on the people and culture of Lesotho. I foresee more of this being produced in the future.

The African Identity
Bill Ainslie

1982

I am totally opposed to any simple, conceptual, ideological acceptance of an African personality. I don't believe that you make yourself African by making your pictures African. I'm working it out for myself. I think it's discovering one's African identity. There is nothing artificial about that. I mean one is actually in the country... one's most crucial experiences have come about in this country, so one's art should grow out of that. But still it is difficult. It's elusive. But one thing that fascinates me is the importance of mark making. The frankness of one's relation to the means. The most immediate contact one has, sculptor or painter, with the media. It tells of energy. It tells of sensibility. Of the artist's preoccupations, in a way. And the way they accumulate – colour... the way they strike or smudge. And another thing that fascinates me is that African art is avowedly spiritual. It has to do with relationships with ancestors and the ancestors' relationship with God. Now spirit has to do with imagery and marks have to do with energy. There is a sort of ancestor worship visible. In a sense when I think of the modern masters like Monet, Gauguin, Picasso, Matisse and their fascination with the primitive... these people are in a sense ancestors. They have opened up, renewed and passed on their inheritance. Here in this country, we get them second-hand through reproduction, but curiously the spirit does bring itself across. I have a vague sense that the paintings I'm after have to do with these things, without them being tied to a religious context. They have to do with celebrations, communal rituals, which are not binding in the religious sense that we found destructive before, but which are still illuminators so that painting does not imitate nature, but conveys the spirit of nature. Klee said that. Now, what is African? That's a lifetime's work. I don't know anyone who's done what I'm thinking of. That's what art's about. One is searching for what is not there.

In terms of my own experience, it's the realisation of the invigoration of the spirit that I sense coming through. While the west has felt it has brought civilisation to Africa, in fact its own civilisation has been re-invigorated by Africa, subliminally, without them realising it. I feel Europe has taken more from Africa though one can't measure these things very easily. I don't think Europe has got around yet to acknowledging the debt in terms of the spirit. One can't get away from the fact that it was the Europeans, and I mean the artists in particular, who allowed this re-invigoration to happen. They had their eyes open and they took from this culture which was alive for them... when their own was going dead on them. That's a sign of a vigorous culture if it happens. We don't realise the things that are on the tip of this continent, otherwise we would find far more serious attention being paid to them. One feels isolated here and that there is a continuous pull to go to the art centres of the world. One wants to go to New York. Someone somewhere has to decide we are going to do it here. That takes enormous energy. That's what America did. They said now we are going to do it here. We don't have to go to Europe.

I think in this country everyone has been traumatised, shaken by events. For me, I think it is a particularly frightening but an invigorating time, because I feel when people are opening their eyes, it's much more invigorating than when closing their eyes. While it's an invigorating time, it becomes a crucial time, a pregnant time and what happens now sets things in motion. It's going to affect the attitudes of the future. I think it's terribly important that people who are moving into the field of painting are no longer being encouraged to go and show their exhibits in the galleries and produce commodities for sale... and cannot any more, because there has been a collapse on that level – because it wasn't properly founded. Now they are going back into themselves and saying... am I enough of an artist to work within that context where the sale of these commodities is not encouraged? If you are, it means you are actually open to the challenge of the situation, and you find this is your vehicle for expression, and you can be serious about it. I think in all societies there is that fear of non-conforming. I think the Afrikaner has it particularly strongly because in a sense his situation may be more vulnerable. But once one has taken this step, one realises what one has been missing. I don't think people need ultimately to be so fearful. I think this is what has been brought home to me – that fear is the most inhibiting thing.

If I was to attempt to sum up in essence, I see my work as a quest to discover... to make a revelation of what is eternally familiar. To give expression to what one knows oneself. But one needs to rediscover it because it underlies all that one has acquired from one's schooling and from simply looking around in the world. That is what one has to dig for. In so far as the question of my reading is concerned, well, I find it necessary to read. I suppose for some people, music or any other arts may do the same. One finds that the arts feed off one another. That when a thing has been said that is illuminating in one medium, it can then illuminate things in another medium. It can clarify and it can give faith that the quest is worthwhile. The search for the ineffable that constitutes a work of art, if it's discovered in any medium, restores one to one's own worth. Perhaps that explains why I quote as much as I do.

To me, an artist in South Africa is necessarily a sort of liminal man. A person on the threshold of society or on the outskirts of society. A person who is on the frontiers of society. A person who cannot simply accept what the society lays down as norms. His or her job is to question them, so that the people within the society itself can have their eyes opened to other possibilities and other realities, which people in their 'busyness' so easily overlook. It's the artist's job to remind people of that transcendent side which underlies or overlays human activity. The artist's job is to look for meaning, to provide the meanings by which man orders his life. And, in that way, he or she is a liminal person, and in any healthy society, this role of the artist will be acknowledged and encouraged. In a society which is fearful, the artist tends to be censored.

recollections from

kenya and uganda

Francis Nnaggenda
Working in Kampala
1992

Francis Nnaggenda
The Monk (detail)
Mixed media

Francis Nnaggenda

Interviewed by Wanjiku Nyachae

When did Nnaggenda feel he wanted to become an artist?

A softly spoken man with a gentle smile and humorous eyes, he returns to a childhood filled with stories.

Our traditional stories follow a format which includes a song. When the story was told by my mother or a grandmother it became so special. I would spend the next day singing or playing the song, creating images and recalling feelings produced by the storyteller's way of mixing the words and rhythms.

The village we lived in was bounded by streams which I would ford, securely fastened to my mother's back. Sometimes, out of joy, she would keep me on her back, continuing our journey and singing to me. She was a good singer.

I had an uncle who carved. Once, he made a number of small wooden aeroplanes suspended on high poles. Each had a propeller, spinning in the wind.

All children play with anything available. From the soft clay pushed up and out of the tops of anthills, I modelled. Flowers when smeared on certain surfaces left colours, but it was in primary school that I first came across pen, pencil and paper. Drawing was taught and I took to decorating the pages I worked on. It got me into trouble.

While still at primary school, he painted a portrait of the late King Freddie, Kabaka of the Buganda, for a great-uncle who was a chief in the Kabaka's court. So impressed was the King that he sought to secure a scholarship for Nnaggenda to study art in the UK. Nnaggenda met Gregory Maloba, who thought him far too young for formal art education abroad, and suggested that he complete secondary school.

Having heard about Makerere, Nnaggenda started to spend his school holidays around the campus and, in the late 1950s, 'informally' attended the Margaret Trowell School of Art there. Elimo Njau, who had seen his work and given him materials, encouraged him to merge into the classes. Lecturers at the School of Fine Art, unaware that Nnaggenda was not a bona fide student, gave him materials as well as tuition. He continued to take his work to Elimo for criticism and in 1960 commenced a three-year correspondence course in art with the Ecole de Dessin in Paris, obtaining an undergraduate degree.

I applied to both Makerere and the Kampala Teachers' Institute at Kiambogo. KTI responded positively first, so I joined in 1963. After one term, Mr Marsh, my Irish art teacher, advised me to join Makerere. Later that year, while waiting to enter the university, I was awarded a scholarship to the University of Fribourg in Switzerland.

I had been training as a painter, and the university started looking for an atelier for me to work in; the only viable offer came from a sculptor in the Black Forest in Germany. I accepted, moved to Germany and into the world of sculpture. In 1964, the sculptor recommended that I go to Munich. I received another scholarship, this time to the Academy of Fine Art in Munich and completed my studies in 1967.

Upon his return to Uganda in 1968, Nnaggenda prepared for an exhibition at the Noma Gallery (Uganda's national gallery), and taught at Mutolere Secondary School and Kitante Secondary School. He applied for a teaching post at Makerere through the University of East Africa but, instead, was offered a post as Tutorial Fellow at the University of Nairobi, which lasted for two years. In 1970 he was appointed Research Fellow and Head of Art Project at the Institute of African Studies, University of Nairobi. Five years later, Nnaggenda took a sabbatical to become Visiting Associate Professor at the University of Indiana. In 1976, he returned to the USA, this time to Texas to concentrate on his work.

The strong narrative tradition in East Africa led to a lot of theatre activity, especially in Kampala after independence, and I understand that once again there are numerous small theatre groups in Uganda, with many spaces being converted into temporary and permanent theatres. Has the popularity of theatre been at a cost to the plastic arts?

Theatre died during the Amin period. In Africa, art is a combination of verbal acts and painting or sculpture. In the 1970s theatre died, and the plastic arts survived because they were less direct and attracted less attention. People were less suspicious of art. This was a period when people were fearful. Some went into exile like Okot p'Bitek. Some died in exile. I had been based in Kenya since 1968 and did not return to Kampala until 1978.

I was in Texas in 1976, completing a piece for the Kennedy Center in Washington, and completing a body of work for two exhibitions. Upon my return

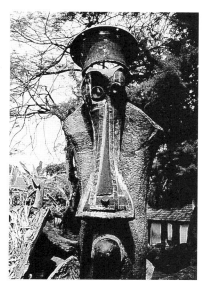

to Kenya, my family and I found that Ugandan refugees had started flooding into Nairobi. We heard about the suffering in Uganda and I wanted to go back. In 1978, I could no longer stand it; one day we loaded as much as we could on to my station wagon and drove towards the Ugandan border. People thought I had gone mad.

The guards at the Ugandan border could not believe we were trying to get into the country. They insisted that I unload everything from the car. Can you imagine, our belongings were piled high and strapped to each other, hanging off the sides of the vehicle, almost doubling its width and height. Something in me changed and I started, literally, to hurl things on to the ground. In the end, the soldiers helped me strap each item back on to the car. We were lucky, the soldiers might have done anything.

The journey was frightening. We could not stop at all, especially not at the checkpoints. I drove fast. At one point we were being followed. The roads had deteriorated into a series of interconnected pot-holes, destroying the car. My wife and children were so brave. Eventually we arrived in Kampala.

In 1979 we were united with some of our relatives at Sentima, a Red Cross camp, until the war was over in 1980. It was very important for my family and me to come back. We shared in the experience of our families and our people.

Between 1979 and 1982, we had Presidents Lule and then Binaisa. I was appointed to a post at Makerere in 1980. The fighting never really stopped once Amin was ousted; the conflict now ran along tribal lines. Milton Obote tampered with the 1982 elections and won. Uganda started to live through the horror of Obote II, and his mass killing. That is when Museveni went into the bush, and war was waged in Buganda.

Between 1982 and 1986, Uganda went through civil war while everyone tried to maintain a semblance of normality. Makerere University stayed open.

People were killed as though they were cockroaches. My feelings about that time came out through my sculpture *War Victim*. The piece is about the resistance of the spirit to the experience of destruction. Destruction exists but the spirit must survive. Amputated but still full of resistance.

Where did you find the material?

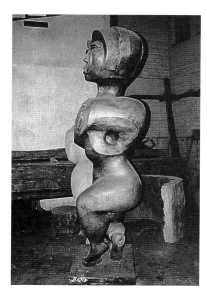

There is a large Mukebu tree on the path to the school. Traditionally the Mukebu is highly respected. One day, while walking home, I saw that somebody had burned grass against this magnificent tree, resulting in part of the trunk collapsing and blocking the path.

I was very upset by this wanton destruction. Somehow it seemed so connected to the war and symbolic of the thoughtless killing of human beings. I rescued the burnt and broken piece of wood: it became *War Victim*. By the way, this piece is not just about Uganda...

How did your spirit survive and continue to be creative during the upheaval after Idi Amin left, and during the civil war years? Have you experienced a change in the way you teach and work?

There was no great transition in the way I worked or great change in the way I teach. My work is informed by the inner being of people and things. I seek the 'good spirit' in all things. As a strong Christian, I look for love in everyone.

Generally, work produced in the school changed during Obote II. Students were producing horrifying images; the work in this exhibition, for example, is mainly from that period.

This was a time of great depression – economic and spiritual. At Makerere, we taught students to become increasingly self-reliant with materials. We reminded or taught artists how to make their own tools and to use found objects. In many ways the depression stretched us all and we worked very hard.

Hope seemed to have died in many people, but art from the period celebrates the strength of the spirit.

Can one develop an East African style?

East African artists must study nature. It's from this deep study that they can produce work with synthesised forms rather than schematised works.

Fabian Mpagi Kamulu

Interviewed by Wanjiku Nyachae in
January 1994

An artist is not made by a school. An artist evolves and this evolution depends on environmental wealth and experimentation.

What are your recollections of the Amin period?

During the Amin period, the pictures coming out were very dark; with time, the palette became increasingly darker and the definitions of form were oppressed.

It was important not to stand out. I painted static, dull, desperate people with hidden faces.

Graduating in 1976, Mpagi was involved with commissions for Amin, who had declared himself 'the conqueror of the British Empire'.

I recall a group of us working on a medal for Amin. We all understood that this tiny object embodied a great deal of meaning for us, for Amin and for the soldiers who would receive it. Each of us invested the medal with a tremendous amount of symbolism.

Did you form groups to discuss ideas, share materials, literature or support? Were group discussions rooted in specific texts?

Yes. Lutwama, Mwebe and I, together with three young undergraduates, formed a small crusade to explore and define our space, as Ugandan artists in Uganda came into being. We studied everything from western art history to the material culture and histories of Uganda's people. We thought about the re-birth of African aesthetics in the context of the European modernist movement.

Ali Mazrui and Okot p'Bitek were enlisted as sources for the development of a stronger local imagery, and we tried to develop a visual language in which form and colour related to us.

The group quickly moved away from its initial scholastic leanings as our work started to employ a new colour palette – the colours of the people, the trees, the sisal, the clay. There was a simultaneous change of focus as we incorporated a new spectrum of media.

This absorption stopped in the later 1970s when we accepted that the shooting and rampaging 'outside' were directly affecting us, that it was happening 'inside'. In other words, a political consciousness emerged, based on a growing awareness and acceptance that the regime and the economic and social state of Uganda directly affected our creative flow.

What was the mood among ordinary people in the late 1970s?

In spite of the political oppression, we, the ordinary people of Uganda, the betrayed people, retained a dynamism. I worked on resistance art. One piece, *Desperadoes*, shows young people holding cigarettes. In times of war, cigarettes come to represent so much – relief, leisure, luxury, a pretence of normality.

However, in the picture, each member of the group has his head deeply bowed and their unsmoked cigarettes bear long heads of ash. There is no relief, and the pretence of leisure – the luxury, even, of normal life – is being allowed to burn out.

During Obote the atmosphere became more oppressive; war erupted in 1982.

In 1983 Mpagi received an Italian scholarship and went to study in Florence. Following the course he went into exile in Kenya from 1984 to 1986.

I went to live with my brother in Nairobi, and set up a studio in his garage. I wanted to depict cultural wealth rather than images of war and suffering. My interest was in the universal concerns of man – both pleasure and pain – so I studied the hidden values of spiritual abstraction.

While in Nairobi, I registered Art-atlanta Professional Studios in 1985, and went on to exhibit at the French Cultural Centre. In 1987, among other things, I won the Habitat Art Competition and was awarded a four-month residency in Paris. In 1988 I came back to Uganda, registered Art-atlanta Professional Studios in Kampala, and concentrated on private practice.

Mpagi sat on the Board of Trustees of the Ugandan National Arts Centre before becoming Director of the Nommo Gallery, Uganda's National Gallery. Hosting an average of eight exhibitions a year of local and foreign art, Nommo has been in existence through changes of location since 1967.

Uganda is in a process of rehabilitation. During the Amin and Obote periods there was a shortage of materials. I believe this still to be the case, even in Tanzania and Kenya where there have been no wars. How have artists in Uganda managed?

Artists should never claim to be limited by a lack of materials; materials are always there for artists. Art is a criterion for which one should live, it should not be the source of a livelihood. In other words, every artist should have an alternative source of income.

How important is the teaching of western art history to art students at Makerere today?

An understanding of western art history is important for African artists, because it is another tool for artists to express their particular and delicate dialogue. It's an important element in developing an artist's vocabulary.

However, art history is a dynamic personal process, part of a holistic development – as mundane as waking, making eggs, deciding how to place a glass, or as profound as learning to paint.

Pilkington Ssengendo in his office at the Margaret Trowell School of Fine Art, Makerere University, August 1992

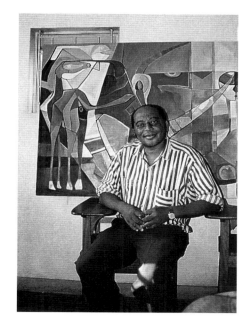

Pilkington Ssengendo

Interviewed by Wanjiku Nyachae

Art produced during times of great economic and socio-political upheaval tends to concretise the concerns and cultural mores of specific moments in that dynamic. Did art in Uganda between 1973 and 1985 become a 'telescreen' and is this era still influencing today's output?

The feelings during those times have gone. To me it felt like a long, continuous period of violence perpetrated by some parties from the north against the people of central and southern Uganda. There was a lot of killing, but it was worse under Obote II. The agony and fear we all lived through was obviously expressed in our work. It took over four years for the students to begin moving away from morbid subjects.

But people move on, life continues and what is most important is the spirit of survival. Ugandans survived and we are not wrapped up in the past. The art made now in Uganda is like art produced everywhere, it is about the preoccupations of life at this moment.

In my own work, for example, I am exploring bark cloth, and its decorative and functional role within certain cultures in Uganda. Bodies are wrapped in it, we use it to partition spaces and as clothing. During the recent coronations, use of bark cloth was prolific, the colour brown saturated the atmosphere.

Did you teach and maintain your own practice as an artist throughout this time?

During the Amin period, I was asked to head a primary school in Kampala which had formerly been Asian.

Idi Amin Dada is of Nubi extraction, a people from southern Sudan. During the colonial period, the British favoured the Nubi as great warriors, recruiting them into 'native' regiments which served as part of the British Army abroad during the Second World War, and all over East Africa in the pre-independence period.

Amin regarded the mass expulsion of the Indian settler community from Uganda as an integral part of his programme to redistribute wealth and access; he also wanted to renew a sense of self-worth and pride among indigenous Ugandans.

His ruthless 'Africanisation' policy consisted of the mass expulsion of all Ugandans and non-Ugandans of Asian descent. Confiscation of their capital and property with minimal compensation achieved a redistribution of wealth and economic power in the space of just a few months. This turned him into a hero for many people.

Within a relatively short space of time, however, the brutality of his regime slowly eroded this elation, replacing it with justifiable fear and insecurity.

As money flowed from the Middle East and the oil crisis rocked the west, Idi Amin, the army and their families became increasingly wealthy, decadent and bloodthirsty. Immigrants from southern Sudan took up positions which could have been filled by Ugandans, while formerly Asian businesses were delivered into the hands of Amin's relatives, military colleagues and cronies.

Initially Idi Amin was popular with the ordinary people. He was not in awe of the west and he made Ugandans proud to be African. In expelling the Asians and giving their businesses to Ugandans, he seemed to have achieved in months something that years of independence and free-market economics had not facilitated in the rest of eastern Africa. Leaders from other African countries were visiting Uganda, and there were no shortages.

Later things changed. When someone was bundled into the boot of a car in front of you there was nothing you could do or say. You knew they would disappear.

So many disappeared.

One was always careful. It was

perfectly feasible for schoolchildren whose fathers were officers to receive fatal consequences if they complained to them of anything.

No one interfered with Amin's rise to power and, at first, the British encouraged him. The world watched his increasingly bizarre behaviour with amusement. People say Amin was stupid. I don't know. However, I did know his brother's children, who are incredibly intelligent young people.

Amin and Obote possessed a natural and deep-rooted understanding of the importance of art as an instrument of glorification. The Margaret Trowell School of Fine Art remained open throughout Amin's dictatorship and Obote's brutalities. It was obliged to keep both regimes supplied with symbols, medals, coats of arms, monuments and murals.

Artists learned to use their medium to subvert both regimes; to criticise, protest and express emotions which were of concern to society.

For example, as Amin became closer to the Muslim states of the Middle East, certain works and texts intimating the relationship of Arabic peoples and Islam to the slave trade in Africa appeared. This upset Amin, and he suppressed them.

If one painted a portrait of Amin decorated like a Christmas tree, knowing it to be subversive, he was usually pleased with the result, viewing the work simply as a figurative representation of his stature and power.

He looked up to the School and commissioned work for himself and for public spaces. When materials were required for official commissions, the government would import whatever had been requested, and this gave the School a degree of independence, as well as access to some of the materials for the School itself. The other side of the coin was that one feared for one's life.

The commissions and designs for Amin or his fellow officers had to be executed professionally. This aspect of the working environment was in itself no bad thing.

With reference to art education at Makerere, was there an identifiable change in teaching practice effected by the political upheaval of 1971–79 and the 1979–87 civil war?

Margaret Trowell had a great vision, that of creating an art school with roots

in Africa. She developed a balanced teaching practice and created the foundations of a truly contemporary art within the School, a tradition rooted in expressing social concerns. Mrs Trowell was not trying to re-create the Slade. Ideas from prominent schools and movements abroad had no impact here beyond the theoretical sphere.

She based art on African crafts, taking on indigenous forms. I was taught by Elimo Njau who in turn was taught by Ntiro and Maloba. They were taught by Margaret Trowell. So you see, there was and remains a constant thread in the School's teaching philosophy.

When the civil war began and the economic situation deteriorated, we started to explore the use of local pigments again. Students had to learn to become self-sufficient, but the original spirit remained the basis behind the teaching practice.

At Makerere, we are now teaching students about managing their lives as well as art. They learn about commerce, too.

During the end of the Amin period and especially during Obote II, did people form groups to share literature or ideas, materials or support?

No. We were all too frightened of espionage, even among the students. Each person found their own way, especially with respect to academic texts. Some of the students were too raw to understand [these texts], others felt intimidated by the lectures and a few even denounced us without using the normal university channels to lodge their complaints. But there were also instances where some lecturers used the area of criticism to abuse students, or even to destroy their work.

Naturally, there are more meetings between faculty members now; we have an Arts Council and an active Artists' Association. This faculty is working to bring standards back up, and to popularise art among the Ugandan people. Last year, during the degree show, we decided to price the work so that anyone wishing to purchase it could afford it. Some prints were only about 100 Ugandan shillings [equivalent to 14 pence in sterling].

Is there an art which can be described as 'African'?

I believe that there is a homogenous African creativity, dominated by an understanding of the supreme being, God.

I also believe that this supreme spirituality governs everything one does. There is life and spirituality in everything.

In Africa, the use of colour and form is informed by a sense of immediacy, where we go straight into the subject. This is very different from the European preference for contemplation.

But all artists have to make a living. With reference to Uganda, in the past some artists made a lot of money painting portraits of army officers and their families, framed by symbols of their newly acquired status. These days, a number of artists work with an eye on the tourist market, while others cater to the demands of the growing middle class for reflections of their achievements.

We used to look at African art in terms of the discourse around primitivism. This in turn was defined by specific forms constrained by a limited range of materials. We have moved beyond that; we are working with different materials and within a different context, so that the treatment is specific to a group which happens to live in Africa.

African art is a major creative force in its own right.

There is a European fixation with three-dimensional art from Africa, which will slowly disappear with increasing exposure to contemporary work from the continent. In time there will be identifible East African styles.

At Makerere, there have been definite styles. From 1939 to 1954 the style was defined by narrative, local and decorative traditions. From 1954 to 1962 it was a fusion of this narrative/decorative style with the introduction of European modernist ideals. This was followed in 1952 to 1972 by a period of formalisation, which is shown in works reflecting modernism and exploring formal abstraction. Then from 1972 to 1985 the work reflects pain, fear and suffering. Some of this work could be compared to that of Bosch and of Grünewald, but without the subtleties.

Since 1986 we have been living in a new era, with the joy of accessing new materials and ideas. We are evolving our own ways of using these materials and understanding the ideas, while interpreting them. The school has a lot of potential, the students are getting access to affordable materials and are able to experiment. The young are quite radical.

Pilkington Ssengendo
Birds in Kampala (detail)

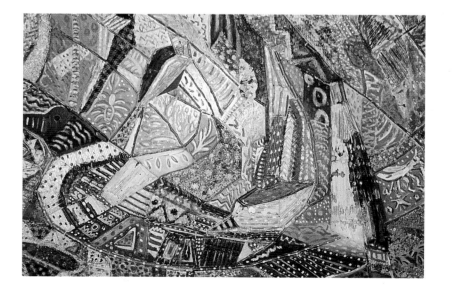

Song of Soldier

Okot p'Bitek

Arrival

He arrived soon after midnight;
The sky was overcast, weeping!
His torchlight lit up the horizon
Like the rising sun.
His black face
Hidden under the bush hat,
His eagle eyes burnt fiercely
Like molten iron.
He caressed the butt of his gun
As the lover fondles the full breasts
Of his young woman.

He sneezed:
A dark whirlwind engulfed the land,
Gripping her tightly
Like a python
Strangulating a waterbuck
Like the killer
Throttling his victim.

He coughed:
The songs of machine guns
Filled the air
Mad jets tore the sky in fury
Scattering death across the land,
Ten thousand mad dogs
Broke loose,
Blood gushed
Like the swollen Nile
After the rains in the mountains.

Young widows mumbled
Their broken dirges
New orphans swarmed the countryside
Like adwek, the hopping young locusts,
Their tears covered the land
Like dew on the lush April grass.

His laugh
Mingled with the muted funeral drums,
His white teeth flashed
Like daggers.
 Freedom!
He shouted,
 Freedom!
All around him
The corpses opened their festering wounds;

Bodies with stomachs cut open
The intestines full of holes
Bored by beetles,
Corpses with penises in their mouths . . .

Freedom!
Freedom to kill!
What am I a soldier for?
Why did they give me this sword
If I am not to use it?
Do you think
I am just going to march past with it?

I heard a great rumbling
On the horizon,
It was like thunder
Like an earthquake.
I saw a cloud of dust
Raised by the marching men
One hundred thousand of them
Ready to crush, to destroy
To conquer the land

Institutions snapped
Like the brittle legs
Of the mosquito,
Like the wings of the white ant
That come off on landing,
Schools and universities
Crunched like the dry bones of fish
Between the teeth of a hungry dog.
Teachers and students hacked with axes
To save bullets
The lucky ones fled
Like rabbits,
Like flies surprised on a dung heap.
Churches filled with
Widows and orphans
And old men and women
Bent like bows
Singing empty hymns
To a deaf god . . .

The birds stopped singing
Bulls stopped roaring
Cows gazed with their bleary eyes
Goats huddled together
Sheep lowered their heads to the ground
Cocks stopped crowing

And chicks hid under
Their mothers' wings,
All the animals and birds
In the village looked lost.
There was no one
To take them to the wild pastures
No one to milk them
No one to feed them
With millet seeds.

My right hand hit the table, bang!
Doors and windows rattled
As if in an earth tremor.
My hair stood up,
A gentle breeze blew through it
And cooled my face.
 Peace! Peace!
A lone widow sang.
 When shall we have Peace?!
I blocked my ears with cotton wool
I closed my eyelids tight
But boiling tears burst through
And tumbled down my chest
Like the water of Wang-kwar Falls,
I sneezed and spat blood . . .

They shot him
On the bridge
The corpse fell
Into the fast flowing Nile
 The crocodiles, hippos, fishes, snakes
 Waiting below
 Snorted, creaked, bellowed and hissed
 Their thanks
 Shouted three cheers
 And feasted.
On a rock
Written in blood
The Epitaph read:
 REBEL
 Executed for treason.

Loyalty
To a Government
He loathed to defend
With his
blood.

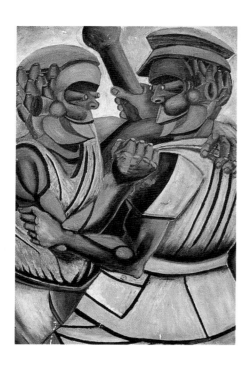

Charles Mukibe
Arrest
1965
Collection of the
Margaret Trowell
School of Fine Art,
Makerere University

Makerere Art School, Kampala

Jonathan Kingdon

Adapted from a conversation with
Wanjiku Nyachae in January 1995

Introduction

From the late eighteenth century onwards,
universities proliferated throughout the
British Empire, largely modelled on those
at home. They were serviced by the more
adventurous, or the more hard-up,
academics, the then Crown agents and
latterly by the Inter-University Council.
But within the larger ambitions of a far-
flung and military empire, these colonial
universities were a rather minor
enterprise. For many, they added still lower
strata to the pyramid of hierarchies
beneath Oxford and Cambridge.

The idea that original and independent-
minded artists could emerge from such a
milieu therefore elicits scepticism in those
who, perhaps unwittingly, maintain a
metropolitan perspective on imperial
history. Some reject outright any belief
that significant art could have found its
nutrients in such a situation. For artists
who began their careers at Makerere
University, stereotyped assumptions such
as these have been a real obstacle to
recognition, especially in Britain. Yet there
are good reasons why artists should have
flourished at Makerere, which are obvious
only from a local, and not from an imperial,
viewpoint.

Perhaps the most elementary
explanation concerns the individual artists'
motivation. In the late 1950s and early
1960s, all ambitions were tied up with
Uhuru, independence. This was not only
about freedom, it was more immediately
about 'taking over'. Reclaiming power
meant inheriting the many institutions of
the state. Government, not commerce, was
the target – and education was the key to
both social standing and a good living in
the future. For a few short years (before
military coups and monetarism proved
otherwise), the universities were gateways
to a golden future – or so it seemed to
many, if not most, ambitious Africans.

It was as a beacon for a whole
generation's hopes that Makerere
University temporarily acquired a mythic
stature. In all societies, the feet of youth
will beat pathways to places where they
can express the ideas that seethe within
them. In East Africa, most of these
pathways led to Makerere, and the Art
School stood at the end of one such lane. A
dispensable luxury for most colonials, art
was a rare option in the higher education
system. The historical serendipity that
had established the Margaret Trowell
School made it the only serious choice for
East Africans seeking an art education
during these decades.

In this all-too-transitory climate of
hope, the most talented artists of their
generation gravitated to Makerere. Their
successors inherited the tradition and its
intellectual and physical tools, but they
turned them to the expression of anger
and despair in the bleak climates of civil
war, corruption and civic collapse that
followed. Paths now radiate in countless
directions, but there were clear social
reasons – bedded in local, not imperial,
aspirations – for the artists' first steps to
pass through Makerere's gates.

The Makerere School

In the late 1950s and early 1960s – the
Uhuru era – there was a ferment of ideas
and ideals throughout newly independent
Africa. The art made at Makerere remains
a unique historical document of that
climate of euphoria – and, later, of
desperation. The world that these images
express is now history.

With *Uhuru*, people with an African
sensibility were coming to terms with new
national and international roles. With that
came new identities, attached to age, race,
gender, tribe and ethnic group – new roles
within family and society. The art students
also were living in an academic
atmosphere and could not escape from the
climate of multidisciplinary thought and
the dominant political and social
preoccupations of that time.

There were illustrative traditions from
the 1920s onwards, dealing with local life
and religion. These were essentially linked
to the influence of missionaries. Most
Makerere students came from Mission
Schools to a school where some of the staff
were also missionaries. An important
source of commissions was in murals for

churches or illustrations for church booklets. Uganda's élite was mainly Christian in those days. Elimu Njau brought together local life and religious themes, which had previously been separate genres. Sam Ntiro, the first major painter at Makerere, exemplified the pastoral themes of folk art everywhere – he was called the Grandpa Moses of East Africa.

The decorative tradition was another thing that was influential in the 1950s. They were just beginning to get a fabric industry going in Jinja, and there was a need for designers. Instead of continuing the old dependence on Manchester or Amsterdam or Bombay, they wanted something done locally. That was another important element: even in those days, Indian and European influences were seen as suppressing local initiative. There is a long tradition in Uganda of resenting the way in which foreign enterprises overpower local culture and talents.

Right from the start the Art School set out to encourage the development of decorative skills, but there was also (in a very muted way) the beginnings of an 'African Identity Crisis', the kind of self-consciousness that comes from promoting oneself in the outer world.

Cecil Todd was appointed to head the School in 1958. He came from South Africa with a ready-made 1940s/1950s art school structure in mind. I arrived in 1960, an opinionated and energetic young man. I had a boss with a weak sensitivity to what was happening in independent Africa. So he concentrated on giving a very good world course. He had done it in South Africa and it was virtually the same, covering as much of the world as possible; he also brought in colour theory and life drawing. He tried to continue some of what Margaret Trowell had done, but it remained unfamiliar territory for him.

Cecil Todd had been appointed through the Inter-University Council to institute a conventional, west European art school practice. The staff grew. I came in originally to set up the Graphics Department. In 1961, the muralist Sam Ntiro was appointed to be an ambassador, so I switched from graphics to being the tutor in painting; Michael Adams replaced me in graphics. I had set up a magazine called *Roho* in 1960; we only did two issues and then *Transition* came on the scene. Much of what we had hoped to do found expression in *Transition*, so staff and students wrote and provided visual material for the new magazine.

Effectively, the painting school was handed over to me. I did not articulate a written manifesto, but in concert with the sculpture tutor Gregory Maloba we set out to make the students' three years there into a new and wonderful experience in their lives, because they would be 'released' in several different ways. They would be released from a variety of constraints: financial, religious, tribal and other conventions. We wanted this time to be a liberating experience in which we 'found' each other as a group, and also found ourselves. In that heady climate of *Uhuru*, being free meant finding out who we were and where we were going. We saw that people could do anything they liked, drawing on their own experiences, skills and sensitivities, and just see where it went. 'You find out who you are through your work,' was the motto. Productivity was an important measure of success.

On the other hand, as soon as people started working, it was soon evident who was driven by ideas and who was feebly tagging along behind. Much of my teaching was done one-to-one; this was necessary because most of the students found it very difficult to accept open criticism. Each year I led the newcomers into this culture of self-criticism very slowly and privately, because they were unfamiliar, even terrified, of the whole idea of criticism and conscious discussion of the decisions that go into a piece of work.

I see paintings, sculptures and so on as the product of a series of decisions made by the person who makes them. Some of those are just blind decisions; some are conscious. Students were going to go out into what we thought of in those days as endlessly expanding new horizons, a twentieth-century society in which there really was a role for the artist. They were therefore, whether they wished it or not, going to be leaders – influential people who guided others and had to be able to defend their own ideas.

The role of these artists was inevitably partly defined by who they played football with and whose rooms they stayed in. That has never been stressed enough – the involvement of Makerere artists in the larger scene of politics and society. Gregory Maloba was very clear about this, and Gregory and I were the principal advocates of an East African social perspective, in contrast to the more scholastic, detached views of Cecil Todd. From 1940 on there had been factions that did not believe that an art school had a

place within the university. Todd, Gregory and myself were all equally determined to change that position. When I first went to Makerere, the presence of artists in a university was still a dubious proposition, and art degrees were also dubious. By the time I left, we had the same status as any other department within the university structure.

Todd institutionalised the School, and gave it a formal, professional standing; many people had previously considered it an amateur institution. It was also the ferment of the 1960s that helped to change this. Gregory Maloba was an important part of that. He was a fine artist on his own terms, and he had an authority among the students which came from the years he had spent there. We agreed from the very beginning that we would try and create in this institution a sense of discovery and liberation. Maloba spanned all three phases of the School; he had been a student during the early, rather naive, Margaret Trowell phase. He was a very independent and thoughtful person. One should not judge him by his more demoralised years in Nairobi. He was a very strong influence in the earlier days of the School. He had his own voice – that's where his authority lay. In 1956 he had a spell at Corsham Court in Wiltshire in the UK – this was a bit like Dartington Hall, a school very much in the Morrison tradition. He came away with good, positive experience of those two years, knowing that he could hold his own. He

Margaret Trowell

was not marginalised, he was respected for his superb craftsmanship in both sculpture and pottery.

Once the School had become a formal department, it became more difficult to question its place within the university. Margaret Trowell got on very well with Bernard de Bunsen, who came from a liberal left-wing family in the UK, with excellent connections with British ministers in Attlee's government. Makerere also had supporters in the Tory aristocracy, including Lord de la Warr, who had chaired the commission that founded Makerere as a university.

That broader university and social context was one basis for the particular self-confidence that some of the students developed. It was not the curriculum nor the format: these students developed a more thoughtful analysis of what their situation was, and what opportunities they were being offered. They knew that this was one moment in their lives that they could do something, a situation in which they could make their own choices. They knew that they would be going on later into some sort of a harness, such as being a schoolteacher directed by the Ministry of Education.

Why did Idi Amin respect the School? Before he got involved with gold smuggling, and before he led the coup, and at a time when he was in a slightly precarious position, Michael Adam invited him to present prizes at the annual 'Hats Ball' (everyone had to make their own hats). He came and gave the prizes: it was the first time he had ever been to 'the hill' (it was about two years before the coup). We all chatted with him, he met the staff, and we had a very jolly evening. He joined in and danced with staff and students. He returned the invitation by inviting the Art School, and quite a few of the other Makerere staff, to the Makindy barracks for a military-style knees-up/booze-up. We were his first hosts ever at the Art School and he never forgot that; but he was also a shrewd guy, he realised that symbols and coats of arms were important, so that later he got the School to design uniforms.

Not long after my departure, Amin wanted a set of coats of arms *quickly* from the Art School. Ali Darwish was in charge and he gathered all his staff, locked them in, and said, 'You will prepare the sketches by tomorrow morning, and I am locking the door.' Then they all worked through the night to complete them, such was the terror of earning Amin's displeasure. (To put this in some perspective, around 1973

Frank Kalimuzo, Principal of Makerere, was taken away from his house at 8 am and was never seen again.) So we know from various sources that Amin thought very highly of the Art School and this may help explain how art education continued throughout the Amin period.

However, Uganda's main debt is to Margaret Trowell (inspired and personally influenced by Marion Richardson). She created the formal infrastructure where art was a part of the curriculum in the schools. She was in the right place at the right time, she started up the institution of art in education and society, and its durability has been amazing. It might have been difficult to start later on, because of bureaucracy and the other vested interests that are the natural enemies of art. Several of us knew when we were at Makerere that it was necessary to go into overdrive whenever somebody came up with prejudiced remarks or a patronising attitude to the Art School. We went for them, and soon learned how to make them look stupid. Occasionally, this situation came up at Senate (the historians were a bit that way, but this is a common prejudice at universities).

There are people who would like to see the Art School at Makerere rubbished as a trivial thing. They want to diminish it by saying that it's 'European', 'over-intellectual', 'has no roots', and so on. By the same argument, few of the other disciplines that are taught at university have any better claims to local roots. Most of us reckoned we were the most 'indigenous' of all the faculties. The sheer quantity and quality of good artists that have come out of Makerere is the surest measure of both the importance of what has happened, and of its being a unique and genuine cultural phenomenon. Unique to Uganda, that is.

Sharing between Disciplines

The Art that Survives exhibition was held during the Obote II period.[1] If anyone had breathed a word that it had anything to do with contemporary Uganda, the exhibition would have been closed down. Quite a lot of the work was in reference to Amin's and Obote's regimes, about a period that spanned both, the injustices and horrors of both periods. London art critics ignored it, of course, but it had extensive coverage from other journalists.

It remains a problem to convey to outsiders something about the quality of

the artists and the meaning of their work. In a way, the complexities and diversity of work show that Makerere succeeded. The work is difficult because there are so many strands going on that you can't expect it to come across just like that. You can't expect audiences themselves to have immediate access. It is more the personal archives of people who have encompassed a century of suffering and joy in only half a lifetime.

In today's consumer society, every product is tailored, each has clearly defined quality labels, and this extends out, so that art that is sold in one context is 'good quality' or serious, and art that comes from another is dismissed as therapeutic stuff or by people in 'the provinces'. The metropolitan economies that make consumer goods also manufacture metropolitan art, with cultural baggage and values to go with it.

This work confounds all that, because external judgements were irrelevant to the situation in which the work was produced. That's what makes it interesting, but also difficult. There are very few situations in the western world today where such a situation pertains. Intellectually, the work can stand up anywhere, but it could not be done in other places because of the weight of influences that prohibit such direct and visceral, yet skilled, imagery. Makerere artists lived through extraordinary and historical circumstances. In their secluded enclave they developed the language and the skills to express their feelings without censors, critics or entrepreneurs.

As for the future, will these artists maintain some kind of internal coherence and not become too dependent on being shown outside? It will be difficult, because the whole trend in the world is to share in an expanding global economy. It is inescapable that their work is going to become better known. In adversity, these artists were rarely trivial. As life improves and the world opens once more, will they escape being trivialised?

The Sisi Kwa Sisi movement was launched by twelve Kenyan artists in 1983, most of whom had been college friends or neighbours, or who had served together on national committees on art. With travelling exhibitions going to social halls, school compounds and open spaces in Nairobi, it was the first major effort by Kenyan artists as a group to take Kenyan art with Kenyan themes to the Kenyan people. The Swahili phrase Sisi Kwa Sisi – which, literally translated, means 'For Us by Us' – was used in all the publicity materials associated with the exhibitions, and on greeting cards designed by and exchanged between the movement's members. By practical deduction it means, in effect: 'For Kenyan artists and their Kenyan audience by Kenyan artists and their inspirational sources – the Kenyan people'.

Sisi Kwa Sisi: an Introductory Note
Etale Sukuro

The ethos of Sisi Kwa Sisi as a movement is a result of several developmental traits in contemporary Kenyan art, as well as other factors. Essentially, the group was formed along the lines of the African socialist philosophy of collectivism with self-respect, as opposed to individualistic materialism. This is manifest in the non-financial objectives that were set regarding theme rendition, exhibition formats and forums. However, the dynamism and contextual development of the movement and its activities can best be expounded by reference to related events in the art scene in East Africa and, in particular, Kenya.

Background

Kenya is one of the few African countries that shed blood to dislodge colonialism. The colonialists – both missionaries and settlers – came with ideologies and the tactics of 'divide, condemn, manipulate and rule'. They denounced indigenous cultural values and taught a few Africans to do the same, only with more vigour. Art was not spared in this censure of traditional values. As with religion, sport and dress, art had to be reclothed in western values: media, style, technique and even theme rendition had to be westernised.

Traditional, pre-colonial, art has existed in Kenya from time immemorial and several studies and state collections attest to its importance. The nomadic lifestyle of the inhabitants of the region ruled out the production of art of the quantity and quality found in West Africa, where some kingdoms had flourished for centuries, but East Africa still has a rich heritage of art from pre-Christian, pre-Islamic and pre-colonial days. External influences were unable by themselves to destroy completely the various traditional art forms. Unlike the French who colonised by assimilation, the British used a system which combined the superimposition of English over African traditional values, and ruled mainly for economic gain with minimal political or social involvement. As long as African traditional values did not interfere with that mission, they were allowed to continue.

But as westernisation became synonymous with civilisation, indigenous artists started blindly copying European forms. Besides copying, they started to depend on postcards and book illustration as a prime source for their themes. They could not afford to go to wildlife parks or the wilderness to see for themselves the animal, flower and landscape subjects they so often depicted for the tourist market. These exotic and romanticised subjects, however, were revered and used by settler European artists in the making of souvenirs and memoirs. A number of settler artists became internationally renowned wildlife painters on this basis, while indigenous artists were relegated to hawking their works in the streets and curio shops. Art galleries, most of them owned by settlers, would not accept indigenous works. Without any soul-searching or self-motivation, copying artists ended up, in the words of

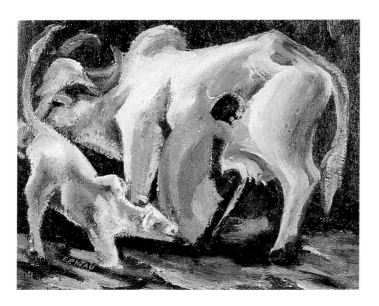

Elimo Njau
Milking
1972
Oil on cloth
40 x 51 cm
Museum für
Völkerkunde,
Frankfurt-am-Main

A. F. Mitchell, former Director of Sorsibie Gallery in Nairobi, as 'unfortunate mechanics who earn their daily bread by carving the eternally reiterated fauna of airport art.'

The earliest school of art in East Africa at Makerere University College was started in 1935 as an afternoon class by Margaret Trowell. The school encouraged the fusion of traditional forms and content with European styles and contexts. In a way, it did counteract the lucrative 'souvenir' themes as well as consolidate the re-clothing of western styles and contexts in 'African' forms and content. Makerere students were to produce 'serious' art, tenaciously portraying 'Africanness' by copying from traditional forms. The lack both of self-motivation and of innovation hindered the development of these artists into masters of identifiably avant-garde art in Kenya. One of the most industrious Makerere graduates, Elimu Njau, conceded in 1967 that 'studies of traditional forms taught students their vitality and spontaneity (through sculpture and rhythm, movement, and through design). However, the serious artist felt that blind copying of traditional motifs was inadequate.' Indeed, the graduates of this school failed to facilitate any continuity from pre-colonial traditional art to modern and post-colonial art in Kenya. They also failed to create a national art, addressed and exhibited to Kenyans, but persistently produced art aimed at a foreign audience.

Art exhibitions organised before independence mainly catered for European settlers, their visitors and tourists in urban centres. Most of these were held by the only artists' guild, The Kenya Art Society, established by colonialists in the early 1930s. Along with most commercial art galleries, the Society did not cater for the local people, and in most cases did not accept works by indigenous artists until well after independence. Many Kenyan artists felt quite displaced in their own country. Some of them changed profession or simply dropped out of the demanding tourist market; others became art teachers in schools and colleges.

The first time the Kenya Art Society held an exhibition aimed at indigenous people was during independence week in December 1963. This was the last exhibition held at the centrally located Memorial Hall in Nairobi; the Society subsequently moved to the Arboretum Gallery, located in a grand suburb of Nairobi difficult for most Kenyans to reach. At the opening, Minister of State Joseph Murumbi lamented that the Society had rejected his works in 1933 because 'they did not understand African or Asian art.'

By the early 1960s, Nairobi had become the capital of African wildlife painting. Artists from all corners of the world came to Kenya to sketch, paint and exhibit. Alphonse Moto, a renowned Zairean artist who emigrated to Kenya around this time, embarked for the first time on wildlife themes because 'tourists here were willing to pay more for my paintings'. The Kenya Art Society had always specialised in naturalistic and photo-realistic portraiture of African wildlife and landscape painting. In 1967, three years after independence, the long-serving president of the society, Mrs Joyce Butler, felt that local artists almost had a duty to paint wildlife pictures. 'There is constant demand for wildlife pictures and we would all be fools if we did not try to fulfil it. After all, tourism means an awful lot to this country,' she observed.

A number of private organisations put up exhibitions of Kenyan art for the Kenyan public. Notable among them were the petroleum companies, such as Esso Kenya Ltd and Total Oil Kenya Ltd. For many years Esso organised annual national art competitions where the best art works from East and Central Africa were exhibited. The company withdrew its sponsorship when a Department of Culture was established within the central government in 1979. Unfortunately, however, the Department did not build on Esso's legacy. The annual art competitions had been a great inspiration to Kenyan artists; if they had spread to the rural areas, the winning works each year would have formed an important national collection. Today, most exhibitions of Kenyan art are held in the cities or outside the country completely. The reasons are twofold: they polish the image of the artist and the country, and help boost both the artists' fees and the country's foreign exchange coffers. Exhibitions that have been directed at the Kenyan people have been, in most cases, small elements in larger national anniversaries or celebrations.

Etale Sukuro
c. 1985
Pastel on paper
Collection of the artist

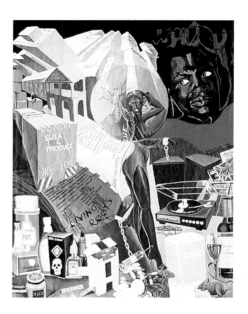

Taking Art to the People

The Sisi Kwa Sisi initiative took inspiration from what was happening in the theatre arts in the late 1970s. Commenting on the performance of the Kenyan cultural delegation to the second Black Festival of Arts and Culture (Festac) in Nigeria in 1977, the *Standard* newspaper editorial urged: 'All the authors and artists connected with *Betrayal in the City* and *Trials of Dedan Kimathi* [plays written by Francis Imbuga, and Ngugi wa Thiong'o with Micere Mugo, respectively] should be encouraged to become important pillars of the National Theatre, Nairobi... They should also be helped to embark on well organised tours within Kenya after their return from Nigeria as thousands of *mwanainchi* [masses] have not seen these two important plays.'

When this appeal failed to solicit national support, especially from the government, Ngugi wa Thiong'o took the theatre to the people. Not only were his two plays *Ngahika Ndenda* [I Will Marry When I Wish] and *Maitu Njugira* [Sing To Me, Mother] performed in a rural setting at Kamirithu, the actors were the villagers themselves. As the packed performances got under way, the government security forces moved in and banned them, razing the structures of the open-air theatre. Ngugi wa Thiong'o fled the country; powerful government ministers were going to see to it that he would never be comfortable 'spreading discontent' among villagers. He is still in exile, but the trend he set of taking theatre to the people remains a great inspiration to the artists of Sisi Kwa Sisi.

After the Kamirithu incident, the University of Nairobi intensified its own travelling theatre performances around the country. Some of the artists who had participated in Festac '77 – such as Diang'a Obaso – opened an open-air theatre and art gallery in rural western Kenya. Several other academicians and sympathisers, like Magioga Seba and Rumba Kinuthia, built rural cultural centres. Ngugi wa Thiong'o's plays are now being performed in rural Kiambu district.

As a matter of principle indicating their commitment to a Kenyan audience, none of the members of Sisi Kwa Sisi dealt with wildlife or abstract themes during their open-air exhibitions of 1983. Their works addressed issues affecting the Kenyan people before, during and after

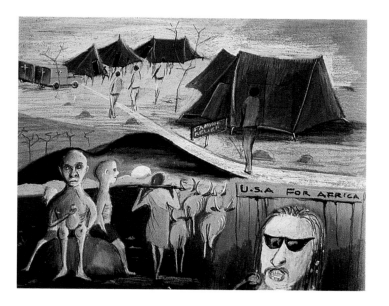

L. G. Karuri
Population Explosion
1987
Pastel
50 x 63 cm
Museum für Völkerkunde,
Frankfurt-am-Main

colonialism, with the depiction of socio-political and economic events taking a pivotal position. Their contention was that 'art should communicate and educate, whether the picture is beautiful or not'. When a wildlife theme was found in their works, it was to show how animals had ended up being more protected and cared for than humans. Certainly, such content could not make a 'beautiful' picture for tourists, commercial galleries or the collector of traditional art.

Other themes of social commentary dealt with the effects of colonialism, neo-colonialism and the westernisation of local cultures and traditions. Themes on the fight for independence were perhaps the most revered among the artists since their college years at Kenyatta University. They believed strongly that through their visual narratives, the true history of Kenya's freedom struggle would be presented and documented. The rendering of traditional themes was viewed by the group as a positive cultural renaissance born out of a century of the colonial denigration of traditional values. Some of the pictures depicted traditional sports, and were aimed at the urbanised youth so that they could copy from them and eventually create the equipment to perform such sports. It worked, and the art became not only a tool of communication but also of instruction. Themes on disappearing cultures were depicted with the same goal of both educating and instructing those who visited the exhibitions.

Using satire, the artists dealt with other political and social elements in several works, attempting to show that it

was not only the heroes and heroines of the struggle for independence who were sidelined by neo-colonialism. Life after independence from British rule has seen many under-privileged Kenyans, especially women and children. A culture of haves and have-nots, oppressed and oppressor, the hungry and the well-fed, the greedy corrupt and the poor has evolved amidst the populace. Such 'sensitive' commentary might be construed as seditious by an intolerant political regime. To avoid direct confrontation with those in power, the artists used caricature and visual proverbs to render this subject matter. However, during the exhibitions of 1982 and 1983, the authorities still questioned the content of some works and on occasion closed the shows down.

This was not the first time the authorities had suppressed what they deemed 'sedition' in art. In 1981, two paintings by Kibachia Gatu had been removed from the Utamaduni wa Sanaa (the first state-sponsored exhibition of art and material culture in Kenya) because their contents were considered seditious. One of the paintings depicted a child being mauled by ferocious dogs at the plantations of Kenya Canners Ltd. Apparently, the guards, who made use of oppressive colonial trespass laws, set dogs on children who were fetching firewood beyond the plantations, claiming that they had mistaken them for pineapple thieves. The injured children received no compensation from the company. Gatu provided a visual memoir of this horrific incident while it was still fresh in people's minds. The painting was bought by the

Department of Culture, sponsor of the exhibition, and that was the last seen of it.

Sisi Kwa Sisi's aim in its exhibitions was not only to show the Kenyan people the scope of aesthetics in their works, but to teach, entertain and interact with people. Exhibitions took place in poor suburbs where all the recreational land had been grabbed and privatised, and in social or school halls. After a sometimes tiring night or day, people on their way to or from work found the exhibitions a rare entertainment.

Schoolchildren were proud to know they had big 'brothers' and 'sisters' who could depict subjects they could relate to. Before the exhibitions, most of them thought that only foreigners could draw and paint. During the exhibitions discussions were held with those who visited the shows and their opinions were documented. In just two years, Sisi Kwa Sisi mounted more exhibitions for more Kenyans than all the exhibitions staged and sponsored by the state since independence; they took art to greater audiences in forums such as seminars, meetings and conventions.

With the exception of the sign-painters whose murals adorn every shopping centre in Kenya, members of Sisi Kwa Sisi have derived more inspiration from the Kenyan masses than any other artists – and reflected it back to them. Despite bans by some officials, despite logistical and financial problems, the exhibitions were a success. Several other Kenyan artists felt as a result that they had been exhibiting in the wrong places for the wrong audiences, and joined the crusades; others put on travelling exhibitions or erected galleries outside the conventional sanctuary of the capital city. Those who did not find appropriate forums to exhibit their works taught or worked in commercial art. One of Sisi Kwa Sisi's most important missions was to show fellow artists that beyond the razzmatazz of commercial art galleries there was satisfaction in communicating with brothers, sisters, parents and other Kenyans. This was not a purist or sectarian mission, but a crusade to bestow – in retrospect – the traditional African values of sharing among the people. Through group travelling exhibitions, Sisi Kwa Sisi proved that it is possible to have a pragmatic association of artists working for the same goals with little or no dependence on handouts from commercial art galleries, foreign cultural centres or even the state. It came into existence as a result of the coming together of Kenyan artists who had the same goals and were faced with a lack of infrastructure for the development of art. They felt they had a duty to re-appraise élitist exhibition venues and formats, and re-define art as utilitarian. By using art as a communication tool, they have reached many Kenyans who are illiterate or semi-literate, enabling the re-marriage of art with the rest of material culture.

Etale Sukuro
DDT
1985
Pastel
50 x 35 cm
Museum für Völkerkunde,
Frankfurt-am-Main*

Etale Sukuro
1970s
Painting
Gallery Watatu,
Nairobi, Kenya

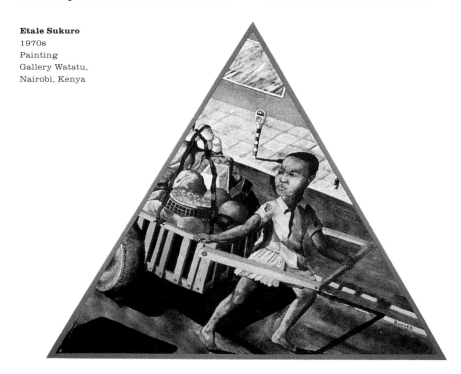

Statement

Etale Sukuro

Nairobi, 1987–88

I do works of social commentary to try and educate the Kenyan mass about their own land, their own fate and role in the development of this nation. These works definitely can't only be exhibited in foreign cultural places. You have to take them to the people. But that requires a lot of money . . .

At the moment, at this stage of our development, the aesthetics are not the ends in art here, because people have got so many problems. I mean, people are looking for food, they are looking for everything, they are walking miles and miles for water. So there is no way you can just go to please them, without actually educating them Knowing very well that the majority can't read or write, the best way to educate the masses is through visual means. And one way is fine art It's easy to get the message across so long as whatever is depicted actually reflects what is within or around your environment Talking in terms of line, form and colours – there is nothing like that. However one tries the approach at the moment, an artwork should be used for education purposes And it will be more interesting if you could use Masai patterns – the particular patterns they have of particular origins when explaining a particular point. That way they relate, they relate so fast – it's like many statements, when we hear the first two words we know what is going to come in the rest. So, exactly, there are some artworks.

I would rather have artworks in public places where they can be seen by a majority, by people who can understand the situation. That's why I can't exhibit these works at Gallery Watatu – these, in fact, don't have a buyer. So I don't even do them thinking about a buyer. That's why you usually find one appreciates these works more than anything, because I sit down and think, and think. Or sometimes I go on a safari round the country Taking the art to the people, and them commenting, is very interesting. It's more rewarding, actually, than even thinking of selling it . . .

In the sixties there was hardly anything on art. The few people who had the opportunity, they were so selfish, they just wanted themselves to be known and, in fact, they just wanted to grab and hold everything. They suppressed all the moves by upcoming artists to really bring their point home. They also gave the impression to the government and the majority of the Kenyan people that there are no artists, there is no point in bothering with a National Gallery or anything, because there are only two or three artists around.

Then we came to the seventies. We started to have graduates from Kenyatta and Nairobi Universities, and these were very active fellows. Now the older generation are sort of silenced. They have gone into hiding, those who feel ashamed. They can hardly come out when these artists are there, because they know what they have been doing trying to suppress national art. We have some artists who have been exhibiting throughout, some have even started their own cultural centres, like John Diang'a. It was due to these artists that the government started supporting art directly.

At the moment, I can tell you, nobody knows much about Kenyan art. There is hardly anything written down. The Department of Culture's collection represents very, very few artists. Even in public buildings, Kenyan public places, there are hardly any artworks by indigenous Kenyan artists. Change will come about if and only when it's initiated by the artists themselves. They should not expect somebody else to do that for them . . .

Etale Sukuro
Third World Farmer
1985
Collage
51 x 32.5 cm
Museum für Völkerkunde,
Frankfurt-am-Main

notes

Elsbeth Court

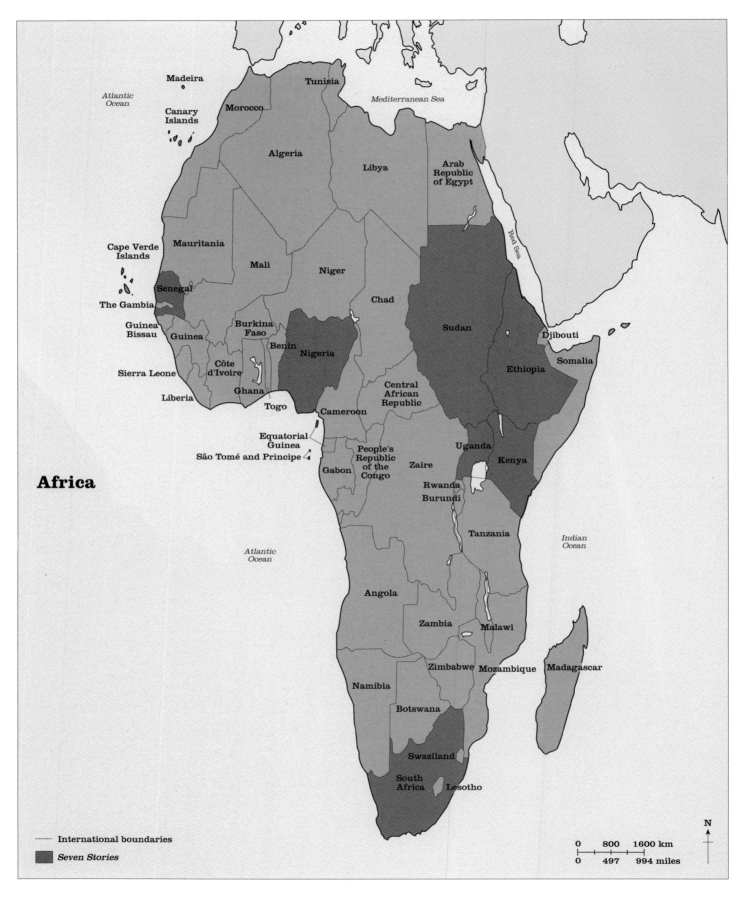

Africa

Atlantic Ocean

Madeira

Tunisia

Mediterranean Sea

Canary Islands

Morocco

Algeria

Libya

Arab Republic of Egypt

Red Sea

Cape Verde Islands

Mauritania

Mali

Niger

Chad

Sudan

Djibouti

Senegal

The Gambia

Burkina Faso

Nigeria

Ethiopia

Somalia

Guinea Bissau

Guinea

Benin

Sierra Leone

Côte d'Ivoire

Central African Republic

Liberia

Ghana

Togo

Cameroon

Equatorial Guinea

Uganda

São Tomé and Principe

Kenya

Gabon

People's Republic of the Congo

Zaire

Rwanda

Burundi

Atlantic Ocean

Tanzania

Indian Ocean

Angola

Zambia

Malawi

Zimbabwe

Mozambique

Madagascar

Namibia

Botswana

Swaziland

South Africa

Lesotho

— International boundaries

Seven Stories

0 800 1600 km

0 497 994 miles

N

makerere art gallery

In 1928 von Sydow, raising the hope
of an African art renaissance, saw
Christianity as both inspirational
and destructive. He considered the
colonial government supervision of
art education, but not 'to force on to
the Negro the mask of European art,
but to train him in his own
individuality.' (E. von Sydow, *Africa*,
vol. I, 1928)

Art colleges, universities
and schools

Short-term workshop
to improve
screenprinting skills,
Bulawayo Polytechnic,
Zimbabwe, 1994

*This section is dedicated to George
Warren Shaw, co-contributor until
his untimely death on 9 June 1995*

Pages 291–95 concentrate on the key art schools
that offer higher education in the visual arts, with
the omission of Ethiopia, for which no up-to-date
information could be obtained. The list on pages
295–96 attempts to cover the full range of art
schools, academies and departments that grant
degrees, and other national institutions that
provide non-degree, but specialised, programmes
in fine arts. Only eighteen countries maintain
degree-granting institutions. Traditional forms of
education, such as Benin bronze-casting or
Amharic manuscript and scroll-painting, are not
covered. Courses generally include training in two-
and three-dimensional media, art history and art
education; however, diverse approaches can be seen
in the assigned names of departments such as Fine,
Applied, Creative, Rural or Industrial Arts.

Opportunities for formal art education in Africa
are very uneven. For example, maximum provision
is found in Nigeria and South Africa, each with
about twenty departments of art at university level
(until recently access in South Africa has been
restricted by race). Minimal provision is also found
in the Southern Africa Development Community,
the former front-line states that are still
overcoming the effects of long-term destabilisation:
Angola, Botswana, Lesotho, Malawi, Mozambique,
Namibia, Tanzania, Swaziland, Zambia and
Zimbabwe. There is no degree-level provision in the
low-income countries of the Sahel, which suffer
drought conditions (Gambia, Mali, Niger,
Mauritania, Chad) or in Benin, Eritrea, Liberia,
Togo and Somalia (although some have
universities). Specialised programmes in art are
provided at a lower level, perhaps equivalent to
secondary school; there are also informal
opportunities, such as learning in artists' studios.

Countries with higher education in art, such as
Ghana, Nigeria, Senegal, Sudan and Uganda, share
a mix of characteristics that include recognition of
their own cultural histories and nationhood, an
active middle class and extensive provision of art
education at school level. In spite of the serious
constraints – economic, material, political, social,
intellectual, critical and commercial – the resilience
of the established schools is impressive.

Makerere School of Fine Arts, and art
education in East Africa

From its beginning, the School of Art has been at
the heart of Makerere University (Kampala,
Uganda). It set the standard for the practice of
modern art through the teaching, exhibiting and
writing of its graduates. Until the break-up in 1970
of the University of East Africa, efforts were
directed towards a three-part division of tertiary

level art education: fine arts at Makerere in
Uganda, applied arts such as architecture and
graphics at Nairobi, Kenya, and theatre arts in
Dar-es-Salaam, Tanzania. Most mature artists have
a Makerere connection, as did half the artists
whose work was exhibited in the London
exhibition, *Sanaa: Contemporary Art from East
Africa* (1984, Commonwealth Institute). However,
recent international shows have featured the
paintings of artists with a non-formal education,
like those associated with Nairobi's Gallery Watatu
or Dar-es-Salaam's Tinga Tinga Cooperative.
Examples are:

Tokyo, *Tinga tinga*, 1990, 1992

Frankfurt, *Wegzeichen [Signs]*, book 1990,
exhibition 1991

New York, *Africa Explores*, 1991

London, *Out of Africa*, 1992

Paris, *Rencontres africaines*, 1994

Factors that contributed to the remarkable
establishment of the School of Fine Arts included
indirect rule through the kingdoms of Uganda,
which maintained their cultural pride; the
existence of formal education at Makerere College
(founded 1921); art classes at nearby mission
schools, and the talents of Mrs K. M. Trowell
(1904–85). Trowell was an English artist who
trained at the Slade, and an art educator who
learned about 'internal imagery' from Marion
Richardson. She researched African material
culture with the Kamba in Kenya, and from 1935
throughout Uganda, where she was director of the
Uganda Museum (1939–45). An active Christian,
she was an astute and determined networker for
her mission to establish a system for modern art in
East Africa. Her publications on African art and art
education include six books and many articles. The
Faculty of Industrial and Fine Art, as it is now
called, began in the mid thirties as a class for
Makerere College students and craftsmen. Trowell
encouraged art associated with local practices,
emphasing skilled work and narrative content. She
introduced new imagery such as picture making
(but taught neither observation drawing nor
formal experimentation), new media such as
commercial paints and screenprinting and offered,
in her own words, 'a rather spasmodic course of
history of art, showing them anything good . . .' The
first London exhibition of 'paintings and
indigenous crafts' from Uganda was held in 1939
at the Imperial Institute, and the paintings were
very well received.

In the same year, art moved to the campus,
sharing a building with the museum and holding
annual exhibitions. At the College, practical art
was made a major subject. Muralist Sam Ntiro

(Tanzania, 1923–93) and sculptor Gregory Maloba (Kenya, b. 1922), Trowell's key pupils, went on to further art education in the UK, returning to teach at Makerere and then in their own countries. Maloba developed his personal style of expression, while a more populist approach via Ntiro continued with Elimo Njau (b. 1932, Tanzania, now living in Kenya), a painter and art personality, who is the long-time director of the Paa-ya-Paa Art Centre, Nairobi.

During the post-war phase, Makerere became a constituent College of the University of London, gradually expanding and upgrading to a three-year diploma course for teachers (1949) and a four-year Diploma in Fine Arts (1953). Trowell negotiated the content of these courses directly with the British Inter University Council, in order to maintain what she considered to be an appropriate course for the East African context. She retired in 1957, several years before independence.

A time of adjustment followed in 1958–71 under Cecil Todd from South Africa, characterised by a tremendous expansion and a diverse staff, which included Maloba, Jonathan Kingdon (b. 1935; a UK-Tanzanian RCA, MU 1963–73, now Oxford), Ali Darwish (b. 1936 Zanzibar; MU, Slade), Taj Ahmad (b. 1933 Sudan; MU 1968–72, RCA, now Saudi Arabia), Michael Adams (b. 1939 UK; RCA, now Seychelles), Teresa Musoke (b. 1941 Uganda; MU, Slade, Penn, now Nairobi), Geraldine Robarts (b. 1937; Witwatersrand, now Nairobi). Certification included Diplomas, BA, BA Ed., MA and, in 1970, the first PhD. The School published two volumes of *Roho* (Swahili, 'vital force, soul') and contributed regularly to *Transition,* the more inclusive college journal published in Kampala until 1972. A modern-style art gallery was opened in 1968 next to the College buildings. Makerere culture was euphoric, confident and cosmopolitan.

A somewhat fallow and disruptive time followed in 1971–85 during the regimes of Idi Amin Dada and the second rule of Milton Obote. The period is recalled by the exhibition *Art that Survives* (Africa Centre, London, 1986) and the sculpture *War Victim* by Francis Nnaggenda (b. 1936; see page 168). Heads of department were East Africans Kingdon, Ali Hussein Darwish and the first Ugandan, George Kakooza (b. 1936). In 1975, the courses were general studies, history of world art (including Africa), painting and drawing, sculpture and ceramics, textile and graphic design.

Since the late eighties, the curriculum has aimed to be responsive to issues of Ugandan–African identity and local conditions, including national rehabilitation and development. Makerere staff number about twenty and the students 140, larger than similar departments in Kenya and Tanzania, while the work of Ugandan artists such as Jak Katirakawe (b. 1940, who was tutored informally by school staff), Musoke and Nnaggenda attract international attention.

Tertiary level art education in Kenya has maintained a stable position for two and a half decades, with architecture and design at the University of Nairobi and fine arts at Kenyatta University, usually in association with secondary teacher education. A consequence of this extended status quo is that a few dissatisfied tutors have started art centres in their home areas, often in association with local teacher training colleges (which, since the late eighties, have conferred degrees). Despite the orientation of the academic fine arts course, from the late sixties there have been various initiatives directed towards the formation of a Kenyan art and design education, following changes in the content of the literature and history courses.

Key examples are mural painting and project work at the then Kenyatta College;[1] projects using natural materials at Kilimambogo Teacher Training College;[2] open-air exhibitions in markets and at schools, and the Material Culture Project of

the Institute of African Studies, University of Nairobi, organised on design principles that intersect social categories.[3] Furthermore, following system-wide reforms initiated in 1985, the status of school art increased. The curriculum now demands drawing, other practical activity and some study of material culture. The effect on higher education is as yet unclear, but there is a considerable increase in the production of popular painting.

In Tanzania, contemporary art, particularly of the pictorial kind, lacks a platform of its own. Although there is some provision in teacher education and in the Department of Art, Music and Theatre, training has been minimal: in 12 years, there have been only 26 art graduates. Art training occurs non-formally, by apprenticeship to a Makonde carver or a Tinga Tinga painter, or in workshops such as Nyumba ya Sanaa (House of Art) or Kinondoni.

Ghana

Art education in Ghana, began in schools as early as 1924, is based on a strong heritage in pottery, textiles, carving, jewellery and metalwork. The first art master at Achimota College, G. A. Stevens, had his students' work exhibited in London in 1927, an early landmark in international recognition. Ceramics were strengthened in 1942 with the arrival of Michael Cardew. The department moved in 1951 to the University of Science and Technology, Kumasi (the capital of the Ashante people), with a teacher training department for primary and secondary art education.

The University has produced a number of well-known graduates, such as its former dean Prof. Ablade Glover (now a gallery director) and the sculptor El Anatsui, who lectures at the University of Nigeria, Nsukka. The current dean is Prof. Kojo Fosu (author of key books on modern African and Ghanaian art), the department head is the painter H. B. A. Delaquis, while innovative approaches with materials and imagery are promoted by Atta Kwami. Study resembles the pattern of a British academy, but with more studio work than theory and 'rural art' on the curriculum, which concerns local crafts and innovation in design technology, especially textiles.

Around 1980, many Ghanaian professionals left the country, driven by economic necessity. This left the University understaffed, but fine arts have remained viable and have recovered, with an increased intake and more courses. In the 1990s over 2,500 secondary students took art as a subject at 'O' level and over 150 at 'A' level, representing about a tenth of all candidates; student enrolment for art at the University is around 200, about one in 20 of the total. Students may take a Diploma or Bachelors degree course, specialising in industrial or applied art (ceramics, textiles, book industry, rural art), or in fine art (drawing, painting, sculpture); the long-awaited Master of Fine Art programme was started in 1993. A Diploma in art education is also available, and also at the School of Art and Design, Winneba Teacher Training College.

Nigeria

The origin of formal art education in Nigeria may be traced to Aina Onabolu (1882–1963), a Lagos artist who studied and painted portraits in London and Paris in 1920–22. On his return he petitioned the colonial government to introduce western pictorial art into schools. Although he was unable to get reform of the syllabus, which remained 'hand and eye' training with drawing optional, he did succeed in becoming the first, and only, art teacher in Lagos. Pressure from Onabolu resulted in the appointment of the Colony's first art education officer, Kenneth C. Murray, in 1927.

Murray was a 'nativist' in his approach, and added traditional craft skills to the curriculum. He also introduced fine arts into three government

Cover of *Roho*, 1960, issued by the Makerere art school

Sam Ntiro
Agony in the Garden
1940s
Oil on canvas
40 x 51 cm
Collection of Michael Graham-Stewart*

secondary schools and art teacher training at Government College, Umuahia. In 1937 he organised an exhibition of Nigerian artists at the Zwemmer Gallery, London. The sculptor Ben Enwonwu (1921–94), an Umuahia student, studied at the art schools of London University; he was Nigeria's Federal Art Advisor 1959–71, responsible for all major government awards and financing.

Between 1949 and independence in 1960, art education was brought beyond the secondary level with colleges of art, science and technology opened in Lagos and in the three regions: Zaria in the north, Enugu (soon moving to Nsukka) in the east, and Ibadan in the west. Yaba College of Technology in Lagos (founded 1952) offered a course in commercial art; Zaria, later renamed Ahmadu Bello University, had a department to train artists and art teachers, which became a degree-awarding course in 1962. Students there started the Zaria Arts Society in 1960, later named (by Kojo Fosu) the Zaria Rebels because they campaigned for the recognition of the status of the contemporary artist in an African context. Nsukka's Department of Fine Art, adopting an American interdisciplinary approach, opened a degree couse in 1961, but it was not until artists from Zaria, dispersed by the Nigerian civil war (1967–70), arrived – notably Uche Okeke – that its standing in fine art became widely recognised.

Zaria produced the Nigerian art establishment of the seventies, including the heads of fine art departments in Yaba (Yusuf Grillo), Nsukka (Uche Okeke) and the new University of Benin (S. I. Wangboje), while Ben Enwonwu became Professor at Ile-Ife University. At school level, government guidelines of 1971 replaced 'hand and eye' training with 'cultural and creative art' as a main subject.

The Nigerian oil boom of the 1970s saw an explosion of talent and an increased demand for academic art training and the creation of many departments in the new universities, often with emphasis on vocational training. Educational reform in 1981 made art a core subject for juniors and elective for seniors; by 1994 there were ten university departments offering degree courses in art, with students selected from over 2,500 applicants. Zaria and Nsukka remain outstanding both in scholarship and artistic innovation.

Senegal

During the era of emerging independent nations, French-speaking African intellectuals were engaged with Negritude, a term first coined in 1939 in *Cahier d'un retour au pays natal* [*Notebook of a Journey Home*] by the West Indian poet Aimé Cesaire, and advanced by Franz Fanon and Pierre Teilhard de Chardin. For its leading exponent, poet and statesman Léopold Sédar Senghor (b. 1906, President of Senegal, 1960–80), Negritude came to involve the dynamic of an ideal, universal African inheritance with national political development (see *Présence africaine*). In part a revolt against colonial rule, it envisaged a contemporary African culture 'that incorporates the modern and the traditional, the political and the poetic, the hiding and the hidden, the flag and the mask'. From his experience as an artist and an African poet in the French Academy, Senghor understood that 'there is certainly no art without the active assimilation of input from abroad, but above all there is no original spirit without rootedness in the original earth, without fidelity to one's ethnicity ... to one's national culture.'

The former capital of French West Africa, Dakar provided an ambitious metropolitan society ready to seize new opportunities, and President Senghor created the infrastructure, particularly in the visual arts, to put his philosophy of Negritude into practice. During his long period of office, 30 per cent of the country's budget was spent on culture and education; a major accomplishment of this golden age was the Dakar School.

The term refers in general to the nation's first generation of fine artists, such as Amadou Bâ, Ibou Diouf, Ousmane Faye, Papa Ibra Tall and Amadou Seck, as well to succeeding painters who carry on their approach: Souleymane Keita, Chérif Thiam, Amadou Sow and, specifically, to the style of two-dimensional imagery that they formulated to represent and express African culture. Their achievement was to fuse ethnic content (from music and narratives, often heroic) and ethnic forms (masks, dense decoration, intense colour) with European kinds of painterly and graphic techniques, modes of imagery ('semi-abstraction') and media (oil paint, mural tapestry). The first major exhibition of this self-consciously African work was during the Premier Festival Mondial des Arts Nègres, held in Dakar in 1966. It was curated by Ibrahim N'Diaye (b. 1928, French art school 1949–57), somewhat ironically because N'Diaye's own, exquisite work is not self-consciously African in style; indeed, for him 'there is not a Senegalese modernity or a western modernity, there is simply modernity.'[4] His work, characterised by superior draughtsmanship and subtle imagery, is more personally expressive than culturally prescriptive and thus the narrow canon of Negritude met its first challenge.

From 1961 to 1972, Senghor upgraded and modified the Masison des Arts (founded 1958) into a more serious art school with two departments, each intended to nurture a particular kind of imagery. *Arts plastiques* was for European fine arts with an academic training under Iba N'Diaye, and *Recherches en arts plastiques nègres* was for studies into African art leading to the visual representation of Negritude. The latter was first headed by Papa Ibra Tall (b. 1931, French education in architecture, painting and applied arts), and then by French mathematician Pierre Lods, previously invited to Senegal by Senghor because of his role in the successful invention of 'African' imagery at the Poto-Poto workshop in Brazzaville, Congo (1951). This department also experimented with local materials and techniques. The two Senegalese artists left in 1965, leaving Lods in charge. N'Diaye decided to paint in Paris, where he has remained, although he makes regular trips to Dakar; Tall, whose tapestries had already gained prominence, started a national tapestry centre at Thiès, a provincial capital.

In 1972, the School was enlarged into an umbrella organisation for the creative arts, the National Institute of Arts of Senegal, in which there were three departments for the visual arts: fine arts, art education, and architecture and town planning. In 1979 this was dissolved and replaced by two schools offering four-year courses. The larger is ENBA, the École Nationale des Beaux-Arts, offering visual arts training in fine art, communications and design; in 1994, the enrolment was 127 students. The other is ENSEA, the Ecole Normale Supérieure d'Education Artistique, for the education of art teachers (in the process of reorganisation).

The euphoria of the sixties ended in the less idealistic political stance and harsher economic conditions of the late seventies. Many art institutions have closed or been scaled down, but there is still some government support for high-profile projects such as new galleries and a Dakar Biennale. Artists maintain a high level of production with serious and interesting work which receives positive local support, but little financial help. To a large extent, artists depend on their salaries if they are teachers, and on the patronage of expatriates and the international market. Negritude, after all, was a cultural policy not a commercial one, but making contemporary art more accessible to the public as many of the second-generation artists are doing (including El Hadji Sy and Issa Samb) is very much in tune with Senghor's ideal.

Notably to my young colleagues, I would give several words of advice: be on guard against those who insist that you must be 'Africans' before painters or sculptors, for those who, in the name of authenticity, which remains to be defined, continue to want to preserve you in an exotic garden. We are not born more talented than others, the majority of us do not come from traditional artistic families in which the profession is transmitted down through generations, but rather we are sons of African cities, created for the most part in the colonial era, crucibles of an original culture, in which, according to the country, foreign or indigenous cultural contributions dominate. We are both the sons and creators of this culture, which so disturbs those nostalgic for the Africa of the 'noble savage'. It is in this role that you have a very great responsibility: to make our profession legitimate in the eyes of our fellow countrymen, and in those of men from all the continents (under whose attentive or anxious gaze Africa is more than ever placed), making us masters of techniques which alone will permit us to overtake the period of infantine imagery, to renew ourselves and to give us the courage to advance the iconogaphic themes of contemporary Africa, 'a shattered continent', more now than ever a victim, but whose artists must contribute to giving a future image of a continent which, liberated from biased images, will elaborate a new 'africanity'.[5]

South Africa

With society in extraordinary flux and transformation, it is important to recognise the special conditions of South Africa's 'otherness'. While the nation is the wealthiest on the continent, 40 years of apartheid, and longer of what is called internal colonialism, have resulted in extensive inequality and gross misunderstanding between segments of this complex society. Within South Africa, people were and are isolated from each other, while internationally there are gulfs between the many exiles and those who remained at home, as well as the isolating effects brought about by decades of international boycotts. An essential challenge facing the New South Africa (President Mandela was elected in April 1994) is 'the breaking of the old concepts of culture' (see CASA, below). In terms of the visual arts, this involves 'restoring our otherness: reflecting on the meaning of Eurocentrism and its effects on South African culture' (Marilyn Martin, Director, South African National Gallery).

By the early eighties, the role of art in the political struggle and cultural regeneration of South Africa had changed significantly, from a registration of discontent to a serious engagement with culture and development. The titles of three key conferences convey this, one held within and two outside South Africa. In 1979 Cape Town University sponsored *The State of Art in South Africa*. Those present urged the state to support art education for all and attempted to enlist artists' refusal to participate in state exhibitions. At the first opportunity, however, when the Department of National Education held an exhibition called *Renaissance II*, only Bill Ainslie and Robert Hodgins, out of 45 invited artists,

In the 1920s John Koenakeefe Mohl was advised not to concentrate on landscape, which was a European specialisation, but rather to paint his people in misery and poverty. 'But I am an African,' he replied, 'and when God made Africa, he also created beautiful landscapes for Africans to admire and paint.' (From T. Couzens, *The New African*, Johannesburg, Raven Press, 1985, page 254)

refused on the grounds of the resolution. In 1982 in Gaborone, Botswana, an international symposium on *Culture and Resistance* discussed strategies for building a relationship, which included practical activities. Sponsored by a resistance arts group called Medu Ensemble, it brought together a range of southern Africans: South Africans, exiles and other cultural workers from the region.

This watershed event led to the 1987 Amsterdam Conference that focused on the formation of *Culture in Another South Africa* (CASA). It was sponsored by the African National Congress and the Dutch Anti-Apartheid Movement, with support from many agencies. More than 300 South African artists from all over the world met for ten days to exchange views about the infrastructure for the arts in a non-racial and democratic South Africa. It was an occasion of grand euphoria, to share the compelling and varied art forms that were looking to the future. From the mid eighties, a series of startling exhibitions of South African contemporary art were seen in Cape Town, Durban, Johannesburg, Oxford, London, Venice, Amsterdam and Stockholm, challenging audiences to consider the wide parameters of contemporary art production in Africa by Africans.

During apartheid the vast majority of people were denied access to formal art education. The ideas and works of black Africans were omitted from both curricula and exhibitions, just as the people themselves were excluded. In 1991 fewer than 0.14 per cent of black students sat for fine arts at matriculation level (compared with 66 per cent for agriculture). But art as a school subject is unpopular with other segments of this racialised society, too. In contrast to the UK or Ghana where about a fifth of students study art at school, enrolment is low: art and design do not rank in the ten most popular subjects, apart from technical drawing which is ranked ninth and tenth by Asians and whites respectively.[6]

For tertiary art education, there are at least 20 departments in South Africa. Several date back to the 1880s, such as Cape Town, Durban and Grahamstown which were established by private patrons and are associated with a 'successful' capitalist society (though nowadays they are maintained by the state). This contrasts with the founding of art schools in other states in Africa by govenment initiatives, often in alliance with nationalist goals (which, ironically, can often no longer be maintained by the state). For the most part, prior to the 1980s, art education lacked scope in both media and contextual studies; the priority was academic painting on canvas, particularly of landscapes. Black Africans were (with very few exceptions) 'historically excluded' from the premier institutions by Bantu legislation of the 1950s. Opportunities to study fine art at degree or diploma level were at the non-white University of Fort Hare (department founded 1976, with an average of 25 students); by correspondence with UNISA, the University of South Africa, and in few teacher training colleges, of which Ndaleni in Natal was well known for its Specialist Art Teachers Course (1952–82).

Teachers adhered to prescriptive pedagogies, geared towards the generation of a defined mode of imagery – i.e. 'European' realism/ naturalism, 'African' expressionism or international formal modernism. In the early days at the Polly Street Art Centre, Cecil Skotnes (b. 1926; Polly Street Director 1953–66) taught his students a naturalistic imagery based upon direct observation, supposedly to encourage the representation of urban living, to render 'township realism'. The main media were drawing and watercolour. A very high standard of poignant understatement was achieved by painters like Durant Sihlali (now Head of Fine Arts at FUBA) and Ephraim Ngatane (1938–71). Later, under the influence of his own discovery of African art and

perhaps of the new art education prevalent in the north, or perhaps through Dr Jack Grossert, an innovator in South Africa, Skotnes modified his methods to encourage the exploration and recovery of African experience.

Similarly to other significant interventionists (e.g. Ulli Beier, Pierre Lods, Frank McEwen and, to a lesser extent, Margaret Trowell), Grossert and Skotnes gave value to the 'untutored African', believing that direct 'tuition was detrimental to the African's natural ability'. These art organisers were advocating the pedagogy, widespread from the late forties, of 'not teaching' art. The teacher's role was to facilitate self-discovery through the provision of workspace, supplies and respect (or interest), rather than through instruction, apart from critical discussions of work. Theirs was a liberal reaction to the perceived failure of structured academic training or, at least, to its occasional inappropriateness and inflexibility.

Although not state-supported, an exemplar of serious art education grew from the studio school of painter and teacher Bill Ainslie (1934–89). The Johannesburg Art Foundation (founded 1972; 6 Eastwold Way, Saxonwold, Johannesburg 2001; tel. 486-1658/9) is a unique, non-profit-making institution that offers a modern art education in a socially mixed environment. It has long been a model for interracial learning and for interaction between artists. It has responded creatively to the challenges arising out of South Africa's particular conditions, in order to meet the black demand for serious lessons and studio space, assist with the formation of community art centres such as FUBA, FUNDA and the International Workshops, and now to facilitate in-service art education for teachers who lack previous art experience, through a special programme with the Curriculum Development Project (CDP) of the National Education and Training Forum. Artists who have strong links with the Foundation include several who are known for their stunning, often surreal, graphic work – William Kentridge (b. 1954) and Helen Sebidi (b. 1943) – and also those known for abstract expressionism, like David Koloane (b. 1938) and Tony Nkotsi (b. 1955).

The Foundation runs a full-time two-year matriculation course equivalent to high school level in practical art and art history, and a number of special and/or part-time courses. In 1995, there are seven full-time teachers (all artists) for 80 full-time and 400 part-time students, of whom 20 per cent receive full bursaries. The teaching is weighted towards modernist approaches such as process work and mixed media. Founder and first director Bill Ainslie stressed the importance of a humanitarian education in which, through art, an individual was able to transcend politics. Comparable programmes might be the Community Arts Project (founded in Cape Town in 1977 by Gavin Younge) and the Community Arts Workshop (Durban, 1983, by Andries Botha).

During the past decade there have been small increases in access to art education at secondary and higher levels. The radical changes in national policy articulated in the broad Reconstruction and Development Programme (1994) call for the building of skills, empowerment and life-long learning, making deliberate connections between the existing formal system and the popular energy and engagement generated through resistance art projects and community-based institutions. The Programme would seem to require a broad concept of art, inclusive of African and other traditions in South Africa. Art departments in some premier institutions like the University of the Witwatersrand have devised proactive means to redress the inequality of past provision – integration of the faculty, 'bridge' or access courses, innovative exhibitions and collaboration with the Katlehong Art Centre.

At school level, numerous and varied initiatives to redress inequity give attention to facilitating

connections or conversion between formal and non-formal systems, to increase access for black South Africans to formal education. Initiatives of the CDP in the creative arts include raising teachers' awareness of the process of learning through art, for the construction of identity, including new theory and practical skills; redressing racial bias in text books, and providing opportunities for children to acquire basic skills. Many of their model activities involve links between institutions in different sectors.

Sudan

In contrast with the modern art of Senegal, South Africa and Uganda, Sudanese contemporary art comes from the wonderful work of the country's expatriate artists since the late sixties. Their extensive international networking – across Africa, the Middle East, Europe and America –- suggests the flexibility of their cultural backgrounds and the impact of their professional training in Khartoum, primarily at the School of Fine and Applied Art, and overseas. The exodus of these artists from their professional base at home is poignant.

Efforts to come to grips with the context for contemporary art in the Sudan are confronted immediately by two hurdles: the country's extraordinary complexity of time, place and peoples (the population of 25 million contains 500 ethnic groups; 40 per cent of Sudanese are non-Muslim), and the present inadequacy of African art studies to address these phenomena (from Ulli Beier to Jean Kennedy). Even an accessible movement like the Khartoum School tends to be reduced to cliché descriptions such as 'traditional Islamic calligraphy transposed to western, fine art canvas', or 'the synthesis of sophisticated Arabic calligraphy and instinctive geometry of African decoration.' Both miss the cultural ideals and range of artistic expression that distinguish this vital project.

Sudan is the largest area of land in Africa. Straddling the Nile between the desert of Egypt and the forest of Uganda, the area gave rise to distinctive kinds of Nilotic societies, associated with cattle pastoralism and divine kingship, whose people shared personal adornment as a key form of aesthetic expression. It both preceded and influenced the kingdoms of Egypt: the pharaohs of the 8th and 7th centuries BC were kings from Nubia.

Significant other layers of historical influence include Kerma, Meröe, Christian, Islamic, Ottoman colonialism (Turkish–Egyptian, from 1821), the Mahdiya (Khartoum local rule), Anglo-Egyptian colonialism (British administration from 1898), post-colonialism (from 1956) and arabisation. For most of this time, regardless of who was ruling from the north, southern Sudan, ethnically akin to Uganda, was underdeveloped, exploited and excluded. Political independence has resulted in little national unity or economic improvement; rather, nationhood has been dominated by civil wars, further aggravated since 1989 by a fundamentalist Islamic military regime.

However, the Faculty of Fine and Applied Art of Sudan University of Technology (formerly Khartoum Technical Institute and Khartoum Polytechnic, not to be confused with the University of Khartoum) has sustained an impressive scale of operation. Organised in eight departments, the staff number about 40 and the students about 400; over 80 per cent are male. The core subjects are drawing and art history; subject specialities range from fine art and calligraphy to more obviously vocational courses like ceramics, industrial design and art education. This institution, 50 years old in 1997, has had four phases: the colonial influence, rising in the thirties; the establishment of a separate school and quest for a modern Sudanese identity, 1947–64; upgrading of the school and further quests, 1964 to the early 1980s, and modification during the current 'state of decline'.

Western-style art education did not begin as a grand personal initiative, like Senghor's for Senegal. Rather, it developed slowly from within the colonial system, as a credible and popular subject, in ways similar to Ghana. In both countries, art lessons commenced at the premier boys' secondary school, in Sudan the Gordon Memorial College (founded in 1902; precursor of the University of Khartoum). In 1934, to complement standard British-style art lessons, the College introduced a design department for the applied arts, with specific efforts to draw on local practices such as calligraphy, leather and woodwork. The instigator was Jean-Pierre Greenlaw, a UK-educated teacher, researcher, illustrator and author, who was passionate about the heritage and cultures of Sudan.

Meanwhile, from its establishment in 1937, the Institute of Education at Bahkt al Ruda had offered art as a component of teacher education, also running short courses on visual aides and producing textbooks. These two initiatives provided a wide base of experience for Sudanese with a secular education, engendering an awareness of the potential for art.

After the Second World War, the Gordon College department opted to separate and become a specialised School of Design, which emphasised the vocational aspects of training. The first supervisor was J.-P. Greenlaw; other staff came from the UK and Sudan, including Shafiq Shawif (in 1947) and master-calligrapher Osman Waqialla (in 1949). Affiliation with the Khartoum Technical Institute in 1951 stimulated the transition into further education. The following year, the renamed School of Fine and Applied Art offered a three-year diploma programme. It proved remarkable in revealing and shaping artistic potential, and was the critical scaffolding for modern art in the Sudan.

Throughout the fifties, the brightest students went overseas to the best art schools in London; nearly all returned to teach at the Khartoum School, which also became the label used for this group of artists. They are: Mohammed Abdalla (Central), Taj Ahmad (RCA), Kamala Ishaq (Slade), El Nigoumi (Central), Amir Nour (Slade, also Yale), Magdoub Rabbah (Slade), Ibrahim El Salahi (Slade), Ahmad Shibrain (Central). A combination of different kinds of excellent training, inspiration and camaraderie guided their efforts towards the creation of a modern artistic identity, which could express their dual African and Islamic identity. This is characterised by graphic inventiveness with calligraphy, usually without colour, 'bending basic marks' into imagery expressive of Africa. Other kinds of syntheses were also created between materials and imagery, as seen in the ceramics of Abdalla and El Nigoumi and the sculpture of Amir Nour. There is some internal debate concerning the patrimony for 'calligraphy on canvas' (Waqialla, El Salahi, Taj Ahmad) and also concerning the group's membership, which has tended to omit those artists who did not conform to the Khartoum canon.

The School became a fully fledged university in 1964, with a four-year programme leading to a BA degree. Until the early eighties, it maintained a rigorous and exciting programme that resulted in a broad range of production and critical activity such as the issuing of manifestoes and research into folklore. An MA in Fine Arts and Art History began in 1995. While the second generation continued to explore calligraphy, it was in more varied media, such as printing and even performance (Hassan Musa). Most artists were engaged in celebrations of colour (Bushara, Diab, Musa) and the development of personal or internal imagery (Ishaq). There was another round of overseas scholarships in the seventies, this time following a first degree in Khartoum and often involving research as well as practice. This group includes Beshir 'Bola' (Sorbonne), Musa (1974,

Montpellier), Diab (1972, Madrid), Bushara (1972, Slade). Their work is stimulating and a strong force in contemporary African art.

Institutions

Institutions that provide formal eduction in art at tertiary level (French *école supérieure*) and at sub-tertiary level for courses leading to diplomas, matriculations, certificates, etc.

The main sources are :

The Commonwealth Universities Yearbook, London, 1994

Guide l'art africain contemporain, Paris, 1992–94

International Handbook of Universities, Paris, 1986, 10th edn.

Higher Education in Africa, Manual for Refugees, Geneva and Nairobi, World University Services, 1986

Janet Stanley, working bibliography for *Modern African Art*, Washington, D.C., 1995

Stephen Williams and Neo Matome, *Visual Art in the Southern African Development Community*, Harare, 1994

The World of Learning 1995, London, 1994

Information has also been gleaned from issues of *Revue noire*, from African embassies in London and numerous people in the field.

The definitive source on national provision of higher education is *The World of Learning 1995*, whose classification 'usually follows the practice in the country concerned.' Countries in Africa that mention tertiary level art education are: Algeria, Egypt, Côte d'Ivoire, Ghana, Guinea, Libya, Morocco, Namibia, Nigeria, South Africa, Sudan, Tunisia, Uganda, Zaire, Zimbabwe. Departments or schools exist and are reported elsewhere, however, for Ethiopia, Kenya and Senegal, but are not cited in this volume, which serves as a reminder to be critical of even well-regarded sources. Countries without evidence of formal provision at school are: Benin, Cameroon, Cape Verde, Chad, Djibouti, Equatorial Guinea, Eritrea, Gambia, Lesotho, Mauritania, Niger, São Tomé and Principe, Somalia.

Algeria
Ecole Supérieure des Beaux-Arts (est. 1881), Algiers

Angola
National Institute of Artistic and Cultural Education (INFAC), Luanda

Botswana
Teacher education at Molepolole Teacher Training College, University of Botswana Faculty of Education, Gaborone

Burkina Faso
Ecole des Arts Plastiques
Institut de Cinématographie, University of Ouagadougou

Burundi
Ecole Technique Secondaire d'Art de Gitega (ESTA), Bujumbura

CAR (Central African Republic)
Ecole Nationale des Arts, Bangui

Congo
Ecole Nationale des Beaux-Arts 'Paul Kamba', Brazzaville
Ecole Peinture de Poto-Poto, Brazzaville

Côte d'Ivoire
Institut National des Arts; Ecole Nationale Supérieure des Beaux-Arts, Abidjan
Université Nationale, Institute of African History, Art and Archaeology, Abidjan
Ecole des Arts Appliqués, Bingerville
College Artistique, Abengourou

Egypt
Alexandria University, Faculty of Fine Arts
Ecole des Beaux-Arts (est. 1913), Cairo
Faculty of the Arts, including Higher Institute of Art Criticism and Higher Institute of Child Art

American University in Cairo: Department of Theatre, Art, Music and Film
Helwan University, Faculty of Fine Arts

Ethiopia
School of Fine Arts, University of Addis Ababa
Princess Menen Handicraft School, Addis Ababa

Gabon
Ecole Nationale des Arts et Manufactures (ENAM), Libreville

Ghana
College of Art, University of Science and Technology, Kumasi
Department of Art Education, College of Design at Winneba Training College
Grannata College of Art, Accra

Guinea
Ecole des Beaux Arts et des Arts Appliqués de Bellevue (1962–76)
Fine arts diploma course at the University of Conakry Faculty of Social Science

Guinée-Bissau
National Institute of Art, Bissau

Kenya
Department of Fine Arts, Art Education, Kenyatta University, Nairobi
Department of Architecture and Design, University of Nairobi
Kenya Polytechnic, Nairobi
Creative Arts Centre, Buru Buru Institute
Also teacher training colleges, with art education secondary speciality at Egoji, Kisii and Sirima

Liberia
Before the civil war in 1990, non-degree courses were offered in art history and studio art at:
University of Liberia
Cuttington University College

Libya
Arts and Crafts School, Tripoli
University al-Fatih College of Art and Information, including Schools of Art Education, Fine Art, Applied Art, Tripoli
Garyunis University, Benghazi
Omar Almukhtar University College of Art and Architecture, Darna

Madagascar
Académie des Beaux-Arts, Antananarivo
Ecole des Arts Appliqués, Tefisoa

Malawi
Chancellor College Department of Fine Arts, Zomba

Mali
Institut National des Arts, Bamako

Mauritius
Institute of Education Department of Visual Arts, Port Louis
Department des Beaux-Arts, Institut Mahatma Gandhi, Moka

Morocco
School of Fine Art, Ecole Nationale des Beaux-Arts, Tétouan
School of Fine Art, Casablanca

Mozambique
Escola de Artes Visuais, Maputo
University of Mozambique, Maputo: drawing in teacher education

Namibia
University of Namibia School of Art (founded 1993), Windhoek

Nigeria
A wide range of art studies in Nigerian universities
Abuja: theatre arts
Ahmadu Bello, Zaria: fine arts, industrial design, textile design, performance arts
Bayero, Kano: arts education
Benin: theatre arts, fine and applied arts
Calabar: arts education, theatre arts
Ibadan: theatre arts (also University International School)

Ile-Ife, Obafemi Awolowo University: wide range
Ilorin: art and design, performing arts
Ibos: architecture, theatre arts
Lagos, Yaba Technical Institute: wide range
Lagos State: creative arts
Maiduguri: arts education
Minna Federal University of Technology:
 architecture
Port Harcourt: theatre arts, music, drama, fine arts
Nsukka, University of Nigeria: fine and applied art
Uyo: fine and industrial art

Rwanda
Ecole d'Art, Nyundo

Senegal
Ecole Nationale des Beaux-Arts (ENBA), Dakar
Ecole Normale Supérieure d'Education Artistique
 (ENSEA), Dakar

Seychelles
Polytechnic of Art and Design, Victoria

Sierra Leone
Fourah Bay College, Department of Fine Arts,
 Freetown
Technical College, Congo Cross
Also teacher education

South Africa
Michaelis School of Fine Art, University of
 Cape Town
Mzuluele Art School
Natal Tecknikon
Pelindaba Museum of African and Modern Art
Rhodes University School of Fine Art
School of Art and Design, Tecknikon, Witwatersrand
University of Bophutatswana, Fine Arts Department
University of Durban-Westville, Department of Art
University of Orange Free State, Department of
 Fine Arts
University of South Africa (UNISA), Department of
 History of Art and Fine Arts
University of Stellenbosch
University of Zululand

Sudan
College of Fine and Applied Arts, Sudan University of
 Science and Technology, Khartoum

Swaziland
Waterford Kamhlabe (International Baccalaureate
 in Art), Mbabane

Tanzania
University Department of Art, Theatre and Music,
 Dar-es-Salaam
College of Arts, Bagamoyo
Nyumba ya Sanaa (House of Art and Design,
 15 workshops)

Togo
Ecole Africaine des Métiers d'Architecture et
 d'Urbanisme (EAMAU), Lomé

Tunisia
University Technical Institute of Art, Architecture
 and Planning, Tunis

Uganda
Makerere University, School of Fine Art, now
 Faculty of Art, Kampala
Uganda Polytechnic, Kyambogo (teacher art
 education)

Zaire
Académie des Beaux-Arts, Kinshasa

Zambia
Evelyn Hone College of Applied Arts, Lusaka
Plus art education courses in 9 teacher training
 colleges

Zimbabwe
Harare Polytechnic
National Gallery of Zimbabwe, BAT Workshop School
University of Zimbabwe, Faculty of Education
Other art education courses in teacher training
 colleges
Bulawayo Polytechnic
Mzilikazi Art and Craft Centre

Ujamaa II Workshop
Open Day, Centro de
Estudos Brasileiros,
Maputo, Mozambique,
1992

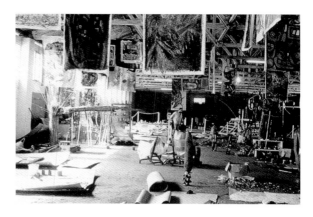

International
workshops

International workshops are special occasions for professional artists to make work together. While there are some precedents such as Oshogbo (Nigeria, 1962–64), Paa ya Paa (Kenya, 1973) and Kisii (with Inuit, Kenya, 1986), it was not until the late eighties that workshops became a more regular feature in several countries in southern Africa. They are an intervention that is helping to improve conditions for artists and, more generally, to create local public awareness about modern art. They are arguably the most significant innovation in contemporary African art (in contrast, for instance, to biennials and blockbuster exhibitions), and international workshops are growing in Africa and elsewhere.

By the end of 1994, seven workshops along the Triangle model were operating in Africa. The original concept, developed in New York by Anthony Caro and Robert Loder in 1982, aimed to create 'a pressure cooker for new art' (Caro, 1989) through a combination of retreat, artist peers and visiting critics. The transition to Africa was first realised as the Thupelo workshop by Bill Ainslie and David Koloane in Johannesburg. Subsequently, the idea spread to Zimbabwe, where Tapfuma Gutsa and Berenice Bickle gathered together a group of sculptors and painters.[7] Thereafter, workshops were established in Botswana by Veryan Edwards; in Mozambique by Fatima Fernandes; and in Zambia, Namibia and Senegal by groups of artists helped by Anna Kindersley acting as co-ordinator.

Though each is artist-led and financially and operationally independent, the workshops operate on a similar basis. Designed to stimulate creativity and encourage experimentation, they last for just two or sometimes three weeks, and are held if possible in a remote location to contain the energy of the occasion and remove day-to-day distractions. They are for committed, mid-career artists, not students; usually about 20 participants work together, without any formal teacher–student relationships. At the close, an exhibition of works in progress involves the public.

While the development of creativity is the prime function, the workshops do of course have a political and social significance. Artists band together in the belief that what is said through art should be independent of the market. The friendships created endure beyond the end of the workshops; artists visit each other's studios (often across country borders), and some keep in touch by electronic mail. Open days and exhibitions have attracted diverse audiences, who are now aware of the potential for art in Africa.

This workshop movement has spread to the Caribbean and the UK and in 1996 will start in India and Kenya. There is no central organisation beyond the co-ordinator who helps to start workshops in new locations and organises the flow of information between workshops; the movement draws its energy from the enthusiasm of the artists. A development related to the workshops is

the provision of studio spaces, initially at the Bag Factory in Johnnnesburg (10 Minnaar Street, Newtown, Johannesburg 2001) and the Gas Works in London (155 Vauxhall Street, The Oval, London SE11 5RH), which allow a longer-term exchange and provide a focus for newly created networks.

Catalogues or yearbooks are produced by the following international workshops held in Africa:

Thupelo, Johannesburg, South Africa (1987, 1988)

Pachipamwe, Zimbabwe (1988–)

Thapong, Botswana (1989–)

Ujamaa, Mozambique (1990–93)

Mbile, Zambia (1993–)

Tulipamwe, Namibia (1994–)

Tenq, Senegal (1995).

Some back copies are available from the Gas Works, London, address above.

New projects for encounters between African and French artists, and African art students, have been organised in Ouagadougou (Burkina Faso), Bamako (Mali) and in several French cities. At present, these are more structured and more comprehensive than the Triangle model – for example, the second Ouag'Art (April–June 1994) involved a group exhibition, public discussions and several two-month courses, as well as experience in studios and in the preparation of small shows. Another initiative, sponsored by Culture et Développement (Grenoble), is *Taxi Couleurs*, which aims to extend talent and build camaraderie through dynamic exchanges. The first phase, in France, involved a study tour in art schools and studios for six art students from Mali, Cameroon and Côte d'Ivoire; the second phase, in Mali, featured two kinds of workshops, involving some of the phase one artists, and an exhibition of workshop art.

Movements, centres, workshops and collectives

Introduction

The many forms of art production that occur outside of formal education or its margins challenge restrictive definitions of modern art, and range from popular sign-painting to themed coffins. In the last decade, non-African curators and scholars have shown such art in, for example, *Magiciens de la Terre* (1989), *Africa Hoy* and its namesakes *Africa Now* and *Out of Africa* (1991–92) and *Africa Explores* (1991–94). This is to the chagrin, if not the fury, of many African and Africanist art professionals for whom the external valorisation of 'non-art' as art is problematic,[8] and also to the exclusion of local practices such as certain kinds of personal ornamentation, ceramics and textile art.[9] None the less, in Africa, the experience of such art forms has contributed significantly to the training of many artists and to a more general awareness of art.

The term 'non-formal' art education is used here to refer to formative experiences that occur out of school, which are often with people who are themselves formally trained. In most African contexts there is little specialisation: spaces and situations overlap, if not merge. Strict categories are not an appropriate means in trying to understand how art happens; interaction is a more apt notion, with art occurring in webs of cooperation. This sampler selects significant examples that demonstrate the range of creativity in new directions of contemporary art production.

In contrast to schooled art, with its general skills and theoretical study, and the intensive specialisation of the academy, non-formal education concentrates on particular techniques and is product-oriented. In instances of general studies in art, the level tends to be similar to upper secondary, or a foundation course in the British system. Yet such provision is also characterised by variety and flexibility of sponsorship, organisation and catchment, with the capacity to be highly responsive to local conditions and knowledge. Furthermore, access to international funds and advice is often more forthcoming. The most recurrent problem concerns standards, whether comparability between institutions or a lack of mechanisms for critical assessment. Non-formal training is often linked to popular forms of visual art, those with widespread local production. References are usually urban in West and Central Africa, but there is also extensive participation in rural areas – for instance, in eastern Africa where there is high demand for sign-painting.[10]

'Workshop' art is often related to external markets and tourism. This is neither new (as indicated by the fifteenth-century Benin–Portuguese trade in ivory souvenirs), nor necessarily destructive – as shown by the maintenance of quality in the production of fine ceremonial textiles such as Kuba cloth, and many kinds of sculpture. These examples represent two typical kinds of interaction with external mentors or patrons who are not 'traditional': reproduction of existing forms, and the generation of new forms.

Some examples of the latter are Zimbabwe stone sculpture and the wood sculpture of the Kamba (Kenya), Makonde (Tanzania) and Venda (South Africa), among others. Many transformations involve two-dimensional representations, such as the Yoruba narratives of Oshogbo in several media, and those by artists associated with Poto-Poto and Kuru, as well as history paintings from the mining regions of Zaire (Lubumbashi) and Zambia, and the social narratives of the Watatu group (Kenya). Numerous and varied innovations involving textiles include woven tapestries from Thiès (Senegal), Harrania (Egypt) and Oodi (Botswana); innovations with batik and silk screen (Oshogbo, and many other places), and appliqué pictures from Weya (Zimbabwe) and Lamu (Kenya). A grand, ecologically inspired banner, the Lamu *Story Snake*, was embroidered by Swahili men and

women to parade at the Earth Summit in Rio de Janeiro, Brazil, in 1992, and has since appeared all over the world. The project was realised by the Wildebeeste Workshops (Kenya) under the guidance of Kenyan–American artist Jony Waite.

From Bamako, Mali, comes a poignant example of change in art that utilises the local textile technology, *bogolanfini*, of the Bamana people. Artists have adapted this mud-resist method to easel painting on canvas, which is now embraced as the national genre, and employs both ethnic and pictorial modes of imagery. The project began in the late seventies through the efforts of the Groupe Bogolan Kasobané, with further development in the regions such as the Djenne women's cooperative started in 1981 by landscape painter Pama Sinatoa.[11] A course in bogolan techniques has recently been added to the curriculum of the Institut National des Arts.

Contacts
- Bogolan: Groupe Bogolan Kasobané, c/o French Cultural Centre, BP 1547, or Gallery Jamana, BP 2043, Bamako, Mali
- Harrania: Ramses Wissa Wassef School, with workshop gallery in Harrania, south of Cairo, Egypt
- Oodi: Lentswa la Oodi, with workshop gallery, PO Box 954, Gaborone, Botswana
- Weya: The Art of Weya (Community Training Centre) for women, at the Amon Shonge Gallery, Cold Comfort Farm, PO Box 8055, Causeway, Harare, Zimbabwe
- Thiès: Maufactures Sénégalaises des Arts Decoratifs (MSAD) with Workshop Gallery, BP A50, Thiès, Senegal
- Story Snake: Wildebeeste Workshops, PO Box 40076, Apt. 506, Nairobi, or PO Box 175, Lamu, Kenya, the latter with workshop gallery.
- Dakawa: Art and Craft Project for screenprinting (ANC project repatriated from a refugee camp in Dakawa, Tanzania), PO Box 733, Grahamstown 6140, South Africa
- Pakhamani Textiles: for hand painting and resist methods, PO Box 18359, Dalbridge, Durban 4014, South Africa

San painting, Botswana and southern Africa

The National Museum and Art Gallery (NMAG) of Botswana, at Gaborone, has a small collection of 'first' drawings on paper by Kuwa, a San hunter-gatherer who lives in the central Kalahari desert, and one of four in his settlement who make drawings. His clearly executed graphic work provides concrete imagery for traditional beliefs and values. Subject matter refers to revered animals, such as the eland or giraffe; the spiritual experience of trance; and fertility, whether food, rainfall or reproduction. His compositions offer disconcerting resonances with the ancient paintings seen at San rock art sites which number over 4000 in the Tsodilo Hills (information kindly provided by Alec Campbell, former Director of NMAG).

In 1989, also in the Kalahari, the Kuru Development Trust at D'Kar initiated a project to develop the connection between drawing and culture. The approach is non-interfering pedagogy, with the provision of facilities, materials and encouragement; media include drawings, canvas paintings, printing and craft work. In 1991, nine artists had their first exhibition at the Art Gallery of the National Museum of Botswana.[11] Further shows have been in Johannesburg (1992, Newtown Gallery), London (1993, 1994, Rebecca Hossack Gallery, with three venues and at the Commonwealth Institute), and other European cities. Some works on paper are in the collection of the Victoria and Albert Museum, London. Other San art projects are in Botswana, Namibia and Angola.

Uli painting, Nigeria

Contemporary *uli* painting – popular, graphic imagery specific to the Igbo ethnic group of eastern Nigeria – is a continuous and defining element of Igbo visual expression. The imagery refers to the patterning that women draw or paint on the surfaces of their bodies and on house and shrine walls. The repertoire of motifs varies greatly, some say by individual, but the style of execution is characteristically curvilinear and graceful, with many repetitions usually in an all-over composition. The idiom has long been used by art school artists in pen and ink (without bright colour), beginning after the civil war in the early seventies at the University of Nigeria, Nsukka; the artist most closely associated with its establishment in fine art is Prof. Uche Okeke. In spring 1995, the Skoto Gallery in SoHo, New York City, presented a small retrospective show entitled *Uli Art: Master Works and Recent Works*; a definitive *uli* exhibition is planned for the National Museum of African Art, Smithsonian Institution, Washington, D.C., in 1997.

Oshogbo art movement, southern Nigeria

Oshogbo two-dimensional art – mostly painting (Muraina Oyelami, b. 1940; Twins Seven-Seven, b. Taiwo Olaniyi, 1944), but also printmaking (Jacob Afolabi, b. 1945), bead work (Jimoh Buraimoh, b. 1943), textiles (Niki Davies, b. 1951), aluminium (Asiru Olatunde, b. 1918) and even cement (Adebisi Akanji, b. 1930s) – draws on the exuberant, decorative imagery used by Yoruba artists to express their beliefs and stories. For many years, the Yoruba genre (artists come not only from Oshogbo itself, but from many places, especially Ife) dominated international perceptions of contemporary Nigerian art, as indicated by its almost exclusive presence in exhibitions and texts. The style continues to command patronage in Lagos and London, according to the veteran Yoruba artist Emmanuel Jegede (b. 1943) and others. The broader scope of Nigerian modern art history has only recently been revealed by African curators and historians.

During the early sixties, a number of creative art centres based upon Igbo community 'club houses' or *mbari*, opened in Ibadan, Enugu, Lagos, Benin, Ife and Oshogbo. Most were financed initially by US funds (possibly the CIA), but the idea has lasted, with the formation of creative arts or cultural centres at many universities and also by individuals in Nigeria and elsewhere in Africa. The most relevant *mbari* features were the integrated or multi-faceted arts programmes, emphases on narration or storytelling, and the provision of occasional short, 'taught' workshops to build specific skills. In 1962 at the Ibadan University Mbari Artist and Writers Centre, a basic visual arts course workshop brought together the artist from Guyana Denis Williams (then at the Khartoum Technical Institute), architect Amencio Guedes (from Mozambique), American painter Jacob Lawrence, town planner Julian Beinart (from South Africa) and the scholar Ulli Beier.

By 1962 the well-known dramatist Duro Ladipo had started the National Theatre Company in Oshogbo, and the Austrian artist Suzanne Wenger had initiated her project to generate a modern Yoruba iconography. A year later, Ulli Beier and artist Georgina Betts promoted a more broadly based arts centre, although nearly all who joined were actors or musicians from Ladipo's group. The club was named Mbari-Mbayo, an adaption of the Igbo name *mbari* to Yoruba, meaning 'when we see it we'll get lucky'. Many Oshogbo artists developed a distinctive, two-dimensional imagery from their imagination or 'inner imagery' which was informed by Yoruba culture, not observation.

From her studio at the Oshogbo club house, Georgina Betts Beier taught informally, either through her own energetic example or by request; her approach was to assist with the manifestation of an artist's inner vision. During the sixties and at intervals ever since, she also helped to organise structured workshops for specific techniques, with an open policy for attendance (in 1964 there was a short course in deep printing conducted by the Netherlands etcher Ru van Rossem, repeated in 1974 at Ife). Joining the Oshogbo members were Bruce Onobrakpeya (b. 1932) and Solomon Wangboje (b. 1930), who have built their artistic careers on graphics.

In 1967, as the civil war spread, the Oshogbo club was dissolved, but the town remains home to a number of artists and their movement. Their style continues to enjoy popularity, indicated by recent London showings of Oshogbo artists and adherents of Yoruba mannerism: in 1988 at the Zamana Gallery and Africa Centre, and in 1993 and 1994 at the October Gallery.

Shona and sculpture, Zimbabwe

Until the middle of this century, present-day Zimbabwe's artistic heritage was known only by its ancient and magnificent stone architecture (the name *zimbabwe* refers to a homestead with a circular stone wall, of which the Great Zimbabwe is the largest). Wood carving was also rich in skill and variety, and Christian mission schools at Cyrene (1939) and Serima (1948) introduced courses, in part to convert these talents into figurative images for telling the story of Christ in an African idiom. However, it was largely through workshops, studios and working communities that modern Zimbabwean stone sculpture, arguably the most extensive movement in modern African art, came into being.

Frank McEwen (1907–94) is recognised as the catalyst for this development. Unlike other expatriate figures associated with new movements, McEwen came to Africa as an established expert in international art exchanges. He had grown up with his father's collection of works from Africa and had studied at the Sorbonne and the Institut d'Art et d'Archéologie with anthropologist Henri Focillon. He had also absorbed the educational ideas of Gustave Moreau and Marion Richardson, who favoured approaches to art that allowed for the discovery of an underlying subjective spirit. After the war, McEwen returned to Paris as the British Council's Arts Officer, and during the 1950s he arranged exchange exhibitions of avant-garde artists (using his extraordinary contacts, from Picasso to Read).

Disillusioned with the art scene in Paris, however, McEwen went to central Africa where he first assisted with the architectural plans for the National Gallery of Rhodesia (1954) and was appointed its Director (1956–73). For the inaugural exhibition in 1957, opened by Queen Elizabeth the Queen Mother, McEwen had arranged to bring outstanding European art 'from Rembrandt to Picasso'. In one section, recalling the mid twenties at the Barnes Foundation, Philadelphia, he hung modernist European painting next to African sculpture, predating William Rubin's New York show by nearly thirty years.

Meanwhile, Thomas Mukarobwa (b. 1924) spent time with McEwen explaining the local Shona religion, its artefacts and the stories behind them. McEwen made him a gallery attendant (racial attitudes of the period would not admit of a black artist), and initiated a new world of art making. A workshop became a studio for the attendants and other interested individuals such as Charles Fernando and Joseph Ndandarika. They began with two-dimensional media, creating highly painterly, densely rendered and richly coloured pictures. Their representations of rural and urban daily life, jazz and local beliefs projected more dynamism than the work of the renowned 'first generation'

sculptors, who preferred the hardest stone, economy of form and concentration of theme. Seven 'new' artists participated in the exhibition to celebrate independence in 1962, of whom Mukarobwa remains the most successful, with four paintings in the permanent collection of MOMA, New York.

In what became a self-supporting workshop school, Frank McEwen did not teach set lessons nor impose the gallery's extensive art collections, which were on view. He encouraged each student to develop his own imagery, based upon African beliefs and experiences. Like other expatriate catalyst–connoisseurs (e.g. Pierre Lods and the Beiers), McEwen's approach involved criticism and selection.

By the mid sixties, all the artists at the National Gallery Workshop School had turned to sculpture. Supplies of stone were plentiful; they already had skills in wood carving and perhaps they saw it as a distinctive mode of expression in contrast to the 'Europeanness' of painting. Among the first to carve in a modern idiom were Tubayi Dube (first exhibited in 1958), Joseph Ndandarika (1942–91; first exhibited in 1962), Joram Mariga (b. 1927; first exhibited in 1962) and Nicholas Mukomberanwa (b. 1940; first exhibited in 1963), who had studied art at Serima Mission.[13] According to McEwen in 1969, regular attendance was about 75, all men, most of whom were from an agrarian background.

The National Gallery of Zimbabwe re-established the workshop school in 1982; it was later renamed the BAT Visual Arts Studio (after its sponsor British American Tobacco Group). Compared with the pre-independence school, it follows a more didactic approach, with a range of three-year courses in several media pitched at upper secondary level. Most work is two-dimensional.

Meanwhile, several sculpture communities grew, close to the rich stone resources, such as that at Tengenenge, started in 1966 on Tom Blomefield's tobacco farm during the international boycott of Rhodesia. Its two most famous sculptors are Henry Munyaradze (b. 1931) and Bernard Matemera (b. 1946). Another loose group formed near Nyanga in the eastern highlands, with the networking of Patricia Pearce (whose daughter Jennifer Senior Reading was exhibitions assistant to McEwen at the Gallery); it included Mariga, the Takawira brothers, Bernard (b. 1945), John (1938–89) and Lazarus (b. 1952) and Sylvester Mubayi (b. 1942), the last said to be McEwen's choice for the most outstanding sculptor. A third artists' group was established at Vukutu Farm. Most of the first-generation sculptors, active prior to independence in 1980, live in rural areas, where many continue to sculpt in studios in their own homes; a few have apprentices.

Group shows first toured outside Africa in the sixties; the first of several exhibitions in London was in 1962, which went on to Paris in the early 1970s (MOMA in New York was cancelled due to sanctions). Zimbabwean sculpture continues to change with its second generation, who have moved beyond ethnicity, gender and the anticipated spiritual kinds of imagery. International standing was reaffirmed during the late 1980s with public exhibitions in the UK. Tapfuma Gutsa (b. 1956), who started with wood carving at a mission, continued with a formal fine art education in London and returned with a widened repertoire of materials and ideas.

Commercial success is apparent from the many galleries in Harare; the leading one deals with over 50 sculptors and maintains a permanent collection, studio spaces and a newsletter. Stone sculpture is now a valuable export, with some works selling for tens of thousands of pounds. Despite the challenges of mass production and largely external patronage, the movement's overall effect has been to foster a positive climate for all forms of artistic expression in the country.[14]

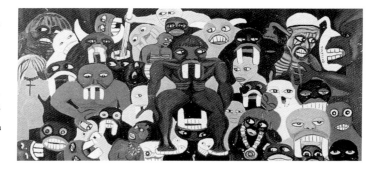

Malangatana Valente Ngwenya
Painting
c. 1970s
Maputo, Mozambique

Art centres in central Africa, Zaire/Congo

For central Africa, modern picture making dates to the mid 1920s with the intriguing works of Albert Lubaki and Djilatendo (Tshyela Ntendu), exhibited in Europe in 1929–31. During the forties and fifties, several expatriate artists and other foreigners, including missionaries, set up workshops on both shores of the Congo–Zaire River, and further along the river in the mining region of the south-east. Two initiatives – in Kinshasa and in Lubumbashi – developed into specialised academies of fine art, but maintaining their initial ethos. The European-style art education class for student teachers at the Ecole St Luc (1943, with a department of art in 1950) grew into the Académie des Beaux-Arts, Léopoldville (1957, now named Kinshasa). Its pedagogy fosters a painterly approach to still life, the human figure, and other western conventions. The dominant style is naturalism, rendered in soft pastel impressionism, as seen in paintings of relaxed, daily life by Mavinga ma N'kondo Ngwala (b. 1936), dean of the academy 1981–86. Patronage and studio space were provided by the entrepreneur Maurice Alhadeff (d. 1972), who also sponsored Negritude painters such as Bela (Chad; Lubumbashi, later Brazzaville, d. 1968) and Thango (1936–1981, from Brazzaville, Kinshasa 1959–75). Recently, teaching workshops have arisen, which are connected with the studios of sign-painting artists; the most famous of these is the satirist Chéri Samba (b. 1956).

In the mid forties in Lubumbashi (then named Elisabethville), French adventurer-artist-visionary Pierre Romains-Desfossés (1887–1954) set up a workshop school for popular indigenous art, known as the Hangar. It aimed to facilitate the invention of 'authentic African' painting and to create jobs (students were perceived as craftsmen-decorators rather than artists for their own sake). Nevertheless, Romains-Defossés thought that imagery emerged uniquely from each person's imagination, without copying others or drawing on existing imagery. With no specific instructions nor life models, he believed that his teaching was non-interfering. He provided a positive atmosphere, space, materials, advice on composition and techniques, and encouragement to explore themes from traditions and nature. The results were original and decorative, as indicated by Bela's tactile, impasto use of earth colours and Pili Pili's meticulous, fine brushstrokes. The Hangar's project was a commercial success, with buyers who were mostly expatriate engineers and miners. However, by the early seventies, during Lubumbashi's heyday for history painting with overt social and political commentary (like that of Tshibumba Kanda), the weight of the market had shifted to the local waged worker. After Romains-Desfossés' death, the Hangar merged with the newly established Académie des Beaux-Arts of Elisabethville, bringing aboard two of its teachers, Pili Pili and Mwenze.

Paa ya Paa Gallery,
Nairobi, Kenya, 1981

Apprenticeship continued to be the model in several of the earliest workshops, with the sign-painters for their brand of popular painting, and also with some artists in their ateliers. Probably the most significant workshop school in terms of longevity and widespread influence is the School of Poto-Poto (founded 1951). The imagery created there has influenced the visual expression of Negritude in Senegal in an almost direct line, while throughout the region of central and eastern Africa it contributed to the spread of portable travellers' art. For decades, small colourful (and inexpensive) paintings, later batiks and prints, of forest or market scenes with elongated figures, or collections of masks and animals, have been sold in front of hotels and in markets in many towns.

In the Congo, Brazzaville's modern art is closely identified with the famous Poto-Poto movement, named after the district housing the Centre d'Art Africain (1951; now named École de Peinture). The idea for the school came from Pierre Lods, a mathematician and amateur painter who travelled in the bush and was inspired by his employees' imagery; one account mentions his domestic Ossali's first oil painting (see pages 219–21), while another cites the drawing of Nicolas Ondongo, his cook.[15] Lods maintained an open studio for his artist friends in Brazzaville and later in Dakar.

A subsidy from the Institut Français Afrique Noire (IFAN) enabled him to build a studio-museum for a post-traditional African art. The Centre d'Art Africain quickly became a magnet for young people with little formal education but enthusiasm for painting and vibrant imaginations. In 1961, after helping to launch a similar project in Dakar, Lods accepted President Senghor's invitation to join the newly formed Ecole des Arts du Sénégal in the department for research into black art, where he became director in 1965.

Well-known painters from Poto-Poto are Nicolas Ondongo (1933–90) and François Thango (1936–81). The imagery of Ondongo (like that of Ossali) featured scattered collections of elongated thread figures in movement, which some say resemble the drawings of palaeolithic rock art; his style remained constant during his career. More variation can be seen in the work of Thango, who was at Kinshasa under Maurice Alhadeff 1959–75, before returning to Poto-Poto. Thango's bold style is quintessential of the school, with strongly coloured and decorated shapes that interlock on the surface, little tone or depth but distinctive qualities of movement and composition. Exhibitions of Poto-Poto artists include the 1987 CICIBA Biennale in Kinshasa and the 1992 *Congo Zaire: Thango de Brazza à Kin* in Paris.

Thiès tapestries, Senegal

Following his stint as department head at the Ecole des Arts, Dakar, Papa Ibra Tall established and then guided the flagship of Senegal's Negritude movement, the Manufacture Nationale du Tapisserie, for ten years (1965–75). Monumental wool tapestries are designed and fabricated for the nearly exclusive patronage of the state, which uses them as gifts and in displays throughout the world. Thiès tapestries can be considered mainstream art because of their direct links to the style of the Dakar School, designs by graduates and students of the Ecole des Beaux-Arts, extensive subsidy by the government of Senegal, and also their quality of fabrication.

The Thiès centre consists of the workshop, an art school (now closed) and gallery. In Tall's time, learning to weave entailed classes at Thiès and further education in France at the Aubusson tapestry manufactory. Well-known painters whose designs have been transcribed into wool include Papa Ibra Tall, Samba Balde, Ousmane Faye, Abdoulaye N'Diaye and Mbaye Zulu. Generic imagery is characterised by Negritude motifs, shallow space, intense hues and powerful compositions that are full of movement. Many tapestries have qualities of colour and light that are similar to the popular art of glass painting.

Recently, output has decreased from about thirty to only four tapestries per year, and direct artistic input has declined, but the quality of workmanship is maintained. In 1986 the centre became the Manufactures Sénégalaises des Arts Décoratifs to denote the addition of ceramics and other decorative arts. Tapestries are on display in government buildings and at the Workshop Gallery, Thiès.

Tinga Tinga arts, Tanzania

Eduardo Saidi, alias Tinga Tinga (1937–72), southern Tanzanian namesake for the popular painting movement, began work as a tractor driver in 1955 near Dar-es-Salaam, capital of Tanzania. Familiar with modern Makonde carving and travellers' art from Congo/Zaire, Saidi made use of Public Works Department materials – hardboard squares and house paints – and invented his own stylised imagery, rendering mostly animals and stories or animal tales in an exuberant and decorative manner. Flattened forms in bright colours often have sharp contrasts, further enhanced with surface patterning on a background plane of colour.

In the sixties, when his paintings attracted attention, he formed a teaching-by-apprentice workshop near the Morogoro shops in Oyster Bay, a suburb of the capital. The range of narrative subject matter has expanded to scenes of daily living, magical medicine and occasionally political commentary. At least twenty of his artist–colleagues have carried on his project through the formation of the Tinga Tinga Arts Cooperative, PO Box 23122, Dar-es-Salaam, Tanzania. Each artist signs his work and most have an identifiable style.

Tinga Tinga painting has gained in stature, with recognition at home and abroad, and exposure in numerous international exhibitions (curated by André Magnin, among others).[16] Tinga Tinga is also spreading south. Recently Rashid Bushiri, son of Mruta (one of the first painters), has transmitted its practice of painting on board, canvas and assorted objects to craftworkers in a project called Swazi Tinga Tinga, sponsored by the Swaziland Ministry of Commerce and the European Community.

Kenya, workshop activity and modern art

In Kenya, art and craft production, inclusive of learning, occurs on a very large scale, involving thousands (perhaps millions) of artisan–artists. Such activity generates new sorts of popular material culture, and its associated commerce competes favourably with agriculture as a cash crop. This phenomenon is due to a mix of circumstances, including existing forms and values for fine craftsmanship; demand from visitors for souvenirs; 30 years of small-scale projects for employment generation; government initiatives, such as the advisory services of the Kenya External Trade Authority (KETA) which helps with fabrication and marketing, and the requirement to teach art and craft at primary school.

Historically, workshop learning for the production of non-traditional objects for sale dates to the First World War in eastern Africa. The standard account is that a talented Kamba carver, Mustiya Munge (b. 1890s), while in the British Carrier Corps in Tanganyika, met up with Zaramo craftsmen who shared their repertoire of wooden household artefacts and figurines (rendered in traditional and Christian idioms), which had been produced as trinkets for a Lutheran mission near Dar-es-Salaam. On his return home to Wamunyu to the east of Nairobi, Munge continued to carve his own figurines, often expressive of motherhood. He encouraged his friends to carve for profit and initiated trade with resident Europeans.[17]

While Wamunyu remains an active centre for carvers, huge complexes of workshop cooperatives also exist in the Tutor and Changamwe sections of Mombasa and at Pumwani in Nairobi, with estimates of employment reaching 10,000 carvers as well as those involved in marketing and other aspects of the industry. Four broad phases can be distinguished: before the Second World War (beginnings on a small scale); after the war (figurines of people and wild animals, a few objects; growing demand); tourist (mass production of light wooden animals, warriors and salad servers), and contemporary (continuation of the tourist line, with variations and interactions with modern Makonde sculpture and gallery art). Comparisons over time serve to highlight associations between imagery, production and patronage, which during the fifties became both tourist-driven and external with most exports going to the USA.

Several artists whose work sells in galleries have trained in Kamba workshops, or are Kambas who utilise imagery derived from Kamba carving. The most significant is sculptor Samwel Wanjau (b. 1936), who began by carving weapons during the Kikuyu nationalist struggle, after which he joined a Kamba production workshop and was liberated from repetition by Elimo Njau, whose motto at the Paa ya Paa Art Centre is 'copying puts God to sleep'. Other artists include Harrison Ndolo who carves modern monsters from wood, such as the 'worm', a metaphor for development aid,[18] and painters Ancent Soi (b. 1939) and Mbono Kivutho (b. 1947), whose figured imagery has a volumetric quality.

A similar movement, though on a smaller scale, is Kisii soapstone carving, for which non-traditional practices date to the 1920s. For the most part, the workshops are located near the main quarry in south-west Kenya, which is remote from any urban area. Beautifully textured soft stone is carved into small figurines, usually for trinkets and chess sets, though in the last decade the range has expanded through direct interaction with the Nairobi workshop of the African Heritage Gallery. Modern sculpture in soapstone has also developed, which, in contrast to the Zimbabwe stone movement, followed the provision of fine arts education at tertiary level. Two of the leading sculptor–tutors from western Kenya are Elkana Ongesa (b. 1944) and John Dianga (b. 1945), both of whom returned to their home areas and promoted local cultural activities; in Dianga's case this includes a centre with workshop. Ongesa's sculptures have been commissioned worldwide, while his educational initiatives include an international sculpture workshop in Kisii town for Kenyans and Inuit sculptors from Canada (1986).

In the story of contemporary art in East Africa, the Tanzanian painter and muralist Elimo Njau is the most outstanding personality (b.1932).[19] A charismatic speaker, he has an unflagging commitment to the promotion of the visual arts. Noted for his 1959 murals at the Church of the Martyrs, Murang'a, which portray Christ's life in a Kikuyu setting, Njau founded the first East African-owned and directed art gallery in 1965; prior to that he had set up the Kibo Art Gallery at his father's home on Mount Kilimanjaro in 1961 and directed the visual arts section of the short-lived Chemi Chemi Centre, Nairobi, in 1963.

The name Paa ya Paa is a rhythmic composite of the Swahili words for 'antelope' and 'rise'; the meaning 'antelope rising' refers to the rebirth or transformation of the carved, curio antelope into a personal kind of art. Nowadays, Paa ya Paa is an art centre with a range of activities, including exhibitions, workshops, artists' residencies (among them the internationally known Rosemary Karuga and Samwel Wanjau), children's classes and short-term conferences. It has an extensive permanent collection and archive which predate independence in 1963, with some fine Makonde sculptures. Paa ya Paa Art Centre is at Ridgeways, off the Kiambu

Road about eight miles from Nairobi centre, PO Box 49646, Nairobi, tel. 254-2-51225.

In 1973 it held a tenth anniversary international workshop, with a symposium and exhibition involving 20 professional artists (only some of whom had an academic training), from Ethiopia, Madagascar and the East African countries: Wosene, Boghossian, Bulima, Musoke, Nikwitkie (a Makonde wood sculptor), Owiti and Wanjau.[20] A conference in 1987, 'Women in Art in East Africa', addressed gender issues with papers on the achievements of Margaret Trowell and Fatma Abdallah (Tanzanian, 1939–93, Makerere graduate, kanga designer and diplomat), with a large group exhibition at the Goethe Institute of works by 54 women artists, half of them African. In 1992 it facilitated a community project in nearby Korogocho which centred on the preparation of a large mural for the Catholic church. Guardian Angels was initiated by visiting artist Lily Yeh in collaboration with Njau and several Kenyans (including Kahari Miano of the Sisi Kwa Kisi Project 2), who contributed both imagery for the mural as well as separate works. An exhibition version travelled to the USA sponsored by Arts International and the Rockefeller Foundation, Nairobi. In 1995 'Interpastoralist Material Culture' was devised by ethnographer–designer Sultan Somjee, who brought together representatives from eight pastoralist groups of northern Kenya for discourse and practical work.

The established galleries and even some curio shops maintain workshop facilities for artists, due to the shortage of studio spaces and crowded living conditions. While these run the gamut of training, design or product development (notably at African Heritage), experimentation (often with materials) and some assistance with professional growth, they are primarily for production. The Watatu Foundation and Gallery Watatu maintains a production workshop with a press for its artists at Dagoretti Corner, at the edge of a massive urban settlement. On occasion, experts conduct sessions for the artists to sharpen their technical skills, usually in joint sponsorship with an external funder, such as the British Council.

Nearly ten years after the establishment of the mini Gallery for East African Contemporary Art, the Kenya Museum Society is undertaking to establish a Museum Studio and Arts Centre, with the backing of local businessmen and the board of the newly constituted Kuona Trust. Part-time workshop classes for novices are under way, conducted by artist–teachers including Teresa Musoke and Etale Sukuro; and plans are being considered for practical and critical sessions. The Museum Studio's inaugural show featured works by eleven 'Women Artists in Kenya', acknowledging and complementing their contributions to 'Women Beyond Borders', a show currently on tour in California.

These initiatives, in conjunction with the new collective Art Force and the renewal of Sisi Kwa Sisi 2, indicate that artists are strengthening local cultural dynamics. At the April 1995 Art Force exhibition, 'the individual and collective talents testify the artists' work is inspired by different cultures and ideas and rendered in various styles and techniques',[14] while the artists of Sisi Kwa Sisi 2 continue to press for accessible imagery, often enhanced with elements of material culture, to express and foster awareness of the plight of Kenya's disadvantaged.

South Africa

The tremendous range of provision in South Africa includes recreation rooms in farms and homesteads; casual classes in community centres and missions (Grace Dieu, now named Setotolwane, was established in 1916); apprenticeships in many crafts; specific tasks for

political projects; sharing artists' studios and, of course, self-teaching. An early example was John Koenafeeke Mohl (1903–85), a goatherd who was discovered drawing on stones and soft hide. After studying in Namibia and Germany, he set up the White Studios in Sophiatown, exhibiting at the South African Academy 1942–46. One of his students was Helen Sebidi, recognised for drawings that express the complexity of the country's social fabric.

Prior to the seventies only a few centres offered structured tuition in art techniques for non-Europeans. Most of these were on a part-time basis and did not lead to certification. Some were parallel in approach to the school system, while others were quite different. For example, a contrast is often made between the Polly Street Art Centre (founded 1948) and the Evangelical Lutheran Church Art and Craft Centre at Rorke's Drift (founded 1963). The first was urban, secular and predominantly male, and concentrated on painting. The second was rural, mission-based, strongly female, and specialises in weaving; some of its funding is municipal, but with considerable input from church missions.[22]

The political and economic conditions of the seventies and eighties – especially the Black Consciousness movement – encouraged the establishment of alternative institutions that offer some training. These include the Johannesburg Art Foundation (see page 294); numerous academies, such as FUBA and Pelmama, and a range of collaborative ventures, such as the Community Arts Project, Cape Town. Often associated with the United Democratic Movement, the last-named aimed to engender community pride through participation in initiatives such as the design and fabrication of banners, posters and murals. The People's Parks in Soweto were created in 1985: reclaimed, urban spaces were filled with art works that expressed political resistance. They were destroyed by the security forces. The 1995 Johannesburg Biennale included a few exhibitions of work from community projects, and has supported the painting of public murals.

Some Community Art Centres and Projects

Polly Street Art Centre, Johannesburg (1948–62), replaced by Jubilee Centre (1962–80), then by Mofolo Art Centre, Soweto (from 1970s)

Lutheran Evangelical Centre (1961); at Rorke's Drift (1963): a fine art course was shortlived

Katlehong Art Centre, Germiston (1977)

Community Arts Project, Cape Town (1977): cooperative efforts for murals, posters, parks

FUBA (Federated Union of Black Artists) Academy, Johannesburg (1980); school and gallery (1983)

Pelmama (from Pelindaba Museum of African and Modern Art) Academy, Johannesburg: creative arts

African Institute of Art, Funda, Soweto, Johannesburg (1984): part- and full-time courses in fine arts (with UNISA), preparation for further study and teacher training (1989)

Alexandra Art Centre, Johannesburg (1986)

Community Art Workshops, Durban (1986)

Dakawa Art and Craft Project (1992), named after the location of the initial ANC programme in Tanzania, which was re-established in Grahamstown.[23]

Adam Madebe
Looking to the Future
1985
Welded metal
National Gallery of
Zimbabwe, Bulawayo

African art in Africa

Frank McEwen with a
Senufo sculpture,
accompanied by Bohumil
Holas and Tristan Tzara at
the first ICAC Conference,
Salisbury, Rhodesia, 1962.

Art galleries and museums

In capital and other major cities, the cultural
agencies of foreign governments, such as the
British Council, the French Cultural Centre, the
Goethe Institute and the US Information Agency
frequently host or sponsor exhibitions and
workshops. In circumstances including lack of
infastructure and patronage and/or political
instability, their sponsorship is significant; in
recent years, both the British and the French
agencies have fostered numerous workshops that
have facilitated regional interchange within Africa.

In most capital cities and in the countries with
tourism, an important source of patronage is the
hotel industry, with accessible displays of work in
foyers, restaurants and bars. Otherwise, the best –
and at times the only – venue for contemporary art
is in the artists' studios. An invaluable sourcebook
is Nicole Guez's guide, *L'Art africain contemporain/
Contemporary African Art* (available from
Fondation Afrique en Créations, 51 rue Sainte Anne,
75002 Paris, France; tel. 1 42 60 61 03;
fax. 1 42 60 60 82).

In the following lists, state institutions are listed
first, followed by commercial galleries; capital cities
come first.

Algeria
Musée Nationale des Beaux-Arts d'Alger, Place
Dar-es-Salaam, El Hamma, Algiers

Angola
Museu Nacional de Antropologia CP 2159, 61 Rua
Frederic Angels, Luanda

Humbiumbi Gallery, Luanda

Benin
Galerie Bikoff, BP 03 1501, Cotonou

Musée Historique de Quidah, BP 33, Ouidah

Musée Ethnographique, BP 125, Porto Novo

Botswana
National Museum and Art Gallery, Private Mail Bag
00114, 331 Independence Avenue, Gaborone (hosts
group shows including a juried annual exhibition,
a national basketry competition, schoolchildren's
work and Thapong Workshop)

Gallery Ann, PO Box 1727, Gaborone

Burkina Faso
Centre National d'Artisanat d'Art, 01 BP 544,
Ouagadougou

Musée du Kadiogo, Ouagadougou

Musée Sympo-Granit, Loango, 25 km from
Ouagadougou

Burundi
Musée d'Art Vivant, BP 1035, Bujumbura

Centre Artistique de Gitenga, BP 125, Gitenga

Cameroon
Musee d'Art Camerounais, BP 1178, Mont Febe,
Yaoundé

Cape Verde
Galeria Alternativa, Sao Vincente; tel. 31 51 65

Central African Republic
Musée Barthélémy Boganda, BP 349, Bangui

Chad
Galerie d'Art et d'Application de Peinture GAAP,
BP 2273, N'Djamena

Musée National Tchadien, N'Djamena

Comoros
Musée National, BP 169, Moroni

Congo
Musée National de Brazzaville

Musée des Arts Africains Contemporains, Tour Elf
Cargo, Brazzaville

Côte d'Ivoire
Musée National d'Abidjan, BP 1600

Djibouti
Centre Nationale de la Promotion Culturelle et
Artistique, BP 2563, Afars and Issas

Egypt
Museum of Contemporary Arts, Opera House, Cairo

Contemporary Art Museum, Alexandria

Plus many commercial galleries

Equatorial Guinea
National Museum, Malabo; tel. 9 24 44

Ethiopia
National Museum, PO Box 76, Addis Ababa: some
contemporary work

Museum of the Institute of Ethiopian Studies,
University of Addis Ababa

Gabon
Centre International des Civilisations Bantu
(CICIBA), BP 770

Galerie d'Art Bantou, BP 1007, Libreville

Musée National des Arts et Traditions Populaires,
BP 4018, Libreville

Ghana
National Museum gallery, PO Box 3343, Accra

Gallery Omanye House (formerly Artists' Alliance,
Director Ablade Glover), PO Box 718, Teshie-
Nungua, Accra

National Gallery of Art, PO Box 2738, Accra

The Loom, PO Box 8020, Accra

The Gambia
African Heritage, PO Box 43, Banjul

Guinea
Musée National de Sandervalia, BP 617, Conakry

Guinea Bissau
Museu Nacional da Guiné Bissao, CP 103, Bissau

Kenya
The number of commercial galleries is increasing
as are sales made directly from artists' studios.

Gallery of Contemporary East African Art,
National Museum, Museum Hill, PO Box 40658,
Nairobi (a 'feeder' gallery with a small permanent
collection)

Paa ya Paa Art Centre, Ridgeways, PO Box 49646,
Nairobi (Director Elimo Njau)

African Heritage Pan African Gallery, Kenyatta
Avenue and Mombasa Road, PO Box 17871,
Nairobi (unique 'fine' craft of its own invention
and continent-wide collection; occasionally
sponsors exhibitions of modern art, especially
from Nigeria; collection of its founder, former
Vice-President Joseph Murumbi, is held in the
National Archives, Department of Culture,
PO Box 67374)

Gallery Watatu, Lonhro House, Standard Street,
PO Box 41855, Nairobi.

Central to the story of contemporary fine art in
Kenya since its opening in 1969. The name
(Swahili, three people) refers to its three
founders, who include the white Kenyan artists
Robin Anderson (known for her silk batiks of
wild life) and Jony Waite (pen and ink paintings
of wild life, numerous hotel commissions and
other public works, e. g. the Lamu *Story Snake*).
Promotes work by local artists, including John
Dianga, Fred Oduya, Ancent Soi, Samwel Wanjau,
as well as those from other parts of Africa, e. g.
Ugandans Jak Katirakawe and Teresa Musoke,
South African Sekano, Sudanese Taj Ahmed and
Rashid Diab, Tanzanians Ali Darwish and Etale
Sukuro. Most patrons are non-Kenyan visitors;
more recently, collectors.

In 1984, international gallerist Ruth Shaffner
began to reshape Watatu by extending local
participation to over 50 artists, establishing a
Foundation (1988 in USA, 1989 in Kenya) and
renovating the premises (1990). For over a

decade, she has been nurturing new talent, helping young artists with supplies, studio space, workshops and determined promotion at home and overseas; their style tends to expressive, painterly realism, full of colour and dynamism. Despite similarities in execution, the personal voices of individual artists are strongly projected. Those who have been internationally shown include Katirakawe, Oduya, Joel Oswaggo, Zachariah Mbutha, Kivutho Mbuno, Sane Wadu, Meek Gichugu, Francis Kahuri and Lucy Njeri. The first five have diverse backgrounds; the others, all Kikuyus, are younger-generation artists from around Nairobi, living in a mixed urban/rural economy.

Lesotho
National Museum, Maseru

Liberia
National Museum, PO Box 3223, Monrovia. The country's most elegant 19th-century building, it was restored during 1983–86 but is without its permanent collections (close to 3000 items were looted during the civil war). Director Robert Cassell arranges exhibitions by Liberian artists; despite the havoc of war, his initiative suggests an ongoing mission for museums in times of social disorder, as well as the resilience of art.[24]

Africana Museum, Cuttington University College, Monrovia

Madagascar
Musée d'Art et d'Archéologie de l'Université de Madagascar, BP 564, Antananarivo (formerly Tananarive)

Centre National des Arts Malagasy, BP 540, Antananarivo

Plus commercial galleries

Malawi
Museums of Malawi, PO Box 30060, Blantyre

Galerie Africaine, PO Box 30301, Lilongwe

Mali
Galerie du Musée National du Mali, BP 91, Bamoko

Galerie d'Institut National des Arts, BP 257, Bamoko

Galerie Jamana, BP 2043, Bamoko

Mauritania
Musée National, Noucakchott; tel. 51 862

Mauritius
Commercial galleries in the capital Port Louis

Morocco
Gallery of the Wafa Bank, Casablanca

Meltem Gallery, Casablanca; tel. 212 2 39 78 70

Museum of the ONA Foundation, Casablanca

Contemporary Art Museum, BP 426, Tangiers

Mozambique
Museu Nacional de Arte, CP 1403, Maputo

Personal collections of master artists, such as the late sculptor Alberto Chissano's home, converted to a museum; also the studio of Malangatana Valente Ngwenya, both Maputo

Museu Nacional de Etnografia (for Makonde sculpture), CP 364, Nampula

Namibia
National Art Gallery, PO Box 994, Windhoek

Loft Gallery, PO Box 5882, Windhoek 9000

Niger
Musée National du Niger, BP 248, Niamey

Nigeria
Modern Art Gallery, National Theatre, Iganmu, PMB 12524, Lagos (houses the permanent collection of over 300 works, primarily figurative paintings and portraits; catalogue *The Nucleus: Maiden catalogue of works in*

Nigeria's National Gallery of Modern Art, Federal Department of Culture, Lagos, 1981)

Didi Museum, 175 Akin Adesola Street, Victoria Island, Lagos (private collection)

Aragon Gallery, 205 Ikorodu Road, Obanikoro, Ikoyi, PO Box 54349, Lagos

Art + Objects, Idowy Taylor Street, Victoria Island, Lagos

Ovuomaroro Gallery and Studio (Bruce Onabakpeya), 39–41 Oloje Street, Lagos

Papa-Ajao, Mushin, Lagos; tel. 522916

Something Special Gallery, 23 Military Street, Onikan, Lagos

Asele Institute (Director Uche Okeke), PO Box 1001, Nimo, Anambra State

Avant Garde Gallery, 10 Giwa Road, Abakpa, Kaduna North

Mumax Gallery, 38 Ali Akilu Road, Unguwan Shanu, Kaduna

Reunion
Espace Jeumon, St Denis

Leon Dierx Museum, St Denis

ART' SENIK (an alternative venue; see *Revue noire*, Spring 1995)

Rwanda
National Museum, BP 630, Kigali

São Tomé and Principe
Museu Nacional, CP 87, São Tomé

Senegal
Since the Musée Dynamique, Dakar (1966–88) was transformed into the Department of Justice, Senegal's extensive national collection has been in storage

Galerie Nationale d'Art, avenue Albert Sarrault, Dakar (holds temporary exhibitions)

Musée de l'IFAN, University of Dakar, Place Soweto (used during the 1992 Biennale)

Art Coiffure, 38 boulevard de la République, Dakar (in a hairdressing shop, for young artists)

4 Vents, rue Félix Faure, Dakar (book store, gallery and publisher of monographs)

La Galerie 8F, Building Allumettes, avenue Albert Sarrault 8F, Dakar

La Galerie 39, French Cultural Centre, avenue Georges Pompidou, Dakar

La Galerie Lézards, 33 rue Wagane Diouf, Dakar

Les Trois Baobabs (Wolof, *Neti Guy*), Ateliers–Espace d'exposition d'arts plastiques, Zone 12, 4B Almadies, Dakar (a new gallery for painters Moussa Baydi Ndiaye and Mbaye Zulu)

Tapestries are on display in government buildings in Dakar, and in the Workshop Gallery at Thiès

Seychelles
Commercial galleries

Sierra Leone
National Museum, Siaka Stevens Street, PO Box 908, Freetown

Gaga Studio (Director Louise Metzger), 1 College Road, Congo Cross, Freetown

Somalia
National Museum, Mogadishu; tel. 21041

South Africa
This listing is not exhaustive and does not give the many commercial galleries

De Beers Centenary Art Gallery, University of Fort Hare, Alice, Ciskei

South Africa National Gallery, PO Box 2420, Cape Town

Michaelis School of Art, UCT, 31–37 Orange Street, Cape Town 8001

Durban Art Gallery, PO Box 4085

African Art Centre, 35 Garden Street, Durban 4001

Johannesburg Art Gallery, Joubert Park, PO Box 23561

Pelindaba Museum of African and Modern Art, PO Box 3422, Johannesburg

University of the Witwaterstrand Art Galleries, PO Box Wits 2050, Johannesburg

Tatham Art Gallery, Commercial Road, Pietermaritzburg 3201

King George VI Art Gallery, Drive Park, Port Elizabeth 6001

Exhibitions
During the colonial era and apartheid, a confounding of race and culture prescribed certain notions of identity and imagery, entailing the exclusion of the majority from exhibiting or even attending public exhibitions. The Johannesburg Art Gallery acquired Gerard Sekoto's *Yellow Houses: A Street in Sophiatown* in 1940, but then omitted black artists and audiences for the next 32 years (in 1989 a retrospective for Sekoto was mounted at the Gallery). Public galleries and institutions began to acquire art by black Africans only from the mid sixties; the premier collection (started 1964) is at the University of Fort Hare, now located at the De Beers Centenary Art Gallery, Alice, Ciskei. Until the eighties, works by black artists were generally held separately as part of 'Africana' or 'ethnic' holdings (e. g. the Campbell collections, University of Natal). Johannesburg Art Gallery's 1988 exhibition, *The Neglected Tradition: Towards a New Art History of South African Art* (catalogue by S. Sack) featured the works of a hundred artists, almost all black, in an attempt to redress the situation.

Diverse participation (without discrimination by race of artist or viewer) has a longer history at the commercial Durban Art Gallery, where *Art S. A. Today* was a mixed race bi-annual (1961–75). The business sector has led in commitment to both equity and excellence, with commercial gallery sponsorship for regular exhibitions by black artists. *Tributaries: a View of Contemporary South African Art* was sponsored by BMW in 1985 (catalogue by the curator Richard Burnett), presenting a diversity of art by media and race, in part to stress the absence of a common South African culture; compelling work by 111 artists travelled in South Africa and Germany. Another achievement for diversity at the Johannesburg Art Gallery was the 1989 exhibition *Images in Wood: Aspects of the History of Sculpture in 20th Century South Africa*, with the work of over 90 artists.

Recent international exposure came with a group exhibition *Art from South Africa* at the Museum of Modern Art, Oxford, UK (1990–91). In 1993, work by some 20 artists was shown at the Venice Biennale and then at the Stedelijk Museum, Amsterdam. In spring 1995, Johannesburg hosted *Africus*, the first biennale of international contemporary art in South Africa. Responding to the broad themes of 'Volatile Alliances' and 'Decolonising our Minds', this massive event comprised close to 80 exhibitions from 67 countries, including 21 from Africa; guest curators included Wanjiku Nyachae for Kenya, Chika Okeke for Nigeria and Salah Hassan for Sudan. Local painters raised alternative and fringe exhibitions at the same time, to fill out representation for Johannesburg's province, Gauteng.

Sudan
National Museum, PO Box 178, Khartoum

Swaziland
National Museum, PO Box 100, Lobamba

Indiugilizi Gallery, Mbabane

Tanzania
National Museum of Dar-es-Salaam and Village Museum, PO Box 511, Dar-es-Salaam

Chawasawata Makonde Sculpture, Mwenge, PO Box 4284, Dar-es-Salaam

Tinga Tinga Cooperative Msasani, Oyster Bay, PO Box 23122, Dar-es-Salaam

Nyumba ya Sanaa, PO Box 4904, Dar-es-Salaam (and Zanzibar)

Mwariko's Art Gallery, PO Box 832, Moshi

Togo
Collectíf Togolais des Créateurs d'Art Visuel (COTCAV), BP 319, Lomé

Musée National, Lomé

Wisdom Art Contemporary Museum, BP 62145, Lomé

Tunisia
Maison des Arts, Tunis; tel. 283 749

Musée d'Art Moderne, Tunis

Centre d'Art Vivant de Ville de Tunis

Galerie Kalysté, Tunis

Uganda
The Makerere University Art Gallery, Kampala (houses collection of works by students and teachers, forming the core of a permanent national collection)

Nommo Gallery, PO Box 6643, Kampala (has some government funding)

Uganda Museum, PO Box 365, Kampala

Zaire
Musée National, BP 4249, Kinshasa

Gallery of the Académie des Beaux-Arts, BP 8249, Kinshasa Gombe

Institut des Musées Nationaux du Zaire (IMNZ), Kinshasa

Musée Mukoie, BP 15368, Kinshasa

Galerie Louis van Bever, 429 avenue des Nations Unies, Kinshasa Gombe (organised the 1992 exhibitions of contemporary art from Zaire at Maastricht, the Netherlands)

Zambia
National Collection, Mulugunshi International Conference Hall, PO Box 30575, Lusaka

Meridien BIAO Bank, PO Box 37158, Lusaka

Mpapa Gallery, PO Box 36472, Lusaka

Henry Tayali Centre, PO Box 37084, Lusaka

Zimbabwe
National Gallery of Zimbabwe, PO Box CY 848, 20 Julius Nyerere Way, Causeway, Harare, and 75 Main Street, PO Box 1993, Bulawayo. The Gallery is housed in two exquisite buildings: one modern, in Harare (planned under Frank McEwen, its first Director, 1957), and the other the Edwardian Douslin House, in Bulawayo, converted and opened in 1994. It has offered continuing support for artists of a kind largely unknown in the rest of the continent. Ongoing activities include the BAT Visual Arts Centre; permanent collection, and annual open salon (unbroken since 1957), now named *Heritage*. A Regional School of Art and Design is under development.

Chapungu Sculpture Park, PO Box 2863, Harrow Road, Msasa, Harare (Director Roy Guthrie)

Galerie Pierre, 9 Normandy Road, Alexandra Park, Harare (Director Olivier Sultan)

Gallery Delta, PO Box UA 373, 110 Livingstone Avenue, Greenwood Park, Harare (Director Derrick Huggins)

National exhibitions
Angola
Annual salons for modern art since 1967, Luanda

Bantu art
CICIBA (International Bantu Civilisation Centre, Libreville, Gabon) sponsors the Biennale of Contemporary Bantu Art, held five times since 1985. While its ideals are similar to those of Negritude, the range of the imagery and fabrication spans the first-generation of Poto-Poto symbolism, realistic caricature, abstract compositions and experiments with mixed media. Participating artists include Ondongo, Ouassa and Piula from Congo; Luesa, Liyolo and Samba from Zaire, and Texeira from Angola. There are year books for 1987 and 1989. Nations who signed the convention that established the CICIBA Centre in 1983 are Angola, Central African Republic, Comoros, Congo, Equatorial Guinea, Gabon, Rwanda, São Tomé and Principe, Zaire and Zambia. Plans for an extensive tour to the USA are under way, featuring the work of seven artists, starting at the University of South Florida, Tampa, in early 1996. For information contact 'Exhibition USA', CICIBA, BP 770, Libreville, Gabon; fax. 70 34 49.

Côte d'Ivoire
Annual prize, sponsored by a newspaper, Abidjan

Gabon
Salon d'Octobre annual since 1978, Libreville; CICIBA Biennale (see above)

Guinea
Exhibitions at the Hotel Camayenne, sponsored by Ernst & Young of Paris and Conakry, and curated by art scholar Marie Yvonne Curtis

Formes et couleurs de Guinée, May 1994
Cotonnade de Guinée, May 1994
Rencontres de la peinture guinéenne, May 1995 (works by 17 artists; catalogue by curator provides useful background)

Kenya
Kenya Panorama, salon since 1992 sponsored by the French Cultural Centre (P. O. Box 49415, Nairobi; fax. 254 2 33 62 53): participants from East Africa and the environs of the Indian Ocean (12 countries in 1993); catalogues provide a good overview of art in this region

Gallery Watatu in cooperation with East African Industries sponsored a competitive search for new talent in 1995: 400 entries led to a selected show of 150, and a finale with four prizes

Salon sponsored by French Cultural Centre

Namibia
The Second Stanswa Biennale had eight categories: painting, graphics, photography, sculpture, wood carving, ceramics, basketry and textiles

Senegal
Musée Dynamique annual salon, Dakar, 1973–77, organised by the Ministry of Culture, exhibiting about fifty Senegalese artists; resumed in 1986 by the National Association of Senegalese Artists (ANAPS) under the leadership of El Hadji Sy

International Biennale DAK'ART 1992, sponsored by the Ministry of Culture: artists from over 35 countries, including 16 African nations; prizes awarded to sculptor Moustapha Dimé from Senegal and painter Zerihum Yetmgeta from Ethiopia

In planning is another Biennale, with a wider range of work by Senegalese artists, including Thiès tapestries, a retrospective for Ousmane Sow and current student work

South Africa
Cape Town Triennial

Johannesburg Biennale, *Africus*, 1995

Zimbabwe
Annual since 1957, sponsored by the National Gallery (formerly the Rhodes Gallery) and industry: important overview of current art; annual catalogues

Works in public places
In many countries (e. g. Ghana, Mozambique, Nigeria and Senegal), there has been a dynamic relationship between the governments and artists and architects in the formation of national cultures. Public art – often idealised, historical or political in content – can be found in parliaments and other government buildings, museums, universities, airports, and central areas and parks in capital cities. Such works are often reproduced on currency and postage stamps.

Other major sources of commissions are decoration of churches (sculpture, murals, stained glass and objects), and the commercial sector such as banks, office buildings, industry and tourism (the last has particular significance in Kenya, Uganda and Zimbabwe). Many works are group-created (those devised by Malangatana in Mozambique and elsewhere in southern Africa) or colloborative (Thiès tapestries in Senegal).[25]

Angola
Antonio Ole, cut metal sculpture for Elf Petrol Company

Cameroon
Doula'Art public murals

Côte d'Ivoire
Sculptures by Christian Lattier (1925–77) in Abidjan, in City Hall, the international airport (murals in rope and concrete), and Caisse de Stabilisation bank (low-relief wood)

Ethiopia
Stained glass by Afewerk Tekle in Addis Ababa's Africa Hall

Ghana
Vincent Kofi sculptures, Kofi Antubam: regalia including the Presidential Chair

Kenya
Lamu *Story Snake*; independence monuments in city parks

Mozambique
Malangatana's public projects, such as his mural at the Natural History Museum

Nigeria
Ben Enwonwu, sculpture *The Three Musicians* (1954) for the Nigerian Broadcasting Corporation in Lagos, with murals inside (the first commission for a Nigerian artist); his many other public works include a bronze Queen Elizabeth for the National Assembly; several statues of the first President, Nnamdi Azikiwe; and the Yoruba god of power, Shango, for Electricity House.

Erhabor Emokpae, large-scale murals in Lagos at Western House; Institute of International Affairs; Standard Bank of West Africa; international airport

Agbo Folarin (b. 1938), murals at the Conference Centre of Obafemi Awolowo University, Ile-Ife; National Theatre, Lagos; international airport

Felix Idubor (b. 1928), carved decorations for the National Assembly

Lamidi Fakeye (b. 1925), church decoration based on Yoruba tradition of door carving and verandah posts (with the encouragement of his mentor Fr Kevin Carroll)

Senegal
Thiès tapestries in government buildings in Dakar; exhibition hall of the Workshop of Senegalese Decorative Art at Thiès; abroad in embassies and the United Nations, New York (designed by the founder Papa Ibra Tall)

Uganda
Francis Nnaggenda, *War Victim*, library of Makerere University, Kampala; two other public works on the theme of *Maternity* at Kenya National Museum, Nairobi

Gregory Maloba and Kefa Sempangi have public works

Zimbabwe
Sculpture Park of the National Gallery of Zimbabwe and Chapungu Sculpture Park both have permanent collections

Adam Madebe, *Looking to the Future*, 1985, courtyard of Douslin House, National Gallery, Bulawayo (a five-metre welded metal figure which won first prize in a municipal competition for public works to represent independence, but was then banned by the City Council because of its nudity, causing great debate)[26]

Associations and organisations

Angola
Uniao Nacional de Artistas Plásticos (UNAP), CP 5985, Luanda

Bantu art
CICIBA, International Bantu Civilisation Centre, coordinates the network of Associations des artistes plasticiens (ABAP), BP 770, Libreville, Gabon; fax. 70 34 49

Benin
Association des artistes plasticiens du Bénin, BP 03 1799, Cotonu

Burkina Faso
Comité national des arts plastiques, 01 BP 544, Ouagadougou

Cameroon
Union des artistes plasticiens du Cameroun (UDAPCAM), Ministère de l'Information et de la Culture (MINFOC), Yaoundé; tel. 23 38 35

Central African Republic
Organisation des artistes plasticiens de Centrafrique, BP 940, Bangui

Chad
Association des artistes graphistes et plasticiens du Tchad (AAGPT), BP 638, N'Djamena

Congo
Union des artistes plasticiens du Congo, BP 825, Brazzaville

Côte d'Ivoire
Section of Association internationale des critiques d'art (AICA), with 21 members

Association des artistes peintres et sculpteurs de Côte d'Ivoire (AAPS), 08 BP 49, Abidjan

Association national des artistes plasticiens de Côte d'Ivoire (ANAPCI), 08 BP 49, Abidjan

Groupe Vohou Vohou, 08 BP 2441, Abidjan

Ethiopia
Artists Association, PO Box 6144, Addis Ababa

Gabon
Association des artistes plasticiens gabonais, ENAM, BP 2185, Libreville

Gambia
Black African Arts Club, PO Box 2286, Serrekunda

Ghana
Association of Visual Artists (GAVA), PO Box 2738, Accra

Guinea
Association des artistes-créateurs de Guinée (AACG), BP 386, Conakry

Atelier Leppi, c/o Musée national de Sandervalia, BP 617, Conakry

Madagascar
Société des artistes peintres et sculpteurs, c/o Direction des Arts, Antananarivo; tel. (2) 262 47

Mali
Association national des artistes du Mali, BP 91, Bamako

Club des artistes peintres et sculpteurs, BP 2412, Bamako

Mozambique
Nucleo de Arte, Maputo; tel. (1) 494 673

Namibia
Arts Association, PO Box 994, Windhoek 9000

Niger
Association des artistes peintres et sculpteurs du Niger, BP 309, Niamey

Association des artistes peintres de Zinder, BP 108, Zinder

Nigeria
AKA Circle of Exhibiting Artists, c/o Department of Fine Art, University of Nigeria, Nsukka, Enugu State

Nigerian Society of Arts, c/o National Theatre, PO Box 12524, Iganmu, Lagos

Society of Nigerian Artists, PO Box 3535, Lagos

Uganda
Artists Association, PO Box 7152, Kampala

Rwanda
Association des artistes plasticiens rwandais (AAPR), BP 857, Kigali

Senegal
Association national des artistes plasticiens du Sénégal (ANAPS), BP 11043, Dakar

Seychelles
Association des artistes des seychellois, BP 45, Mahé

South Africa
South African Association of Arts (SAAA), PO Box 6188, 0001 Pretoria (national office; plus many regional branches)

Tanzania
Chawasawata (Makonde sculptors), PO Box 55003, Dar-es-Salaam, or PO Box 4284, Mwenge

Tinga Tinga Cooperative, PO Box 23114, Dar-es-Salaam

Zaire
Section of the Association internationale des critiques d'art (AICA), BP 8332, Kinshasa 1

Association national des artistes zaïrois en arts plastiques (ANAZAP), c/o Académie des Beaux-Arts, BP 8249, Kinshasa Gombe

Association professionnelle des artistes ndjilois (APAN), Zone Ndjili, BP 277, Kinshasa

Zambia
National Visual Arts Council, Henry Tayali Centre, PO Box 37084, Lusaka

Zimbabwe
Visual Artists Association of Bulawayo (VAAB), PO Box 2101, Bulawayo

Conferences and Events

1955 Paris, France: Society for African Culture

1959 Dakar, Senegal: Congrès des Artistes et Ecrivains Noirs

1962 Salisbury, Rhodesia (now Harare, Zimbabwe): First International Congress of African Culture (ICAC) (1 August–30 September). Under Frank McEwen, a festival of art and music with an ambitious programme of exhibitions, performances and a Congress to address the aesthetics of contemporary art in Africa. Artists, scholars and critics from Africa, Europe and the USA included Alfred Barr of MOMA, New York; Dr S. O. Biobaku of the University of Ile-Ife; William Fagg of the British Museum, London; Dr Bohumil Holas; Nathan Shamuyarira, Minister in the current government; Jahnheinz Jahn; Jean Laude; Alan Merriam; Roland Penrose of the ICA, London, as well as the Dada surrealist, Tristan Tzara.

The three exhibitions – African, new African and neo-African – featured a survey of traditional African art with over 230 objects, with 'non-traditional' art from Ghana (Kofi), Mozambique (Malangatana), Nigeria (Enwonwu), Rhodesia (Workshop School, also Shelby Mvusi; many works are in the Gallery's permanent collection); Uganda (Makerere art school). A small display suggested 'African influences upon western schools' with 50 photographs and a few works such as Picasso's *African Dancing Girl*. A superlative occasion for the participants, it attracted local hostility, with visiting black artists being mistreated (one newspaper headline read 'No Coffee for Kofi in the Cafe').

Publications: prospectus brochure and catalogue raisonné, with essay, 'Influence of Africa', by Frank McEwen:

But who 'discovered' that African art was 'art'? Before the Expressionists, before the Picasso group and long before the movements of independence, a vertiginous fascination for it spread over Europe. It was like pattering rain, announcing a violent squall. The squall blew up at the turn of the century while Africa was still in the great sleep and Spanish, French and German artists – explorers in aesthetics – were blown before its blast like full-rigged ships under bare poles . . .

The hard African sky is where the storm came from. Its blast struck sugary aesthetics and, at the same time, another vision of virile creations is close at hand – a new, non-traditional, African art. Again, it may lack in Latin softness. It is now concerned with the realities of life and death – with the drum beat of a vast heart where warm blood flows and wiser spirits become incarnate.

As time advances rapidly, significant facts of the controversial African affair will become apparent. It will be seen that, in the twentieth century, Africa was the first to make her contributions to the western humanities – to art, faith, music, enthusiasm. Her donations to the west were, however, discreetly, even unconsciously made. They were not paternalistically proclaimed by missionaries, freedom-riders or peace corps! There was no cashing in, hurriedly, on all that was being done for the backward, 'underdeveloped', continents or Europe and America! . . .

But the strange affair of 'give and take' has several facets. One is our present concern – to show what European genius owes to the ancient genius of Africa.

1966 Dakar, Senegal: Premier Festival Mondial des Arts Nègres

1969 Algeria: Premier Festival Culturel Panafricain, opened by President Boumedienne. Papers from, among others, Ben Enwonwu and Sam Ntiro.

1973 Kinshasa, Zaire: Congrès Extraordinarie de l'Association des Internationale Critiques d'Art (AICA)

1977 Lagos, Nigeria: Festac, the Second World Black Festival of Arts and Culture. 17,000 participants from 56 countries; Erhabor Emokpae in charge of the art displays; most Nigerian artists were graduates from Zaria; occasion marked by opening of National Arts Theatre which houses National Gallery of Modern Art.

1992 DAK'ART, Biennale de Dakar: major visual arts biennial with artists from African countries, USA and Europe.

1995 Johannesburg, South Africa: *Africus* Biennale (28 February–30 April), Africa Museum and other venues. Participating African countries: South Africa, Angola, Benin, Botswana, Cameroon, Egypt, Gabon, Ghana, Côte d'Ivoire, Kenya, Mauritius, Morocco, Mozambique, Namibia, Nigeria, Reunion, Senegal, Sudan, Tanzania, Uganda, Zimbabwe. Profusely illustrated catalogue with fifteen essays.

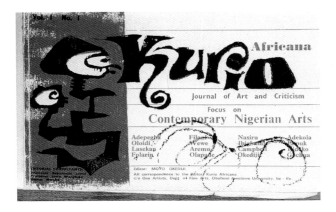

Cover of *Kurio Africana,
Journal of Art and Criticism*
from Ile-Ife, vol. 1, no. 1,
1988, focusing on
contemporary Nigerian
arts, edited by Moyo Okediji
and Bolaji Campbell

Journals

Only a few journals published in Africa are dedicated
to the visual arts, but most have some relevant
articles. Regular reviews and criticism appear in the
local press.

Algeria
Revue du musée national des beaux-arts d'Alger, 1987–

Botswana
Zebra's Voice, Gaborone

Côte d'Ivoire
Godo-godo, Abidjan

Ethiopia
Journal of Ethiopian Studies, Addis Ababa

Gabon
Muntu, Libreville, CICIBA

Ghana
Bambolse, Kumasi, 1990– (the name means 'more
attractive', with the connotation of ingenuity; Atta
Kwami and Pamela Clarkson)

Kenya
Kenya Past and Present, Nairobi, National Museum

Morocco
Vision, Casablanca

Nigeria
Arts Illustrated Weekly; Artifacts; Nigeria Magazine,
Lagos
Nigerian Journal of Arts and Culture, Benin City
Kurio Africana, Ile-Ife
Nsukka Journal of the Humanities, Nsukka
Nigerian Journal of Art Education; Eye; Savanna,
Zaria

Sierra Leone
Africana research bulletin, Freetown, South Africa
ADA: Art, Design, Architecture, Cape Town, 1986–
Community Arts Project (CAP) newsletter, Cape Town
Staffrider, Johannesburg
De arte, Pretoria
*South African Journal of Art and Architectural
History*, Pretoria

Uganda
Transition, Kampala, Makerere, 1964–72

Zambia
Zambia Heritage News, Livingstone, Zimbabwe
The Artist, Harare, 1990–92
Chapungu Newsletter (and other monographs), PO
Box 2863, Harare
Gallery: The Art Magazine, Gallery Delta, PO Box UA
373, Harare, 1994–
Southern African Art, Harare, 1992–93
Zimbabwe Insight, Harare, up to 1989

International events

Exhibitions of modern art

1927 London, Imperial Institute
Gold Coast (Ghana) student work, arranged by
G. A. Stevens, art teacher at Achimota School

1929 Brussels, Palais des Beaux-Arts
Exhibit of 63 watercolours by Albert Lubaki from
the Belgian Congo, organised by Georges Thiry;
toured to Paris, Geneva and Naples

1937 London, Zwemmer Gallery
Five young Nigerian artists, including
Ben Enwonwu, organised by art teacher
Kenneth Murray

1939 London, Imperial Institute
Students from Uganda, organised by
Margaret Trowell following a show in Uganda;
G. A. Stevens wrote that this exhibition
confirmed the arrival of African art on the
international scene

1947 London, Imperial Institute
Second exhibition of students' art from Makerere,
Uganda, organised by Margaret Trowell

1948 London, Camden Arts Centre
Nigerian art

1949 London, Cyrene Workshop
Exhibition of work from Rhodesia in various
media

1962 London, Commonwealth Institute
Art from the Commonwealth included stone
sculpture from Rhodesia

**1963 London, Commonwealth Institute,
then 1965 Commonwealth Arts Festival,
South Bank Centre**
New Art from Rhodesia

1967 London, Transcription Centre
Contemporary African Art focused on artists from
Oshogbo, Nigeria, with Ibrahim El Salahi from
Sudan and Skunder Boghossian from Ethiopia[27]

1969 London, Camden Arts Centre
Contemporary African Art surveyed the work of
90 artists from twelve countries; at least three of
the works exhibited (by Jimoh Buraimoh and
Asiru Olatunde) are in the permanent collection
of Wolfson College, Oxford; catalogue

1969 Los Angeles, Otis Institute
Contemporary African Art featured Oshogbo,
Nigeria; catalogue

1969–70 London, Grosvenor Gallery
Makonde Sculpture

1970 Paris, Musée d'Art Moderne
Sculptures contemporaines de Vukutu

1971 Paris, Musée Rodin
Sculpture contemporaine des Shonas d'Afrique;
travelled to London, Institute of Contemporary
Art, 1972

1972 London, Africa Centre
Contemporary Nigerian art, mostly in the Yoruba
genre; catalogue has three essays by Emmanuel
Taiwo Jegede

1974 Paris, Grand Palais
Art de Sénégal showed 46 artists; travelled to the
Boston Museum of Fine Art and other US venues;
catalogue

**1974 London, Commonwealth Institute
Art Gallery**
Contemporary Makonde Sculpture; also *Oshogbo
and Western Nigerian Artists*

1977 Washington, D.C., Howard University
African contemporary art featuring the work of
45 artists from 15 countries curated by Kojo
Fosu; seven artists attended the opening at the
invitation of the university

1979 Berlin, Staatliche Kunsthalle
Moderne Kunst aus Afrika Horizonte '79 Festival der Weltkulturen, showed 397 works by 47 artists featuring Oshogbo, sign-boards, Makonde and Shona sculpture, Malangatana, El Salahi and some newer work from East Africa; a 1981 version was exhibited in London at the Commonwealth Institute as *Art from Africa*

1984 London, Commonwealth Institute
Sanaa: Contemporary Art from East Africa, curated by Fatmah Abdallah, Mordecai Buluma and Elimo Njau

1985 London, Africa Centre
The Art that Survives, Uganda 1960s–1980s, curated by Jonathan Kingdon and Ali Darwish; catalogue

1986 London, Whitechapel Art Gallery
From Two Worlds, curated by an unusual collaboration of artists, gallery staff and the director Nicholas Serota. Africa-born artists were Bhimji from Uganda; Douglas Camp from Nigeria; Jantjes from South Africa; Niati from Algeria, and Himid from Zanzibar. The catalogue essay by Nigerian critic Adeola Solanke stressed 'a lived cultural plurality'.

1987 London, Africa Centre
Modern Art from Mozambique showed Makonde sculpture and Malangatana

1988 Paris, Institut du Monde Arabe
Art contemporain arabe: collection of the musée du Institut du Monde Arabe, arranged by Brahim Alaoui of the Institute, with works by 30 artists from North Africa and Sudan

1988 London, Zamana Gallery
Contemporary Arts from Western Africa – The Oshogbo School showed 24 artists; repeated in 1990 as *Contemporary art from Western Nigeria: Oshogbo* at the Africa Centre, with ten artists; catalogue

1988 London, Barbican Centre
Contemporary Stone Sculpture from Zimbabwe, an outdoor exhibition of 60 works by 20 artists, curated by Keith Shire of the Africa Centre and opened by H. R. H. The Prince of Wales in the presence of McEwen, Matemera and Mukarobwa; catalogue

1989 Oxford, Museum of Modern Art
Makonde: Wooden Sculpture from East Africa from the Malde Collection was a limited survey from one collection, noted here because of the controversy caused by the prime venue, which 'challenged preconceptions of the range of serious art' (the policy of MOMA); advisor Jeremy Coote; catalogue. A complementary small, splendid display of Makonde sculpture was and remains on show at Oxford University's Pitt Rivers Museum.

1989 London, Hayward Gallery, South Bank Centre
The Other Story: Afro-Asian Artists in Post-War Britain, curated by Rasheed Araeen, brought attention to the modern art of non-white British-based artists, including Egonu from Nigeria, and Himid from Zanzibar; catalogue

1989 Stockholm, Kulturhuset, and tour to the Nordic countries
Art/Images in Southern Africa, pictorial art by 16 artists from Angola, Mozambique, South Africa and Zimbabwe; curated by K. Danielssen and sponsored by the Swedish International Development Agency; catalogue contains some sharp essays

1989 Paris, Centre Georges Pompidou
Magiciens de la terre was curated by Jean-Hubert Martin, a global show featuring the work of 100 artists, of whom 22 were from Africa, including

coffin-makers and sign-painters as well as Cyprien Toukoudagba, Esther Mahlangu and Henry Munyaradzi. Strongly criticised for ignoring the work of modern artists from developing countries, it strengthened notions of ethnic sorts of 'otherness'; excellent illustrated catalogue.

1990 New York City, Studio Museum, Harlem, and tour
Contemporary African Artists: Changing Tradition, curated by Grace Stanislaus, selected gallery art by El Anatsui from Ghana and Nigeria; Bath from Côte d'Ivoire; Glover from Ghana; Karuga from Kenya; Keita from Senegal; Gutsa, Mukomberanwa and Munyaradzi from Zimbabwe; Onobrakpeya from Nigeria; catalogue with essays including a fine preface by Wole Soyinka

1990 Vienna, Grazer Kunstverein and Academy of Fine Arts
Lotte or the Transformation of the Object, curated by Clémentine Deliss, looked at the material object of culture in the work of West African, European and US artists; catalogue in German and English

1990 Glasgow Art Gallery, and tour
Art from the Frontline featured 200 art works by 92 artists from the seven states constituting the 'frontline' before 1994 majority rule in South Africa: Angola, Botswana, Mozambique, Namibia, Tanzania, Zambia, Zimbabwe; project director was Peter Sinclair and curator Emma Wallace; catalogue

1990 Oxford, Museum of Modern Art
Art from South Africa, curated by David Elliot and David Koloane, was the first UK/RSA diversity show, similar in scope to the South African exhibition *Tributaries* but organised by communities; 64 artists featured; catalogue

1990 Bretton Hall, Wakefield, Yorkshire Sculpture Park
Contemporary Stone Carving from Zimbabwe surveyed the work of 36 sculptors from the first and second generations of production; curated by the director Peter Murray with the National Arts Council of Zimbabwe; catalogue

1991 Paris, L'Arche de la Défense
Art sur Vie, exhibition of Senegalese artists curated by Alioune Badiane

1991 Frankfurt am Main, Museum für Völkerkunde, and tour
Mit Pinsel und Meibel, Zeitgenossische afrikanische Kunst [Signs of the Time: New Art from Africa] curated by Joanna Agthe and Christina Mundt, selected works from the Museum's permanent collection by artists from

Nigeria (mostly Oshogbo painting), East Africa (Katirakawe, Oswaggo, Kaigwa, Sukuro, Wadu), Senegal (a wide range), South Africa (prints), Zaire (popular urban painting) and Zimbabwe (first-generation sculpture and drawings by women in the Weya project). Accessible, figurative imagery emphasised; catalogue (abridged version in English); supporting texts.

1991–94 New York City, Center for African Art, and tour
Africa Explores: 20th Century African Art was a grand presentation of the scope of visual arts production, opening in two sites in New York and then touring in smaller versions to more than ten venues in the USA and Europe. Generally well received by western art critics, it was controversial for many African artists and critics because the selection was heavily weighted towards work by popular artisans (for example, tombs and signs). Catalogue raisonné.

1991 Las Palmas de Gran Canaria, Centro Atlantico de Arte Moderno, and tour
Africa Hoy was curated by André Magnin from Jean Pigozzi's collection of contemporary African art; catalogue, with essays by non-Africans; toured subsequently as *Africa Now*, and in 1992 as *Out of Africa* at the Saatchi Gallery, London

1991 Paris, Musée National des Arts d'Afrique et d'Océanie
Congo/Zaire: Thango de Brazza à Kin (Cahiers de l'ADEIAO); catalogue

1991 London, Commonwealth Institute
A Grain of Wheat, a continent-wide group exhibition by mostly overseas African artists in support of UNICEF, was organised by the Director of the Savannah Gallery, Leroi Coubagy of London and Accra; essay by Olu Oguibe

1992 Kassel
Documenta
Included Mo Edoga from Nigeria and Ousmane Sow from Senegal

1992 Seville, Expo '92
Included nine artists from Mozambique

1992 Maastricht
Les Peintres du Grand Atelier (Kinshasa) and *Painters of Lubumbashi, Zaire*, organised by Galerie van Bever, Kinshasa; catalogues for both

1992 Brussels, Musée Royal de l'Afrique centrale, Tervuren
La naissance de la peinture contemporaine en Afrique centrale, 1930–70 [The birth of contemporary painting in central Africa], inclusive of Zaire and Congo, Brazzaville, surveyed paintings by 35 artists in the context of the colonial-era schools; catalogue

Chéri Samba,
L'Espoir fait vivre,
1988

1994 Paris, Institut du Monde Arabe
Rencontres africaines, in which Jean-Hubert Martin (of *Magiciens de la terre*) and Ibrahim Alaoui (of the Institute) arranged encounters between the curators, Moroccan Farid Belkahia and Malian Abdoulaye Konaté, and artists from North Africa and from south of the Sahara; catalogue with interviews

1994 Liverpool, Bluecoat Gallery
Seen/Unseen, a group show curated by Olu Oguibe, presented some explorations by African artists resident in the UK concurrent with the visit of *Africa Explores* to the Tate Gallery, Liverpool; brief catalogue

1994 Las Palmas de Gran Canaria, Centro Atlantico de Arte Moderno
Otro Païs Escalas Africanas [Another Country: African Stopovers] featured 24 artists from Africa and the African diaspora displaying three forms of syntheses: myth, breath, dreams. Curated by Simon Njami; catalogue in three languages

Some international organisations

ACASA, the Arts Council of the African Studies Association of the United States of America, is a professional organisation founded to promote scholarship, communication and collaboration among scholars, artists, museum specialists and others interested in African and African diaspora arts. It sponsors a triennial symposium, the ACASA Newsletter (three times a year; compiled by Janet Stanley, National Museum of African Art Library, Smithsonian Institution, Washington, D.C. 20560; fax 202 357 4879), and various proactive activities to assist colleagues in Africa. The membership of 750 covers north America, Europe and Africa (about 250 members are resident in Africa; some of the others are Africa-born). For membership information, contact K. Curnow, ACASA Secretary-Treasurer, Art Department, Cleveland State University, Cleveland, Ohio, OH 44115; tel. 216 687 2105; fax. 216 932 1315.

AICA, the Association internationale des critiques d'art [International association of art critics], was founded by UNESCO in 1947 and is the professional organisation for about 2,000 critics worldwide. A bi-annual Congress is its main activity. About 2 per cent of the membership is from Africa : two active sections are in Côte d'Ivoire (21 members) and Zaire (22). Further information from AICA, 11 rue Berryer, 75008 Paris; tel. 1 42 56 17 53; fax. 1 42 56 08 42.

Afrique en Créations, a funding body supported by the French Ministry for Cooperation, is an agency for the encouragement of the contemporary arts in sub-Saharan Africa, inclusive of fine arts, photography, poetry and dance. The association (formerly a foundation) is dedicated to the promotion, celebration and dissemination of avant-garde art in Africa and abroad. For information contact Afrique en Créations, 51 rue Sainte Anne, 75002 Paris; tel. 1 42 60 61; fax. 1 42 60 60 82.

InSEA, the International Society for Education through Art, founded by UNESCO in 1951, is the professional organisation for art educators, sponsoring a triennial Congress and a newsletter (three times a year). With a membership of about 1,500 from 90 countries, there are 35 members from ten countries in Africa. For membership information, contact the InSEA Secretary, Box 1109, 6801 BC Arnhem, The Netherlands.

Some dedicated institutions

Only a few public places out of Africa are dedicated solely to African art or have ongoing exhibitions of African art.

National Museum of African Art of the Smithsonian Institution (Director Dr Sylvia Williams), 950 Independence Avenue SW, Washington, D.C. 20560; tel. 202 357 4600. This contains the premier library for contemporary African art (Chief Librarian Janet Stanley) and New York City's Museum for African Art (Director Grace Stanislaus), 593 Broadway, New York, NY 10012; tel. 212 966 1313. The founder Dr Susan Vogel, now of the Yale Art Gallery, set new standards for exhibitions; her curatorial verve is unsurpassed.

Africa Centre, 38 King Street, London WC2E 8JS; tel. 0171 836 1973. This is longer term, but much smaller in scale, and has sponsored solo and group exhibitions since 1982. These have featured well over 100 artists from 19 African countries and the African disapora, including Douglas Camp, Glover, Malangatana and Onobrakpeya. In 1995, a tenth anniversary exhibition of contemporary art featured work from the 1970s and earlier, including Oshogbo, Tanzanian work, Makonde sculpture and Tinga Tinga painting.

Biennales

Havana, Museo Nacional de Bellas Artes

The Havana Biennale is the major South or Third World juried exhibition, in which artists mostly from central and southern Africa have participated since 1984 (15 in 1994). Angola's Antonio Olé and Mozambique's Malangatana were awarded honours in 1986.

Venice Biennale

1968 Pierre-Victor Mpoy, a painter from Zaire, exhibited; there was also work from South Africa.

1991 selected by Grace Stanislaus for Studio Museum, Harlem, show *Contemporary African Artists: Changing Tradition* (see above).

1993 Museum for African Art, selected by Dr Susan Vogel; see Thomas McEvilley, *Fusion: West African Artists at the Venice Biennale*, Museum for African Art, New York, 1993. Also *Incroci del Sud: Affinities, Art from South Africa*, South African Embassy, Rome.

africa95

The UK season africa95 included a large number of visual art exhibitions. The most important catalogues were produced by: the Royal Academy of Arts, London (*Africa: The Art of a Continent*); the Crafts Council, London (*African Metalwork*); the Barbican Art Gallery, London (*Technology, Tradition and Lurex: The Art of African Textiles*); Ikon Gallery, Birmingham (*Self Evident*), and the Photographers' Gallery, London (*Exposing the Archive: Visual Dialogues between Photography and Anthropology*).

Further reading

Abdal, Rahim M. 'Arabism, Africanism and Self-Identification in the Sudan', in Yusuf Fadl Hasan, ed., *Sudan in Africa*, Khartoum, IAAS Publications, Khartoum University Press, 1971

Abdul-Hai, Muhammad, *Conflict and Identity: The Cultural Poetics of Contemporary Sudanese Poetry*, Khartoum, IAAS Publications, Khartoum University Press, 1976

Adedeji, J. A., 'A profile of Nigerian theatre 1960–1970', *Nigeria Magazine*, 107/109, December–August 1971

Aethiopien in der volkstumlichen Malerei, Institut für Auslandsbeziehungen Galerie, Stuttgart, 1993

Africa in Antiquity: the Arts of Ancient Nubia and the Sudan, New York, Brooklyn Museum, 1978, 2 vols.

African Art Today: Four Major Artists, exhibition catalogue, New York, African-American Institute, 1974

African Artists in America, New York, African-American Institute, 1977

African Arts, Los Angeles, California, 1967– , quarterly. An excellent historical source for modern African art during 1967–72. In the mid 1990s non-traditional art is again being featured in portfolio space and articles. Coleman African Studies Center, 405 Hilgard Avenue, Los Angeles, CA 90095.

Agthe, Johanna, *Wegzeichen – Kunst aus Ostafrika [Signs – Art from East Africa] 1974–89*, Frankfurt am Main, Museum für Völkerkunde, 1990; German and English text. The bulk of this major, well illustrated book comprises the catalogue for the Museum's extensive collection of East African contemporary art, weighted towards Kenyan social paintings of the 1980s (Kaigwa, Oswaggo, Sukuro, Wadu), but also including works associated with Tinga Tinga and Makonde. The collection is weak on art from Uganda and generally on artists with formal education (for these see Miller, *Art in East Africa*). Excellent interviews with artists and many informative site photographs.

Ali, W. with S. Bisharat, eds., *Contemporary Art from the Islamic World*, London, Scorpion Publishing, on behalf of the Royal Society of Fine Arts, Amman, Jordan, 1989. Includes artists from Algeria, Egypt, Libya, Morocco, Tunisia and Sudan, but not Africa south of the Sahara. Essays introduce the national contexts for the related exhibition held at the Barbican Art Gallery, which showcased the contemporary Arab and Islamic collection of the Jordan National Art Gallery. One of the few texts available in English.

Araeen, Rasheed, 'Our Bauhaus Others' Mudhouse,' *Third Text*, vol. 6, 1989

Araeen, Rasheed, *The Other Story: Afro-Asian Artists in Post-War Britain*, London, Hayward Gallery, 1989. Essays by the curator Araeen, and Brett, Himid and Jantjes tell the 'other story' and present arguments for a plural mainstream; useful chronology.

Arnold, M., 'A Change in the Regime: Art and Ideology in Rhodesia and Zimbabwe', in Nettleton and Hammond-Tooke, eds., q.v.

Arnold, M., *Zimbabwe Stone Sculpture*, Bulawayo, Louis Bolze, 1986. The most scholarly account of the subject, but dated to events before independence in 1980.

Art/Images in Southern Africa, exhibition catalogue, Kulturhuset, Stockholm, 1989

The Art that Survives, Uganda, 1960s–1980s, exhibition catalogue, Africa Centre, London, January 1985

Atkins, Robert, *Artspoke*, New York, Abbeville Press, 1993

Axt, Friedrich and El Hadji M. B. Sy, *Bildende Kunst der Gegenwart in Senegal [Anthology of Contemporary Fine Arts in Senegal]*, Frankfurt am Main, Museum für Völkerkunde, 1989; German, French and English text. A comprehensive description of the infrastructure (history, exhibition spaces, education) for contemporary art in Senegal; anthology of over 40 artists; profusely illustrated.

Beier, Ulli, *Contemporary Art in Africa*, London, Pall Mall Press, and New York, Frederick A. Praeger, 1968. Seminal work that has shaped notions about the processes and imagery of non-traditional art in Africa, with concern for the negative effects of formal art education; five of the ten chapters are on Oshogbo. Compare with his 1991 text, below.

Beier, Ulli, ed., *Thirty Years of Oshogbo Art*, Iwalewa Haus, University of Bayreuth, 1991; accompanied exhibition of the same name at the Goethe Institute, Lagos, Nigeria. Fascinating overview of the sixties at the Mbari-Mbayo Club, Oshogbo, with many photographs; three sets of memories by eight artists, expatriate catalysts and Nigerian collectors. Iwalewa Haus, a centre for Third World art events and studies, publishes a stream of publications; Munzgasse 9, University of Bayreuth, 95440, Bayreuth, Germany.

Benjamin, Tritobia H., 'Skunder Boghossian: a Different Magnificence', *African Arts*, Los Angeles, summer 1972

Benjamin, Tritobia H., intro., *Universal Aesthetics: AfriCobra/Groupe Fromaje*, Gallery of Art, Howard University, Washington, D.C., 1989

Beshir, M. O., *Educational Policy in the Sudan: 1898–1959*, Oxford, Clarendon Press, 1969

Biasio, Elizabeth, 'The Burden of Women – Women Artists in Ethiopia', in *New Trends in Ethiopian Studies: Papers of the Twelfth International Conference of Ethiopian Studies*, New Brunswick, The Red Sea Press, and Michigan State University, 1994, pages 304–33

Biasio, Elizabeth, *Die verborgene Wirklichkeit: drei äthiopische Maler der Gegenwart [The Hidden Reality: Three Contemporary Ethiopian Artists]*, Zürich, Völkerkundemuseum der Universität, 1989; German and English text. Artist-curated exhibition of Ethiopian contemporary art of an academic style shown in an ethnographic museum, intended to complement an existing collection of popular paintings. Background essays on the two genres and on the Fine Arts School in Addis Ababa.

Biko, Steve, *I Write What I Like*, ed. Aelred Stubbs, Heinemann, London, 1978

Brauvmann, Rene A., *Islam and Tribal Art in West Africa*, London, Cambridge University Press, 1974

Brown, Evelyn S., *Africa's Contemporary Art and Artists: a review of creative activities in painting, sculpture, ceramics and crafts of over 300 artists working in the modern industrialized societies of some of the countries of sub-Saharan Africa*, New York, Division of Social Research and Experimentation, Harmon Foundation, 1966. Key historial text for the mid sixties in the form of a directory.

Burnett, Richard, *Tributaries: A View of Contemporary South African Art*, BMW Communications Department, 1985. Catalogue for exhibition at the Africana Museum, Johannesburg, and in Germany.

Burt, Eugene, *An Annotated Bibliography of the Visual Arts of East Africa*, Bloomington, Indiana University Press, 1980

Camden Arts Centre, *Contemporary African Art*, London and New York, Studio International, 1969. Survey of 90 modern artists from 12 countries with essays by Beier, McEwen, Roland Penrose, J. Delange and P. Fry.

Chojnacki, Stanislaw, 'On the Ethiopian Flag', *Proceedings of the Third International Conference of Ethiopian Studies*, Addis Ababa, 1966, vol. 1, pages 137–53

Coleman, Floyd W., 'Toward an Aesthetic Toughness in Afro-American Art,' *Black Art – An International Quarterly*, vol. 2, no. 3, spring 1978

Centre Georges Pompidou, *Magiciens de la terre*, Paris, 1989. General essays on 'the other' and an entry for each of the 100 artists, of whom 20 are from Africa.

Cornet, J. A., R. de Cnodder, I. Dierickx, W. Toebosch, *60 Ans de peinture au Zaire*, Brussels, Les Editeurs d'Art Associés, 1989. From the first exhibition in Europe, in 1929, of indigeneous Congolais easel painting. Three large sections cover precursors of modern painting, the workshop school in Lubumbashi (Elisabethville) and painting in Kinshasa (Leopoldville), with minimal attention to the capital's caricature painting (e. g. Samba, Moke) and none to the history painting of Lubumbashi. The resource for the 1992 Brussels Tervuren exhibition. For a compact version of the story focusing on the painter Thango, see *Congo/Zaire: Thango de Brazza à Kin*, Cahiers de l'ADEIAO, 10, 1991.

Court, Elsbeth, 'Pachipamwe: the avant garde in Africa?', *African Arts*, vol 25, no. 1, January 1992

Debela, Achamyeleh, 'A Pioneer in Spite of the Odds: Gebre Kristos Desta of Ethiopia (1932–81)', *Third International Conference on the History of Ethiopian Art*, 9–12 November 1993, The Ethiopian Studies Institute, Addis Ababa University

de Jager, E. J., *Images of Man: Contemporary South African Black Art and Artists*, guide to the collection of the De Beers Centenary Art Gallery, University of Fort Hare, Alice, Ciskei, Fort Hare University Press, 1992. Catalogue raisonné for what is regarded as the premier collection of art by black South Africans living under apartheid, started in 1964, including work by 170 artists from differing milieus.

Demerson, Bamidele Agbasegbe, 'Canvas and Computer Painting and Programming: Tradition and Technology in the Art of Acha Debela', *International Review of African-American Art*, vol. 10, no. 2, 1992

Deressa, Solomon, 'A Letter from Addis', *African Arts/Arts d'Afrique*, vol. II, no. 2, winter 1969

Dictionary of Art, London, Macmillan, forthcoming. Editors for African art south of the Sahara are Dunya Hersak and Jeremy Coote. Encyclopedia-based format, with alphabetical and cross-referenced entries for nearly all countries in Africa, covering colonial and post-colonial periods with continuing traditions and new directions in contemporary art, including artists, varied periods, education and institutions. Major multipartite survey on 'traditional' art and architecture of sub-Saharan Africa; separate articles for 50 African peoples (Akan to Zulu), major sites and other significant manifestations.

Donaldson, Jeff R., 'Ten in Search of a Nation', *Black World*, October 1970

Durozoi, G., ed., *Dictionnaire de l'art moderne et contemporain*, Paris, Hazan, 1992. Global survey of artists, movements and journals, including 17 African countries. The entries for African artists, by André Magnin, reflect an almost exclusive bias for work by artists without an academic training (in particular, those featured in *Africa Hoy*).

Ebong, Ima, *Negritude: Between the Mask and the Flag – Senegalese Cultural Ideology and the Ecole de Dakar*, 1991, in Susan Vogel, ed., *Africa Explores*, q.v.

'El Salahi, a Painter from the Sudan: Rhythm and Structure of Arabic Alphabet Underlie Most of his Forms', *African Arts,* autumn 1967, vol. I, 1, pages 16–26

Fanon, Franz, *The Wretched of the Earth,* New York, Grove Press, 1963 (and various editions)

Fisher, J., ed., *Global Visions: Towards a New Internationalism in the Visual Arts,* London, Kala Press, in association with the Institute of International Visual Arts, 1994. Proceedings of symposium held at the Tate Gallery, which initiated dialogue between the London mainstream, the diaspora and other non-occidental cultures on issues of diversity and curatorship. In contrast to the scholars who spoke for other parts of the world, the two talks on the African experience were presented by self-exiled Africans.

Fisseha, Girma and Walter Raunig, *Mensch und Geschichte in Aethiopiens Volksmalerei,* Innsbruck, Pinguin-Verlag, and Frankfurt am Main, Umschau-Verlag, 1985

Fosu, Kojo, *Twentieth Century Art of Africa,* first edition Zaria, Gaskya Press, 1986; revised edition Accra, Artists Alliance, 1993. Comprehensive survey of modern art in Africa, with many references to ideal forms and state art; anedcotes enliven the text; illustrations are poor.

Fransen, Hans, *Three Centuries of South African Art,* A. D. Donker, 1982

Gallery, art magazine from Gallery Delta, PO Box UA 273, Harare, Zimbabwe

Gaudibert, P., *L'Art africain contemporain,* Paris, Diagonalles, 1991. Introductory survey to contemporary art in Africa south of the Sahara, weighted towards francophone settings. Categorisation of artists is by their training (*savantes,* professional art school; or *populaires*), with many reproductions, useful chronology, but little analysis.

Gilroy, Paul, *The Black Atlantic – Modernity and Double Consciousness,* London, Verso, 1993

Glasgow Art Gallery, *Contemporary Art from Southern Africa: Art from the Frontline,* London, Karia Press, 1990. Catalogue with biographies and essays by country (Angola, Botswana, Mozambique, Namibia, Tanzania, Zambia, Zimbabwe) and by form of creative art.

Goldwater, Robert, *Primitivism in Modern Painting,* New York, Random House, 1938; rev. 1966; enl. Cambridge, MA, Harvard Belknap Press, 1986. The seminal book on the topic which many consider the best yet.

Graburn, Nelson, ed., *Ethnic and Tourist Arts,* Berkeley, University of California Press, 1976

Graebner, W., ed., 'Popular Culture in East Africa', *Matatu* special issue, no. 9, Amsterdam and Atlanta, Georgia, 1992

Grierson, R., ed., *African Zion: Sacred Art of Ethiopia,* exhibition catalogue, Schomburg Center for Research on Black Culture, New York City; New Haven, Yale University Press, 1993

Guez, Nicole, *Guide: L'Art africain contemporain [Contemporary African Art],* Paris, Association Dialogue entre les Cultures, 1992–94. Useful reference to contemporary African art that lists 4000 artists, galleries and art workers by 42 countries; a new version is due in autumn 1995. Available from Fondation Afrique en Créations, 51 rue Sainte Anne, 75002 Paris.

Gwala, Mafika, 'Towards a National Culture', *Staffrider,* vol. 8, no. 1, 1989

Hale, Sondra, 'Musa Khalifa of Sudan', *African Arts,* vol. 5, no. 3, spring 1973, pages 14–19

Harden, B., *Africa: Dispatches from a Fragile Continent,* New York, Norton, and London, Fontana, 1991. Introduction to the challenges of contemporary Africa by award-winning journalist, in accessible and sympathetic case studies that include Ghana, Kenya, Nigeria, Sudan and Zaire.

Hassan, Salah M., *The Art of Rashid Diab,* Museum of the National Center of African-American Artists, Boston, 1994

Hassan, Salah M., *Creative Impulses/Modern Expressions: Boghossian, Diab, Khalil, Nour,* Ithaca, Africana Center, Cornell University, 1993; reprinted as 'African Art Today' in *NKA,* vol. 1, 1995, page 2. Significant interrogation of terms in African art scholarship, arguing for attention to art and artists, rather than to their formation.

Head, Sydney W., 'Conversation with Gebre Kristos Desta', *African Arts/Arts d' Afrique,* summer 1969

Hevesi, J., 'The Paintings of Kamala Ishaq', *Contemporary African Art.,* exhibition catalogue, Camden Arts Centre; London, Studio International, 1969

Highet, J., 'Africa: State of the Art', *Arts Review,* vol. XLIV, May 1992

Hiller, Susan, ed., *The Myth of Primitivism: Perspectives on Art,* London and New York, Routledge, 1991. Papers by critics, scholars and artists from a seminar at the Slade School of Art that offer London-based and often personal perspectives on issues of identity and definition in cultural interactions. Despite unevenness and a lack of essays authored by Africans or Africanists, this book helps to take stock.

Hirst, Terry, 'New Art from Kenyatta College', *African Arts,* summer 1971

Hollburg, S. and G. Sievernich, eds., *Moderne Kunst aus Afrika Horizonte '79 Festival der Weltkulturen,* exhibition catalogue, Berlin, Staatliche Kunsthalle, 1979. Contains 23 essays, including one by collector Günther Péus.

Hountondji, Paulin, *African Philosophy: Myth or Reality?,* New York, 1982

Hultén, C. O., ed., *Modern Konst I Afrika [Modern Art in Africa],* special issue of *Kalejdoskop,* vols. 6 and 7, 1977, Lund, Sweden, 1978; Swedish text with English summaries. Wide survey of contemporary art primarily in West and Central Africa in the mid 1970s by Sweden's foremost expert. Movements include Thiès, Poto-Poto, Oshogbo and national summaries; specific artists include Boghossian, Kofi, Seck; informative essays by several authors on forms of art, schooling, monumental art (murals, textiles, sculpture) and festivals; unique site photographs of public works. Excellent base study for comparison with current activity.

International Handbook of Universities, Paris, 1986, 10th edn.

International Review of African-American Art

Institut du Monde Arabe, *Art contemporain arabe: collection du musée de l'Institut du Monde Arabe,* Paris, 1988; text in French and Arabic. Catalogue for the permanent collection, with seven essays on essential characteristics, the use of calligraphy and the contributions of this aesthetic to western art.

Institut du Monde Arabe, *Rencontres africaines,* Paris, 1994. Encounters between the curators, Brahim Alaoui and Jean-Hubert Martin, and the guest curators, Belkahia and Konaté. Another 'dialogue' between Martin and A. Mebbeb discusses the veracity of locating Maghreb art within African situations.

Jahn, Janheinz, *Muntu: the New African Culture,* New York, Faber and Faber, 1961

Kelly, B., comp., and J. Stanley, ed., *Nigerian Artists: a Who's Who and Bibliography,* published by Hans Zell, UK, for the Smithsonian Institution, 1993. A colossal compendium that documents Nigeria's extensive activity in contemporary art with biographies of over 353 artists in Nigeria (1920–90) and an extensive, annotated bibiography of over 300 texts.

Kennedy, Jean, 'Introduction to Contemporary African Art', in *Contemporary African Art,* Washington, D.C., Museum of African Art, 1974

Kennedy, Jean, *New Currents, Ancient Rivers: Contemporary African Artists in a Generation of Change,* Washington, D.C. and London, Smithsonian Institution Press, 1992. Introduction to contemporary art by Africans (many resident in the USA), which stresses connections between art forms, especially literature. Strong on Nigerian art.

Kennedy, Jean, 'Wosene Kosrof of Ethiopia', *African Arts,* Los Angeles, May 1987, pages 64–67

Kidane, Girma, 'Four Traditional Ethiopian Painters and Their Life History', *Proceedings of the First International Conference on the History of Ethiopian Art,* London, 1989

Kingdon, Jonathan, ed., *Makerere Art Gallery Catalogue,* Kampala, 1985

La Duke, B., *Africa Through the Eyes of Women Artists,* Trenton, N.J., Africa World Press, 1991. Twelve biographical sketches of women artists from seven African countries (three from Nigeria) and the diaspora, imbued with a flexible attitude towards art and feminine sympathy.

La Duke, B., *Africa: Women's Art, Women's Lives,* forthcoming. Women's artistic production in six countries, including Burkina Faso, Cameroon, Eritrea and Zimbabwe.

Lloyd, P. C., *Africa in Social Change,* London, Penguin, 1968

Lucie-Smith, Edward, *Race, Sex and Gender in Contemporary Art: the Rise of Minority Culture,* London, Art Books International, and New York, Harry N. Abrams, 1994. Chapter 10, 'Modern Africa and Asia', serves well as a reminder that establishment contemporary art criticism tends to categorise art other than its own in an undifferentiated construct of the 'exotic'. The central discussion explores the location of minority (or rather pseudo-minority) art in 'a once unitary art world', raising the consideration of what happens to an African work of art when it leaves Africa.

McEvilley, Thomas, *Art and Otherness – Crisis in Cultural Identity,* Documentext, McPherson and Co., 1992

McEvilley, Thomas, *Fusion: West African Artists at the Venice Biennale,* Museum for African Art, New York; Munich, Prestel, 1993. Interviews with M. Dimé, Tamesir Dia, Onattara, G. Santoni.

Malan, Nancy E. 'Photographs in the Harmon Foundation Collection, *African Arts,* vol. 5, no. 2, winter 1973, pages 33–36

Manaka, Matsemela, *Echoes of African Art, a Century of Art in South Africa,* Johannesburg, Scotaville, 1987. First comprehensive view of contemporary art by black South Africans, from artefacts to urban murlas, by a black author.

Melotti, Umberto, 'Occidente Terzo Mundo: un incontro nel nome dell'arte', *Il Sud del Mundo: L'altra arte contemporanea [The Other Contemporary Art],* exhibition catalogue, Milan, Gabriele Mazzotta, 1991

Memmi, Albert. *The Colonizer and the Colonized,* Boston, Beacon Press, 1965

Miller, Judith D., *Art in East Africa,* London, F. Muller, 1975. The only comprehensive listing of artists and art institutions in Kenya, Uganda and Tanzania; well illustrated; now out of date.

Mit Pinsel und Meissel, Zeitgenossische afrikanische Kunst, exhibition catalogue, Museum für Völkerkunde, Frankfurt am Main, 1991

Molina, Juan Antonio, 'Art and Individual at the Periphery of the Postmodern', catalogue of the Fifth Havanna Bienniale, 1994

Mount, Marshall Ward, *African Art: the Years since 1920*, Bloomington and London, Indiana University Press, 1973; reprinted New York, Da Capo Press, 1989. Standard historical survey of contemporary art up to the seventies, with emphases on the means of change.

Mphahlele, Es'kia, *Afrika My Music, an Autobiography 1957-1983*, Johannesburg, Ravan Press, 1984

Msangi, Kiure Francis, 'The Place of Fine Art in the East African Universities', 18th Annual Meeting of the African Studies Association, San Francisco, 1975

Mudimbe, V. Y., *The Invention of Africa*, London, 1988

Musée Royal de l'Afrique Centrale, Tervuren, *La Naissance de la peinture contemporaine en Afrique centrale, 1930-70*, 1992. The catalogue, vol. 16 of *Annales sciences historiques*, has five descriptive essays and is well illustrated; see also Cornet, J. A. et al.

Museum of Modern Art, Oxford, *Art from South Africa*, London, Thames and Hudson, 1990. Catalogue for the exhibition and Zabalaza Festival (ANC); fragmented but very informative text, composed of varied essays concerning current issues; excellent chronology.

National Gallery of Zimbabwe, *Zimbabwe Heritage*, annual catalogue from 1980

National Museum of Botswana, *Contemporary Bushman Art of Southern Africa*, 1991

'New Sculpture from I. M. Nour', *African Arts*, summer 1971, pages 54–57

N'Diaye, Ibrahim, *Peindre est se souvenir*, Dakar, NEAS-Sépia, 1994

Nettleton, A. and D. Hammond-Tooke, eds., *African Art in Southern Africa: From Tradition to Township*, Johannesburg, A. D. Donker, 1989. Excellent collection of informative and well argued essays about art's diversity in southern Africa.

Nigerian Artists: a Who's Who and Bibliography, published by Hans Zell, UK, for the Smithsonian Institution, Washington, D.C., 1993

Njau, Elimo, 'Copying puts God to Sleep', *Transition*, vol. 3, no. 9, June 1963, pages 15–19

NKA, Journal of Contemporary African Art, New York, NKA Publications, 1994– . Bi-annual journal that aims to sharpen debate, jointly edited by poet Okwui Enwezor from Nigeria, critic Olu Oguibe from Nigeria, and historian Salah M. Hassan from Sudan. NKA Publications is at 247 Charlton Avenue, Brooklyn, New York, NY 11205; fax. 718 935 0907; in summer 1995 the journal is relocating to the Africana Research Center of Cornell University, Ithaca, New York; fax. 607 255 0784.

Oguibe, Olu, ed., *Third Text: Special Africa Issue*, no. 23, 1993. Excellent collection of writings by mostly British-based African artists or Africanists on a variety of topics concerning art in eastern Africa.

Okeke, Uche, *Art in Development – a Nigerian Perspective*, Nimo, Asele Institute, 1982

Okwesa, Kenneth, 'Abdalla, Sudanese Potter', *African Arts*, vol. 3:2, winter 1970, page 29

Oligive, G. with C. Graff, *The Dictionary of South African Painters and Sculptors, including Namibia*, Johannesburg, Everard Read, 1988. Key reference book for 1800 painters with appendices on museums, galleries and art centres.

Oloidi, Ola, 'Abstraction in Modern African Art', *New Culture: a Review of Contemporary African Arts*, vol. 1, no. 9, 1979

Otro País, Escalas Africanas [Another Country, African Stopovers], exhibition catalogue, Las Palmas, Grand Canary, 1994

Pankhurst, Richard, 'The Removal and Restoration of Third World's Historical and Cultural Objects: the Case of Ethiopia', *Development and Dialogue*, Dag Hammerskjold Foundation, Uppsala, vol. 1–2, 1981, pages 134–40

Pittura etiopica tradizionale, intro. Lanfranco Ricci, Rome, Instituto italo-africano, 1989

Pratt, S. A. J., 'West African Art at Oxford', *Africana: the Magazine of the West African Society*, vol. 1, no. 2, April 1949

Présence africaine: revue culturelle du monde noir, Paris, 1947–

Rankin, E., *Images in Wood: Aspects of the History of Sculpture in 20th Century South Africa*, Johannesburg Art Gallery, 1989. Painstaking research into a number of topics related to art education and museum practices.

Rencontres africaines, exhibition catalogue, Institut du Monde Arabe, Paris, 1994

Revue noire: Art contemporain africain/African Contemporary Art, ed. Jean Loup Pivin, Simon Njami et al., Paris, 1991– ; texts in French and English. Exuberant and highly visual quarterly dedicated to sharing the expressive avant-garde arts of Africa and the African diaspora. Each issue features a place and/or theme; 1994–95 covered Mediterranean Africa, Cameroon, Mozambique, Indian Ocean, with special features on photography and dance, as well as reviews, an art calendar and a letter from La Fondation Afrique en Créations. At 8 rue Cels, 75014 Paris.

Rhodes, Colin, *Primitivism and Modernism*, London, Thames and Hudson, 1995. A scholar's concise version of the story, better on the 'Primitivism' parts of twentieth-century art history than on post-modern curatorial practice; up-to-date to *Magiciens de la terre*.

Sack, S., *The Neglected Tradition: Towards a New Art History of South African art (1930-1988)*, Johannesburg Art Gallery, 1988. Six chapters relate a historical narrative.

Sahlström, Berit, *Political Posters in Ethiopia and Mozambique: visual imagery in a revolutionary context*, Uppsala, 1990

Said, Edward W., *Culture and Imperialism*, New York, 1993

Senghor, Léopold S., *Ce que je crois*, 1988

Senghor, Léopold S., *Prose and Poetry*, sel. and trans. John Reed and Clive Wake, London, Heinemann, 1976

Serima: Towards an African Expression of Christian Belief, Gwelo, Zimbabwe, Mambo Press, 1974

Seyoum, Wolde, 'Some aspects of post-revolution visual arts in Ethiopia', *Proceedings of the 9th International Conference on Ethiopian Studies*, 26–29 August 1986, Moscow, Nauka Publishers, Central Department of Oriental Literature, 1988, pages 7–25

Somjee, Sultan, *Material Culture of Kenya*, Nairobi, East African Educational Publishers, 1993

Spellman, A. B., 'The Pan Africanist Movement in Art', *The Washington Post*, 20 August 1978

Staffrider, Ten Years of Staffrider Magazine 1978–1988, ed. Andries Walter Oliphant and Ivan Vladislavic, Johannesburg, Ravan Press, 1988

Stanley, Janet, *Modern African Art: a Basic Reading List*, Washington, National Museum of African Art Library, 1995 (to be updated annually). A unique annotated bibliography of publications, mostly books and catalogues, organised by survey, exhibition and country, not by artist; the pithy summaries are both enjoyable and informative. A work-in-progress of tremendous service to scholarship on modern African art.

Studio Museum, Harlem, *Contemporary African Artists: Changing Tradition*, New York, 1990. Catalogue of the exhibition curated by Grace Stanislaus, with essays and profiles on the nine featured artists.

Sultan, Olivier, *Life in Stone: Zimbabwean Sculpture, Birth of a Contemporary Art Form*, Harare, Baobab Books, 1992. A concise version of the story with good photographs.

Tadesse, Taye, *Short Biographies of Ethiopian Artists*, Addis Ababa, 1991

Thiong'o, Ngugi wa, *Decolonising the Mind*, London, James Currey, and Nairobi, Heinemann, 1981

Thiong'o, Ngugi wa, *Moving the Centre: the Struggle for Cultural Freedoms*, London, James Currey, and Nairobi, Heinemann, 1993

Tradition and Contempora(neity), exhibition catalogue, Khartoum, 1981

Trowell, Margaret, *African Arts and Crafts: their Development in the School*, London, Longman, 1937

Vansina, Jan, *Art History in Africa*, London, Longman, 1984

Vansina, Jan, 'Arts and Society since 1935', in A. Mazrui, ed., *UNESCO General History of Africa*, vol. VIII: *Africa since 1935*, London, Heinemann, and Berkeley, University of California Press, 1993, pages 582–632. An encompassing and considered essay on the growth of the new expressive arts of Africa, including visual arts. The discussion explores contextual criteria and stresses interactions between domains of artistic activity.

Vogel, S. with I. Embong, *Africa Explores: 20th Century African Art*, New York, Center (now Museum) for African Art, 1991. The exhibition's controversial criteria for arrangement of African art by 'strains', referring to 'the function' of an art form. For each 'strain', there is an explanatory essay, a specialised essay and a list of art works with reproductions.

Vlahos, Olivia, *African Beginnings*, New York, Viking Press, 1967

Wahlman, Maude, *Contemporary African Arts*, exhibition catalogue, Chicago, Field Museum of Natural History, 1974

Wenzel, Marian, *House Decoration in Nubia*, London, Duckworth, 1972

Willet, Frank, *African Art*, London, Thames and Hudson, 1971

Williams, Denis, 'A Sudanese Calligraphy', *Transition*, June 1963

Williams, Raymond, *The Politics of Modernism – Against the New Conformists*, London, Verso, 1989

Williams, Sylvia, *Mohammed Omer Khalil, Etching; Amir Nour, Sculpture*, Washington, The National Museum of African Art, 1994

Williamson, S., *Resistance Art in South Africa*, London, David Philip, 1989

Winter Irving, C., *Stone Sculpture in Zimbabwe: Context, Content and Form*, Harare, Roblaw Publishers, 1991. Described by Janet Stanley (Chief Librarian of the National Museum of African Art Library, Smithsonian Institution) as 'the most useful book to begin a study of the subject'.

World of Learning 1995, The, London, 1994

Yorkshire Sculpture Park, *Contemporary Stone Carving from Zimbabwe*, 1990. Important essays by Vice-President Joshua Nkomo, McEwen and Mariga; well illustrated.

Younge, G., *Art of the South African Townships*, London, Thames and Hudson, 1988

Contributors' biographies

Clémentine Deliss

A critic and curator, she lives in London where, during 1995, she worked on developing the artistic direction of africa95. After a Ph.D. on exoticism and eroticism in 1930s French anthropology, she published articles on the reception of contemporary African art in an international setting. Exhibitions she has curated include *Lotte or the Transformation of the Object* (Grazer Kunstverein/Akademie der Bildenden Künsten, Vienna, 1990) and *Exotic Europeans* (South Bank Centre, London, and tour, UK, 1990–91). In 1992–93, with a Research Fellowship in African art from the School of Oriental and African Studies, University of London, she set up a series of artists' talks and seminars on contemporary criticism of African art.

Salah M. Hassan

Born in Juba, Equabria Province, in western Sudan, he gained a Ph.D. from the University of Pennsylvania, and is now Assistant Professor of African art history at Cornell University Africana Studies and Research Center. The author of *Art and Islamic Literacy among the Hausa of Northern Nigeria* (Edwin Mellen Press, 1992), he recently curated *Creative Impulses, Modern Expressions, Four African Artists: Skunder Boghossian, Rashid Diab, Mohammed Omer Khalil, Amil Nour* for the 1993 Festival of Contemporary African Arts at Cornell.

David Koloane

Born in Alexandra, Johannesburg, in 1938, he is an internationally distinguished painter with a studio in the Bag Factory artists' complex in Johannesburg. He was instrumental in setting up initiatives for black artists in South Africa, including the Thupelo painting workshops in Johannesburg in the mid eighties, which were based on the Triangle model. He is a regular exhibitor; recently, in the exhibition of South African art at the Venice Biennale, and at the Stedilijk Museum, Amsterdam. He has published several texts, including a contribution to the recent South Africa edition of *Revue noire*.

Catherine Lampert

Director of the Whitechapel Art Gallery since 1988, she studied art history and sculpture at Brown University and Tyler School of Art, then began organising and curating exhibitions for the Arts Council of Great Britain, principally at the Hayward Gallery, South Bank Centre, London. These included *Sacred Circles: 2000 Years of North American Indian Art* (1976) and *In the Image of Man* (1982); for the Whitechapel, *Living Wood, Sculptural Traditions of Southern India* (1992). She has written extensively on British artists, especially Lucian Freud, Frank Auerbach, Barry Flanagan, and on Rodin.

Everlyn Nicodemus

An artist and writer, she was born in 1954 in Kilimanjaro, Tanzania; she has lived in Sweden and France, and is currently based in Antwerp, Belgium. Her work has been exhibited since 1980 in Africa, Europe, India and Japan, and she was a guest student at the Hochschüle der Künste in West Berlin in 1988. A member of the advisory board of *Third Text* in London, and the *Journal of Contemporary African Art* in New York, she is widely published and has given papers at many international arts conferences.

Wanjiku Nyachae

Born in Kenya in 1961, she was educated there and at the School of Oriental and African Studies and University College, London, before returning to Kenya to work for the Watatu Foundation in Nairobi. She has extensive knowledge of East African art and was curator of the Kenyan work for the Johannesburg Biennale in 1995.

Chika Okeke

An artist, poet, critic and curator, he was born in Nigeria in 1966; he graduated with first-class honours in Fine and Applied Arts from the University of Nigeria, Nsukka, where he is currently a lecturer in art. His work has been shown in Nigeria and Berlin, and his writing has appeared in numerous magazines, including *The Eye, West Africa, African Guardian, African Concord* and the *Daily Times*. He has curated several exhibitions in Nigeria and, in February 1995, the Nigerian section of the Johannesburg Biennale.

El Hadji Sy

Born in Senegal in 1954, El Hadji Sy (El Sy) studied fine arts at the Ecole Nationale des Beaux-Arts in Dakar. A widely exhibited artist, and a curator, he has worked on projects on contemporary Senegalese art both in Africa and Europe; these include co-editing, with Friedrich Axt, an *Anthology of Senegalese Contemporary Art*, and compiling a collection of works for the Museum für Völkerkunde, Frankfurt am Main, in 1989. In Dakar he was President of the Association of Visual Artists of Senegal (ANAPS) for several years, and has organised a number of exhibitions and initiatives, including the Village des Arts and the Laboratoire Agit-Art. He was the main contributor to the Dakar issue of *Revue noire* in December 1992. In September 1994 he hosted Tenq/Articulations, the first Triangle Workshop to be held in Senegal.

Tayo Adenaike

Born in Nigeria in 1954, he graduated in art at the University of Nigeria, Nsukka, in 1979, with a thesis on Oshogbo artists. He has exhibited in Nigeria, the USA and Germany, and is the creative director of Dawn Functions, an advertising agency in Enugu, Nigeria.

Bill Ainslie

Born in 1934, he studied art at Natal University, and dedicated his life to making and teaching art to all races in apartheid South Africa. His schools evolved into the multiracial Johannesburg Art Foundation; through this, his own painting, and the art centres and workshops he initiated, his influence on South African art was profound. His painting won many awards, and is now well represented in major private collections in Europe and the USA, and in galleries in South Africa, including the National Gallery. He died in a car crash in 1989.

Skunder Boghossian

Born in Ethiopia in 1937, he moved to the USA in 1969 and became a member of AfriCobra, the Panafrican artists' collective based at Howard University, Washington, D.C. He has exhibited worldwide and is recognised as one of Ethiopia's foremost artists, who introduced the scroll and traditional elements such as goatskin and Coptic iconography into contemporary painting.

Elsbeth Court

Born in Connecticut, she lived and worked for 17 years in East Africa and since 1990 has been lecturer in African art history at the School of Oriental and African Studies, University of London. Her primary research is on culture and drawing in Kenya, but she also writes more widely on contemporary arts in Africa.

Achamyelah Debela

Born in Addis Ababa, Ethiopia, in 1947, he studied fine arts at Zaria, Nigeria, before doing postgraduate work in Baltimore and Columbus, Ohio, where he specialised in computer graphics and art education. A widely exhibited artist and an art curator, he is currently Professor of Art at North Carolina Central University.

Abdou Diouf

Born in Senegal, he succeeded Senghor as President in 1981 and is still in office.

Jeff R. Donaldson

Born in Pine Bluff, Arkansas, he is an artist, historian, and currently Dean of Howard University, Washington, D.C. He was a founder member of AfriCobra in 1968, the artists' collective which sought a Panafrican aesthetic and involved members from Africa and the African diaspora in the USA.

Jacob Jari

Born in Nigeria in 1960, he studied art at Zaria and is one of the founding members of The Eye, a society based at the university. He is editor of *The Eye* magazine and a full-time artist.

dele jegede

Born in Nigeria, his professional activities span both painting and art history. He has recently completed a Fellowship at the Smithsonian Institution in Washington, D.C., and currently teaches art history at Indiana State University, Terre Haute.

Fabian Mpagi Kamulu

Born in 1953 in Kyabatuga, Uganda, he studied fine arts at Makerere University, Kampala, and is now Director of the Nommo Gallery in Kampala.

Jonathan Kingdon

Born in Tabora, Tanzania, in 1935, he is a professional zoologist and painter who lived for many years in Uganda. He was external examiner for the Royal College of Art in the early 1970s and was Dean of the Margaret Trowell School of Art at Makerere University, Kampala.

Wosene Kosrof

Born in Addis Ababa, Ethiopia, in 1950, he currently lives in Germany where he works as an artist, exhibiting regularly in Europe and the USA. Wosene took part in the exhibition *The Hidden Reality: Three Contemporary Ethiopian Artists*, Völkerkundemuseum der Universität, Zürich, in 1989.

Pierre Lods

A French mathematician, he was an amateur painter who started the Poto-Poto school in the Congo in 1951.

As M'Bengue

Born in Senegal in 1953, he is a philosopher and professor of humanities. He has taught in Dakar and is currently based in Libreville, Gabon.

Es'kia Mphahlele

Born in South Africa, he spent several years of his life in exile, keeping closely in touch with South African artists and intellectuals who found homes in Europe and the USA.

Hassan Musa

Born in western Sudan in 1951, he studied fine art and art history in Khartoum and Montpellier, France; he now lives near Nîmes where he works as a teacher, painter and writer. Recent art includes performance pieces in Algeria, France and the UK, and the illustration of several books.

Njabulo S. Ndebele

President of the National Arts Coalition, he is a former President of COSAW, the Congress of South African Writers. A leading player in the struggle for educational and cultural change in South Africa, his essays on literature and culture have shaped recent discussion on the arts .

Francis Nnaggenda

Born in 1936 in Buganda, Uganda, he taught at the universities of Nairobi and Indiana during the seventies, and is now Professor of Sculpture at Makerere University, Kampala.

Uche Okeke

Born in Nigeria in 1933, he was a founder member of the Zaria Art Society, a pioneer in the development of modern *uli* art, and founder in 1958 of the Asele Institute in Jos, a centre for research into Nigerian visual arts (later moved to Nimo during the Nigerian civil war). His work as an artist and educator has earned him respect both at home and abroad.

Andries Walter Oliphant

Born in South Africa, he lectures in the theory of literature at the University of South Africa, and is editor of *Staffrider* magazine. He heads a task team of the Ministry of Arts, Culture, Science and Technology, set up to develop a democratic arts policy for South Africa. He is widely published as a playwright, and on the visual arts, the media and cultural policy.

Ola Oloidi

Born in Nigeria in 1944, he is Professor of Art History at the University of Nigeria, Nsukka. He has written extensively on Nigerian modern art, its relationship to colonialism and to the lives of Kenneth Murray and Aina Onabolu.

Bruce Onobrakpeya

Born in Nigeria in 1932, he studied at Zaria in the late 1950s and has since established himself as one of Nigeria's foremost printmakers and artists. He runs his own workshop and studio, the Ovuomororo Gallery in Lagos, and has exhibited extensively both in Africa and elsewhere.

Okot p'Bitek

Born in Uganda in 1931, he was a poet of liberation with a deep sensibility for his home country. He was appointed lecturer in the department of sociology and anthropology at Makerere University, Kampala, after independence in 1963. In exile from 1968 to 1979, he died in 1982.

Ivor Powell

Born in South Africa, he is a writer and art critic who has contributed to numerous debates on contemporary South African art in the international arena.

Issa Samb

Born in Senegal in 1945, Issa Samb (alias Joe Ouakam) is a painter, performance artist and philosopher, whose activities at the Laboratoire Agit-Art in Dakar have been central to Senegalese visual expression over the last twenty years.

Léopold Sédar Senghor

Born in Senegal in 1906, he was President of Senegal from 1960 to 1980, during which time he created an art infrastructure including museums, art schools, tapestry industries and local patronage of the arts. One of the most important exponents of Negritude, a philosophy of African existence which he wove into his politics, he has been a member of the Académie Française since 1983.

Warren Shaw

Born in Belfast in 1927, he lived and worked in Africa for nearly 20 years, first as an education inspector in Sudan and then as the British Council representative in Ghana, Nigeria and Tanzania. Awarded the O.B.E. for his services, he is the author of several books on language and modern history. He died in London in 1995.

Pilkington Ssenggendo

Born in 1941 in Buganda, Uganda, he studied at Makerere University, Kampala, from 1962 to 1966; he is now Dean of the School of Fine Art and senior lecturer.

Etale Sukuro

Born in Nairobi, Kenya, in 1954, he grew up in Tanzania and studied at Dar-es-Salaam University, before becoming an active figure in grass-roots art movements, such as Sisi Kwa Sisi, in the early 1980s. His work was shown in the 1990 New York exhibition *Africa Explores*, and is in the collection of the Museum für Völkerkunde, Frankfurt am Main.

7 + 7 = 1, pages 13–27

1. Introduction to exhibition catalogue, *Contemporary African Artists: Changing Tradition*, Studio Museum of Harlem, New York, 1990, curated by Grace Stanislaus.

2. John Picton is the former Head of the Department of Art and Archaeology at the School of Oriental and African Studies, University of London, and Reader in African Art. I am very grateful to him and to S.O.A.S. for supporting this early research.

3. The marker exhibitions are *Magiciens de la terre*, Centre Georges Pompidou and La Villette, Paris, 1989, curated by Jean-Hubert Martin; *Africa Explores – Digesting the West,* Center for African Art, New York, 1990, touring to Liverpool, UK, in 1993; *Africa Hoy/Out of Africa* (the collection of Jean Pigozzi, curated by André Magnin), Centro Atlantico de Arte Moderno, Las Palmas de Gran Canaria, 1991, touring to the Saatchi Gallery, London, in 1992. In addition, the Paris-based magazine *Revue noire* emerged in 1991, presenting for the first time a well-informed, visually rich if somewhat uncritical survey of the arts in different African and African-diaspora countries. The 1992 Dokumenta in Kassel showed work by Mo Edoga (Nigeria) and Ousmane Sow (Senegal), and the Venice Biennale included African artists in 1991 and 1993.

4. 'Extinct' is one of the categories Susan Vogel proposed in *Africa Explores* to demarcate art in Africa that is no longer produced but exists only in iconic form, e.g. a Benin bronze head imaged on a postage stamp. Other categories included 'Traditional', 'New Functional', 'Urban' and 'International'.

5. Valuable exhibitions have taken place over the last thirty years in London at the Commonwealth Institute, the Africa Centre, and a number of smaller galleries such as the 198 Gallery in Brixton, the Black Art Gallery in Finchley, and the October Gallery. These exhibitions introduced the work of African and African-descent artists to audiences in London, but remained nevertheless on the periphery of the art establishment. Rasheed Araeen's *The Other Story* at the Hayward Gallery in 1989 was groundbreaking in that it took on board the presence of black artists within the British mainstream since the 1950s.

6. The selectors of *Magiciens de la terre* reverted to the catch-all concept of the 'magician', which was made to cover both western and non-western artists. Research on art works in Africa came through ethnographers and museologists rather than artists or critics working in Africa. The complexities of art production were inaccessible, and the selectors had no choice but to limit information all round. This inevitably raised questions on the interpretative specificities of the work on show.

7. See Notes and Further Reading.

8. Thomas McEvilley, who supported *Magiciens de la terre* for the post-modernist premise upon which it was based, deplores 'the atrocious catalogue statements by the curators themselves, with their talk of spirituality implying universals they may not have intended, and their rather clumsy, gung-ho enthusiasms' (*Art and Otherness*, page 155).

9. James Hall, art critic of *The Guardian*, in conversation with the author in Senegal, September 1994.

10. E.g. Le Premier Festival des Arts Nègres, Dakar, 1966; Algeria 1969; Nigeria 1977 (see Notes for details).

11. Susan Vogel writes: 'International African artists address an international audience, represent their countries in international gatherings such as the Panafrican Games or in Biennale exhibitions in places as various as São Paolo, Libreville and Paris and exhibit internationally mainly under government auspices.' Her generalisations on international artists become more and more untenable as she develops the category: 'International artists not only avoid dealing with their immediate surroundings, they virtually never paint strongly felt or topical subjects. Their work is rarely critical or satirical and only obliquely political.' She concludes: 'International artists in Africa share few concerns with the avant-garde artists of the main western art centres. Perhaps because their art aspires to be socially useful, none seems to have been touched by any of the western avant-garde movements' (*Africa Explores*, page 194).

12. See Thomas McEvilley, *Art and Otherness – Crisis in Cultural Identity*, Documentext, McPherson and Co., 1992; introduction, page 10.

13. Raymond Williams speaks of 'border-crossing' as part of the living reality of the intellectual and the artist in the first thirty years of this century; see *The Politics of Modernism – Against the New Conformists*, London, Verso, 1989. The relationship beween the racial, national and cultural identities and modernity in Africa, Europe and the USA is explored by Paul Gilroy in *The Black Atlantic – Modernity and Double Consciousness*, London, Verso, 1993.

14. The nucleus consisted of Robert Loder, Simi Bedford, the Royal Academy of Arts and myself. I was charged with developing the africa95 concept in consultation with artists in Africa and the UK and with helping to seek the support of other UK arts institutions and producers.

15. Ulli Beier met the Englishman Julian Beinart in the late 1950s, in what was then Lourenco Marques (now Maputo), capital of Mozambique. Beinart, together with the Portuguese architect Pancho Guedes, had developed a teaching method for art which Ulli Beier described later as 'shock treatment' or a 'Blitzkrieg' technique. Beinart would make his students do extreme exercises using unusual materials in order to rid them of their inhibitions. In contrast, Beier felt that his young would-be artists in Oshogbo, Nigeria, had no need for this treatment, since they had no inhibitions or preconceived ideas to cloud their expression. His *tabula rasa* approach has been much criticised as romantic and silent to the realities of artistic cross-fertilisations in Nigeria (see Ulli Beier, *Contemporary Art in Africa*, London, Pall Mall Press, 1968, page 107). Thomas McEvilley reminds us that 'the question of influence or affinity involves much broader questions, such as the nature of diffusion processes and the relationship of Modernist aesthetics to the Graeco-Roman and Renaissance tradition. In cultural history in general, diffusion processes are random and impersonal semiotic transactions. Images flow sideways, backwards, upside down. Cultural elements are appropriated from one context to another not only through spiritual affinities and creative selections, but through any kind of connection at all, no matter how left-handed or trivial' (*Art and Otherness*, page 41).

16. Thomas McEvilley, introduction to *Art and Otherness*, 1992.

17. Franz Fanon, 'On National Culture', in *The Wretched of the Earth*, 1965, page 179.

18. Raymond Williams, *The Politics of Modernism – Against the New Conformists*, 1989.

19. Conversation with Issa Samb in the Laboratoire Agit-Art, Dakar, 9 December 1993.

20. The Laboratoire Agit-Art has worked with Youssou N'Dour, Bouna Medoune Seye, Seyba Lamine Traoré, Babacar Traoré and many others.

21. Antonin Artaud, 'The Theatre of Cruelty: First Manifesto', 1932, reprinted in *Antonin Artaud – Selected Writings*, ed. Susan Sontag, Berkeley, University of California Press, 1988.

22. Ibid.

23. 'A direct communication will be re-established between the spectator and the spectacle, between the actor and the spectator, because the spectator, by being placed in the middle of the action, is enveloped by it and caught in its cross-fire'; Antonin Artaud, 'The Theatre of Cruelty: First Manifesto'.

24. The cowrie shell was proposed by El Hadji Sy as the icon for the africa95 season. It signifies cultural currency by connecting an ancient symbol of value with a future system of exchange and collaboration between artists.

25. Emokpae's work, writes jegede, 'buries the bogey of modernism as an exclusive white property. Abstraction which has been appropriated by the white cultural establishment and sanctimoniously installed as the soul of modernism is, in the artist's view, modern only to them: African art has always been based on abstraction. In other words, long before latter-day apologists of modern art arrived in Nigeria in the sixties armed with maps and compasses, bags full of brown papers, brushes and emulsion paint and a new philosophy of cultural imperialism, Emokpae and artists like him had demonstrated, in thoughts and in deed, the nascence of modernism on the African continent.'

26. Uche Okeke and Chika Okeke are not related, although they know each other well.

27. Kojo Fosu, *Twentieth Century Art of Africa*, Zaria, Gaskya Press, 1986, page 12.

28. The terms need highlighting to indicate that their own definitions are contested.

29. Kojo Fosu, op. cit., page 6.

30. *Decolonising the Mind*, London, James Currey/Heinemann, 1986, page 87.

31. '*L'esthétique sans le savoir*' not only suggests that aesthetic appreciation is non-contrived and part of everyday life in Senegal, but also indicates the strong line of non-criticality that characterises much of Senegalese art today. This non-criticality is less an anti-intellectual, *embourgeoisiment* of practice, than the more complex and experimental attempt to conceive of the legitimation of the movement or the aesthetic action before its encapsulation in a verbal mode.

32. The conception of a visual memory plays an important part in this relationship. The Malian philosopher Amadou Hampaté Bâ writes about the prodigious memory of African peoples, and in particular the Peul who live in regions that cross over

from Mali into Senegal and Niger: 'C'est que la mémoire des gens de ma génération et plus généralement des peuples de traditions orales qui ne pouvaient s'appuyer sur l'écrit, est d'une fidélité et d'une précision presque prodigieuses. Dès l'enfance, nous étions entraînés à observer, à regarder, à écouter, si bien que tout évènement s'inscrivait dans notre mémoire comme dans une cire vièrge. Tout y était: le décor, les personnages, les paroles, jusqu'à leurs costumes dans les moindres détails. Quand je décris le costume du premier commandant de cercle que j'ai vu de près dans mon enfance, par exemple, je n'ai pas besoin de me "souvenir", je le vois sur une sorte d'écran intérieur, et je n'ai plus qu'à décrire ce que je vois. Pour décrire une scène je n'ai qu'à la revivre.'

33. Interestingly, Antonin Artaud's discussion of Flemish painting corresponds closely with the visions proposed in the Ugandan paintings. He writes: 'The nightmares of Flemish painting make an impression on us because of the juxtaposition to the real world of what has become a caricature of this world. They present us with phantoms which we might have encountered in our dreams. They have their source in those semi-conscious states which give rise to abortive gestures and absurd slips of the tongue. Next to an abandoned child they place a leaping harp; next to a human embryo swimming in subterranean waterfalls they show a formidable fortress below which a veritable army advances. Next to dreamlike uncertainty the march of certainty, and beyond a yellow underground light and orange glow of a huge autumn sun about to disappear'; 'The Theatre of Cruelty: First Manifesto', page 270.

34. Conversation with Jonathan Kingdon, April 1995.

35. See Notes for full listings on the southern African workshops.

36. Tenq came about as a result of the meeting of El Hadji Sy and David Koloane at the Seven Stories forum at the Whitechapel Art Gallery in October 1993. El Hadji Sy, together with a group of Senegalese artists and Anna Kindersley from the Triangle Arts Trust, raised local funds and invited 26 artists from ten African countries and the UK to take part in what became the first africa95 event.

37. While the Johannesburg Biennale of 1995 may have drawn greater international attention to South Africa by placing the spotlight on artists from over 65 countries as far apart as Chile and Bulgaria, it appears to have missed out on the opportunity of investing intensively in small-scale local projects that would have responded more effectively to audience development at home, while providing outside onlookers with a greater specificity of artistic expressions and their cultural infrastructures in South Africa.

38. For example, Rachid Kureishi (Algeria) and Nja Mahdaoui (Tunisia).

Inside. Outside, pages 29–36

1. Franz Fanon, The Wretched of the Earth, London, 1967.

2. Edward W. Said, Culture and Imperialism, New York, 1993.

3. Juan Antonio Molina, 'Art and Individual at the Periphery of the Postmodern', Catalogue of the Fifth Havanna Bienniale, 1994.

4. Ngugi wa Thiong'o, Moving the Centre, London, 1993.

5. Ola Oloidi, 'Growth and Development of Formal Art Education in Nigeria', Transafrican Journal of History, Nairobi, 1988.

6. V. Y. Mudimbe, The Invention of Africa, London, 1988.

7. Ibn Khaldun, Prolegomena. Introduction to the World History (Swedish translation, 1989).

8. Uche Okeke, 'History of Modern Nigerian art', Nigeria, Lagos, 1979.

9. Steve Biko, 'Some African Cultural Aspects', I Write What I Like. A Selection, London, 1978.

10. Leon Wieseltier, 'Against Identity', The New Republic, trans. in Die Zeit, 1995.

The Khartoum and Addis Connections, pages 102–39

1. I am invoking here the Bakhtinian concepts of 'intertextuality' and 'dialogic' principle in relation to the study of literature. This dialogic relationship is assumed to exist on temporal as well as spatial and historical levels. Within this reality, these art works can be seen as existing in one contemporary space and interacting with each other in a 'dialogic' manner.

2. This is often in response to the interest and taste of foreign tourists. Some artists have opened galleries in major cities to sell mainly reproductions of ancient monuments or traditional works of art of historical significance.

3. See Elizabeth Biasio, The Hidden Reality: Three Contemporary Ethiopian Artists, Zürich, Ethnological Museum of the University of Zürich, 1989, page 85.

4. The visitors' book from El Salahi's exhibition in Paris in October 1962 includes a signed and dated compliment from Skunder Boghossian. The two artists are old friends and hold each other's work in high regard.

5. Some excellent artists also opted to stay at home; they have remained productive and creative despite shortages and the absence of basic liberties under Haile Selassie's monarchy and the Derge regime in Ethiopia, or the successive military regimes in Sudan. Today, the situation in Sudan is tragic. Khartoum College of Fine and Applied Art has deteriorated since the military government came to power in 1989. Several excellent artists and teachers have left the country or been forced into exile; others have been harrassed and intimidated. The Ministry of Culture is now headed by elements close to the Islamic Fundamentalist party and the National Islamic Front.

6. In general, British colonialism in Sudan (1898–1956) resulted in structural changes at the socio-economic level which in turn created a 'duality' within Sudanese society and culture – i.e., a traditional sector undergoing gradual destruction and articulation into the central market economy; and the subsequent rise of modern urban centres. At the level of culture and arts, this duality produced two major forms: a 'folk' culture and art within the traditional sectors of society; and the gradual rise of a modern élite and 'popular' cultures and art in modern urban centres.

7. M. O. Beshir, Educational Policy in the Sudan: 1898–1959, Oxford, Clarendon Press, 1969, pages 23–24.

8. As I have learned in a recent interview with the Sudanese artist Osman Waqialla, London, July 1993. Jean-Pierre Greenlaw, the British founder of the College of Fine and Applied Arts,

was a liberal humanist influenced to a great extent by William Morris, John Ruskin and the arts and crafts movement. A skilled painter, and a musician who mastered several instruments to sing and play Sudanese songs, he was fluent in Sudanese colloquial Arabic and very much admired by his Sudanese students.

9. Prior to his appointment as General Director of Education in Sudan, Mr Cox, a humanist and a liberal educator rather than a politician, was Dean of New College, Oxford. The others heading the committee were Lord Delaware and Mr Griffith, the Principal of Bakht al-Rudha Institute. See The Delaware Report on Education in the Sudan, 1936.

10. Jean-Pierre Greenlaw's role was equivalent to those played by Kenneth Murray in Nigeria, Margaret Trowell in Uganda and Frank McEwen in Zimbabwe.

11. The Khartoum Technical Institute (KTI) later became Khartoum Polytechnic, and is now Sudan University of Technology.

12. The College started with two-year courses leading to a diploma; recently it became a four-year college offering a B.A. See College of Fine and Applied Arts prospectuses for 1968, 1969 and 1972. Subjects like industrial design and weaving were late introductions; folk art studies are expected in the future.

13. After studies at Camberwell School of Art, London, 1946–49, Waqialla went to the School of Arabic Calligraphy and College of Applied Arts in Cairo. He was also a poet, journalist and broadcaster.

14. In his series of works of calligraphic variations on themes of Quranic texts, such as the Prophets' Series [Al-Anbiyaa] or the Abbreviated Letters of the Quran Series [Al-Huruf al-Nuraniya], Waqialla's non-canonical creative treatment of sacred text is masterfully expressed; his secular explorations are best exemplified by his series on Sudanese modern poetry. To this date, he continues explorations of these two themes, which he calls the 'third' and the 'fourth dimensions'.

15. According to an interview conducted by Hassan Musa, Taj Ahmad claimed to have been the first to incorporate Arabic calligraphy into his paintings on canvas.

16. Again with the exception of Osman Waqialla, this early chapter in the history of modern art did not produce any clear philosophical orientation or a definitive aesthetic inclination, nor did it reflect any socio-political or intellectual issues. Perhaps these pioneers felt the challenge of mastering academic skills; perhaps they were influenced by rather rigid, uninspiring British teachers who advocated 'art for art's sake.'

17. The term Khartoum School, coined primarily by Dennis Williams, a scholar and art critic from Trinidad who taught in the College of Fine and Applied Art in the early 1960s, was echoed by other western art critics. It has proved problematic, however, if taken to mean a 'school' as the term is used in western art circles.

18. Other patrons are foreign tourists, expatriates and the cultural centres of western countries, in addition to a small sector of upper-middle-class Sudanese. The government now offers limited support through education, museums, galleries and commissions for public monuments. Artists themselves have formed associations for mutual support and to mount

exhibitions and other activities.

19. All major language groups are represented in Sudan except the Khoisan language of southern Africa. See R. C. Stevenson, 'The Significance of the Sudan in Linguistic Research', Sudan in Africa, ed. Yusuf Fadl Hasan, Khartoum, IAAS Publications, Khartoum University Press, 1971, pages 11–25; M. O. Beshir, Cultural Diversity and National Unity in Sudan, Khartoum, IAAS Publications, Khartoum University Press, 1980.

20. The cultural diversity of Sudan and the relationship of its two major elements have drawn the interest of social anthropologists, historians and political scientists, who have tried to stress one element over the other or a reconciliation of both by claiming its fusion into a synthesis. See M. Abdal Rahim, 'Arabism, Africanism and Self-Identification in the Sudan', Sudan in Africa, ed. Hasan, op. cit., pages 244–39; Abdal Magid Abdin, Tarikh Al Thagafa Al Arabia fi Al Sudan [History of Arabic Culture in the Sudan], Beirut, Dar Al Thagafa, 1967; Ali A. Mazrui, 'The Multiple Marginality of the Sudan', Sudan in Africa, op. cit., pages 240–55; Muhammad Abdul-Hai, Conflict and Identity: The Cultural Poetics of Contemporary Sudanese Poetry, Khartoum, IAAS Publications, Khartoum University Press, 1976; Muhamad al-Makki Ibrahim, Al Fikr Al Sudani Usuluh Wa Tatawurhu [The Sudanese Thought: its Origin and Development], Khartoum, Ministry of Culture and Communication, 1976. Several other studies could be cited; the subject is still of major concern to the scholars of Sudan.

21. M. Abdul-Hai, op. cit., pages 6–7.

22. Ibid., page 13.

23. Hamzah Tambal, 'An Essay in Sudanese Literature', Al-Fajr. vol. 3, no. 1, March 1937, page 3.

24. The poetry of Muhammad Al Fayturi is a good example of identity crises solved poetically through stressing the African element; see his collection of poems, Ashig min Afriqiya [A Lover from Africa].

25. Muhammad al-Makki Ibrahim, from Ummati [My Nation], Khartoum, Ministry of Culture, 1969, page 123, trans. in M. Abdul-Hai, op. cit., pages 50–53.

26. Salah Ahmad Ibrahim, from Ghabat Al Abanus [The Forest of Ebony], Beirut, 1958, page 45; trans. in M. Abdul-Hai, op. cit., page 52. Al Nur 'Uthman Abbakar stresses the 'return to roots' as follows:

This is the deliverance of fire
collect the roots of the sources
 in the rock
in the depth of the nights of the forest
and in the cellar of early legends.

From Sah wu Al Kalimat Al Man Siyyah [The Awakening of the Forgotten Words], Khartoum, Khartoum University Press, 1972, page 62.

27. The members of this group were mostly influenced by Marxism, existentialism and other philosophies of the left.

28. This marginality, and its accompanying 'return to roots' claim that characterises most third-world intellectual movements, constitutes the socio-cultural drama of the colonial élites or native 'petty bourgeoisie'; see Amilcar Cabral, Anthology, vol. 1: Capitalism. Imperialism, New York, International General, 1979, pages 205–12, 207; Franz Fanon, The Wretched of the Earth, New York, Grove Press, 1963, page 248.

29. As Amilcar Cabral has said: 'It is felt

significantly only at the vertex of the social pyramid – the pyramid colonialism itself created – and specifically affects a very limited number of workers in urban centres' (op. cit., page 206). This situation derives on one hand from the necessarily obscurantist character of imperialist rule which, while despising and repressing the cultures of the dominated people, has no interest in promoting acculturation of the masses who are the source of forced labour and the prime object of exploitation, and on the other from the effective cultural resistance of those masses who find in their own culture the support to preserve their own 'identity'.

30. Ulli Beier, brochure, Contemporary African Art Exhibition at the Institute of Contemporary Arts, London, 1967.

31. 'El Salahi: a Painter from the Sudan. Rhythm and Structure of Arabic Alphabet Underlie Most of his Forms', *African Arts*, vol. I, 1, autumn 1967, pages 16–26.

32. Ibid.

33. Robert Serumaga, 'Conversation with Ibrahim El Salahi', *Topic*, no. 24, 1967, pages 14–15.

34. M. Ward Mount, *African Art: The Years Since 1920*, Bloomington, Indiana University Press, 1973, page 110.

35. Interview with Ibrahim El Salahi, Oxford, August, 1994.

36. Evelyn S. Brown, *Africa's Contemporary Art and Artists*, New York, Harmon Foundation, 1966, page 109.

37. Sondra Hale, 'Musa Khalifa of Sudan', *African Arts*, vol. 5, no. 3, spring 1973, page 14.

38. Solar engraving resembles the 'hot rod iron' engraving technique, used by traditional artists in Sudan to decorate calabashes and gourds. Traditionally, African women use a paste from powdered henna to create geometric and abstract patterns on feet and hands. Henna is also used as a hair colouring by both men and women.

39. The Arabic calligraphy decorating the gate in the painting is similar to words used to adorn the gates of houses belonging to pilgrims returning from Mecca.

40. Several essays and exchanges related to that debate were published in the weekly culture and arts section of *Al-Ayyam*, the daily newspaper, and in the *Journal of Sudanese Culture* (published by the now defunct Department of Culture). The debate took place during the military dictatorship of General Nimerie (1969–85). Between the early 1970s and the early 1980s, the regime managed to co-opt liberal and independent left-wing intellectuals to work within its ranks, who tried to make intelligent use of the space allowed them to further their own artistic and literary agenda.

41. Interview with Kamala Ishaq, London, August 1994.

42. J. Hevesi, 'The Paintings of Kamala Ishaq', *Contemporary African Art*, exhibition catalogue, Camden Arts Centre, London, Studio International, 1969, page 276.

43. Excerpts were published in the daily newspaper *Al Ayyam*.

44. Hassan M. Musa, 'Fi Al Khalfiya Al Igtima 'iyah lil Jamaliyah Al 'Irqiya' [On the Social Background of Ethno-Aesthetics]', *Majallat Al Thagafa Al Sudaniya [Journal of Sudanese Culture]*, no. 4, August 1977, pages 59, 68.

45. Sami Salim, 'hiwar Maa' Bola [Dialogue with Bola]', *Majallat Al Thagafa Al Sudaniyya [Journal of Sudanese Culture]*, vol. 5, no. 19, November 1981, page 108.

46. Musa, op. cit., page 70. Musa also rejected the naming of works of art, which was adopted by Khartoum School artists.

47. Abdalla Bola, 1981, page 107.

48. The Society for Islamic Thought was formed in the early 1980s by members of the Muslim Brotherhood; it is now known as the National Islamic Front and is a fundamentalist Islamic group, although it has tried to recruit non-fundamentalists.

49. See Sharbal Daghir, *Al Hurufiyya al Arabiya: Fan wa Hawiya [Arabic Calligraphism: Art and Identity]*, Beirut, The Printing Company for Publishing and Distribution, 1990.

50. See Shakir H. Al Said, *al-Usul al Hadariya wa al Jamaliya lil Khat al Arabi*, Baghdad, 1988.

51. Ulli Beier, *Ibrahim El Salahi, an Interview*, Bayreuth, Iwalewa-Haus, University of Bayreuth, 1983.

52. Abdalla graduated in 1957 and then studied at the Central School of Art and Design, London, until 1962. He headed the Ceramic Department at the Camden Arts Centre, north London, for more than 15 years.

53. Abdalla works principally in stoneware and porcelain, and all his pots are thrown, the goblets in two sections. Simple, felipathic glazes are in most cases combined: oatmeal and white, transparent and green. His pots are biscuit fired to 1100°C and glaze fired to 1280°C.

54. El Khatim, born in Omdurman in 1942, graduated from the College of Fine and Applied Art in 1967. He then obtained an M.A. in Education from the University of Wales, and now teaches in the Department of Education in the College of Engineering, Sudan University of Technology, Khartoum.

55. See Sylvia Williams, *Mohammed Omer Khalil, Etching; Amir Nour, Sculpture*, Washington, The National Museum of African Art, 1994. Both were graduates of the College of Fine and Applied Art in the late 1950s, and have lived and worked in the USA for 20 years. Nour travelled to Britain in the late 1950s on a scholarship and studied at the Slade and the Royal College of Art in London; in 1969 he went to Yale University School of Art and Architecture. He works in a variety of media, including bronze, stainless steel, cement fondu, plaster, wood and moulded plastic. Mohammed Omer Khalil studied for three years at the Academy of Fine Arts in Florence, where he began his lifetime interest in printmaking; he also studied fresco and mosaic media.

56. Richard Pankhurst, 'The Removal and Restoration of Third World's Historical and Cultural Objects: The Case of Ethiopia,' *Development and Dialogue: a journal of international development*, Dag Hammerskjold Foundation, Uppsala, 1981, 1–2, pages 134–40.

57. Achamyeleh Debela, 'A Pioneer in Spite of the Odds: Gebre Kristos Desta of Ethiopia (1932–81)', *Third International Conference on the History of Ethiopian Art*, 9–12 November 1993, The Ethiopian Studies Institute, Addis Ababa University.

58. Elizabeth Biasio, 'Contemporary Painting', *Die verborgene Wirklichkeit: drei äthiopische Maler der Gegenwart [The Hidden Reality: Three Contemporary Ethiopian Artists]*, Zürich, Völkerkundemuseum der Universität, 1989, pages 65–86.

59. Taye Tadesse, *Short Biographies of Ethiopian Artists*, Addis Ababa, 1991.

60. The original course of study was five years, graduating with a diploma. The first three years focused on realistic drawing and painting, based on observation and the reproduction of objects and landscape. In the fourth and fifth years, students were free to experiment with modern styles and techniques (see Sydney W. Head, 'Conversation with Gebre Kristos Desta', *African Arts/Arts d'Afrique*, summer 1969, pages 20–25, and Elizabeth Biasio, 'Contemporary Painting', op. cit.). Major subjects taught included drawing, painting, woodcut and sculpture, with other subjects such as English and art history. After the rise of the Marxist dictatorship of the Derge, the course was reduced to four years. New subjects useful for political propaganda were introduced, such as graphic design and mural painting, in addition to photography, book illustration and ceramics.

61. See Achamyeleh Debela, Recollections, pages 248–49.

62. Few of Desta's work are in Ethiopia today. He left more than thirty paintings with his brother, with the wish that they should be repatriated to Ethiopia if a democratic government came to power. They are temporarily housed in the Staatliche Museum für Völkerkunde, Maximilianstrasse, Munich, and are in the process of being prepared for an exhibition and then returned to Ethiopia; personal correspondence with Girma Fisseha, Head of the Ethiopian Department, 1993.

63. Biasio, op. cit.

64. See Jeff R. Donaldson, Recollections, pages 249–51.

65. 'Wax and gold' refers to a poetic convention of writing simultaneously at two different levels. The wax is a metaphor for the outer layer of meaning, and gold for the inner and hidden meaning; see Jean Kennedy, *New Currents, Ancient Rivers: Contemporary African Artists in a Generation of Change*, Smithsonian Institution, Washington, D.C., and London, 1992, pages 123–41.

66. See Kennedy, ibid.

67. Wosene, 1993. See Recollections, page 247, for an artist's statement.

68. Biasio, op. cit.

69. For women artists active inside Ethiopia, see Elizabeth Biasio, 'The Burden of Women – Women Artists in Ethiopia', in *New Trend in Ethiopian Studies: Papers of the 12th International Conference of Ethiopian Studies*, New Brunswick, The Red Sea Press, and Michigan State University, 1994, pages 304–33. Kebedish is another rising artist, studying at Howard University; see unpublished paper by Omari, 1995.

70. Interview with the artist, Washington, D.C., October 1994.

71. See Bamidele Agbasegbe Demerson, 'Canvas and Computer Painting and Programming: Tradition and Technology in the Art of Acha Debela', *International Review of African-American Art*, vol. 10, no. 2, 1992.

72. See Wolde Seyoum, 'Some aspects of post-revolution visual arts in Ethiopia', *Proceedings of the 9th International Conference on Ethiopian Studies, 26–29 August 1986, Moscow*, Nauka Publishers, Central Department of Oriental Literature, 1988, pages 7–25, and Berit Sahlström, *Political Posters in Ethiopia and Mozambique: visual imagery in a revolutionary context*, Uppsala, 1990.

73. With the exception of Seyoum who seems, perhaps for political reasons, to take a non-critical view of these positions, Sahlström's is the only study on artistic development during the Derge era.

74. A book on Eritrean women artists by Patti Laduke is forthcoming in late 1995 from the Red Sea Press.

Moments in Art, pages 140–57

1. Hans Fransen, *Three Centuries of South African Art*, A. D. Donker, 1982.

2. *Tributaries: a View of Contemporary South African Art*, catalogue of the BMW Kultur Programm.

3. Ibid.

4. *Art From South Africa: a Catalogue*, London, Thames and Hudson, 1990.

5. A. Nettleton and D. Hammond-Tooke, eds., *African Art in Southern Africa*, A. D. Donker, 1989.

6. *Art From South Africa: a Catalogue*, op. cit.

7. *African Art in Southern Africa*, op. cit.

8. *Art From South Africa: a Catalogue*, op. cit.

9. Ibid.

10. *Three Centuries of South African Art*, op. cit.

11. *African Art in Southern Africa*, op. cit.

12. *Picturing Our World*, catalogue from the South African National Gallery.

13. *African Art in Southern Africa*, op. cit.

14. *Art From South Africa: a Catalogue*, op. cit.

Concrete Narratives and Visual Prose, pages 158–89

1. Johanna Agthe, *Wegzeichen, – Kunst aus Ostafrika 1974–89*, Museum für Völkerkunde, Frankfurt am Main, page 73.

2. Such as the Omani Arabs on the East African coast.

3. Kivuthi Mbuno, in *Wegzeichen*, op. cit., page 233.

4. Jak Katarikawe, in *Wegzeichen*, op. cit., page 210.

5. Jak Katarikawe, in *Wegzeichen*, op. cit., page 212.

6. *Wegzeichen*, op. cit.

7. Margaret Trowell lived and worked in Uganda from 1935 to 1957. She established art classes at Makerere College in the early 1940s; a three-year diploma course for teachers in 1949, and a four-year Diploma in Fine Arts in 1953.

8. Jonathan Kingdon, personal interview, Oxford, January 1995. Dr Hugh Trowell, a colonial medical officer first in Kenya and then in Uganda, was a nutritionist who became a parson after his retirement.

9. The University of East Africa grew out of Makerere University College in Uganda, Nairobi University College in Kenya, and Dar-es-Salaam University College in Tanzania.

10. Kiure Francis Msangi, 'The Place of Fine Art in the East African Universities', 18th Annual Meeting of the African Studies Association, San Francisco, 29 October–1 November 1975.

11. Fabian Mpagi, personal interview, Kampala, January 1995.

12. 'Universal Civilisations and Other Cultures', *History and Truth*, trans. Charles A. Kelby, Evanston, Illinois,

Northwestern University Press, 1965, page 278.

13, Francis Nnaggenda, personal interview, Makerere, Kampala, January 1995; see Recollections, pages 272–73.

14. Kefa Sempangi, section on Christian fetishes, *Makerere Art Gallery Catalogue*, ed. Jonathan Kingdon, 1985.

15. Kingdon was Head of Graphics and the renowned Kenyan sculptor Gregory Maloba was Head of Painting. Maloba had graduated from Makerere in 1945; studied at the RCA, London, 1956–57, and taught at Makerere 1945–66.

16. Jonathan Kingdon (RCA, London; Oxford); Ali Darwish (Zanzibar; Makerere; Slade, London); Taj Ahmed (Sudan; RCA, London; Saudi Arabia); Michael Adams (RCA, London; Seychelles), and Theresa Musoke (Makerere; Slade, London; Penn, Nairobi).

17. Pilkington Ssengendo, personal interview, Makerere, Kampala, January 1995.

18. Francis Nnaggenda, personal interview, Makerere, Kampala, January 1995.

19. Jonathan Kingdon, personal interview, Oxford, January 1995.

20. A student at Makerere 1983–87, Nabulima completed her M.A. in the early 1990s and currently teaches in the sculpture school.

21. Francis Nnaggenda, personal interview, Makerere, Kampala, January 1995.

22. Etale Sukuro, *Wegzeichen*, op. cit., page 145.

23. Joseph Murumbi was founder of the Kenya National Art Foundation and founding director of African Heritage Ltd.

24. Judith Von D. Miller, *Art in East Africa*, 1975, page 13.

25. When the East African community collapsed in 1970, art education at primary and secondary levels had been introduced, but fine art was still being offered only to a very small number of people at Kenyatta College (later incorporated into Kenyatta University College). The University of Nairobi continued to offer architecture and design, but competition for places at Kenyatta was stiff.

26. Nairobi at independence had two galleries: the Sorsbie Gallery (1960–63), presided over by artist-in-residence Elimo Njau (a Makerere graduate from Tanzania), housed in Lord and Lady Sorsbie's elegant small replica of the Versailles Grand Trianon in Muthaiga, Nairobi; and The New Stanley Gallery, located centrally in the New Stanley Hotel (1960–70), which fared rather better, being far more accessible. Gallery Africa replaced the New Stanley Gallery in 1970, but closed a year later. In addition, the Chemchemi Cultural Centre opened in 1963, lasting three years; its board went on to form Paa Ya Paa, which still exsists outside Nairobi, directed by Elimo Njau and his wife Phillida Njau. In 1969, three of the New Stanley's participating artists opened Gallery Watatu, which was bought by Ruth Schaffner and is Nairobi's foremost gallery of contemporary art. The Tyron Gallery (an extension of London's Tyron Gallery) opened in 1972, but does not appear to have exhibited work by indigenous East Africans. The East Africa Wildlife Society Gallery appears to have functioned largely as a resource centre for the society rather than as a fine art gallery. See Judith

Von D. Miller, *Art in East Africa*, op. cit., pages 40–44.

27. Hezron Watindi, 'The State of Art and Artists in East Africa, as exemplified in art dealership in Nairobi', paper given at 'An East African Artists' Workshop', Goethe Institute, Nairobi, Kenya, 1973.

28. Based in Malindi, Sarenco was formerly in partnership with Tanzini, an Italian entrepreneur with whom he developed Malindi Artists Proof.

29. Sheby Odipo, quoted by Etale Sukuro, in *Wegzeichen*, op. cit., page 147.

30. Daniel Miller, 'Primitive Art and the Necessity for Primitivism in Art', in Susan Hiller, *The Myth of Primitivism*, page 50.

31. Richard Onyango, *Salambo Nights*, Gallery of Contemporary East African Art, 1992, was an exhibition of a series of paintings that formed a visual diary, recording moments in his relationship with Drosie, his Danish lover, who had died tragically in a road accident.

32. The GSU is a governmental armed paramilitary organisation used to enforce 'public order'.

33. *Mwanainchi* means, literally, citizen.

34. Robert Atkins, *Artspoke*, New York, Abbeville Press, 1993; page 144.

35. Ngugi wa Thiong'o, *Decolonising the Mind*, James Currey/Heinemann, 1981, page 65.

36. Joel Oswaggo, quoted in *Wegzeichen*. op. cit., page 321.

37. *Wegzeichen*, op. cit., page 109.

Art and Nationalism in Colonial Nigeria, pages 192–94

Adapted from an article in the *Nsukka Journal of History*, 1, December 1989, pages 92–110.

1. Nnochi I. Okongwu, 'History of Education in Nigeria, 1842–1942', unpublished Ph.D. thesis, University of New York, 1946, pages 1–2.

2. Ola Oloidi, 'Onabolu, Pioneer of Modern Art in West Africa: an Introduction', unpublished MS, University of Nigeria, Nsukka, page 18.

3. See Ola Oloidi, 'Abstraction in Modern African Art', *New Culture: a Review of Contemporary African Arts*, vol. 1, no. 9, 1979.

4. Janheinz Jahn, *Muntu: the New African Culture*, New York, Faber and Faber, 1961, page 174.

5. Jeff R. Donaldson, 'African Influence on Black-American Art', unpublished lecture on fine arts criticism, Howard University, Washington, D.C., 1972.

6. S. A. J. Pratt, 'West African Art at Oxford', *Africana: the Magazine of the West African Society*, vol. 1, no. 2, April 1949, page 26.

7. Ola Oloidi, 'Growth and Development of Formal Art Education in Nigeria, 1900–1960', *Transafrican Journal of History*, Nairobi, Kenya, 1988.

8. E. A. Udo, 'The Methodist Contribution to Education in Eastern Nigeria, 1893–1960', unpublished Ph.D. thesis, Boston University, 1965, page 63.

9. Record of Sunday service (RSS), Catholic Mission, Agba, 29 September 1935.

10. Roman Catholic Mission, Esa Oke, 8 September 1935.

11. As note 10.

12. Olivia Vlahos, *African Beginnings*, New York, Viking Press, 1967, pages 231–60. For more information on

Islam and African art and culture, see Rene A. Brauwmann, *Islam and Tribal Art in West Africa*, London, Cambridge University Press, 1974, and John E. Means, 'A Study of the Influence of Islam in Northern Nigeria', unpublished Ph.D. thesis, Georgetown University, Washington, D.C., 1965.

13. D. Agoro, 'Aina Onabolu: Pioneer of Modern Art Tradition', unpublished B.A. thesis, University of Nigeria, Nsukka, 1980, pages 5–7.

14. Akinola Lasekan, 'Foundation of Nigerian Art', unpublished note, 1965.

15. Ola Oloidi, 'Onabolu, Pioneer . . .', op. cit.

16. Onabolu's visitors' book, London, 1920.

17. As note 15.

18. As note 15.

19. K. C. Murray, 'Art Teaching in Nigeria: Important Suggestions', unpublished notes, 1940.

20. K. C. Murray, draft of brochure for Zwemmer Gallery, London, exhibition of work by his Nigerian students, 1937.

21. As note 20.

22. D. Ajidahun, interview with Lasekan's wife, Owo, January 1980.

23. Information on Lasekan has come largely from his own private and unpublished documents.

24. Nnamdi Azikiwe, letter of recommendation to the Royal Society of Arts, London, 6 March 1962.

25. Nnamdi Azikiwe, letter to Lasekan, 18 October 1963.

26. Uche Okeke, from address delivered to the Zaria Art Society, October 1959.

The Essential Emokpae, pages 198–201

dele jegede would like to express his appreciation to those who assisted him in obtaining materials, without which this contribution would have been impossible. In particular, his appreciation goes to Obiora Udechukwu and Segun Ojewuyi, who responded to his plaintive pleas for help with incredible speed.

1. This is from a personal conversation that Eromosele Oniha had with Erhabor Emokpae in Lagos in 1973; see Odia Eromosele Oniha, 'Five Nigerian Modern Artists', unpublished B.A. thesis, University of Nigeria, Nsukka, June 1974, page 7.

2. Interview conducted with Yusuf Grillo by Segun Ojewuyi at the author's instigation, Ikeja, 8 January 1995. Immense gratitude is hereby expressed to Segun Ojewuyi for his tremendous assistance in facilitating this interview, as well as procuring other necessary materials for this essay.

3. Mathilda Obaseki Emokpae gives a personal account of the life and times of her husband in Nduka Nwosu, 'A Dual View on Erhabor Emokpae', *Daily Times*, Lagos, Saturday, 18 May 1985, page 5.

4. Erhabor Emokpae, in Cyprian Ekwensi, 'High Price of Nigerian Art,' *Nigeria Magazine*, no. 88, March 1966, page 4.

5. Although the Society ceased to function as an association after its members graduated, its manifesto is at the core of the works of two of its former members: Uche Okeke and Bruce Onobrakpeya. In addition to these two, the other members were Oseloka Osadebe, Emmanuel Odechukwu Odita, Ogbonaya Nwagbara, Simeon Obickezie Okeke,

Yusuf Grillo and Demas Nwoko.

6. Erhabor Emokpae, in Cyprian Ekwensi, 'High Price of Nigerian Art', op. cit. Emokpae painted at least two versions of *The Last Supper*. The one he refers to here belongs to Dr Moses Majckodunmi; the one illustrated on page 53 belongs to Colonel Ahmadu Yukubu. There are subtle differences in the arrangement of the elements.

7. See Chuks Iloegbunam, 'Tribute to Talent', *The Guardian*, Lagos, 11 March 1984, pages B1, B4, B7.

The Oshogbo Experiment, pages 202–7

Article adapted from B.A. thesis, Department of Fine and Applied Arts, University of Nigeria, Nsukka, June 1979.

1. Aduni Olabinpe, personal interview, Oshogbo, March 1978.

2. J. A. Adedeji, 'A profile of Nigerian theatre 1960–1970', *Nigeria Magazine*, 107/109, December–August 1971, pages 3–14.

3. Ibid.

4. Ibid.

5. Suzanne Wenger, personal interview, Oshogbo, March 1978.

6. J. A. Adedeji, op. cit.

7. Suzanne Wenger, personal interview, Oshogbo, March 1978.

8. Ulli Beier, 'Experimental Art School', *Nigeria Magazine*, 86, September 1965, page 199.

9. Suzanne Wenger, personal interview, Oshogbo, March 1978.

10. Jacob Afolabi, personal interview, Oshogbo, March 1978.

11. Jimoh Buraimoh, personal interview, Oshogbo, March 1978.

12. Twins Seven-Seven, personal interview, Oshogbo, March 1978.

13. Ibid.

14. Obiora Udechukwu, private communication, Nsukka, May 1979.

15. Demas Nwoko, personal interview, Nsukka, June 1978.

16. Chinua Achebe, personal interview, Nsukka, June 1978.

17. Uche Okeke, personal interview, Nsukka, November 1977.

18. Bruce Onobrakpeya, personal interview, Lagos, August 1978.

19. Ibid.

Natural Synthesis, pages 208–9

Article reprinted from Art Society, Zaria, October 1960.

Growth of an Idea, pages 210–11

Article reprinted from Art Society, Zaria, September 1959.

The Eye Society, pages 213–14

1. But see Bruce Onobrakpeya, Recollections, pages 195–97, where he states that the membership of the Zaria Art Society began and remained at eight.

2. M. Mount, *African Art: The Years Since 1920*, Bloomington, Indiana University Press, 1973, page 133.

The Painters of Poto-Poto, pages 219–21

Reprinted from *Présence africaine*, Special Edition, vol. I, 'L'unité des cultures nègro-

africains', Second Congress of Black Writers and Artists, Rome, 26 March–1 April 1959.

The Painters of the Dakar School, pages 222–23

1. *Tenq* means pin or joint, and is the title of the annual exhibition at the Village des Arts, Dakar.

Picasso en Nigritie, pages 228–30

1. Author's emphasis.
2. See Jean Leymarie, *Picasso, metamorphoses et unité*, page 54.

Art Against Apartheid, pages 234–35

The opening address by the President of the Association Nationale des Artistes Plasticiens du Sénégal (ANAPS) on 19 May 1986, on the occasion of the second Salon des Arts Plastiques, *Art Against Apartheid*, 23 May–23 June 1986, held at the Musée Dynamique, Dakar, Senegal. The exhibition was chaired by the President of the Republic and President in Office of the Organisation for African Unity, His Excellency Abdou Diouf, and his wife Elisabeth Diouf. Artists who took part were members of ANAPS, and non-members who had been selected by committee.

Art Against Apartheid, pages 236–37

Address by His Excellency the President of the Republic of Senegal at the inauguration of the Exhibition of Visual Arts organised by the Association Nationale des Artistes Plasticiens, Dakar, 23 May 1986.

African Proverbs of My Own Invention, pages 240–41

The translation from French by Salah M. Hassan attempts to remain faithful to the spirit of the artist's original text in terms of words and expression.

1. A literal translation of *con-texte*, conveying the sense of a marginalised text. But *con* may also convey its colloquial vulgar meaning in French, and the associated use of it as a pejorative adjective.
2. This is based on a French colloquial proverb, '*Qui va à la chasse perd sa place*,' meaning 'The one who leaves his or her place loses it.'
3. *Char* means tank, and *charité* contains the word *char*.
4. This proverb can also be translated, Hassan Musa suggests, as 'People die once, and Africans die twice; once of hunger and once of boredom.'
5. In translating *art-à-fric-âne* it is interesting to note that *à* conveys a sense of belonging; *fric* is a popular word for money, and *âne* means donkey. Yet Hassan Musa prefers it to be translated as 'Art-african-ism', a term he used in a performance he conducted in 1992.

The Crystalist Manifesto, page 242

The translation by Salah M. Hassan is based on the text published by Muhammad Hamid Shaddad in the catalogue of the exhibition *Tradition and Contempora(neity)*, part of the Third Cultural Festival at the Friendship Hall,

Khartoum, 1981. It attempts to remain faithful to the spirit of the original Arabic text, in terms of words and expressions.

1. The literal translation from Arabic is 'seas of poems'. Old Arabic metric (*Jahili*) poetry is classified into different types called *Buhur*, seas.

Artist's Statement by Skunder Boghossian, page 243

First published in *The International Review of African-American Art*, vol. 6, no. 3, 1985.

Gebre Kristos Desta: the Artist/Teacher, pages 248–49

Exerpt from 'A Pioneer in Spite of the Odds: Gebre Kristos Desta (1932–81)', unpublished manuscript, 1993.

1. Sydney W. Head, 'Art Exhibition of 40 Paintings by Gebre Kristos', *Ethiopia Observer*, 9 April 1966, pages 285–86.

AfriCobra and TransAtlantic Connections, pages 249–51

1. Jeff R. Donaldson, 'Ten in Search of a Nation', *Black World*, October 1970, page 80.
2. Ibid., pages 80–86.
3. In its early Chicago years, AfriCobra enjoyed extensive aesthetic interaction and joint formal presentations with the Association for the Advancement of Creative Musicians (AACM) and the Organization of Black American Culture Writers' Workshop (OBAC). The AACM, headed by Muhal Richard Abrams, included Thurman Barker, Anthony Braxton, Kalaparusha, Joseph Jarmon, Leroy Jenkins, Steve McCall, Leo Smith, John Stubblefield, Henry Threadgill and other prominent personalities in contemporary music. The OBAC Writers' Workshop was organised by Hoyt W. Fuller. Some of its better known writers included Johari Amini, Mike Cook, Sam Greenlee, Angela Jackson, Haki Madhubuti, Carolyn Rodgers and Sigmund Carlos Wimberli. Gwendolyn Brooks was also active and a spiritual mentor to this group.
4. Floyd W. Coleman, 'Toward an Aesthetic Toughness in Afro-American Art,' *Black Art – an International Quarterly*, vol. 2, no. 3, spring 1978, page 32.
5. Tritobia Benjamin, Introduction/Acknowledgements, *Universal Aesthetics: AfriCobra/Groupe Fromaje*, Gallery of Art, Howard University, 6 November–17 December 1989. Since CONFABA, virtually every major publication on African-American Art in the USA has been written and/or edited by CONFABA participants.
6. A. B. Spellman, 'The Pan Africanist Movement in Art', *The Washington Post*, 20 August 1978.
7. Salah M. Hassan, *The Art of Rashid Diab*, Museum of the National Center of African-American Artists, Boston, 1994, page 12.
8. Ibid., page 14.
9. Ibid., page 40.
10. Barbara Jones-Hogu, another AfriCobra founder, lives in Chicago but is no longer active.
11. The group has been extensively chronicled in art journals and print media such as *Art in America*, *The Black Collegian*, *Ebony Man*, *The Washington Post*, *The Chicago Tribune*, *The Atlanta Constitution*, among others. AfriCobra and/or individual members have been subjects

of dissertations at Northwestern University, the Sorbonne, Syracuse, Howard, Wisconsin, Emory and several other distinguished universities.

Paris in the Sixties, pages 254–56

Extract from 'Nigeria, France, Kenya 1957–1966', *Afrika My Music, an Autobiography 1957–1983*, Johannesburg, Ravan Press, 1984.

A Human Face: the Death of Steve Biko, pages 257–60

1. Jacques Derrida, 'Racism's Last Word', '*Race*', *Writing and Difference*, ed. Henry Louis Gates Jr, University of Chicago Press, Chicago and London, 1985.
2. Steve Biko, 'Black Consciousness and the Quest for a True Humanity', *I Write What I Like*, ed. Aelred Stubbs, Heinemann, London, 1978.
3. Steve Biko, 'On Death', *I Write What I Like*, op. cit.
4. Steve Biko, 'Black Consciousness and the Quest for a True Humanity', op. cit.
5. Mafika Gwala, 'Towards a National Culture', *Staffrider*, vol. 8, no. 1, 1989.
6. Matsemela Manaka, *Echoes of African Art*, Johannesburg, Skotaville Publisher, 1987.

The Writer as Critic and Interventionist, pages 266–68

The majority of this article is taken from *Ten Years of Staffrider Magazine 1978–1988*, ed. Andries Walter Oliphant and Ivan Vladislavic, Johannesburg, Ravan Press, 1988. The paragraphs about art come from a later interview on a wider range of subjects, which took place in 1995.

1. These essays by Lewis Nkosi have since been published under the title *Home and Exile*, Longman.

Makerere Art School, Kampala, pages 280–82

1. *The Art that Survives, Uganda, 1960s–1980s*, Africa Centre, London, January 1985. Wanjiku Nyachae notes that, unusually, the artists represented had the skills and opportunity to express themselves with integrity and with little censorship.

Notes, pages 284–308

1. *African Arts*, vol. 4, 1971, pages 36–38.
2. Kibacia Gatu, 'Development of material culture and education in Kenya – Post Independence', 1984, unpublished.
3. Sultan Somjee, *Material Culture of Kenya*, Nairobi, East African Educational Publishers, 1993.
4. Ibrahim N'Diaye, *Peindre est se souvenir*, Dakar, NEAS-Sépia, 1994; trans. E. Harney, 1998, page 65.
5. Ibrahim N'Diaye, op. cit., page 49.
6. University of Orange Free State, Bloemfontein, *Education and Manpower Development*, 1993.
7. Elsbeth Court, 'Pachipamwe: the avant garde in Africa?', *African Arts*, January 1994.
8. See, for example, *African Arts*, vol. 26, page 1; *Third Text*, vol. 23; *NKA*, vol. 1.
9. John Picton, *Oxford Art Journal*, 1992, vol. 15, page 2.

10. See Susan Vogel, *Africa Explores*, Section III, 'Urban Art: Art of the Here and Now'; Bogumil Jewsiewicki, 'Painting in Zaire: From the invention of the west to the representation of the social self', and Ilona and Johannes Fabian, 'Art, History and Society: popular painting in Shaba, Zaire', *Studies in the Anthropology of Visual Communication*, 1976, vol. 3, page 1.
11. B. La Duke, *Africa Through the Eyes of Women Artists*, Trenton, N.J., Africa World Press, 1991.
12. Documented in National Museum of Botswana, *Contemporary Bushman Art of Southern Africa*, 1991.
13. Mukomberanwa recalls his meeting with Frank McEwen in the *Chapungu Newsletter*, July 1994, pages 7–8.
14. In London there is a specialist exhibition centre for Zimbabwe stone sculpture; by appointment only, contact Felicity Wright, 22 Allington Street, London N1 8NY; tel. + fax. 0171-359 9225.
15. Musée Royal de l'Afrique Centrale, Tervuren, *La Naissance de la peinture contemporaine en Afrique centrale, 1930-70*, 1992, page 82.
16. The best reproductions are found in books that have texts in Japanese and Danish/Swahili, such as B. Kirknaes, *Hadithi na visa kutoka Tanzania*, UNESCO, Denmark and Tanzania, 1988.
17. Walter Elkan, 'East African Trade in Woodcarvings', *Africa*, vol. 28, 1958; J. D. Miller, *Art in East Africa*, London, F. Muller, 1975, pages 26–30.
18. See Johanna Agthe, *Wegzeichen – Kunst aus Ostafrika 1974–89*, Museum für Völkerkunde, Frankfurt am Main.
19. Elimo Njau was at Makerere Art School, Uganda, 1952–57; teacher at the Makerere University Demonstration School to 1962; part-time lecturer, Department of Fine Arts, Kenyatta University, during the 1980s, and juror for Zimbabwe Heritage 1986, 1987 and 1990.
20. Paa ya Paa Workshop catalogue with essays, December 1973; a grant was given by the Goethe Institute, Nairobi.
21. *Weekly Review*, Nairobi, 31 March 1995.
22. See E. Rankin, *Images in Wood: Aspects of the History of Sculpture in 20th Century South Africa*, Johannesburg Art Gallery, 1989.
23. Further accounts of some of these projects are available in: David Koloane, 'The Polly Street Scene', in A. Nettleton and D. Hammond-Tooke, eds., *African Art in Southern Africa*, A. D. Donker, 1989; S. Sack, 'Garden of Eden or political landscape?': Street art in Mamelodi and other townships', in ibid.; E. Rankin, *Images in Wood*, op. cit.; S. Williamson, *Resistance Art in South Africa*, London, David Philip, 1989; G. Younege, *Art of the South African Townships*, London, Thames and Hudson, 1988.
24. See W. Siegmann, 'Museums, War and Healing', *African Arts*, vol. XXVII, autumn 1994, pages 1, 6–8.
25. For Kenya, Tanzania and Uganda, see Judith Von D. Miller, *Art in East Africa*, 1975, pages 76–77, for a list of art on public display.
26. For a critical review of public sculpture in Zimbabwe, see M. Arnold, 'A Change in the Regime: art and ideology in Rhodesia and Zimbabwe', in Nettleton and Hammond-Tooke, eds., op. cit.
27. See Dennis Duerden, 'Letter from London', *African Arts*, autumn 1967.

Credits

The contributors and publishers would like to thank all those who kindly lent photographs and/or gave permission for the reproduction of illustrations and texts in this book. Every effort has been made to contact copyright holders; the Whitechapel Art Gallery apologises for any inadvertent omissions, and invites interested parties to contact it at the address on page 2.

The numbers refer to the pages on which illustrations fall.

Norbert Aas
57

Mohammed Ahmed Abdalla
108, 122, 123

ADEIAO, Paris
220 (both)

Fieke Ainslie
142

El Anatsui
58

Friedrich Axt
218 (right)

Sala Casset
235, 236

Peter Cattrell
72 (both), 89

Elsbeth Court
300, 302 (bottom)

DACS © 1995
228

Achamyeleh Debela
138

Clémentine Deliss
44, 45, 50 (both), 51, 53, 54–55, 56, 61, 62, 67, 69, 70, 71, 78, 80 (right), 82 (both), 90, 91 (both), 92, 93 (all), 94 (both), 95, 96, 101, 145, 151, 155, 160, 169, 174 (left), 177 (all), 182, 184 (left), 193, 195, 197, 200, 201, 203 (both), 204 (bottom), 209 (all), 211 (both), 212, 214, 218 (centre), 257, 259, 273 (all), 275, 277, 279, 280, 283, 284 (both), 285, 286 (both), 287

Rashid Diab
242 (top), 245 (all), 246 (all)

Guibril André Diop
81

Paul Fox
148, 254, 256

Gallery Watatu, Nairobi, Kenya
184 (right), 186, 187 (bottom)

The Goodman Gallery, South Africa
149 (both)

Jackie Grille
291 (bottom)

Salah M. Hassan
107, 111, 112, 118, 119, 137, 242 (centre), 243

Wadsworth Jarrell
249

Johannesburg Art Gallery
146 (both), 147, 150 (all), 156, 157

Jide Adeniyi Jones
204 (top)

Abdel Basit El Khatim
124

David Koloane
152–53, 262

Wosene Kosrof
104, 135

Robert Loder
296

Manufacture Sénégalaises de Tapisserie
224

Chris Moore
154, 166, 170–71, 172, 173 (both), 174 (right), 175, 176, 187 (top)

Hassan Musa
120, 121 (both)

Museum für Völkerkunde, Frankfurt-am-Main
185

Wanjiku Nyachae
168 (both), 178

Nkiru Nzegwu
31

Maria Obermaier
185

Chika Okeke
40, 49 (all), 59, 60, 63, 64, 66, 74, 75

John Pinderhughes
250

Reportage
235

Ibrahim El Salahi
116

Sarenco
183

Schmitz-Fabri
219

Bouna Médoune Seye
84, 85, 86 (all)

Sunmi Smart-Cole
198

Staatliches Museum für Völkerkunde, Munich
131, 133

Djibril Sy
80 (left), 97

El Hadji Sy
83, 87 (both), 88 (left), 98 (all), 100 (all), 221, 227, 232, 233

Obiora Udechukwu
47

Mansour Wade
218 (left)

Stephen Williams
302 (top)

Published in 1995 by
Flammarion
26, rue Racine
75006 Paris

* All captions marked with
an asterisk indicate works
exhibited.

ISBN: 2-08013-599-6
Numéro d'édition: 1046
Dépôt légal: September 1995

Printed and bound in Great Britain by
P. J. Reproductions, London